Asian American Art

A History, 1850–1970

Gordon H. Chang
Senior Editor

Mark Dean Johnson
Principal Editor

Paul J. Karlstrom
Consulting Editor

Sharon Spain *Managing Editor*

Stanford University Press Stanford, California

STANFORD UNIVERSITY PRESS
Stanford, California

© 2008 by the Board of Trustees of the
Leland Stanford Junior University. All rights reserved.

Published with assistance from the following institutions: The Getty
Foundation; National Endowment for the Humanities; San Francisco
State University; Office of the Dean, The School of Humanities and
Sciences, Stanford University

Library of Congress Cataloging-in-Publication Data

Asian American art: a history, 1850–1970 / Gordon H. Chang,
senior editor ; Mark Dean Johnson, principal editor ; Paul J. Karlstrom,
consulting editor ; Sharon Spain, managing editor.
 p. cm.
 Includes index.
 ISBN 978-0-8047-5751-5 (cloth : alk. paper)
 ISBN 978-0-8047-5752-2 (pbk. : alk. paper)
 1. Asian American art—19th century. 2. Asian American art—
20th century. I. Chang, Gordon H. II. Johnson, Mark Dean, 1953–
III. Karlstrom, Paul J. IV. Spain, Sharon.
 N6538.A83A835 2008
 704.03'95073—dc22 2007051705

Original printing 2008

FRONTISPIECE: Yun Gee, *Where Is My Mother*, 1926–1927 (detail, fig. 167).
PAGE VII: Yasuo Kuniyoshi, *Fisherman*, 1924 (detail, fig. 77).

Forms of Utang
Payback and Tribute
(In Filipino)

To give time to each artist in this publication would be our utang, *or ancestral offering.* Utang *is the Filipino word for "tribute" or "what you owe."* Utang, *the way my parents used the term, particularly when a member of the family died, took on a ceremonial aura. When it was used otherwise, there was a tone to it that carried an urgency; not to be taken lightly. For this publication, I offer an* utang *to the artists represented, as well as the people who made the book and the research material happen and appear.*

It means that succeeding generations of Asian American artists won't have to "recuperate" or "reinvent" themselves in the same way that I and other artists who preceded them have had to do to live in our times. It is for them to fill in and build upon this foundation, strengthening this historical document for future productions. Whether we are Asian American or not, as we study each piece, regard and contemplate social histories as well as aesthetic issues, and whether it shows or not, we should remember these images are in themselves individual monuments about personal pride amidst a time of fierce xenophobic hostility. The research of and the work in this publication makes me free. Every day that I think of those who have come before, I feel warmed from my utang.

Carlos Villa

Contents

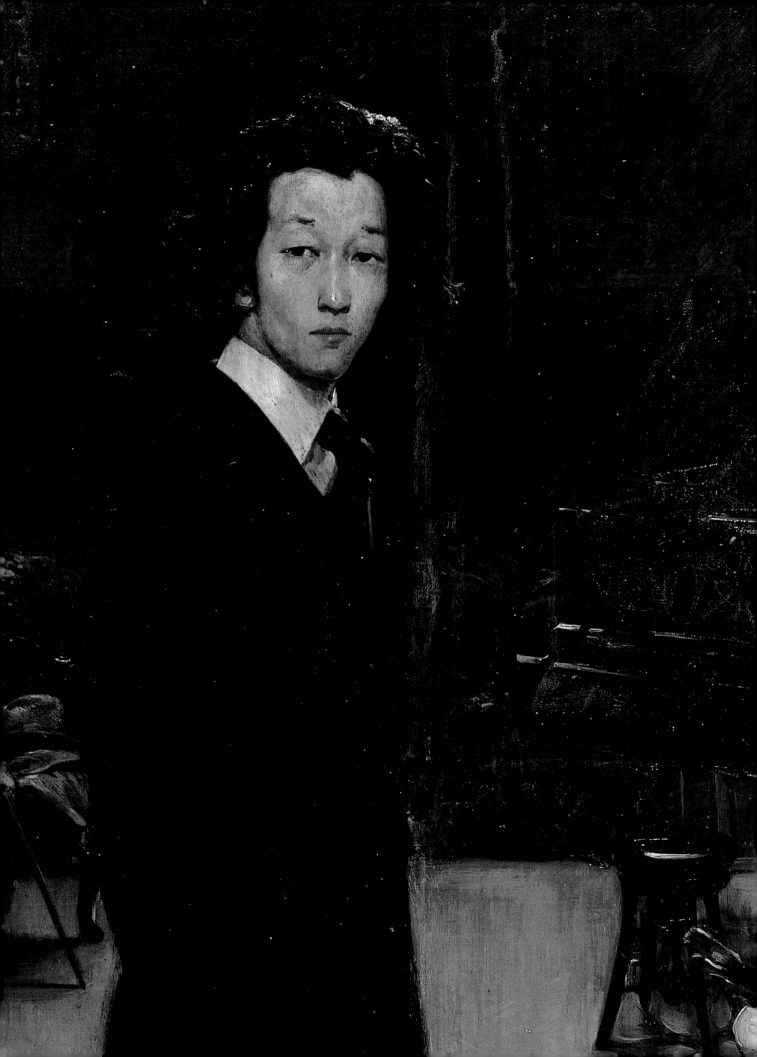

Emerging from the Shadows

Foreword The Visual Arts and Asian American History

Gordon H. Chang

Asian American art history, not to speak of work by contemporary Asian Americans, is being recovered from the shadows of neglect. Art produced by Asian Americans years ago is now gracing the covers of important new books.[1] Several major studies about the artistic production by Asian Americans in the past and present have appeared.[2] Historical exhibitions of work by Asian American artists also are now occurring regularly. Even though much of this work was created decades ago, the public has just rediscovered it and is beginning to give it due appreciation. The artwork has waited patiently to be seen again—it has been largely invisible before the public's very eyes for years.

Why has this treasure been outside our vision?

Both art historians and social historians might address this interesting question. I am not in a position to discuss at length the reasons that mainstream art criticism neglected to study Asian American artists, other than to state perhaps the obvious, which is that the history of Asian Americans, like that of other marginalized racial groups, commanded little

respect from any quarter of mainstream America. Although Asian Americans had been the objects of considerable popular and scholarly attention and speculation since their first arrival in the United States in large numbers in the mid-nineteenth century, sustained scholarship that seriously studied their lived experiences or their life as creative communities is a relatively recent development. This new attitude is a direct result of the rise of what is known popularly as "ethnic studies." Today, the study of "Asian American history" is a vigorous and growing field of investigation.

But the past scholarly neglect of Asian American art history does raise important questions of how and who determines what is "art" and who is an "artist" worth studying. These and many other questions related to art criticism, it seems to me, form a potentially large and rich area for discussion. A good number of Asian American artists in this volume received great acclaim, won prizes, and were commercial successes during their active careers, but they fell into oblivion over the years. For some, art critics and art historians never could quite understand how to label or characterize their work: Were the artists Americans, Asians, or some other sort of animal? Was their

Kyohei Inukai, *Self-Portrait*, 1918 (detail, p. 489).

artwork American, Japanese, Chinese, or something else? Oriental? Eastern?

Isamu Noguchi, arguably the most famous artist of Asian ancestry in America, is now widely celebrated. But during his lifetime, critics often didn't know how to refer to him. Even though he was born in the United States and spent most of his professional career here, critics often described him as Japanese, sometimes using epithets. New York critic Henry McBride dismissed him in 1935 as "wily" and predicted he would not amount to much in the public's eyes: "once an Oriental always an Oriental," he pronounced.[3] Dong Kingman, one of the most popular mid-twentieth-century artists in America, could not escape racial caricature, even when praised. "Bouncy, buck-toothed little Dong Kingman" was how *Time* magazine celebrated him in its pages in the 1940s.[4] Virtually all the other artists discussed in this volume suffered similar treatment during their careers. (One of the most bizarre may be the apparent caricature of famed painter Yasuo Kuniyoshi at the hands of author Truman Capote and film director Blake Edwards, who include a Japanese American artist, a Mr. I. Y. Yunioshi, in *Breakfast at Tiffany's*. Mickey Rooney's yellow-face portrayal of an obnoxious buffoon is one of the most racially repugnant in modern film history.) Aesthetic judgment in America was never race-free but was always racially constrained. Viewers could rarely free themselves from the assumption that art produced by persons who looked "Asian" somehow had to express something "Asian." Mainstream spectators assumed that racial or immutable cultural sensibilities indelibly marked artistic production. For many past observers, conscious or not, art was the trans-historical, transcendent materialization of race.

Kingman once commented on the confused and quixotic reaction to his art: "Western painters call me Chinese. Chinese painters say I'm very Western. I would say I'm in the middle." He also once observed, "Everyone writes that my work is half East and half West, that I'm in between." He himself wasn't quite sure what to think about this perceived "in-betweenness." "I don't know," he said. "I just want to be myself."[5]

But of course, Kingman and other Asian Americans could never be just themselves, unmarked by race, in America. Kingman in many ways endured the same ambiguities and challenges that Asians historically faced in the United States: not until 1965 did Congress lift the last of the immigration laws that overtly discriminated against Asians. The United States had deemed Chinese, Japanese, Koreans, Filipinos, and South Asians "aliens ineligible to citizenship" for much of the nineteenth and twentieth centuries. They could not become naturalized citizens. Dominant society marginalized Asians and believed it virtually impossible for them to become acceptable members of American life. Similarly, art produced by them was rarely considered "American." At best, their art was constantly subjected to the trope of being a bridge between "Eastern" and "Western" art. Though often said in a complimentary way, the evaluation still assumed that the mainstream of American art was, as America itself, entirely Europe-derived. At worst, they were simply dismissed or not taken seriously, as they were not European American.

Also necessary to note is that prevailing trends in art criticism influenced the way past art was viewed at a particular moment in time. The fascination with modern abstraction and nonrepresentational art, especially after World War II, turned public eyes away from art that appeared to have social messages or overt ethnic connections. Art produced by Asian Americans, other racial minorities, and women in America that displayed such markers now appeared nonmodern and was eclipsed by the interest in abstraction. Art that reflected the quandary of exile (such as that suffered by Chinese diasporic artists—Wang Ya-chen, Chang Shu-chi, and Chang Dai-chien, for example—in the mid-twentieth century), displacement (such as that experienced by

artists who worked in the United States during the height of racial antagonism, such as Yun Gee or Chiura Obata), and persecution (the Japanese artists who suffered internment, Eitaro Ishigaki and others, hounded because of their political beliefs) fell out of fashion. Painting techniques that appealed to abstract painters, such as calligraphy in the post–World War II period, interested some in America precisely because they could be used to pursue abstract, modernist purposes.

But one must also ask, why have historians dedicated to studying the Asian American past themselves neglected to appreciate the importance of art in Asian American lives? The historical work that Asian Americanists produced before the 1990s contains virtually no mention of Asian American art, the personal identities or experiences of any Asian American artists, or any sense of the place of art in the everyday lives of Asian Americans.

One might offer several explanations for this lacuna. For one, there is the historical circumstance of the emergence of Asian American studies. From its birth, this field of study was closely connected to the development of heightened racial and ethnic identity and self-assertion in America, and Asian American historians in the main attempted to reconstruct the broad outlines of this history to serve that political/ideological purpose. What is more, much of the early historical writing reflected an overriding interest in social history and in history viewed from the perspective of "from the bottom up." Evidence of mass political and social resistance to racial discrimination, laboring experiences, and social marginalization in America was given special place. Individuals, and certainly intellectuals, attracted less attention.

Art and art history, when it was considered, was often viewed as an elite, even elitist, realm, one that did not touch the lives of, and was irrelevant to, the laboring masses, the subject of much early Asian American historical imagination. Historians were interested in writing history that could help "claim America" for Asian Americans, that is, to show that Asian American experiences were an integral part of the social and political fabric of the country. They also hoped to help "claim Americanness" for Asian Americans, to assert that Asian Americans were as much American as others in the country. Asian Americanists hoped to end the stigma of perpetual foreignness placed upon people of Asian ancestry. One consequence of this effort was to downplay the transnational connections of Asian Americans and, somewhat ironically, the heritages from their lands of ancestry. Artists whose work may have displayed influences from East Asian art therefore fit less comfortably in the historical project.

But it may also simply be that Asian American art eluded attention because it is an especially challenging subject. The language of art and its interpretation (styles, themes, aims, and audiences, if one thinks of art as a "text") among Asian Americans is not easily approached. The artwork itself posed difficult questions, such as: Was it really possible to locate and define a body of art that might be called "Japanese American," "Chinese American," or even "Asian American"? How would one understand the relationship of these productions to "American art" or to "East Asian art"? Could one use established analytical tools and critical vocabulary to understand this art, or would new categories and approaches be needed? And, most of all, what "relevance" did all of this have to understanding Asian American lives in the past?

In recent years, there has been much greater understanding of the complexity of social identity in a highly racialized society. These days, the new recognition that identities are often multiple, contextual, hybrid, shifting, transnational, or unstable enables us to better appreciate the circumstances of Asian Americans past and present, including artistic production and intellectual work in general.[6] Such understanding helps us break the reification of categories such as "American" or "Eastern" art that

had been constructed over many years. In addition, scholars are moving beyond the laboring masses to view other social classes among Asian Americans.[7]

One might consider the study of Asian American literature in thinking about the emerging possibilities in Asian American art history. The examination of Asian American literature began simultaneously with that of the historical project. Like history, literary study was a way to understand identities, past and present, and as a way to reclaim voices that, like Asian American historical experiences themselves, had been marginalized or even buried by the dominant society. Asian American literature seemed to be an approachable subject: it is, as has been studied, a body of texts created by people of Asian ancestry living in America writing primarily in English. The characters, contexts, and issues in this literature also tend to be clearly related to America-based experiences. The dominant concern, at least as has been interpreted to this point, is the place of the Asian in American life and her or his understanding of America. Literary scholars could engage the formal and historical qualities of these English-language literatures directly; at the same time, they relatively quickly established a discourse of interpretation that engaged older Asian American work, and American literatures more broadly, with contemporary Asian American expression. The potential to do the same was not as clear in the visual arts. In fact, to many, Asian American visual arts in the 1970s and 1980s appeared detached from any ethnic inspiration or model from the past.

What might be the value of art history to historians of the Asian American experience?

To begin with, it appears that art and artists in fact occupied a very important position in the everyday lives of many Asian Americans. The number of Asian American artists alone is impressive. The biographical survey that appears later in this volume covers 159 artists in California, just a portion of the more than 1,000 artists documented in that state alone. This survey comprises the most extensive historical study of *any* occupational or professional group of Asian Americans. This recovery of hundreds of identities will become the starting point of countless numbers of future projects in a wide variety of disciplines and interests.

One might even argue that the visual arts were a uniquely attractive and important avenue of expression for creative Asian Americans in the past. This may have been so for a variety of reasons: ancestral traditions that highly valued visual arts; freedom from the demands of English fluency that writers faced; and mainstream interest in Asian aesthetics (Asian American artists were seen as embodying an "Oriental" talent) all may help account for the relatively large number of Asian American artists.

And apart from the artists themselves, the prominent place that the visual arts occupied in the daily lives of many Asian Americans is striking. Art production, its display in the home and community, its enjoyment in individual and in organized ways, and its celebration were all highly popular activities in Asian American communities ever since their arrival in the United States in the mid-nineteenth century. For example, Yamato Ichihashi, a Stanford history professor who studied Japanese Americans, once claimed when he was in a World War II internment camp that the Japanese were the most artistically inclined people in the world. His comment, though certainly chauvinist, did in fact highlight the special place that the display and appreciation of the arts occupied among Japanese Americans. His internment camp diary is filled with references to and descriptions of art classes and exhibitions. During incarceration, he himself spent many hours with a painter friend.[8] Important Asian American cultural figures such as Younghill Kang, Mine Okubo, Jade Snow Wong, and Chiang Yee are known mainly for their published writing, but they devoted as much or even more of their lives to art. In rereading local histories and old accounts of Chinese Americans, one is

struck by the frequent mentions, brief and undeveloped as they usually are, of painting and the arts in community activities.[9]

Can one even go so far as to suggest that, given the number and productivity of Asian American artists, the special place accorded art by many people of Asian descent, and the connections of these artists with the general American art world (unacknowledged as they have been), the visual arts are an especially rich site for study of Asian American experiences? As a site of cultural and social expression, might visual art even be considered for Asian Americans akin in importance to the central place that music occupies in the African American experience? Might it be that Asian Americans have made special and unique contributions to the visual arts?

A number of other areas of study of Asian American life may benefit from a greater appreciation of the visual arts:

THE ARTWORK AND CAREERS of the artists themselves offer fresh material to enlarge our understanding of Asian American social and intellectual history. If we understand this art as social as well as personal expression, it can help us gain insights into a wide variety of subjects, such as identity formation and projection, felt experience, perceptions of racial and ethnic identity and place, the texture of daily life, and intellectual and personal interaction with other communities, both white and minority.

ART HISTORY CAN LEAD to greater understanding of the internal organizational and institutional dynamics of Asian American communities, especially art clubs and societies, festivals, and even commerce (the ubiquitous art and curio stores, and galleries) and the business of art.

ART, IN ITS MANY FORMS, often played an important role in the daily lives of Asian Americans. Art, for many, was not something distant or only for the "privileged" but was an important and integral element in the home, family, and community. This recognition helps us begin to recover a sense of the actual lived experience of Asian American lives.

ART MAY LEAD US to better understand the forms of political expression. Some artists were thoroughly apolitical and detached from social activism, but a great many of the artists mentioned in this volume were profoundly affected by contemporary social movements and participated as artist activists. Asian American artists such as Yasuo Kuniyoshi and Yun Gee strongly opposed Japanese aggression in Asia during the 1930s and 1940s. Eitaro Ishigaki and Isamu Noguchi used their art to protest American racism. In the 1960s and 1970s, Lewis Suzuki, Nanying Stella Wong, Mitsu Yashima, and, of course, many younger Asian American artists used their creative talents to oppose the Vietnam War.

ASIAN AMERICAN ART OFFERS the exciting possibility of viewing the *familiar*, such as places, people, and life experiences, in *unfamiliar* ways, of seeing America with "new eyes." Chiura Obata's *Setting Sun: Sacramento Valley* (see Mark Johnson's essay, fig. 10) and Chang Dai-chien's vision of Yosemite, *Autumn Mountains in Twilight* (see page xiv), offer fresh perspectives on the American landscape. We might gain new ways of understanding how others in the past have viewed traditional themes such as the "West," man and nature, the city, and, of course, race. Asian American art also might reveal the *unfamiliar* (at least for many other Americans), such as the internment experience or the attachment to heritage prompted by exile and social alienation.

THIS ARTWORK ALSO ENCOURAGES us to think about the many ways that cultural influences from Asia have influenced America. T'eng K'uei (Teng Baiye) came from China in 1924, studied art at the University of Washington in Seattle, did graduate work at

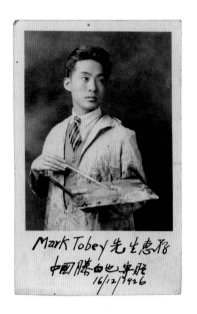

Portrait of T'eng K'uei with dedication to Mark Tobey, 1926.

Harvard University, then returned to China in 1931. While living in the Seattle area, he became friends with Mark Tobey and gave Tobey early lessons in Chinese brushwork. One of the great influences on Tobey's own work was a trip to China and Japan in 1934, during which time he visited T'eng K'uei in Shanghai and attended lectures and classes with his friend. How have artists such as T'eng K'uei been creative agents of this influence? How did they actively explore aesthetic interaction? In what ways have Asian American artists themselves been cultural translators, transmitters, or interpreters?

THE WAYS THAT DOMINANT SOCIETY received and understood Asian American artists may lead to new ways of understanding the dynamics of race and racial ideologies in America.

* * *

ALL IN ALL, REGARDLESS OF whatever importance Asian American art may have for the future understanding of history, these newfound artifacts from the past, these wonderful creative expressions, can now be enjoyed once again as their creators had intended: as works of emotion, of beauty, of protest, of intellectual engagement, or deeply personal sentiment. These works of art can speak to us across the divide of time. There is no Asian American aesthetic to which a work must adhere to be appreciated.[10] Exactly how we will view these works will depend on how receptive we are to challenges to our assumptions about "American art," "modern art," "Asian art," and even about Asian Americans themselves.

Chang Dai-chien, *Autumn Mountains in Twilight*, 1967. Mineral pigments and ink on paper, 75⅝ × 40¾ in.

Notes

The author thanks Mark Johnson, Valerie Matsumoto, and Sharon Spain for their help with this foreword.

1 A photograph from San Francisco Chinatown's May's Photo Studio is on the dust jacket for Yong Chen, *Chinese San Francisco, 1850–1943: A Trans-Pacific Community* (Stanford: Stanford University Press, 2000); a painting by Jade Fon Woo is on the front of Lon Kurashige and Alice Yang Murray, eds., *Major Problems in Asian American History* (New York: Houghton Mifflin, 2003); a Jack Chikamichi Yamasaki painting is reproduced on Mae M. Ngai, *Impossible Subjects: Illegal Aliens and the Making of Modern America* (Princeton: Princeton University Press, 2004); and a Henry Sugimoto painting is reproduced for Brian Masaru Hayashi, *Democratizing the Enemy: The Japanese American Internment* (Princeton: Princeton University Press, 2004).

2 For multi-artist studies, see, for example, Deborah Gesensway and Mindy Roseman, *Beyond Words: Images from America's Concentration Camps* (Ithaca, NY: Cornell University Press, 1987); Michael D. Brown, *Views from Asian California, 1920–1965* (San Francisco: Michael D. Brown, 1992); Alice Yang, *Why Asia? Contemporary Asian and Asian American Art* (New York: New York University Press, 1998); Margo Machida et al., *Asia/America: Identities in Contemporary Asian American Art* (New York: The Asia Society Galleries, 1994); Amy Ling, ed., *Yellow Light: The Flowering of Asian American Arts* (Philadelphia: Temple University Press, 1999); Elaine H. Kim (with Margo Machida and Sharon Mizota), *Fresh Talk/Daring Gazes: Conversations on Asian American Art* (Berkeley and Los Angeles: University of California Press, 2003); Jeffrey Wechsler, ed., *Asian Traditions/Modern Expressions: Asian American Artists and Abstraction, 1945–1970* (New York: Abrams in association with the Jane Vorhees Zimmerli Art Museum, Rutgers, the State University of New Jersey, 1997); Irene Poon, *Leading the Way: Asian American Artists of the Older Generation* (Wenham, MA: Gordon College, 2001); and Karin M. Higa, *The View from Within: Japanese American Art from the Internment Camps, 1942–1945* (Los Angeles: Japanese American National Museum, 1992). Studies on individual artists are also increasing.

3 Quoted in Masayo Duus, *The Life of Isamu Noguchi: Journey Without Borders*, trans. Peter Duus (Princeton: Princeton University Press, 2004), 151–152.

4 "Dashing Realist," *Time* 46, no. 10 (September 3, 1945).

5 Quoted in Leonard Slater, "Sight and Sound," *McCall's*, September 1961, 12; and "Meeting of East & West," *Time* 53, no. 16 (April 18, 1949).

6 See, for example, the essays in Wanni W. Anderson and Robert G. Lee, eds., *Displacements and Diasporas: Asians in the Americas* (New Brunswick, NJ: Rutgers University Press, 2005); Lane Ryo Hirabayashi et al., eds., *New World, New Lives: Globalization and People of Japanese Descent in the Americas and from Latin America in Japan* (Stanford: Stanford University Press, 2002); Lisa Lowe, *Immigrant Acts: On Asian American Cultural Politics* (Durham, NC: Duke University Press, 1996); and David Palumbo-Liu, *Asian/American: Historical Crossings of a Racial Frontier* (Stanford: Stanford University Press, 1999). An example of an emerging trans-Pacific intellectual history is August Fauni Esperitu, *Five Faces of Exile: The Nation and Filipino American Intellectuals* (Stanford: Stanford University Press, 2005).

7 Bert Winther-Tamaki, *Art in the Encounter of Nations: Japanese and American Artists in the Early Postwar Years* (Honolulu: University of Hawai'i Press, 2001).

8 Gordon H. Chang, *Morning Glory, Evening Shadow: The Internment Writing of Yamato Ichihashi, 1942–1945* (Stanford: Stanford University Press, 1995). The painter was Ernest Kare Kuramatsu, who had lived in the Monterey Bay area of California.

9 See, for example, Lisa See, *On Gold Mountain: The One-Hundred-Year Odyssey of a Chinese-American Family* (New York: St. Martin's Press, 1995). Also see photographs of building interiors reproduced in Arthur Bonner, *Alas! What Brought Thee Hither? The Chinese in New York, 1800–1950* (Madison, NJ: Fairleigh Dickinson University Press, 1997); and Marie Rose Wong, *Sweet Cakes, Long Journey: The Chinatowns of Portland, Oregon* (Seattle: University of Washington Press, 2004).

10 For a contemporary discussion, see "Is There an Asian American Aesthetics," chapter 30 in *Contemporary Asian America: A Multidisciplinary Reader*, eds. Min Zhou and James V. Gatewood (New York: New York University Press, 2000), 627–635.

Beyond East and West

Introduction Artists of Asian Ancestry in America

Mark Dean Johnson

This publication turns a bright light on the great history of Asian American art, too long hidden in shadow. Although still far from exhaustively complete, the current volume represents the most comprehensive survey of the field to date. It looks at the period from the gold rush to the historic 1965 Immigration Act, and beyond; explores several of the hottest spots of urban cultural production in the continental United States; and exhumes the careers of more than two hundred artists—most of whom are seen here for the first time in many decades, some in more than a century.

Our title, *Asian American Art: A History, 1850–1970*, requires explanation. Although our focus for this volume is the exploration of fine art produced by persons of Asian ancestry in America, the artists active in the period being reviewed most likely would not have identified themselves as "Asian American." Indeed, that phrase was only first coined in 1968.[1] But these two words summon forth the diverse communities that are today commonly grouped under this rubric. Use of this term has two important consequences. First, it links this study to understandings

of contemporary Asian American art and suggests myriad ties between a seemingly remote past and more recent expressions. Second, it clearly points to our focus on the study of race and ethnicity in the United States in relation to art and culture.

Race and ethnicity are now understood to be core issues in American history and studies. Certainly, race has explosive implications in many aspects of American politics, and the specificity of legislation that impacts Asian communities—including immigration, full citizenship, and civil rights —should be remembered as an important backdrop for appreciating artists' activities discussed here. And while this book does not focus explicitly on the humiliations or violence these artists endured, an oppressive atmosphere of societal racism affected virtually every one of them.[2] Also important to note is that the predominant representation of persons of Chinese and Japanese ancestry and, to a lesser degree, of Filipino and Korean ancestry in this volume reflects the demographics of the time, but it does not match the far more diverse Asian American population of the United States today, which includes people of Southeast Asian and South Asian ancestry. And, while the practice is well understood within the

Tseng Yuho, *Silent Action*, 1955 (detail, fig. 175).

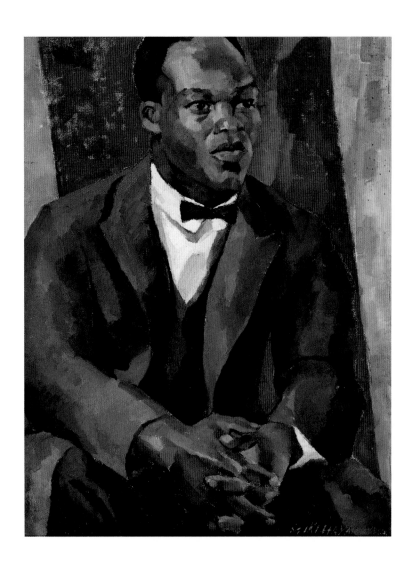

Miki Hayakawa, *Portrait of a Negro*, 1926.
Oil on canvas, 26 × 20 in.

discipline of Asian American studies, our grouping together diverse nationalities separated by distinct language and cultural expression does not indicate that we mean to collapse the very real differences between these communities—even though we will see that the arts became a place for interethnic association, as evident in the paired portraits by Miki Hayakawa and Yun Gee (this page and next).

Race, ethnicity, and national origin also have meaningful relationships to Asian American cultural expression in ways too numerous to detail in this brief introduction. The incredible range of stylistic explorations and participation in the broader art world defies an easy enumeration of themes, beyond underscoring that there is no "one" Asian American art or a single approach to its appreciation. We can only highlight a few of the more salient here. While many artists were engaged in Western modes

of expression, others forged a more self-consciously hybrid path. Art education, in both ideological theory and practical training, that individuals received in Asia and/or the United States impacted artistic production in complex ways. This background is compounded by one's generational relationship to immigration,[3] as some cultural priorities and understandings may be transformed and reinterpreted over time. Nevertheless, much of this work contains a sense of subtle and unexpected exploration of both the high cultures associated with Asian models and the international modernism generally associated with Europe—and everything in between. The result is a multidimensional matrix that unfortunately has become codified as a straightforward polarity of "East and West." We can see the play of popular culture in some of these artists' work, such as the influence of origami, *manga*, and animation. There is also rich

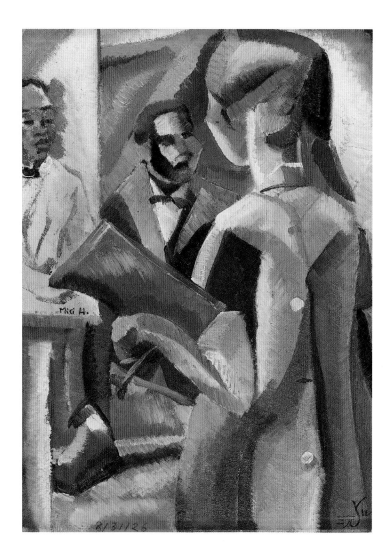

Yun Gee, *Artist Studio*, 1926.
Oil on paperboard, 12 × 9 in.

evidence of broader community engagement and support of the arts. This involvement is visible in the activities at alternative exhibition spaces, the formation of art clubs and schools, the support of political associations, and the dialogues about art initiated in newspapers and journals. And while distinction in printmaking, ink painting, and ceramics might be expected from artists with an interest in reflecting Asian heritage, leadership in nonobjective painting and sculpture and the developing media of photography demonstrates a commitment to contemporary innovative exploration. Distinctive in many ways from the political and visual art histories of other marginalized or minority communities, yet sharing much with both these and mainstream trajectories, this volume is meant to initiate dialogue and spark new interpretive and comparative scholarship.[4]

By beginning our chronicle in the earliest peri-

ods of artistic production during the mid-nineteenth century, our intention is to present a historic lens for the study of Asian American art. And, as Asian immigrants generally came first to the West Coast, this volume also explores the geographic emergence of artists and art production first from this region. This directional orientation stands in marked opposition to most conventional American art histories that grow out from the East Coast, reflecting European immigration to the United States.

Our project is also specifically grounded in a primary research initiative, developed over more than ten years, as a partnership between San Francisco State University and the Smithsonian Institution's Archives of American Art, Stanford University, and the University of California at Los Angeles. One intended outcome of this long-term research initiative was the reconstruction of professional biographies

for California Asian American artists active before 1965—a date deliberately selected to reflect artistic activity prior to the major change in immigration after that year.[5] Of more than 1,000 artists who were identified during research, 159 are represented by biographies included in this publication. The names of artists whose careers are profiled in this biographical section appear in boldface the first time they are mentioned in each section of the text. An accompanying chronology that spans 1850 through 1965 places their achievements in a broader historical context. The sheer quantity of artists contradicts the stereotype that early generations of Asian immigrants were important only as laborers, as in the building of the transcontinental railroad or in agriculture. In his foreword, Gordon Chang explores the gap generated by this erroneous assumption, ironically constructed in part by Asian American scholars who have worked to document labor history at the exclusion of highlighting a cultural profile. Another outcome of the research initiative was the development of the ten interdisciplinary essays that comprise this book's principal text. These essays were developed after several colloquia hosted by Stanford University's Research Institute for Comparative Studies in Race and Ethnicity and the Stanford Humanities Lab, involving the present authors and many other distinguished scholars.[6]

The ten essays represent both interdisciplinary and international perspectives. They draw upon American history, American studies, American art history, and Asian art history to provide a wider arena for the contextualization of these diverse artistic achievements. A reflection of the global web of transnational culture that is among the principal hallmarks of much art since the late nineteenth century, this study tackles American examples by exploring the developments in several cities where historically significant production was centered, as well as alternately focusing on media, style, gender, and historical moment.

In the first essay, this author recalls the rich Asian American cultural history in San Francisco, an epicenter of Asian immigration and artistic production from the gold rush up to World War II. In the second, Karin Higa points to the sophisticated network that connected Los Angeles's Little Tokyo to an international avant-garde during the period between the two world wars. Kazuko Nakane in the third essay chronicles several generations of artists in her survey of Seattle's Asian American art community and further demonstrates how these artists were embraced to shape that city's conception of its own artistic identity. In the fourth essay, Tom Wolf provides an exciting introduction to early Asian American artists in New York, where several artists, rivaling the preeminent figures of their day, achieved a high degree of recognition for their innovative contributions. The dramatic tear in the fabric of time that World War II produced is suggested in several essays, and the impact of the war and its cold aftermath on artists of diverse ancestry is the principal topic of Gordon Chang's essay, number five. The brilliantly pioneering and unparalleled contributions to photography by Asian American artists, including the stylistic artistry of pictorial, modern, and community-based orientations, is presented by Dennis Reed in the sixth essay. Valerie Matsumoto chronicles the uniquely difficult situations that impacted women artists in California, otherwise separated by class, generation, and family responsibilities, in the seventh essay. Mayching Kao offers a Chinese perspective in the eighth essay to help illuminate approaches that are generally unfamiliar in the West, identifying acclaimed diasporic painters and more obscure artists who participated in both mainstream and ethnic-specific artistic dialogues. In the ninth, using oral history as a guide, Paul Karlstrom reflects on California post–World War II developments to probe the specificities of an Asian American modernism. Finally, in the tenth essay, Margo Machida returns to the San Francisco Bay Area—the site of

the founding of Asian American studies—to explore the moment of the conceptualization of both an Asian American art and an Asian American identity that connects to our contemporary, postmodern understanding of the international art world.

These diverse methodologies are not meant to be prescriptive; instead, they suggest a potential range of approaches to this great wealth of material. As in any anthology, they provide only partial glimpses of the larger subject. In this case, they also reflect the West Coast bias of the research that is the foundation of this publication. Together, the essays add insight into many historical periods, complementing publications that focus on post–World War II and contemporary developments. This volume further questions the ways in which visions of our national heritage have been limited by restrictive ideas about art. At the same time that we acknowledge that in many cases first-generation immigrants served as ambassadors of Asian culture for the burgeoning curiosity here, among the most troubling themes we find is the racially essentialized notion of a fixed, foreign, and even backward Asian tradition and personality that was somehow hardwired into artists of Asian ancestry. As we remember that European training was commonly available in Asia even in the nineteenth century, and that stylistic developments in ink on paper were generally as innovative as those in oil on canvas, we can expand our appreciation of the work we encounter as international and decidedly modern.

Our research also has uncovered how the appreciation of Asian American artwork has been hindered. Wars, earthquakes, and internment were destructive forces. In addition, stories abound of entire bodies of work being lost during international transit. Legislation that curtailed immigration by women from Asia and anti-miscegenation laws created a "bachelor society" that limited the potential for the safeguarding of materials by families. The relative difficulty in locating important information

buried in Asian language journals, compounded by the transformation of language over time, further limited access. The return migration of some artists to Asia and lingering perceptions at all levels of American society that these individuals weren't "American" also contributed to erasure. Even today, works by such artists as Ruth Asawa, Chiura Obata, and C. C. Wang—who spent their entire careers in the United States—sometimes appear in auctions of "Asian" art. We have repeatedly seen the impact of the deaccession of many works from museum collections by artists once recognized as important but subsequently viewed as out of step because of a lack of contextualization.[7] Without such institutional context, many collections were discarded and lost. This publication joins others to help construct a framework and context for further retrieval and interpretation.

In addition to the interpretive essays, artists' biographies, and art/history chronology, a major component of this publication is the reproduction of approximately two hundred works of art in all media created by these artists. The reproductions range from selections by artists for whom large bodies of work exist to artworks that might be the only extant examples of work by an artist; still others are reproductions of previously reproduced imagery of works whose whereabouts are unknown. Furthermore, some works reproduced here have not been cleaned or conserved. Reproduced in the biographies and chronology are approximately one hundred eighty additional images that include portraits of the artists, period photographs, and newspaper or journal illustrations. We hope these illustrations help revivify both the artists and their times.

Although dense with detail and complicated by multidisciplinary analysis, our story is still far from complete, and lacunae abound. Perhaps most glaring is the absence of an extended discussion of artists in Hawaii, which was a U.S. territory since the turn of the twentieth century before becoming a state in

1959. Certainly, artists active there in the period before statehood, including Hon Chew Hee, Toshiko Takaezu, and Isami Doi, are critical to understanding the national Asian American artistic scene.[8] Another area not covered in this volume is the New York art scene of the 1960s, when Yoko Ono, Natvar Bhavsar, and so many others contributed to global art activity.[9] Many other writers and artists, such as Okakura Tenshin in Boston and Takuma Kajiwara in St. Louis, warrant further study for a fuller national survey.

Artists included here were painters, sculptors, printmakers, photographers, textile artists, and ceramicists who were active for roughly a decade or more in the United States, recognizing that citizenship was denied Asian-born immigrants before the mid-twentieth century and, as a result, many artists eventually returned to their country of birth. While some may be surprised that diasporic artists who arrived after mid-century, such as Chang Dai-chien, whose work is predominantly "non-Western" appear here within the rubric of "American art," it is important that we expand our lens and understanding to reflect their internationalism and the reciprocal influences that their work in fact reflects. We focus for the most part on the period prior to the Immigration Act of 1965, as this date marks both an explosion of the Asian population in the United States and a blossoming of a civil rights consciousness that gave rise to an Asian American political and artistic movement that transformed what came after. Our goal is to retrieve what came before.

The ten-year-residence criterion we employed means that this volume omits many influential figures who participated at high levels in American art circles but who never maintained permanent residences in the United States. Examples include Long Chin-san,[10] renowned for his experimental montage photographs, who traveled and exhibited in the United States for many decades and was honored by the Photographic Society of America in 1937; and Hamada Shōji, who led influential workshops throughout the West that helped revolutionize American ceramics in the 1950s. Countless accomplished others who contributed to American culture throughout their careers as floral designers (including ikebana), landscape gardeners, calligraphers, architects, filmmakers, and designers—in art forms not conventionally privileged as "fine arts"—are also missing from this account. We await further explorations with great anticipation.

Our goal is to suggest a radical reenvisioning of Asian American art to include a long view of its own history. Through ten essays, hundreds of reproductions, 159 artists' biographies, and a detailed chronology, *Asian American Art: A History, 1850–1970* offers an array of information about and new approaches to the appreciation of art produced by artists of Asian ancestry in the United States. We hope the magnificence of the many constellations that appear within these pages provides sources for future discovery, appreciation, and dialogue as the field of Asian American art continues to expand and inspire.

Notes

The author wishes to thank Gordon Chang, Sharon Spain, and Paul Karlstrom for their feedback in developing this introduction.

1 The term *Asian American* is generally credited as having been coined in 1968 by Yuji Ichioka at the University of California, Berkeley, at the start of academia's burgeoning interest in ethnic studies.

2 There are too many instances of racially motivated harassment to fully enumerate and detail here. Examples can be cited from every generation. Lai Yong's and Mary Tape's activism points to their struggle to win social equity during the nineteenth century. Yoshio Markino's chronicle of verbal slights and physical assaults parallels Chiura Obata's description of being spat upon and

struck as he walked down the street around the turn of the twentieth century. Both Mitsu Yashima and Hisako Hibi encountered difficulties locating housing for rent in the mid-twentieth century. The physical assault of James Leong left him blind in one eye. Countless examples of marginalization also can be cited.

3 In the preface to the exhibition catalog *With New Eyes: Toward an Asian American Art History* (San Francisco: Art Department Gallery, San Francisco State University: 1995), author and cultural critic Maxine Hong Kingston argues that such commonly used Japanese terms as *Issei, Nisei,* and *Kibei* can be applied in a broader way across Asian American ethnicities to help understand different generations of artists' relationships to immigration and education.

4 This publication does not cover the vast influence of Asian artistic forms on American art; nor does it cover Caucasian American artists who lived, studied, or worked in Asia.

5 The "California Asian American Artists Biographical Survey," originally a project of San Francisco State University in cooperation with the Smithsonian Institution's Archives of American Art, funded in part by the National Endowment for the Humanities, is further discussed by Sharon Spain in her remarks introducing the biographies in this volume.

6 In addition to the authors represented in this volume, such scholars and artists as Michael Sullivan, Kuiyi Shen, Richard Vinograd, Bryan Wolf, Rae Agahari, Darlene Tong, Irene Poon Andersen, Tim Yu, Cecelia Tsu, Wei Chang, Daniell Cornell, Carlos Villa, Shelley Sang-

Hee Lee, Bruce Robertson, and Ilene Susan Fort participated in these colloquia and related discussions.

7 Examples include the deaccession of works by Hideo Date, Yoshida Sekido, and Walasse Ting by such museums of "Western art" as the Whitney Museum, the San Francisco Museum of Modern Art, and the Minneapolis Institute, respectively; the deaccession of work by Chang Dai-chien by Pasadena's Pacific Heritage Museum is an example from an Asian art museum.

8 Marcia Morse provides a partial history of developments in Hawaii relating to Japanese American artists in an essay in the catalog that accompanied the exhibition *Legacy: Facets of Island Modernism* (Honolulu: Honolulu Academy of Arts, 2001). An extensive biographical article about Isami Doi by David Hehlke appears in the Honolulu journal *Bamboo Ridge,* no. 73 (Spring 1998).

9 Yoko Ono first arrived in the United States in 1935, when she joined her father in San Francisco, but she went back to Japan after a few years. She returned for another year in 1940–1941, this time to New York, and then moved in 1953 to Scarsdale, New York, where she attended Sarah Lawrence College and became active in New York City, which led to her involvement with the Fluxus group by the late 1950s. Natvar Bhavsar arrived in the United States in 1962.

10 Although the artist exhibited throughout the United States as Chin-san Long, he is known throughout the Chinese world as Long Chin-san. Sharon Spain explores more fully the complex issue of name order in the introduction to artists' biographies in this volume.

Asian American Art

A History, 1850–1970

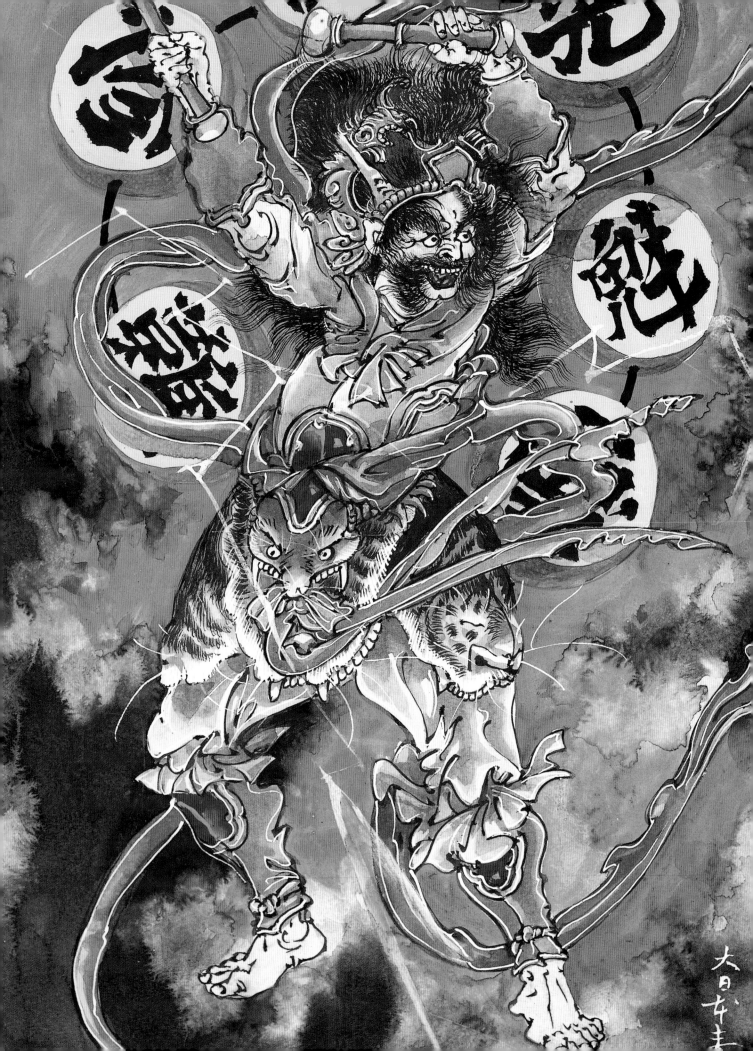

Uncovering Asian American Art in San Francisco, 1850–1940

Mark Dean Johnson

RECONSTRUCTING
PRE-EARTHQUAKE SAN FRANCISCO

The American West Coast cities of Honolulu, Los Angeles, San Francisco, and Seattle all reflect historically strong Asian populations and cultural profiles. But San Francisco may be unique for the degree to which it has embraced an Asian cultural identity. During the nineteenth and early twentieth centuries, when the Golden Gate was the primary portal for emigration from Asia, no urban center in the United States could match the strength of San Francisco's Asian American visual culture. However, the cataclysmic 1906 earthquake and fire obliterated important aspects of the city's art historical record. The district and community that was perhaps most severely impacted by the conflagration was Chinatown and its predominantly Chinese residents, as every building in the entire neighborhood was leveled to the ground and burned. It is difficult to imagine that any art objects survived there.

Toshio Aoki, *Untitled (Thunder Kami),*
ca. 1900 (detail, fig. 6).

Chinese American Visual Culture, 1850–1906

Despite the losses, an extraordinarily rich profile of the Chinese community emerges from clues about nineteenth-century visual culture. The abundance of imagery created by nineteenth-century non-Asian artists such as German-American photographer Arnold Genthe, African American painter Nelson Primus, and San Francisco–born Theodore Wores from their exploration of Chinatown subjects are among the best known, reflecting the inspiration drawn from difference that is common in art.[1] At the same time that we acknowledge the painful restrictions almost quarantining Asians in California, we can see "Chinatown" as it developed in several Northern California communities as itself a kind of artwork, an installation of collective Chinese aesthetics. The approximately one hundred joss houses built during the nineteenth century and the many community parades held throughout Northern California provided stunning visual evidence of the spiritual wealth of Chinese culture. Photographs of lanterns suspended from balconies and awnings and elegant clothing styles of embroidered silk suggest why the visual differences of this community captured the

1

romantic imagination of diverse artists beginning in the 1850s.

But the richness in the production of art by Asian American individuals and the ways in which this art has been ignored and misread is the principal subject of this study. Although newspaper accounts of Chinese theater and Chinese photography studios can be traced to the early 1850s, among the earliest extant objects available for study is the circa 1860s Chinese portrait photograph from the studio of Kai Suck (fig. 1). The young sitter's classically planted posture and out-pointed toes immediately recall the ancient tradition of Chinese ancestor painting, suggesting one reason for the emphasis on pose and format (rather than facial expression) noted during the period.[2] The unemotional and symmetrical stance reflects the conventions of Confucian portraiture. Although these early cartes de visite and cabinet cards were created primarily as family documents,

their aesthetic value demonstrates the democratic accessibility of relatively inexpensive portraits for the first time to modern Chinese workers.

Pioneering photography historian Peter Palmquist noted that many Chinese worked in a number of different capacities for non-Chinese photography studios during the nineteenth century.[3] Citing studio listings of persons who staffed the largest studios, Palmquist documented the varied positions held by Chinese. This information suggests that some Chinese learned photography skills in California, while others may have brought their skills with them from Canton.[4]

By 1869, the year the transcontinental railroad was completed, at least sixteen self-described professional artists and photographers were active in San Francisco's Chinese American community, according to records compiled by the Chinese Six Companies.[5] The most prominent of these, and with the longest history (dating from at least the late 1860s to approximately 1880), is the studio of **Lai Yong**, and a number of his works have survived. His photographs of "Chinese gentlemen" evidence similar accessories and attitudes seen in those from the Kai Suck studio, but in the example reproduced in this volume's chronology, the man's legs are more casually crossed (see p. 478). Although we know little of Yong's biography beyond what might be drawn from the youthful informality of a photographic self-portrait intended as an advertisement for his studio (see p. 469), census records, and a provocative political statement published as an 1874 pamphlet,[6] we know that he also excelled as a portrait painter.

The 1870 painted portrait of Adolph Sutro by Lai Yong (fig. 2) is important for many reasons beyond its portrayal of a politically and economically powerful Caucasian sitter. Clearly signed and dated,

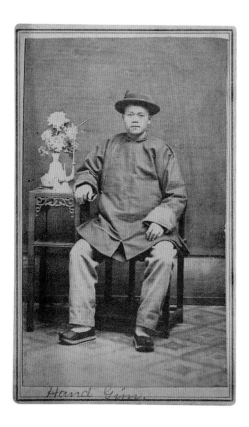

FIG. 1 Kai Suck, *Untitled (Portrait of a Young Man)*, ca. 1867. Carte de visite, 3¾ × 2¼ in.

2

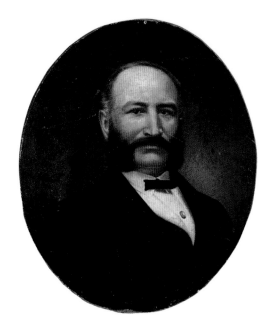

FIG. 2
Lai Yong, *Portrait of Adolph Sutro*, 1870.
Oil on canvas mounted on wood, 24 × 20 in.

it demonstrates why the artist, the first successful Chinese painter in America, attracted attention in the press.[7] This painting's photo-based verisimilitude and exquisitely glazed, glass-like surface are as accomplished as the work of any artist working in California at that time.

The subject of Yong's painting is Adolph Sutro, one of San Francisco's best-known nineteenth-century politicians. Sutro served the city as mayor in the 1890s and developed spectacular baths that also housed the impressive Egyptian Museum at the city's rocky northwestern corner. The 1870 portrait dates from two decades earlier, when Sutro was building his fortune in silver mining. One might read the painting's cameo-format shape as a metaphor, evocative of a mirror, reflecting this Chinese artist's access to the financial elite at the same time that Chinese laborers were being enlisted to work under harsh conditions in the mines.[8]

An actual mirror frame painted by **Mary Tape** in 1885[9] (fig. 3) provides a different reflection of Chinese art activity during the nineteenth century. Tape is remembered as a civil rights and education activist during the years that followed the passage of the 1882 Chinese Exclusion Act (see Valerie Matsumoto's es-

say in this volume for more information), but she was also active in photography and in china and easel painting. The mirror frame's black ground and asymmetrical design of birds and flowers evoke Chinese decorative painting. However, the apparent use of Western brushes and the somewhat stiff consistency of oil paint create a completely different sensibility, and result in a hybrid aesthetic quality. Although other Chinese painters were active in San Francisco during the nineteenth century,[10] only a few objects have been located.[11]

Historic nineteenth-century photographs from Northern California reveal artistic developments not related to easel painting or studio photography that are nevertheless important markers of Asian American cultural exchange. An 1893 photograph by A. W. Erickson of ten-year-old Jackson Ames—whose father was a Chinese miner and whose mother was an American Indian—amid a line of Yurok Jump-Dance ceremonialists in full regalia at the reservation vil-

FIG. 3 Mary Tape, *Painted Mirror Frame*, ca. 1885. Oil on wood, 22½ × 18½ in.

lage of Pecwan in remote Northwestern California provides an early portrait of an individual who became a respected tribal ceremonial leader. Such images remind us that some individuals of Chinese ancestry contributed significantly to non–European American cultures. Photographs that showcase Chinese wood carving, basket weaving, and fine calligraphy on banners also point to other directions in artistic production. A pre-earthquake photograph of a Chinese theater stage in San Francisco shows at least a half dozen paintings displayed as backdrops and along the balcony (fig. 4). Because of local Chinese opera's long history and because the theater paintings more closely follow the conventions of Western landscape painting than those of Chinese landscape painting, we can assume these decorative backdrops were created locally. Although no local nineteenth-century Chinese opera painted backdrops and no examples like these theater paintings have as yet been found, surviving works in this genre that were created after the earthquake in San Francisco are of significant artistic merit. The Chinese theater in San Francisco attracted famous Caucasian actors to its audiences, including Edwin Booth (who studied with Chinese theater actor Ah Chic) and the legendary actor Sarah Bernhardt. The influence in America of the Chinese theater acting style, as well as its costuming (which featured glitter, tinsel, and painted backdrops), remains an important area for subsequent study.

Japanese American and South Asian American Visual Culture, 1880–1906

Although studio portrait photography was a dominant area of cultural production for the nineteenth-century Chinese community in California, that was not exclusively the case in the Japanese community. Important artistic contributions by Japanese individuals in San Francisco can be traced to the 1880s, when a number of young artists and art students, hired by leading merchants, arrived to create decorative objects for sale in department stores. Although interest in Japanese styles was strong during this period, most artists did not stay long. Nevertheless, several advanced their art education, joining other Japanese who were studying Western techniques at the California School of Design (Mark Hopkins Institute of Art).[12] Theodore Wores's activities and reputation in Japan may have attracted Japanese students to the school. Some students achieved high levels of visibility and acclaim; **Katsuzo Takahashi** and **Senko Kobayashi** (see p. 483) won important prizes for their figurative, landscape, and still-life oil paintings in the 1890s. Both artists returned to Japan, where their oil paintings were exhibited, sometimes amid controversy.[13] Takahashi's life-sized *Enlightened Nun* synthesizes the artist's San Francisco academic training and a story from Japanese history (fig. 5).[14]

These artists worked within a difficult, oftentimes hostile environment. **Yoshio Markino**

FIG. 5 Katsuzo Takahashi, *Enlightened Nun*, 1905. Oil on canvas, 71 × 48 in.

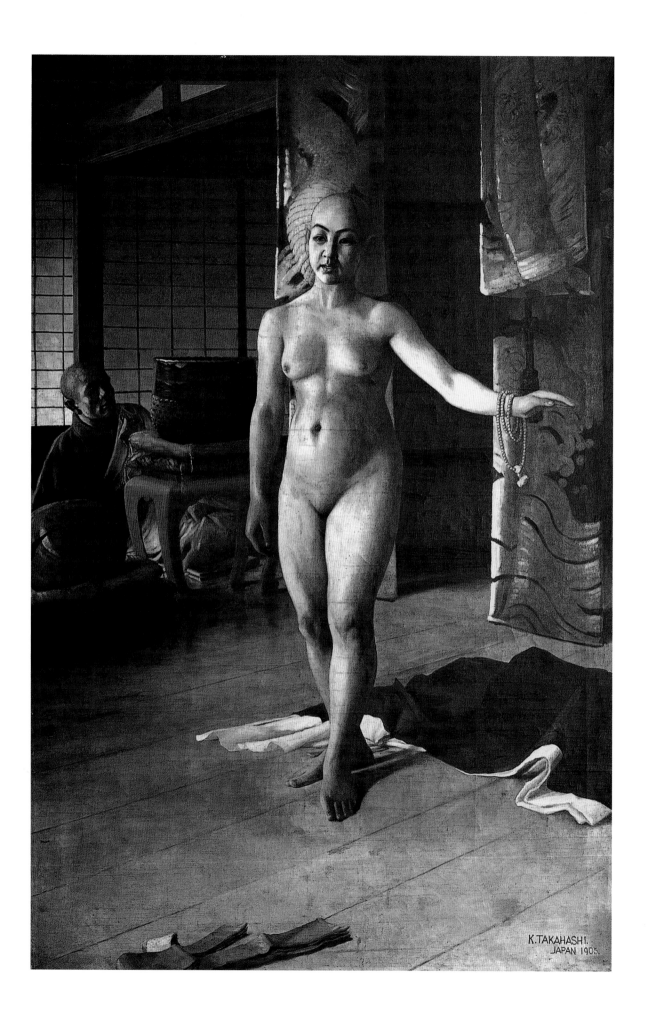

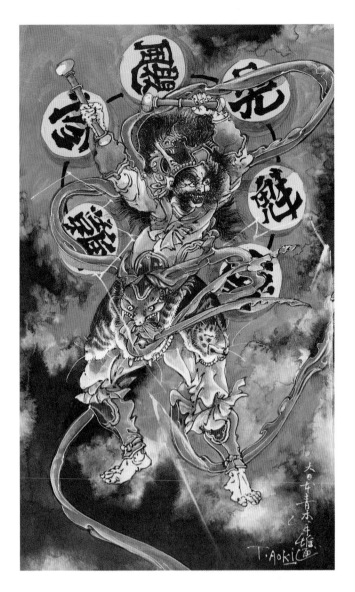

eloquently recalled the deprivation and racism he endured while studying in San Francisco in 1893–1897. In his 1910 memoir, *A Japanese Artist in London*, Markino wrote about trying to make a living as a houseboy and eating stale French bread, which in actuality had been provided by the school "to rub out the charcoal." However, his most damning criticism concerned the people he met in San Francisco:

> I was rather amused with my poor life, but by no means did I feel pleasant with the way those Californians treated me. It is the world-known fact that they hate Japanese. While I have been there four years I never went out to the parks, for I was so frightened of those savage people, who threw stones and bricks at me. Even when I was walking on the street the showers of pebbles used to fall upon me often. And I was spat on more occasionally. Of course they were very low-class peoples, but even better-class peoples had not a very nice manner to the Japanese.... Once I went into a cable car in Sutter Street. I saw my classmate young lady opposite me. I took my hat off and greeted her. She turned her face away. I could not understand why, as she used to be so intimate to me in the class-room. The next day I went to the school. As soon as she saw me she began to apologize me, saying it was not her idea at all to insult me, but she was so frightened that those other occupants of the car might be indignant with her speaking to a Japanese.... Even now, after some thirteen years' stay in London, I often have nightmares of California, and wake up in midnight and wonder where I really am. When I realize that I am in London I feel so happy.[15]

The most important Japanese painter in California during this period was **Toshio Aoki**, who had first arrived in San Francisco in the 1880s to work as a commercial artist for a department store.[16] Although he sometimes painted in oil on canvas, creating imagery that included still lifes,[17] Aoki later achieved success and renown for his Japanese classical subjects and decorative commissions. This work can be discussed within the context of *nihonga*, a modern art movement in Japan characterized by the innovative use of Japanese classical subjects and styles that arose in the late nineteenth century to counter the Western artistic educational models embraced during the Meiji period. Embodying California's Arts and Crafts passion for *Japonisme*, Aoki's *nihonga* works often depict Buddhist deities based on widely recognized ancient images from Japan. These works on paper and board were created in traditional Japanese media using mineral pigments and animal collagen binder. Aoki's *Untitled (Thunder Kami)* (fig. 6) replicates the pose of a famous wrathful

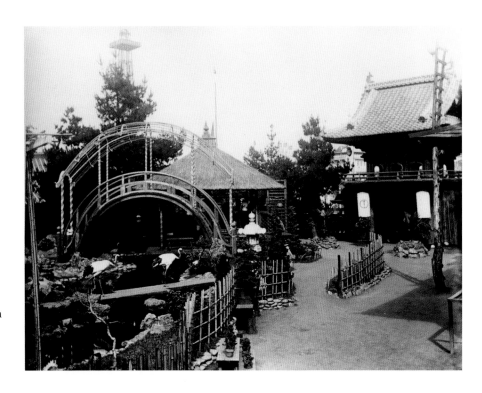

FIG. 7

Japanese Tea Garden at Midwinter Fair in Golden Gate Park, 1894.

figure well known from such examples as the wooden figure from Kyoto's Kamakura-period Sanjūsangen-dō Temple of roughly 1250. His designs for room interiors filled the homes of wealthy elite, especially in the years following 1895, when he worked in Pasadena during the winters and traveled throughout the United States during the summers. Newspaper accounts of his fabulous Japanese-themed dinners in Pasadena, with guests including John D. Rockefeller and J. Pierpont Morgan, suggest that Aoki was one of the wealthiest California artists of his day.

After Aoki's death in 1912, his adopted daughter, Tsuru, married the important actor **Sessue Hayakawa** in 1914. She appeared as his costar in a remarkable silent film, *The Dragon Painter*, which Hayakawa filmed in Yosemite and released in 1919. One can appreciate this adaptation of Mary Fenollosa's 1906 popular novel as an Asian American tribute to a literary classic authored by the wife of Ernest Fenollosa, the influential mouthpiece for *nihonga*, as well as a more personal tribute to Toshio Aoki, the couple's adoptive, artistic California parent.

Other aspects of Japanese aesthetics were popularized as well. The opening in 1894 of the Japanese Tea Garden in Golden Gate Park (fig. 7), the first Japanese garden in America, gives striking evidence of the developing passion for Japanese culture during this time. The garden was designed by Makoto Hagiwara and his family for the Midwinter Exposition of that year, at the instigation of George T. Marsh, an Australian-born businessman who had lived in Japan.[18] Decorative gardening and some of the state's most important architecture were influenced by Japanese aesthetics. Japanese artists making regular visits, such as printmaking master Yoshida Hiroshi, who first passed through California in 1899, introduced woodblock printmaking and calligraphy at demonstrations and exhibitions throughout California. That a dramatic circa 1900 photograph of the Cliff House restaurant by Tsunekishi Imai became one of the city's most collected postcards also points to the popularity of images by Japanese artists during this period (fig. 8).

Asian philosophy as well as art was being embraced in California by the turn of the twentieth century. D. T. Suzuki, Dharmapala, and Vivekananda all lectured in San Francisco in the 1890s and traveled to the World's Parliament of Religions in Chicago. Within a few years, Japanese Buddhist monks in San Francisco found an audience for Zen practice outside of their community congregations, and Vivekananda's Vedanta Society was flourishing in

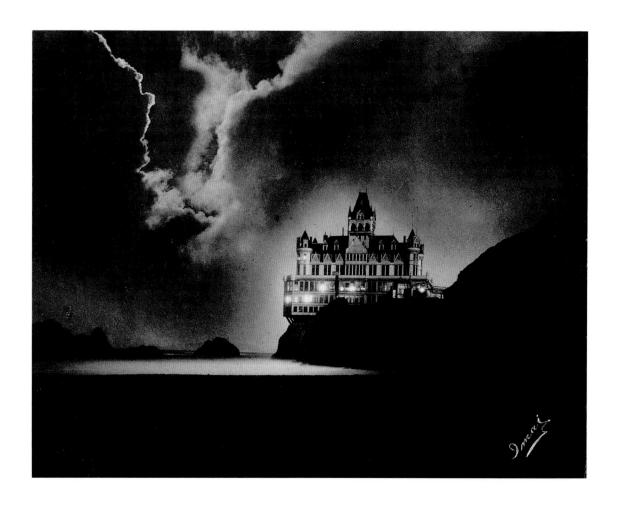

several communities in California. San Francisco's Vedanta Temple (fig. 9), designed by Swami Triturnitida, is a spectacular example of turn-of-the-century Victorian architecture reflecting a South Asian religious aesthetic.[19] Dr. Sun Yat-sen's repeated visits to San Francisco at the turn of the twentieth century are yet another sign that this region's Asian American political, intellectual, and cultural milieu may have been the most complex and important in the Americas during the years before the 1906 earthquake.

AN ASIAN AMERICAN RENAISSANCE

Northern California's principal contribution to the development of American modernism may lie in its fostering of an ethnic voice. This voice can be sensed in the regional museum exhibitions of the 1920s and 1930s. It is further sensed in the ways art was embraced by the Asian ethnic enclaves, which suggests it was a central component of the experience of immigrants of Asian ancestry in America.

FIG. 8 Tsunekishi Imai, *Cliff House, San Francisco*, ca. 1900. Silver bromide print, 5½ × 6¼ in.

FIG. 9 Vedanta Temple, San Francisco, ca. 1910.

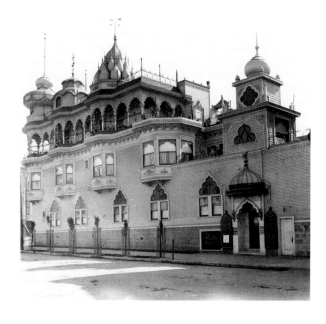

Among San Francisco's most important post-earthquake exhibitions of work by regional artists was the 1925 forty-eighth annual San Francisco Art Association exhibition, the first to be held at the California Palace of the Legion of Honor. The exhibition featured Dirk Van Erp's familiar, hand-hammered copperware and Sargent Johnson's sculptural portrait of his infant daughter, Pearl, as well as strikingly prominent multiethnic imagery in paintings by Caucasian artists Emily Carr, Maynard Dixon, and many others. However, perhaps the exhibition's largest, most original and spectacular work was *Setting Sun: Sacramento Valley*, a nine-foot-tall silk scroll of elemental transformation featuring a sky of fire and an earth under water by the forty-year-old painter **Chiura Obata** (fig. 10). The eeriest work in the exhibition may well have been **Teikichi Hikoyama**'s vampyric 1923 painting on wood, *Spider of Dawn* (fig. 11). These sophisticated works showcased the fullness of experimental *nihonga* developments by artists who had lived in California for more than twenty years. The exhibition also included work by seven other artists of Japanese ancestry: **Miki Hayakawa, George Matsusaburo Hibi, Kazuo Matsubara, Shiyei Kotoku, Henry Yoshitaka Kiyama**, Kiichi Nishino, and K. Tanaka.

Yet none of the nine Japanese American artists who participated in this museum exhibition had shown work in the city's major galleries. Their representation in this major West Coast museum exhibition and catalog months after the 1924 Immigration Act legislated a virtual halt to all Asian immigration clearly shows that an important "underground" of Asian American art had achieved a mainstream high profile by the mid-1920s. To date, little attention has been paid to California's "proto-multicultural" developments. The museum exhibitions and multiple Asian American associations that presented solo and group exhibitions at the Kinmon Gakuen (Golden Gate Institute) in the Western Addition—an area that became known as Japantown (Nihonmachi)—warrant increased recognition as early manifestations of California's developing cultural heterogeneity in the arts.

The Artists of the East West Art Society

As noted earlier, Japanese artists first achieved prominence in the San Francisco mainstream art world in the late nineteenth century; the first Japanese American art association was founded in 1896 in San Francisco.[20] However, the early 1920s exhibitions of the East West Art Society (EWAS), first in late 1921 at the Kinmon Gakuen and then in 1922 at the San Francisco Museum of Art, can be considered pivotal. Although art associations were commonplace in Japan by this time, the mounting of an exhibition sponsored by a multiethnic American art association at a major museum was unprecedented in California. The second exhibition in 1922 was accompanied by a fine catalog with a unique "East-West" seal on its cover that incorporated both a rectilinear cross and a circular yin/yang symbol, likely printed from a woodcut by Hikoyama (see p. 490).[21] Correspondence of the time suggests that the lead organizers were Japanese artists, including George Matsusaburo Hibi, Teikichi Hikoyama, and Chiura Obata.[22] Hibi's writing style can be sensed in the unsigned manifesto that appears as an introduction. It claims the EWAS was born

> as the outcome of [the] ardent desire for researches of Occidental and Oriental Arts...where the East unites with the West, desire which had long been cherished among us, young and ever aspiring painters, musicians, dramatists, poets and writers.

The success of their ambition can be gauged by the inclusion of so many of these and other Northern California Japanese artists in the 1925 San Francisco Art Association exhibition at the Legion of Honor,

FIG. 10 Chiura Obata, *Setting Sun: Sacramento Valley*, ca. 1925.
Hanging scroll: mineral pigments and gold on silk, 107½ × 69 in.

FIG. 11 Teikichi Hikoyama, *Spider of Dawn*, 1923.
Oil painting on wood, dimensions unknown.

suggesting that the artists of the EWAS were embraced even if their association did not continue.

The opening day of the second exhibition alternated European and Japanese music and dance performance and also featured ikebana flower arrangement and tea ceremony. Twenty-seven artists of different ethnicities from both Northern and Southern California exhibited artwork, but more than half of the works presented were by Asian American artists, and some of the other works of art depicted Japanese places or themes. Asian American painters included Japanese painters from the Bay Area and several from Southern California, as well as Chinese painter **Chee Chin S. Cheung Lee**, while Sergey Scherbakoff's imagery of Kyoto was an example of the work of non-Asian artists painting Asian themes. Several artists, including **Tokio Ueyama**, Chiura Obata, and Shiyei Kotoku, featured imagery of the Monterey coastline. An account of the Japanese artists' colony and makeshift gallery at Point Lobos (figs. 12 and 13) from the journal of artist **Henry**

Sugimoto recounts that artists were welcomed at this beautiful site by the Kodani family, who operated a canning company there, which helps explain why this area appears so frequently in early Japanese American California art.[23]

Obata's two-panel screen from the same exhibition, *Moonlight, Point Lobos* (fig. 14), provides a very different perspective of this setting. Like his *Setting Sun: Sacramento Valley*, which makes use of gold metallic highlights, the silvery *Moonlight, Point Lobos* incorporates a reflective metallic pigment. Obata's Japanese training is reflected in his use of these pigments and animal collagen glue binder on paper and silk, as well as his stylistic referencing of *nihonga* teachers. The fine lines and delicate coloring in his works points to his training with Hashimoto

FIG. 12 Gennosuke and Fuku Kodani at Guest House Art Gallery in Point Lobos, ca. 1930.

FIG. 13 Interior of Gennosuke and Fuku Kodani's Guest House Art Gallery, ca. 1930.

Gahō, while his fluid, angular *sumi-e* work suggests the influence of Kanō Hōgai, who had taught at the Japan Fine Arts Academy before Obata was a student.[24] But it is Obata's novel application of his educational training to the specificity of the California landscape that imbues his work with its fresh and compelling vision.

After the 1922 exhibition, Obata's career took off with a number of "firsts" for any American artist of Asian ancestry. Within a year, he was invited to design stage sets for the San Francisco Opera's production of *Madame Butterfly*. His 1928 solo ex-

FIG. 14 Chiura Obata, *Moonlight, Point Lobos*, 1922. Folding screen: mineral pigments and silver on paper, 64 × 66 in.

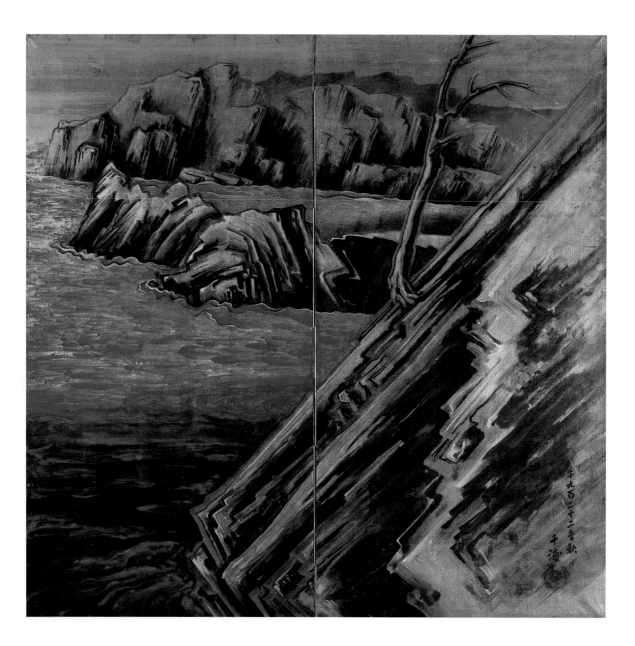

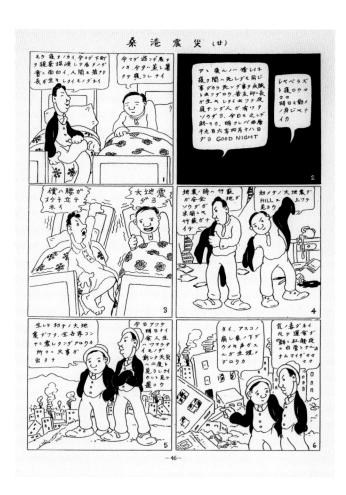

FIG. 15
Henry Yoshitaka Kiyama,
"The Great San Francisco Quake"
from *Manga Yonin Shosei*, 1931.

hibition at the thriving East West Gallery (a private, commercial art gallery unrelated to the Art Society) of Yosemite paintings—many of which were painted during a six-week backpacking trek with two of the period's preeminent Caucasian artists, Worth Ryder and Robert Boardman Howard—generated pages of newspaper press. Obata's own article on Japanese art appeared on the front page of the respected art journal *The Argus* in the same year. These developments opened the door to his prestigious tenured professorial appointment at the University of California, Berkeley, an important source of economic support in a region with traditionally limited patronage. His later solo exhibition at the California Palace of the Legion of Honor in 1931 and national recognition in *Time* magazine demonstrate his unprecedented success.[25]

In the later 1920s, both George Matsusaburo Hibi and Teikichi Hikoyama participated in separate art associations that presented exhibitions at the Kinmon Gakuen,[26] but the shows and the artists'

solo exhibitions there failed to attract much attention outside of Japantown. Nevertheless, an impressive level of community art energy is suggested by the activities of these and other art clubs that presented lectures and exhibitions, as well as by the appearance of different Japanese American camera club exhibitions in nearby storefronts. In 1927, San Francisco's Sangenshoku Ga Kai (Three Primary Colors Art Group) collaborated with the Los Angeles–based art association Shaku-do-sha and mounted an exhibition, first at the Kinmon Gakuen in October and then at the Central Art Gallery in Los Angeles for one week. (See Karin Higa's essay for more information on the Shaku-do-sha.)

Throughout this period, most of the painters and art photographers struggled to support themselves by working menial jobs, including those depicted in Henry Yoshitaka Kiyama's unique autobiographical, book-length comic, *Manga Yonin Shosei* (*The Four Students Comic*) (fig. 15). This innovative book shows Japanese immigrant men, known as

"school boys," who worked as house servants, or in agriculture—sometimes in racist environments. Several artists, including George Matsusaburo Hibi and Teikichi Hikoyama, like Toshio Aoki before them, generated income by creating newspaper illustrations. In addition, Hibi taught Japanese language and was a teaching assistant at the California School of Fine Arts, although nominally he was employed as the caretaker. Most artists found survival difficult, and several, including Kiyama, eventually returned to Japan.

A Proliferation of Exhibitions:
Yun Gee, Yoshida Sekido, and Others

By the late 1920s, Asian American artistic activity was not limited to the East West Art Society. **Yun Gee**'s sudden and spectacular success at the Modern Gallery provides one such example[27] (see illustrations in the introduction and in the essays by Mayching Kao and Tom Wolf). Gee's widespread recognition was reported in a contemporary Japanese-language newspaper in a series of articles by Matsusaburo Hibi, who wrote with sarcasm about Gee's work. The forty-one-year-old critic wrote that after studying in San Francisco for two years, the twenty-one-year-old Gee "is relatively skilled in technique and gained some sort of ultra-modern style. So he uses colors like red, blue, yellow and green as if one squished a parrot on the canvas...some Caucasian artists who studied in Paris for twenty years consider this guy to be a genius."[28] Hibi continued by writing that after Gee "had three one man shows in Chinatown—he must have thought he was a master. He grew his hair long with a mustache and beard and has a pipe that is bigger than his head. He dresses like a golf player and walks through Chinatown as if he owns it."[29]

Hibi's Japanese-language articles were in part directed at Gee's young Japanese American classmates, whom Hibi had mentored, and who were then exhibiting together in Japantown with the Sangenshoku Ga Kai. They also point to the dynamic conflict of modernist styles embodied in the work of two preeminent figures: Obata, whose *nihonga* example Hibi praised, and Gee, whose Euro-American, cubist orientation he criticized. Beyond the powerful boldness of his work and his flamboyant sartorial style, Gee is remembered as the founder of the Chinese Revolutionary Artists Club, a modernist school, ersatz office, and clubhouse at 150 Wetmore Place, an alley off Clay Street. Although the exact membership of the club is not documented, some individuals who were associated with this group later participated in the Chinese Art Association and the Chinatown Artists Club,[30] which suggests that the demand for such a club spanned two decades.[31] Although club members were Chinese speaking, cross-cultural dialog transcending language-specific clubs and ethnically segregated neighborhoods was occurring during the period. Gee's 1926 painted portrait of Miki Hayakawa painting a portrait of an African American model in a bow tie at the California School of Fine Arts, reproduced in the introduction to this volume, provides a brilliant example.

During the 1920s, some of California's most prestigious museums presented exhibitions of works by Asian-born artists, including Shiyei Kotoku's 1923 exhibition at the Los Angeles Museum and **Noboru Foujioka**'s 1927 exhibition at the California Palace of the Legion of Honor. Both of these shows were well received: Kotoku's *The Cliff, Carmel-by-the-Sea* (see fig. 33, p. 37) was praised as exemplifying an internationally innovative stylistic synthesis,[32] and Foujioka's controversial and crudely illustrative *American Spirit* (fig. 16), depicting a card game within a clubhouse art gallery, was acquired by a wealthy collector and gifted to the de Young Museum. In addition to the solo exhibitions at various venues already discussed, an unprecedented number of commercial exhibitions were mounted at the East West Gallery in 1928. These shows included solo exhibitions of work by **Yasuo Kuniyoshi** and **Wah Ming Chang** and the first American presentation of work by the Chinese

FIG. 16 Noboru Foujioka, *American Spirit (The Poker Game)*, 1925. Oil on canvas, 36 × 40 in.

classical painter **Yang Ling-fu**, ten years before she moved to San Francisco. Also in 1928, the *San Francisco Chronicle* reported that the founding of a university and museum of Asian culture was discussed at a dinner hosted by the East West Gallery with prominent art patrons, including Albert Bender.[33]

But the 1930s saw the most significant museum exhibitions, principally at the California Palace of the Legion of Honor. Not only did group shows regularly include oil and watercolor paintings by then-familiar artists such as George Matsusaburo Hibi, whose visionary painting *Wings* (see fig. 191, p. 239) was a standout in the 1931 San Francisco Art Association exhibition, but they also showcased a developing, younger generation. Legion of Honor exhibi-

tion records list San Francisco artists **Takeo Edward Terada**, Sam Fong, and Filipino American **Sylvester P. Mateo**, as well as Los Angeles and New York artists such as Tokio Ueyama and Yasuo Kuniyoshi. Most striking is the parade of solo exhibitions presented at the museum during this decade: first, Chiura Obata in 1931, then **Yoshida Sekido**, Noboru Foujioka, Isami Doi, and **Isamu Noguchi** in 1932,[34] followed by Henry Sugimoto in 1933. (Chee Chin S. Cheung Lee, **Reuben Tam**,[35] and others would have solo shows there in the 1940s.) These exhibitions represented an even higher profile for Asian

FIG. 17 Yoshida Sekido, *Untitled (Approaching the Ferry Building)*, ca. 1930. Ink and pigments on silk, approx. 24 × 30 in.

American artists at San Francisco municipal museums than is seen today.

Yoshida Sekido's 1932 Legion of Honor museum exhibition was unusual in that the artist had only arrived in California the year before. But he soon won recognition as the preeminent *nihonga* painter in the city after Obata moved to Berkeley to begin his teaching appointment. Yoshida's *Approaching the Ferry Building* from the early 1930s shows the waterfront before the construction of the Oakland Bay Bridge within an atmospheric haze created using an ancient Asian splashed-ink-on-silk technique called *pomo* in Chinese (fig. 17). Others in San Francisco creating work rooted in Asian art techniques included Nichiren Buddhist priest and master calligrapher **Nitten Ishida**, who was an acclaimed teacher in Japantown beginning in 1931 (fig. 18). His activity also demonstrated that diverse sects of Buddhism were active in San Francisco during that time. The participation of artists **David P. Chun**, **Jade Fon Woo**, Miki Hayakawa, **Dong Kingman**, **Kiyoo Harry Nobuyuki**, **Koichi Nomiyama**, Kenjiro Nomura, **Yajiro Okamoto**, Henry Sugimoto, Takeo Edward Terada, Kamekichi Tokita, and Yoshida Sekido in the 1935 inaugural exhibition of the San Francisco Museum of Art further underscores the profile of Asian Americans in the city's established modern artists' community.

The New Chinatown

After the 1906 earthquake, the Chinese American quarter was rebuilt in stages and with increasing levels of chinoiserie decoration. The new construction featured electric lights on rooflines and stylized streetlights—as though a precursor to Las Vegas—as well as architectural motifs borrowed from classical Chinese garden and temple architecture, which hyperrealized the ghetto's emporiums, telephone ex-

FIG. 18 Nitten Ishida, *Calligraphy*, 1931. Ink on paper, 25 × 10 in.

16

change, apartments, family associations, bars, and restaurants.[36] The 1909 Portola Parade, a pageant of extravagant costumes and elaborate floats through the new Chinatown, was described as the "most conspicuous" parade ever.[37] By 1930, some Chinese American residents felt that Chinatown represented utopian potential: T. Y. Tang, then secretary of the Chinese Chamber of Commerce of San Francisco, wrote of Chinatown as

the natural cross-road for commerce between the two sister republics . . . [where] we are planning to develop a new civilization, which is a combination of the best that can be assorted from the Occident and the Orient. Some of our leaders in the Chinese community have had the advantage of receiving the fundamental Chinese culture plus a higher learning from the American Universities. We firmly believe that philosophical China, combined with the scientific West, will produce a civilization that will be much better than the civilization of which the almighty dollar has the most to say, or of one that does not progress because of pharisaic pride.[38]

Chinese aesthetics became widely embraced in the visual culture of the city: in the late 1920s Rudolph Schaeffer opened his arts and crafts school at the edge of Chinatown, showing Asian prints and hiring Asian art teachers to educate his largely Caucasian student body;[39] the Chinatown YWCA, which opened in 1934 and featured imported Chinese tiles, was designed by one of the period's premier architects, Julia Morgan;[40] Beniamino Bufano's massive, minimal Sun Yat-sen monument was installed at St. Mary's Square; and Ansel Adams exhibited folding screens with clouded mountain imagery—all evidenced Chinatown's inspiration and importance for non-Asian artists. The appearance of visitors such as Eleanor Roosevelt, Anna May Wong, and opera star Mei Lanfang in the 1930s added to Chinatown's perceived glamour that contrasted with the actual pov-

erty of its residents. By the mid-1930s, **Chingwah Lee** and David Chun were proponents of further expanding the Chinese attributes of Chinatown,[41] which by then comprised diverse constituencies, including Filipino Americans and Japanese Americans.

These developments attracted the attention of Hollywood, which exploited exotic notions of Chinatown in films and appropriated elements of Chinese fashion, such as the cheongsam dress, further enhancing the community's reputation as a mysterious and sexy tourist destination. In the later 1930s, several nightclubs opened in quick succession; perhaps the best known was Charley Low's Forbidden City, located outside the new Chinatown gates on Sutter Street. The Forbidden City was famous for its fine multiethnic Asian crooners and dancers as well as its revues that exaggerated international ethnic costume. While these activities can be criticized as embracing "Orientalism," they can also be viewed as evidence of a keen struggle for visual and economic presence within the culture of the city.

Chinatown's Cultural Milieu: Chinese Digest *and the Chinese Art Association*

Such outside interest helped cultivate a veritable art renaissance in Chinatown, which was in full bloom by 1935, synchronous with the excitement surrounding the final stages of construction of the Bay Bridge.[42] Fong Fong soda fountain opened that year, with **Nanying Stella Wong**'s interior murals and neon ice cream marquee, and became an important destination for a new generation that was largely American born (fig. 19). An important journal, the *Chinese Digest*, was also founded in 1935 to report on Chinatown's contemporary cultural news and events, record and reminisce about the early history of the community, and provide a forum for the general discussion of Chinese history, art, and literature.[43] Cofounded by a team of Chinese American professionals,[44] the journal also included wonderful photographs by **Wallace H. Fong Sr.** and illus-

FIG. 19
Nanying Stella Wong,
*Untitled (Fong Fong Soda
Fountain Mural)*, 1935.
Lacquer on panel,
48 × 96 in.

trations by such artists as Nanying Stella Wong and James Richard Lee. Asian art dealer and cofounding editor Chingwah Lee brought an art focus to the journal and occasionally contributed witty illustrations (fig. 20), as well as lending his gallery's backroom for the journal's production. Another 1935 highlight was the Aztec-themed artists' ball, the Parilia, which was sponsored by various groups associated with the California School of Fine Arts. However, both the Japanese Artists of San Francisco and the Chinese Art Association of America helped produce this extravaganza. Newspapers credited the Chinese American artists' participation as outstanding, and **Eva Fong Chan** and Nanying Stella Wong appeared in several photographs wearing elaborate costumes (see fig. 140, p. 168).[45] The following year's ball was organized around the Asian theme of Angkor Wat.

On December 10, 1935, the important first museum exhibition of the Chinese Art Association opened at the de Young Museum. The exhibition was eclectic in media, encompassing oil painting, pen and ink, etchings, sculptures, and carvings. Exhibiting artists included Nanying Stella Wong, Eva Fong Chan, Chee Chin S. Cheung Lee, Wahso Chan, Longsum Chan, Suey B. Wong, David Chun, **Hon Chew Hee**, **Hu Wai Kee**, Sui Chan, Hu Gee Sun, and Dr. Lau Chun Lum.[46] A publicity photo, including young models often (but mistakenly) assumed to be Eva Fong Chan and Nanying Stella Wong,[47] shows club president David Chun in white robes, while the association's senior member, Chee Chin S. Cheung Lee, sits on the left in his painter's smock (fig. 21). Included in the exhibition was Chee Chin S. Cheung Lee's *Mountain Fantasy* (fig. 22), which depicts a nude woman with long black hair contemplating a waterfall at the base of a cliff face alive with rocky

A "REAL" CHINESE ALPHABET

ЛБСПЕҒ҃ЕНІƷ水〥爪
冂口尸又R彐丁凵厶山乂丫之

FIG. 20
Chingwah Lee, A "real"
Chinese alphabet,
reproduced in *Chinese
Digest*, May 1938.

18

FIG. 21 Chinese Art Association
at the de Young Museum
publicity photograph, 1935.

FIG. 22 Chee Chin S. Cheung Lee, *Mountain Fantasy*, 1933. Oil on canvas, 36 × 48 in.

outcroppings that themselves suggest nudes in a brilliant depiction of the living *qi* of the landscape.[48] The artists of this group later re-formed as the Chinatown Artists Club and presented four consecutive annual exhibitions at the de Young Museum starting in 1942.

Watercolorists Dong Kingman and Wing Kwong Tse

In 1936, while Yang Ling-fu's traditional Chinese ink painting exhibition in Chinatown went largely ignored, Dong Kingman's paintings were described as "the freshest, most satisfying water colors that have been seen hereabouts in many a day,"[49] and work by this Chinese American artist in a seemingly Western style was regularly acclaimed and collected. Kingman's 1936 successes also included the First Purchase Prize for his *Church #1* (fig. 23) in the annual exhibition of the San Francisco Art Association.[50] Many of Kingman's earliest paintings depict dark waterfronts or industrial, isolated scenes, but he quickly became noted for his renderings of familiar landmarks. His fresh, loose paint handling belied the accuracy of his drawing and compositions, and his evocation of

FIG. 23 Dong Kingman, *Church #1*, 1936. Watercolor on paper, 14¼ × 20 in.

20

the local foggy atmosphere made his work popular with both Caucasian and Asian collectors.[51] Kingman credited his Chinese education with helping him develop his painterly strengths, both his suggestion of cloudy atmospheres and his compositional accuracy.[52] By mid-century, Kingman had become one of the most famous artists in America—possibly the most famous Chinese person in the country. Although he relocated to New York after World War II, he maintained a strong presence in and relationship to San Francisco until the time of his death.

Not every artist associated with the 1930s Chinatown renaissance participated in museum and art association programs. **Wing Kwong Tse** is an important exception. In a North Beach studio at the edge of Chinatown, Wing Kwong Tse developed an individualized watercolor style based on photographic portraiture. He combined elements drawn from multiple photographs to create highly detailed, startling photorealistic images that blend ancient motifs and contemporary styles (fig. 24). This evocation of antique models is common in Chinese painting, and a clear source for Tse's work is the fine modeling of ancestor portraits. However, Tse's incredible detailing brought a modern edge to familiar faces. His paintings, which sometimes took months to complete, were avidly collected but infrequently exhibited outside his studio.

Other Traditions: Muralism

Art historian Anthony Lee has written about the significant visit of Diego Rivera, the Mexican artist and political activist, to the Wetmore offices of the Chinese Revolutionary Artists Club a few years after founder Yun Gee's departure for Paris.[53] Rivera's influence throughout the visual arts in Northern California can hardly be overstated; in the 1930s, such diverse Asian American artists as Hon Chew Hee, **Peter Lowe, Hideo Benjamin Noda**, Chee Chin S. Cheung Lee, Sylvester Mateo, and **Mine Okubo** worked for periods by his side. Rivera's influence can

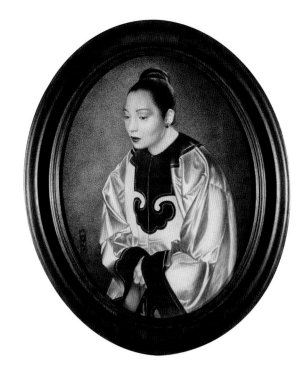

FIG. 24 Wing Kwong Tse, *Eva Wong*, 1958. Watercolor, dimensions unknown.

also be seen in the large number of murals that were created in Chinatown and elsewhere during these years: Takeo Edward Terada's 1934 murals at Coit Tower, Nanying Stella Wong's 1935 sprayed-lacquer murals for Fong Fong soda fountain, David Chun's 1936 murals for Charley Low's Chinese Village nightclub, Hideo Noda's 1937 mural for Piedmont High School, **Roberto Vallangca**'s *Fountain of Youth* at the Golden Gate International Exposition in 1939, Mine Okubo's 1940 murals for Fort Ord, and Dong Kingman's 1941 mural at the Chinatown YMCA (as well as those of Southern Californians **Tyrus Wong** and **Hideo Date**). Terada and Noda even worked together on a mural in Japan in 1936. Later examples of murals by Asian artists include those at Kan's Restaurant in San Francisco by **Jake Lee**, Hon Chew Hee's murals for the Oakland Naval Supply Center, **James Leong**'s *One Hundred Years: History of the Chinese in America* for the Ping Yuen public housing project (see p. 506), and monumental projects by **Tseng Yuho** and **Ruth Asawa** (see Valerie Matsumoto's essay for more information on these women). Although many of these works have been destroyed, the circa 1936 anonymous mural reproduced in the *Chinese Digest*

FIG. 25 "Chinatownia" mural reproduced in
Chinese Digest, November 13, 1936.
Three panels, described as 6 × 9 ft. each.

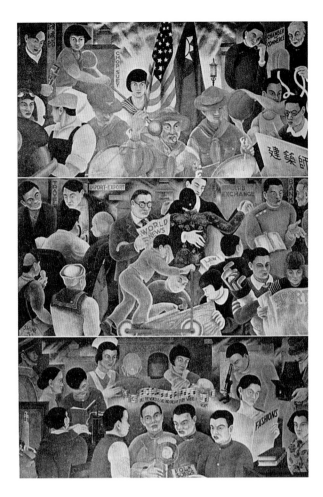

(fig. 25) and the four-by-eight-foot fragment from
Nanying Stella Wong's Fong Fong mural suggest the
stylistic eclecticism and imagery of those years, pro-
viding a glimpse of what has been lost.

Chinese American Photography, Film, and Survival

During this period of renaissance, the Chinese Amer-
ican community still supported its photographic
portraitists. By 1923, the premier Chinatown por-
trait studio was established: **May's Photo Studio**
represented the entrepreneurial partnership of Yai
S. Lee and his wife, Isabelle May Lee. Her status as a
third-generation San Franciscan with family ties to
the local Chinese theater assured the studio's social
position within the community as well as its role as
the foremost studio for theater and opera photogra-
phy. Yet it is the unparalleled invention displayed in
May's photographs—sometimes panoramic, some-
times large, hand-painted, and encrusted with glit-
ter (see fig. 113, p. 140), sometimes incorporating
cutouts and collage to reconstitute separated fami-
lies—that made this work uniquely important, pro-
vocative, and successful.

In addition to operating professional studios,
Chinese Americans also flocked to join amateur cam-
era clubs that were operating in the YMCA and other
community centers. Photographers active in later
decades have recounted how their first exposure to
photography was through older family members al-
ready active as amateur photographers. **Benjamen
Chinn**'s older brother taught him how to print pic-
tures and develop prints, and **Irene Poon**'s father
maintained a darkroom in the family's basement.

Chinese American amateur and independent
film history dates back to at least 1916.[54] Several
Chinese-language films were produced locally in the
1930s. *Heartaches*, a film produced by Quan Yum
Lim, was released in 1936 by Kwong Ngai Talking
Picture Company of San Francisco (later renamed
Cathay Pictures, Ltd., of "Hollywood," although the
company was located on San Francisco's Washington

Street). Several locals were lured to Southern Cali-
fornia to act in films, including photographer Ches-
ter Gan and art writer/dealer Chingwah Lee. The
1937 filming and release of Pearl S. Buck's *The Good
Earth* was seen as a triumph for the community, even
though the leading roles were played by Caucasian
actors. Mission High School graduate Frank Tang's
calligraphy that appeared in some scenes won spe-
cial recognition in the *Chinese Digest*.

Despite these links to Hollywood, the 1930s
were dire times economically for artists and non-
artists alike. In the later 1930s, the WPA offered
relief to a number of California artists, including sev-
eral Asian Americans. In Northern California, Pe-
ter Lowe, Mine Okubo, Dong Kingman, Chee Chin
S. Cheung Lee, Violet Nakashima, Yoshida Sekido,
and others worked for a time for the WPA.[55] For
many others, the economic hardships were oppres-
sive, and many careers in California ended. Shiyei
Kotoku moved to France. Teikichi Hikoyama and

Suey B. Wong returned to Asia, but the developing war there deepened the wedge between communities. By 1939 Obata's watercolors of the Berkeley campus were reproduced as covers for the school's alumni magazine, eighty of Yoshida Sekido's works were exhibited at the Golden Gate International Exposition's spectacular palace-like Japan Pavilion, and an exciting new generation of artists had surfaced, including **Hisako Hibi**, Violet Nakashima, and **Miyoko Ito**. Yet an epic event was in the making that would result in the obliteration of much of what had come before. War had already swept Europe and Asia and was about to involve the United States.

REFLECTIONS

In reviewing the remarkable achievements of Asian American artists during the pre–World War II period, we find in Northern California a historical center for Asian American artistic innovation, museum exhibitions, and art criticism. While no single or dominant artistic profile can be traced, several important threads are evident. Asian Americans were leaders in the rise of the regional watercolor movement: California Watercolor Society exhibition records document the involvement of now-familiar names, including Jade Fon Woo, Dong Kingman, Chee Chin S. Cheung Lee, Chiura Obata, **Richard D. Yip**, and others,[56] several of whom were additionally influential as teachers. Artists such as Mine Okubo and Nanying Stella Wong were important in the rise of a distinctive Berkeley watercolor school. Unfortunately, because of the light sensitivity of papers and pigments that preclude the long-term display of these works, the history of many aspects of water-media painting is less known.

As noted earlier, several artists were also revered as authorities on art, such as Toshio Aoki, George Matsusaburo Hibi, and Chiura Obata, who sometimes lectured or wrote articles on art and culture; some wrote in English, while others wrote in Asian-language newspapers. Writers Chingwah Lee

and **Sadakichi Hartmann** also proffered expertise in Asian art and culture. In general, however, critical appreciation among Euro-American writers of early Asian American artists' achievements seems limited by the writers' lack of sophistication about Asian art practices and philosophies. Some accounts in the California press point to a rigidly perceived polarity in which Asian traditions were restricted to a continuum that ranged only between "grotesque" and "decorative," as in the following 1908 account of an aesthetic argument between writer Rene T. de Quelin and artist Toshio Aoki:

Aoki, who has a charming studio in Pasadena, was present [at an exhibition in the Blanchard Hall galleries], and in a discussion with the writer made the claim that Caucasians did not know how to draw, simply because they always draw with the pencil instead of a brush; when the writer stated that the Japanese did not draw correctly from an anatomical point of view and that all their figures were more or less grotesque, Mr. Aoki at once refuted the statement and claimed that all Japanese were great students of anatomy, but gave great spirit and action to their drawings, and to confirm this at once started to make an outline drawing of a figure, a man fishing, to show how accurately he could draw the figure. As usual, it was the ordinary grotesque figure full of wild impossibilities of comparative sizes and conformation. Mr. Aoki speaks of having been in Paris and London, and having watched and seen hundreds of artists working, yet he did not seem to know that the majority of painters started right in with their work, and the brush without any previous outlining with a pencil or the charcoal. He also claimed that we should now approach the Japanese in the rendering of flowers. The writer has failed yet to find a Japanese, in forty years close observance of their work, who could render flowers on paper, we will say, as beautifully or as perfectly as Paul de Longpre.... Whilst a Japanese work has a charm of

its own, and is decorative from the oriental stand-point, still they should not attempt comparisons with our works… The result would certainly not be favorable to them.[57]

In point of fact, art writers more commonly extolled the hyperaesthetic value of Asian stylistic approaches. Eugene Neuhaus's 1915 statement in the catalog for the Panama-Pacific International Exposition reads with the proponent fervor of an arts and crafts enthusiast:

> Why the modern Japanese artists want to divorce themselves from the traditions of their forefathers seems incomprehensible. There is not a thing in the western styles in this gallery of Japanese painting that comes anywhere near giving one the artistic thrills won by their typically Japanese work. I think the sooner these wayward sons are brought back into the fold of their truly oriental colleagues, the better it will be for the national art of Japan, the most profound art the world has ever seen.[58]

This kind of attitude can result in anachronistically bizarre and blindly prescriptive responses to Asian American work. The account of Rinaldo Cuneo's response to the Chinese Art Association of America's 1935 exhibition at the de Young Museum stated:

> Chinese historic painters are the world's greatest, alongside which the European painters are but amateurs. "The capacity of the Chinese artist to organize his material, his fine sense of color, of form, and of vibration enables him to produce masterpieces which appear like a world held in captivity," said Professor Cuneo. He pointed out how the modern Chinese-American painter is absolutely sincere, but is confused by attempting to imitate the American art style.[59]

This latter sort of generalization dismisses the work of many artists trained in European styles at California schools, including the California School of Fine Arts and the University of California, Berkeley.[60] But, even there, some Asian American art students such as Michi Hashimoto at UCLA were encouraged to mine their Asian roots (see Michi Hashimoto's biographical entry).

The dismissal of work in apparently Western styles misses the subtle blending of iconography, media, and style that some artists were then attempting. Several artists trained in Asia were clearly working in styles related to Asian painting philosophies, including the *nihonga* painters Aoki and Obata, and others, such as many of the pictorialist photographers, brought shallow space and Asian-identified motifs to the emerging field of fine-art photography (see Dennis Reed's essay in this volume). Artists who received much of their education in Asia, like Dong Kingman and Yoshida Sekido, enabled a stylistic subtle middle ground that reflected both accuracy in perspective and calligraphic paint handling. Similarly, several artists associated with the East West Art Society, even if their work was stylistically dissimilar, shared an interest in depicting mysterious forces of nature. The theme of transformation itself is strong in some of the best work of Matsusaburo Hibi, Obata, and Gee. Innovative English-language seals and inscriptions that give a nod to Asia appear in the work of such artists as Teikichi Hikoyama and Wing Kwong Tse, providing a clue that their work was internationally informed.

Artistic imagery protesting the widespread social inequities that Asian American communities faced during this period is virtually nonexistent. However, politically powerful images, evocative of Depression-era ideology, appear in the work of a few artists, especially those who relocated to New York, such as Hideo Noda (see Tom Wolf's essay for more information on New York political art). In Noda's 1934 *Untitled (City)* (fig. 26), innovative explora-

tions of transparency reveal interior vignettes of urban poverty. With even greater subtlety, some artists evoked a sense of alienation or longing. Both David Chun and **Taizo Kato** depicted lonesome figures gazing across the sea (fig. 27). But what is most provocative to this writer is the early formulation of an Asian American international artistic sensibility in statements, imagery, and lifestyle. Examples include the manifestos and exhibitions of art associations, as well as novel explorations of Asian art historical genres and motifs, such as new interpretations of bird and flower paintings, atmospheric landscapes, and ancestor portraits, that together comprise a compelling evocation of transnational experience.

Notes

1 That unfamiliar people and aesthetics were among the principal inspirations of non-Asian artists is not surprising. What is perhaps surprising is the number of Caucasian women artists who took Asian names (such as Swiss-born Frieda Hauswirth, who painted Indian subjects under the name F. H. Das), who dressed in Asian robes (as sometimes did bohemian *comadre* Alice B. Toklas), or who moved to Asia (including Bertha Lum and Helen Hyde, who lived and exhibited in Japan and became well known for their orientalized depictions of children) to more fully immerse themselves in non-Western culture.

FIG. 26 Hideo Benjamin Noda, *Untitled (City)*, 1934. Oil on canvas, 18 × 39¾ in.

FIG. 27 Taizo Kato, *Untitled*, from the album *The Records of an Unbroken Friendship but the Mortal Severance, 1907–1924*, ca. 1920.

2 One 1882 account records, "The desire of the Chinese to have their photographs taken amounts to a passion.... [However,] a Chinaman doesn't care whether you touch up the wrinkles in his face or tone down the unevenness of his features. He does not seem to have an eye for such things, but he wants every line of his dress brought out as clearly as possible. He is particular to have his toes pointed out, and wants to have his shoes clearly in the picture as clearly as his hands and fan.... If he has a picture taken with a bouquet of flowers, he wants to see every flower done justice to." Some Caucasian photographers specialized in portraits of Chinese, creating environments of Chinese furniture and accoutrements to reflect Chinese conventions and aesthetics. From *Photographic Times and American Photographer* 12 (1882): 158; quoted in Peter E. Palmquist, "In Splendid Detail: Photographs of Chinese Americans from the Daniel K. E. Ching Collection," *Facing the Camera: Photographs from the Daniel K. E. Ching Collection*, exh. cat. (San Francisco: Chinese Historical Society of America in joint sponsorship with Asian American Studies Department, San Francisco State University, 2001), 8.

3 See Peter E. Palmquist, "Asian American Photographers on the Pacific Frontier, 1850–1930," in *With New Eyes: Toward an Asian American Art History in the West*, by Irene Poon Andersen et al. (San Francisco: Art Department Gallery, San Francisco State University, 1995), 15–17. Of special note is Palmquist's recording of the 1854 *Daily California Chronicle* article "Progress of the Arts among us," which reads, "Daguerreotypists, look out! John Chinaman, so famous for his imitative powers, is in the field. In our ramble round town to-day, we noticed in the upper part of that street noted for coffins and crackers, 'yclept [known as] Sacramento, that 'Ka Chau' has opened a 'Daguerrean Establishment.' His place is immediately above 'Maige, Patissier.' There, the passers by will observe on the street wall some very beautiful specimens of Ka Chau's handiwork, many of which are of course portraits of Chinese men and women. There is no reason why Chinamen should not enter and succeed in any profession among us which requires nice manipulation. If some of the better class from China would only learn the English language, discard a few of their now exclusive national customs,

and enter into ordinary business, as handicraftsmen—from cabinet-making up to jewelry,—we think the public opinion against the race would soon be materially modified in San Francisco"; *Daily California Chronicle*, June 8, 1854, 2.

Late-nineteenth-century Chinese American photographers sometimes worked with stereoscopic cards, painted backdrops, and other media and materials to create individual and group portraits in both formal and casual poses. The study of work created in the studios of Wai Cheu Hin, Chin Toy, Ann Ting Gock & Co. (presumably the first woman to operate a photography studio under her own name), and others is beyond the scope of this essay but may be a rich area for future study.

4 See Jan Stuart and Evelyn S. Rawski, *Worshipping the Ancestors: Chinese Commemorative Portraits* (Washington, D.C.: Sackler/Freer Galleries, and Stanford: Stanford University Press, 2001). Photography studios developed more slowly in China than in California, although a Chinese-owned studio in Hong Kong is documented as early as 1859. It is just as likely that Chinese artists trained in America took their skills back to China.

5 The November 27, 1869, edition of the *Sacramento Daily Union*, 4, used the records maintained by the Chinese Six Companies to report the professions of 13,932 Chinese professionals in San Francisco. See Helen Virginia Cather, *The History of Chinatown* (San Francisco: R and E Associates, 1974), 35. (Originally published as author's thesis for the University of California in 1932.)

6 Lai Yong et al., *The Chinese Question, from a Chinese Standpoint*, translated by Rev. O. Gibson (San Francisco: Cubery & Co., 1874). See Lai Yong's biographical entry in this volume for more information.

7 Palmquist, "Asian American Photographers," 16. This attention in the press, however, was significantly xenophobic: "Lai Yung [*sic*], our only Mongolian artist, is painting 'heep plicture Melican man,' and charging 'Melican man's' prices for the same. His principal success is in portraits."

8 Contemporary Bay Area artist Hung Liu has cited one newspaper account dated 1870 which reports that the remains of 1,200 deceased Chinese American railroad workers, weighing ten tons, were shipped home to China in that year.

9 Although the work is undated, it is likely the "mirror" found on the checklist of works exhibited by Tape at the 1885 Mechanics' Institute exhibition. The year 1885 also saw the first group exhibition of women artists in San Francisco at the School of Design, although Tape did not exhibit there.

10 Theodore Wores taught Western-style painting to a group of Chinese students in the early 1880s; Wores's young art student and studio assistant, Ah Gai (nicknamed Alphonse), helped with translation when needed. This art class is believed to be the first provided by a Caucasian artist for non-white students in the United States. See Lewis Ferbrache, *Theodore Wores: Artist in Search of the Picturesque* (San Francisco: California Historical Society, 1968), 12, 15.

11 See Mayching Kao's essay in this volume for other examples of Chinese portrait painters in nineteenth-century America.

12 During the Meiji period, art in Japan was stylistically politicized. Works in a Western, European style were referred to as *yōga*. At that time, the California School of Design (Mark Hopkins Institute of Art) strongly emphasized life drawing and painting, and work of Japanese students typically included nude and clothed figure studies in charcoal and oil paint. Because several artists who were trained in San Francisco returned to Japan, this American training played a role in Japanese *yōga*. Poets—including Yone Noguchi, the first Japanese to publish poems in English in the United States and the father of Isamu Noguchi—also worked in California during those years, further suggesting that the cultural exchange went both directions.

13 See the artists' biographical entries for more information.

14 This painting depicts an important event in the life of the Buddhist nun Eshun (ca. 1364–ca. 1402). Because of her beauty, she was harassed by temple monks. To rebuff one especially ardent admirer, she made a compact in which she agreed to embrace his advances if he followed her instructions. At a large gathering of monks at the Saijōji Temple, Eshun disrobed and called out to the monk, offering herself to him there. He quietly disappeared. Thanks to Yoriko Yamamoto, Sakamoto Makiko of the Masakichi Hirano Museum of Fine Art, and Saijōji Temple monks for this information.

15 Yoshio Markino, *A Japanese Artist in London* (Philadelphia: George W. Jacobs & Co., 1910), 5, 6, 8.

16 See "Death Calls T. Aoki," *Pasadena Daily News*, June 27, 1912, 1.

17 One still-life example features a Native Indian basket, which was typical of the period, filled with persimmons, a fruit often associated with Japanese painting.

18 Toshio Aoki was employed at the G. T. Marsh store in Pasadena two years later, in 1895, and Marsh contributed to the popularization of Japanese art through his commercial ventures.

19 Our focus on the fine arts leaves uncovered some manifestations of Asian visual culture. The original illustrations found in the politically focused newspaper *Hindustan Gadar*, dating to the early 1910s, are examples of material culture of the South Asian community in San Francisco that is otherwise not represented here.

20 Senko Kobayashi founded Bijutsu Kyokai in San Francisco in 1896; other clubs were founded in Los Angeles and Seattle during the 1910s.

21 Hikoyama's woodcut style is typified by intricately cursive, evenly weighted lines. Earlier unsigned newspaper illustrations that evidence this style are also likely his work.

22 San Francisco Museum of Art Collection, East West Art Society Folder, 1922, San Francisco Art Institute Archives.

23 Sugimoto's journals include this entry: "I knew I had come to the Carmel coast from the white sand on the beach and the green cypress trees blowing and bending in the wind.... I kept drawing until a little before noon and as my sketch was starting to take shape, an elderly man who appeared to be Japanese came walking towards me. And after looking at what I was drawing, this Japanese man said, ... 'My name is Kodani and I live in a house in the woods near here with my family. I used to have a canning factory, a small one, here, and I hired several divers from Japan and I would have them go out to the shore and get abalone and we would can them and sell them on the market, but recently this entire area was made into a national park [1933] and so they took the canning factory away from us and we couldn't do any canning anymore. But my house and the cabins that the fishermen lived in are still here, and no one is living in them, and so instead of staying in

your tent, please come. I would be happy to have you come and stay as many days as you would like to do your sketching. If it becomes known that a Japanese painter went to Carmel to sketch and didn't stay at Kodani's, I would be embarrassed.'

"I became his guest in their cabin. Mrs. Kodani even made me all my meals, breakfast, lunch and dinner. This was the first time something like this had happened to me. That night, I slept in the cabin by myself. In that cabin, there were framed paintings of all shapes and sizes hung on the walls . . . I saw among those paintings one by an artist I knew from San Francisco. . . . The scenery around Carmel is the best coastal scenery in all of the United States, and along with Yosemite, I believe that it is among one of the most beautiful places in America." Collection of the Japanese American National Museum; translated by Emily Anderson.

24 Several writers have discussed Obata's relationship to Japanese painters of the late nineteenth century. Susan Landauer has written about the relationship of his work to that of Okakura Tenshin, Hishida Shunsō, and his teachers Hashimoto Gahō and Murata Tanryō, as well as the influence of Ernest Fenollosa more generally. See Chiura Obata, *Obata's Yosemite: The Art and Letters of Chiura Obata from His Trip to the High Sierra in 1927*, essays by Janice T. Driesbach and Susan Landauer (Yosemite National Park, CA: Yosemite Association, 1993).

25 Since this essay does not address ikebana artists, the work of Chiura's wife, Haruko, is not discussed. However, there is no doubt that Mrs. Obata's artistry and personal support helped contribute to her husband's success.

26 Hikoyama's work was featured in several exhibitions of the Sangenshoku Ga Kai, and Hibi's Amateur and Professional Artist Society continued to showcase his own and student work.

27 Chee Chin S. Cheung Lee as well as printmaker/velvet painter Wy Log Fong and Chinese theater set painter Mok Huk Ming were active during the mid-1920s.

28 George Matsusaburo Hibi, untitled article, *Shinsekai Asahi* (translated from the Japanese), August 8, 1927. Collection of the Japanese American History Archives, San Francisco.

29 George Matsusaburo Hibi, untitled article, *Shinsekai Asahi* (translated from the Japanese), August 9, 1927.

Collection of the Japanese American History Archives, San Francisco.

30 Eva Fong Chan joined the Chinese Revolutionary Artists Club around 1930 and later served as secretary for the Chinese Art Association. Family interviews suggest that David P. Chun was also involved with both groups; Chun served as president of the Chinese Art Association in the mid-1930s. The involvement of Suey B. Wong with the Radical Group exhibitions at the Art Center Gallery on Montgomery Street in 1931, a few years before Yun Gee's exhibition there, also suggests his possible acquaintanceship with Gee. See *San Francisco Chronicle*, June 12, 1931, D7.

31 A different Chinese Art Association is active in the Bay Area to this day, presenting exhibitions of members' work and often featuring innovative ink painters whose work is grounded in traditional idioms.

32 "A Son of Nippon with Originality," *Los Angeles Times*, December 16, 1923, part 3, 24.

33 "Oriental Art Center Here Contemplated," *San Francisco Chronicle*, January 15, 1928, D7.

34 At that time, Doi was living principally in Hawaii, and Noguchi principally in New York.

35 Reuben Tam studied at the California School of Fine Arts in 1940 and presented his solo exhibition at the California Palace of the Legion of Honor, and the Crocker Museum in Sacramento, later that year.

36 Some Chinatown merchants promoted the incorporation of Chinese architectural motifs in the rebuilding of Chinatown as a tourist destination, as part of their argument to keep Chinatown in its central, downtown location, rather than relocating it to an outlying neighborhood.

37 See Chingwah Lee, "Culture," *Chinese Digest*, November 20, 1936, 9. After the Chinese Revolution of 1911, community interest in the parade lessened for a time, but the parade was reborn after World War II as a signature event for the community.

38 See T. Y. Tang, "An Interpretation of our Chinatown's Tomorrow," *Official Program of the Pagoda Festival*, San Francisco, 1930; quoted in Cather, *History of Chinatown*.

39 Although the faculty of the Rudolph Schaeffer School of Design has not been fully researched, post–World War II faculty included Chingwah Lee and ink painter Lim Tsing-ai.

40 Interestingly, during roughly the same time, several buildings in Shanghai were being built in a Spanish colonial style.

41 See "Seven Steps to Fame," *Chinese Digest*, December 6, 1935, 8, for Chingwah Lee's seven-point manifesto (originally written in 1930) concerning the benefit to Chinatown of its Chinese attributes. See also "Chinese Argue in Tong Rooms, Quote Sages, Over Proposals to Orientalize Chinatown," *The San Francisco News*, July 17, 1935.

42 The Bay Bridge opened in 1936. The Golden Gate Bridge was also in construction at that time but did not open until 1937.

43 Published for five years, the *Chinese Digest* began as a weekly, but it transformed into a biweekly, then a monthly, and ended as a quarterly magazine in 1940.

44 Founders included Thomas Chinn, William Hoy, and Chingwah Lee.

45 *San Francisco News*, 1935, undated clipping, courtesy Colin Lee.

46 Fine Arts Museums of San Francisco Archives, Chinese Art Association Records.

47 Nanying Stella Wong reported that she was away in New York at the time of the opening.

48 The *California Art Research* 1937 biography of Chee Chin S. Cheung Lee repeatedly lists 1923 as the date of *Mountain Fantasy*, but the extant work is clearly dated 1933. It is unknown if this is a mistake in the publication or if the artist repainted or redated his work.

49 Junius Cravens, "Freshness Apparent in 20 Water Colors by Dong Kingman," *San Francisco News*, April 4, 1936; quoted in Dong Kingman, *Portraits of Cities* (New York: 22 Century Film Corp., 1997), 48–49.

50 Kingman painted with the Chinese Art Association in 1935 but did not participate in the de Young exhibition.

51 In a conversation with the author at the San Francisco Marines' Memorial Club in 1998, Kingman recounted that his two most important early patrons were Albert M. Bender and Dr. Colin Dong, the principal physician within the Chinese community.

52 Conversation with the author, San Francisco Marines' Memorial Club, 1998.

53 Anthony Lee, *Picturing Chinatown* (Berkeley: University of California Press, 2001), 201–205. Lee has also written about the political aspirations and perspectives the club embodied.

54 *The Curse of Quon Gwon*, written and directed by Marion Wong, the aunt of Nanying Stella Wong, was filmed in Niles Canyon in 1916. It is now acknowledged as the earliest-known Chinese American feature film, and one of the first films directed by a woman.

55 Asian Americans in New York, Los Angeles, Seattle, and other cities also worked for the WPA. In New York, Asia-born artists working for the WPA were deemed ineligible for support through this program after 1937, as they were not U.S. citizens.

56 "The California Watercolor Society Index to Exhibitions 1921–1954," in Nancy Dustin Wall Moure, *Publications in Southern California Art 1, 2, & 3* (Los Angeles: Dustin Publications, 1984).

57 Rene T. de Quelin, "Among the Artists," *Graphic* (Los Angeles), May 16, 1908, 18–19.

58 Eugene Neuhaus, *The Galleries of the Exposition: A Critical Review of the Paintings, Statuary and the Graphic Arts in the Palace of Fine Arts at the Panama-Pacific International Exposition* (San Francisco: Paul Elder and Co., 1915).

59 "Art Lecture Given," *Chinese Digest*, December 20, 1935, 3.

60 Artists trained at the California School of Fine Arts include George Matsusaburo Hibi, Hisako Hibi, Miki Hayakawa, Yun Gee, Eva Fong Chan, Chee Chin S. Chung Lee, Hideo Noda, Takeo Edward Terada, and many others. Artists trained at the University of California, Berkeley, include Mine Okubo, Chingwah Lee, and Nanying Stella Wong, and Chiura Obata became a revered and influential teacher. Wing Kwong Tse attended the University of Southern California, Michi Hashimoto was a student at UCLA, and Henry Sugimoto attended the California School of Arts and Crafts.

Hidden in Plain Sight

Little Tokyo Between the Wars

Karin Higa

The story begins and ends in Little Tokyo, Los Angeles, among the streets and alleys in the literal shadow of City Hall and its majestic, pyramidal tower. The time is the decades before World War II, when Los Angeles was not considered a major metropolis. In this way, our story may seem a provincial one. After all, in a city yet to make its mark, Little Tokyo was an ethnic ghetto described by a special commission of the State of California as containing "all the evils of a foreign quarter" with no discernible "American influence...bad housing, frightful overcrowding, congestion of people."[1] Yet the artistic activity centered in Little Tokyo presents tantalizing evidence of a dynamic nexus of artists, art, audiences, and intellectual exchange. This essay explores this terrain by delving into the world of Little Tokyo and the work of some artists who inhabited it in the period between the two world wars. Their lives, their art, and their web of associations led away from the ethnic ghetto and into both crosstown and global contexts, at the same time remaining firmly rooted in the Japanese American community. Little Tokyo, therefore,

and the stories of its artist-inhabitants, requires a shift in the operative frameworks of analysis from those that focus on local and ethnic history to others that consider national and transnational contexts as well as the fluidity of cultural influences in early-twentieth-century America.

ETHNIC GHETTO/GLOBAL CITY

Perhaps because transportation and communication networks in the early decades of the twentieth century seem so antiquated by today's standards, it is easy to think of communities as being physically and intellectually isolated and operating outside of national and international forces, especially in the realm of art and culture. With the period's limited technical means of movement and communication—trans-Pacific crossings of more than a fortnight; no mass penetration of telephone technology, even[2]—and a still-nascent mass media, many scholars have underestimated the tremendous fluidity of ideas, bodies, and capital in the early twentieth century and its import for assessing cultural production, especially emergent modernisms. In her recent study of global cities, sociologist Janet Abu-Lughod suggests that the common assumption that characteristics asso-

FIG. 28 Toyo Miyatake, *Untitled (Little Tokyo Alley, Los Angeles)*,
1924. Bromide print, approx. 13½ × 10½ in.

31

ciated with globalism are a new phenomenon, generated by the development of an all-encompassing world system (variously termed as late capitalism, postindustrialism, or the informational age), is misguided. Rather, she argues that all of the characteristics of global cities were present, albeit in embryonic form, in earlier periods; in the case of Los Angeles, she locates this early stage in the beginning of the twentieth century, precisely the period under assessment here.[3]

Further still, in the case of Japanese American cultural production, one must read against the history and politics of exclusion as manifested by the formation of ethnic ghettos. Scholars of the Asian American experience have rightly assessed and analyzed the discourses of the anti-Asian movement or, alternately, the agency and success of Japanese Americans in the face of such discrimination. In the first case, the proliferation of overt anti-Japanese sentiment—whether it be hostile legislation on the state and federal levels or garden-variety expressions of racism such as reduced job possibilities and restrictive housing covenants—demonstrates institutionalized marginalization and limited access to dominant power structures. In the second, the ability to collectively and efficiently organize vertically integrated networks of commerce, such as with the produce, floriculture, and nursery industries as well as the formation of diverse organizations such as *kenjinkai* (associations based on common districts of origin in Japan), business networks, sporting associations, and churches and temples, gave the impression that the Japanese American community was not only forced to be, but actually flourished as, a discrete, separate, and parallel community, prompting figures such as the normally astute Carey McWilliams to erroneously conclude that Little Tokyo was "more or less a self-contained community, an island within an island."[4]

Yet for Japanese American artists, Little Tokyo's borders were porous. Their art found a receptive au-dience in such far-flung places as New York, London, and Mexico City, just as it did closer to home, whether it was in an exhibition at the Los Angeles Museum of History, Science and Art, a nightclub in Chinatown, or the home of a Hollywood star. What's more, within the "island" of Little Tokyo, one could regularly see art by its inhabitants and others in exhibitions, in the *Rafu Shimpo* (the Japanese American daily newspaper), or through the regular reviews featured in the *Los Angeles Times*. The effects of the anti-Asian movement touched upon every aspect of Japanese American life, yet it did not fully circumscribe it. The dense, global urbanism of Little Tokyo provided fertile ground; its web of art and ideas was complex and dynamic.

EAST FIRST STREET

Sometime in the late 1910s, around the time of the state's withering report on the Japanese enclave, **Toyo Miyatake** was walking down East First Street, the main artery and heart of Little Tokyo, when he was seized with the idea to become a photographer. Perhaps this youthful declaration, uttered to himself, would have meant little if within a few minutes Miyatake had not run into a close friend to whom he confided his revelation. The friend quickly pointed toward the Tomoe Hotel on the corner of Second and San Pedro streets and said, "Harry Shigeta has a room on the second floor over there and he gives classes in photography," whereupon Toyo crossed the street and commenced his life as a photographer.[5]

At age twenty, Miyatake had been living in the United States since 1909. He had migrated at the behest of his father, who had left the family in Kagawa earlier to establish a base in America before calling them over. Seattle was chosen as the port of entry because immigration officials were rumored to be more lenient than in San Francisco. Toyo, his mother, and two brothers then traveled down the West Coast to Los Angeles and settled in the back of his father's con-

fectionery shop, Shofudo. Over the next ten years, Miyatake attended Amelie Street Grammar School, helped with the family business, and tried his hand picking grapes in Central California. Miyatake was to become the most prominent Japanese American photographer of the twentieth century, who made work without interruption for nearly sixty years. But in 1920s Little Tokyo he was one among many young Japanese Americans interested in the pursuit of art (fig. 28).

Miyatake's meeting of Shigeta was fortuitous. The older man had opened a photography studio on San Pedro Street, just south of First Street, in 1918. But that in and of itself was not particularly significant. Photographers and photography studios were ubiquitous in Little Tokyo. Panoramic photographs commemorated almost any formal gathering, from banquets to funerals. They were printed in multiples and sold to those depicted, so that even today, one frequently finds several prints of the same event despite the passage of more than ninety years and the upheaval caused by mass incarceration. Moreover, many immigrants (as Miyatake's father had been initially) were separated from their families. Photographs were a means of making a tangible connection and were exchanged from both sides of the Pacific. If families could not be together "in the flesh," they could be united in pictures. Using "double printing," separated families could be combined into one family portrait.[6] The immigrants' desire to have visual proof, or visual fabrication in some cases, of their success in America kept photography studios and their retouching departments busy in Little Tokyo. In the 1910s, the majority of marriages in the Japanese American community were made through intermediaries in Japan with the exchange of photographs a significant part of the "courtship" process. Men often forwarded photographs taken in their youth or retouched to conceal age, blemishes, or baldness so that many picture brides were genuinely shocked to see their husbands: "Suave, handsome-

looking gentlemen proved to be pockmarked country bumpkins."[7]

Shigeta provided an especially expansive model for Miyatake. By the time Shigeta opened his studio in Little Tokyo, he was already an established photographer with deep connections inside and outside of Little Tokyo. Born in 1887, the Nagano native migrated to the United States at age fifteen.[8] Within a year, he left the West Coast to enroll at the St. Paul School of Fine Arts in Minnesota, where he took an integrated course of fine and applied arts, studying everything from drawing, illustration, and sculpture to ceramics, leather- and metal-working, and bookbinding. Accounts of Shigeta suggest a man of many talents and an entrepreneurial spirit whose manual dexterity and training as an artist served him well. He initially turned to photography as an aid to draw live models but quickly parlayed this knowledge to secure employment at a St. Paul portrait studio. By the early 1910s, Shigeta moved to Los Angeles, where he found work as a portrait photographer, appeared onstage as a professional magician for the Orpheum Theater chain, and became an expert retoucher at Edwards Histead Studio, among other places, applying his acumen to make his portrait subjects like Cecil B. DeMille and Wallace Berry more attractive in print.

That Shigeta was both a practicing magician and a photographer mirrors the diversity of his approach to the latter medium. His extant photographs of the period represent a heterogeneous range of styles and techniques, from conventionally staged portraits, often of people in their homes artfully surrounded by choice objects, to a stunning study of a nude and sand dune or a simple and stark depiction of trees, which has an effect quite modern in sensibility. What is remarkable about the extant work is how little there is—in both style and subject matter—that is a cultural expression of his ethnicity. One exception is *Fantasy*, 1923 (fig. 29), a combination print that utilizes the pictorial conventions of

FIG. 29 Harry K. Shigeta, *Fantasy*, 1923.
Bromide print, 13⅜ × 7¼ in.

ukiyo-e woodblock prints. Willow branches hang asymmetrically to the right of a distant crescent moon, which upon closer viewing consists of the arched body of a nude woman. Yet even though the compositional reference for the photograph is clearly Japanese, the nude bears none of the hallmark signs of "Orientalness," and her body reads as European American. Given the societal and legal restrictions placed on Japanese Americans, the fact that Shigeta's portraits and his models were European American suggests the ability of Japanese Americans to function, and even flourish outside of a strict Japanese American context. It also underscores how integrated early Japanese American experiences could be.

It is unclear what specifically Shigeta's curriculum was, how many students he had, or for how long he taught photography, but his studio in Little Tokyo

was short-lived. In 1920, Shigeta closed it to work as a staff photographer for *Filmland* magazine, a new vehicle for the promotion of Hollywood stars. But ultimately feeling limited in Hollywood, Shigeta left in 1924 for more expanded job possibilities in Chicago. Within fifteen years, he became a financially successful advertising photographer and one of the most prominent photographers working in a pictorialist vein, whose essays and lectures on the relationship of pictorialism to commercial photography became influential texts. During this period, he continued to explore combination printing, producing surrealist-inspired compositions akin to *Fantasy*, but with no

visual signifiers of the "Orient" (fig. 30). Instead, his published work in this period is filled with dream-like juxtapositions suggestive of his earlier forays into magic. "The experience of being a magician was good training for me . . . I also learned that human eyes can be deceived by tricks and illusions," Shigeta wrote before concluding, "these findings were very useful to me as a photographer."[9]

SHAKU-DO-SHA

As Shigeta was preparing to leave Los Angeles, Ka-oru Akashi of Paris Photo Studio at 233½ East First Street decided to sell his business.[10] In November

FIG. 30 Harry K. Shigeta, *Curves, A Photographer's Nightmare*, 1937. Silver gelatin print, 14 × 11 in.

1923, Toyo Miyatake marshaled his resources and found himself the proud owner of an established studio in the heart of Little Tokyo, which he renamed Toyo Studio.[11] But in addition to establishing a foothold in the commercial photography studio market, Miyatake found himself the proprietor of a de facto salon, where a regular cadre of people would stop by and hang around. The actor and director **Sessue Hayakawa**, opera singer Yoshie Fujiwara, cinematographer **James Wong Howe**, and Tokyo-based artist Takehisa Yumeji were among those who regularly stopped by the studio, as did the Japanese American painters, poets, and photographers associated with the Shaku-do-sha.[12]

The Shaku-do-sha[13] was a newly formed association "dedicated to the study and furtherance of all forms of modern art."[14] Founded by the Japanese American painters **Tokio Ueyama**, Hojin Miyoshi, and **Sekishun Masuzo Uyeno** and the poet T. B. Okamura, the group was intellectually and organizationally ambitious. In June 1923, a major exhibition organized under its auspices was held in the newly constructed Union Church and featured twenty-four paintings by seven artists.[15] An eighteen-page catalog, replete with reproductions of five of the paintings and accompanied by five original woodcuts (including a cover image by Ueyama [fig. 31]), opened with an extended quote by Jean-François Millet (in Japanese rather than the original French) that ruminates on the struggles inherent in making art—that from pain and suffering, the expression of art derives its power. But the Millet quote also explicitly links these Japanese American artists to European traditions, signaling their connections to an artistic heritage beyond Japan.

The publication's nine pages of advertising at the back paint a broad portrait of the Little Tokyo community. The ads, mostly in Japanese with some

English—for "Diamond Brand" shoes, "Selected Gifts that Last for June Brides and Graduates," violin lessons by a Maestro Uesugi who appears dressed in tails, and the Shofudo confectionery shop[16]—all represent concerns located on First Street. Since Miyatake had yet to purchase his studio at the time of this catalog, his ad simply states, "Toyo-o Miyatake, Photographer" and is represented by a strikingly graphic woodcut of a man, arm outstretched in front of a luminous sun (fig. 32). In its juxtaposition of Japanese-language text and American brands and holidays, high-cultural offerings of art and street-level commerce, the advertising provides a glimpse of the depth and texture of Japanese American community life in Little Tokyo. It also provides evidence that the Shaku-do-sha enjoyed widespread community

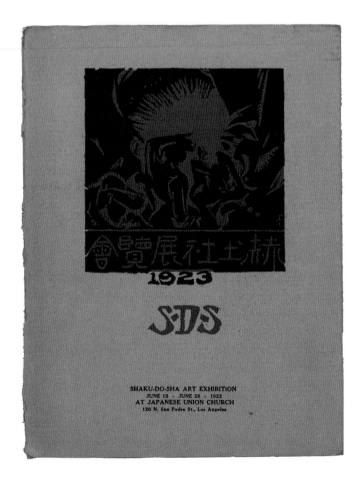

FIG. 31 Tokio Ueyama, Cover for the *Shaku-do-sha Art Exhibition* catalog, 1923.

36

FIG. 32 Toyo Miyatake, Advertisement
for the *Shaku-do-sha Art
Exhibition* catalog, 1923.

support and was not an isolated or aberrant group.
Not only were artists a part of the Little Tokyo life,
they were a significant component of the cultural
landscape.

Community support notwithstanding, a review
of the exhibition took pains to critically assess each
of seven artists. Written by **Taizo Kato**, himself a pic-
torialist photographer, and the proprietor of the Ko-
rin art and photography supply store (and likely the
Kato named as a member of the Shaku-do-sha in the

exhibition's catalog), the review noted with frank-
ness which works were masterful and which needed
something more.[17] Even Ueyama joined the criti-
cal fray.[18] His review focused on three of his co-
exhibitors, Hojin Miyoshi, **Shiyei Kotoku** (fig. 33),
and Sekishun Uyeno, and he is far from fawning. Like
Kato, he made careful observations about the relative
merits of the paintings and did not shy from making
specific assessments, some positive, but others quite
critical.[19] That the Shaku-do-sha continued in ear-
nest throughout the decade with the core of artists
intact suggests that an engaged, critical dialogue was
part of the group's appeal. They needed the support

FIG. 33 Shiyei Kotoku, *The Cliff, Carmel-by-the-Sea*,
ca. 1923. Oil on canvas, 38½ × 40⅜ in.

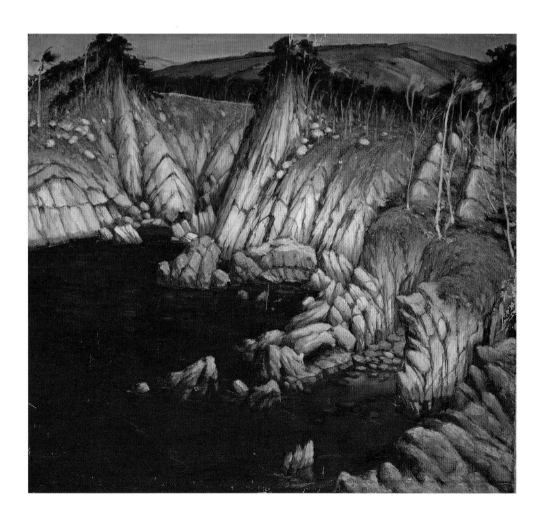

of one another, yes. But they also thrived on intellectually and formally challenging each painting. Direct criticism strengthened their resolve to make art. Pain and suffering fueled their expression.

In 1922, Ueyama was invited to participate in the second exhibition of the East West Art Society at the San Francisco Museum of Art.[20] Throughout the 1920s and 1930s, many of the Japanese American artists in Little Tokyo participated in exhibitions in other parts of Los Angeles, in San Francisco, and elsewhere in the United States, especially the annual exhibitions of the San Francisco Art Association. Whether they traveled to see the exhibitions in person is unclear,[21] but they were fully aware of the currents in contemporary art of the period—Japanese American or otherwise—and exchanged information about their activities.[22] Moreover, the diverse paintings by Japanese American artists demonstrate that no single formal or stylistic expression existed. Within the Shaku-do-sha, artists favored styles along a range from American realism and American impressionism to the influence of Cézanne, but there was no prevailing or limiting aesthetic framework. Citing one of the many exhibitions of Japanese American art in Little Tokyo, the *Los Angeles Times* noted that among the exhibiting artists "several different schools are in evidence," but only one of them carried on in the "Japanese manner."[23]

The seeming incongruity of Japanese ethnicity, Western-style painting, and slang-spouting Japanese Americans provided humorous fodder for a review by *Los Angeles Times* art critic Arthur Millier. Recounting an exchange between a "young college sheik" and a "newspaper man" overheard at an exhibition in Little Tokyo, Millier noted with wry amusement that there was nothing strange about it "until one suddenly realizes that both speakers were Japanese. Then the words become almost a key to the exhibition."[24] Of the twenty-four artists included, he commented that very little could be specifically linked to Japanese traditions. Instead, "they had completely embraced the modern occidental attitude towards life and art, dropped their old painting tradition founded on rhythmic line, yet were presenting us with works of real vitality, entirely lacking the hybrid feeling we might expect from such a revolutionary change."[25]

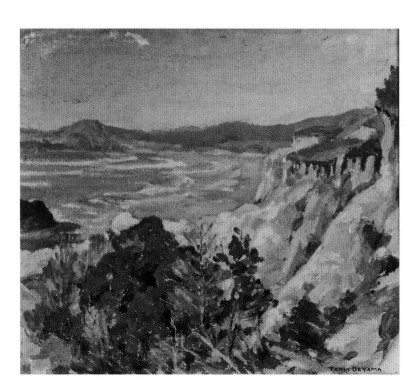

FIG. 34 Tokio Ueyama, *Coast Sketch no. 2*, ca. 1930s. Oil on canvas, 15 × 17 in.

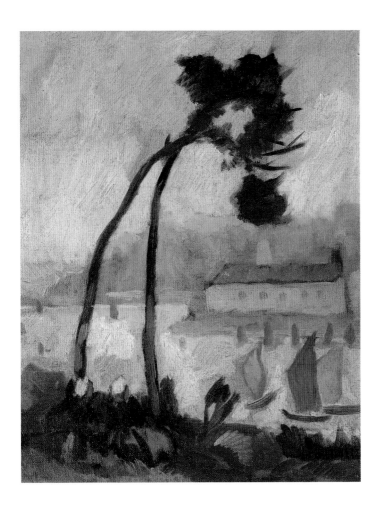

FIG. 35 Kazuo Matsubara, *Untitled (Sailboats Scene)*, 1927. Oil on canvas, 16 × 13 in.

Among the artists Millier singled out are Ueyama (fig. 34) and **Kazuo Matsubara** (fig. 35), a painter principally based in San Francisco. He went on to write that "not the least significant sign of the interest Los Angeles Japanese take in the work of the artists of their race was the liberal sprinkling of sold tags placed on the works."[26] Not only were Japanese Americans viewing art in Little Tokyo, they were buying it.

PHOTOGRAPHY

The Shaku-do-sha was not the only group of artists in Little Tokyo. In the early 1920s, the Japanese Camera Pictorialists of California was organized under the strident leadership of Kaye Shimojima. As Dennis Reed has explored in exhibitions and books, these Japanese American photographers created the most dynamic photographic work in Los Angeles of the period and were likewise recognized by inclusion in major national and international publications and exhibitions.[27] The first of many exhibitions organized by the Japanese Camera Pictorialists was sponsored by the *Rafu Shimpo* in 1924 with Margrethe Mather, N. P. Moerdyke, and Arthur F. Kales as judges; in 1926, Will Connell was enlisted. The involvement of these prominent European American photographers suggests a depth of interaction between Japanese American artists and their fellow photographers that unfolded and continued over time.

But the Shaku-do-sha is credited with the most-cited exhibition of photography in Little Tokyo. First in 1925, and then again in 1927 and 1931, in the Sumida Music Store on East First Street, the Shaku-do-sha sponsored exhibitions of Edward Weston's photographs. The late 1910s to the mid-1920s were tumultuous years for Weston. By the mid-1910s, his work was gaining increasing critical acclaim, including a favorable notice by the critic **Sadakichi Hartmann** writing under the pseudonym Sidney Allen.[28] Amid this growing prominence, however, upheaval in Weston's romantic life and a tenuous financial sit-

uation produced what one scholar termed "melancholia."[29] Money was especially tight after Weston's return from Mexico, where he had traveled with photographer Tina Modotti, his lover. Weston's entry in his *Daybooks* underscore with enthusiasm the Japanese American support—intellectual and financial.

> August 1925. The exhibit is over. Though weary, I am happy. In the three days I sold prints to the amount of $140.—American Club Women bought in two weeks $00.00—Japanese men in three days bought $140.00! One laundry worker purchased prints amounting to $52.00—and he borrowed the money to buy with! It has been outside of Mexico my most interesting exhibition. I was continually reminded of Mexico, for it was a man's show. What a relief to show before a group of intelligent men! If Los Angeles society wishes to see my work after this, they must come to the Japanese quarter and rub elbows with their peers—or no—I should say their superiors. I owe the idea for this show to Ramiel—and his help made it a success.[30]

Though short, the entry provides an interesting sketch of Little Tokyo from the perspective of a European American artist. It presents the opinion that within Los Angeles, Little Tokyo was a prime place for stimulating intellectual exchange and indicates that there was an active market consisting of Japanese Americans, who purchased art even when cash was not available. Notwithstanding his barely concealed contempt of the "American Club Women" versus the "man's show" in Little Tokyo, Weston's invocation of Mexico is an interesting one. Ueyama had traveled to and exhibited in Mexico City the previous year, and up until World War II, a number of Japanese American artists, including Central California–based **Henry Sugimoto**, made the trek south of the border, where they met Mexican artists such as Diego Rivera and José Clemente Orozco as well as connected with Japanese who had settled there. The appreciation that Weston felt for his Japa-

nese supporters in 1925 continued throughout his *Daybooks* to the point where lack of sales in any particular instance was accompanied by the refrain "not like the Japanese" or some such variation.[31]

MICHIO ITO AND TOYO MIYATAKE

Because Edward Weston is universally recognized as among the most significant photographers of twentieth-century America, it is easy to forget that at the time of his experiences in Little Tokyo, he was one among many of promise in the field. When choreographer Michio Ito arrived in Los Angeles in 1929, however, he had already achieved international status as a pioneering choreographer of modern dance in both Europe and the United States. Born in 1892 in Tokyo, Ito was the son of a prominent architect. Around 1910, he left Tokyo to study voice and music in Paris. He became disenchanted with opera and spent his time traveling throughout Europe and actively engaging in the provocative offerings of new art. He became acquainted with figures such as Auguste Rodin and Claude Debussy and formed lifelong friendships with painters Tsugouharu Foujita and Jules Pascin. After reportedly witnessing Vaslav Nijinsky and his company at the Theatre Chatelet in June 1911 and possibly meeting Isadora Duncan in Berlin shortly thereafter, Ito turned to dance. He identified Hellerau as a place to study and began formal training in Émile Jaques-Dalcroze's Institute of Eurythmics, an integrated approach to dance, music, and drama.[32]

With the outbreak of World War I, Ito moved to London, apparently with little financial resources. A strikingly handsome figure with long, straight, black hair, Ito soon frequented the Thursday evening salons of Lady Ottoline Morrell, where his solo performances to music performed by Lady Ottoline's husband, Philip, launched a "career." At Lady Ottoline's Ito met Ezra Pound and W. B. Yeats. Pound had come across the manuscripts of Ernest Fenollosa, the American Orientalist, who had been trans-

lating Noh plays into English, which Pound then transformed into verse. Yeats saw Noh as a viable way of reinterpreting theater and likened its "otherness" to the alternative traditions of the Irish theater. The appearance of Ito in London was perceived as fortuitous for the Western writers who sought his assistance. But Ito was initially hostile to Pound's request. "Noh," in Ito's estimation, "is the damnest thing in this world": an arcane, old tradition.[33]

This anecdote suggests one critical conundrum for Japanese artists of the late nineteenth and early twentieth centuries: namely, as European modernists looked to the simplicity and exotic otherness of Asia as a source to reinvigorate Western art forms, Japanese artists were automatically assumed to have some special relationship to their ancestral heritage. Yet this idea of a native informant presented complex opportunities, and in 1916, Ito and Yeats collaborated on *At the Hawk's Well or The Waters of Immortality*, which had several performances in London. This liberal reinterpretation of the Noh style met with immediate and positive critical response. T. S. Eliot remarked that upon seeing *At the Hawk's Well*, "Thereafter one saw Yeats rather as a more eminent contemporary than as an elder from whom one could learn."[34]

Dance, of course, is an ephemeral art. One of the few documents of Ito during this period are the photographs by Alvin Langdon Coburn (fig. 36), an expatriate American photographer, whose European circle included writers H. G. Wells, George Bernard Shaw, and John Galsworthy; and artists Auguste Rodin and Henri Matisse; in the United States, Alfred Stieglitz and Gertrude Stein were two of his cohorts. Coburn was among those who were associated with Stieglitz's *Camera Work*. A Japanese aesthetic was valorized in *Camera Work* in both direct and indirect

ways. In the second issue, for instance, Sadakichi Hartmann (again writing as Sidney Allan) authored "The Influence of Artistic Photography on Interior Decoration," which discussed the Japanese interest in harmonious interior design as a model for the display of "artistic" photography. In the following issue, one of Mary Cassatt's *ukiyo-e* inspired paintings appeared, and two years later a woodblock print by Utamaro was published in issue ten.[35] The modernist interest in Japanese culture provided a means by which a marginalized ethnic group in a Western context had access to high cultural associations.

Ito left London for New York shortly after his collaboration with Yeats. Between 1916 and 1929, Ito performed extensively in New York, where Martha Graham was among his dancers and Hungarian American Nickolas Muray and Japanese American Soichi Sunami, both photographers, documented him on film. During this period, the young **Isamu Noguchi** sought out Ito, who had known his father,

FIG. 36 Alvin Langdon Coburn, *Dancer Michio Ito*, ca. 1916. Negative, gelatin on nitrocellulose roll film, 4¾ × 3½ in.

the poet Yone Noguchi, in London. Isamu Noguchi offered to design masks for Ito's New York 1925 performance of *At the Hawk's Well*.[36] Noguchi's bronze head of Ito based on the original papier-mâché designs riffs on the characteristically smooth features of traditional Noh masks while clearly capturing Ito's likeness and slight angle of his head (fig. 37). The elongated strand of hair reproduces another characteristic of Ito—his quite dramatic use of hair—but inventively employs it as a handhold for the mask. In almost all estimations of Noguchi's work, the Ito portrait appears as one of the earliest examples of Noguchi's engagement with modernist sculpture, one that registers the shift from his earlier studies with Gutzon Borglum, the stone carver of Mount Rushmore.[37]

FIG. 37 Isamu Noguchi, *Michio Ito*, 1925. Cast bronze, approx. 24 × 8 in.

In 1929, Ito moved to Los Angeles, where he dropped by Miyatake's studio with a mutual friend.[38] For the next decade, Miyatake took on the task of fixing permanence to the fleeting forms of Ito's movements (fig. 38). In Ito's dance poems, as he called them, music regulates and controls the movement. The foundation of Ito's choreographic practice was an intricate system of gestures: ten basic arm movements in two forms—masculine and feminine—that could be combined into an infinite number of sequences. Miyatake's photographs of Ito capture this process of gesture. Ito's contorted hands appear as if bound, while the intensity of his facial expressions remains concealed by his trademark long hair. As in most of Miyatake's interpretations of Ito, the shadow enters into play as if another body participating in the action. It becomes a menacing witness to the articulation of the gesture. The stark depictions reverberate: "Ito's gesture is never final; it merely enters the spectator's mind, where it beckons the imagination into the future."[39] Miyatake appears to have engaged in an active collaboration with Ito and his dancers: "he and his almost anthropomorphic camera were always in evidence. Looking out from a prompter box, on top of a ladder or behind an arclight, sometimes on his knees, his side and once in a while on his feet."[40] But his friend James Wong Howe also gave him insight into the role of light and shadow,[41] which he utilized in other photographs besides his Ito works.

Throughout the early 1930s, Miyatake was the primary interpreter of Ito performances, as Coburn had been in the 1910s and Muray and Sunami in the 1920s. For Miyatake, the work with Ito presented new opportunities, pushing his photographic experimentation and providing a connection, through Ito's past experiences, to a dynamic international arena of art and ideas. One photograph of *At the Hawk's Well*

FIG. 38 Toyo Miyatake, *Michio Ito in Pizzicati*, 1929. Bromide print, 13½ × 10½ in.

from 1929 found its way to the London Salon of Photography in 1930. Photographs of dance were not an uncommon subject among photographers of this period, especially staged tableaux that suggested antiquity or reenactment of mythological tales. However, Miyatake's interpretations of Ito and his students are concerned both with formal compositional issues and with the difficulties of capturing movement in a static form. Miyatake's experimentation with light and movement culminated in some of his most provocative works of the decade. The body of the dancer is reduced to the flicker of light in motion, cutting a wide sweep across the space of the photograph.

THE NEXT GENERATION

Education in early-twentieth-century America was a democratizing force, and this held true for Japanese Americans as well. As the generation of Japanese Americans born in the twentieth century reached college age, they found access to postsecondary education remarkably open, though prospects upon graduation were still quite limited. But in art, more possibilities existed. As Bumpei Usui commented, "The least prejudice against our race is still in the art world."[42] Los Angeles's first formal art school, the Otis Art Institute, was founded in 1918 as an adjunct to the Los Angeles Museum, followed by the establishment of Chouinard and the Art Center College of Design in 1921 and 1929, respectively. Young Japanese Americans enrolled at all three institutions in the pre–World War II period. Otis, in particular, seemed to attract a diverse student body, which in turn nurtured relationships among students of different backgrounds. For three years beginning in 1929, Otis's highest honor, the Huntington Assistance Prize, went to Japanese Americans: **Charles Isamu Morimoto**, **Benji Okubo**, and Kiyoshi Ito, and **Hideo Date** received a "Day School" scholarship and selection by the College Art Association for the *Young Painters* exhibition at the Ferargil Galleries in New York. The Otis publication

El Dorado, Land of Gold (fig. 39), "a series of pictorial interpretation of the history of California with accompanying rhythmic story by students of Otis Art Institute," featured woodcuts by twenty-nine students, of which five were Japanese American: Date, Ryuichi Dohi, Ito, Morimoto, and its editor Okubo. Without a hint of irony, the students' work accompanied poetic verse that mused on the mythic founding of California by Spanish settlers with titles such as "Junipero and his Indian," "Conquest of the Gringos," and "Bartering their Goods for Candles." Between 1930 and 1941, **George Chann**, **Henry K. Fukuhara**, **Hideo Kobashigawa**, **Sueo Serisawa**, and **Tyrus Wong** were among the other Asian American artists who attended Otis. In roughly the same period, **Gyo Fujikawa**, **Chris Ishii**, **Ken Nishi**, **Keye Luke**, **Gilbert Leong**, **Milton Quon**, and **Gene I. Sogioka** studied at Chouinard.

The Art Students League of Los Angeles and its charismatic leader, Stanton Macdonald-Wright, formed another nexus where Asian American artists were active players. The league was founded in 1906 and provided a setting for the study of art outside of a traditional art school. In 1910s Paris, Macdonald-Wright and Morgan Russell, who later taught at the league as well, developed a theory of abstraction in painting based on complex color theory linked to music. Synchromism, as they termed it, placed Macdonald-Wright and Russell at the vanguard of modernist painting, but upon returning to Los Angeles in 1919, Macdonald-Wright abandoned pure abstraction in favor of figurative work inspired by Asian art. Under his leadership, the Art Students League became a bohemian outpost that attracted a wide range of creative innovators such as director John Huston and architect Harwell Hamilton Harris in addition to artists Lorser Feitelson, Herman Cherry, and Albert King. That Macdonald-Wright was so enamored of Asian art provided a milieu where Japanese and Chinese ancestral heritage was valued and valuable. Date and Okubo were key participants

FIG. 39 Benji Okubo, from cover of *El Dorado, Land of Gold*, Otis School of Art publication, 1928.

in the league. Date intermittently lived at the league studios, and Okubo was its director in the period before World War II.

In 1939, Macdonald-Wright was invited to be the guest editor for an issue of *California Arts and Architecture* that aimed to "give the reader an impression of Chinese influence in California" (fig. 40).[43] Tyrus Wong and Milton Quon created the cover. Macdonald-Wright wrote about Chinese artists in California, **Chingwah Lee** covered Chinese art, and articles on James Wong Howe, Chinatowns in America, and Chinese plants, drama, music, architecture, and garden design rounded out the issue.

The relationship between Asian American communities and Asia in the pre–World War II years was far more complex than can be efficiently summarized. In the case of Japanese Americans, it was not unusual for Japanese Americans to make trans-Pacific crossings: as individuals, with family, or as part of formal groups.[44] In 1929, Date interrupted his studies at Otis to spend a year in Tokyo studying

at the Kawabata Gakkō, a private studio established by Kawabata Gyokushō, a well-regarded painter in the *nihonga* style, and Date traveled to Tokyo again in 1936 as a translator for a European American acquaintance interested in ikebana.[45] *Nihonga* emerged in the late nineteenth century as a painting style that self-consciously adapted traditions of Japanese painting—from material to method—and was conceived as a direct response to the promulgation of Western-style oil painting in the decades after the Meiji restoration. Date returned to Japan with the explicit intent to study Japanese-style painting, but his choice of the Kawabata school was by chance; a Japanese American artist gave him a letter of introduction to an artist in Japan who eventually introduced him to the school, further evidence of artistic connections formed across the Pacific.

Date's paintings and works on paper from this period combine an exquisitely rendered line with atmospheric renderings, which have a controlled, but dreamlike effect. In the *Bather*, ca. 1930s (fig. 41),

FIG. 40 Tyrus Wong (with calligraphy by Milton Quon), *California Arts & Architecture* cover, October 1939.

green and yellow lines form a mane of hair. The precise lines contrast with the sensitive modeling of the face and background, which Date created through painstaking successive washes of watercolor. But it is the contrasting pictorial strategies that produce a dynamic tension. The work is flat and graphic at the same time it is sensitively modeled. In many of Date's works, graphic patterns of gouache anchor the lower part of the sheet: a stylized textile design, adornment, or floor pattern, despite its recession into space, reads with a graphic sensibility akin to that of Japanese prints.

An odd and unnatural quality is further created by his juxtaposition of contrasting colors—a chartreuse face with orange hair, for instance—something Date attributed to Macdonald-Wright's color theories. Macdonald-Wright's influence can also be seen in the muscular, largely scaled bodies and faces of Date's women, which derive from Macdonald-Wright's interest in Michelangelo. Date's women contain a charged sexuality, which mirrors what we know of Date and his sitters. Some of the women were his sexual partners, and accounts suggest that within their small circle of friends, various cou-

plings occurred over time. In a period when anti-miscegenation laws were in effect, such liaisons were far from unusual, but making them public and official was taboo and illegal.

Although Benji Okubo was a Nisei, having been born and raised in Riverside, California, and Hideo Date was an immigrant from Japan, they were good friends and artistic compatriots. Okubo's paintings relate to an interest in the arts of Asia, but the mysterious figures, strange compositions, and psychological introspection of his work also align him with aspects of California surrealism, most notably with Lorser Feitelson and Helen Lundeberg.[46] In *The Kiss*, ca. 1930s (fig. 42), the face of the artist is partially obscured by a small, floating, upside-down figure, which holds onto the left side of his face. The intensity of the man's eyes recalls Persian miniatures, a subject upon which Macdonald-Wright often lectured. This painting, like others of the period, makes no attempt at an easy narrative, though by the World War II incarceration, the haunting commentary in Okubo's work becomes more explicit, and radically critical of the political situation.

In 1933, Date and Okubo exhibited together in

FIG. 41 Hideo Date, *Bather*, ca. 1930s. Watercolor and gouache on paper, 28 × 20½ in.

FIG. 42
Benji Okubo,
The Kiss,
ca. 1920–1930s.
Oil on canvas,
10 × 11 in.

a two-person show sponsored by the *Rafu Shimpo* and *Kashu Mainichi*, another vernacular newspaper, held on East First Street. In 1934, Date and Okubo, along with Tyrus Wong (fig. 43) and Gilbert Leong (fig. 44), exhibited as the "Los Angeles Oriental Artists' Group," under the auspices of the Foundation of Western Art, an association of artists that supported the art of the West Coast. The exhibition featured twenty-two works, including one by Date that had already entered the collection of the Los Angeles Museum and was accompanied with a foreword and biographical notes by Macdonald-Wright, who aptly commented that "today, and especially here on the West coast, the flow from the East is again evident." Both the sensitive artist and the sensitive layman "will find in the work of these four young Asiatics much to inspire and instruct."[47] That same year Date, Wong, and Leong participated in *The Contemporary Oriental Artists* exhibition, also sponsored by the Foundation of Western Art, which included

ten painters each from San Francisco and Los Angeles. Henry Sugimoto, **Miki Hayakawa**, and Tokio Ueyama were among them. Until the outbreak of World War II, Date, Okubo, and Wong continued to exhibit in such contexts and were joined by Sueo Serisawa, **Mine Okubo**, **Jade Fon Woo**, and Keye Luke. "I met Henry Sugimoto through his paintings before I met him in person," Date recounted. Thus, the exhibitions provided a means to "meet" artists who lived up the California coast.

HOLLYWOOD

Perhaps the most visible project by Okubo was a mural he designed and executed with Tyrus Wong and Hideo Date for the Dragon's Den, a restaurant and club in Chinatown that was owned and run by Eddy and Stella See. On the whitewashed brick walls, they painted the Chinese Immortals watching over the steady stream of Hollywood stars such as Anna May Wong, Sidney Greenstreet, Peter Lorre, and Walt Dis-

48

ney, as well as friends and artists from the Art Students League, Chinatown, and nearby Little Tokyo.[48] Date was responsible for another mural, this one for a room at Pickfair, the infamous house owned by Mary Pickford and Douglas Fairbanks. Described as "Oriental-inspired," the room's blue carpets, golden curtains, red chairs, silver-leafed walls, and Date mural provided the backdrop for kimono-clad servants serving cocktails.[49]

The growing industry of Hollywood provided employment to many Japanese American artists—behind the camera or at the animation table. Photographer and painter Kango Takamura worked as a cameraman at RKO Studios. Chris Ishii, Tom Okamoto, Tyrus Wong, Milton Quon, **Wah Ming Chang**, James Tanaka, **Robert Kuwahara**, and Gyo Fujikawa all worked for Disney at some point in the pre–World War II period. Fujikawa was unique in being

a young Nisei woman and a published children's book illustrator[50] (see Valerie Matsumoto's essay for more information), who moved to New York before the mass incarceration. When faced with suspicion there during the war, she would often tell people she was Anna May Wong. Upon recounting the story to Disney, he chastised her and exhorted her to proclaim her status as an American citizen, which she henceforth did.[51]

LITTLE TOKYO

Harry Shigeta "learned that human eyes can be deceived by tricks and illusions." After a brief exploration of Little Tokyo and the artists who lived and passed through it in the 1920s and 1930s, one won-

FIG. 43 Tyrus Wong, *Self-Portrait*, late 1920s. Watercolor on paper, 14 × 21⅜ in.

ders: Is it tricks and illusions that prompted one to see a self-contained community, an island within an island, rather than a place of dynamic and diverse artistic activity? Perhaps the fact that Little Tokyo was an ethnic ghetto in a global city is a partial explanation. Its intense urbanism, its "congestion of people," its density, and its manifestation of racial segregation made it difficult to see it as an international arena of art and ideas, where ripples of association radiated out and back in again. That there were so many artists, of different generations and artistic interests, and with numerous associations within and beyond Little Tokyo, confuses the search for a single group or emblematic individual who can represent what it meant to be an artist of Japanese descent.

East First Street was the hub of Little Tokyo. There, Miyatake had his studio-cum-salon, Weston exhibited his photographs, Michio Ito presented modern dance,[52] and Date and Okubo showed new work. There, paintings and photography by Japanese American artists were on view in storefronts and restaurants.[53] But just as First Street extended beyond Little Tokyo in two directions, the art and ideas of the enclave moves and matters in multiple directions.

FIG. 44 Gilbert Leong, *The Good Earth*, ca. 1937.
Terra cotta and copper, approx. 60 × 15 × 15 in.

Notes

1 California Commission of Immigration and Housing, Community Survey of Los Angeles (Sacramento, 1918), cited in John Modell, *The Economics and Politics of Racial Accommodation: The Japanese of Los Angeles, 1900–1942* (Urbana: University of Illinois Press, 1977), 69.

2 In 1920, there were approximately twelve phones for every hundred people. Transcontinental service was initiated in 1917; transatlantic service began in 1927.

3 Janet L. Abu-Lughod, *New York, Chicago, Los Angeles: America's Global Cities* (Minneapolis: University of Minnesota Press, 1999), 3–4, 133–163.

4 Carey McWilliams, *Southern California: An Island on the Land* (Santa Barbara and Salt Lake City: Peregrine Smith, Inc., 1973), 321. Originally published as *Southern California County: An Island on the Land*, 1946.

5 This story originally comes from "Toyo Miyatake" by Shigemori Tamashiro, which appeared in vol. 4 of *Ayumi no Ato*, published by the Southern California Pioneer Center, 1980. Cited in *Toyo Miyatake Behind the Camera 1923–1979*, ed. Atsufumi Miyatake, Taisuke Fujishima, and Eikoh Hosoe, 2 (Tokyo: Bungeishunjū Co. Ltd., 1984), special English edition, trans. Paul Petite.

6 Combination printing in photography emerged at photography's origins, though initially it was utilized as a means to create "art" rather than as a method for manipulating the facts. Its first apologist, Oscar G. Rejlander (1813–1875), wrote, "To me double printing seems most natural . . . the manual part of photographic composition is but wholesale vignetting." He argued further that photography was "excellent for details. You

may take twenty good figures separately, but they cannot be taken at once. You cannot take even four good ones at once; but then you cannot draw or paint a picture at once." See "An Apology for Art-Photography" (1963) in *Photography in Print*, ed. Vicki Goldberg (New York: Simon and Schuster, 1981), 141–147.

7 Yuji Ichioka, *The Issei: The World of the First Generation Japanese Immigrants, 1885–1924* (New York: The Free Press, 1988), 164–168.

8 All biographical information comes from Christian A. Peterson, "Harry K. Shigeta of Chicago," *History of Photography* 22, no. 2 (Summer 1998): 183–198; and the exhibition catalogue *Harry K. Shigeta: Life and Photographs* (Ueda City, Japan: Ueda City Museum of History, 2003).

9 *Harry K. Shigeta: Life and Photographs*, 31.

10 Why Akashi sold the studio is unclear. In 1922, he published a photographic directory of Japanese in Southern California. With a foreword by Ūjirō Ōyama, consul of Japan—who wrote that Akashi was "one of the successes" of the Japanese community and "as a photographer has taken pictures of many of our compatriots"—the ambitious volume includes photographs of businesses, farmers, fishing concerns, educators, doctors, and other professionals. Although the directory remains one of the most important resources of 1920s Japanese America, perhaps the cost of its publication outweighed the profits realized, forcing Akashi to sell his studio. Strangely, the only photography-related business represented is Korin Kodak at 408 W. Sixth Street, an art-supply-cum-photography shop co-owned by pictorialist photographer Taizo Kato (d. 1924). The author thanks Emily Anderson for her translation of the Akashi book.

11 When purchasing the studio, Miyatake dropped the long "o" of his first name and simply transliterated it as "Toyo." He was thereafter known as Toyo, rather than Toyoo or Toyo-o.

12 Archie Miyatake, conversation with the author, October 3, 2005.

13 The Japanese characters of Shaku-do-sha literally translate as "Glowing Earth Society," though the character for "shaku" is usually pronounced "kaku." A homonym, "shakudo," is an alloy of bronze, which has symbolic meaning as long-lasting and durable. Artists in this period commonly selected names that had multiple resonances, and the founders of Shaku-do-sha likely intended such confusion.

14 July 7, 1927, article in the scrapbook of the artist; cited in Karin Higa, *The View from Within: Japanese American Art from the Internment Camps, 1942–1945* (Los Angeles: Japanese American National Museum, 1992), 31.

15 The seven artists were Shiyei Kotoku, Hojin Miyoshi, Sojiro Masuda, Kainan Shimada, Terasu Tanaka, Sekishun Uyeno, and Tokio Ueyama. The members of Shaku-do-sha at the time were listed in alphabetical order on page six: Hiroshi Abe, [first name] Hayashi, [first name] Inouye, Kiyoko Iwa[?], [first name] Kato, Shiyei Kotoku, Hojin Miyoshi, Toyoo Miyatake, Kotori Okamura, Shizuko Otera, Kamejiro [last name], [first name] Sasaki, Terasu Tanaka, [unknown], Tokio Ueyama, [first name] Uesugi, Ryuji Komeda [?], [first name; a woman] Yamaguchi. (This list reflects the most current translation available.)

16 This same Uesugi was a member of Shaku-do-sha. Shofudo was owned by Toyo Miyatake's father. The catalog also contains an ad for the Korin Bijutsuten (formerly Korin Kodak; see n. 10), now located at 522 S. Hill Street.

17 Taizo Kato, Review of Shaku-do-sha exhibition, *Rafu Shimpo*, June 23, 1923. Shiyei Kotoku biographical file, Asian American Art Project, Stanford University.

18 Tokio Ueyama, Review of Shaku-do-sha exhibition, *Rafu Nichi Bei*, June 20, 1923. Shiyei Kotoku biographical file, Asian American Art Project, Stanford University.

19 About Hojin, Ueyama wrote that "people wouldn't be surprised if the painting sells," suggesting that even in the early 1920s, a market existed for these paintings. Regarding Kotoku, Ueyama remarked that his painting "looks much tighter than last year."

20 See Mark Johnson's essay in this volume for a discussion of Northern California Asian American artists.

21 For example, a box of Ueyama's art, valued at $500, appears on a list of shipments made by the American Railway Express Company for the San Francisco Art Association, covering items taken from the California Palace of the Legion of Honor on June 24, 1930.

22 A copy of the 1923 Shaku-do-sha catalog in the permanent collection of the Japanese American National

Museum comes from the personal papers of Berkeley-based Chiura Obata.

23 *Los Angeles Times*, December 21, 1930, part 3, 15.

24 *Los Angeles Times*, December 29, 1929, part 3, 9. This same anecdote and a summary of Millier's review appeared in "Japanese Artists Show Occidental Works," *The Art Digest*, January 1, 1930, 19.

25 Ibid.

26 Ibid.

27 See Dennis Reed's essay in this volume. See also Dennis Reed, *Japanese Photography in America, 1920–1940* (Los Angeles: George J. Doizaki Gallery, Japanese American Cultural and Community Center, 1985); and Michael G. Wilson and Dennis Reed, *Pictorialism in California: Photographs 1900–1940*, exh. cat. (Malibu: The J. Paul Getty Museum; and San Marino: The Henry E. Huntington Library and Art Gallery, 1994).

28 Sidney Allan, "Looking for the Good Points," *Bulletin of Photography* (November 1916); reprinted in *Edward Weston Omnibus*, ed. Beaumont Newhall and Amy Conger (Salt Lake City: Peregrine Smith, 1983), 9–10.

29 Weston J. Naef, "Edward Weston: The Home Spirit and Beyond," in Susan Danly and Weston J. Naef, *Edward Weston in Los Angeles*, a catalog of an exhibition held at the Huntington Library and the J. Paul Getty Museum, 1986–1987, 33.

30 Nancy Newhall, ed., *The Daybooks of Edward Weston* (New York: Aperture, 1990), 122.

31 In his *Daybooks*, Weston repeatedly invoked "the Japanese" as a paragon of an intellectual and appreciative audience of collectors. "How rarely I sell to Americans! How appreciative, understanding and courteous the Japanese!" (April 6, 1927). In response to a nonsale of a shell print, Weston wrote, "The Japanese would have bought,—I never waste time with them!" (Wednesday, June 8, 1927). For Weston's show with his son Brett at the Los Angeles Museum of History, Science and Art in October 1927, he wrote, "Nothing has been sold as yet. Not much like the Japanese exhibit!" (October 20, 1927) and later, "That exhibit brought me no results,—financial I mean. Not one print sold: Quite different from the Japanese" (December 7, 1927); 14, 26, 39, 41.

32 All biographical information comes from Helen Caldwell, *Michio Ito: The Dancer and His Dances* (Berkeley:

University of California Press, 1977); and Jan Breslauer, "New Legs for a Legend," *Los Angeles Times*, Calendar Section, March 15, 1998, 7, 84.

33 Caldwell, *Michio Ito*, 44.

34 Ibid., 50.

35 Alfred Stieglitz, *Camera Work: The Complete Illustrations* (Cologne: Taschen, 1997), 119–121, 129, 218.

36 These masks were the first of Noguchi's designs for dance and are no longer extant. Noguchi continued to work with choreographers, creating well over thirty-five collaborations, most significantly with Martha Graham. Most likely Noguchi was introduced to Graham through Ito; Graham had been one of Ito's dancers in his Greenwich Village Follies performances of 1923. For a discussion of Noguchi's designs for performance, see Robert Tracy, *Spaces of the Mind: Isamu Noguchi's Dance Designs* (New York: Proscenium Publishers, Inc., 2001).

37 Bonnie Rychlak, *Noguchi and the Figure* (Monterrey, Mexico: Museo de Arte Contemporáneo de Monterrey, 1999), 38–39.

38 Toyo Miyatake, *A Life in Photography: The Recollections of Toyo Miyatake*, with Enid H. Douglas (Claremont, CA: Oral History Program, Claremont Graduate School, 1978), 19.

39 Caldwell, *Michio Ito*, 5.

40 Barbara Perry, cited in *Miyatake: Behind the Camera*, ed. Miyatake et al., 10.

41 Archie Miyatake recounted how his father discussed the impact of James Wong Howe's cinematography on his photography; interview with the author, July 5, 2005.

42 Bunji Omura, "Japanese Arists Born in America Excel Many in Nippon, Experts Say," *The Japanese American Review* (New York), August 9, 1941, 8.

43 "Editorial," *California Arts and Architecture* 56, no. 4 (October 1939): 3.

44 For instance, Toyo Miyatake was in Japan from 1932 to 1933. Gyo Fujikawa traveled there from 1929 to 1930.

45 For information on Date, see Karin Higa, *Living in Color: The Art of Hideo Date* (Berkeley: Heyday Books, 2001).

46 For a discussion of surrealism in Los Angeles, see Susan Ehrlich, ed., *Pacific Dreams: Currents of Surrealism and Fantasy in Early California Art, 1934–1957* (Los Angeles:

UCLA at the Armand Hammer Museum of Art and Cultural Center, 1995).

47 Stanton Macdonald-Wright, exhibition catalog of Los Angeles Oriental Artists' Group, collection of the Japanese American National Museum.

48 Lisa See, *On Gold Mountain: The One-Hundred Year Odyssey of a Chinese-American Family* (New York: St. Martin's Press, 1995), 193–198.

49 David Wallace, *Lost Hollywood* (Los Angeles: LA Weekly Books, 2001), 68.

50 Upon the release of Dorothy Walter Baruch's *I Like Automobiles* (New York: John Day Co., 1931), with illustrations by Fujikawa, reviewers commented that "her drawings are a unique revelation of the adaptability of Japanese art made of Western subjects"; cited in "News of Day in Brief," *Rafu Shimpo*, November 20, 1931.

51 Elaine Woo, "Obituary: Children's Author Dared to Depict Multicultural World," *Los Angeles Times*, December 13, 1998.

52 Ito and his company performed at Koyasan Temple, located on the south side of First Street, between San Pedro and Central avenues.

53 For instance, a painting of a desert landscape by Sueo Serisawa, ca. 1927, hung on the wall of Mansei-An restaurant until January 1942, when Japanese Americans were incarcerated. Collection of the Japanese American National Museum, gift of Yoshiko Hosoi Sakurai.

Facing the Pacific

Asian American Artists in Seattle, 1900–1970

Kazuko Nakane

Facing the Pacific Ocean, Seattle is encroached on by Puget Sound, with views of the Olympic mountain range to the west and Mount Rainier looming to the south. During long rainy months, gray skies cast subtle variations of light over evergreen forests as time passes. The weather plays a role in differentiating and isolating the Northwest from the more southern regions of America's West Coast. In this quiet city, Asian American artists have long asserted a prominence equal to that of other local artists, developing their own artistic identity, rooted in their Asian heritage but adapted to the new life in America.

By the beginning of the twentieth century, world expositions had opened America's eyes to the cultural offerings of the wider world, and especially to the literature, theater, and art of Asia: British control of India had tightened during the nineteenth century, China had opened to the West following the Opium War of 1842, and Japan had been opened by Commodore Perry in 1853. An idealized image of Asian culture and religion had gradually become synonymous with ideas of higher spirituality in Europe and the

Paul Horiuchi, *Abstract Screen*, 1961 (detail, fig. 63).

United States. In the Pacific Northwest, the strong presence of Asian Americans in the local art scene, particularly first-generation artists, provided additional stimulus for this region to be influenced by Asian philosophies and art.

The first known Asian American artist in Washington was a photographer living along the frontier: Frank S. Matsura (1873–1913) (fig. 45).[1] Boxes of

FIG. 45 Frank Matsura, *Okanogan Bachelors But One*, 1913. Reprint from original negative.

FIG. 46 Frank Matsura, *The First Auto Stage in the Okanogan Valley* (Frank Matsura in foreground), August 9, 1910. Reprint from original negative.

his glass plates were donated to a small museum in Okanogan County in 1975, but not until 1980 did the significance of the photographs and photographer begin to surface. Matsura, a Christian from a former samurai class, had left Tokyo for America in 1901; he traveled by stagecoach to eastern Washington, arriving in the town of Conconully in 1903 with his own photography equipment. Soon after his arrival, he received a draft notice from the Japanese government to fight in the Russo-Japanese War (1904–1905), but he chose to stay in the United States.

In 1907, Matsura opened a photography studio in Okanogan County. His photographic documentation caught life on the frontier at a pivotal time, capturing the flux of daily life and lending dignity to the special occasions of the citizenry (fig. 46). Writers have found Matsura's images of Native Americans unusually honest for their time.[2] Unlike the somber romanticism of the contemporaneous Edward Curtis portraits meant to preserve a dying Indian past, Matsura's photographs reflect the diversity of the regional community's present—Indian cowboys in angora chaps and bear coats, families in traditional clothes, and girls in Victorian dress. The quality of

his photos was recognized, and his work was included in an exhibition at the Alaska-Yukon-Pacific Exposition in 1909.

Although he spoke English flawlessly, Matsura never spoke much about his past. However, recent scholarship documents his early life in Japan. After losing his mother at the age of two and his father at eight, he attended a mission school managed by his relatives and was trained in photography in Tokyo. A principal of the mission school, Kumaji Kinoshita, who visited the United States and was fluent in English and interested in photography, baptized Matsura and may have been a great influence.[3] According to Matsura's Washington friend William Compton Brown, who later became a Superior Court judge, Matsura "brought wit, a style of winning friends."[4] Okanogan County was Matsura's home and community, and more than three hundred people—white, Indian, and perhaps some Chinese—attended his funeral. Judge Brown preserved Matsura's thousand-plus photographic plates after his death.

From 1900 to 1910, Seattle grew dramatically, its population increasing from 80,671 to 237,174. The Alaska-Yukon-Pacific Exposition also helped Seattle become more cosmopolitan. Yasushi Tanaka (1886–1941) (fig. 47), an independent-minded man from Saitama Prefecture,[5] had come to Seattle in 1904 with the first major flood of immigrants that began

FIG. 47 Yasushi Tanaka, from the *Paris Review: An American Magazine in France*, ca. 1921.

in 1900. He was a self-taught oil painter who studied art and art history through books borrowed from the library. A graduate of the local Broadway High School with good language skills, he was determined in his ambition and, though he did his share of manual labor, soon acquainted himself with the local art scene. Other Japanese painters lived in town; in 1916, Tanaka took part in *The Japanese Painters Exhibition* with Toshi Shimizu (1887–1945) and Kenjiro Nomura (1896–1956), all of whom took classes from Fokko Tadama (1871–1937), a Dutch immigrant from Indonesia, at Tadama Art School (fig. 48).[6] Seattle had even gained enough cultural appreciation to form a premier art organization: the Seattle Fine Arts Society, founded in 1906.

A flood of Japanese men had immigrated to the Seattle area just before the enforcement of limited immigration through the Gentlemen's Agreement of 1907–1908. The well-known painter **Yasuo Kuniyoshi** was one of these, arriving in 1906; but he stayed in the area, doing manual labor, for only a year before leaving for Los Angeles and then New York City. Shimizu was another, arriving from Tochigi in 1907. (See the essays by Tom Wolf and Gordon Chang for more information on Kuniyoshi; also see Wolf's es-

say for information on Shimizu's later life.) Shimizu also did manual labor—on a farm, on a railroad, and in a sawmill—before being able to take classes from Tadama in 1912.[7] Nomura, who originated from Gifu, had grown up in Tacoma, where his father was a tailor. At the age of sixteen, he remained alone in the United States when his family returned to Japan. After doing hard physical labor in Tacoma, he eventually found a job at a Japanese business in Seattle in 1916.[8]

In 1914, after studying with Tadama for two years, Shimizu had a one-man show. Tanaka's recognition in town came with his own show, also in 1914, sponsored by the Seattle Fine Arts Society, and with his participation with Tadama in the Panama-Pacific International Exposition in San Francisco the following year, where he exhibited *The Shadow of the Madrone* (fig. 49). Tanaka took his submission to the Panama-Pacific International Exposition as a model for experimentation, creating his related *Cubist Abstraction* (fig. 50). The Seattle Fine Arts Society continued to sponsor shows by Tanaka. He also had his own art studio, where he taught painting. Tanaka soon looked beyond Seattle to the contemporary art movements that succeeded impressionism in Europe

FIG. 48 Kenjiro Nomura (seated front left) at Tadama Art School, ca. 1916.

and the United States; he reinterpreted concepts from cubism and the works of Cézanne, Whistler, and Kandinsky in his paintings.[9]

Tanaka met Louise Gebhard Cann in 1913, at a lecture on cubism and futurism.[10] The daughter of Judge Thomas H. Cann,[11] Louise Cann had studied at Cornell University (where her former husband taught mathematics) and had taken classes at the University of Washington. She was also a published poet, playwright, and art writer. By 1915, Tanaka had established himself as a respected art teacher at the Fine Arts Society, but his circle of acquaintances was greatly expanded through Cann's familiarity with the most innovative people of the time, including Imogen Cunningham (1883–1976) (see Chronology, p. 488), known at that time for her pictorial photographs of nudes. In 1917, Tanaka's paintings of nudes became a sensational topic of conversation. Tanaka sent a letter defending his work to the Seattle Fine Arts Society;[12] he then created a new scandal by marrying Cann.[13]

The new Mrs. Tanaka shared her happiness in a newspaper article,[14] stating that their union disregarded the difference of "mystic Orient and Occident" because of their shared artistic spirits. "The Orient," she said, "has built up a religious and mystical civilization." She continued, "Rabindranath Tagore, the great Hindu poet, whom we entertained last year, . . . represents the highest individual type of civilization." In 1920, Tagore (1861–1941) was one of five thousand people who attended the farewell Seattle exhibition of one hundred paintings by Tanaka, before the couple's departure for Paris.[15]

For Tanaka, art was the result of an individual's need for expression. "Art, in its spontaneous sense," he stated, "is decidedly a spiritual matter itself."[16] He was hungry for growth and experimentation, something he thought he could no longer get in conservative Seattle. Cunningham had already left for San Francisco in 1917; Shimizu also moved the same year to New York City.[17] Tanaka hoped to find in Paris a community with a better understanding of art and a better appreciation for his work.

Around this time, Kyo Koike (1878–1947) arrived in Seattle. Koike, certified as a physician in both Shimane Prefecture[18] and the state of Washington, expressed his inner spirit through photography. He was a haiku poet and a lover of nature (figs. 51 and 52) who often roamed the mountains.[19] Having left Okayama at the mature age of thirty-nine, Koike was well acquainted with the Japanese literature of his time; he was also a friend of Suzuki Miekichi, a founder of the innovative children's literature magazine, *Akai Tori* [Red Bird].[20] The photographer Yoshio Noma (1914–2005), one of Koike's young friends and admirers, remembered seeing a scroll of calligraphy by the writer Natsume Sōseki, widely considered to be the foremost Japanese novelist of the Meiji era, at Koike's home in the 1940s.[21]

FIG. 49 Yasushi Tanaka, *The Shadow of the Madrone*, ca. 1915. Oil on canvas, 23⅛ × 18 in.

FIG. 51 Kyo Koike, *Summer Breeze*, ca. 1920s.
Bromide print, dimensions unknown.

In October 1924, Koike and other pictorial photographers founded the Seattle Camera Club, the only organization of photographers in Seattle at that time.[22] The club held monthly meetings and invited prominent speakers, including, in 1925, the avant-garde painter Mark Tobey.[23] Tobey, who later became one of the most influential artists in the Pacific Northwest, had come to Seattle from New York to teach at Cornish School in 1922. Although still searching for his own direction, Tobey was already interested in Asian thought and art. He had converted to the Bahá'í faith in 1918 and had begun practicing Chinese calligraphy in 1924 with T'eng K'uei, a Chinese student who had recently entered the University of Washington.[24]

In February 1925, the Seattle Camera Club began a bilingual (Japanese and English) monthly magazine, *Notan*,[25] with Glenn Hughes as the English associate editor.[26] Hughes was a close friend of Mr. and Mrs. Tanaka, with whom he shared prominent literary friends in Paris, where Tanaka was slowly establishing his reputation in the Salon painters' circle.

Hughes traveled to Paris in 1928; there he met Ezra Pound, who in 1916 had published a (posthumous) book by Ernest Fenollosa on the Noh theater of Japan,[27] with an introduction by William Butler Yeats, whom Hughes also met in Paris. (See the essay by Karin Higa for more information regarding Yeats, Noh theater, and dancer Michio Ito.)

Trained in English through his translating of Japanese literature,[28] Koike knew of the fine collection of Japanese art in the Museum of Fine Arts in Boston and was familiar with many art publications, which he introduced in *Notan*. Though he was aware of the works of the critic and art historian **Sadakichi Hartmann**, he found *Composition: A Series of Exercises in Art Structure for the Use of Students and Teachers* by Arthur Wesley Dow to be more in line with his own artistic sensibilities. Dow was a key figure in the late-nineteenth-century Arts and Crafts and

FIG. 52 Kyo Koike, *Girl with Violin*, ca. 1920s.
Photograph, dimensions unknown.

Japonisme movements, the influence of which was seen throughout the varied art media in the United States: in architecture, ceramics, photography, and woodblock print.[29] Dow practiced block print, painting, and, to some degree, photography. He was largely inspired by Japanese woodblock prints, particularly the work of Hokusai. Dow had met Fenollosa in 1891 at the Museum of Fine Arts in Boston and became his curatorial assistant in 1903. Another associate of Fenollosa was Okakura Tenshin (Kakuzō), who became an adviser on Chinese and Japanese art at the Museum of Fine Arts, Boston, in 1904. "Asia is one," the first sentence in *The Ideals of the East*, one of Okakura's best-known books, is a well-known saying that represents his beliefs. Okakura wrote many

FIG. 53
Frank Kunishige,
Aida Kawakami, ca. 1927.
Bromide print, 13 × 9 in.

articles and books to introduce Asian art to the West, and his *The Book of Tea* has been well read, continuing even up to the present to influence the American view of Asian art.[30]

Members of the Seattle Camera Club were mostly Japanese immigrants, although Caucasian membership increased gradually to one-fourth of the club's composition by the time the club dispersed in October 1929. The club broke up just after hosting the *Fifth International Exhibition on Pictorial Photog-*

raphy, which included photographers from thirty countries.[31] Besides Koike, the most prominent and active members, who won numerous awards from international exhibitions, were Frank Kunishige, Ella McBride, Y. Morinaga, H. Onishi, and **Hiromu Kira**.[32] Kunishige (1878–1960) (fig. 53),[33] who had taken photography classes in Illinois and was professionally trained in the darkrooms of Asahel Curtis Studio and the Ella McBride Studio, was familiar with works and techniques of noted American

pictorial photographers. In contrast, Koike's search for simple composition and poetic beauty in nature derived from Japanese literature. Koike hoped to find the idealistic junction of East and West while the country struggled with a deteriorating economy and rising anti-Japanese sentiment. The high quality of the work produced by members of the Seattle Camera Club was recognized internationally but sometimes dismissed by critics, who even argued against including work by Japanese American artists in American photography salons.[34] Other writers were comfortable promoting works by Japanese Americans that emphasized perceived Japanese aesthetics but were apparently uncomfortable with any reflection of "Europeanism" or "trying to reproduce the American art"—further underscoring the racialized environment in which art was seen during the 1920s.[35]

After the demise of the Seattle Camera Club in 1929, a number of Asian American photographers in Seattle continued to be influenced by pictorial photography. **Chao-chen Yang**,[36] who was born in Hangzhou and studied at Hsing-Hwa Academy of Arts in Shanghai, moved to Chicago in 1933. He took classes in painting, sculpture, and photography at the Art Institute of Chicago from 1935 (fig. 54), until he came to Seattle as Chinese deputy consul in 1939. Yang submitted pictorial photographs to many salons, had a show of his work at the Seattle Public Library (1941), and took part in *The International Exhibition of Photography* at the Seattle Art Museum (1943).[37] He won respect for his dedication, as well as for his pioneering expertise in color photography (fig. 55). He experimented in various color techniques as early as 1938 and even went to

FIG. 54 Chao-chen Yang, *Three Men*, 1938. Photograph, dimensions unknown.

FIG. 55 Chao-chen Yang, *Apprehension*, ca. 1951.
Color photograph, 20 × 16 in.

Hollywood to study color motion picture production in 1946.

Yang taught courses in photography at his Northwest Institute of Photography (1947–1951) and in 1951 founded Yang Color Photography, a business that created color photographic advertisements. Johsel Namkung (b. 1919), a Korean who had immigrated to the United States in 1947 with his Japanese wife, Mineko,[38] learned the basic techniques of color photography from Yang in 1957. He also acquired the skill of color enlargement at Chroma Inc. in Seattle at around the same time.[39] Another Seattle photographer, Que Chin (1911–1974), who immigrated from Guangdong, China, was known for his portraiture, which featured the use of chiaroscuro reminiscent of Rembrandt's light. In the 1930s, Chin was a watercolorist and a member of the Chinese Art Club before opening his photography studio in the 1940s. Chin taught photography at his school of photography until his death in 1974.

During the 1930s, a new environment evolved in Seattle that would nurture a group of local artists who came to represent the art of the Pacific Northwest. The federally funded Works Progress Administration (WPA) projects provided employment and fertile ground for artists to continue to create work in the face of the devastating economic depression. Many of these artists looked forward to the competition of the *Northwest Annual Exhibition* at the Seattle Art Museum. The Seattle Art Museum had opened in Volunteer Park in 1933; Kenjiro Nomura, who had won first prize at the previous *Northwest Annual*, had his one-man show at the museum its opening year (fig. 56). The director of the museum, Richard Fuller, was a supporter of both Asian art and the regional art of the Pacific Northwest and hired a local painter, Kenneth Callahan, as a part-time curator in

FIG. 56 Kenjiro Nomura, *Street*, ca. 1932.
Oil on canvas, 23¾ × 28¾ in.

(1892–?) and Genzo Tomita.[40] Nomura, Tokita, and Fujii were included in a 1937 publication, *Some Works of the Group of Twelve*, along with other prominent Seattle painters, including Kenneth Callahan, Morris Graves, Walter Isaacs, and Ambrose and Viola Patterson.[41] George Tsutakawa (1910–1997) remembered Nomura and Tokita as fine painters who were knowledgeable about European and American art.[42] Many artists talked about the painting fundamentals of composition, form, and color. Callahan talked about the language of painting as bounded by certain rules in order to capture "the eternal truthfulness that lies below the surface of life and objects."[43] For Nomura and Tokita, painting was a struggle to combine the influences of Cézanne and Sesshū, the fifteenth-century master of Japanese brush painting.

By the 1930s, the Asian American community of Seattle had grown to include a new generation of foreign-born and American-born residents. At that time, it was common for families to send their children back to Asia for portions of their education.

1934. Callahan remained in this position until 1954. Asian art specialist Sherman E. Lee served the Seattle Art Museum as an assistant director from 1948 to 1952 after working for the U.S. military as an advisor for art from 1946 to 1948.

Also during the 1930s, Nomura and Kamekichi Tokita (1897–1948) owned the Noto Sign Company, painting signs for Japanese and Chinese businesses (fig. 57). Weekends, Nomura and Tokita went out to sketch and paint the surrounding cityscape of Seattle (fig. 58) with fellow painters Takuichi Fujii

FIG. 58
Kamekichi Tokita,
Boathouse, 1947. Oil on
board, 13½ × 17¼ in.

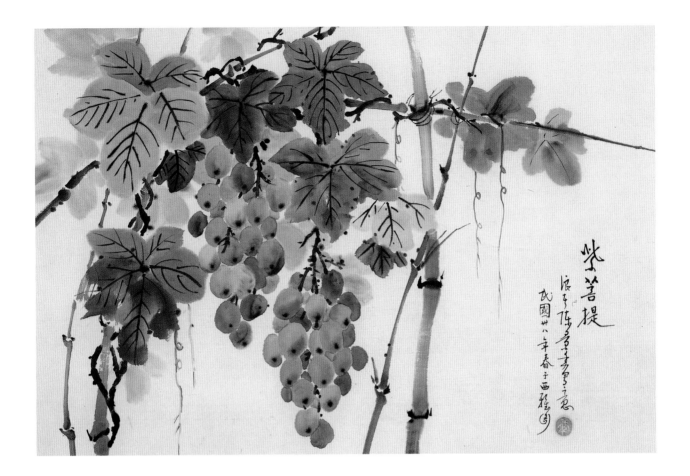

FIG. 59 Andrew Chinn, *Grapes*, 1943.
Watercolor and ink on rice paper, 21 × 27 in.

Tsutakawa was educated in Fukuyama, Hiroshima, and returned to Seattle in 1927. Fay Chong (1912–1973), who had emigrated from Guangdong to Seattle in 1920, returned to learn calligraphy in 1935. Andrew Chinn (1915–1996) was sent to be educated in China several times, staying for sixteen years altogether. Along the way, he learned the rudiments of traditional brush painting (fig. 59). He returned home to Seattle for good in 1933.[44] These older students attended Broadway High School, where they learned linoleum block print from Matilda Piper and Hannah Jones, and spent time together after classes. They later fondly remembered these high school art teachers encouraging and nurturing their special students, who had to cope with new adjustments each time they crossed the Pacific. (Morris Graves also attended Broadway High School, where Tsutakawa recalled seeing him.)

Unlike many other Asian American artists, who remained largely self-taught, Tsutakawa had his art education broadened at the University of Washington, where he studied under Dudley Pratt and a vis-

iting artist, Alexander Archipenko, and received a degree in sculpture in 1937. Paul Horiuchi (1906–1999), who was called by his father to leave a village in Yamanashi Prefecture to come to Rock Springs, Wyoming, when he was fourteen, often visited Seattle to meet his relatives and to submit his paintings to the *Northwest Annual*. Horiuchi also took painting classes from Vincent Campanella, at a WPA project in Wyoming in 1938, to be better grounded in Western art. All these young artists soon began to be accepted into the *Northwest Annual Exhibitions* and participated in the local art scene.

Chinn and Chong, while still students, had founded the Chinese Art Club (1933–1937) at 826 South Jackson Street.[45] Among the members were the watercolorist Lawrence Chinn (1914–1994), the oil painter Howard Sheng Eng (1909–1949), and a commercial painter, Yippe Eng (who remained in the building after the club dispersed). The group of

FIG. 60 Fay Chong, *Lake Union Shoreline*, 1963. Watercolor
and chinese ink on rice paper, approx. 12¾ × 22½ in.

artists regularly mounted exhibitions, not only of members' work but also of invited Caucasian painters. William Cumming remembered taking part in the life-drawing sessions.[46] The club was also a place to socialize, where other painters such as Morris Graves, Jacob Elshin from Russia, and Guy Anderson (who received a Tiffany Foundation scholarship in 1926 and was a close friend of Graves) often dropped by to spend time or to find sketching partners. The young artists met other local artists at the WPA project based in Bailey Gatzert School in Seattle. Chong also met Hilda Grossman from New York and her future husband, Carl Morris from California, both of whom taught at the Art Center for the WPA project in Spokane.

After his high school art education, Chong studied with a local artist, Leon Derbyshire, at the Leon Derbyshire School of Fine Arts. Derbyshire had a classical art education from the Pennsylvania Academy of the Fine Arts in Philadelphia and had studied as well at Tadama Art School, and with André Lhote in Paris in the 1920s. After meeting Tobey in 1937, Chong also visited his art classes,[47] at the same time as he started to paint with watercolor on rice paper

(fig. 60). He also took art classes at the University of Washington in 1954 and later completed his M.A. in art in 1971.

According to a review by Callahan in 1934,[48] Chong's block prints, quite beautiful in their movement of line, were completely Westernized. Chinn, on the other hand, moved back and forth between vibrantly colored, Westernized painting, Chinese painting on silk, and black-and-white block prints such as *Bamboos* and *Love Birds*. Chinn had developed his skill in brush painting in China and also took years of art classes from Walter Isaacs and Ray Hill beginning in 1939.

During the 1930s, many artists created idealized American Scene paintings, but the artists in Seattle continued to look beyond national boundaries in a search for their own forms of modern American art. European cubism was a dominant influence, as was surrealism. Many Caucasian artists were intrigued by the work of the Mexican muralists and visited Mexico. Callahan met Tobey in Mexico in the 1930s. Tobey, Callahan, Anderson, Graves, and the Morrises were all fascinated by Native American art and interested in Asia as well. Callahan had visited Asia while he worked on ships in 1927.[49] Graves had traveled to Asian countries in 1928, and again twice in 1930; he also visited local Buddhist temples in Se-

attle. He was introduced to Zen Buddhism, tea ceremony, Noh theater, and the thinking of Fenollosa and of psychologist Carl Jung in the later 1930s.[50] These artists also looked to American thinkers; Anderson remembered Graves reading Ralph Waldo Emerson and William James.[51]

Mark Tobey taught at Dartington Hall, in Devon, England, from 1931 to 1937,[52] but he traveled widely, including to Paris and New York, and often back to Seattle. Tobey visited Shanghai with ceramicist Bernard Leach, with whom he became close friends at Dartington Hall. In China, he met his old calligraphy partner, T'eng K'uei. Tobey also studied in Kyoto for a month in 1934, where he practiced *ensō*, calligraphy of the circle, at a Zen temple. After returning from Japan, Tobey created the highly influential all-over line abstraction, *Broadway Norm*, in 1935. The painting was immediately noticed by Graves and impacted artists in the Northwest for years to come.

After the Japanese attack on Pearl Harbor, President Franklin D. Roosevelt issued Executive Order 9066 on February 19, 1942. Most of the Japanese American community in Seattle were sent to the internment camp at Minidoka. Horiuchi, who was living outside the exclusion zone of the Pacific coast, was fired by Union Pacific Railroad. He and

his wife packed everything they could in a small car and, with their children, drove out to look for odd jobs. Tsutakawa joined the U.S. Army. At the end of the war, the first Japanese Americans who came back from camp faced difficulties. Koike passed away in 1947 soon after returning to Seattle; Tokita suffered from deteriorating health and died in 1948.

Near the end of the 1940s, art patron Betty Bowen saw Mark Tobey at Far West, an antique shop owned by Tamotsu Takizaki (1882–1962) from the late 1940s to 1961. Takizaki was known in the Japanese American community as an expert in the martial art of kendo, as well as for having a good eye for antiques, both Western and Japanese; more than anything else, however, he was known for his ability to explain Zen teachings. Nisei painter Frank Okada (1931–2000), who grew up in Seattle and began taking weekend art classes from Leon Derbyshire during high school, remembered witnessing Takizaki and Tobey discussing Zen and the pleasures of antique appreciation. Horiuchi, Tsutakawa, Namkung, and John Matsudaira (1922–2007) often participated in these discussions as well (fig. 61). Such encounters with an internationally renowned artist like Tobey stimulated these as well as other local artists.

Matsudaira was born in Seattle but educated in Kanazawa from 1928 to 1934, when he returned to Seattle.[53] He served in the 442nd and 100th Nisei regimental combat teams in Italy during World War II,[54] becoming one of the handful of survivors of the most decorated units (for its size and length of service) in U.S. military history. He began to paint in 1946 after being hospitalized for thirty months for injuries suffered in the war. Around 1950, Matsudaira took art classes from Elshin and Nick Damascus at the Burnley School of Art. He tried many paths, but by the 1960s he was creating abstract expression-

FIG. 61 Tamotsu Takizaki, Mark Tobey, Betty Bowen, George Tsutakawa, Paul Horiuchi, and Cy Spinola at Tamotsu Takizaki's home, 1954.

FIG. 62 John Matsudaira, *Quiet Motion and Blue*, 1961. Oil on canvas, diptych, 60½ × 80½ in.

ist paintings as well as linear cityscape abstractions (fig. 62).

The impact of Tobey's innovative white writing and abstractions of cityscapes was profound; it was difficult to escape from his influence. Kenjiro Nomura, who painted watercolors of community life in the Minidoka internment camp, began to paint linear abstractions in the early 1950s. Paul Horiuchi continued to paint the scenery of his surroundings after moving to Seattle in 1946. He resumed participation in the *Northwest Annual* and in 1952 received a purchase prize for his painting *Dawn*. In this work, the landscape of Lake Washington is semi-abstract on a distorted ground plane in beautiful color harmonies. The work marks the beginning of many experiments Horiuchi made to find his own way to abstraction.

George Tsutakawa also resumed submitting to the *Northwest Annual*; after the war, his landscape paintings incorporated abstracted lines and colors on a flat plane.[55] He continued his art education by pur-

suing an M.A. and afterward taught art at the University of Washington until retiring in 1976. Teaching alongside professors in the architecture department, he was introduced to concepts from the Bauhaus. For Tsutakawa, Bauhaus thinking stood for a "relationship of the total space—and everything in it, including time, and light, and movement, rhythm, and scale . . . size, volume, weight and vibration."[56] At the same time, he experimented in photography, furniture making, oil painting, and sculpture.[57] Tsutakawa learned more about American artists in 1949, when Kuniyoshi visited Seattle to promote Artists Equity of America and stayed with Horiuchi.[58]

The *International Exhibition* in Chinatown, held in conjunction with Seattle's annual summer Seafair celebration, started in 1950 and continued for several years. Most participants were Asian American, and

70

a few were African American. Chinn, Chong, Eng, Horiuchi, Matsudaira, Nomura, Tokita, Tsutakawa, Milton Simmons, and James Washington Jr. took part in the exhibitions. At the time, Chong was creating watercolor landscapes for illustrations, and he also began to create cityscapes that resembled the linear abstractions of Lyonel Feininger. Chinn continued to paint watercolor landscapes of his surroundings.

For a short time, in the winter of 1957–1958, Tobey experimented with *sumi-e* abstraction, inspiring Horiuchi, Tsutakawa, and Okada to practice their own abstract *sumi-e*. The experiment was intended to introduce a certain state of creative mind. In "Japanese Traditions and American Art," an article Tobey wrote for the fall 1958 *College Art Journal*, he stated: "Today the European influence is on the wane, and we are developing an indigenous style. However, we are growing more and more conscious of what I would term the Japanese aesthetic. This can be seen

in residential architecture particularly in the West, in the decorative arts especially in pottery and weaving, and recently in abstract painting and sculpture." He mentioned that Zen Buddhism was becoming popular among American artists and noted that Japanese painters were using abstraction as a part of a Zen idea to express the spirit, which certain American artists were also considering. He quoted the words of Takizaki to explain it simply, "Let nature take over in your work."[59]

Paul Horiuchi went through different phases of experimentation with abstraction. During the latter half of the 1950s, he created three series of paintings: of shrimp, of rain, and of abstract color-fields of white, red, and black. Supposedly Tobey once told Horiuchi, "Aren't there plenty of shrimp in the market and enough rain in Seattle?" In 1954, Horiuchi made his first rice-paper collage based upon a weathered bulletin board in Chinatown (now called the International District). Subsequently Horiuchi personalized the collage medium (fig. 63). He purchased handmade rice paper from Japan and painted each piece,

FIG. 63 Paul Horiuchi, *Abstract Screen*, 1961. Paper collage with gouache on six-panel screen, 52¾ × 108 in.

FIG. 64
Paul Horiuchi, George
Tsutakawa, Zoe Dusanne,
John Matsudaira, and
Kenjiro Nomura at
Dusanne's gallery, 1954.

then pasted and tore the paper and painted over it, repeating the process in a spontaneous, seemingly accidental manner. His abstract collage method was a perfect harmony of Eastern and Western aesthetics. He created a Northwest art from the delicate balance between poetic details and large-scale collage forms that evoked nature or the universe.

In 1950, Zoe Dusanne, who was in touch with the art scenes in New York and Europe, opened a gallery on Eastlake Avenue in Seattle. Her private collection of art included works by Feininger, Léger, de Chirico, Klee, Mondrian, and American artists such as Stuart Davis, whose paintings had been shown at

the Seattle Art Museum in 1947. During the 1950s, Dusanne represented Tobey and hosted a series of shows of Japanese American artists; Horiuchi, Matsudaira, Nomura, and Tsutakawa exhibited at her gallery (fig. 64). At that time, Matsudaira was painting poignant, semi-abstract, naive-looking images of children—symbolic depictions of malnourished children he had seen in Italy during the war. Horiuchi, at the age of fifty, had his first one-man show at the gallery in 1957, which brought him great success and recognition locally.

Through church activities, Horiuchi and Matsudaira knew another painter whose work was quite

unique. Valeriano (usually shortened to Val) Laigo (1930–1992) was born in Naguilian in the Philippines and came to Seattle in 1941. After receiving a degree from Seattle University, he went to study painting in 1956–1957 at Mexico City College, where he was inspired by the Mexican muralists. He returned to Seattle and taught at Seattle University for twenty years until his retirement in 1985. It is not simply Laigo's brilliant colors that single him out from other Northwest painters. Being Roman Catholic, he painted religious themes early on; later, his large-scale vision was filled with life force, and stories and symbols derived from the Philippines, Catholicism, and mythologies, all of which found a place in his murals (fig. 65). "My teacher is the Universe,"[60] he stated. He enjoyed reading science fiction and books by Joseph Campbell. Nick Damascus, his fellow professor at Seattle University, quoted Nietzsche to describe Laigo: "You must have chaos in you in order to give birth to a dancing star."[61] Unique as Laigo was, other artists in the Pacific Northwest shared his concept of the universe as inspiration and theme.

The 1962 World's Fair brought first-class world art to Seattle and stimulated many local artists, who also showed their work at the fair. The city slowly caught up with the national art scene. In the late 1950s, Tsutakawa made a major change due to his encounters with Tobey, who had told him many times to look to his heritage: Tsutakawa dropped oil painting to continue explorations of *sumi-e* and watercolor. At the same time, he created *Obos*, a series of wooden sculptures inspired by Tibetan religious stone piles, which Tsutakawa had seen in William Orville Douglas's *Beyond the High Himalayas*.[62]

In the 1960s, many artists worked in large-scale abstract metal sculpture, and Tsutakawa began designing the bronze fountains for which he is best known today. His first commission for a fountain was in 1960 for the downtown branch of the Seattle Public Library (fig. 66). Tsutakawa had to look for a technician; luckily, he found Jack Uchida (1915–1997), a Seattle native and Boeing engineer who had received a degree from the University of Washington. Uchida sensitively understood what Tsutakawa wanted to do. Tsutakawa continued to receive commissions for fountain sculptures, and he completed more than sixty in the United States and Japan (fig. 67). Tsutakawa's abstract fountains exemplify the life forces of plants and water. The falling water, sound, light and its reflection, and surrounding environment are all part of a configuration that serves as an invitation to contemplate nature.

Frank Okada met Horiuchi for the first time in 1950 at Horiuchi's business, Paul's Body and Fender shop. Later, when injury forced Horiuchi to close the body shop, Okada continued to visit Horiuchi at

FIG. 65 Val Laigo, *Untitled (Mural at A. A. Lemieux Library, Seattle University)*, 1967. Acrylic and mixed media on linen, triptych, 100½ × 734 in.

FIG. 66
George Tsutakawa, *Fountain of Wisdom* at the Seattle Public Library, 1958–1960. Bronze, approx. 12 × 6 × 6 ft.

the studio behind his small antique shop, Tozai (fig. 68). Okada became a rising star, receiving numerous prizes, from the Western Washington State Fair in Puyallup in 1953 to purchase prizes at the Seattle Art Museum's *Northwest Annual* in both 1955 and 1959. The artistic environment in Seattle and the art education he received from Derbyshire in his youth were the foundation for his success; he adhered to the fundamental values of oil painting and the colors and forms of early-twentieth-century art. Even after his painting style matured, Okada continued to refine these classic qualities.

A John Hay Whitney Opportunity Fellowship in 1957 enabled Okada to witness the most exciting transitional time of the New York art scene; a 1959 Fulbright scholarship allowed him to see the finest *sumi-e* paintings in Kyoto; and a Guggenheim grant exposed him to the wealth of European art, including that of the early twentieth century, in Paris. In 1969, Okada settled in Eugene to teach at the University of Oregon, where he used layers of small brushstrokes on the canvas to create geometric forms in magical colors (fig. 69). He continued to search for ways to make his painting purer, sometimes producing a warm luminosity that sensitively and optically responded to the moody light of the Northwest, yet

George Tsutakawa with
drawings and maquettes
of his fountains, ca. 1960s.

Paul Horiuchi with a painting
in front of Tozai, his antique
shop, ca. late 1950s.

still culminated in large, powerful, abstract, color-field paintings.

During the 1950s and 1960s, Zen became a popular discussion topic among many creative Americans and expanded interest in Japanese art, literature, and culture. In 1953, the Seattle Art Museum hosted the *Exhibition of Japanese Painting and Sculpture*, a show of exceptional quality, sponsored by the Japanese government. The year before, Bernard Leach, Hamada Shōji, and Yanagi Sōetsu, prominent proponents of the *Mingei* folk-art movement in Japan, had visited the United States after attending the First International Conference on Pottery and Weaving at Dartington Hall, England.[63] Hamada was invited to teach at the University of Washington in 1963.

Japanese ceramics was one of the many interests of Robert Sperry, a ceramics instructor who taught at the University of Washington from 1955 to 1982. He filmed the community of Onta, Japan, known for its ceramics, through a grant from the Center for Asian Art in 1963. One of Sperry's students at that time, Patti Warashina (b. 1940) (fig. 70), took classes from Hamada and became fascinated by the works of another Japanese folk ceramicist, Kawai Kanjirō, whose works are more abstract in form and in their painterly color surfaces.

FIG. 69 Frank Okada, *Consanguineous*, 1969. Oil on canvas, 72 × 72 in.

FIG. 70

Patti Warashina with her ceramic work, ca. late 1960s.

Johsel Namkung, *Cape Johnson, Olympic National Park, September 8, 1967.* Color photograph, 16 × 20 in.

Seattle's art world went through a major transition during the 1960s and 1970s. Between the World's Fair in 1962, the resignation of the Seattle Art Museum's founding director, Richard Fuller, in 1973, and the termination of the *Northwest Annual* and the death of Tobey in 1976, a space was made for a new kind of art. One of the local artists who pushed open the Seattle art scene with utterly original, whimsical ceramics was Warashina. Though Peter Voulkos and Japanese ceramics were the dominant influences in American ceramics in the 1960s, she sought her own vision. Warashina often visited the San Francisco Bay Area to go to City Lights Bookstore and to see funk ceramics. She was also stimulated by the Chicago funk art of the Hairy Who when she taught at Eastern Michigan University in Ypsilanti (1966–1968). These funk works demonstrated an unleashed imagination that inspired her to be-

come more creative with her own clay forms. In the 1960s, Warashina was already making outrageous nonfunctional ceramics, allowing her to break out of the confines of the vessel. Her works were covered with bright colors created by low fire glaze and acrylic pigments.

Johsel Namkung emerged as an accomplished nature photographer with a painter's eye. In large-scale color prints, his straightforward confrontation with the landscape catches the breadth and beauty of the natural world (fig. 71). In the mountains, he would stand in the cold for hours waiting for the moment in which light, color, and form coalesce in a powerful composition. He had a solo exhibition at

the University of Washington's Henry Art Gallery in 1966.

The new kind of art was evident as well in the medium of painting. Roger Shimomura (b. 1939), who grew up with the paintings of Northwest artists, found his own form of pop art while studying for his M.F.A. at Syracuse University in New York in 1968–1969. His paintings, which spoof *ukiyo-e* woodblock prints, question issues of racial identity in humorous but political terms.

A history of Asian American art in the Pacific Northwest is not an isolated ethnic art history, nor is it an extension of the history of Asian art. Rather,

it is a central component of what we recognize today as the art of this region. The engagement with ideas and aesthetics from Asia has been among the most important inspirations for the art created in the Pacific Northwest. The level to which each individual artist interacted with these concepts varied widely; some artists were recognized as important interpreters, while others were more indirectly influenced. Yet what is clear is that an accurate history of Pacific Northwest art would not be complete without consideration of these complex connections and interactions, and an appreciation of the important role that artists of Asian ancestry have played.

Notes

1 Ishikawa Kō, "Commentary," in *Frontier Photographer F. S. Matsura* (Tokyo: Heibonsha, 1983), 21. This essay is a new addition to the Japanese translation of *Frank Matsura—Frontier Photographer* by JoAnn Roe (Seattle: Madrona Publisher Inc., 1981). According to Ishikawa and Kuwahara Tatsuo in *Furanku to Yobareta Otoko* [Man Who Was Called Frank] (Tokyo: Jōhō Center Shuppan Kyoku, 1993), Matsura's Japanese name was Sakae Matsura, and he was a descendant of the Hirado Matsura clan.

2 See Rayna Green, "Rosebuds of the Plateau: Frank Matsura and the Fainting Couch Aesthetic," in *Partial Recall: Photographs of Native North Americans*, ed. Lucy Lippard (New York: New Press, 1992), 46–53.

3 Photography was introduced to Japan early. The Lord Nariakira Shimazu owned the first set of apparatus for a daguerreotype in 1848, and during the 1860s already about a dozen independent photo studios were scattered throughout Japan; *The Advent of Photography in Japan* (Tokyo: Tokyo Metropolitan Museum of Photography and Hakodate Museum of Art, Hokkaiddo, 1997). The Seattle city directory documents Japanese-owned photo studios from 1901.

4 Roe, *Frank Matsura*, 17.

5 Ōkubo Shizuo, *Tanaka Yasushi: The Painter Who Worked in Seattle and Paris* (Saitama: Museum of Modern Art, Saitama, 1997), 9. According to Ōkubo, Tanaka was

born in present-day Iwasaki City, Saitama Prefecture. The Tanaka family were samurai, serving the Lord Ōoka until dispersion of the four classes in 1871.

6 Fokko Tadama, born to Dutch parents in present-day Sumatra, was trained in art in Holland and settled in Seattle in 1910. His studio attracted many Japanese students. Though they were critical of his academic approach, they received a foundation in painting skills from him.

7 Yaguchi Kunio, "Toshi Shimizu—Documents," in *The Proceedings of Tochigi Prefectural Museum of Art*, no. 6 (1978): 45.

8 June Mukai McKivor, ed., *Kenjiro Nomura: An Artist's View of the Japanese American Internment* (Seattle: Wing Luke Asian Museum, 1991), 9.

9 Yasushi Tanaka, correspondence with Frederic C. Torrey, art dealer in San Francisco, 1915–1924, Archives of American Art, Smithsonian Institution; Regional Art Scrap Books, Fine and Performance Art Department, Seattle Public Library. These varied influences can be observed in multiple experimental styles of paintings executed in Seattle in Ōkubo, *Tanaka Yasushi*.

10 The futurism show from Italy came to Chicago in 1913, but not to Seattle, which was still a conservative small town. According to the lecture, the cubists, futurists, and postimpressionists were an expression of a general lack of discipline, and a speaker cited analogous

instances in modern literature, architecture, politics, and philosophy; *Town Crier*, May 10, 1913. *Town Crier* was a Seattle weekly magazine published from 1910 to 1937.

11 Thomas H. Cann (1833–1915) served as a justice of the peace from 1898 to 1908. In a letter dated February 9, 1886, he wrote, "We would be better off without Chinese." Pamphlet Collection, Special Collections, University of Washington Libraries. The Chinese Exclusion Act was enacted in 1882. His statement coincides with riots in Seattle and Tacoma in 1885 and 1886.

12 Seattle Art Museum Records, Accession No. 2636, Box 36, Special Collections, University of Washington Libraries.

13 Anti-miscegenation laws varied by state; they were enacted in California in 1919 but not in the state of Washington at that time.

14 A newspaper article (n.d., n.p.) in the file of Yasushi Tanaka, correspondence with Frederic Torrey, Archives of American Art, Smithsonian Institution. A similar article, "Louise Cann Weds Japanese Artist 'to Explore His Mind;' Writes of 'Cosmic Matings,'" was published in a local newspaper, *The Seattle Star*, November 24, 1917.

15 Stephen N. Hay, "Rabindranath Tagore in America," *American Quarterly* 14, no. 3 (Fall 1962): 439. Tagore was a poet, philosopher, playwright, and painter. His idealized view of universality in art attracted many poets and artists in the West, such as William Butler Yeats, Ezra Pound, and Isamu Noguchi. He received the Nobel Prize in Poetry in 1913 and visited the United States numerous times.

16 *Town Crier*, April 3, 1915, 8. His statement was printed along with those of Carl F. Gould (president of the Seattle Fine Arts Society and an architect who designed many buildings at the University of Washington), Imogen Cunningham Partridge, John Butler, and Roi Partridge.

17 Another artist who followed the eastward trajectory was Sumio Arima (1901–1987), who came to Seattle from Tokyo in 1918. He went to New York to study art under John Sloan in 1923–1924 but had to return to Seattle after 1930 at the request of his father to run his family's business, the Seattle newspaper *Hokubei Jiji* (*The North American Times*) (1902–1942).

18 Yoshio Noma, interview with the author, July 19, 1989. According to Noma, Koike practiced medicine in Okayama before he came to Seattle.

19 Koike's book on taking photographs of mountains was published in Japan using his pen name: Banjin Koike, *Sangaku Shashin no Kenkyū* [Studies on Photographing the Mountains] (Tokyo: Arisu Publisher, 1932).

20 Kyo Koike, Introduction for his translation of *History of Ancient Japan*, Kyo Koike Papers, Accession No. 1374, Box 1, Special Collections, University of Washington Libraries.

21 Noma, interview, 1989.

22 The Seattle Camera Club was the only camera club in town until the Seattle Photographic Society was founded in October 1933. Noma was later inspired by Koike to form a new Seattle Japanese Camera Club with other Japanese in 1940 and other groups after World War II. Koike recommended that Noma eliminate "Japanese" from the name of the club because the club should include all Americans.

23 "Seattle Camera Club the Fifth Meeting," *Notan*, no. 11 (April 10, 1925): n.p. Tobey was invited for the March 13, 1925, meeting. Showing his own works, he compared the approach of the academic school and futurism, and explained why he rejected the former and took interest in the latter.

24 *Seattle Times*, December 25, 1924; *Mark Tobey* (Madrid: Museo Nacional Centro de Arte Reina Sofía, 1997), 450. T'eng's ink finger paintings were reproduced in *Town Crier*'s Christmas issue of 1924.

25 The word *nōtan* means "variation of dark and light." Ernest Fenollosa used *nōtan* numerous times in *Epochs of Chinese and Japanese Art: an outline history of East Asiatic design* (London: William Heinemann Ltd.; New York: Frederick A. Stokes Company, 1912). It also was a very important term used by Arthur Wesley Dow in *Composition: A Series of Exercises in Art Structure for the Use of Students and Teachers* (New York: Doubleday, Page & Company, 1899).

26 Although Glenn Hughes was interested in poetry and wrote numerous short plays, he is best known as an educator in the English and drama departments at the University of Washington. He is the author of *The Story of the Theatre* (New York, Los Angeles, and London: Samuel French, Ltd., 1928), an educational text that

covers the global history of theater, including that of East Asia, with a bibliography for each region.

27 Ernest Fenollosa, *Certain noble plays of Japan: from the manuscripts of Ernest Fenollosa, chosen and finished by Ezra Pound, with an introduction by William Butler Yeats* (Churchtown and Dundrum, Ireland: The Cuala Press, 1916). Interestingly, Pound also published Fenollosa's *The Chinese written character as a medium for poetry* in 1936 (later reprinted by City Light Books, San Francisco).

28 Besides writing haiku, Koike in 1934 founded a group to share haiku, Rainier Ginsha, which still exists in Seattle.

29 Dow left a phenomenal impact on creative minds across America: through his years of teaching at Pratt Institute in Brooklyn (1895–1903) and at Teachers College, Columbia University (1904–1922)—where he was responsible for hiring pictorial photographer Clarence White—as well as through his publications. Koike must have found kinship in Dow and Fenollosa's shared admiration for Japanese art, and in their search for an aesthetic that speaks for the universality of art. Dow stated in *Composition*, "An experience of five years in the French schools left me thoroughly dissatisfied with academic theory. In a search for something more vital I began a comparative study of the art of all nations and epochs" (4). Fenollosa believed that his grandiose interpretation of Chinese and Japanese art within a global perspective, as presented in his *Epochs of Chinese and Japanese Art: an outline history of East Asiatic design*, would bring an understanding of a higher level of aesthetics capable of bridging the whole of humanity in both East and West. Fenollosa proposed, "We are approaching the time when the art work of all the world of man may be looked upon as one, as infinite variations in a single kind of mental and social effort" (xxiv).

30 Okakura Kakuzō, *The Book of Tea* (New York: Fox, Duffield and Company, 1906).

31 *Notan*, farewell issue, October 11, 1929.

32 Hiromu Kira moved to Los Angeles but kept in touch with Koike.

33 Frank Asakichi Kunishige, from Yamaguchi Prefecture, landed in San Francisco in 1896, attended a school in Illinois in about 1911, and came to Seattle in 1917.

34 Shelley Sang-Hee Lee, "Good American Subjects Done through Japanese Eyes: Race, Nationality and the Seattle Camera Club, 1924–1929," *Pacific Northwest Quarterly* 96, no. 1 (Winter 2004/2005): 29.

35 Ibid., 30.

36 Mrs. Chao-Cheng Yang provided biographical information; interview by Alan Lau and the author, January 22, 1990.

37 "Yang Wins Top Place in Photo Exhibit," *Seattle Post Intelligencer*, August 28, 1943.

38 Mineko Namkung (1918–1998) was born in Taiwan to Japanese parents. She submitted her prints and paintings to competitions from 1962 to the 1970s, including the *Northwest Annual Exhibitions*. She and her husband, Johsel Namkung, owned Hanga Gallery from 1957 to 1962 and were instrumental in introducing the medium of printmaking as a legitimate art form (especially work from Japan). They exhibited the works of Japanese artists Munakata Shikō, Onchi Kōshirō, and Saitō Kiyoshi and local artists such as Glenn Alps and Gordon Gilkey.

39 Johsel Namkung, taped and transcribed interview by Alan Lau, October 5, 1989, 4; Archives of American Art, Smithsonian Institution.

40 Kenjiro Nomura and Kamekichi Tokita, "Seattle's Japanese Artists," *Town Crier*, May 28, 1932, 6. The short article starts, "Another outdoor sketching season has arrived. The Seattle Japanese artists are expecting to go out every Sunday if the weather allows."

41 *Some Works of the Group of Twelve* (Seattle: Frank McCaffey, Dogwood Press, 1937). The other artists included were Margaret and Peter Camfferman, Elizabeth Cooper, and Earl Fields. These artists did not actually form a group, according to Fay Chong (interview by Dorothy Bestore, February 14 and 20, 1965; Archives of American Art, Smithsonian Institution), and the author found no documentation of group activities outside of this publication.

42 George Tsutakawa, interview by Martha Kingsbury, September 8, 12, 14, and 19, 1983, 37; Northwest Oral History Project, Archives of American Art, Smithsonian Institution.

43 Ibid.

44 Andrew Chinn, interview by Matthew Kangas, August 9, 1991, 6, 7, and 33; Northwest Asian American Project, Archives of American Art, Smithsonian Institution.

45 *Seattle Times*, December 3, 1933. Chinese students an-

nounced the organization with their slogan, "Art for Art's Sake," and opened their first show at the Chinese school on Seventh Avenue South and Weller Street. Block prints by Chong, winner of the second prize of the National Scholastic award of 1933, were featured.

46 William Cumming, *Sketch Book: A Memoir of the 1930s and the Northwest School* (Seattle and London: University of Washington Press, 1984), 154.

47 Fay Chong, interview by William Hoppe, July 17, 1972; Archives of Northwest Art, Special Collections, University of Washington Library. According to Chong, students brought their works, and Tobey would analyze each work and provide constructive criticism. The classes were at Tobey's home near N.E. Fiftieth Street on Brooklyn Avenue N.E. in the university district.

48 Kenneth Callahan, "Seattle Art Museum," *Seattle Times*, 1934; Mary Chinn family file.

49 Kenneth Callahan, video recording by Donald A. Schmechel, 1984; Seattle Public Library.

50 Ray Kass, *Morris Graves: Vision of the Inner Eyes* (New York: George Braziller, Inc., in association with The Phillips Collection, Washington, D.C., 1983), 24.

51 Guy Anderson, interview by Martha Kingsbury, February 1 and 8, 1983, 57; Northwest Oral History Project, Special Collections, University of Washington Libraries. Anderson himself did not visit Japan until October 1983 for the *Pacific Northwest Artists and Japan* show at the National Museum of Art, Osaka.

52 At Dartington Hall, Tobey met many influential authors and thinkers, including Pearl Buck, Aldous Huxley, Rabindranath Tagore, and Arthur Waley; Arthur Dahl, *Mark Tobey/Art and Belief* (Oxford: George Ronald, 1984), 6. The founder of Dartington Hall, Leonard Elmhirst, advised Tagore on agriculture and rural economy for his teaching at Santiniketan; Bernard Leach, *Hamada* (Tokyo and New York: Kodansha International, 1975), 164.

53 John Matsudaira, telephone interview by the author, June 7, 1990.

54 Louis R. Guzzo, "Buddies Cast in Conflicting Roles," *Seattle Times*, September 28, 1961, 32.

55 Martha Kingsbury, *George Tsutakawa* (Seattle: University of Washington Press and Bellevue: Bellevue Art Museum, 1990).

56 Tsutakawa, interview, 1983, 58.

57 Tsutakawa joined the camera club Yoshio Noma organized after World War II and accompanied Kyo Koike on photo outings.

58 Tsutakawa, interview, 1983, 49.

59 Mark Tobey, "Japanese Traditions and American Art," *College Art Journal* 18, no. 1 (Fall 1958): 21, 22, 24.

60 Val Laigo, interview by the author, October 19, 1989.

61 A pamphlet for the Val Laigo retrospective at Seattle Center Pavilion, May 26–29, 1995.

62 William Orville Douglas, *Beyond the High Himalayas* (Garden City, N.Y.: Doubleday, 1952).

63 Leach, *Hamada*, 188.

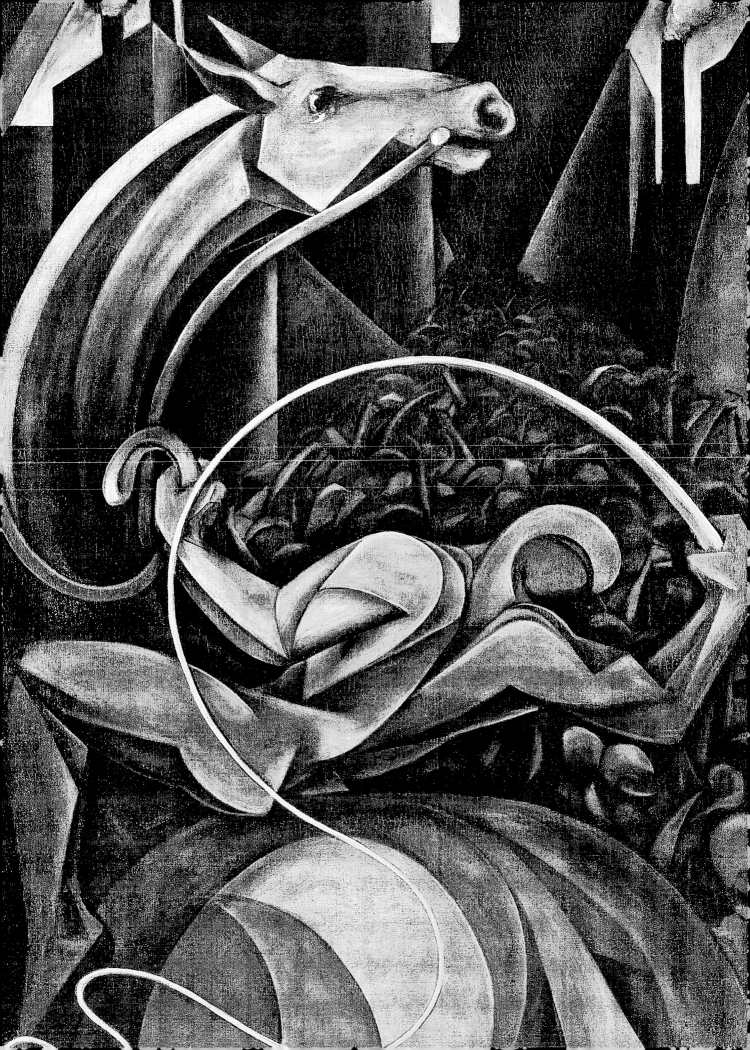

The Tip of the Iceberg

Early Asian American Artists in New York

Tom Wolf

The natural path of emigration from Asia to the United States is across the Pacific Ocean. Consequently the most populous concentrations of Asian immigrants have been on the West Coast, with important centers in Los Angeles and San Francisco, as well as in Seattle and Portland. After coming to the West Coast, relatively few who arrived from Asia continued eastward, which is true for artists as well as for other members of the community. But New York in the final decades of the nineteenth century became the artistic capital of the country, a role it fulfilled throughout the entire twentieth century. It is also a city of great visual dynamism: "I enjoy sketching in the asphalt jungle—the big city," wrote **Dong Kingman**, who achieved success as an artist in San Francisco and then moved to New York for the rest of his career.[1] Lured by New York's energy and sophistication, some of the most ambitious Asian American artists relocated to this artistic center, and the history of their accomplishments has yet to be written.

This essay surveys the works and careers of a number of the most interesting of these artists, concentrating on the little-studied but dynamic years of the first half of the twentieth century. Some of the artists were born here; many came from Asia. They were adventuresome, independent people who traveled extensively. Many paid extended visits to Paris, the center of modernism, and several returned to Asia for the concluding phases of their careers.

The artists who came from Asia brought their native traditions with them into their new country where, for much of the twentieth century, they were discriminated against and not permitted to become citizens. In their writings, often in the titles themselves, they frequently acknowledged their dual identities. **Yasuo Kuniyoshi**'s major autobiographical essay was titled "East to West."[2] **Yun Gee** wrote an essay about his years in France called "East and West Meet in Paris."[3] **Isamu Noguchi**, who was born in the United States but spent his youth in Japan, wrote in *A Sculptor's World*, his autobiographical memoir, "With my double nationality and double upbringing, where was my home?"[4] The painters manifested this doubleness in their work in several ways. They were comfortable with the techniques of Asian art, particularly water-soluble black ink applied to paper

Eitaro Ishigaki, *The Man with the Whip*, 1925 (detail, fig. 81).

FIG. 72 Chuzo Tamotsu, *East 13th Street*, 1937.
Lithograph, image: 17½ × 11¾ in.

with brushes; living in the West, they also learned the European technique of oil on canvas. Yun Gee, for one, saw himself adopting this new method to revitalize the Asian artistic traditions he knew from his youth:

> I had studied watercolor painting in China under the master Chu, and having learned the techniques of the Chinese masters I naturally desired to become acquainted with the masters of the West. Through the museums and galleries my eyes were soon opened to their great achievements and to the unlimited possibilities of painting in oil. Observing the similarities and dissimilarities between the art of the two cultures, I determined to create a technique and philosophy of art which would transcend the differences or bridge the gap.[5]

Most of these artists attended art schools in the United States, and their art reveals a dialog between Euro-American concepts of space and form and Asian practices. Sometimes they adhered to Western models of three-dimensional forms modeled in light and shade set in a perspectival space, but at other times they favored flatter images. Beyond technique and form, subject matter was an area in which these artists could express their Asian identities. Also, they sometimes signed their works with their Asian names or inscribed texts in Asian languages on their pieces. These practices took place in a fluid and shifting field, particularly as they were available to Euro-American artists as well: the adoption of Asian effects by non-Asian artists was widespread from the late nineteenth century on, and modernist painting's embrace of the two-dimensional surface was encouraged by Asian prototypes. Still, allusions to Asian traditions were more commonly made by artists of Asian descent, who affirmed their origins by reflecting them in their works. It is not unusual to find a spectrum of effects in the lifework of an Asian American artist: some pieces seem entirely

Western, while others actively incorporate Asian references. For example, take Chuzo Tamotsu, who left his native Japan to spend six years exploring Europe before settling in New York from 1920 to 1941, and then moving to New Mexico. The prints he made in New York under the auspices of the Works Projects Administration include *East 13th Street* (fig. 72). Here he depicted kids frolicking in the water from a fire hydrant on a city street, an American subject typical of the urban realist style then prevalent in New York. He adopted an American style and a technique foreign to Asian artistic traditions, lithography. Later, in the mid-1950s, he made a series of linocuts of horses, timeless subjects not particularly modern or urban, and he used the block-print technique to evoke Japanese woodcuts and brush-and-ink drawings (fig. 73). In the *East 13th Street* print he carefully shaded the forms with small strokes of the lithographic crayon; in the later block print he carved his image with a few quick, dramatic strokes, and signed the print with a red seal, or chop, an Asian practice. Here East meets

West not as an artistic fusion in a single work, but as alternative traditions called up in separate works by the same artist.

AT THIS STAGE of my research I have discovered little about Asian American artists active on the East Coast in the late nineteenth and early twentieth centuries, although they were already visible on the West Coast. Those who did come to New York found a receptive cultural climate due to the enthusiasm for Japanese art and culture that had developed in the late nineteenth century. Artist Arthur Wesley Dow, one of the main popularizers of that vogue, was a famous teacher and had many disciples. In 1899 he published his vastly successful book, *Composition*,

FIG. 73 Chuzo Tamotsu, *Horse*, ca. 1957.
Linocut, 18 ⅝ × 12 in.

which he claimed was based on principles derived from Japanese art.[6] Art critic **Sadakichi Hartmann** was an important member of the avant-garde circle around Alfred Stieglitz. He was half German and half Japanese, and his multicultural heritage was reflected in his writings. In the early years of the century, he published a pair of complementary books, *Japanese Art* and *A History of American Art*, and at various times in his career he wrote three plays titled *Buddha, Confucius*, and *Christ*.[7]

BY THE LATE 1910s, ambitious Japanese artists in New York started banding together in groups to hold exhibitions, and one can get a sense of their activities, although much has been lost. This area of art historical investigation is fairly new, and the writing about it has mostly been done in Japan, which is true of the collecting of the art as well.

The Japanese artists in New York supported each other as friends with a shared heritage at the same time as they were involved with the larger art scene. Their sense of community was manifested in the group exhibitions they organized. A show held in 1917 was titled *Young Japanese Artists in New York*, at the Yamanaka Galleries on Fifth Avenue.[8] It featured ten artists, including T. K. Gado, who made some remarkable paintings in New York in the early 1920s that have recently come to light.[9] While most of the Japanese artists working in New York in this period studied at the Art Students League and painted fairly straightforward scenes of urban life, Gado plunged into a radically modernist style with paintings such as *Subway* (also known as *Communication in the Under Surface*) (1923) (fig. 74). The painting recalls Max Weber's avant-garde *Rush Hour, New York* from 1915, but it is even more frenetic in its futuristic evocation of the jostling dynamism of the subway, as the artist combines a pulsating surface with a plunging space,

T. K. Gado, *Subway*
(or *Communication in the
Under Surface*), 1923.
Oil on canvas, 37¾ × 27⅝ in.

representing the human energy of the metropolis at its peak. Gado graduated from the Tokyo University of Art before coming to the United States, and he returned to Japan in 1924. While in New York, he worked as a designer for export china, and only about a dozen works in this ambitious modernist style are believed to exist today.

In New York, Gado showed his paintings annually with the Society of Independent Artists, which began its revolutionary series of nonjuried exhibitions in 1917. Japanese artists were frequent participants.[10] The exhibitions at the Society of Independent Artists were complemented by the open exhibitions at the MacDowell Club, where any self-

organized group of artists could rent the gallery for a nominal fee and hold a two-week show. In 1918, a dozen Japanese artists exhibited at MacDowell, calling themselves the Japanese Art Association.[11] This show included Yasuo Kuniyoshi, who had made his exhibiting debut the previous year at the inaugural exhibition of the Society of Independent Artists, and who would become one of the most prominent painters, Asian or otherwise, in the United States in the decades between the two world wars.

A photograph of the artists who exhibited as the Japanese Artists Society in 1922 is symptomatic of the state of research: although we know the names of the exhibitors, today only five of the twelve artists

pictured can be identified (fig. 75).[12] By 1922 a group of artists had developed who would periodically show together through the 1930s. Artists would come and go, but usually participants included Kuniyoshi, **Kyohei Inukai**, **Eitaro Ishigaki**, Gozo Kawamura, Toshi Shimizu, Kiyoshi Shimizu, Chuzo Tamotsu, Bumpei Usui, and **Torajiro Watanabe**.

Another group show, *The First Annual Exhibition of Paintings and Sculpture by Japanese Artists in New York*, held at The Art Center on East Fifty-sixth Street in early 1927, included many of the same artists.[13] Again, a formal photograph documents the occasion (fig. 76), but in this picture Kuniyoshi has moved from the far right to the center, a position befitting his rising status in the New York art world.

The acclaim Kuniyoshi achieved was an even greater accomplishment considering that he came to the United States alone in 1906, barely seventeen years old, with the idea of making money and no intention of becoming an artist. A year later he moved from Seattle to Los Angeles, finding unskilled jobs to support himself. In Los Angeles he took the advice of a high school teacher who encouraged him to study art. In 1910 he moved to New York City, where he tried out several progressive art schools un-

til he found a place he felt happy, the Art Students League. The league, which is still active today, appealed to many immigrant artists because of its liberal structure: no entrance requirements, no mandatory attendance, no examinations, no diplomas, and no degrees.[14] The theory was, if students were serious about becoming artists, they would provide their own discipline. The faculty included prominent academic painters as well as the leaders of the socially concerned Ashcan school, Robert Henri, John Sloan, and George Bellows, who influenced many of the Japanese immigrant artists. Kuniyoshi studied at the league from 1916 to 1920 and then returned as a teacher in 1933.

Critics writing about Kuniyoshi's art commonly referred to an "Oriental" quality in his work, usually without getting specific about what they meant. Their vagueness was due in part to the originality and the weirdness of his paintings, particularly in the 1920s, when he made his reputation, and invented such peculiar subjects as *Boy Stealing Fruit* and *Al Perkins Drying Fish*. The artist himself claimed that his aim was to bring together East and West, and Asian references are particularly marked in a series of highly finished black-ink drawings he made in the

FIG. 75 Japanese Artists Society, New York, 1922.

FIG. 76 *The First Annual Exhibition of Paintings and Sculpture by Japanese Artists in New York, 1927.*

1920s.[15] *Fisherman* (1924) is a whimsical scene drawn in the traditional Asian technique of black ink on paper (fig. 77). The fisherman emerges from a floating, nonperspectival space to grab a fish. Below him is a collection of sea creatures, common subjects in the art of Japan, an island nation. In the far background the artist placed a mountain peak that hovers above the earth, a motif common in Chinese and Japanese landscape painting.

Kuniyoshi took two extended trips to Paris, in 1925 and 1928. They resulted in a change in his style, from painting from his imagination to painting from the model, from flat space, "like kakemonos," to perspective space.[16] From the late 1920s to the mid-1940s he produced some of his best-known paintings, of brooding, scantily dressed women. In the backgrounds of many of these, such as *I'm Tired* (1938), he developed beautiful passages of swirling, impasto pigment that reveal his fascination with the sensuality of oil paint (fig. 78). These paintings have

encouraged some writers to see him as a totally Westernized artist, a view that ignores pieces such as his ink drawings, which, with their high degree of finish, stand as independent works of art, as they would in China or Japan.[17] In his own words, his aim as an artist was "to combine the rich traditions of the East with my accumulative experiences and viewpoint of the West."[18] Even his most Parisian paintings, American critics felt, contained something Asian in their "refinement," but when Kuniyoshi took his only trip back to Japan in 1931 to visit his ailing father, the Japanese art community greeted his work as Western. Still, at his most Europeanized, working with perspective and oil paint, he sometimes chose themes like *Japanese Toy Tiger and Odd Objects* (1932), whose subject refers to Asia.

After World War II, Kuniyoshi entered the last phase of his artistic career. He brightened his palette and developed a shallow, layered space in what he saw as a fusion of his early and middle periods, "to

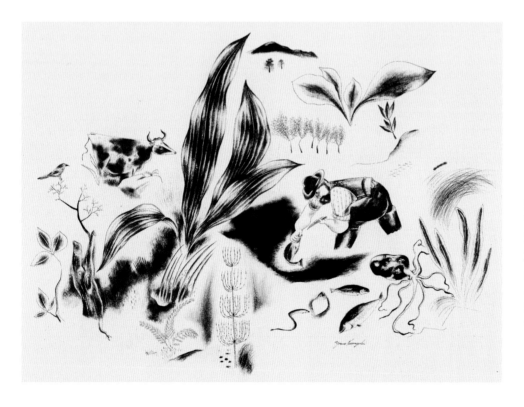

FIG. 77
Yasuo Kuniyoshi,
Fisherman, 1924.
Dry brush and india ink
on paper, 22 × 28⅜ in.
Art © Estate of Yasuo
Kuniyoshi/Licensed by
VAGA, New York, NY.

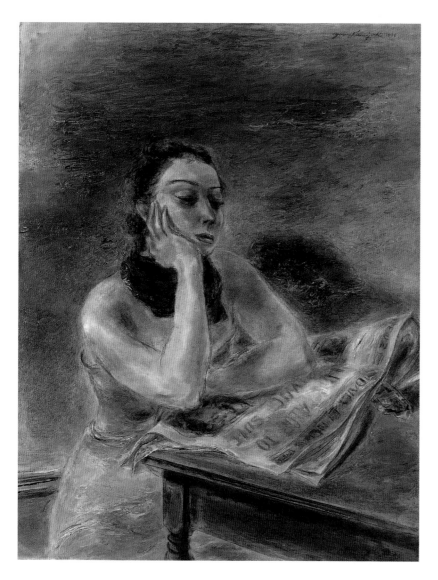

paint ideas as in his early work but with the feeling of reality of his middle work."[19] And he continued to include Asian references in his subjects—his last painting was *Oriental Presents* (1951)—before concluding his career with a series of dark, grim *sumi-e* ink paintings.

ALTHOUGH KUNIYOSHI WAS THE most prominent Asian American artist of his time in terms of recognition and prestige, others of his Japanese friends in New York were active in the art world, making paintings that look very interesting today. Those friends include Toshi Shimizu and Eitaro Ishigaki, whose works and documents have been preserved in Japanese museums, so more information is available about them than about some of their peers.[20]

Toshi's brother, Kiyoshi, for example, regularly exhibited paintings of New York street scenes with the Japanese American groups and with the Society of Independent Artists in the 1920s and 1930s, but his paintings are dispersed and little is known about his career today. In contrast, the works of Toshi, who returned to Japan and the bulk of whose paintings are in the museum of his native prefecture, can be studied in several publications.[21]

Toshi Shimizu came to the United States in 1907 at the age of twenty, intending to raise money to study art in Paris. Instead, he studied in Seattle with Fokko Tadama, a Dutch painter of academic persuasion who had several Japanese students (see Kazuko Nakane's essay for more information). In 1917, Shimizu moved to New York, where he studied at the Art Stu-

dents League and worked as a painter before moving to Paris in 1924. He spent three years there before returning to Japan. At the Art Students League, Shimizu befriended John Sloan, the urban realist painter who was also the president of the Society of Independent Artists, where Shimizu and many of his Japanese contemporaries exhibited their works. Shimizu adopted the ideals of the Ashcan school artists, who believed in painting realistic scenes of everyday life in the city. He depicted the sidewalks of New York crowded with their busy vegetable markets, shoppers, and beggars. His slightly caricatured figures were painted loosely, with a keen eye for costume as an indicator of social and economic class. But when he looked at urban reality, he saw more Asian figures and subjects than did the American artists who inspired him. Robert Henri, the leader of the Ashcan school, created some portraits of Asians as part of his democratic program to depict all types of people, and Sloan painted one, *Chinese Restaurant* (1909). But Sloan's *Chinese Restaurant*, where an attractive Caucasian woman in a plumed hat plays with a cat, could be any restaurant. When Shimizu painted the same subject in 1918, a Chinese waiter was prominently included along with white sailors and their women.

In 1919, Shimizu interrupted his stay in New York to return to Japan and get married. This trip resulted in several paintings in which he applied his urban realist style to Japanese subjects, including *Yokohama Night* (1921), painted from an elevated point of view with dozens of figures going about their varied activities. He showed it first at the Independents and then at the Art Institute of Chicago, where it won a prize that was subsequently revoked because he was not an American citizen. The *American Art News* account of the episode was titled "Chicago Overrules Jury and Bars Jap."[22] Similar alienating stories come up repeatedly in the careers of Asian immigrant artists: by law, they were not permitted to become American citizens, and their lack of citizenship then became an excuse to further exclude them.

Back in New York, Shimizu painted *New York, Chinatown at Night* (1922) from a high point of view like that in *Yokohama Night*, its deep urban space filled with fifty-six figures, including a 1920s version of the tour buses that still prowl through Chinatown today (fig. 79). Here he took the bustling Lower East Side setting loved by Ashcan school artists like Bellows and George Luks and relocated it a few blocks west, replacing the immigrants from Eastern Europe with immigrants from Asia. After he moved to Paris, he continued to paint urban realist subjects, but his style gradually stiffened and started becoming more abstract. In Shimizu's *Merry-Go-Round* (1925), a subject popularized by urban realist Reginald Marsh, the child riding the carousel horse is Asian. When Shimizu turned to the definitively modern subject of the movie theater, he continued a subject explored by Sloan in *Movies, Five Cents* from 1907, echoing Sloan's diagonal view of the people watching the film. Both Sloan's and Shimizu's paintings anticipate Edward Hopper's famous *New York Movie* of 1939, but unlike Sloan and Hopper, Shimizu included an Asian parent and child in the theater audience.

His tendency toward abstraction continued after he returned to Japan in 1927. But as Japan became more militarily aggressive, Shimizu joined some of his contemporaries—most famously Tsugouharu Foujita, who had returned to Japan from Paris in 1933 —in painting monumental, realist military paintings such as *Charge!* (1943) (fig. 80) that, despite being painted in anti-Western wartime Japan, were modeled on nineteenth-century European history paintings.[23]

WHILE SHIMIZU WAS IN Japan painting scenes of war, Eitaro Ishigaki was in New York making art that protested Japanese militarism. He had been summoned to the United States by his father, who had immigrated after losing his job as a carpenter when the whaling business in Japan declined. After working at menial jobs on the West Coast, Ishigaki began

FIG. 79 Toshi Shimizu, *New York, Chinatown at Night*, 1922. Oil on canvas, 39 × 44¾ in.

FIG. 80

Toshi Shimizu, *Charge!*,
1943. Oil on canvas,
51⅜ × 64 in.

studying art in 1913 at William Best School of Art and then at the San Francisco Institute of Art. He also became interested in socialism, encouraged by Sen Katayama, a founder of the Communist parties in Japan and the United States.

In 1915 Ishigaki moved to New York, where he, like Shimizu, studied with John Sloan at the Art Students League. His works alternated between scenes of street life in New York and paintings with political themes, peopled with muscular, struggling figures, sometimes nude, that evoke Michelangelo's paintings as well as those of the Mexican muralists then active in the United States. *The Man with the Whip* from 1925 is a powerful early example, though the geometrical stylization of the figures is more modernist than usual for the artist (fig. 81). Much of its tension derives from the contrast between cubist angles and art-nouveau curves. These create a conflicted image of a whip-bearing man on horseback who represents the oppressive forces of capitalism as he dominates a crowd of faceless workers set against a backdrop of the factories where they are forced to labor.

Ishigaki was active in left-wing groups and in 1929 was a founding member of the John Reed Club. During the Depression he painted two ambitious murals for a courthouse in Harlem, *The Independence of America* and *The Emancipation of the Slaves*. Although patriotic, they were still controversial. In each six-by-ten-foot painting Ishigaki juxtaposed a static group of portraits of American heroes with active figures, all larger than life-sized. In one scene they enacted the American Revolution, and in the other, the oppression and freeing of slaves. His portrait of George Washington was criticized as making him look "cruel," although it was clearly based on Gilbert Stuart's eighteenth-century portraits. Emancipation of the slaves was still a volatile subject in

the 1930s, and Ishigaki's portrait of Abraham Lincoln was criticized for being too negroid in its features and skin color—a troubling critique.[24] The Municipal Art Commission in charge of the job removed the paintings due to the controversy, and they were eventually destroyed.

Ishigaki was a tempting target for racist critics because he had already established himself as a dedicated leftist artist who in 1931 painted *Lynching*, a dark and violent condemnation of racial murder. In 1935, there were two exhibitions in New York protesting lynchings, one organized by the NAACP and one at the ACA Gallery, the leftist gallery where Ishigaki would have solo shows in 1936 and again in 1940.[25] Although Ishigaki did not take part in either of the two anti-lynching exhibitions, his paint-

FIG. 81 Eitaro Ishigaki, *The Man with the Whip*, 1925. Oil on canvas, 57 ¼ × 42 in.

FIG. 82 Eitaro Ishigaki, *Woman with Baby*, illustration from Haru Matsui's *Restless Wave*, ca. 1940.

ing foreshadows many of the works shown there.[26] *Lynching* stands apart, however, in the prominence Ishigaki gave to the women in the mob. They are in the foreground, illuminated by a lantern that makes them visible against the dark surroundings, and one holds the lethal rope.

The prevalence of active female protagonists is characteristic of Ishigaki's art, suggesting that his desire for equality among all races extended to both genders, as the artist frequently portrayed powerful women. In his Harlem *Independence* mural, a woman led the revolutionaries below Washington and Franklin, reminiscent of Delacroix's *Liberty at the Barricades*. Later in the decade, when he made paintings protesting the rise of fascist militarism, Ishigaki's images of Basque women throwing around Italian men—such as *Resistance*, from 1937—received a lot of attention in the press, and his 1948 *Triumph of Women*, in which women physically brutalize some victimized men, is an unusual image in the history of sexual politics. Ishigaki was married to a prominent journalist in the Asian American community, Ayako Ishigaki, who chronicled her rebellion against her traditional Japanese upbringing in her autobiography, *The Restless Wave*, published in 1940 under the pseudonym Haru Matsui and illustrated by her husband.[27] In these graceful illustrations Ishigaki exhibited the artistic dualism that is characteristic of many of the artists discussed here. He was one of the most Westernized of the Japanese American painters working in New York. But when he turned to illustrate his wife's autobiography, he put away his oil paints and switched to brush and black ink to represent ikebana arrangements, Japanese lanterns, and women in kimonos, which evoked his and his wife's youth in Japan (fig. 82).[28]

The controversy about Ishigaki's Harlem murals was complicated by the fact that after two years of work he was removed from the project, and it was finished by assistants. The murals were commissioned by the government's Works Project Adminis-

tration in 1935, and in 1937 it was decided that only American citizens were eligible for its aid, resulting in the dismissal of three thousand workers from the program.[29] Once again Asian-born artists were discriminated against due to the laws that made it impossible for them to become citizens. This time some of them protested.

The 1930s in the United States, with the Depression at its worst, was a time of great political unrest, and the Communist Party and related leftist organizations were very active.[30] Artists of Asian ancestry worked with liberal organizations like the American Artists Congress, perhaps because the left claimed to be color-blind. The Communist Party was trying to woo African Americans, and some conservatives feared an alliance between blacks and Asians.[31] Kuniyoshi played a leading role, as an officer in the American Artists Congress before World War II, the president of An American Group, and one of the founders of the socially concerned ACA Gallery. After the war he was the founding president of Artists Equity, which is still active today supporting artists' rights. When curator Lloyd Goodrich questioned Kuniyoshi about his political involvement, the artist's response had less to do with specific issues than with the role of political engagement in his life. According to Goodrich, Kuniyoshi expressed an attitude that probably applied to his Japanese immigrant artist friends as well:

he spoke at some length and emphatically about how strongly he believes in such activity, and how much he feels it has done for him. He said that he has always given some time to such work, and that he feels that it has helped him develop. I got quite clearly the feeling that this has been very important to him in overcoming his feeling of being an alien; that it has helped a great deal to make him feel at home in America and to give him a sense of security and belonging.[32]

In response to the WPA policy of firing non-citizens, the ACA Gallery held a series of three "pink-slip" exhibitions protesting the exclusion of Asian-born artists from the program. Here for the first time we find Chinese American artists emerging to join forces with the better-known Japanese Americans. The first exhibition opened just two weeks after the ban went into effect and featured more than seventy artists, almost twenty of whom were of Asian ancestry. The last, in September 1937, was sponsored by the Artists Union of the American Artists Congress; it included only artists of Asian descent and served as a survey of Asian Americans in the New York art world at the time.[33] They were united in their opposition to the WPA cuts, but they also had another bond: their antagonism toward Japanese military aggression in China.

In reviews of the show, several critics praised the collaboration of artists from two nations that were at war with each other. Most of the Japanese artists in New York were liberal in their politics and opposed Japan's military ambitions, giving them common ground with the Chinese artists. Still, tensions did exist, as Emily Genauer mentioned in a series of insightful remarks about the ACA show. She indicated Kuniyoshi's influential status as well as the relative scarcity of Chinese artists working in New York's art world:

Outside of the pictures themselves there are several aspects of the show that are interesting. One is the fact that some of the Japanese were loath to submerge their intense nationalism and exhibit in the same show with Chinese artists. Another is that there are so few Chinese painters, comparatively, in New York, and that their work is so much more academic than that of the Japanese. Still a third angle is the homogeneity of the Japanese artists' work as contrasted with that of the Chinese. It is difficult to say whether they all paint with something approaching the unique brushwork and coloring of Kuniyoshi because that approach is singularly Japanese, or because Kuniyoshi, today considered one of America's most important painters, is their model.[34]

The names of a few Chinese artists working in New York have come down to us, thanks to reviews of these shows, but so far their works are not known. Chu H. Jor, C. W. Young, and Don Gook Wu were cited by Melville Upton in the *New York Sun*, who felt they were "under Western influence."[35] Wu seems to have made the greatest impression on the critics in the three "pink-slip" shows, as he is mentioned most frequently; Jacob Kainen described his *Unlovely Sunset* as "wild Expressionism a la Orient."[36]

Chu H. Jor was active in Chinatown and founded the Chinese Art Club, which began in 1935 on Pell Street and then moved for several years to 175 Canal Street. The purpose of the club was to encourage young artists and art appreciation, and "to introduce Chinese arts to the American public and Occidental arts to the Chinese public."[37] The club held a series of exhibitions in the late 1930s, featuring works by Chinese artists plus some by non-Chinese. There were several shows of children's art as well as of photography, and the art shows featured examples of Chinese-style painting, including those by Yee Ching-chih, who offered classes in Chinese painting at the club. But most of the works were Western in style, probably including those of Jor, whose paintings are unknown today but who

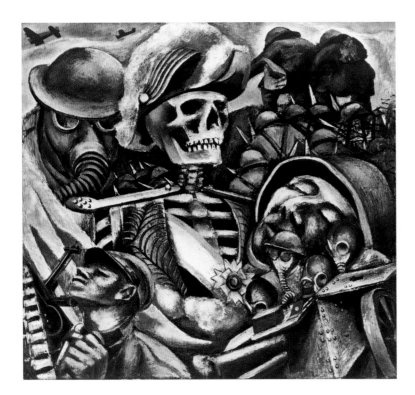

FIG. 83 Sakari Suzuki, *War*, ca. 1937. Oil on canvas, dimensions unknown.

studied with American art teachers such as George Bridgman and Dimitri Romanovsky from the Art Students League.[38]

THE JAPANESE ARTISTS most frequently singled out in reviews of the "pink-slip" shows, other than Kuniyoshi, were Chuzo Tamotsu, Eitaro Ishigaki, and **Sakari Suzuki**. Suzuki, like several of his peers, was born in Japan and studied art in San Francisco before moving to New York. In 1936 at the Willard Parker Hospital in New York City he painted a mural illustrating medical achievements, with monumental figures reminiscent of Diego Rivera's; the building was subsequently torn down. He also showed in group exhibitions, where his work was frequently described as "Surrealist." His *War*, reproduced in a 1937 newspaper, is a monumental composition, again recalling Rivera's influential style. Densely packed soldiers surround a triumphant, leering skeleton in extravagant military garb (fig. 83). The painting was shown at an ambitious exhibition organized by the American Artists Congress titled *In Defense of Democracy: Dedicated to the Peoples of Spain and China*. Held at a rented loft space on Fifth Avenue in December 1937, the show featured two hundred artists. Several critics emphasized the conflict between propaganda and

artistic quality, while singling out a few artists as succeeding with both, like Ishigaki with his *Flight* painting about victimized Chinese and Philip Guston with his powerful *Bombardment* tondo. The exhibition was supplemented by a meeting of the artists' congress, which included the reading of anti-fascist statements by Thomas Mann and Picasso, whose etching *Dream and Lie of Franco* was included in the show. Kuniyoshi was one of the artists who made a speech before the congress; he spoke about the rights of Asian American artists in the United States.[39]

During this period of activism, Herman Baron, the director of the ACA Gallery, continued his gallery's commitment to political art by hosting an international traveling exhibition of graphic art by contemporary Chinese artists in January 1938. Jack Chen (Chen I-wan), the artist who organized the show, contributed black-and-white works, one depicting a proud Communist soldier and another of a Chinese peasant grimly squatting beside a dead child, a rifle at his side for his future combat with the Japanese.[40] Works with similar themes were again exhibited in March at the Chinese Art Club in a show dedicated to "the Chinese struggle against Japanese aggression," which included a drawing of a woman volunteer by Jack Chen and a watercolor of a refugee by Moo-Wee

Tiam, who was then president of the club. However, a reviewer pointed out that the show was composed mostly of conventional still lifes, landscapes, and figure paintings, with only five pieces having a direct political thrust.[41]

When Japanese artists living in New York put together an exhibition at the Municipal Art Gallery in June 1938, pro-Chinese subjects were again visible, particularly in the works of the militant Ishigaki.[42] But the paintings of many of these artists were not overtly political, as exemplified by the work of Kuniyoshi; he, however, took a firm stance against Japanese militarism in his public statements, and in his willingness to loan works to leftist exhibitions. As the international situation worsened, rifts developed in the American Artists Congress, between those who advocated total adherence to the Soviet party line and those who insisted on independence from it. With the signing of the Hitler-Stalin Nonaggression Pact in August 1939, the split intensified until the congress became ineffectual as a voice for liberal artists.

AFTER THE JAPANESE bombing of Pearl Harbor on December 7, 1941, the situation for Japanese-ancestry artists transformed terribly. Kuniyoshi wrote, "A few short days have changed my status in this country although I myself have not changed at all."[43] The government confiscated his telescope and camera. His bank account was impounded, and he had to fill out papers to travel from his studio on Fourteenth Street to his summer home in Woodstock, New York. Since he was on the East Coast, not in one of the areas designated to send Japanese to internment camps, he was spared imprisonment.

Kuniyoshi believed strongly in the democratic system, which had allowed him to rise to success, and he firmly opposed Japanese military aggression. He organized a retrospective exhibition surveying his career; proceeds from the admission charge and the raffle of one of his paintings went to China relief.

Although he could not be included in the huge *Artists for Victory* exhibition at the Metropolitan Museum because he was not a citizen, he worked for the Office of War Information, making two pro-democracy radio speeches that were broadcast to Japan and a series of propaganda drawings. In a speech on the second anniversary of Pearl Harbor, Kuniyoshi said,

> I know the sting of segregation and the look that condemns one as an enemy. But after the initial confusion and excitement had subsided a more lenient attitude evolved. Democracy has prevailed in this country despite global chaos.[44]

In 1944 he won the first prize in the annual Carnegie survey of contemporary art, despite being a Japanese citizen, and he felt "to have received the prize at this crucial stage of the war seemed almost beyond belief."[45]

Only one poster was made from Kuniyoshi's sketches for the war effort, but his propaganda drawings contain a level of violence foreign to his earlier work and reflect the crisis he was facing. They include images of Japanese soldiers brutalizing nuns and babies, and of a huge hand holding a bag full of symbols of Japan, such as a samurai sword and the national flag, about to dump it. Following the bombings of Hiroshima and Nagasaki at the end of the war, he immediately went to work to help people in Japan and Japanese Americans who were being resettled following internment.

Other Japanese artists of the time, like Tamotsu, included similar symbols in their art—as did Yun Gee, who was of Chinese descent. Gee came to New York in 1930 and started participating in pro-China efforts soon after Japan's invasion of Manchuria in 1931. Today Gee is the best-known Chinese American artist active in the first half of the twentieth century, appreciated especially for the strikingly modernist paintings he made in San Francisco in the 1920s (see introduction illustration and Mayching Kao's essay, fig. 167).[46] He immigrated to California in 1921 at age

FIG. 84 Yun Gee, Mural, 16 Mott Street, 1931.
Medium and dimensions unknown.

Chinese Here Paints Mural to Aid Flood Victims

Flood scene in homeland painted by Yum Gee, artist, living in New York. The mural, seventeen feet long, is
shown at the Chinese Public School, 16 Mott Street

fifteen, summoned by his father, who was able to get him American citizenship. There he studied painting and developed his synchromist-related style, building up images from geometrical planes of vivid color. After he achieved some success in San Francisco, and organized the Chinese Revolutionary Artists Club, patrons invited him to Paris, where he soon found venues to exhibit his art.[47] In Paris he added expressionist distortions to his cubist-derived modernism and drew on Chinese cultural history to represent figures such as Confucius and Lao-Tse. After three years he moved to New York in an attempt to make money to support his new French wife. There he immediately started showing his work in galleries and at the Museum of Modern Art, and was also active in pro-Chinese demonstrations.[48] He lived in bohemian Greenwich Village and had contact with nearby Chinatown, painting actors from the Chinese theater and performing Chinese music at such places as the University Settlement House. When parts of China were menaced by massive floods in 1931, Gee painted a seventeen-foot-long mural as a benefit for flood victims (fig. 84). The mural, now lost, was installed on the façade of a public school on Mott Street, the central artery of Chinatown. Gee painted a long, scroll-like scene of floodwaters with figures in Chinese dress floating in front of the shallow space.

As Japanese aggression against China intensified in the 1930s, Gee made political cartoons for Chinese newspapers. In one, a Japanese soldier stands over a field of dead bodies, the same imagery that Kuniyoshi used in some of his World War II drawings. The conflict also inspired several of Gee's paintings, including one shown at the leftist John Reed Club, which had been founded in part by Ishigaki. In his *Tanaka Memorial, Japanese Imperial Dream* (1932), Gee created a bizarre scene of swirling, nightmarish space and figures that combine elements of cubist geometry with expressionist distortion (fig. 85). The subject is somewhat obscure today—it refers

to a notorious letter from Prime Minister Tanaka to Emperor Hirohito outlining a plan for Japanese military conquest of the world. In the painting, Tanaka kneels before three figures: the emperor, the empress (who is brazenly naked except for her crown), and a Buddhist monk. Tanaka gestures up toward his vision: three figures representing China, Russia, and the United States who are surrounded by Japanese warriors wielding samurai swords.[49] A decade later the Japanese soldier at the upper right, swinging his sword behind the back of the United States, could have been seen as a prophecy of the surprise bombing of Pearl Harbor.

While Gee's political imagery paralleled that of contemporary Japanese immigrant artists, signs of competitiveness were evident, as Gee indicated in 1931: "My attitude towards the Japanese artists as Kuniyoshi, Foujita and others is that of most Chinese towards the Japanese: that of a grandfather to a grandson."[50] Gee returned to Paris in 1936 and stayed for three years and then came back to New York, where he spent the rest of his life. In those late years he showed his work infrequently, and his production from that period has received little attention.

AFTER GEE, THE MOST celebrated Chinese American artist working in New York before the 1960s was Dong Kingman, who was born in Oakland in 1911 but

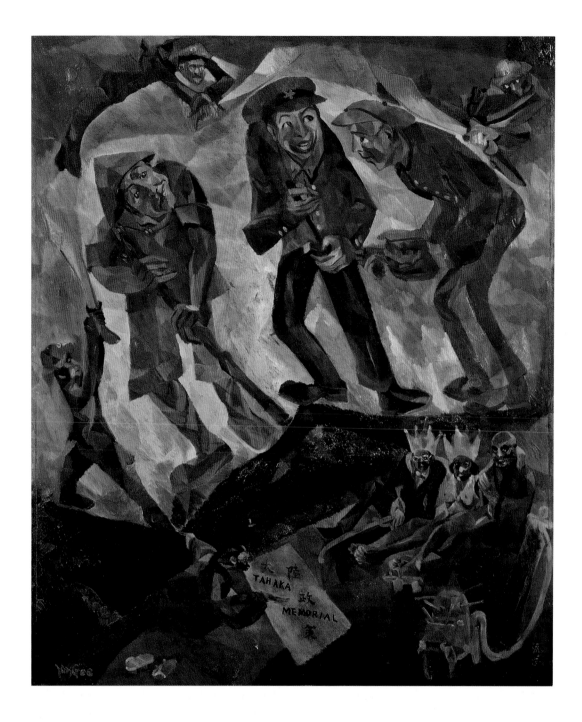

FIG. 85 Yun Gee, *The Tanaka Memorial,*
Japanese Imperialist Dream, 1932.
Oil on wood, 47¾ × 40⅛ in.

spent his youth in Hong Kong. There he studied tra-
ditional Chinese painting and then returned to Cali-
fornia. Like Gee, he made his reputation on the West
Coast before moving to New York. As an American
citizen, he benefited from having the WPA pay him
to work on his painting during the Depression. King-

man's art was devoted to views of the modern urban
landscape, and after he moved east in 1946 his main
subject became New York. He almost never used oils,
preferring watercolor, and his works are comparable
to watercolors of New York scenes by John Marin
and Edward Hopper. They also relate to the bustling
city scenes painted by Mark Tobey, the Washington-
based American artist who preferred water-soluble
pigments on paper to oil on canvas, and who had an
intense interest in Asian art (see Kazuko Nakane's

essay for more information). Kingman's lively watercolors were widely published in books and magazines. His largest commission was for a mural on a wall of the Lingnan Restaurant on Broadway and Ninety-fourth Street, for which he chose a scene of the New York harbor with a Chinese junk sailing through, in a tribute to his Asian heritage.

KUNIYOSHI'S STATUS WAS underlined in 1948 when he was given the first-ever solo retrospective of a living artist at the Whitney Museum of American Art. Twenty years later the Whitney again honored a New York–based Asian American artist with a retrospective exhibition: the sculptor Isamu Noguchi.[51] Noguchi's dual identity is the subject of much of his writing, and of the writing about him. He was a legal citizen of both the United States and Japan, as he was born in the United States of an American mother and a Japanese father, a famous poet who rejected his firstborn son to return to Japan and have a Japanese family. While Noguchi's career flourished in the 1950s and after, the period dominated by the abstract expressionist movement, his artistic beginnings were rooted in the milieu of the socially concerned artists working in New York in the 1930s.

When Noguchi was two, his mother moved with him to Japan to be near his father; when he was fourteen, she sent him back to Indiana for school. In 1922, he moved to New York, where he studied art and began to exhibit his works. He then moved to Paris in 1927 and worked for an influential period as assistant to the sculptor Constantin Brancusi. In the 1930s, Noguchi was based in New York, establishing himself as a sculptor. In 1936, he spent eight months in Mexico with the leftist muralists and executed in relief a large mural about Mexican history. Back in New York he supported himself making skillful portraits, while his sculpture became increasingly abstract. A few of his works were pointedly political in intent, while others were not. His *Death (Lynched Figure)* stands out because it is a major early piece,

an image of suffering unusual for Noguchi (fig. 86). It appeared in both 1935 anti-lynching exhibitions mentioned earlier, and it paralleled Ishigaki's painting *Lynching* (1931) in its opposition to racial persecution.[52] To execute this piece, Noguchi moved to the Woodstock art colony, where Kuniyoshi had bought a house in 1932 and where **Hideo Benjamin Noda**, Sakari Suzuki, and **Jack Chikamichi Yamasaki** had shared a house in 1931.

Death (Lynched Figure) presents the contorted figure of a man hanging from a rope supported by a rectangular armature. Its brutality shocked critics, particularly Henry McBride, who called it "a little Japanese mistake."[53] The figure was based on a photograph, published in the communist magazine *Labor Defender*,[54] of African American George Hughes being lynched above a bonfire. Unlike most photographs of hangings, which showed the victims hanging limp in death, this one documented Hughes's agony as he writhed to get away from the fire. The Mexican muralist José Clemente Orozco used the same photograph as the basis for a lithograph that was also shown in the New York anti-lynching shows, as both he and Noguchi selected an image that emphasized the sadistic cruelty of the act. By suspending the sculpture instead of having it stand on a base, Noguchi confronted spectators directly with the horrific figure. Although it is quite common now to hang sculptures, in the 1930s the practice was highly unusual. Perhaps only Giacometti, in works like *Suspended Ball* (1930–1931), had utilized such an approach, and the examples from his work are much smaller in size than Noguchi's shocking vision.

In the later 1930s, the political concerns of New York's artists turned from lynching to the world situation, but the liberal views of progressive Asian American artists were not shared by all in Asian American communities. Ayako Ishigaki, the journalist wife of the artist Eitaro Ishigaki, wrote a distressed report before Pearl Harbor about Little Tokyo in Los Angeles, where Japanese newspapers defended Japan's

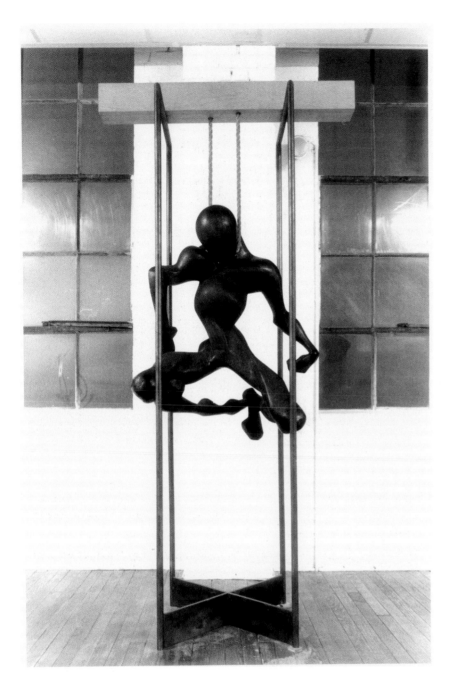

FIG. 86 Isamu Noguchi, *Death
(Lynched Figure)*, 1934.
Monel metal, wood, metal,
and rope, ht. 89¼ in.

invasion of Manchuria. She attended a lecture by a visiting Japanese military officer that was greeted with such enthusiasm by the working-class crowd that they decided "to present an airplane to the Japanese Army, as a patriotic contribution from the Los Angeles Japanese."[55] The rapprochement between Chinese and Japanese artists in New York inspired by the WPA cuts seems to have shattered due to the outbreak of war in Asia, which created tensions and challenges among Asian Americans. This trouble is suggested in a cartoon by Yun Gee, who previously

had protested anti-Chinese bigotry in his writings. Titled *Jap Spy*, it depicts the proprietor of a flower shop who stands in front a map of the United States dotted with Japanese flags as he whips off a demure-looking mask to reveal a grimacing, pig-snouted face. Soon after the bombing of Pearl Harbor, internment camps were established for Japanese residing on the West Coast. Noguchi reacted quickly by volunteering to be interned at the Relocation Center in Poston, Arizona, hoping to help improve the conditions of those imprisoned there. After seven months,

FIG. 87 Isamu Noguchi, *Sunken Garden for Chase Manhattan Plaza*, 1961–1964. Diam. 60 ft.

disappointed with his lack of progress, he managed to leave.[56]

Following the war, Noguchi embarked on a life as a world traveler. His art was extraordinarily diverse, although consistently based on biomorphic forms, often in contrast with angular ones. He made freestanding sculptures in a wide range of materials and also extremely innovative garden environments. The latter were inspired in part by Japanese Zen gardens but commissioned by capitalist corporations; an example is his *Sunken Garden for Chase Manhattan Plaza* (1961–1964) in the financial district of New York City (fig. 87). In addition, he had a profitable career as a designer of lamps and furniture. By 1950 he had studios in both New York and Japan, and after his death in 1988 his home and studio in each country were turned into museums in his honor, continuing his dual legacy to the present.

NOGUCHI IS GENERALLY CONSIDERED part of the abstract expressionist generation of the 1950s that abandoned the social concerns and the representa-

tional imagery of the 1930s and 1940s in an attempt for a mythic, universal art. Young artists of Asian ancestry participated in this impulse. Typically they worked through various realist and modernist styles and then achieved a personal synthesis in an abstract mode that had a complicated relationship to the flat spaces of much traditional Asian art and to Asian calligraphy. Several of the major abstract expressionists in New York, such as Willem de Kooning, Jackson Pollock, and Franz Kline, painted in a spontaneous, gestural mode and made many paintings using only black and white. Consequently, the issue of their relationship to Asian calligraphy is a debated one, while evocations of calligraphy take on an added resonance in the art of painters who have Asian ancestry.[57]

In the later years of World War II, immigration restrictions affecting Asians were relaxed in the United States, and Asians entered the country in greater numbers. Thomas Messer and Anne Jenk's

1958 exhibition, *Contemporary Painters of Japanese Origin in America* at the Boston Institute of Contemporary Art, showed eight painters working in a painterly, abstract mode that reflected the style developed by New York's pioneering abstract expressionists a decade before. They included Kenzo Okada, whose softly contoured, delicately hued forms personified Asian "refinement" in the eyes of many critics, who also saw suggestions of aerial views of Zen gardens in his paintings (see Gordon Chang's essay, fig. 110).

Also in the show was Genichiro Inokuma, a respected artist and teacher in Japan, who lived in New York from 1955 to 1975 making intricate abstract paintings.

Notable artists of Asian ancestry came to New York from Hawaii in the postwar years. Isami Doi spent important phases of his career in the metropolis in the 1920s and again in the 1950s. In the first instance he was a student, making delicate black-and-white prints and surrealist-influenced figural paintings. When he returned to New York, he painted broad, brightly colored, nature-based abstractions. **Reuben Tam** went from Hawaii to California in

FIG. 88 Reuben Tam, *Edge of Place*, 1948.
 Oil on canvas, 26 × 40 in.

1940 and then to New York. He exhibited his color-saturated paintings widely, being represented by Edith Halpert's Downtown Gallery, where Kuniyoshi also showed. While quite abstract, his paintings at the same time evoke misty seascapes, which in Tam's case were often inspired by the ocean at Maui or at Monhegan Island in Maine (fig. 88). They suggest impressionism, the foggy vistas seen in Chinese landscape paintings, and the color-field experiments of Tam's abstract expressionist contemporaries.

Alfonso Ossorio (fig. 89) was in the thick of the abstract expressionist milieu, as he lived in East Hampton and was a friend and early collector of

Jackson Pollock. Ossorio was born in the Philippines. Typical of that ethnically diverse country, his father was Spanish, while his mother was part Spanish, part Filipina, and part Chinese. Although he left the Philippines when he was eight, he returned in 1950 for a lengthy stay to paint a large mural on his family's sugar plantation. At the time he wrote a poem that expressed his anxieties about his mixed ethnic background and possibly also referred to his struggle with his sexual identity:

> The necessity of being
> an Eurasian, deracinated
> never at home in any
> conventional category...[58]

After its debut in 1954, the Mi Chou Gallery—created by people of Chinese ancestry and exhibiting mainly contemporary Chinese and Chinese American artists—was active for fifteen years in Manhattan; it has been called "the first Chinese American art gallery." Artists who exhibited there included Chen Chi-kwan, Seong Moy, C. C. Wang, Dale Joe, Gary Woo, Katherine Choy, Chang Shu-chi, and Walasse Ting.[59] Yayoi Kusama, an esteemed artist today, spent a crucial part of her early career (1958–1973) in New York, developing innovative performances and obsessively intricate abstract paintings before returning to her native Japan. Her career announces a new era in which more possibilities exist for Asian American women artists to achieve prominence than in former years. Nam June Paik was born in Korea and spent part of his youth in Tokyo, studied in Germany, and first visited New York in 1964. Paik, with his absurdist performances, was a central member of the international Fluxus movement, and he became a major pioneer of video art. In the 1970s he was increasingly drawn to New York, where he eventually made his home. The freedom of movement around the globe that he enjoyed has become normal for many recent artists. Similarly, On Kawara, who left

Japan in 1959 after starting his career as a painter there, settled in New York but constantly travels worldwide. He is best known for his modest-sized, conceptual paintings of dates—the image on each canvas is the date of the painting. Kawara renders the date in the conventional manner of the country he is in at the time of making the painting—May 21, 1970, in New York would be 21 May, 1970 if painted in Paris—as witness to his cosmopolitanism.

In recent years an art history of Asian American artists has begun to emerge. Jeffrey Wechsler's 1997 exhibition at Rutgers University, *Asian Traditions/Modern Expressions*, which traveled to Japan, presented fifty-eight painters and sculptors, from Korean and Hawaiian backgrounds as well as Chinese and Japanese, who worked in abstract styles in the United States in the 1950s and 1960s. The cata-

log of this exhibition is a pioneering investigation of the activities of Asian American artists in the United States in postwar years and opens up a new area for scholarly art historical research.

As international communications and transportation have become more rapid, Asian artists exhibit their work in New York with great frequency, and increasing numbers follow Noguchi's example of having studios in both New York and Asia. Additionally, opportunities for artists of Asian ancestry born in the United States continue to expand. The situation has greatly changed from the one that Asian American artists in New York faced in the first half of the twentieth century. This investigation is the tip of the iceberg, to use an American expression, or like a rock in a Zen garden that suggests it is the peak of an immense mountain that lies below.

Notes

My research for this essay was helped greatly by two trips to Japan made possible by grants from the Freeman Fund and the Bard College Research and Travel Fund. In Japan Yasuo Kuniyoshi scholars Ozawa Yoshio and Ozawa Ritsuko were extremely generous helping me with my research, as was Hoshino Mutsuko.

1 Quoted by Alan D. Gruskin, "The Story of the Artist," in *The Watercolors of Dong Kingman, and How the Artist Works*, by William Saroyan and Alan D. Gruskin (New York: Studio Publications, 1958), 40.

2 Yasuo Kuniyoshi, "East to West," *Magazine of Art*, February 1940, 72–83; republished as *Yasuo Kuniyoshi*, American Artists Group monograph no. 11 (New York: American Artists Group, 1945).

3 Yun Gee, "East and West Meet in Paris" (1944), in *Yun Gee: Poetry, Writings, Art, Memories*, ed. Anthony W. Lee (Seattle: Pasadena Museum of California Art in association with University of Washington Press, 2004), 181–182.

4 Isamu Noguchi, *A Sculptor's World* (New York: Harper and Row, 1968), 11.

5 Yun Gee, "East and West," 181. He voiced similar opin-

ions about using oil painting to revitalize Chinese artistic traditions in "The Chinese Artist and the World of Tomorrow" (ca. 1926), p. 142, of the same volume.

6 Dow's *Composition*, published in 1899 by Joseph Bowles in Boston, has been reprinted in more than twenty editions since.

7 The two art history books were first published by L. C. Page, Boston, *American Art* in 1902 and *Japanese Art* in 1903.

8 For the catalog, see the Archives of American Art microfilm, roll 4859, frames 1231–1238. The artists were K. Ashiwara, T. K. Gado, I. Kagawa, T. Ono, S. Shimotori, I. Takanosu, M. Tsuchiya, M. Uwagawa, T. Wake, and T. Kikuchi, who showed photographs.

9 My thanks to Sugimura Hiroya, curator of the Tochigi Prefectural Museum, who discovered Gado's works and has generously shared his information with me.

10 In 1926, an art critic remarked about the current Independents show, "As usual, there are many Japanese painters"; *The New York Times Magazine*, March 21, 1926, 17. The critic mentioned works by Norobu Foujioka, Eitaro Ishigaki, Kiyoshi Shimizu, Torajiro Wata-

nabe, and sculptor Masaji Hiramoto. Several contemporary accounts in other newspapers also discussed Japanese artists' contributions to this show. My information here, and for many other footnotes, comes from the Eitaro Ishigaki Papers in the Wakayama Prefectural Museum in Japan, where I was given invaluable assistance by Yasugi Masahiro and Hamada Takushi.

11 The artists exhibiting at MacDowell were K. Ashiwara, T. K. Gado, S. Hamachi, I. E. Hori, K. Inukai, K. Kimoto, Y. Kuniyoshi, G. Sakaguchi, G. Shimotori, George Tera, M. T. Tsuchiya, and M. Uwagawa. The catalog of the show is in the MacDowell Club Papers in the Library of the New York Historical Society.

12 The exhibition, sponsored by *The Japanese Times*, was held at the Civic Club. The group was sometimes known as the Japanese Artists Association. The artists so far identified in this photograph are Eitaro Ishigaki, far left in the second row; Kyohei Inukai (who, although appearing in the photograph, is not listed as participating in the exhibition), next to him; Toshi Shimizu, fourth from left in the second row; T. K. Gado in the light suit in the front center; and Yasuo Kuniyoshi, far right in the first row. The other artists in the show were Kunie Ando, Makoto S. Hara, Shotaro Inaba, Ryokichi Miki, Michio Misaki, Tetsuen Tera, Bumpei Usui, Torajiro Watanabe, and sculptors Masaji Hiramoto and Gozo Kawamura; *Japan in America: Eitaro Ishigaki and Other Japanese Artists in the Pre–World War II United States* (Wakayama, Japan: Museum of Modern Art, Wakayama, 1997).

13 The exhibition was again sponsored by *The Japanese Times*. It included Noboru Foujioka, Kikuye Fujii, Seimatsu Hamachi, Masaji Hiramoto, Kyohei Inukai, Eitaro Ishigaki, Kentaro Kato, Gozo Kawamura, Seioh Kitamori, Yasuo Kuniyoshi, Ryokichi Miki, Michio Misaki, Mrs. Yukio Murata, Ryuko Saito, Kiyoshi Shimizu, Toshi Shimizu, Soichi Sunami, Chuzo Tamotsu, Tetsuen Tera, Takashi Tsuzuki, Bunpei [sic] Usui, Torajiro Watanabe, Sekido Yoshida, Kiyoharu Yokouchi, and Anonymous. My thanks to Michael Owen for bringing the catalog to my attention; it is in the Frick Art Library, gift of Dr. Clark Marlor.

14 For information about the Art Students League, see Marchal E. Landgren, *Years of Art: The Story of the Art Students League of New York* (New York: Robert M. Mc-

Bride & Co., 1940); and Raymond J. Steiner, *The Art Students League of New York: A History* (Saugerties, NY: CCS Publications, 1999). Many other Japanese artists also studied at the league.

15 I have discussed this issue more thoroughly in "Kuniyoshi in the Early 1920s," in *The Shores of a Dream: Yasuo Kuniyoshi's Early Work in America*, by Jane Myers and Tom Wolf (Fort Worth, TX: Amon Carter Museum, 1996), 21–42.

16 Lloyd Goodrich, "Notes on a Conversation with YK," January 13, 1948. Kuniyoshi said, "My inheritance was Japanese painting. Like kakemonos." Archives of American Art, roll M670.

17 David Teh-yu Wang has written that Kuniyoshi discarded his ethnic and cultural heritage totally and "is determinedly Americanized in every respect"; "The Art of Yun Gee Before 1936," in *The Art of Yun Gee* (Taipei, Taiwan: Taipei Fine Arts Museum, 1992), 23. Bert Winther-Tamaki has written about Kuniyoshi, "But neither the imagery he depicted nor the style in which he painted bear conspicuous traces of Japanese cultural identity"; "Japanese Thematics in Postwar American Art: From *Soi-Disant* Zen to the Assertion of Asian-American Identity," in *Japanese Art After 1945: Scream Against the Sky*, ed. Alexandra Munroe (New York: Harry N. Abrams, 1994), 55.

18 Kuniyoshi, "East to West," 73.

19 Lloyd Goodrich, "Notes on a Conversation with YK," January 6, 1948, Archives of American Art, roll M670.

20 The pioneering text that covers this material is the catalog for the exhibition *Japanese Artists Who Studied in U.S.A. and the American Scene*, organized by the National Museum of Modern Art in Tokyo and Kyoto in 1982. The exhibition focused on four Japanese artists—Kuniyoshi, Ishigaki, Hideo Noda, and Toshi Shimizu—and put their works in the context of works by contemporary American artists. The catalog is mostly in Japanese, with the essays about the four translated into English. In 1995, Okabe Masayuki organized *Japanese and Japanese American Painters in the United States*, which traveled to three museums in Japan; its catalog has short summaries of the essays in English. In 1997, the Museum of Modern Art, Wakayama held the exhibition *Japan in America: Eitaro Ishigaki and Other Japanese Artists in the Pre–World War II United States*, organized

by Yasugi Masahiro; the catalog text is in Japanese, with picture captions in English.

21 In 1996, the Tochigi Prefectural Museum held the *Shimizu Toshi Retrospective Exhibition*, with a catalog in Japanese by Sugimura Hiroya.

22 *American Art News*, November 12, 1921. Thank you to Mr. Sugimura from the Tochigi Prefectural Art Museum for this reference.

23 For an illuminating study of this development—which does not, however, include Shimizu—see Bert Winther-Tamaki's "Embodiment/Disembodiment: Japanese Painting during the Fifteen-Year War," *Monumenta Nipponica* (Tokyo) 52, no. 2 (Summer 1997): 145–180.

24 Ishigaki's portrait of Washington criticized as looking "cruel" was reported in *The New York Post* and *The Daily News*, both on April 1, 1938. The Ishigaki Papers at the Wakayama Prefectural Museum (see n. 10) are the source for most of my Ishigaki discussion.

25 Ishigaki showed *Lynching* at the 1931 exhibition of the Society of Independent Artists and again at his 1936 ACA show, where he showed a related painting, *Ku Klux Klan* (1936), of a muscular white man fighting three hooded figures while defending a black man with his hands bound behind his back. The two anti-lynching exhibitions of 1935 have received considerable art historical attention in recent years, beginning with a seminal study by Marlene Park, "Lynching and Antilynching: Art and Politics in the 1930s," *Prospects: An Annual of American Cultural Studies* 18 (1993): 311–365. Subsequent studies include Margaret Rose Vendryes, "Hanging on Their Walls: *An Art Commentary on Lynching*, The Forgotten 1935 Art Exhibition," in *Race Consciousness: African American Studies for the New Century*, ed. Judith Jackson Fossett and Jeffrey A. Tucker (New York: NYU Press, 1997), 153–176; and Helen Langa, "Two Antilynching Art Exhibitions: Politicized Viewpoints, Racial Perspectives, Gendered Constraints," *American Art* 13, no. 1 (Spring 1999): 10–39.

26 In painting an African American man tortured by sadistic whites in a nighttime scene, Ishigaki was following the lead of George Bellows in his 1923 lithograph, *The Law Is Too Slow*.

27 Haru Matsui, *Restless Wave: An Autobiography* (New York: Modern Age Books, 1940). It has been republished as Ayako Ishigaki, *Restless Wave: My Life in Two Worlds*, with an afterword by Yi-Chun Tricia Lin and Greg Robinson (New York: The Feminist Press, The City University of New York, 2004).

28 Jacob Kainen wrote, "Ishigaki's work possesses few of the attributes we have come to associate with Japanese art. Rather, his work is in the tradition of Occidental painting"; *Daily Worker*, March 18, 1936. Charmion von Wiegand wrote, "Eitaro Ishigaki, born in Japan, has spent the major part of his life in the United States and has become an American painter working in the tradition of the West"; *New Masses*, April 28, 1936.

29 *New Masses*, July 27, 1937.

30 For a good discussion of artists' involvement with leftist organizations, see Andrew Birmingham's *Artists on the Left: American Artists and the Communist Movement, 1926–1956* (New Haven, CT: Yale University Press, 2002).

31 Amy Lyford, "Noguchi, Sculptural Abstraction and the Politics of Japanese American Internment," *The Art Bulletin* 85, no. 1 (March 2003): 150, n. 14.

32 Lloyd Goodrich, "Notes on Interview with Yasuo Kuniyoshi," January 6, 1948, Archives of American Art, roll M670.

33 The catalog of the exhibition included an introduction by Harry Gottlieb, president of the Artists Union. The artists in the exhibition were Yosei Amemiya, Eitaro Ishigaki, Chu H. Jor, Roy Kadowaki, Yasuo Kuniyoshi, Kaname Miyamoto, Thomas Nagai, Fuji Nakamizo, Kiyoshi Shimizu, Sakari Suzuki, Bunji Tagawa, Chuzo Tamotsu, George Tera, Moo-Wee Tiam, Bunpei [*sic*] Usui, Don Gook Wu, Chikamichi Yamasaki, and C. W. Young.

34 Emily Genauer, "Oriental Artists: Exhibit," *New York World Telegram*, September 18, 1937.

35 Melville Upton, *New York Sun*, September 18, 1937; he wrote about the entire exhibition, "A rather ironic feature of it all is that there is nothing noticeably Oriental about the display."

36 Jacob Kainen, "The Art World," *New Masses*, September 18, 1937. Upton, ibid., felt that Wu was the most striking of the Chinese artists, although "obviously under the influence of Renoir," while the critic in October's *Art Front* mentioned Wu's "colorful impressionism"; "Chinese and Japanese Artists," *Art Front* 3, no. 7 (October 1937).

37 The Chinese Art Club, *First Chinese Children's Exhibition of Paintings, Drawings and Calligraphy, Sculpture* (New York, 1937); a copy of this rare catalog is in the Thomas J. Watson Library of the Metropolitan Museum of Art.

38 The entry for Jor in *Who's Who in American Art*, vol. 2 (New Providence, NJ: Marquis Who's Who, 1938–1939), 281, says he was born in Canton, China, on October 2, 1907, and lists his teachers as George Bridgman, Michel Jacobs, and Dimitri Romanovsky.

39 The conference was discussed by Jerome Klein, "Art Comment, Democracy Aided by World Figures at Art Congress," *New York Post*, December 18, 1937.

40 The exhibition was shown in Moscow, London, Oxford, and Edinburgh. Jack Chen's drawing of the Communist soldier was reproduced with seven other works from the show in Lin Yutang's article "A Chinese Views the Future," *New York Times Magazine*, January 30, 1938, 6, 7, and 27. The image with the dead child, along with four others from the exhibition, were reproduced in *Life* magazine, January 17, 1938. For related black-and-white woodcut prints produced by Chinese artists on political themes, see *China in Black and White*, with commentary by Pearl S. Buck (New York: An Asia Press Book, The John Day Company, 1944).

41 "Chinese Art Club Displays Paintings," *New York Times*, March 3, 1938, 19.

42 The ten artists in the show were Ishigaki, Roy Kadowaki, Kuniyoshi, Kaname Miyamoto, Thomas Nagai, Fuji Nakamizo, Suzuki, Tamotsu, Takeo Watari, and Chikamichi Yamasaki. The exhibition was reviewed in the *New York World Telegram*, June 25, 1938, and in both the *New York Times* and the *New York Herald Tribune*, June 26, 1938.

43 This quote appears in my essay "The War Years," in *Yasuo Kuniyoshi* (New York: Whitney Museum of American Art at Philip Morris, 1986), from papers then in the possession of Sara Kuniyoshi, which now are in the Archives of American Art.

44 Ibid.

45 Ibid.

46 Considerable literature exists about Yun Gee, including Joyce Brodsky, *The Paintings of Yun Gee* (Storrs, CT: William Benton Museum of Art, University of Connecticut, 1979); *The Art of Yun Gee* (Taipei, Taiwan: Taipei Fine Arts Museum, 1992); and *Yun Gee*, ed. Lee.

47 For the Chinese Revolutionary Artists Club, see Anthony W. Lee's *Picturing Chinatown: Art and Orientalism in San Francisco* (Berkeley: University of California Press, 2001).

48 Gee showed New York scenes in the Museum of Modern Art's important *Murals by American Painters and Photographers* exhibition in 1932.

49 The contemporary press identified the figures in this fashion. In Gee's drawing for the painting, the United States appears in the center of the trio, as Uncle Sam. In the painting, China is to the left, with a coolie hat and slippers, Russia is in the center, wearing a hat with a red star, and the United States is at the right, holding an automobile.

50 Arthur A. Young, "Yun Gee: Chinese Interpreter of East to West," in *Yun Gee*, ed. Lee, 158.

51 The next artist of Asian descent to have a retrospective at the Whitney was the Korean Nam June Paik in 1982. In a poll of art critics and curators about the best painters in the United States published in *Look* magazine, February 3, 1948, 44, Kuniyoshi was rated third, after John Marin and Max Weber, and before Stuart Davis and Edward Hopper. The literature about Noguchi is extensive; key texts include Noguchi, *A Sculptor's World* (New York: Harper and Row, 1968); Dore Ashton, *Noguchi East and West* (New York: Knopf, 1992); Bruce Altshuler, *Isamu Noguchi* (New York: Abbeville Press, 1994); various writings of Bert Winther-Tamaki, especially in *Art in the Encounter of Nations* (Honolulu: University of Hawai'i Press, 2001); and Masayo Duus, *The Life of Isamu Noguchi: Journey Without Borders*, trans. Peter Duus (Princeton: Princeton University Press, 2004).

52 Other young artists of Japanese extraction who made works protesting the plight of African Americans include Hideo Noda, with his *Scottsboro Boys* (1933), and sculptor Leo Amino, with his *Lynching*, where a stylized figure carved from black ebony hangs from an actual fork of a tree.

53 Henry McBride, "Attractions in the Galleries," *New York Sun*, February 2, 1935, 33.

54 To view the photograph, see A. Jakira, "As If to Slaughter," *Labor Defender* 5 (June 1930): 126. *Labor Defender* was published by the International Labor Defense, the legal defense arm of the Communist Party of the United States. As a bound volume, it is under the title *Equal Jus-*

tice. My thanks to Betsy Cawley, librarian at Bard College, for helping me track down this elusive reference.

55 Ayako Ishigaki, *Restless Wave*, 237.

56 For information about Noguchi's incarceration, see Robert J. Maeda, "Isamu Noguchi: 5-7-A, Poston, Arizona," *Amerasia Journal* 20, no. 2 (1994): 61–76; and Amy Lyford, "Noguchi, Sculptural Abstraction, and the Politics of Japanese American Internment," *The Art Bulletin* 85, no. 1 (March 2003): 137–151.

57 The question of the relationship between Asian calligraphy and abstract expressionist painting has been discussed thoughtfully by Jeffrey Wechsler, "From Asian Traditions to Modern Expressions: Abstract Art by Asian Americans, 1945–1970," in *Asian Traditions/ Modern Expressions*, ed. Jeffrey Wechsler (New York: Abrams in association with the Jane Voorhees Zimmerli Art Museum, Rutgers, the State University of New Jersey, 1997); and Bert Winther-Tamaki (see n. 51).

58 Ossorio, quoted in Francis V. O'Connor, *Alfonso Ossorio: The Child Returns, 1950—Philippines, Expressionist Paintings on Paper* (New York: Michael Rosenfeld Gallery, 1998), 5.

59 Frank Fulai Cho, "Reminiscences of Mi Chou: The First Chinese Gallery in America," in *Asian Traditions*, ed. Wechsler. Also see Mayching Kao's essay in this volume for more information.

Deployments, Engagements, Obliterations

Asian American Artists and World War II

Gordon H. Chang

Just three days after the attack on Pearl Harbor, the federal government's Office of Emergency Management announced, of all things, a nationwide art contest. Some twelve hundred artists from across the country immediately rallied to the call and submitted their best efforts. "Most artists stated their patriotism," *Life* magazine praised, "in simple, natural terms, devoid of self-conscious regionalism."[1] The OEM selected 109 items for exhibition at the National Gallery in Washington and then sent them on tour around the country. Artists' lives and the artistic process and the disruption and destruction of war have always been closely intertwined. War has provoked much of the world's great art, but such was not the case this time. Little of the work, carrying titles such as *War Paint* (camouflaged airplanes and ships), *Air Raid Watchers* (vigilant spotters atop a Victorian country house), or *Albuquerque Bombing Range* (a desert landscape), was memorable. Most was heavy-handed, and many pieces resembled war mobilization poster efforts. The story, however, highlights the deep connection between war and art and the power

Henry Sugimoto, *Longing*, 1944 (detail, fig. 100).

and effect of art in influencing the public mood in America during World War II.

The stories of Asian American artists and the fate of their artwork during World War II offer especially poignant evidence of the inseparability of war and art. Their tales reveal some of the strange moments that war presents to artists and the terrible ways that war destroys art and the creative process. Emphasizing how Asian American art was used and received during the war years—years that are pivotal in the experiences of Chinese and Japanese Americans—this essay will examine its "deployment," the purposeful efforts to influence sentiment on the home front during the war: art was used as an ideological weapon. Another aspect of the wartime employment of art was "engagement," an interaction of aesthetics and politics, broadly construed. Artists and their promoters took advantage of the cultural spaces that the anti-fascist war opened to try to expand the artistic visions and social identities of Americans. The final aspect of wartime art was "obliteration," the utter destruction of art as the result of war's passions and the sudden social transformations that war provokes. These war metaphors, though, are only heuristic, to help us interpret the varied, complex, and multiple

FIG. 90 David P. Chun, *War Painting—A Prayer for Nanking*, ca. 1937. Oil on canvas, 24 × 22 in.

wartime experiences of Asian American artists, the significance of their work, and the reception their art received. The metaphors, though not attributive of the artists themselves or their work, can help us understand how the war years profoundly affected, even fundamentally transformed, the lives of Asian American artists and their art because of their racial identities, their ancestries, and their unique social position in America.

DEPLOYMENTS: THE USE
OF ASIAN AMERICAN ARTISTS

In the years before the American entry into World War II, many Chinese American artists, moved by the death and destruction caused by the Japanese invasion of China in the 1930s, depicted Japanese military atrocities in their artwork. **Yun Gee**, **Kem Lee**, **Nanying Stella Wong**, and **David P. Chun**, among others, created anguishing images of Chinese suffering and Japanese military brutality (fig. 90). These powerful images, though, had limited impact on the greater American public, whose attention was elsewhere. Japanese American artists such as **Hideo Date**, **Yasuo Kuniyoshi**, and **Isamu Noguchi** also used their talents to condemn European and Japanese fascism and encourage American support for the Chinese victims of Japanese aggression (fig. 91). But it was the Japanese attack on Pearl Harbor in

1941 that established an indelible connection between art, race, and war for these and other Asian American artists.

During the war years, many Chinese American artists found their work in public demand. Because of their particular work and social position—perceived as in some ways culturally representative, at least in part, of a valued wartime ally—these artists found new opportunities and receptive audiences for their work. **Dong Kingman**, the Chinese American artist often described as America's most popular watercolorist in the mid-twentieth century, first became nationally recognized during the 1940s. His work impressed powerful patrons and benefactors, and they in turn promoted his work, deploying it in ways they believed helpful to the national war effort. Even in the U.S. Army, in which he found himself for a short while, Kingman was given special opportunities to pursue his work and found eager audiences for his art.

Kingman, born in Oakland and educated in Hong Kong in a distinctive southern Chinese watercolor style and in Western-style oil painting, was an aspiring and regionally recognized artist before World War II. He participated in important shows in San Francisco in the 1930s and worked for the Works Projects Administration as an artist during the Depression. But he gained national prominence during the war years when, just six months after the outbreak of war, the Guggenheim Foundation awarded him an unusual two-year fellowship, which he used to travel extensively in the country to become acquainted with its physical appearance and social makeup. The fellowship was providential for his career. He developed an appealing style interpreting varied American city scenes. His work found immediate receptivity by audiences inspired by wartime Americanism. By the time he was drafted into the army in late 1944, he had come to the attention of important patrons, including Henry Luce, the publishing magnate and a leading supporter of Nationalist China in the United

States. Before war's end in 1945, the Luce empire energetically promoted Kingman, giving him commissions to complete illustrations for *Fortune* and a feature review of his artwork with reproduction in *Time*, the first Asian American artist the magazine so honored. Eleanor Roosevelt, the president's popular wife, even provided Kingman with an unofficial letter of introduction from her supporting his location-painting in militarily sensitive areas.[2]

Why were these national figures drawn to Kingman's art? His paintings certainly possessed great aesthetic appeal, with their bold colors and unusual use of line that integrated traditional Chinese and Western brush and color techniques, but his sub-

FIG. 91

Hideo Date, *Unholy Trinity*, 1940. Watercolor, gouache, and metallic paint on paper, 28 × 20 in.

FIG. 92 Dong Kingman, *The El and Snow*, 1949.
Watercolor on board, 21¾ ×29⅞ in.

ject matter and its presentation rose to the critical historical moment. Kingman's work contributed to the construction of a national self-consciousness stimulated by the war. In the 1940s, Kingman, in the words of one of his biographers, painted "the mining towns of Nevada and Colorado, the busy streets of Chicago, the cornfields of Illinois, the mountains of Arizona, the charm of New Orleans, and the still-careening 'elevateds' of New York"[3] (fig. 92). But what is more, this work came from one whom the sympathetic media described as an "Oriental," Chinese, or at least as someone clearly visually distinct from mainstream white America. These usually socially marginalized identities actually served Kingman well in the war years—his Chinese ancestry helped bring him to the attention of Luce and others who wanted to keep China prominent in America's vision; simultaneously, his interpretation of the American landscape was familiar, reassuring, optimistic, but fresh.[4]

In the fall of 1945, Kingman, even though a cor-

poral in the U.S. Army, continued to paint at a furious pace. In quick succession he held museum exhibitions and gallery shows in San Francisco, New York, and Washington, D.C. Those in attendance included Eleanor Roosevelt and Bess Truman. Public praise from them and rave critical reviews in national publications elevated his reputation. But even as Kingman was promoted as an especially talented visual interpreter of the American scene, he was at the same time presented as an interpreter of social life in China. Even though he had not been in China since the 1920s, *Fortune* commissioned him to illustrate a major feature article entitled "Industrializing the Good Earth," invoking Pearl Buck's emblematic description of the country. Kingman's evocative line drawings and paintings, many apparently developed from photographs of Chinese scenes that King-

man actually found in the New York area, provided charm and power to an otherwise turgid essay on the commercial potential of postwar China. Lending further authenticity to his work was his prominent and abundant use of Chinese characters for title illustrations and his signatures, something he rarely did for his American scenes. The magazine described Kingman's China work as capturing the "change and changelessness" of the country.[5]

Kingman's experience was clearly exceptional—the use of the talents of other Chinese American artists during the war were much more prosaic: Seattle artists Fay Chong and Andrew Chinn worked as illustrators in war industries or in the military[6] (see Kazuko Nakane's essay for more information on these artists), **Hon Chew Hee** worked in the Pearl Harbor sign shop; he was at work the day of the attack. Filipino American artist **Federico Dukoy Jayo** worked in Europe making propaganda posters and drawing maps. Their artistic careers would develop after the war. But another Chinese American's wartime career paralleled that of Kingman's celebrity.

James Wong Howe had already established himself as one of the world's leading cinematographers in the prewar period, but he found his abilities in special demand during the war. Howe was raised in eastern Washington State and came from modest beginnings. His father had been a railroad worker, and Howe himself had first distinguished himself as a prizefighter. Howe, however, had an early interest in the arts, including Chinese painting, and retained a strong sense of his ancestral cultural heritage throughout his life, even when he was helping create iconic American films. As a critic praised Howe in the late 1930s, "Howe as a person retains more of his Chinese feeling for things than the casual observer is likely to realize, but he is at the same time American in many ways." In the mid-1930s he was already the "best-known cameraman in the world," though he was also an accomplished still photographer. Before the war, he tried to produce films

in China, but with little success. After the outbreak of the war, he recalled that he wore an "I am Chinese" button to escape the anti-Japanese rage directed against Japanese Americans that erupted after Pearl Harbor; he himself found the internment of Japanese Americans shameful. Though he was a member of the U.S. Army for a short while, he spent most of the war years making dramatic films that supported the war effort in explicit ways. Known already for his photographic naturalism, his work during these years confirmed his reputation as one of the founders of "realism" in American cinema. His war films played an important part in the development of this particular approach to his art form.[7]

After Pearl Harbor, the War Department and Hollywood film director John Ford tried to enlist Howe to film documentaries for the navy, but because Howe was an alien made ineligible for citizenship by decades-old federal anti-Asian immigration laws, bureaucratic obstacles blocked his commission, and he did not join Ford's project. The Chinese Nationalist government also tried unsuccessfully to get Howe to document the exploits of General Claire Chennault's legendary Flying Tigers unit in China. Howe then spent the war years on the back lot of Warner Brothers making pseudo-documentary films, such as *Air Force* (1943) and *Objective Burma!* (1945). Both Pacific War films are characterized by his "realist" techniques; these were also evident in his other wartime films, *Passage to Marseilles* (1944), a Humphrey Bogart movie, and James Cagney's flag-waving *Yankee Doodle Dandy* (1942).[8]

Howe's work, like Kingman's, contributed to constructing and confirming a domestic wartime identity that embraced long-standing American nationalistic notions about the national self and the enemy other. His pseudo-documentary films encouraged hatred of the Japanese enemy and support for American fighters; as a reporter enthusiastically praised Howe's film efforts on the set of *Passage to Marseilles*, Howe encouraged the Chinese American

actors who were playing Japanese villains in the film to be "more vicious" in appearance.[9] "You look too sympathetic," Howe reportedly said. "Be more hateful." Reviews of Howe's wartime films highlighted their realistic presentation of the drama of war and gave special recognition to Howe for photography that lent a "documentary quality" to the films.[10]

At the same time, Howe's work helped build sympathy for his fellow Chinese Americans as links to the wartime ally of America. In a major pictorial feature entitled "Chinatown, San Francisco," *Look* magazine commissioned Howe to focus "his searching lens on his people in America." The photos and captions emphasized Chinese Americans' cultural difference from white-bread America but also their putative Americanness in that they were all "solidly united in the war effort." "The day of the queue and the tong war has passed," declared the magazine, "the day of the pin-up and ice-cream cone has come [fig. 93]. Chinatown still appears Chinese, but beneath its oriental façade it is as American as a piping plate of Boston baked beans."[11]

Howe's fellow Chinese American in Hollywood, actor **Keye Luke**, began his professional career as did Howe, in the Pacific Northwest. Although the movie-going public knew him best in the 1930s as one of Charlie Chan's sons in the detective movies, drawing, set design, and murals continued to hold a particular passion for him. Some of his best work was in an art-deco style. In 1936 in Los Angeles, Luke exhibited work that a reviewer described as including "remarkable Oriental fantasies in black-and-white, together with painting and portraits of motion picture celebrities."[12] (The curious mix of paintings must have made for an unusual gallery experience.) Using the interpretive trope of "East" and "West" that was almost universally employed in any discussion of Asian American artists, the review described Luke's work as bringing the "Orient and Occident" together, uniting "the serene mysticism of the Orient with the formal sculptured purity of a Grecian

frieze" (fig. 94). During the war years, Luke was in fact in double demand: first, as an actor, because of his racial appearance (in twenty movies made in the war years, he played variously Chinese, Korean, and Japanese characters, including a menacing Japanese agent in the Humphrey Bogart film *Across the Pacific*); and second, as a talented artist who could create intriguing backdrops and sets for the myriad films set in an imagined past or present China. He completed murals for *Shanghai Gesture* (1941) and *Macao* (1950). Not until the latter 1950s did he become better known as an actor than as an artist.

The celebration of the work of Kingman, Howe, Luke, and other Chinese Americans, given their stylistic, personal, and even physical associations with a wartime ally, provides a powerful example of how art was employed for ideological purposes during these years. The use of the work of **Mine Okubo** during the war years can certainly be interpreted in ways similar to that of Kingman and Howe, in that race, art, and war are inextricably implicated. But while Kingman's cityscapes helped visualize an American national identity and Howe helped the American public imagine the Pacific battlefield, and Luke the Chinese friend and Japanese enemy, Okubo's work— which took the internment camp experience of Japanese Americans as its subject—was deployed for different effect. Okubo's very different experience and inspired work were founded, of course, in the dramatically different position of the artist and her perceived racial identity.

Okubo was an established artist before the outbreak of war, and her work had attracted critical notice. With a graduate degree in art from the University of California, Berkeley, and association with leading regional and international artists, such as Diego Rivera, Okubo had completed murals and mosaics for federal projects in the San Francisco Bay Area. The San Francisco Museum of Art held solo exhibitions of her work in 1940 and 1941. But the art she completed during internment catapulted her to national

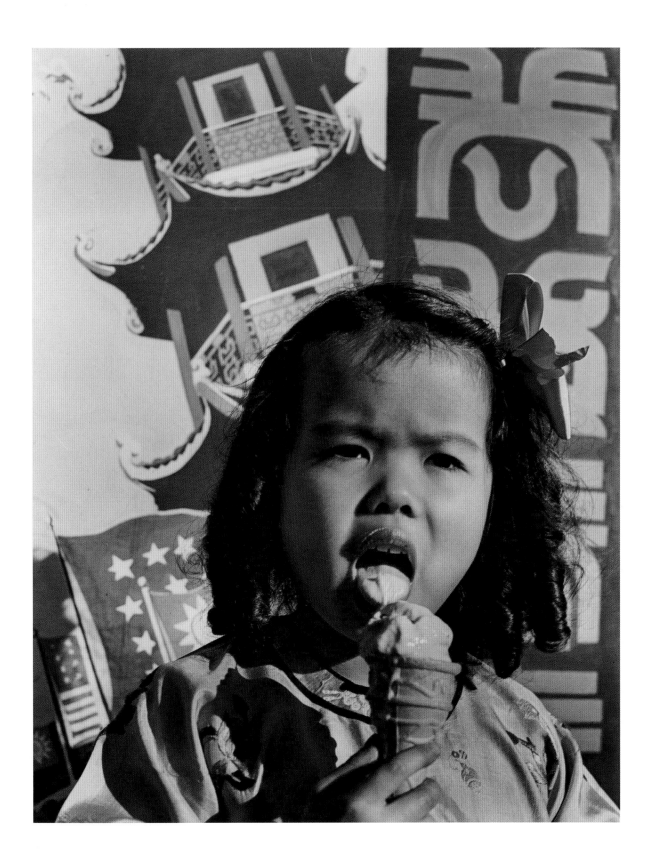

attention, a prominence of some mixed blessing, her wartime work overshadowing the efforts of her long and richly productive pre- and postwar career, which is much more artistically significant.[13]

As with Kingman, *Fortune* magazine played a decisive role in employing Okubo's work. In December 1943, the magazine commissioned her to complete two major illustrations for an article that considered what the United States might expect in the difficult war with Japan, even though Okubo had never been to Japan and was formally trained entirely in the idioms of Western art. While still interned at the Topaz Relocation Center in Utah, Okubo completed two illustrations, stereotypic in many ways, for *Fortune*. One depicted "submissive" Japanese citizens ready and willing to do anything for Authority, and a second imagined corpses of Japanese soldiers who found supposed fulfillment in their battlefield deaths. Her images helped reinforce the cultural assumptions of most Americans.[14] But her work for an issue of *Fortune* several months later, in April 1944, proved the

turning point in her career and established Okubo as *the* visual interpreter of the internment of Japanese Americans during the war. *Fortune*'s editors said Okubo's line illustrations of life in the internment camps "exactly suited our purpose," using them to accompany one of the first major articles in a national periodical on the camps.[15] As the editors praised Okubo's visual record as "remarkable for humor, poignant observation, and above all objectivity," the illustrations apparently complemented the magazine's mildly critical account of internment. Okubo's postwar publication of these and other illustrations in *Citizen 13660* won her widespread recognition and continue to serve as one of the most important statements about the internment experience today.[16]

In addition to Okubo, *Fortune* commissioned other Japanese American artists to illustrate the magazine's special issue on Japan. **Taro Yashima** (Jun Atsushi Iwamatsu) completed the magazine cover, a bold rendering of the ideographs for "Japan" and for other illustrations inside the issue (fig. 95). Ya-

shima and his wife, artist **Mitsu Yashima** (Tomoe Iwamatsu), had fled to the United States in 1939 from Japan because of persecution for their left-wing political views and involvement in proletarian art circles. In 1943, Taro published their stories in the United States as *The New Sun*, a moving anti-militarist account told largely through his brush-work illustrations. Not publicly acknowledged during the war years, however, was the use of his talents by the U.S. military. Taro worked for the Office of War Information and the Office of Strategic Services to produce a series of illustrated tracts directed at Japanese soldiers. One, "Unga Naiso," or "No Luck," reportedly was the most widely distributed piece of American propaganda in the Pacific theater. Taro's familiarity with Japanese iconography and cultural values enabled him to produce especially effective messages that aimed to demoralize the enemy.[17] Other young Japanese American artists, including **Chris Ishii**,[18] **Ken Nishi**, and **Lewis Suzuki**, volunteered their talents and were similarly employed by the U.S. military during the war.

A third Japanese American artist who contributed to *Fortune*'s issue on Japan was **Yasuo Kuniyoshi**, one of the most distinguished artists of Japanese ancestry in America at the time. He provided powerful sketches depicting Japanese militarist atrocities against civilians. Though he had acquired all his formal training as an artist after arriving in the United States from Japan as a teenager (he had attended art school in Los Angeles and New York), had only infrequent interactions with fellow Japanese Americans, and had traveled back to Japan only once in 1931 to visit his ailing parents, Kuniyoshi could never separate himself or his art from his perceived racial persona and ancestry. Commentators regularly saw Japanese cultural influences in his art, highly personalized paintings, even though they were rendered with Western techniques.

As with others, Pearl Harbor immediately changed Kuniyoshi's world: he felt awkward and conspicuous. He was placed under house arrest; his personal funds were impounded, and his photographic equipment was confiscated. Nevertheless, he devoted himself to supporting the war effort and quickly agreed to work with the Office of Emergency Management; he broadcast speeches to Japan condemning its militarist dictatorship and praising American democracy.[19]

Though Kuniyoshi experienced painful moments of ostracism during the war, he also found a warm reception for his anti-fascist artwork and his efforts to organize other artists to contribute to the war effort. In a speech called "Civilization Besieged: The Artists' Role in War," for example, he called on other artists not only to work to meet the spiritual and aesthetic needs of the people but also to go further and "help destroy the forces that are menacing" the world.[20] He chaired the Arts Council of Japanese Americans for Democracy (Isamu Noguchi and Taro Yashima were also members) and other art groups;[21] he raised funds for United China Relief; and he created powerful anti-fascist images for Office of War Information publications. His illustrations depicted the savagery of Japanese militarism and the suffering of the common people at the hands of the fascists. One painting from this period, *Headless Horse Who Wants to Jump*, incorporated an anti-torture poster Kuniyoshi had earlier created, but the message of this surreal work, which includes a headless horse rearing up, is more ambivalent and mysterious (fig. 96). In 1944, the Carnegie Institute awarded him first prize in its prestigeous annual arts competition.[22] In 1946, he organized a Harvest Festival Dance in Woodstock, New York, to benefit Japanese Americans interned during the war and even tried to volunteer for the U.S. Army to travel to Japan to help in the occupation.[23]

ENGAGEMENTS: WAR AND AESTHETICS

Audiences and patrons, private and governmental, deployed the work of Kingman, Howe, Luke, Okubo,

Taro Yashima, and Kuniyoshi in ways that explicitly supported the war effort, anti-fascist sentiment, and domestic morale. Work by other artists of Asian ancestry in America during these years engaged audiences in ways that were sometimes less explicit, less overt in their political messages, but deeply embedded in other forms of cultural politics. The subject matter was not figurative of war victims or participants, nor descriptive of the mobilized home front. This art in fact appeared to be anti-depictive of war. Yet these artistic efforts were nevertheless inextricably and deeply linked to the war because of the circumstances of the art production or the context of the artists and their work. They worked in a period of American history when romantic notions of China captivated the American public.[24]

This is perhaps most easily seen in the work of several artists of Chinese ancestry who moved their lives and work from China to the United States during the war years and continued to paint in what appeared to be traditional methods. The Japanese invasion of China in the 1930s had thrown the art world in China into turmoil and provoked some artists, such as Chang Shanzi (1882–1940), **Yang Ling-fu**, and Wang Jiyuan (1893–1975), to leave China and pursue their work overseas. After Pearl Harbor, these and other Chinese artists experienced a heightened reception for their work in this country, as they were extolled as cultural representatives of a valued war ally. Their work, considered by American audiences as treating traditional subjects in Chinese brush styles and idioms far removed from the horror and emotion of war, appeared to embody the Chinese nation and its culture. While Chinese artists long before the 1940s had traveled across the Pacific to visit the United States, few were of the stature of those who came as a result of the war and the Chinese civil war that ensued.

Among these was **Chang Shu-chi**, sent by the Chinese Nationalist government in the fall of 1941 as a "goodwill ambassador" to strengthen friendly feelings of the American people toward China. Commissioned by Chinese leader Chiang Kai-shek to create a large painting to honor Franklin Roosevelt's third election as president, Chang sent his *Messengers of Peace* (sometimes known as *100 Doves of Peace*) to the White House (fig. 97). Stranded in the United States after the attack on Pearl Harbor, he stayed until 1946. During the war years, he led a frenetic life, holding major shows at the Metropolitan Museum in New York, the Nelson Gallery in Kansas City, the Chicago Art Institute, the de Young Museum in San Francisco, and scores of other institutions around the country and enthralling thousands of spectators at his painting demonstrations (see Mayching Kao's essay, fig. 170).

Though he had been born into a family of artists who practiced traditional Chinese techniques, Chang's first formal training in China had been in Western art technique. Chang decided early in his career, however, to work largely with Chinese painting media and subject matter. His mixed aesthetic made him an especially appealing cultural representative, as his work seemed to the untrained American eye fully representative of Chinese painting; yet few knew that his earlier art training and chosen style made his work more accessible to American audiences. None of Chang's paintings displayed any overt reference to human suffering, the devastation of war, or the conflict of nations, which made his work even more useful for public commentators who used his work to engage the American public artistically and to encourage support for China as the wartime ally. The apparent complete apoliticalness of the art, with birds and flowers as the principal subject matter, allowed interpreters tremendous latitude in their messages that freely mixed art and political/cultural commentary.

The famous friend of China, author of *The Good Earth*, and Nobel Prize winner Pearl Buck celebrated the ways Chang's non-war art contributed to the war effort: Chang's art, Buck wrote, carried "the implicit

FIG. 97 Chang Shu-chi, *Messengers of Peace*, 1940.
Mineral pigments and ink on silk, 64 × 140 in.

influence of wartime China." She saw a "confidence in his paintings and calm and resolution. But there is beauty, too, something of the beauty of the old China, which still remains the eternal soul of China's people." In Buck's view, Chang's work was important because "not only military leaders are living and succeeding today in China against the enemy. It is even more significant that artists are living and succeeding."[25]

William C. White, curator of the East Asiatic Collection at the Royal Ontario Museum, also directly connected Chang's non-war art to the war. His *Messengers of Peace*, according to White, was a "symbol of peace; a peace not of appeasement but of the unconquerable will of free men." And Alfred Frankenstein, the art critic for the *San Francisco Chronicle*, also understood the special effectiveness of Chang's work in engaging a public occupied by war. "The British send us paintings of the London blitz and reconnaissance photographs of bomb destruction over Germany. The Russians send us savage posters and cartoons. The Chinese send us Chang Shu-chi... [His] war propaganda figures forth peonies and roses, small birds, cocks and ducks, mysterious mountains, and the splittering abstraction of bamboo leaves and stalks."[26] Chang himself rarely wrote or spoke publicly about the war, limiting himself to messages that encouraged cultural understanding and a unity of art-loving peoples, even

森亂橘禄不此此也平年岳義礼群
雄舍天家宇休岳信使延剏兇
宅宣
　中華民國三十四年秋松杭科張書祈
教授作示鶴國鳥記
奧斯汀縣九三屆北城人典花橙平庚
原居久書

forecasting a day when there would be no "eastern painting and no western painting, just painting."[27]

In contrast to the veiled engagement of Chang's art with an American public preoccupied with war is that of Isamu Noguchi, who became one of the most celebrated artists of Asian ancestry—of any ancestry—in America later in his life. He was one of the most active in trying to use his art and fame to engage the American public explicitly in issues related to war, race, and art during the war years. Before the war, he used his highly personalized, modernist approach to sculpture and design to encourage an aesthetic that has been described as a kind of "artistic democracy," to expand the boundaries of democracy artistically and politically by drawing from the artistic vocabularies of other cultures, past and present.

But the attack on Pearl Harbor propelled him into a heightened political/artistic activism and apparently forced him to confront his own racial identity in ways that he had previously avoided.

Of European and Japanese ancestry, Noguchi in the prewar years had struggled to understand his complicated racial, national, and artistic identities, what he himself called his "peculiar background."[28] The coming of war appears to have jolted him. Traveling in California when he heard the radio report on the Pearl Harbor attack, he thought to himself, "My God, I'm a Japanese or I'm a Nisei, at least; I'd better get in touch with other Nisei and see what's going to happen."[29] He then traveled to San Francisco, where he helped organize a group called Nisei Writers and Artists Mobilization for Democracy that aimed to use art to ameliorate the conditions of camp internment and promote the national effort against Japanese militarism.[30] In an unconventional arrangement, Noguchi volunteered to go to the Poston, Arizona, internment camp to oversee an arts program for the internees. (The federal government's internment order applied only to persons of Japanese ancestry in the Western military zone; Noguchi resided in New York at the time of the order and therefore was not bound by it.) At Poston, Noguchi found himself busy. He directed the landscaping and recreational and park planning for the camp, as well as for its cemetery(!). He wanted to start ceramics and woodworking shops. But he was also distressed. He wrote his friend Carey McWilliams, the well-known author and activist: "Personally I feel very deeply isolated from America and her war effort—the more truly American we were, the more must we feel the strangeness of the surrounding faces—the unfairness of the situation."[31] Noguchi's art programs never developed, and after just a few weeks, he applied to exit. Though he had entered the camp voluntarily, authorities delayed his departure for seven months. In November 1942, he was finally given a "temporary" leave and left Poston for

FIG. 98 Isamu Noguchi, *My Arizona*, 1943.
Magnesite and plastic, 18 × 18 in.

til just two years before, Noguchi—a "Eurasian," as he called himself—identified with the young Japanese Americans who seemed to have no comfortable place in America. Yet he seemed to understand that such liminality had its value, even great potential, for them—and, by implication, for him as well. "To be hybrid anticipates the future," he began his essay, a statement that was as much predictive of America as it was autobiographical. "This is America, the nation of all nationalities. The racial and cultural intermixture is the antithesis of all the tenet[s] of the Axis Powers." Much of the essay is a commentary on the administration and resident life in Poston, but toward the close of his article, Noguchi returned to art. He confessed that although he could find little in common personally with the older, Japan-born residents of the camp, he admired them for knowing "what to make with their hands," a supreme compliment from a sculptor. "Everywhere they are carving wood, making flower arrangements, making gardens, they put on plays and play the flute." Might not the Nisei learn from them, he wondered? "Tapping the artistic resources of the Issei" could produce something wonderful: a "middle culture for a middle people might grow. Thus may the springs of their creative imaginations be released and themselves and America be enriched." Noguchi may very well have been envisioning his own artistic future as one who remained unresolved about his personal and social identity throughout his life. Being physically neither "East" nor "West," Noguchi appears to have understood the general position of Japanese Americans as occupying a similarly marginal and insecure place. The solution, he suggested for the Nisei—and, it seems, for his own artistic production—is to understand and exploit the unique potentialities of such a fluid social position.[33] Forced to face his Japanese ancestry in ways he had never experienced before, Noguchi soon entered a period of active study of Japanese art and culture and after the war spent much of the rest of his life working in Japan.

New York, never to return. The war and internment left an indelible impression on him—even though he had been associated with left-wing and anti-racist circles in the 1930s, when he set foot in Poston, he confessed that he "suddenly became aware of a color line I had never known before."[32] He revealed these thoughts in an unusual essay he drafted shortly before leaving Poston. Only a few works of art point to his creative output while interned (fig. 98).

In October 1942, he drafted "I Become a Nisei" for publication in *Reader's Digest*. The title is telling, for it came from one who was notoriously private and circumspect about his personal history, and one who rarely had associated with other Japanese Americans. Though the piece was never published, he kept a copy of the manuscript in his personal papers. The essay is largely a critical description of life in the camps as he found it, but interspersed are Noguchi's musings about the artistic implications of his newly understood identity as a "Nisei," as he put it, one who was neither Japanese nor American, a "middle people with no middle ground." Admitting that he had never even heard the word "Nisei" un-

FIG. 99 Sueo Serisawa, *Nine O'Clock News*, 1939.
Oil on canvas, 30 × 40 in.

OBLITERATIONS AND REENGAGEMENTS

While World War II drew from the talents of various Asian American artists, it obliterated the work and careers of others, most notably those of Japanese ancestry in America. A few, because they lived away from the West Coast or were young enough to serve in the U.S. military, managed to pursue their work, as described above. Nevertheless, they were never able to escape the shadow of the war with its racial implications. **Sueo Serisawa** suffered the misfortune of having his one-man show open at the Los Angeles Museum on December 7, 1941 (fig. 99). He was afraid to attend its opening, but a friend persuaded him to go. Within weeks, he and his wife packed up their things and, taking advantage of a short-lived moment of opportunity, moved to Colorado to avoid internment.[34] Because of a federal order to confiscate cameras from Japanese Americans, master pictorial photographer Kyo Koike had to deliver two of his to the Seattle police. (Though the event appeared on the front page of the local newspaper, no mention was made of his skill in photography or of his leadership in the famed Seattle Camera Club.)[35] Other

Japanese American artists in the West who didn't move were interned in federal "relocation" camps and saw their professional work disrupted, even destroyed. Sent to desolate locations in remote corners of the country, these artists had little access to art supplies, lived under harsh conditions, and endured emotional pressures that tested their spirits. None could pursue their creative activities as they had before the war; all had their artistic trajectories fundamentally altered. The losses were tragic; the war and internment destroyed health and will, ending the creative work of painters such as Takuichi Fujii, Sumio Arima, **Benji Okubo**, **George Matsusaburo Hibi**, and **Kiyoo Harry Nobuyuki**.[36]

For others, though, after obliteration came rebirth. From a life of painting, gallery shows, and world travel, **Henry Sugimoto** instantly found himself, as did fellow internees, confined under suspicion due to his ancestry. Because of Pearl Harbor, he recalled, "I thought that my artist life was finished."[37]

Sugimoto and his family were forced to leave their California Central Valley home to live first in an assembly center in Fresno and then in an internment camp in Denson, Arkansas. Sugimoto's life as a celebrated painter ended, but his life as an artist did not. His subject matter dramatically changed: from a painter of French- and Mexican-influenced land- and cityscapes, he transformed into a chronicler of the human drama he witnessed. He continued to paint while incarcerated, ultimately producing more than one hundred paintings and numerous sketches depicting his three and a half years of internment. Today, his works present a powerful visual record of the drama (fig. 100). At war's end, Sugimoto moved to New York City with his family. Unable to support them with his artwork, he hired on at a textile company to create surface designs for fabrics.[38]

Like that of Sugimoto, the world of one of Cal-ifornia's most distinguished artists, **Chiura Obata**, was shattered by the internment order. He was forced to close his Berkeley studio and stored his collection at the campus residence of Robert Sproul, president of the University of California, Berkeley, where Obata had taught art since 1932. In internment, Obata used his creative energies to paint what he saw: he began to capture his internment experience on paper the day he reported to register his family. Eventually he produced two hundred paintings and scores of sketches based on his and his family's confinement at Tanforan and then Topaz, Utah. The work is poignant and careful, sometimes dispassionate, often beautiful or haunting, and always sensitive (fig. 101).[39]

Obata also found ways to use his talents to help his fellow internees. Within days of arriving at the Tanforan Assembly Center, Obata organized an art school in the belief that art could help others deal with the adversity. In his request to the camp authorities for approval for the school, Obata wrote, "Art is one of the most constructive forms of education. Sincere creative endeavoring, especially in these stressing times, I strongly believe will aid in developing a sense of calmness and appreciation, which is so desirable and following it come sound judgment and a spirit of cooperation."[40] Other artists joined Obata, and the school soon attracted more than six hundred students of all ages. At Topaz Obata continued his educational efforts as well as his own work.

As Karin Higa has written, wartime internment of Japanese American artists "affected their capacity to make and show art; their trajectories as artists were cut short, sidetracked, or derailed." But she also celebrates their "determination" and "passion" to carry on.[41] Indeed, art did not die in the camps—the creative impulse drove artists to find new avenues of expression. In some ways, art actually flour-

FIG. 100 Henry Sugimoto, *Longing*, 1944.
Oil and charcoal on canvas, 72¾ × 58¼ in.

FIG. 101 Chiura Obata, *Silent Moonlight at Tanforan Relocation Center*,
1942. Watercolor on paper, 15¼ × 20½ in.

ished, perhaps because of the abysmal conditions of daily life.[42] In addition to Obata, other artists such as Matsusaburo Hibi and **Hisako Hibi**, Mine Okubo, Henry Sugimoto, and Masao Yabuki organized art classes in the internment camps that attracted thousands of adult and youth students, including **Ruth Asawa**, **Kay Sekimachi**, and **Taneyuki Dan Harada** (fig. 102). At Heart Mountain, Hideo Date and Benji Okubo organized an art school that they called the Art Students League, borrowing the name of their Los Angeles organization.[43] Isaburo Nagahama, a professional embroiderer, supervised around four hundred students at Heart Mountain.[44] **Toyo Miyatake** operated a photographic studio in Manzanar,[45] and **Tokio Ueyama** (fig. 103) supervised the art department at Granada with **Koichi Nomiyama**. Their examples exemplify the power of the artistic will under adver-

FIG. 102 Taneyuki Dan Harada, *Barracks Huddled Together*,
1944. Oil on canvas, 26 × 20 in.

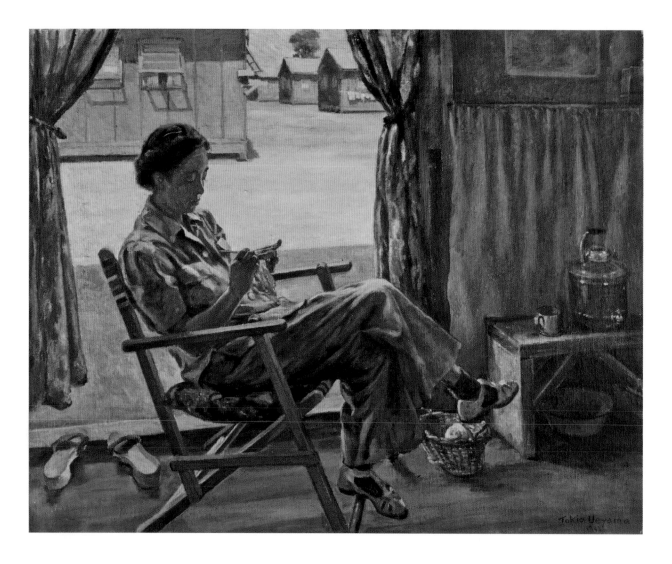

FIG. 103 Tokio Ueyama, *The Evacuee*, 1942.
Oil on canvas, 24 × 30¼ in.

sity. Internees regularly organized art shows in the camps to display their paintings, sculptures, handicrafts, and flower-arranging created behind barbed wire. These shows attracted thousands of visitors, at times almost the entire camp population (fig. 104). Some artists continued their own work in internment, even sending paintings to exhibitions as they had in the prewar years. When he submitted work for a 1945 museum exhibition, Matsusaburo Hibi, interned at Topaz, Utah, wrote the curators, who were "old friends," "I am now inside of barbed wires but still sticking in Art—I seek no dirt of the earth—but the light in the star of the sky."[46] The show displayed two of Hibi's block prints of Topaz, as paintings were more difficult to ship. Paintings from this period capture the emotional atmosphere of the environment (fig. 105). His wife, Hisako Hibi, Kiyoo Nobuyuki, and Henry Sugimoto also sent work to San

Francisco exhibitions during the war.[47] Some depicted life in the camps; others did not. Mine Okubo's *On Watch* was a 1943 San Francisco Art Association exhibition prize winner (fig. 106). Taken together, these works from internment have become among the best-known Asian American artworks to date.

The art of internment served purposes beyond internee diversion and individual artistic expression. Art sent out from the camps also became an unusual but highly effective media for communication with the "outside" world. These were reminders for the public at-large, reengagements of the artists with the America outside of the barbed wire. During the war years, individual artists and the camp art schools regularly sent exhibitions of work for display through-

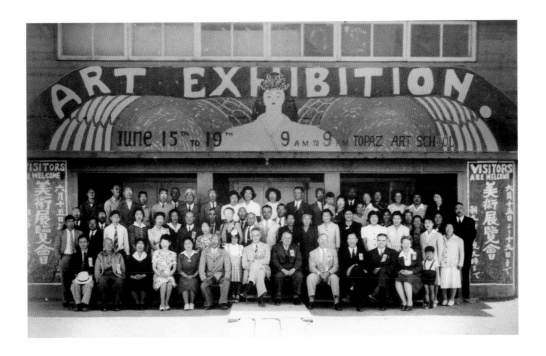

FIG. 104 Final art exhibition, Topaz, Utah, June 1945.

out the country. This work, which often included internment camp subject matter, helped to humanize Japanese Americans, just as art was used at times to help demonize an enemy or encourage fighting will on the home front. Depictions of the difficulties of life under incarceration, such as Hisako Hibi's *Fetch Coal for the Pot-Belly Stove* (fig. 107), encouraged empathy for the internees; depictions of other subjects reminded audiences that those incarcerated were not the demons the racists said they were.

These exhibitions, which have been neglected subjects of study, began almost immediately after internment began. In June 1942, Obata arranged for work by his students at Tanforan to be displayed at Mills College in Oakland and at sites in Berkeley. A year later, the Friends Center in Cambridge, Massachusetts, sponsored an exhibition entitled *Relocation Center Art Exhibition*. Obata and other artists from all ten of the internment camps, including **Frank Taira** from Topaz, Kakunen Tsuroka, and **Gene I. Sogioka** from Poston, exhibited at the show, which received national attention. The periodical *Asia and the Americas* reproduced some of the prize winners from the exhibition and described the paintings as revealing "the bleakness, the sense of being apart and uprooted, but often, too, they discovered a certain beauty in

the very austerity of the surroundings."[48] In February 1944, Henry Sugimoto exhibited approximately fifty works at Hendrix College, a small college near his internment camp in Denson, Arkansas. The paintings included scenes of life in the camp. Some of his paintings were also included in a show organized by the California Watercolor Society that traveled for two years to army camps and united service organizations throughout the country.[49] In March 1945, Mine Okubo exhibited her work at a show sponsored by the Common Council for American Unity.[50] Masao Yabuki exhibited work, including paintings completed in internment, at the Women's University Club in Philadelphia in April 1945.[51] For two weeks in May 1945, hundreds of viewers visited an exhibition described as an "American-Japanese Art show," which displayed work by internees, such as Benji Okubo and the Hibis, as well as Japanese Americans outside of the camps, including Kuniyoshi of New York City and Lewis Suzuki, then in the army. Organized by the college librarian and the chairman of the art department, the show at the New Jersey College for Women (now Douglas College) displayed thirty paintings and woodcarvings, which were then sent on tour to galleries and colleges around the country. Information about internment was made available at the show.[52]

Perhaps the most dramatic obliteration of the

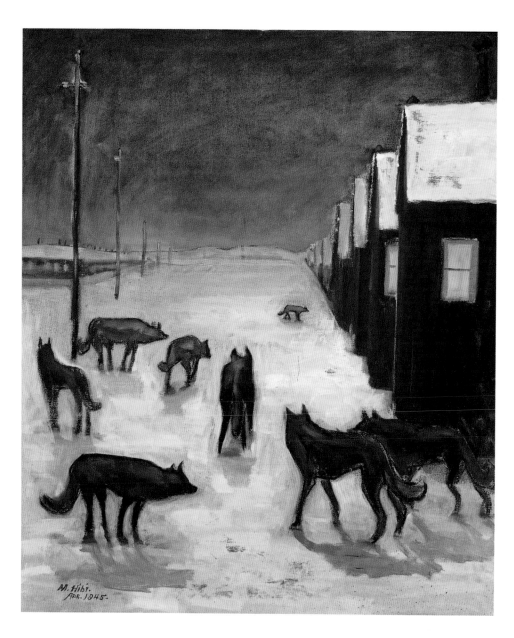

FIG. 105

George Matsusaburo Hibi, *Coyotes Came Out of the Desert*, 1945. Oil on canvas, 26 × 22 in.

work of an individual Japanese American artist was that of **Yotoku Miyagi**, who died at age forty after torture and brutal mistreatment in the infamous Sugamo Prison in militarist Japan in 1943. Miyagi, an Okinawan by birth, had entered the United States in 1919 to join his father, who had emigrated earlier. After attending art schools in San Francisco and San Diego in the 1920s and working along the West Coast and likely in Alaska, Miyagi began a promising career as an artist in the Little Tokyo district of Los Angeles. His exhibited portrait and landscape oil paintings impressed critics such as Arthur Millier, art critic of the *Los Angeles Times*, who found the work highly origi-

nal and of "exceptional quality."[53] At the same time that he pursued his art, Miyagi was also drawn to revolutionary politics and in 1931 joined the American Communist Party. He illustrated several issues of the Japanese-language Socialist journal for the Southern California Proletarian Culture League (fig. 108). In his later confession given in jail, Miyagi stated that he had joined the radical movement allegedly because of the "tyranny of the governing classes" but "above all" because of "the inhuman discrimination against the Asiatic races" in America.[54]

Soon after, he traveled to Japan in what he believed would be a short trip to work as a Comintern

FIG. 106 Mine Okubo, *On Watch*, ca. 1943.
Tempera on paper, dimensions unknown.

Twenty years later they were moved to Japan. Today, he is once again honored in Japan as an artist but is virtually unknown in the United States, where he became an artist and completed most of his work.[56]

THE COLD WAR

The end of the war came quickly, and the horror of the atomic bomb devastation of Hiroshima and Nagasaki stunned many around the world, none less so than a number of Japanese American artists, some of whose families were from Hiroshima. In paintings, Obata and **Eitaro Ishigaki** imagined the nightmares of the atomic destruction (fig. 109). Noguchi submitted proposals for the Hiroshima memorial to the dead. In America, critics sometimes found Noguchi too "Oriental" or Japanese for their tastes; in Japan, his proposals were rejected, he believed, because he was American.

The work of these and other artists of Asian ancestry continued to reflect their social being in America, which is to say they could never fully dis-

agent and was eventually implicated in what became known as the Sorge spy ring, which has been called the most successful espionage effort of World War II. Using his painting of local scenes as a cover to travel the country, Miyagi acted as a courier of information among the various European and Japanese agents, often using art museums as meeting points. He was arrested and imprisoned in 1941.[55] He died in prison two years later. Prevented from interring his ashes in Japan, Miyagi's family laid them to rest in Mexico.

FIG. 107
Hisako Hibi, *Fetch Coal for the Pot-Belly Stove*, 1944. Oil on canvas, 20 × 24 in.

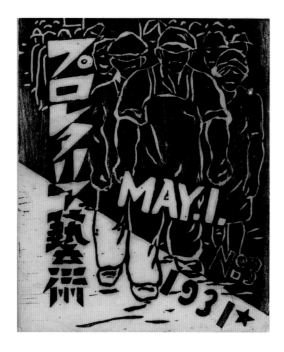

FIG. 108 Yotoku Miyagi, Cover of Southern
California Proletarian Culture League
publication, May 1931.

associate themselves from their perceived racial position, even if they had so wanted.[57] That truth continued to shape the lives of Asian artists in America in the early Cold War years, but in different ways due to the dramatic changes in world geopolitics. The United States emerged from World War II as a true global power, with ambitions in and anxieties about every area of the world. American culture, popular and elite, became fascinated by cultures and peoples as never before; the Korean War and the stationing of hundreds of thousands of American military personnel throughout Asia in the 1950s brought that region especially close. Washington resurrected Japan from hated enemy to valued partner in the global contest with communism, and art helped cement the relationship: Hardly before the dust had settled on Nagasaki and Hiroshima, General Douglas MacArthur, head of the U.S. occupation of Japan, endorsed the idea of sending a major exhibition of Japanese art treasures on tour to the United States. In 1951, San Francisco's de Young Museum exhibited a huge show of Japanese traditional arts to accompany the signing of the Treaty of Peace with Japan in San Francisco, and the very next year an exhibition of contemporary Japanese painting made its way to the California Palace of the Legion of Honor in San Francisco.[58]

These shows helped fuel a rage in Japanese arts and "Eastern" traditions—especially Zen, Taoism,

brush painting, and ceramics—that swept the United States in the late 1940s and 1950s, in part as a reaction against Cold War materialism and imperial ambition. This interest in turn encouraged an unprecedented number of major artists from China and Japan to come to the United States, many of them staying for long periods or settling permanently.

Among the Japanese artists who moved to and then remained in the United States were Kenzo Okada—who settled in New York City and became perhaps the most well-known transplanted artist from Japan (fig. 110)—and **Saburo Hasegawa**, one of the pioneers of abstract art in Japan. Hasegawa had traveled in the United States and Europe from 1929 to 1932 but had suffered in the war years in Japan because he refused to create art for military propaganda purposes. He recalled that he had been "arrested for disloyalty."[59] But his interest in Japanese traditional arts and modern abstraction brought him to attention in America. He moved to the United States, where he taught and lectured on Japanese arts and philosophy, and developed working relationships with American abstract painters Willem de Kooning and Franz Kline and writers such as Alan Watts. He died at his home in San Francisco's Japantown.[60] Remarkably, in just a few years, the attitude of the American public toward Japanese art went from one of disparagement to inestimable respect.[61] (See Paul Karlstrom's essay, fig. 187).

A number of intellectuals and artists in China, dislocated due to the war and the political upheavals during the Chinese civil war of the late 1940s, also left their land of ancestry and came to the United States. Chang Shu-chi, Chen Chi-kwan, **C. C. Wang** (Wang Chi-chi'en), **Chang Dai-chien**, **Tseng Yuho**, Wang Ya-chen (1894–1983), Chiang Yee (1903–1977) (fig. 111), and Chen Chi (1912–2005) moved to the United States or began long associations with the country.[62] Their work in the United States often embodies a stylistic transnationalism, sometimes depicting American sites with ink and soft brush

FIG. 109 Eitaro Ishigaki, *Disaster by Atomic Bomb*, 1946. Oil on canvas, 26 ¼ × 30 in.

(see Mayching Kao's essay, fig. 172). **S. C. Yuan**, also known as Wellington S. C. Yuan, had not been an established painter in China, but after immigrating to the United States in 1950, he began a successful career in the Carmel/Monterey area.[63]

The Cold War was also responsible for sending Asian American artists in the opposite direction. The United States government found Dong Kingman's work useful in the Cold War to showcase what it believed was the racial diversity of America. In 1954, when the Supreme Court handed down its landmark decision outlawing school segregation, the State Department selected Kingman to "sell" American democracy in an official tour to non-Communist Asia. Kingman spent months in Asia painting exotic sights and scenes that helped Americans believe in a bright new America-oriented future in Cold War East Asia.[64] Ceramicist and writer **Jade Snow Wong** was sent on a similar tour of Asia.

But the rise of America as a geopolitical and artistic hegemonic power in the postwar period also obscured, even obliterated work—much art was forgotten or marginalized, in part due to modernist prejudices against styles that seemed inflected by ethnicity or tradition.[65] The art of the internment was displaced for decades, perhaps because it invoked a too uncomfortable part of America's war experience. The anti-radicalism and conservatism of the Cold War adversely affected careers and reputations. Kuniyoshi, Noguchi, Howe, Chris Ishii, Lewis Suzuki, and other progressive artists found themselves suspect because of their liberal views and activism during World War II. Perhaps the most prominent Asian American artist who suffered grievously in the early Cold War was Eitaro Ishigaki. Brought to the

FIG. 110 Kenzo Okada, *Quality*, 1956.
Oil on canvas, 70 × 76 in.

United States from Japan at the age of sixteen by his father, Ishigaki grew up in Seattle and Bakersfield, California. Attracted simultaneously to the world of art and Marxism, he went through art school in California and then moved to New York City. By the time of the onset of the Great Depression in 1929, he had developed a dynamic and accomplished social realist style. He became one of the most talented and prominent artists of any ancestry during the 1920s and 1930s. His canvases powerfully critiqued American racism, militarism (both American and Japanese), and capitalism. In 1937, for example, he exhibited in New York a work described as anti-imperialist, depicting "two Spanish subjects of Basque women hurling Italian fascist 'volunteers' into the sea."[66] His wife, Ayako Ishigaki, was an outspoken and eloquent social critic in her own right. In 1940, she published the first account in English by a Japanese woman of her life in Japan and America, which offered a strongly feminist and class-conscious perspective.[67] But in 1951, federal authorities threatened to deport the Ishigakis to Japan, apparently because of their association with communism in the United States. They chose to leave, and Ishigaki hurriedly cut his paintings from their stretcher bars to take them with him. The works were badly damaged. More tragic was the damage to his spirit, which never recovered. He died broken in 1958.[68]

* * *

WORLD WAR II is often understood as a turning point in the history of Asian Americans. The beginning of the end of the discriminatory anti-Asian immigration restrictions, the internment of 120,000 Japanese Americans, and an improvement in the Ameri-

called Lewis Suzuki, who was trained in Japanese and Western painting techniques before the war, made him decide to stay in the United States.[70] **Carlos Villa** never forgot the acutely racialized atmosphere of wartime America. Though of Filipino ancestry, Villa recalls his family being vilified on the streets of San Francisco because they were mistaken for Japanese.[71] However, the war "made" **Ernie Kim** an artist. He developed his talents during his recuperation from a serious war wound and as part of his rehabilitation therapy (fig. 112). The postwar arrival of many talented artists from China, Japan, and Korea contributed to broadening the aesthetic sensibilities of Americans, captivated by "Eastern" traditions.[72] Many of these artists were welcomed by other American artists, intellectuals, and the elite art world in unprecedented ways. But the style and approach of these artists from Asia, with rare exceptions, rarely resonated with the new generation of ethnically aware and politically motivated Asian American artists who emerged in the late 1960s.[73] For them, an artist with a kindred soul, such as Eitaro Ishigaki, was unknown: the Cold War had effectively dispatched and buried him. For young Asian American artists, there seemed to be no relevant history of art among Asian Americans—that is, not until recently. A once vibrant, and then obscured, visual past is now being seen again.

can public's postwar attitude toward race all had great and direct consequence for Asian American communities. For Chinese Americans, the war is usually seen as the start of their entry into mainstream America.[69] Journalists began to resurrect and reconfigure the reputations of Japanese Americans as soon as the war ended and the camp doors opened. And while it might be argued that the socioeconomic position of Asian Americans steadily improved postwar, the fate of art among Asian Americans was more complex and troubled. The camps completely ended the professional careers of many Japanese American artists; a number of them moved to New York and other cities away from the West Coast after the war, disrupting their lives and careers, some irreparably. **Hideo Kobashigawa**, Mine Okubo, the Hibis, Hideo Date, Frank Taira, and Henry Sugimoto were among those who transplanted themselves in New York. The war and Japanese aggression, re-

FIG. 112 Ernie Kim, *Perforated Vase*, ca. 1950. Stoneware, 12 × 12 in.

Notes

1 "U.S. Government War Art," *Life* 12, no. 14 (April 6, 1942): 60ff. From its inception the popular picture magazine was especially proud of its coverage of "Art." In March 1942, it announced its own "art competition for men of the armed services." A committee of *Life* editors and curators from leading museums in the New York area would purchase eleven works of art from active military personnel to help record "part of America's cultural heritage." See *Life* 12, no. 9 (March 2, 1942): 47. The magazine carried some sort of art feature in almost every issue.

2 Dong Kingman, *Paint the Yellow Tiger* (New York: Sterling Publishing, 1991), 77–90; *Fortune* 32, no. 5 (November 1945): 148–157, 178ff; "Dashing Realist," *Time* 46, no. 10 (September 3, 1945); and letter from Dong Kingman Jr. to Gordon H. Chang, June 12, 2002, in author's possession.

3 Alan D. Gruskin and William Saroyan, *The Watercolors of Dong Kingman, and How the Artist Works* (New York: Studio Publications, 1958), 30.

4 *Fortune* reproduced the painting *San Francisco* in its February 1945 issue. The magazine's description of the creation of the painting reveals the strange and conflicted consequences of race in war, and the ways that Kingman's appearance and ancestry both helped and hindered him: Kingman's painting of San Francisco Bay, the magazine wrote, "called for rare pertinacity. For his vantage point he selected a spot on the Bay Bridge. Mr. Kingman, a native U.S. citizen, happens to be of Chinese parentage; and in hypersensitive California the passing motorists' glimpse of an Oriental sketching the anchorage of troopships and armed freighters would likely have produced a four-alarm commotion. But the authorities, military, naval, and civil, cooperated handsomely. Mr. Kingman was installed on one of the tiny platforms suspended at intervals over the side of the bridge. On it he erected an Army pup tent to shield him from the bitter wind. Swaddled in sweaters, topcoat, hunting cap with earflaps, gloves, and sustained with hot tea from a thermos, Mr. Kingman spent a thoroughly miserable day." The painting accompanied an article entitled "Ports of the Pacific"; *Fortune* 31, no. 2 (February 1945): 126. Kingman recalled that he painted the work specifically for *Fortune*; *Paint the Yellow Tiger*, 90. He exhibited the painting in his August 1945 show at the de Young Museum in San Francisco, and it was then reproduced in the September 3, 1945, issue of *Time* (vol. 46, no. 10). *Time* captioned the image, "Dong Kingman's San Francisco. Occidental Reportage with Oriental Overtones."

5 *Fortune* 32, no. 5 (November 1945): 148–157, 178ff.

6 Mayumi Tsutakawa, ed., *They Painted from Their Hearts: Pioneer Asian American Artists* (Seattle: Wing Luke Asian Museum/University of Washington Press, 1994), 26–27.

7 Sylvester Davis, "The Photography of James Wong Howe," *California Arts and Architecture* 56, no. 4 (October 1939): 9. The entire issue of the periodical was devoted to "Chinese" art and artists, including Chinese Americans, and reproduced a Howe photograph of a Chinese woman. Rocky Chin and Eddie Wong, "An Afternoon with James Wong Howe," *Bridge*, June 1973, 11–14.

8 Todd Rainsberger, *James Wong Howe, Cinematographer* (San Diego: A. S. Barnes, 1981), 22, 201–206. Howe's work includes *The Thin Man* (1934), *Algiers* (1938), *Abe Lincoln in Illinois* (1939), *Kings Row* (1941), *The Rose Tattoo* (1955), *The Old Man and the Sea* (1957), *Hud* (1963), and *This Property Is Condemned* (1966). He was involved in 125 films and received the Academy Award for cinematography in 1955.

9 "A Chinese Camera Man Made New Film Due at the Hollywood," *New York Herald Tribune*, February 13, 1944, 3.

10 See, for example, reviews of *Objective Burma!* in *The New York Times*, January 27, 1945, 15, and *Time* 45, no. 9 (February 26, 1945): 92; the review of *Air Force* in *San Francisco Chronicle*, April 1, 1943, 9; and the review of *Passage to Marseilles* in *San Francisco Chronicle*, March 24, 1944, 8.

11 "Chinatown, San Francisco: James Wong Howe focuses his searching lens on his people in America," *Look*, December 26, 1944, 22–27.

12 Sonia Wolfson, "Work of Chinese Artist Wins Praise: Orient and Occident Meet in Fascinating Symbolism," *Saturday Night* (Los Angeles), January 11, 1936. Ferdinand Perret Research Materials on California Art and Artists, 1769–1942, reel 3859, frame 1349, Archives of American Art, Smithsonian Institution.

13 See the special issue of *Amerasia Journal* 30, no. 2 (2004) devoted to Okubo.

14 Okubo did not mention these early illustrations when she was interviewed about her work. She recalled that her covers for the Topaz magazine *Trek*, the first issue of which appeared in December 1942, originally caught the attention of the *Fortune* editors, who subsequently brought her to New York in 1944. But how she came to complete the earlier work for *Fortune* is not known. Though her work is clearly signed in the illustrations, the magazine does not identify her or attribute them. See Shirley Sun, *Mine Okubo: An American Experience* (Oakland, CA: Oakland Museum, 1972), 41. The *San Francisco Chronicle* may have been the first major publication to draw attention to her work. The paper used one of her drawings for the cover of its Sunday magazine supplement and others to illustrate her article on the internment camps. See "This World," *San Francisco Chronicle*, August 29, 1943, cover, and Mine Okubo, "An Evacuee's Hopes and Memories," 12–13.

15 See "Issei, Nisei, Kibei," *Fortune* 29, no. 4 (April 1944): 8ff.

16 For example, see the following reviews, some of which also reproduced her work: M. Margaret Anderson, "Concentration Camp Boarders, Strictly American Plan," *New York Times Book Review*, September 22, 1946, 7; Alfred McClung Lee, "Concentration Camps, U.S. Model," *Saturday Review of Literature*, September 28, 1946, 12; and Millard Lampell, "A Nisei Pictures Life Behind Barbed Wire," *New York Herald Tribune*, October 13, 1946.

17 Taro Yashima, *The New Sun* (New York: Henry Holt, 1943). In 1947, Yashima published a continuation of his story, *Horizon Is Calling* (New York: Henry Holt, 1947). The volume is dedicated to the 442nd and 100th battalion soldiers and their parents. David Holley, "Japanese Artist Who Aided U.S. in War Finds Acceptance," *Los Angeles Times*, August 2, 1982, C1.

18 Martha Nakagawa, "Rebels with a Just Cause," *Rafu Shimpo*, December 11, 1997, 1.

19 Quote from Tom Wolf, "The War Years," in *Yasuo Kuniyoshi* (New York: Whitney Museum of American Art at Philip Morris, 1986), n.p. Also see the artist's statement in *Yasuo Kuniyoshi* (New York: American Artists Group, 1945).

20 Wolf, "The War Years." See also, for example, "Japanese Here in Protest: Arts Council Decries Atrocities Against Captive Americans," *New York Times*, February 14, 1944, 6.

21 *Heart Mountain Sentinel*, February 19, 1944, 1. Kuniyoshi also served on the advisory board of the Japanese American Committee for Democracy, based in New York. Other board members included Franz Boas, Pearl Buck, Albert Einstein, and Adam Clayton Powell Jr.

22 "Still-Life Painting Takes First Prize," *New York Times*, October 13, 1944, 32.

23 Wolf, "The War Years."

24 See Karen Leong, *The China Mystic: Pearl S. Buck, Anna May Wong, Mayling Soong, and the Transformation of American Orientalism* (Berkeley: University of California Press, 2005), 155–171.

25 Quoted in exhibition catalog, M. H. de Young Memorial Museum, San Francisco, November 5–December 5, 1943.

26 White, quoted in exhibition catalog, Elsie Perrin Williams Memorial Art Gallery and Museum, November 13–17, 1942; Alfred Frankenstein, "The Chinese Send Us Chang Shu-Chi," *San Francisco Chronicle*, This World, November 14, 1943, 12.

27 Chang Shu-chi lecture notes, n.d., Chang Family Collection.

28 Isamu Noguchi, "I Become a Nisei," unpublished manuscript prepared for *Reader's Digest*, ca. 1942; quotes here and below courtesy of Isamu Noguchi Garden Museum.

29 Isamu Noguchi, *A Sculptor's World* (New York: Harper and Row, 1968).

30 Noguchi was also preparing a show of his sculpture for the San Francisco Museum of Art. It would open during the summer of 1942, when he was in the Poston, Arizona, internment camp. A review of the show emphasized his mixed ancestry, describing Noguchi as "a kind of one-man melting pot"; Alfred Frankenstein, "Around the Art Galleries," *San Francisco Chronicle*, This World, July 12, 1942, 16.

31 Noguchi to McWilliams, June 11, 1942, Carey McWilliams Papers, Box 2, Letters from Evacuees, Hoover Institution Archives. Noguchi and McWilliams carried on an active correspondence; this letter is one of many between the two.

32 Amy Lyford, "Noguchi, Sculptural Abstraction, and the Politics of Japanese American Internment," *The Art*

Bulletin, March 2003, 137–151; Isamu Noguchi, "I Become a Nisei." Noguchi also published "Trouble Among Japanese Americans" for *The New Republic* 108, no. 5 (February 1, 1943): 142–143, in which he sharply criticized camp conditions and newspaper reportage about the camps. This is not to say that the war prompted Noguchi to finally resolve the conflict he felt about his racial/cultural identity. Bert Winther-Tamaki maintains that Noguchi was tormented throughout his life and that his artistic sensibilities were marked by a lifelong "oscillation between American and Japanese cultural identities"; Bert Winther-Tamaki, *Art in the Encounter of Nations: Japanese and American Artists in the Early Postwar Years* (Honolulu: University of Hawai'i Press, 2001), 110–172. Also see the biographical studies of Noguchi by Robert J. Maeda, "Isamu Noguchi: 5-7-A, Poston, Arizona," in *Last Witnesses: Reflections on the Wartime Internment of Japanese Americans*, ed. Erica Harth (New York: Palgrave, 2001), 153–166, and "Noguchi and Gorky: American Outsiders," *Amerasia Journal* 27, no. 2 (2001): 30–49. When he departed Poston, Noguchi publicly said that he was leaving on a "furlough" and had every expectation of returning in a month, unless something unforeseen "keeps me out." He also told the camp newspaper that despite the limitations of confinement, possibilities for artistic creation were in some ways greater at Poston than "on the outside." "The very limitations here have driven the people to seek materials in the distant hills for iron-wood, petrified wood, mesquite, and so forth"; *Poston Press Bulletin*, November 13, 1942, n.p. Perhaps Noguchi with his evasiveness was just trying to comfort those left behind.

33 Noguchi, "I Become a Nisei." Many years later, when he wrote his autobiography, Noguchi used similar words to describe his newfound understanding of race and his personal identity with the coming of war. Writing about Pearl Harbor, he wrote, "With a flash I realized I was no longer the sculptor alone. I was not just American but Nisei"; Noguchi, *Sculptor's World*, 25. Also see Dore Ashton, *Noguchi East and West* (New York: Knopf, 1992), 69–71.

34 Sueo Serisawa and Marsha Serisawa, CAAABS project interview, May 17, 2000, Idyllwild, CA. Transcript, Asian American Art Project, Stanford University.

35 *Seattle Post-Intelligencer*, December 27, 1941, 1; Shelley Sang-Hee Lee, "'Good American Subjects Done Through Japanese Eyes': Race, Nationality, and the Seattle Camera Club, 1924–1929," *Pacific Northwest Quarterly* 96, no. 1 (Winter 2004–2005): 24–34.

36 The story of Estelle Peck Ishigo, an accomplished watercolorist, provides unusual evidence of the effect of the internment camps on art. Ishigo, a Caucasian woman, voluntarily joined her Japanese American husband in internment. The harsh conditions ground them down. Her story is told in Steven Okazaki's poignant 1990 documentary film *Days of Waiting*.

37 Kristine Kim, *Henry Sugimoto: Painting an American Experience* (Los Angeles: Japanese American National Museum, and Berkeley: Heyday Books, 2001), 84.

38 Ibid.

39 See Kimi Kodani Hill, ed., *Chiura Obata's Topaz Moon: Art of the Internment* (Berkeley: Heyday Books, 2000).

40 Quoted in ibid., 38. An article by Obata's friend H. L. Dungan, art critic for the *Oakland Tribune*, reproduced a slightly reworded version; see "500 Students in Tanforan Art School," July 12, 1942.

41 Karin Higa, *Living in Color: The Art of Hideo Date* (Los Angeles: Japanese American National Museum, 2001), 24.

42 Timothy Anglin Burgard, "The Art of Survival: Chiura Obata at Tanforan and Topaz," in *Topaz Moon*, ed. Hill, xiii–xviii.

43 Higa, *Living in Color*, 18.

44 *Heart Mountain Sentinel*, November 28, 1942, 8.

45 *Manzanar Free Press*, April 21, 1943, 1.

46 George M. Hibi, letter dated December 9, 1944; quoted in Grace L. McCann Morley, "Foreword," *Ninth Annual Drawing and Print Exhibition, San Francisco Art Association*, January 31–February 25, 1945.

47 San Francisco Art Association, catalogs: *Sixth Annual Watercolor Exhibition*, May 6–31, 1942; *Seventh Annual Watercolor Exhibition*, March 10–April 4, 1943; *Seventh Annual Exhibition of Drawings and Prints*, March 10–April 4, 1943; *Eighth Annual Drawing and Print Exhibition*, March 1–March 19, 1944; *64th Annual Painting Exhibition*, September 21–October 15, 1944; *Ninth Annual Drawing and Print Exhibition*, January 31–February 25, 1945; and *Ninth Annual Watercolor Exhibition*, May 15–June 10, 1945.

48 Hill, ed., *Topaz Moon*, 43; and *Asia and the Americas*, October 1943, 584–585. The magazine used the paintings to accompany a major article on the camps written by

Nisei internee George Morimitsu entitled "These Are Our Parents."

49 *Jerome Tribune*, February 15, 1944, 3; and Kim, *Henry Sugimoto*, 85.

50 *Colorado Times*, March 24, 1945, 1.

51 *Colorado Times*, April 5, 1945, 1. Articles about art-related activities appeared constantly in the internment camp newspapers. In addition to noting major shows, the papers reported on small shows held at local public libraries and schools. See, for example, *Gila News-Courier*, October 28, 1942, 2; *Rohwer Relocator*, September 28, 1945, 4; and *Topaz Times*, January 22, 1944, 1.

52 *New Brunswick Times*, May 27, 1945, 9–10; *Colorado Times*, May 26, 1945, 1. In addition to works cited in other notes, see, for example, Deborah Gesensway and Mindy Roseman, *Beyond Words: Images from America's Concentration Camps* (Ithaca, NY: Cornell University Press, 1987); and Karin M. Higa, *The View from Within: Japanese American Art from the Internment Camps, 1942–1945* (Los Angeles: Japanese American National Museum, 1992).

53 "City's Japanese Show Art: Exhibit Here Revealed Several Fine Talents and Wide Interest in Local Colony," *Los Angeles Times*, December 29, 1929.

54 Karl G. Yoneda, *Ganbatte: Sixty-Year Struggle of a Kibei Worker* (Los Angeles: Asian American Studies Center, UCLA, 1983), 21–22; and Charles A. Willoughby, *Shanghai Conspiracy: The Sorge Spy Ring* (New York: E. P. Dutton, 1952), 52.

55 Chalmers Johnson, *An Instance of Treason: Ozaki Hotsumi and the Sorge Spy Ring*, expanded ed. (Stanford: Stanford University Press, 1990), 11, 92–97, 144.

56 Nomoto Ippei, *Miyagi Yotoku: imin seinen gaka no hikari to kage* (Naha, Japan: Okinawa Taimususha, 1997); and "Sunday Museum," NHK television documentary program about Miyagi, December 18, 2001. Videotape, Asian American Art Project, Stanford University.

57 Winther-Tamaki, *Art in the Encounter of Nations*, 128–129 and 1–18.

58 "Japan May Send Paintings to U.S.," *New York Times*, December 17, 1949; catalog, *Art Treasures from Japan* (San Francisco: M. H. de Young Memorial Museum, 1951).

59 Saburo Hasegawa, "Abstract Art in Japan," *The World of Abstract Art* (New York: Abstract American Artists, 1957), 69–74.

60 Jeffrey Wechsler, ed., *Asian Traditions/Modern Expressions: Asian American Artists and Abstraction, 1945–1970* (New York: Abrams in association with the Jane Voorhees Zimmerli Art Museum, Rutgers, the State University of New Jersey, 1997), 153–154; Saburo Hasegawa, Biographical Folder, Oakland Museum of California.

61 See, for example, "'The 47 Ronin': The Most Popular Play in Japan Reveals the Bloodthirsty Character of Our Enemy," *Life* 15, no. 18 (November 1, 1943): 52–56.

62 See the essay by Mayching Kao in this volume.

63 Brenda Morrison, *S. C. Yuan* (Carmel, CA: Carmel Art Association, 1994).

64 Gruskin and Saroyan, *The Watercolors of Dong Kingman*, 30–38. Also see Gordon H. Chang, "America's Dong Kingman—Dong Kingman's America," in *Dong Kingman in San Francisco*, by Chinese Historical Society of America (San Francisco: Chinese Historical Society of America, 2001), 20–24.

65 See the essay by Paul Karlstrom in this volume.

66 "Chinese and Japanese Artists" and "Flag Waving vs. Art," *Art Front* 3, no. 7 (October 1937): 3, 4, 22.

67 Haru Matsui (Ayako Ishigaki), *Restless Wave: An Autobiography* (New York: Modern Age Books, 1940).

68 Discussion with Mr. Okumura, curator of the Wakayama Museum, July 30, 2005.

69 See K. Scott Wong, *Americans First: Chinese Americans and the Second World War* (Cambridge, Mass.: Harvard University Press, 2005), 193–209.

70 Dorothy Bryant, "The Suzuki Odyssey," *Berkeley Daily Planet*, February 1, 2005.

71 Cynthia A. Charters, "A Biographical Sketch," in *Carlos Villa: Selected Works, 1961–1984*, by Carlos Villa (Davis, CA: Memorial Union Art Gallery, University of California, Davis, 1985).

72 See Wechsler, *Asian Traditions*, and Winther-Tamaki, *Art in the Encounter of Nations*.

73 See the essay by Margo Machida in this volume.

The Wind Came from the East

Asian American Photography, 1850–1965

Dennis Reed

Photography has been a part of the Asian American experience from the beginning—the beginning of Asian immigration to the United States, and nearly the beginning of photography itself.[1]

When Chinese immigrants began settling in San Francisco during the 1850s, many had their portraits taken at studios run by Caucasians. Within a surprisingly short time, however, Chinese proprietors opened their own studios in Chinatown to serve the growing Chinese population.[2] One such photographer, Ka Chau, opened a portrait studio in San Francisco in 1854, a mere fifteen years after the invention of photography.[3]

Amateur photographers were also active before 1890, which is even more surprising, given the considerable expense and leisure time required. **Mary Tape** and Wong Hong Tai each photographed street scenes and took portraits during the 1880s. She worked with dry plates of her own making and used a camera lens made by Wong, who was an avid inventor as well as a photographer.[4]

Over the ensuing years, numerous Asian-owned studios—amateur and commercial—were established in Chinatown and other Asian American communities. One of the most prominent enterprises was San Francisco's **May's Photo Studio**, which opened in 1923. Among the studio's specialties were large photographs of Chinese opera stars. These photographs were used for handbills or marquees. Many are striking works, often hand-painted, with glitter applied to simulate sequins on the opera singer's gown (fig. 113).[5] While these were commercial works, the artistry is undeniable.

Among the most interesting photographs made by May's Photo Studio are "composite" portraits, such as the one of a Chinese man shown seated in front of a hand-painted Chinese backdrop (fig. 114). Two additional portraits, one of a Chinese woman and the other a Chinese boy, have been glued into the scene to the right of the original sitter. The initial portrait was composed in such a way that the sitter (or the photographer) was able to paste in photographs sent from China of the sitter's wife and son. All of the figures appear before a backdrop painted in Eastern themes. The immigrant man wears a Western suit and tie, a sweater vest, and wingtip shoes, while his pasted-in

FIG. 113 May's Photo Studio, *Untitled (Seated Actress with Fan)*, 1923. Hand-colored photograph with applied glitter, 30¾ × 20½ in.

wife is clothed in traditional Chinese attire. The boy, who is standing, is dressed in a Western coat and tie, but his footwear is Chinese. The boy dutifully holds a book.[6] The resulting photographic montage is poignant, intriguing, and complex.

This photograph serves as an introduction to the mixture of cultural traditions, social practices, and visual conventions that inform many of the photographs made by Asian Americans. It suggests larger issues, often conflicting, that affect all new immigrants, Asian or non-Asian. How does one assimilate into a new culture? Does one retain and honor one's heritage? How does one do so? Subsequent generations, born in the United States, confronted

their own challenges of navigating the often unfamiliar world of their immigrant parents or grandparents while dealing with a larger society that too frequently assumed them to be immigrants also. To varying degrees, evidence of these complex issues, faced by Asian immigrants and their offspring, is present in all types of photographs, including community pictures, commercial portraits, and those made as art.

Whether we were born in America or not,
we were all immigrants. —VICTOR WONG[7]

Benjamen Chinn and **Charles Wong** enrolled in a new photography program started by Ansel Adams in 1946 at the California School of Fine Arts. Chinn was a member of the first class, and Wong joined in 1949. The three-year program was one of the first to teach

FIG. 114 May's Photo Studio, *Untitled (Family Portrait)*, ca. 1930. Montage of two gelatin silver prints, 8 × 10 in.

fine-art photography within the context of a college art curriculum. Students received extensive technical training and benefited from a faculty who emphasized aesthetics. Faculty members included photographer Minor White and artists Dorr Bothwell and Mark Rothko. Imogen Cunningham and Dorothea Lange were among the guest lecturers, and there were frequent trips to visit Edward Weston in Carmel.

As a part of the program, Chinn and Wong photographed the place of their births, San Francisco's Chinatown. Both grew up during a time when life within Chinatown remained distinct from that of the rest of San Francisco (and most of the United States), but the confines of its borders were lifting. Their experiences within—as well as outside—Chinatown gave them a unique perspective, that of members of the community rather than outsiders.

From its inception, Chinatown has been the subject of photographs, usually taken by nonresidents. In the nineteenth century, Isaiah West Taber and Carlton Watkins were among the photographers to document the early scenes of Chinatown. Arnold Genthe, who photographed the area from about 1897 until 1911, remains one of the best-known photographers of Chinatown. Genthe's pictures are interpretive art rather than documentation, with details altered significantly—sometimes he removed entire figures, often Caucasian, to simplify a composition and portray a culture of quaint mystery. Genthe's images often say more about his own conceptions than they do about Chinatown and its people.

Countless tourists, cameras in hand, have traversed the streets of Chinatown, as if it were a foreign land, in search of the exotic and forbidden. Rarely has Chinatown been photographed skillfully, for the sake of art, by one of its own residents—by someone who knows Chinatown close up, as the site of home and work and day-to-day life. The photographs of Chinn and Wong filled that gap. Their work explores many of the same subjects and themes: the

dignity of Chinatown's residents, the differences between the generations of old and new Chinese, and the coexistence and interweaving of Chinese and American cultures. These themes came directly from their personal experiences.

Chinn and Wong were teenagers and young adults in the Chinatown of the 1930s and 1940s, a period that has been lamented for its "theme park features" of "piled on sinocized details" catering evermore to tourists' expectations.[8] Midcentury Chinatown was a battlefield of opposing cultural forces, many of them represented visually through such things as dress, advertising signs, and cultural customs. It was a conflicting and complicated world, one that was increasingly a commercialized tourist destination, but it was also a place where the Chinese cultural heritage was held dear and celebrated in a variety of ways, such as holiday and religious rituals. Writer Anthony Lee describes the period as replete with "the in-betweenness of cultures."[9] This in-betweenness is central to the photographs of both Chinn and Wong.

When issues of in-betweenness are evident in Chinn's work, they are present because they are manifest in the subject itself. For example, in one of Chinn's photographs, three men are reading the Chinese financial news taped on the window of the Bank of America (fig. 115). The commingling of cultures is clear but not artificially manufactured by Chinn. He photographed a commonplace occurrence that was a part of his everyday life. The duality is present in the photograph because of the inherent nature of Chinatown.

Wong's work was consciously based on social and political concerns. If those issues are not immediately apparent in an individual print, they are evident in the portfolio he produced as a result of winning, in 1951, the first Albert Bender Memorial Trust Grants-in-Aid offered in photography. Entitled *The Year of the Dragon—1952*, the portfolio is a per-

FIG. 115

Benjamen Chinn, *People Reading Financial News at Bank of America, 933 Grant Avenue*, 1947. Gelatin silver print, 4⅝ × 3⅝ in.

sonal reflection, a social document, and a political indictment (fig. 116). The portfolio contains fifty-two photographs, primarily street scenes suggesting social and political concerns that are made more specific by artfully placed verse that ends in a political commentary about an alleged Chinese Communist extortion racket being played upon Chinese Americans at the time. Wong asks in his text, "How much could a man pay a blackmailer for the safety of his family still in China? Would there be enough money?"[10]

Chinn's and Wong's work reflects their academic training, but their photographs still reveal Chinese artistic influences. A fine example is Wong's *Merry-Go-Round*, from *The Year of the Dragon* (fig. 117). The two vertical poles divide the space into a triptych of three panels, thereby recalling a Chinese folding screen. The space between the middle and right panels becomes noncontinuous, creating a spatial ambivalence that violates Western linear perspective. This visual structure contributes to the issue of cul-

tural duality seen most clearly in the central figure of a Chinese girl in bobby sox and saddle shoes.

The themes explored by Wong and Chinn have been carried on by **Irene Poon**, another first-generation Chinese American born in Chinatown some two decades after Wong and Chinn. Her *Memories of the Universal Café*, with its large areas of impenetrable blacks and floating forms, is full of mystery and disorientation (fig. 118). Poon is fundamentally a street photographer. Her work explores the richness of living in a culture within a culture, and the need to explore one's identity and to find individual respect.

BEFORE 1965, THE MAJORITY of Asian immigrants who came to California were from China or Japan. But Japanese immigrants took up photography in far greater numbers than did their Chinese counterparts. Some opened commercial studios. Others made their living in unrelated jobs while pursing photography as an avocation.

During the early 1920s, Japanese-language

144

FIG. 116 Charles Wong, *Dragon*, 1952. Gelatin silver print, 13¼ × 10½ in.

FIG. 117 Charles Wong, *Merry-Go-Round*, 1952.
Gelatin silver print, 9¼ × 7⅝ in.

newspapers sponsored photographic competitions in Los Angeles and San Francisco. In Seattle, a local department store, Frederick & Nelson, organized competitive exhibitions for photographers (called salons) beginning in 1920.[11] Encouraged by these competitions, Japanese Americans formed camera clubs in all of these cities.

The Seattle Camera Club was founded in 1924.[12] It was part of an active Asian American arts community that included writers, musicians, painters, actors, and dancers. Often, these artists were the subject of photographs by club members, as was Seattle's lush scenery (see Kazuko Nakane's essay, figs. 53 and 51).

The Seattle Camera Club published a bulletin entitled *Notan*. The name refers to the Japanese characters for *light* and *shade*. The publication chronicled the club's activities and the many locations worldwide where members' photographs were exhibited. One 1926 issue of *Notan* records the club leader, Kyo Koike, a medical doctor by profession, exhibiting sixty-one photographs in twenty-two exhibitions, mostly in foreign countries. Fellow club member Frank Kunishige did even better, showing seventy-three prints in twenty-four salons during the same year.[13]

Members of the Los Angeles club, the Japanese Camera Pictorialists of California (JCPC), exhibited widely as well.[14] The JCPC first met in a Buddhist temple in 1923 and was formalized as a club three years later. They maintained rooms for meetings and critiques, set up darkrooms for processing and printing their work, and went together on excursions to parks, mountains, and beaches, often photographing the same subject (fig. 119). They organized an annual salon beginning in 1926, and they exhibited widely in international salons, producing many of the finest examples of Japanese American photography (figs. 120–123, 126–129). Unfortunately, they produced no newsletter and left little documentation other than their annual salon brochures.[15]

Documentation about the Japanese Camera Club of San Francisco is even more scarce. They were

FIG. 118 Irene Poon, *Memories of the Universal Café*,
1965. Gelatin silver print, 8½ × 7½ in.

FIG. 119
Kentaro Nakamura, *Untitled
(Japanese Camera Pictorialists
of California)*, 1929. Photograph,
7¾ × 9¾ in.

a large group, though their works were exhibited less frequently than those of members of the clubs in Seattle and Los Angeles. An exception was Frank Y. Sato, a club member and officer who did show his work frequently, but little else is known about him (fig. 124).

Some photographers did not belong to or associate with camera clubs. One such photographer was Akira Furukawa (fig. 125), who lived in Hawaii and worked in relative isolation. But this solitariness was the exception to the rule, as most Japanese American photographers were club members.

That Japanese Americans chose to work in such groups is not surprising. Japanese emigrants formed extensive organizations of all kinds upon their arrival in the United States. Undoubtedly, this tendency was a result of the highly organized social and cultural life in Japan. In more practical terms, traveling as a group during excursions provided protection from anti-Japanese sentiments among the general population—sentiments that were clearly evident in the quota restrictions passed in the 1924 Immigration Act that virtually halted all Japanese immigration to the United States.

The Japanese photography clubs were typical of a movement called pictorialism, which began in the 1890s and continued until at least World War II. Pictorialists believed that photographs could convey

personal expression and thus could be art. Toward this end, pictorialists pursued the subjective rather than the objective. That is, they used photography to convey their emotions, not to depict objective reality. Beauty was their ultimate goal. They often sought out subjects that they regarded as romantic and picturesque, rendering them in moody, soft-focus prints. The style was important to the development and acceptance of photography as art, but over the years much of the pictorial style became stilted and codified.

The Japanese in America worked within this tradition while adding an entirely new viewpoint. Their subjects were often those of traditional Japanese art. Nature, especially water, was favored. Sources of inspiration included the economy of haiku, the design of flower arranging, the precision of tea ceremony, and the patterns and shapes used in textiles, as well as the structure drawn from Japanese painting and woodblock prints. Photography provided Japanese Americans with a way to embrace and extend the artistic heritage they knew and treasured.

In composing their photographs, Japanese Americans employed the visual language of their homeland. This visual vocabulary included aerial perspective, bold geometric shapes, striking patterns and shadow elements, asymmetrical compositions, and, on occasion, tall scroll-like formats, all of which

FIG. 120 Kaye Shimojima, *Edge of the Pond*, ca. 1928. Gelatin silver bromide print, toned, 13⁷⁄₁₆ × 10½ in.

FIG. 121 Ichiro Itani, *Eel Fisherman*, 1932. Bromide print, 11 × 13¾ in.

FIG. 122 I. K. Tanaka, *Asa Giri*, ca. 1930. Bromide print, 9¹¹⁄₁₆ × 12½ in.

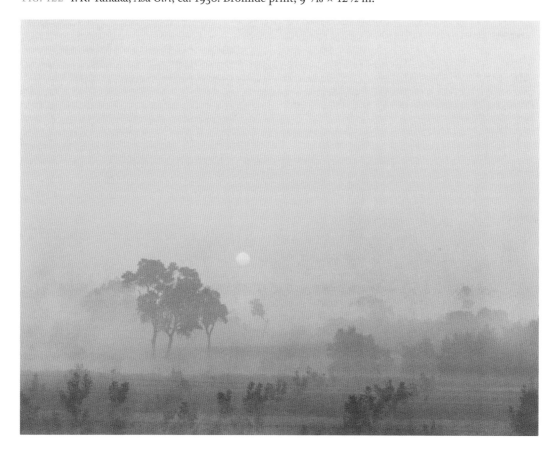

FIG. 123 Shinsaku Izumi, *The Shadow*, ca. 1931. Bromide print, 10¼ × 13¼ in.

resulted in a sophisticated, distinctive two-dimensional decorative style. To provide a flat backdrop for this decorative style, they often photographed against a wall, thereby creating a flat area roughly parallel to the picture plane. Or, to accomplish the same end, they tilted their cameras downward toward a flat surface, which also caused the horizon line to lift up out of the picture.

Some conservative critics found the Japanese American decorative style objectionable. An English critic, F. C. Tilney, warned American photographers who had begun to emulate Japanese Americans against this influence. He wrote:

Why should American photographers try to work on the same principle, getting up to high viewpoints and pointing down to ground shapes, foamlines, seawalls that make diagonals from corner to corner of a print? These things are neither good Japanese nor good American art. They are bastard trifles.[16]

The work of the Japanese Americans did not fit comfortably within what Tilney understood to be the proper limits of pictorial photography. He saw their work as representing a foreign intrusion, depicting unacceptable subjects and being composed from odd, high angles. He referred to their work as "stunts."[17]

While Tilney believed that the Japanese decorative style was an affront to the conventions of pictorialism, most pictorialists welcomed the work of the Japanese Americans. Photographs by them were published internationally. From 1925 through the early 1930s, many issues of American photography magazines featured at least one example of their work. In addition, reproductions of their photographs were published in Germany, Japan, England, and France. This was particularly true of signature works by

FIG. 124
Frank Y. Sato, *Tree and Steps*,
ca. 1930. Bromide print,
13⁵⁄₁₆ × 10¼ in.

members of the JCPC, such as *Evening Wave*, by Kentaro Nakamura, and *Reflections on the Oil Ditch*, by Shigemi Uyeda, which were reproduced more than once (figs. 126 and 127). Both appeared in *Soviet Foto*, for example. So pervasive was the work of the Japanese Americans that the editor of *The American Annual of Photography* wrote in 1928, "The influence of this group on our Pacific coast has put a lasting mark on photography in this country, the repercussions of which are echoing throughout the world."[18]

This influence extended beyond the world of club photography. New York street photographer Helen Levitt once described visiting an exhibition of the Pictorial Photographers of America. She was impressed with a "picture of a wave" by a Japanese photographer.[19] The print was almost certainly Na-

kamura's *Evening Wave*, which was included in the 1929 *Pictorial Photography in America* publication and in a subsequent traveling exhibition sponsored by the Pictorial Photographers of America.

Modernist László Moholy-Nagy, who had recently immigrated to the United States, reproduced Uyeda's *Oil Ditch* in his 1938 book, *The New Vision*.[20] Moholy-Nagy used Uyeda's image as an example of a modernist vision—the machine-age world of geometric forms and repetition seen from new points of view. Indeed, Japanese design paralleled many of the visual devices of the European avant-garde, such as the use of bird's-eye view, diagonal composition, and repetition.

A number of the Japanese American photographers in Los Angeles were modernists, even while

FIG. 125
Akira Furukawa, *Untitled
(Faucets, Beaker, Mortar and
Pestle)*, ca. 1930. Bromoil print,
9^{11}/$_{16}$ × 7^{7}/$_{8}$ in.

working within the pictorialist movement. JCPC members J. T. Sata, A. Kono, and **Hiromu Kira** each created abstract works that are more modern than pictorial (figs. 128 and 129). Kira, who was associated with the club but not a member, produced a number of photographs with abstracted backgrounds of geometric and art-deco shapes (fig. 130).[21] He also made elegant studies of glassware whose cool formalism is similar to that of the New Objectivity movement of Germany during the 1920s (fig. 131).

But where did such modernist notions come from? Japanese Americans were familiar with European and Japanese publications, of course. More importantly, in Los Angeles, Japanese American photographers benefited from a vital community of modernists: architects, painters, writers, and intel-

lectuals, many brought to Los Angeles, directly or indirectly, by the movie industry.[22]

Kira's modernist ideas were fueled by exhibitions of Edward Weston's work, which were held in Los Angeles's Little Tokyo in 1925, 1927, and 1931.[23] Included in these shows were photographs done after Weston had disowned pictorialism in favor of what is known as straight photography, a time during which Weston was producing his now famous still-life images of nudes, shells, and fruit. These shows had a great impact on the area's Japanese Americans. For example, after seeing the 1927 exhibition, Kira began to produce his modernist series of paper bird and glassware photographs.

Other individuals, many of whom were also associated with Weston, were connected to the Japanese

FIG. 126 Kentaro Nakamura, *Evening Wave*, ca. 1927. Gelatin silver print, 12½ × 10⅛ in.

FIG. 128
J. T. Sata, *Untitled (Portrait)*, 1928.
Gelatin silver print, 19⅞ × 15¾ in.

photographic community in Los Angeles. Painters Henrietta Shore and Peter Krasnow attended at least one of Weston's shows in Little Tokyo. Photographers Margrethe Mather and Will Connell were each closely associated with the Los Angeles Japanese and juried exhibitions of their photography. Bookstore owner Jake Zeitlin, impresario Merle Armitage, architect Lloyd Wright, and designer Kem Weber were among the close associates of both Weston and Connell and were acquainted with Japanese American photographers. Karl Struss, the former member of the Photo-Secession, collected the work of the Los Angeles Japanese American photographers.

The exhibitions of Weston's work in Little Tokyo had been arranged by **Toyo Miyatake**. Like Kira, he was associated with the JCPC, though he was not a member. Miyatake belonged to another group, the Shaku-do-sha, an affiliation of Japanese intellectuals, artists, and poets who were interested in modern ideas (see Karin Higa's essay for more information).

Miyatake's photography was influenced by Weston, and by another important member of the Los Angeles art community, the dancer Michio Ito. Ito settled in Los Angeles in 1929 and taught Miyatake about theatrical lighting and movement. Miyatake subsequently produced a series of dynamic, abstract studies of light and motion that are among the most modern photographs done in Los Angeles before World War II (fig. 132).

Historians have generally dismissed pictorialists as being backward-looking, overly sentimental, and out of step with the forward march of modernism. This description is not true of all pictorialists. It is certainly not true of the Japanese Americans who worked in Los Angeles. In fact, no other

FIG. 129
A. Kono, *Perpetual Motion*,
1931. Toned bromide print,
12 × 10⅜ in.

FIG. 130
Hiromu Kira,
The Thinker, ca. 1930.
Bromide print,
10¼ × 13¼ in.

FIG. 131 Hiromu Kira, *Curves (Glass Circles)*, ca. 1930. Photograph, 13⅝ × 8⅝ in.

FIG. 132 Toyo Miyatake, *Untitled*
(*Light Abstraction*), 1936.
Bromide print, 13 × 10¼ in.

photographic collective formed by immigrants from a single nation—Asian or non-Asian—attained the level of artistic accomplishment and influence achieved by the group of Japanese Americans who worked in Los Angeles.

Sadly, much of the achievement of the Japanese American photographers was lost amid the hysteria that followed the bombing of Pearl Harbor. Many works by club members were destroyed during the relocation of Japanese Americans. Cameras were confiscated or surrendered to local authorities, which was required of those of Japanese ancestry, including those born in the United States.

Even so, a few Japanese Americans continued to photograph. **Jack Masaki Iwata** was a photographer who had been employed by Miyatake before the war (and later would be the only Japanese American to officially photograph the Academy Awards). He

and Miyatake documented the systematic removal of Japanese Americans from their community in Los Angeles (fig. 133).

Once relocated, internees managed to photograph within the confines of the camps. Miyatake smuggled into the Manzanar Relocation Center a lens and film holder that he used to construct a makeshift camera. Sympathetic camp officials allowed him to use the camera and, later, arranged to have his regular equipment sent to him from storage. Miyatake, Iwata, and others were instrumental in establishing a photography studio at Manzanar. Eventually, photographic exhibitions were held within the camp.[24] Photography was allowed at other camps as well, including Heart Mountain and Tule Lake.[25] When Iwata was transferred to Tule Lake from Manzanar, he was assigned by the assistant director to make a photographic record of camp life.

FIG. 133 Jack Masaki Iwata,
Bird's-eye view of the
Nishi Hongwanji Buddhist
Temple, Los Angeles, as
Japanese Americans are
subjected to forced removal
and incarceration, 1942.

Prior to the war, Japanese American photographers typically did not explore social issues in their art, as the Chinese Americans Chinn and Wong did later. In fact, when figures did appear in photographs by Japanese Americans, they generally were placed for compositional counterpoint rather than for social or personal insight. This is true even though the lives of Japanese Americans were as much a mixture of two cultures and filled with as many strange ironies as the lives of Chinese Americans.

This limited engagement with social issues changed with the relocation. The images Japanese Americans made during their incarceration are invaluable documents of the conditions of camp life and the indomitable spirit of those interned.[26] Miyatake's images, in particular, depict the humiliations, ironies, and touching personal moments in the lives of the internees. His photographs demonstrate a sense of community, and sometimes a feeling of quiet isolation (fig. 134).

FIG. 134
Toyo Miyatake,
Manzanar, ca. 1944.
Gelatin silver print,
4⅜ × 6⅜ in.

WHILE THE MAJORITY of Asian American photographers were located on the Pacific Coast, particularly in California, other areas of activity existed. Harry K. Shigeta, for example, had been an early member of the Los Angeles community before moving to Chicago in 1924, where he opened a commercial studio that is still in business (see Karin Higa's essay, figs. 29 and 30). In Chicago, he joined the Fort Dearborn Camera Club, where he continued his pictorialist work. **Chao-chen Yang** attended classes at the Art Institute of Chicago from 1935 to 1939 and then relocated to Seattle, where he pursued a career as a photographer (see Kazuko Nakane's essay, figs. 54 and 55). Soichi Sunami worked in New York making photographic copies of artwork for the Museum of Modern Art. He also photographed still lifes

and many of the famous dancers who came through the city.

For some Asian Americans, making art was not the primary motivation for taking up photography. Some photographers chose to document their communities. **George Lee**, for example, portrayed the aging men of Santa Cruz's Chinatown. His subjects represent the last vestiges of a generation that came to California for prosperity but found instead harsh work and racism (see p. 499). **Frank A. Mancao** documented the daily life—family picnics, gambling, funerals—of the Filipino community in Reedley, California, of which he was a part (see p. 495). In San Francisco, **Kem Lee** operated several studios and worked as a photojournalist. He was hired so frequently to photograph the events of Chinatown that he was referred to as its "official photographer" (fig. 135).

James Wong Howe, the Academy Award–win-

FIG. 135 Kem Lee, *Man Walking in Chinatown*, ca. 1950. Photograph, dimensions unknown.

ning cinematographer of *Hud* and *The Rose Tattoo*, created still photographs throughout his life. Many of his early works are rendered in a soft-focus, romantic style. He was influenced by Karl Struss, who won the first Oscar in cinematography for the 1929 film *Sunrise*.[27] Howe made portraits of actors and artists, and he photographed possible film locations (fig. 136). In 1944, he was commissioned by *Look* magazine to photograph San Francisco's Chinatown.[28] (See Gordon Chang's essay for more information.) Howe brought a gifted eye and sympathetic view that resulted in artful documentation, done before Chinn or Wong (although Howe was not a native of Chinatown, as were they).

For those prospective photographers who wished to make art with their cameras, learning their craft usually required joining camera clubs, reading how-to publications, apprenticing to commercial photographers, or enrolling in schools that dealt primarily with technical issues. This situation began to change during the 1930s, when photography programs were developed that emphasized aesthetics and encouraged experimentation, such as programs at the Art Center School of Design (1930) in Los Angeles and the New Bauhaus (1937) in Chicago.[29] This change accelerated after World War II when former servicemen (and a few women) took advantage of the GI Bill to study photography. In addition to joining camera clubs, many of the most promising young photog-

FIG. 136 James Wong Howe, *6th Ave. New York at 5:30am Nov. 1956—Taken from my hotel window*, 1956. Gelatin silver print, dimensions unknown.

raphers enrolled in these new programs, including one at the California School of Fine Arts and, later, university programs.[30] These schools were important centers of activity and influence beyond the camera club tradition.

Asian Americans, such as Chinn and Wong, were among these students, as was Yasuhiro Ishimoto. He had been interned in the Granada Relocation Center in Amache, Colorado, during the war years. After his release, he joined the Fort Dearborn Camera Club, but, in 1948, he enrolled in the New Bauhaus, which by then was known as the Institute of Design.[31] The school had been founded by László Moholy-Nagy and modeled after the famed Bauhaus of Germany. Its curriculum emphasized design, problem solving, and experimentation.[32] Ishimoto's work during this period is in keeping with that done at the institute—

experimental or Chicago-style street photography (fig. 137). He was regarded as one of the institute's most talented students, and his work is among the most interesting done by any Japanese American. His influence in the United States was limited, however, by his move to Japan in 1953, where he had studied as a young man.[33] In Japan, where he currently lives, he has been named a "Person of Cultural Merit."

Painters and sculptors sometimes employed photography for expressive purposes. **Yasuo Kuniyoshi**, the highly regarded postsurrealist painter, made photographs during the 1930s (before he surrendered his camera to wartime authorities). Instead of the large-format cameras typically used by camera club members, Kuniyoshi used one of the new small-format 35mm cameras, which offered him the opportunity to experiment with visual ideas as quickly

FIG. 137

Yasuhiro Ishimoto, *Untitled*, 1949–1950. Gelatin silver print, 8¼ × 8 in.

as they came to him. Like those of the Los Angeles Japanese American pictorialists, Kuniyoshi's photographs often employed modernist formal elements, such as diagonal compositions, long shadows, and bird's-eye viewpoints. Many of his photographs appear compositionally haphazard, with figures truncated at the edge of the picture frame. They have a decidedly European feel (fig. 138). The spontaneity in his work is not seen in the carefully studied photographs of the pictorialists, and, unlike most Japanese American pictorialists, people were his primary subject.[34]

Isamu Noguchi, certainly the best-known Asian American artist, also made photographs as a minor part of his oeuvre. His aesthetic foundation having been influenced by European modernism through his studies with Constantin Brancusi, Noguchi had become disenchanted with the New York art world that was busy establishing a new American art. He sought to reinvigorate his vision by exploring other cultures, including that of Japan, his own heritage.

His photographs are the result of twice traveling the world between 1949 and 1956, financed by a Bollingen Foundation Fellowship.

While a few Asian Americans artists, such as Noguchi and Kuniyoshi, were embraced by the world of mainstream art galleries and museums, entrée into the upper reaches of the art world would have seemed all but impossible to most Asian Americans. This hard truth holds particularly for those who were photographers. Few museums collected photography during the years of the mid-nineteenth century to the mid-twentieth. Museums did host pictorialist salons, but few organized exhibitions as we think of them today—exhibitions selected by a curator to explore a particular theme or to celebrate the work of a particular photographer. Moreover, few commercial galleries showed photography regularly.[35]

Works by Asian Americans were occasionally included in major museum exhibitions. Tosh Matsumoto is a good example. While interned at the

FIG. 138

Yasuo Kuniyoshi, *Woman in a Crowd*, ca. 1937. Gelatin silver print, 7 3/16 × 9 3/8 in. Art © Estate of Yasuo Kuniyoshi/Licensed by VAGA, New York, NY.

FIG. 139 Tosh Matsumoto, *Untitled (Children Playing with Ball)*, ca. 1947–1951. Gelatin silver print, 5½ × 8⅜ in.

Granada Relocation Center, he borrowed a camera from a fellow internee, and he made a makeshift enlarger from another old camera. With these, he taught himself the basics of photography. After his release, he traveled to New York, where he photographed the celebration in Times Square on VJ Day. He stayed in New York and supported himself doing laboratory work in the fashion studio of John Rawlings. In his off-hours, he made photographs for personal expression. The predominant theme of his photographs is the presence of people, often seen indirectly through the details of their lives. His work was admired by Edward Steichen, who included it in three exhibitions at the Museum of Modern Art (fig. 139).[36]

For most Asian American photographers, when some degree of recognition was received, it was short lived. The work of Charles Wong, for example, was published in *Aperture* and *U.S. Camera*, and his work was included, along with that of Benjamen Chinn, in an exhibition called *Perceptions* at the San Francisco Museum of Art in 1954.[37] But Wong and Chinn ceased actively exhibiting shortly thereafter, and their photographs have been forgotten until recently. Such has been the unfortunate fate of most Asian American photography created before 1965.

Notes

1 "The wind came from the East," quoted from Charles Wong, *The Year of the Dragon—1952*, a portfolio of photographs and text housed at the San Francisco Art Institute library, n.p.

2 Anthony Lee, *Picturing Chinatown: Art and Orientalism in San Francisco* (Berkeley: University of California Press, 2001), 29. Also see Peter E. Palmquist, "In Splendid

Detail: Photographs of Chinese Americans from the Daniel K. E. Ching Collection," in *Facing the Camera: Photographs from the Daniel K. E. Ching Collection* (San Francisco: Chinese Historical Society of America in joint sponsorship with Asian American Studies Department, San Francisco State University, 2001) 8–17. It is surprising that prejudice did not preclude Caucasian

photographers from accepting Chinese sitters, but competition was fierce among area photographers. Perhaps commercial necessity overcame the prevailing atmosphere of prejudice.

3 Ibid.

4 "Our Chinese Edison," *San Francisco Examiner*, August 4, 1889, 10.

5 Irene Poon Andersen, Mark Johnson, Dawn Nakanishi, and Diane Tani, *With New Eyes: Toward an Asian American Art History in the West* (San Francisco: Art Department Gallery, San Francisco State University, 1995), 38.

6 Photograph from the George C. Berticevich Collection. The author wishes to extend his gratitude to Mr. Berticevich for the opportunity to review his collection and for his insights into the work.

7 Victor Wong, "Childhood 1930's," in *Ting: The Caldron, Chinese Art and Identity in San Francisco*, ed. Nick Harvey (San Francisco: Glide Urban Center, 1970), 24.

8 Lee, *Picturing Chinatown*, 251.

9 Ibid., 285.

10 Wong, *Year of the Dragon*, n.p.

11 Kazuko Nakane, "Interweaving Light with Shadow: Early Asian American Photographers in the Pacific Northwest," in *They Painted from Their Hearts: Pioneer Asian American Artists*, ed. Mayumi Tsutakawa (Seattle: Wing Luke Asian Museum/University of Washington Press, 1994), 53.

12 It was the only Japanese photographic group to include Caucasian photographers among its members.

13 *Notan*, no. 33 (1927): 5; see also Robert Monroe, "Light and Shade: Pictorial Photography in Seattle, 1920–1940, and the Seattle Camera Club," in *Turning Shadows into Light*, eds. Mayumi Tsutakawa and Alan C. Lau (Seattle: Young Pine Press, 1982), 18–20. The list was topped by two others: Hideo Onishi, who exhibited an astounding 122 prints in 27 salons; and Y. Morinaga, who showed 85 prints in 22 salons.

14 The club was originally known as the Japanese Camera Pictorialists of Los Angeles. They inexplicably changed the location in their club name to "California" in the second year, even though all of the members were from the Los Angeles area.

15 Other than period literature, information on the club and area photographers came from interviews with photographers Harry Hayashida, Ichiro Itani, Kaneshige Kato, Hiromu Kira, Kango Takamura, and George Sayano beginning in 1981; and with the families of Shinsaku Izumi, Shigemi Izuo, Ryoji Kako, Hiseo Kimura, Tadazo Mukai, James Tadanao Sata, Thomas Koryu Shindo, Kango Takamura, and Shigemi Uyeda, also beginning in 1981; and with Hiroshi Namadzue in 1983.

16 F. C. Tilney, "American Work at the London Exhibitions," *American Photography* 21 (1927): 666–668.

17 Ibid.

18 Frank R. Frapie, ed., "Our Illustrations," *The American Annual of Photography, 1928*, vol. 42 (New York: American Photographic Publishing Company, 1927), 136.

19 Maria Morris Hambourg, "Helen Levitt: A Life in Part," *Helen Levitt* (San Francisco: San Francisco Museum of Modern Art), 47.

20 The version of *Oil Ditch* reproduced in *The New Vision* is a variant of the one reproduced herein.

21 Kira had been a founding member of the Seattle Camera Club before moving to Los Angeles.

22 A more complete understanding of the Los Angeles art scene during the 1920s and 1930s has only begun to emerge recently. See Victoria Dailey, Natalie W. Shivers, and Michael Dawson, *LA's Early Moderns: Art/Architecture/Photography* (Los Angeles: Balcony Press, 2003).

23 Previous histories—Ben Maddow's *Edward Weston: Fifty Years*, Amy Conger's *Edward Weston: Photographs*, and this author's *Japanese Photography in America, 1920–1940*—have claimed that an exhibition of Weston's work was held in Little Tokyo in 1921. Amy Conger was the first to revisit this notion and to call it into question. At this point, it seems prudent to dismiss the idea of a 1921 show as an unfortunate misunderstanding.

24 Archie Miyatake, Toyo's high-school-age son, also photographed at Manzanar. Hiseo Kimura, one of the former members of the Japanese Camera Pictorialists of California, worked in the photography lab at Manzanar.

25 Ryoji Kako photographed at Heart Mountain, for example.

26 Photographs of the relocation and camp life were also made by non-Asians, such as Dorothea Lange, Ansel Adams, Clem Albers, and Russell Lee. Bob Nakamura, who was interned at Manzanar as a child, returned later to photograph the camp site.

27 Struss shared the award with Charles Rosher.

28 "Chinatown, San Francisco: James Wong Howe focuses his searching lens on his people in America," *Look*, December 26, 1944, 22–27.

29 There is evidence that the Art Center program began in 1930—see Michael Dawson, "South of Point Lobos," in *LA's Early Moderns: Art/Architecture/Photography*. The college itself uses the date of 1931. The experimental work done at the Art Center School during the 1930s and 1940s has not been fully appreciated by critics and writers, with the exception of Leland Rice—see "Los Angeles Photography: c. 1940–1960," *LAICA Journal* 5 (1975): 28–37.

30 Most college and university art photography programs were created after 1965, a period beyond this study's consideration.

31 David Travis and Elizabeth Siegel, eds., *Taken by Design: Photographs from the Institute of Design, 1937–1971* (Chicago: The Art Institute of Chicago in association with The University of Chicago Press, 2002), 240.

32 The school previously had two other names, first the New Bauhaus and then the School of Design.

33 He also returned to the United States for two years. The author wishes to thank Colin Westerbeck for his assistance.

34 See Tom Wolf, "Kuniyoshi as Photographer," in *Yasuo Kuniyoshi* (Tokyo: Tokyo Metropolitan Teien Art Museum, 1989), and *Yasuo Kuniyoshi: Artist as Photographer* (New York: Bard College and the Norton Gallery and Art School, 1983).

35 Early galleries that exhibited photographs included Alfred Stieglitz's galleries (The Little Galleries of the Photo-Secession, later known as Gallery 291, Anderson Galleries, the Intimate Gallery, and An American Place), Helen Gee's (second wife of Yun Gee) Limelight Gallery, and Julian Levy's gallery. None are known to have shown the work of Asian American photographers.

36 Keith Davis, *An American Century of Photography: From Dry Plate to Digital: The Hallmark Photographic Collection*, 2nd ed. (Kansas City, MO: Hallmark Cards, Inc.), 285–286, 313. Additional biographical information was provided in interviews with Matsumoto and Tom Jacobson, August 2005. Matsumoto's debut exhibition was *In and Out of Focus* in 1949.

37 Chinn's and Wong's work was shown in 1954 in the *Perceptions* exhibition at the San Francisco Museum of Art, which included the work of many of the area's best-known photographers: Ansel Adams, Wynn Bullock, Imogen Cunningham, Dorothea Lange, and Minor White, among others. Wong's work was included in a few other university and museum shows, including a one-person show at the George Eastman House Study Room in 1956.

Pioneers, Renegades, and Visionaries

Asian American Women Artists in California, 1880s–1960s

Valerie J. Matsumoto

This essay addresses twenty-four women who were active as artists in California before 1965. Of these, one is Korean American, nine are Chinese American, and fourteen are Japanese American, a ratio that roughly reflects patterns of early Asian immigration and settlement. Their recognition is vital, yet the lack of data available in many cases constituted the first in a series of obstacles to gaining a sense of these artists and their work.

Lumping together such an eclectic group under the rubric of gender constituted another problem. These artists, whose lives span the mid-nineteenth century to the present, defy neat, simple categories. The range among them in terms of generation, family circumstances, intellectual influences, genre, and style is tremendous. Their media include painting, drawing, sculpture, ceramics, enamelware, quilting, weaving, mixed media and collage work, calligraphy, woodblock prints, lithographs, and photography. Their diversity strains the fabric of any umbrella under which one might attempt to crowd them. The main commonality produced by their gender—in tan-

dem with race—may well be the way that perceptions of them as female and Asian/Asian American have limited their valorization by art historians, critics, museums, and galleries.

What was most astonishing in surveying this material was discovering what vibrant careers many of these artists had (and still have), in stark contrast to their omission from the art history record (fig. 140). For example, in a 2002 textbook on twentieth-century American art published by the Oxford University Press, eight Asian Americans were mentioned, all but one of them artists who have debuted since the 1960s.[1] Of the twenty-four artists discussed in this essay, not one is included. Nisei **Ruth Asawa** is arguably one of the preeminent American sculptors to emerge in the post–World War II period, yet she was virtually ignored for decades.[2]

One must acknowledge at the outset the problematic nature of the term "Asian American woman artist." The designation "Asian American," coined by activists involved in the Asian American movement of the 1960s and 1970s, reflects a political consciousness that developed in a specific period and is itself an imperfect, though useful, umbrella for dozens of ethnic groups. As Karin Higa has astutely pointed out,

FIG. 140 Eva Fong Chan and Nanying Stella Wong at the Parilia, the Artists' Ball of the San Francisco Art Association, 1935.

the ambiguity of the term "Asian American woman artist" makes it dependent on situational context for meaning: "Since contexts are ever changing, then a characterization like 'Asian American woman artist' could be used to affirm, to delimit, to marginalize, or to valorize—all subject to slight (or major) differences in context."[3] Perhaps the present utility of the category is to draw attention to these artists, many of whom have been omitted from or obscured in the art history canon because of the hierarchy of categories of gender and race throughout much of the American past.

This category also obscures and flattens the differences among these artists—differences that make it difficult to generalize about them. Their lives and careers span more than a century, from the early industrial period to the present age of e-world consciousness and commerce. During this time, women's roles—not to mention race relations, media, technology, and ideas about art—have undergone tremendous change. In addition to the shifting historical context that has framed their lives, two key areas of difference among the artists are generation and class.

As legions of social scientists have documented, immigrants and the American-born second and third generations often differ in their worldview, gender-role expectations, political perspectives, and sense of cultural heritage and identity. The generational divide among these artists is important to note. Twelve are immigrants; the earliest, **Mary Tape**, arrived from Shanghai at age eleven in 1868; the most recent, **Tseng Yuho**, left China for Hawaii in 1949. Eleven are second-generation daughters, born in the United States between 1904 and 1933; **Bernice Bing**, born in 1936, is the one third-generation Asian American among them.

Class constitutes another significant division. It is hard to generalize about women of working-class, middle-class, and elite backgrounds, given the range of their experiences and opportunities. For ex-

ample, consider linking a nineteenth-century artist who was orphaned and reared by missionaries, who came of age long before women could vote or Asians could become naturalized citizens, and who battled racially segregated schooling in San Francisco with another Asian immigrant artist of the scholar-gentry class, trained by members of the Chinese imperial family, who achieved the highest degrees in education, whose work debuted in Paris and New York, and who prepares her Powerpoint presentations on a laptop computer. How can one compare and connect the experiences of daughters of the Asian elite who came to the United States to pursue university education with those of second-generation women who grew up doing farm labor and garment factory work in marginalized ethnic communities? The task is challenging.

These artists also vary in their relationships to California. Some have spent the majority of their lives in the Golden State; others came here temporarily during key periods. All, however, have been part of the transnational currents of commerce, politics, and art that have made California an energetic hub of the Pacific Rim.

In this essay, after first placing these artists in the landscape of Asian American history, I will sketch out the intellectual range of their work, including the influence of their Asian and Western training. Their innovative experimentation with materials and techniques has afforded them a variety of strategies by which to communicate their ideas. Finally, I will consider their differing career trajectories, the obstacles they faced, and the fruitfulness of exploring their myriad legacies.

HISTORICAL BACKGROUND

The difficulties encountered during research undertaken for this project reflect the obstacles one often encounters when trying to document American women's lives in the late nineteenth century and the first half of the twentieth century. In the case

of these artists, the constraints of class and gender-role expectations have often been compounded by female role expectations within immigrant communities as well as by racial discrimination in the larger society.

To gain a sense of what it meant for first-, second-, and third-generation Asian American women to pursue the arts in this time frame, long before the advent of the civil rights movement or the women's movement, it is important to understand the position of Asian immigrants and their children in the often turbulent history of the West Coast. From the mid-nineteenth century to the early twentieth century, driven by economic hardship and the dislocations of colonialism and war, many Asians pinned their hopes on finding their fortunes in the fabled "Gold Mountain," as the Chinese called America. While large-scale growers and businessmen recruited their labor for the fields and orchards, railroad construction, canneries and mines of the U.S. West, many of the white working class perceived them as competitors. By the 1880s, anti-Asian sentiment became a rallying cry for politicians and organized labor, resulting in residential segregation, vigilante violence, and a thorny thicket of legal restrictions, including alien land laws and laws to prevent interracial marriage and culminating by 1924 in the immigration exclusion of all Asians except Filipinos.

Women constituted a small percentage of the early waves of Asian immigration, deterred on the one hand by U.S. immigration laws and employer preferences for male labor and, on the other, by Chinese, Japanese, and Korean cultural expectations that respectable women should stay home to serve their families of birth or marriage. Mary Tape, who was reared in a Shanghai orphanage and came to America with missionaries, was one of 46 Chinese females to immigrate in 1868, as compared with 5,111 Chinese men.[4] From the turn of the century, a growing number of Japanese women entered the country, as Japanese immigrant leaders began to advocate long-term residency and Japan's status as a rising world power delayed the passage of exclusionary laws such as the ones aimed at the Chinese. Between the Gentlemen's Agreement of 1907 and the Immigration Act of 1924, many Japanese women came to reunite with husbands already living in the United States, or, like **Chio Tominaga**, they arrived as picture brides, anxiously scanning the docks to find their new spouses. After Japan's annexation of Korea in 1910, Koreans became subject to U.S. immigration laws covering the Japanese, including the provisions of the Gentlemen's Agreement that barred male laborers but permitted the entry of wives and children of men already resident. More than a thousand Korean picture brides went to Hawaii in this period, and a tenth of that number joined men in the continental United States.[5] Due to the sex-ratio imbalances in these immigrant waves, Asian American families and communities grew at different rates.

Early Asian American settlements took root in port cities along the coast. San Francisco was the key port of entry for both Chinese and Japanese in California. The San Francisco Chinatown became home to a slowly growing community of families such as that of ceramicist, enamelware artist, and writer **Jade Snow Wong**. After the San Francisco earthquake of 1906, a southward exodus made Los Angeles the center of the Japanese American population, many of them engaged in agriculture. Ruth Asawa grew up on the farms her parents leased in southern California, working until late at night bunching and packing vegetables. Communities also sprang up in the Central Valley, in places like Sacramento and Stockton. Quilter Chio Tominaga, her husband, and their eight children were among the Japanese Americans who migrated through the San Joaquin Valley following farm work in the 1920s and 1930s.

Second-generation daughters like Jade Snow Wong and **Julia Suski** grew up synthesizing the expectations of the immigrant community and the values of the larger society. As she grew older, influ-

enced by exposure to public school and Mills College teachers, the strictly reared Wong began to critique the role of women in the Chinese American family. Many of the second generation, schooled to regard themselves as Americans, by adolescence became conscious of boundaries of race and ethnicity. Painter and writer **Nanying Stella Wong**, whose talents won early recognition by her teachers, recalled that someone nominated her for class president in high school but added, "You wouldn't get it because you're Chinese American."[6] In public school, the second-generation artists often encountered both sobering lessons about racial boundaries and encouraging validation of their creative endeavors.

The desire for higher education in the United States drew a few young women from well-to-do families, who had very different experiences as elite immigrants. **Lanhei Kim Park**, the first-known Korean American woman artist, after attending the prestigious Ewha University in Seoul, entered UCLA as an art major in 1928. Park, who was also a poet and writer, viewed America as "the keystone of the wishes I had made and longed to satisfy for all of my youth. This was the first stepping stone from which I was going to reach out for the rest of my wishes."[7] **Anna Wu Weakland** came to study sociology at Columbia University in 1947 but shifted to art after meeting master painter Wang Ya-chen, who became her mentor.

The years of the Great Depression were difficult for many Asian Americans, as for the larger public. Yet the 1930s also saw the continuing development of lively art worlds in Northern and Southern California. In San Francisco, **Eva Fong Chan** participated in the Chinese Revolutionary Artists Club and the Chinese Art Association; one of her paintings appears to depict a plein-air session by one of the groups (see Chronology, p. 494). Such enthusiastic networks of photographers, painters, actors, dancers, and musicians spurred each other on in Chinatown and Little Tokyo. They drew inspiration not only from Western

figures but also from artists and performers of Asia, for whom these urban ethnic communities were part of an international circuit. For example, while **Gyo Fujikawa** was a student at the Chouinard Art Institute in Los Angeles (1926–1931), she also studied dance with internationally known performer and choreographer Michio Ito.

The advent of World War II brought watershed change to all Asian American communities. New opportunities opened for Chinese Americans such as Jade Snow Wong, who went to work in the defense industry. Japanese American enclaves, however, were devastated by the forced removal of more than 110,000 Issei and Nisei from the U.S. West, including the families of Ruth Asawa, **Miki Hayakawa, Hisako Hibi, Miyoko Ito, Emiko Nakano, Mine Okubo, Kay Sekimachi**, Julia Suski, and Chio Tominaga, who were incarcerated in internment camps. Artist and activist **Mitsu Yashima** may have been the only Japanese immigrant to come to California *during* the war: she first encountered overt racism when she moved temporarily from New York to San Francisco under government auspices to work on a radio program called *Voice of the People*. While her artist husband **Taro Yashima** served with U.S. forces in India, she searched alone for housing in the San Francisco Bay Area, finding doors slammed in her face with shouts of "No Chinese or Japanese!"[8]

Only recently have historians begun to examine what happened to Asian American families and communities after the war, and we know very little about them in the 1950s and early 1960s. During that time, shadowed by red-baiting and fresh memories of the internment camps, Chinese Americans and Japanese Americans hunkered down to weather the Cold War and lingering anti-Asian prejudice and discrimination. But significant changes were afoot: for example, the California anti-miscegenation law was overturned in 1948. In 1949 in San Francisco, Ruth Asawa married Albert Lanier, a European American architect from Georgia, whom she had met at

Black Mountain College. Seven of the twenty-four Asian American women artists discussed here married interracially, a much higher percentage than in the overall Asian American population of this era. In light of the strictures against interracial marriage in both the larger society and Asian immigrant communities, this development reflects the greater degree of acceptance and interracial interaction in artists' networks, as well as the independent spirit of racial-ethnic women who dared to pursue careers in art.

INTELLECTUAL RANGE

The range in the artistic and intellectual influences among these artists is tremendous. Formal training, including knowledge of both technique and theory, was critical to their development as artists, as well as to their acceptance into art circles. Only one, the nineteenth-century immigrant Mary Tape, appears to have been a self-taught artist, and she assiduously read the latest works on photographic methods. "I not only take my own pictures but prepare my own plates and make my own prints," she explained to a journalist in 1889, "...everything I know has come from reading different authorities on the subjects

and then studying the methods to see which was the best."[9] A member of the California Camera Club, she garnered a number of awards for her photography (fig. 141).[10]

For most, training began early in childhood, whether in Asia or in America. In China, Tseng Yuho's grandmother taught her painting and embroidery from the age of two or three. In Korea, Lanhei Kim Park's two grandmothers introduced her, as she recalled, to "the ethics of Confucianism and the symbolic representation of nature in the design of oriental paintings and art objects with which our home was generously furnished."[11] Abstract painter Miyoko Ito, a Nisei who spent her years in prewar Japan, recalled the mixed pain and joy of her schooling; the joy derived from the way calligraphy, creative writing, and painting were interconnected and emphasized in that system. Ito excelled at painting and remembered her calligraphy teacher saying, "'Oh, you write like a man,' which was a big compliment."[12] Both Anna Wu Weakland, who grew up in China, and Jade Snow Wong, who lived in San Francisco, had educated Christian fathers who advocated basic schooling for girls as well as boys. Both learned

FIG. 141 Mary Tape, *Untitled (Crown Paper Factory)*, ca. 1920. Photograph, 3 × 4 in.

the brushwork of Chinese calligraphy as young girls. In addition to attending public school, Nisei daughters such as Kay Sekimachi and Ruth Asawa attended Japanese-language school, where they studied calligraphy. While these artists responded to their training in different ways, it constituted a common thread among them.

Both Yang Ling-fu and Tseng Yuho received extensive, rigorous art training in China. Yang Ling-fu, born in 1888, studied with thirty different art teachers, becoming accomplished in calligraphy, painting, and poetry.[13] Her skill won official acknowledgment: she won awards from Presidents Yuan Shih-kai and Li Yuan-hung, was invited to participate in the Philadelphia Exposition in 1926, and in 1927 surpassed three thousand other artists to win a contract with the Mukden Museum to paint ninety-six portraits of Chinese emperors and empresses.[14] Born in 1925 to a distinguished scholarly family, Tseng Yuho also received early recognition and encouragement of her talent; when she was a young teenager, her portraits of Western movie stars such as Shirley Temple were selling in Beijing art shops. Her first painting mentor was Pu Jin, a distinguished artist and cousin of the last emperor. In about 1940 she entered Furen University, where she mastered a range of Chinese painting and calligraphy techniques as well as studied Western art history from Gustav Ecke, whom she married in 1945.[15] By the time they moved to Hawaii four years later, she had also learned traditional Chinese mounting and repair techniques, which would figure in her development of *dsui hua*, an innovative painting genre. While pursuing a doctorate in Chinese art history in New York in the late 1960s, she also completed a second major in contemporary art of the West. This multifaceted training links these women artists.

In addition to the cultural and aesthetic influences of their families (and ethnic-language schools, in the case of the second-generation women), all of these artists were exposed to the ideals of West-

ern art. The résumés of nineteen artists record their study at the California College of Arts and Crafts, the California School of Fine Arts (which became the San Francisco Art Institute), Mills College, Stanford University, and the University of California, Berkeley, in Northern California, and at the Chouinard Art Institute and UCLA in Southern California. College steeped them in different heady currents of art. Hisako Hibi, who arrived in the United States as a teenager in 1920, attended the California School of Fine Arts (CSFA), where she was influenced by impressionism and especially Cézanne. There she met her husband, another Japanese artist, **George Matsusaburo Hibi**, who admired Cézanne as well.[16] Portrait and landscape painter Miki Hayakawa (fig. 142), who also studied in the early 1920s at the CSFA and the California College of Arts and Crafts (then known as the School of the California Guild of Arts and Crafts), was similarly influenced by Cézanne.[17] Hayakawa's fellow classmates at the CSFA included **Yun Gee**, whose influence is evident in the fauvist colors and cubist forms of Hayakawa's 1920s paintings.

In 1924 Michi Hashimoto, who began attending UCLA in the early 1920s, was singled out for a solo exhibition at the Los Angeles Museum, which was reviewed in the *Los Angeles Times*. She exhibited widely in the 1920s and 1930s (fig. 143) and presented portraits of friends and relatives in a 1940 exhibition.

The Mills College art department was another influential center, particularly for ceramicists Jade Snow Wong and **Katherine Choy** (also known as Choy Po-yu). Wong had entered Mills College with the goal of becoming a social worker in Chinatown, but a class she took in 1942 to fulfill an art requirement proved to be a turning point. At Mills she studied with F. Carlton Ball, Bernard Leach, and Charles Merritt and became fascinated by ceramics. Bernard Leach, himself influenced by Japanese potters, transmitted their style to the Mills students, emphasizing

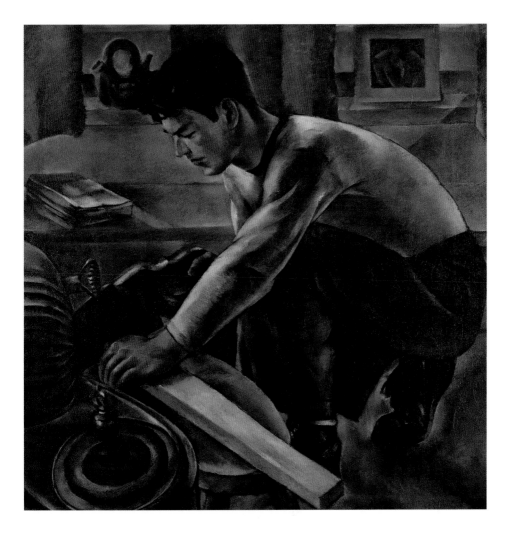

FIG. 142

Miki Hayakawa,
Man Sawing Wood,
ca. 1937. Oil on canvas,
26 × 26 in.

"the importance of strength and dignity in form."[18] In 1943 Wong joined the Mills Ceramics Guild, spending nights and weekends developing her pottery skills. She also began to experiment with jewelry enamels, striving to create beautiful objects that "could be used in the average home"[19] (fig. 144). In 1948 Katherine Choy entered Mills, where she worked with both Ball and Antonio Prieto.[20]

The radical experimentation of Black Mountain College in North Carolina shaped Ruth Asawa's approach to art. During World War II, after graduating from high school in the Rohwer Relocation Camp in Arkansas, she had entered Milwaukee State Teachers College but was unable to finish her degree requirements because anti-Japanese sentiments led to her being barred from serving as a student teacher. In 1946 she applied to Black Mountain College, where she studied with influential artists and thinkers such as Josef Albers and Buckminster Fuller. She later re-

called, "They taught me that there is no separation between studying, performing the daily chores of living, and creating one's own work. Through them I came to understand the total commitment required to be an artist."[21]

Mentorship was also important to fiber artist Kay Sekimachi, who in the 1950s studied with noted designer and weaver Trude Guermonprez at the California College of Arts and Crafts, and with Jack Lenor Larsen at the Haystack Mountain School of Crafts in Maine. Sekimachi remembered Guermonprez as a wonderful teacher who "really made you think, and she made you want to go on and explore on your own."[22] Sekimachi's vision of what weaving could encompass expanded dramatically as Guermonprez introduced her to Bauhaus theories and the ideas of Anni Albers; at this time she began to create tapestries, room dividers, and wall hangings.

Two mentors played pivotal roles for Anna Wu

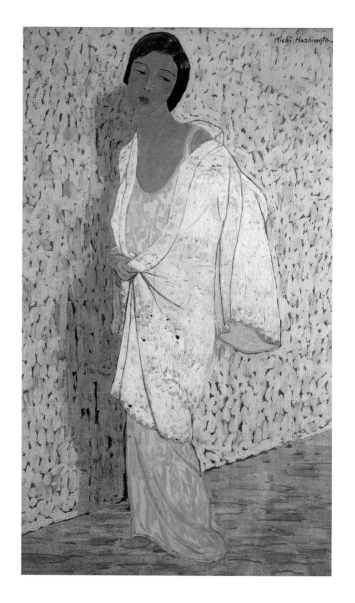

FIG. 143 Michi Hashimoto, *Self-Portrait*, ca. 1928.
Oil on canvas, 32¼ × 19¼ in.

Weakland. Her first role model was her father, who had completed degrees at Shanghai University and Columbia University and became a Christian minister, lawyer, publisher, and educator; he believed that both sons and daughters should receive education. She followed his academic path to Shanghai University and then to Columbia, where she earned an M.A. in sociology in 1948. In America she found her mentor in art: her life shifted course dramatically after she was asked to serve as translator for Wang Ya-chen, who had come to New York to curate an exhibition of Chinese contemporary art at the Metropolitan Museum of Art. Under the tutelage of the noted Shanghai painter, her eyes and heart opened to the world of Chinese art, and she became both his student and his assistant. She also studied the artistic techniques of Qi Bashi and **Chang Dai-chien**, spending a great deal of time with the latter during his frequent trips to New York. Weakland pursued Asian art in London, Paris, Kyoto, and Hong Kong, as well as studying Western painting at Stanford University from 1953 to 1955 (fig. 145).

A number of the second- and third-generation artists were likewise exposed to Asian teachers in

FIG. 144
Jade Snow Wong,
Large Bowl, 1942.
Earthenware with glaze,
17¼ × 3 in.

FIG. 145 Anna Wu Weakland, *A Patch of Garden*, 1965. Ink on board, 16 × 11½ in.

spent a year in Japan, where she studied the art of Hiroshige, Sesshū, and Utamaro.[25] In 1960, **Midori Kono Thiel** (like Bing, an abstract expressionist who admired Franz Kline) went there to study woodcut techniques and calligraphy, as well as Japanese music and theater (fig. 147). In 1975, a trip to Japan gave Kay Sekimachi the opportunity to connect with her history as the daughter and granddaughter of weavers. As members of national and international art circuits, these women crossed paths with Asian artists, at home and abroad. Jade Snow Wong met Kitaōji Rosanjin and many other eminent potters during her travels in Asia;[26] Noriko Yamamoto served as interpreter for Rosanjin, Hamada Shōji, and others who gave lectures on Japanese art in the San Francisco Bay Area.

Travels in Europe and Mexico also proved influential for several women. When Yang Ling-fu's paintings were exhibited in a group show in San Francisco in 1928, a reviewer noted, "She studied in Paris and in her original paintings one feels very clearly the Occidental influence on Orental [*sic*] tradition."[27] Yang, who in that same year became president of the Art College in Harbin, in 1934 fled Manchuria in the wake of the Japanese invasion. For three years, she lived in Berlin (where Adolf Hitler commissioned a painting from her and received a strong political critique[28]) before moving to Northern California in 1938. Mine Okubo traveled in Europe on an art fellowship until the declaration of war by England and France in 1939 ended her year abroad.[29] In 1945, Ruth Asawa made her first trip to Mexico City, where she studied Mexican architecture and fresco painting and saw mural art by José Orozco and Diego Rivera; Nanying Stella Wong also studied in Mexico City. For Tseng Yuho, sixteen months of exhibiting and traveling in Europe in the mid-1950s were a turning point in her career. There she observed and discussed modernist developments with Georges Salles, director of the Louvre, and artists such as Max Ernst, Man Ray, Paul Klee, Marc Chagall, and Georges Braque. In

the United States. Both **Noriko Yamamoto** (see fig. 189, p. 238) and Bernice Bing studied with **Saburo Hasegawa**, a Zen Buddhist painter who taught at the California College of Arts and Crafts in 1955. As a CCAC student in the 1950s, third-generation Bernice Bing was affected both by Hasegawa and by existentialism, which she credited as "the first influence that persuaded me toward the abstract expressionist school of painting. The philosophical bases of existentialism—one's responsibility for making one's own nature as well as personal freedom, independent decision-making, and the importance of commitment—were to me the attitude of the abstract way of painting."[23] Her exploration of abstraction continued as she studied with Elmer Bischoff at the California School of Fine Arts, stimulated by the company of fellow students Joan Brown, Manuel Neri, and Jay DeFeo. She also found inspiration in avant-garde figures such as Willem de Kooning and Franz Kline, jazz musicians John Coltrane, Ornette Coleman, and Thelonius Monk, and writers Albert Camus, André Gide, Simone de Beauvoir, and Gertrude Stein (fig. 146).[24]

Bing, who later studied calligraphy in China, was one of several American-born women who pursued art training in Asia. Around 1930, Gyo Fujikawa

1966–1967, Tseng returned to Europe as a Fulbright lecturer in Munich, Germany.

Many of these women artists themselves served as influential teachers. During World War II, Hisako Hibi and her husband taught art in the Tanforan Assembly Center in Northern California and the Topaz Relocation Center in Utah. Painter Mine Okubo also taught art in both camps, while doing sketches of camp life that would become her book, *Citizen 13660.* There Okubo became a friend and inspiration to Kay

FIG. 146 Bernice Bing, *Mayacamas No. 6, March 12, 1963,* 1963. Oil on canvas, 49 × 48 in.

Sekimachi, who had been a neighbor before the war; Sekimachi later taught at a number of schools, including San Francisco Community College and the California College of Arts and Crafts, where she had been a student. Okubo also taught at the University of California, Berkeley, during the 1950s. Katherine Choy became professor of ceramics at Newcomb

FIG. 147 Midori Kono Thiel, *In a Quiet Garden*, 1957. Color woodcut, image: 12 × 8 in.

College at Tulane University in 1952 and in 1957 co-founded the Clay Art Center in Port Chester, New York. One of her former students, Dean Mullavey, recalled, "She pursued everything that interested her whether it was pottery, weaving, designing, with equal intensity. Just being around her was infectious, and she inspired us to do greater things."[30] Tseng Yuho, who received her doctorate in art history from the Institute of Fine Arts at New York University in 1972, taught both Chinese art history and studio art at the University of Hawaii for many years.

As can be seen in the development of abstract expressionism, a number of these women made important contributions to their fields. In the 1950s, Emiko Nakano achieved high visibility for her landscape-inspired abstraction of views of the Bay Area (fig. 148). Noriko Yamamoto's work was featured in the prestigious *Young America* exhibition at the Whitney Museum in New York in 1960, and in Chicago, Miyoko Ito developed a unique abstract visual language that foregrounded geometric elements (fig. 149).

The art of these Asian American women communicates a range of philosophies and social as well

as aesthetic concerns. As a poised twenty-six-year-old, Nanying Stella Wong called her paintings "cosmic art" and employed abstract symbols to express such things as anger, love, and music. A 1941 journalist reported, "A serious student of Buddhism, Stella bases her philosophy of art on the Buddhist teaching that as man grows spiritually he becomes a part of all nature."[31] Wong retained this vision throughout her long life, saying in a 1997 interview, "I consider myself a galactic artist."[32]

Nanying Stella Wong's art explores as well the juncture of place, community, and history. Through her lush representational watercolors, Wong captured the routines and reference points of life in San Francisco's Chinatown. She coupled some of her paintings with her poetry to convey an intimate perspective on Chinese American experience, including the humiliation of detention at the Angel Island Immigration Station. Eva Fong Chan's paintings similarly provide glimpses of early community life. One 1930s picture shows her nattily attired husband, Bo Kay Chan, golfing with a friend (fig. 150); another presents a Chinese woman in festive traditional dress, with a hint of fashionably marcelled hair.

Ruth Asawa also connects viewers with place, community, and history through her public art commissions in the San Francisco Bay Area. She was one of the first women to move into this arena. As Norma Broude and Mary D. Garrard have asserted, the growing involvement of women artists in the late 1970s and 1980s transformed the field of U.S. public art: "Women introduced new attitudes and iconographies to public art projects, in which they sought to express the self not simply as the personal 'I,' but worked instead to blend the personal with the public, pointing the way toward a reconciliation of the traditional concerns of the artist with those of the community."[33] Two well-loved local landmarks are Asawa's whimsical mermaid fountain in Ghirardelli Square (1968) and the Grand Hyatt Hotel fountain in Union Square (1973). The owner of the

FIG. 148 Emiko Nakano, *February Painting #1*, 1959.
Oil on canvas, 46 × 58 in.

Ghirardelli site originally wanted an imposing abstract sculpture as the centerpiece of the square, but Asawa realized that, given the area's strong winds, a tall fountain would drench everyone in the vicinity. She also wanted to bring a sense of the bay into the plaza and thus designed a welcoming circular fountain that features bronze mermaids, turtles, and frogs. Despite criticism by the landscape architect of the square, who attacked the fountain as "out of character with the space that it is in," it was quickly embraced by the public.[34] In 1973, with the participation of family and friends, Asawa created forty-one bronze frieze panels for the circular base of the fountain on the steps of the Grand Hyatt Hotel. The fountain conveys in riotous detail the lively spirit of San Francisco: as a Chinese New Year's procession of dragon dancers, a St. Patrick's Day parade, and

a peace march wend their way through the streets, Seiji Ozawa conducts the symphony orchestra at the Opera House, nude sunbathers relax in Golden Gate Park, Father Junipero Serra keeps watch by Mission Dolores, and crowds flock to Union Street to hear the Grateful Dead in concert.[35] These and many other scenes of "the City" make the fountain "a traffic-stopper for native and tourist alike"[36] (fig. 151).

An abstract interpretation of the California landscape and spirit unfolded grandly across Tseng Yuho's multi-panel mural *Western Frontier*, commissioned by the Golden West Savings and Loan Association in San Francisco in 1964. According to Melissa Walt, this monumental work consisted of "nine

FIG. 149 Miyoko Ito, *The King Bird*, 1952. Oil on canvas, 49 × 36 in.

FIG. 150 Eva Fong Chan, *Bo Kay Chan Golfing, Thomas Kwan Watching*, ca. 1931. Oil on board, 9 × 13½ in.

panels whose abstract design was inspired by the silhouettes of redwood trees." Varying her *dsui* technique in this instance, Tseng used gold, palladium, and vivid colors across a ground of honey-colored paper. Her mural reflected the "northern California locale, with its tremendous wealth of natural resources, but also expressed the idea of growth—both natural and economic—as befitted the business setting of the work"[37] (fig. 152).

Without focusing solely (and unfairly) on the documentary aspect of their art, it is important to acknowledge that the works by Hisako Hibi and Mine Okubo stand as eloquent, courageous portrayals of

life within the World War II internment camps. As curator Kristine Kim has noted, artists were initially also subject to censorship by the War Relocation Authority that ran the camps. One day, a Topaz camp guard confiscated Hibi's sketchbook. She wrote, "[I] was terrified and too afraid at the time to ask him what was wrong with sketching that scene."[38] Nevertheless, she continued to draw and paint, insisting on "maintaining artistic freedom."[39] Hibi's paintings provide intimate views of internment (fig. 153), showing an Issei woman pausing in her chores to read a letter from her son in the U.S. Army, and younger mothers, lacking bathtubs, bathing their children in a laundry room. Kim states, "As a first-person representation of the experience of incarceration, art from the camps has the power to communicate what factual information does not convey."[40]

Mine Okubo also began to record the details of camp life, to share with friends on the outside. She initially had an exhibition in mind, but the drawings became her book *Citizen 13660* (1946), one of the first books to portray internment from a Japanese

FIG. 151
Ruth Asawa in front of Grand Hyatt Hotel fountain, ca. 1973.

Panels of Tseng Yuho's mural
Western Frontier for Golden West
Savings and Loan Association,
San Francisco, 1964. Palladium
and gold leaf, handmade paper,
tapa cloth, and acrylic paint on
panel, approx. 10½ × 75 ft.

Hisako Hibi, *Homage
to Mary Cassatt*, 1943.
Oil on canvas, 24 × 20 in.

FIG. 154 Mitsu Yashima, from the *Vietnam Series*
(*Mother and Child*), ca. late 1960s. Pencil
and watercolor on paper, 16½ × 16½ in.

American point of view. In this series of wry drawings, which included herself as both spectator and subject, Okubo chronicled the beginning of the war, the forced uprooting of the Japanese Americans from the West Coast, and life behind barbed wire in an internment camp (see Gordon Chang's essay and fig. 106), ending with her departure for New York in 1944. She said she recorded what happened "so others can see and this may not happen to others."[41] When her book was reissued in 1984, it won the American Book Award.

Another Nisei artist, Gyo Fujikawa, was one of the first to break color barriers in children's literature and reached a vast audience through the forty-six children's books she authored, as well as the nine others she illustrated. Fujikawa produced a wide range of artwork, including the design of six U.S. postage stamps, notably the adhesive thirty-two-cent yellow rose of 1997, but she is best known for her children's illustrations. She said, "I like to include lots of details, small objects and variety that make children give a lot of attention to the illustrations. Children want facts. While they can enjoy visual abstractions, they enjoy realistic renderings more."[42] Her detailed images of adventurous round-faced tots with dots for eyes have captivated thousands of children. According to journalist Elaine Woo, she is often cited as the first children's writer to portray a multiethnic cast

of characters. In Fujikawa's first two books, *Babies* and *Baby Animals*, "she proposed showing 'an international set of babies—little black babies, Asian babies, all kinds of babies.' But this was the early 1960s and a sales executive at Grosset & Dunlap told her to take the black babies out for fear they would kill sales in the South. Fujikawa . . . refused. Today the books have sold more than 1.5 million copies and have been translated into more than 20 languages."[43]

Mitsu Yashima's strong political convictions infused her art and her life. As members of the Proletarian Artists' Union in prewar Japan, she and her husband, Taro Yashima, "tried to combine artistic and social revolution in their works. They painted workers and peasants and arranged exhibits to protest the increasing repression, militarism and worsening working conditions in Japan."[44] She and Taro were both imprisoned for their activism.[45] In 1939 they arrived in New York on tourist visas and joined the Art Students League. Mitsu did art piecework to bring in a steady income; their son, Mako, recalls her painting poodles on hundreds of soap dispensers for department stores. Taro moved to Southern California in 1952, joined by Mitsu and their daughter, Momo, around 1954. Mitsu taught for a while at the Yashima Art Institute that the couple established, but she again turned to art piecework for regular income. Due to long-standing and widening marital differences, by 1970 she had moved to the San Francisco Bay Area; there she became a leader in the Japantown art movement and the Japantown Art and Media Workshop. At Kimochi, a Japanese American senior center, she taught art and creative writing.[46] She spoke with passion about the importance of "people's art," believing that "young people are trying to understand the culture which they have been cut off from," but "all one sees in books is 'emperor's art,' not the art of the people."[47] In her view, "All paintings have purpose of that time. Alive because expressing the need of that time. That's why it's good. Like art, good food is healthy for body. To

184

be healthy is first quality to have. Some art you look at and it makes you dizzy or sick, eyes hurt because colors too sharp. Art should make people feel good, sometimes it should make them angry."[48] Her own nuanced portraits of family, neighbors, and war-ravaged Vietnamese reflect both aims (fig. 154).

Though Tseng Yuho early mastered traditional Chinese painting techniques, the continual evolution of her work shows both her originality of vision and her engagement with the intellectual currents of the time. As she has said, "Strongly influenced by 20th-century logic, I cannot adhere to the frame of mind of a 19th-century Chinese literati painter. After studying much Western wisdom, I have found that East and West share many cultural inclinations. Today what is labeled 'modern art' has opened up cultural frontiers.... Like the economic, political and social world, art today is a global affair."[49] This development is amply reflected by her many solo and group exhibitions in the United States, Asia, and Europe. For Tseng, "The crucial issue is how I, as an artist, can express the intangible mind through art. I am anxious to impose a logic upon the mystics, to order the irrational."[50] In this endeavor she has turned the elements of landscape—mountain, tree, and cloud—into a language of endless variety.

FORMS AND STRATEGIES
OF COMMUNICATION

These Asian American women artists developed an array of forms and strategies of presentation by which to communicate their ideas. Experimentation with many materials and techniques has given them an enormous vocabulary of expression, with many nuances. The protean Tseng Yuho has channeled her creativity and insight into intertwined art, scholarship, and institution-building. Her explorations of Chinese calligraphic technique and history, for example, have produced a striking body of work ranging from paintings that resemble old rubbings to meditative abstractions. As she once said, "Calligraphy sup-

plied me with even more ideas of skeleton structures that lay behind my compositions."[51] Spurred by intellectual thirst to understand calligraphy more deeply, and with characteristic thoroughness, Tseng spent fifteen years researching and writing her magisterial work, *A History of Chinese Calligraphy.*

Tseng Yuho is also renowned for *dsui hua* painting, a unique form she began to develop in the 1950s utilizing traditional methods "while at the same time creating a totally new genre of painting that is still identifiably Chinese."[52] Learning Chinese mounting and repair techniques led her to experiment with torn pieces of paper that she incorporated into her works. Tseng stated, "My discovery of this new means of expression with paper opened up a world of infinite possibilities for me. In brushwork painting, I usually know exactly how a work will turn out. With the new medium, no matter how well prepared I am, there is always an element of the unexpected in each painting. I welcome this element of contingency."[53] She also introduced metallic colors, then gold and aluminum foil, to convey a sense of otherworldly solemnity. To her layering of paper and pigment, Tseng added explorations of pictorial space. She drew inspiration from a display of quartz crystals and gems at a natural history museum, noting "the way their geometric forms overlapped in complex transparent layers." The ability to thus see several planes simultaneously spurred her to start making "overlapping renderings" that contribute to the sense of movement and life in her painting (fig. 155).[54]

The love of experimentation and facility with a wide range of materials are evident as well in the private and public art of Ruth Asawa. After being challenged by Josef Albers's exercise in achieving transparency, she taught art one summer in a Mexican village; there she was struck by the local basket weaving and started to think about how she could achieve form and transparency simultaneously. She began to crochet forms with wire, using her fingers instead of a crochet hook. Her geometric medita-

FIG. 155 Tseng Yuho, *At Second Sight*, 1962. Ink and collage on gold paper with seaweed, 68 × 26 in.

tions in wire played with the notions of intersecting planes, or disrupted oblate and spherical shapes, by introducing apertures that created the delicate ruffling of deep-sea life forms. Both abstract and organic, her woven hangings challenged conventional notions of sculpture—they did not sit on a pedestal, and they lacked the unyielding hardness of bronze or marble—and spurred debate and redefinition (see Paul Karlstrom's essay and fig. 198).

The commission for the Grand Hyatt Hotel fountain in Union Square, San Francisco, provided Asawa with a different opportunity for experimentation in both material and method. She had become intrigued by the possibilities of baker's clay (a dough made of flour, salt, and water) as a modeling compound, which she used first with her own children and then in the still-thriving Alvarado School Art Workshop that she founded with Sally Woodbridge. Having admired the exuberant scenes she and the children produced, the architect of the Grand Hyatt Hotel proposed that she do a similar sculpture, to be cast in bronze, for the fountain.

The project was unusual for its communal process as well as its medium. As Asawa mapped out portions of San Francisco, scores of friends, family members, and schoolchildren helped make figures of people, animals, buildings, and trees, working on one section at a time. Asawa explained, "When the fountain came along I thought it was a great opportunity to show how group skills could be used to make something that people usually think of as high art— one product from one person's mind and hands. We have this egocentric idea that the artist has to do his own thing alone. Because of this I think art has become weaker in many ways and less able to satisfy us. There have always been great individuals in art, but great art has also been produced by skilled people working together."[55]

Like Asawa, potter Katherine Choy responded to theoretical challenges: "In working I establish a theoretical problem, like decorating in a two-

FIG. 156 Katherine Choy, *Two Abstract Vessel Forms*, late 1950s. Glazework patched with black, brown, and bluish green glazes and raw clay, ht. 18½ in. each.

dimensional area on a three-dimensional form, bringing pattern and form into a unity."[56] She undertook research and experimental work on ceramic glazes in the Jade Snow Wong studio in San Francisco in 1951.[57] Early on, Choy's experimentation with form, size, and brilliant color attracted attention. Curator Ulysses Dietz deemed her a pioneer, citing her "large sculptural vessels with irregular broken shapes and brushed glaze work" that appeared in 1957 (fig. 156). He asserted: "Such radical innovations in scale and form were just beginning to appear in American studio ceramics in the 1950s. Today it is most often the men [such as Peter Voulkos and John Mason] who are remembered for these innovations, but there is no question that Katherine Choy was one of the first American clay artists, male or female, to make this artistic leap."[58] Her death at age twenty-nine cut short the dynamic career of an already influential artist and teacher.

The energetic Chio Tominaga first employed her ingenuity to face challenges of family survival. Mak-

ing a virtue of necessity, she used recycled materials to create bold quilts, cushions, patchwork purses, yo-yo clown dolls, rugs, blankets, and doilies. While farming with her family in the Central Valley before World War II, Tominaga would stay up late at night working by kerosene lamp to make all her children's clothes, from their caps and shirts to slippers. When the clothing wore out, she used it for quilts, sometimes piecing together half-inch scraps. Tominaga never bought new material, preferring to improvise with unraveled onion sacks and socks, carpeting fiber, and old fabric, which she often dyed. Her quilts and pillows are distinguished by their "strong contrast, two-sided borders, irregular piecing, changes in scale and juxtaposition of dissimilar patterns"—design elements often seen in African American quilts, and possibly influenced by her Berkeley neighbors (fig. 157).[59] The prolific Tominaga, who lived to be one hundred three, made hundreds of quilts and other handicrafts for family and friends.

Fiber artist Kay Sekimachi has been called a "weaver's weaver" for her mastery of a variety of techniques—from card weaving to ply-split braiding —and for her creative vision and experimentation. Working with a wide array of materials, she has produced innovative meditations in plane geometry. Sekimachi, too, has explored form and transparency, creating on the twelve-harness loom multidimensional hangings of monofilament, a new material she first received from DuPont in 1956 (fig. 158).[60]

FIG. 157 Chio Tominaga, *Pillows*, ca. 1960. Disassembled indoor/outdoor carpet and pieced fabric, diam. 10¾ in. each.

According to Signe Mayfield, "This series riveted the attention of generations of weavers and placed her in the forefront of contemporary fiber art in the mid-1960s."[61] Her linen nesting boxes and her later *hako* (box) series melded Western weaving methods with origami construction. Indeed, she drew on an origami box design that Ruth Asawa had taught her to create a woven *takarabako* (treasure box) with an asymmetrical folded top.[62] She has also woven double-sided books, made containers and tall columns of stitched antique Japanese paper, and constructed striking bowls of leaf skeletons and hornet's nest paper.

Both Nanying Stella Wong and Jade Snow Wong sought to attract attention to their work and ideas through the dramatic staging of art production, a strategy that drew appreciative audiences. Upon the publication of Lin Yutang's book *A Leaf in the Storm* (1941), Nanying Stella Wong reviewed the book before an audience at the Capwell, Sullivan & Furth store in San Francisco. In the course of her review, she painted eight pictures "illustrating the characters and action of the novel."[63] She also did Chinese calligraphy demonstrations at the same store, selling the calligraphic paintings for fifty and seventy-five cents (see p. 456). Nanying Stella Wong's dramatic streak may have been derived from her "prominent theatrical family," including a mother who was "a well-known actress on the legitimate stage and also appeared in early motion pictures."[64]

With great flair, Jade Snow Wong drew attention to her new ceramics venture in 1945 by renting a storefront in Chinatown and shaping pottery in the window (see p. 452). Traffic slowed and spectators packed the street to watch as she threw balls of clay on her wheel. Although many Chinese storekeepers initially laughed at her, her success commanded respect: "Caucasians came from near and far to see her work, and Jade Snow sold all the pottery she could make."[65] The launching of her multifaceted career as artist, author, and business owner not only constituted her personal declaration of independence but also expanded other women's sense of their own possibilities. Wong's first book suggested to Maxine Hong Kingston that she, too, could become a writer. Wong's decision to become an artist, Kingston said, "taught me to think out my values and to be true to myself."[66]

CAREER TRAJECTORIES

These artists had a variety of career trajectories. Some were quite short, curtailed by the demands of family life and the need to shift to work that would provide more steady income. The briefest was that of Julia Suski, whose work delighted her family and the Los Angeles Japanese American community for the few years that she drew one-panel comics for the English-language section of the *Rafu Shimpo (Los Angeles Japanese Daily News)*, edited by her sister Louise (fig. 159). Suski, who taught piano in Little Tokyo

FIG. 159 Julia Suski, Illustration for *Rafu Shimpo*, August 1, 1926.

Lou-lia—Some terrible things can be caught from kissing.
Dorita—I believe it. You ought to see the poor fish our Aggie caught.

and performed frequently, regarded herself more as a musician than as an artist. Yet her witty drawings offer rare 1920s images created by an Asian American woman for a public venue, conveying the collegiate humor of the day and the preoccupations of middle-class, mainstream youth and showing their familiarity to the urban Nisei. Her drawings often featured elegantly gowned women engaged in sassy repartee. Some of her images showed her young readers faces like their own, including the flapper style and makeup so many had adopted, to the consternation of their parents.

The artists encountered a range of family responses to their pursuit of art. Women from affluent or upper-class families, such as Lanhei Kim Park and Tseng Yuho, were more likely to receive encouragement for their artistic ambitions. Having a parent who was an artist—as Mine Okubo (and her artist brothers Benji and Yoshi) did—also helped. Okubo's mother, who as a poor immigrant with seven children had had to give up her own artistic aspirations, was always supportive of her daughter's goals. Observing her mother's situation solidified Mine's resolve: "Seeing her try to carry on with painting along with having to bring up a large family, seeing her futile struggle helped me to be determined and to achieve the thing I want to do most—paint"[67] (fig. 160).

For others, trying to establish a career in art meant braving parental opposition. When Miki Hayakawa's father, a history teacher and pastor, learned of her artistic ambitions, he objected angrily, saying, "Very well, if you must paint, please leave the house."[68] At fifteen, she began to "work her way through art school, washing windows, cleaning floors, and designing costumes."[69] Some families, struggling to eke out a living during the Great Depression and getting by with limited resources, were simply unable to provide material support.

With or without family approval, many artists faced years of struggle and sacrifice. After World War II, in one of a series of trying jobs, gifted playwright and artist Wakako Yamauchi painted flamingos and palm trees on shower curtains. Mitsu Yashima spent perhaps two decades doing art piecework—mainly painting bath accessories—to support her family. Hisako Hibi encountered great difficulties in pursuing her art. In the aftermath of World War II, disheartened by news of the hostile reception many Japanese Americans faced on returning to California, she and her family resettled in New York City. In less than two years, her husband passed away, leaving her the sole support of two young children (fig. 161); she worked as a seamstress in a dress factory and began to attend union meetings with her coworkers. She found respite in studying oil painting once a week after work at the Museum of Modern Art: "I was happy there. Through painting I could forget everything and go beyond everyday life, as the imaginative world is unlimited and infinite."[70] After returning to San Francisco in 1954, Hibi continued to work as a sewing-machine operator in garment factories. She eventually became a housekeeper and cook in a private home and gradually began to find time to sketch and paint again. In the postwar years, her paintings became less representational and more loosely abstract, displaying brighter colors and incorporating Japanese calligraphic text. She remarked, "Art consoles the spirit, and it continues on in timeless time."[71]

These artists' motivations for pursuing art reveal the limited career paths available to racial-ethnic youth during the Great Depression and World War II, as well as how many of them, like Hibi, found consolation, stimulation, and camaraderie in art. The art scene of the urban West, as Karin Higa has noted, included many Asian Americans (mostly men); that they were able to play significant roles as leaders, organizers, and teachers of art provides a sharp contrast to the strenuous efforts to exclude Asians from other fields of work.[72] For some, art was initially a place of welcome, a refuge beyond the racial barriers that hedged other avenues. Nanying Stella Wong said, "In

Mine Okubo, *Mother and Cat*, 1941.
Tempera on Masonite, 29¾ × 24 in.

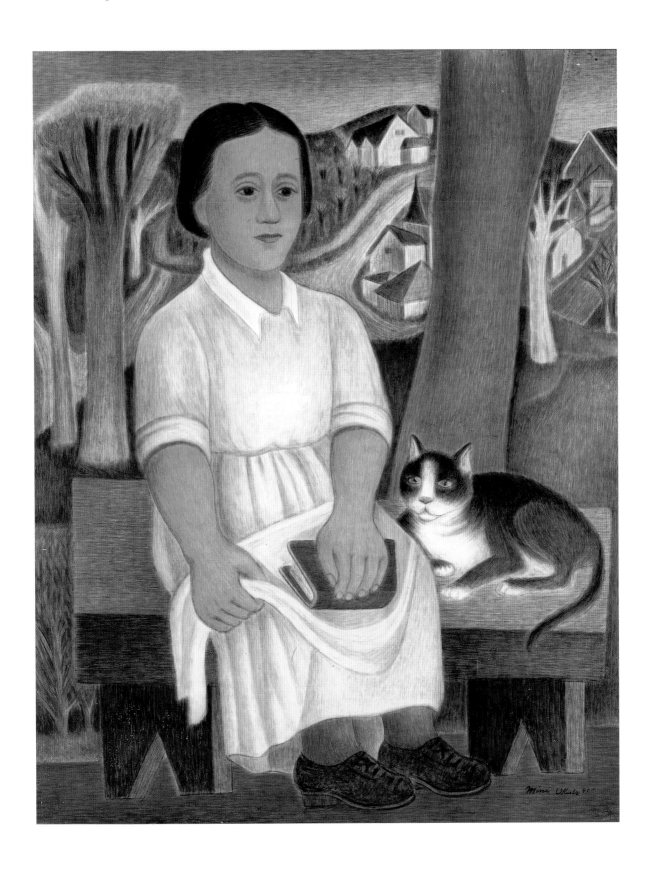

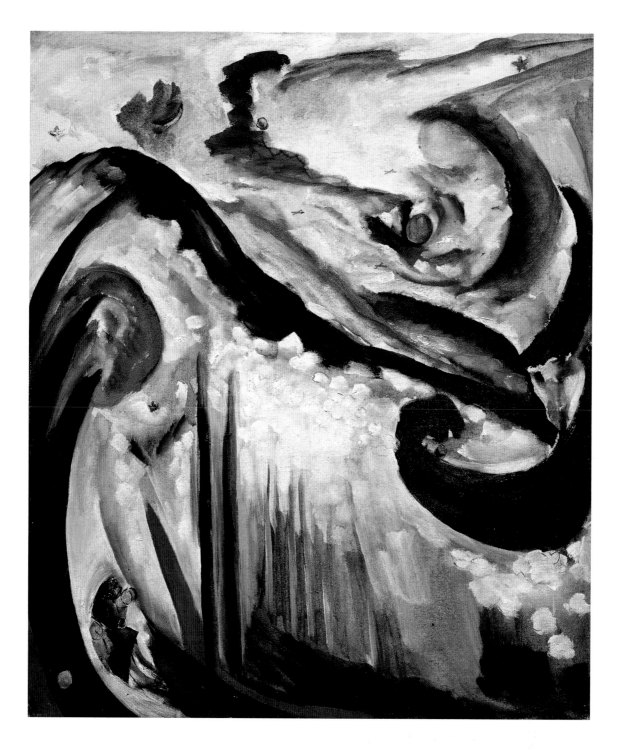

FIG. 161 Hisako Hibi, *Fear*, 1948.
Oil on canvas, 25¾ × 22 in.

the art world I didn't come across racial prejudice. It only came upon me when…my family [was] looking for houses…and…in a more subtle way when I graduated from high school."[73] Likewise, Kay Sekimachi characterized the weavers she knew as warm and accepting. Miki Hayakawa found a place for herself in the European American art colony in Santa Fe, New Mexico. Not only was Ruth Asawa the star

student of Josef Albers and Buckminster Fuller, but also they became close friends, as did San Francisco photographer Imogen Cunningham (see p. 292).

Of course, other women did encounter racial boundaries and prejudice in the art world. Miyoko

FIG. 162 Gyo Fujikawa,
Westways cover, March 1934.

Ito, an abstract painter who later had an active career in the postwar Chicago art community, recalled, "Even though I was totally accepted in school [at the University of California, Berkeley], I was never invited to their homes. And I understand that because, you know, they might have a Japanese gardener or Japanese servant waiting on us, a lack of sensitivity."[74] Racial stereotyping nearly cost Gyo Fujikawa significant assignments. As she forged a career in commercial art—moving from Walt Disney Studios to advertising and then to freelance illustration for magazines and books (fig. 162)—she faced the challenge of convincing potential clients that her work was not limited to "Oriental" depictions. A major ice cream maker and the Beech-Nut Baby Foods manufacturer initially balked at hiring her, but both were won over after seeing her designs.[75] As Virginia Scharff has noted, Native American women artists in New Mexico similarly "found themselves always contending with established ideas about what kind of art people of their heritage ought to make."[76]

A flourishing art career in Asia did not necessarily lead to similar success in the United States. Despite having exhibited internationally and having been president of an art college in Manchuria, artist and poet Yang Ling-fu found scant interest in her paintings when she came to Northern California in 1938. She supported herself by working as a photo developer, giving workshops in Chinese art, and teaching Chinese language and cooking. Nevertheless, she continued to produce art (fig. 163) and published two volumes of poetry as well as a book about her paintings.

Jade Snow Wong sought in an art career an autonomy and opportunity that were rarely accessible to racial-ethnic women during that era. She said, "Having worked in offices that were part of the American corporate structure, I knew that a young female of Chinese descent could never rise to the top in a male-dominated field. I loved making pottery, but would I be able to make a living for myself? Other than the love of it as the work of my hands, it also gave me a deep emotional freedom. For my whole life, I had been bound by the tenets of the Chinese culture and its restrictions on my activities.... If I could make a career of being a potter, no one would be telling me what to do or when to do it."[77] With skill, determination, and flexibility, she and her husband, Woodrow Ong, were able to fulfill their dream of pursuing art by working as a team: he concocted jewel-like glazes and copper forms for her ceramics and enamelware, and together they ran an art shop that sold her wares, as well as a travel agency that was one of the first to specialize in tours to Asia.[78]

Jade Snow Wong was one of the artists who, with considerable effort, managed to weave her family life together with her pursuit of an art—and literary—career. Two of her four children have also become artists and writers. Ruth Asawa, like Wong, purposefully integrated family life with art. Asawa, the mother of six, said, "Because I had the children, I chose to have my studio in my home. I wanted them to understand my work and learn how to work." While she taught them, they also influenced the direction of her art: "If I hadn't spent all those years staying home with my kids and experimenting

FIG. 163

Yang Ling-fu,
Wild Rose. Ink on paper,
dimensions unknown.

For Asian American women, the risks of pursuing an art career were often exacerbated by factors of gender, race, class, and community. They faced a double bind: marriage sometimes meant subordinating one's career, but going it alone also entailed difficulty. The stakes were particularly high for single or widowed women such as Mine Okubo, Gyo Fujikawa, Yang Ling-fu, Bernice Bing, and Hisako Hibi, who lacked the safety net—whether primary or supplementary—of a partner's income. In the late 1960s, Mine Okubo, mindful of the gamble involved, decided, "You can't serve two masters at the same time. You either pursue the art business–show business system as a promotion game, or you're on your own which often means that your works don't sell. I didn't follow any trend or anyone. My work was not accepted because you are judged by those who play the 'game'—the critics and the dealers."[82] Consequently, she said, the doors of the museums and galleries were closed to her. Tseng Yuho was also unwilling to play this game. After her glittering debut in Paris and New York, she chose not to pursue a career there in an environment she believed might compromise her values. The exchange of sexual favors for advancement that she had observed conflicted with her gender-role and class upbringing. She opted instead for a mix of art and academia that would enable her to maintain her integrity and creative focus.[83]

In addition to the hurdles artists faced in dealing with the mainstream art galleries and museums, the ethnic community was not always receptive or supportive. At the outset of her pottery business in Chinatown, Jade Snow Wong faced prejudice both as an independent woman and as a college-educated person perceived to be dabbling in a dirty job. Ruth Asawa remarked that the postwar Japanese American community was focused on "getting ahead"[84]— the terrible losses exacted by internment included the disappearance of the flourishing art scene of the 1920s and 1930s. Art received little attention until the Asian American movement of the late 1960s

with materials that children could use, I would never have done the Ghirardelli and Hyatt fountains."[79] Of the twenty-four artists profiled here, it appears that nineteen married and fifteen had children.[80]

Not all of these women were able to mesh their domestic life with an art career so seamlessly. Lan-hei Kim Park, who married political scientist Dr. No-Yong Park, ended her pursuit of art with the birth of their two daughters in the 1950s. Similarly, Eva Fong Chan painted for about twenty years, stopping with the arrival of her children; however, she continued to earn money by giving piano lessons and assisting in her husband's import-export business. Miyoko Ito remarked that her own artistic output slowed when her two children were little but picked up by the late 1950s[81] (perhaps coinciding with their being in school).

and 1970s revitalized interest in ethnic culture and creative expression. In the same era, the women's movement, though it often overlooked the concerns and contributions of women of color, also began to awaken interest in women's art.

CONCLUSION

It is impossible not to consider the work of these Asian American women artists in the light of subsequent developments in art history, including the reassessments catalyzed by feminist art scholarship. In their examination of women artists of the 1950s and 1960s such as Helen Frankenthaler and Grace Hartigan, Norma Broude and Mary D. Garrard have contended that "these women and their art can never be comfortably accommodated within the structures of the male-dominated and male-defined movements in which they originally worked—unless or until we are willing to acknowledge the historical experience within these movements of the different voices of women, and to modify our characterization of modernism accordingly."[85] Attention to the work and careers of artists such as Ruth Asawa, Bernice Bing, Katherine Choy, Kay Sekimachi, and Tseng Yuho might help produce a dramatic recontouring of the American modernist landscape and its attendant canonical narratives. This would mean, for example, acknowledgment of Asian American women's impact on their fields, as illuminated by the ways in which Ruth Asawa's woven-wire hangings forced the redefinition of sculpture and greatly enlarged the parameters of possibility. It would also mean acknowledging the interplay of culture, class, and gender in how women made choices—and sacrifices—in pursuing art, as Tseng Yuho's career decisions suggest.

Also important to bear in mind is that most of these women came of age and forged their art paths before the formation of the women's movement of the 1970s or the related emergence of feminist art history, or the rise of an Asian American movement. It is doubtful that many of these artists would identify with the term, "feminist" or "Asian American." As Jade Snow Wong stated, "In 1942, there was no feminist movement. I didn't think a brain was limited by being in a woman's head. Of course, I was aware of prejudice against women and against Chinese in the Western world. That is why I chose to work in ceramics, writing, travel, and running a gift shop."[86] Studying these artists within the context of family, community, generation, training, and time reveals the complicated negotiations and strategies they needed to build long-term careers in art.

In the past three decades, women artists of Asian descent have entered the art world with a wider array of choices, although, as Moira Roth has pointed out, deep racial and gender inequities persist in galleries and museums, as well as in the educational institutions that produce art historians and critics. In 1989, responding to these shifting opportunities and continuing obstacles, Bernice Bing, Betty Kano, and Flo Oy Wong founded the Asian American Women Artists Association in the San Francisco Bay Area to sustain and publicize Asian American women's art. Hisako Hibi, a link to generations of earlier artists, was also a member. As Karin Higa noted, "AAWAA recognized Hibi's continued aesthetic explorations, and saw in her a model of personal integrity and commitment to art that was crucial to support."[87] Hisako Hibi provides an unnerving example of how nearly a talented artist and her work may be lost without the attention of the institutions that document and validate art.

To gain a sense of the true impact of these artists, one must acknowledge the influential roles many have also played as teachers and institution builders. In 1968, frustrated by the lack of resources for children's art education, Ruth Asawa and art historian Sally Woodbridge cofounded the Alvarado School Art Workshop in San Francisco. Their aim was not only to provide art training but also to teach self-reliance and self-awareness.[88] The experimental program began with a budget of only sixty dollars but

was fueled by the energy of parents, a few teachers, and volunteering artists. Working with the children, they gradually transformed the school environment, painting bright murals and planting gardens. The workshop curriculum expanded to include music, dance, theater, and gardening, and at one point had spread to fifty San Francisco schools.[89] The Alvarado School Art Workshop still flourishes: in 2002, Asawa's son ceramicist Paul Lanier was the artist-in-residence and her daughter Aiko Cuneo taught art classes there. In the Seattle area, Midori Kono Thiel has also introduced many children, teachers, parents, and college students to Japanese art and culture. Thiel's study of traditional Japanese theater and dance (Noh and *Kyōgen*) had inspired her interest in kimono-dyeing and -weaving and in music, which in turn led her to learn to play the *koto* and *shamisen* (two stringed instruments). She came to view art holistically, observing that one thing leads to another.[90] Her teaching reflects this sense of interconnection: during a 2001–2002 art residency, in the course of teaching brush painting to elementary school students, she played the koto and *shamisen* and also performed "serious and comic *kyōgen* dances."[91] Thiel's artistic and educational endeavors have also introduced her calligraphy into the realm of cyberspace, via her contribution to *Beyond Manzanar*, a three-

dimensional interactive virtual-reality installation designed as a response to September 11 by her daughter artist Tamiko Thiel and Iranian American writer Zara Houshmand.[92] Midori Kono Thiel's elegant calligraphy, along with poems of exile in Farsi and English, hang suspended from the barbed-wire fence surrounding an internment camp, inviting exploration of the effects of incarceration and the creation of inner sanctuary.

The range and reach of these women's art—through exhibitions, museum holdings, private collections, public art commissions, and interactive video, as well as their books, poetry, and essays, and their roles as teachers, curators, and art advocates—are impressive. Tracing the trajectories of their careers, some seen only in fleeting glimpses, reveals the critical importance not only of formal training but also of mentorship, as exemplified by Ruth Asawa's relationship with Josef Albers, or Anna Wu Weakland's relationship with Wang Ya-chen. This preliminary survey also suggests these artists' incredible range, long obscured by their omission both from the canon of major texts and key narratives in art history, and, I might add, from Asian American studies. May this book spur the examination of the rich, complex legacies of these dynamic women pioneers, renegades, and visionaries.

Notes

Many thanks to Ruth Asawa, Albert Lanier, Jade Snow Wong, Mark Ong, Kay Sekimachi, Tseng Yuho, Ruthanne Lum McCunn, Don McCunn, Irene Poon Andersen, Sharon Spain, Mark Johnson, Gordon Chang, Marian Kovinick, Brian Niiya, Karen Umemoto, Lee Lundin, John Lundin, Suzanne Baizerman, Sadie Tominaga Sakamoto, Moira Roth, Jessica Wang, Ellen Brigham, Sharon Bays, Steven Doi, Daniel Lee, Bernice Zamora, Wakako Yamauchi, Mako, Momo Yashima Brannen, Nancy Hom, Rich Tokeshi, and Terry and Sachi Matsumoto for their insights and generous assistance with this essay. Thanks are also due to the John Randolph and Dora Haynes Foundation for their generous support of my research on Nisei women in pre–World War II Los Angeles, including artists Julia Suski and Gyo Fujikawa.

1 Erika Doss, *Twentieth-Century American Art* (Oxford: Oxford University Press, 2002).

2 In 2005, the de Young Museum in San Francisco acquired a significant collection of Asawa's work for a permanent installation. A major retrospective and monograph were organized by the de Young in 2006.

3 Karin Higa, "What Is an Asian American Woman Artist?" *Art/Women/California, 1950–2000*, ed. Diana Burgess Fuller and Daniela Salvioni (Berkeley: University of California Press, 2002), 92.

4 Judy Yung, *Unbound Feet: A Social History of Chinese Women in San Francisco* (Berkeley: University of California Press, 1995), 294.

5 Sucheng Chan, *Asian Americans: An Interpretive History* (Boston: Twayne Publishers, 1991), 109. In this period, the number of Filipina immigrants was small, and it is estimated that fewer than thirty South Asian women immigrated before World War II. The Korean American population, mainly in Hawaii and California, numbered about ten thousand until 1950.

6 Nanying Stella Wong, interview by Irene Poon Andersen, August 19, 1997.

7 Lanhei Kim Park, *Facing Four Ways: The Autobiography of Lanhei Kim Park (Mrs. No-Yong Park)*, ed. Chinn Callan (Oceanside, CA: Orchid Park Press, 1984), 133. Her six wishes—all fulfilled—were to graduate from Ewha University, to go to America for education, to marry a Korean scholar in America, to have an intelligent family, to become a naturalized U.S. citizen, and to write her autobiography (117).

8 Suzin Fong, Joyce Kawasaki, and Jeanne Quan, "The People's Artist: Mitsu Yashima," *Asian Women* (Berkeley: Asian Women's Journal, University of California, Berkeley, 1971), 40–41. Exactly when Mitsu Yashima first came to Northern California is difficult to determine.

9 Leland Gamble, "What a Chinese Girl Did: An Expert Photographer and Telegrapher," *San Francisco Morning Call*, November 23, 1892. Mary Tape was a painter as well as an award-winning photographer. She was also an activist, in 1885 challenging the San Francisco Board of Education when her daughter Mamie was denied admission to public school; Tape won in court, but the school district continued its practice of segregation by establishing a separate school for Chinese children. See Yung, *Unbound Feet*, 48–49. See also Daniella Thompson's essay "The Tapes of Russell Street: An accomplished family of school desegregation pioneers" (2004–2005), http://www.berkeleyheritage.com/essays /tapefamily.html.

10 Peter E. Palmquist, "In Splendid Detail: Photographs of Chinese Americans from the Daniel K. E. Ching Collection," in *Facing the Camera: Photographs from the Daniel K. E. Ching Collection*, exh. cat. (San Francisco: Chinese Historical Society of America in joint sponsorship with Asian American Studies Department, San Francisco State University, 2001), 16.

11 Kim Park, *Facing Four Ways*, 55.

12 "Oral History Interview with Myoko [*sic*] Ito at the Oxbow Summer School of Painting, Saugatuck, Michigan, July 20, 1978," Dennis Barrie, interviewer; Smithsonian Archives of American Art.

13 "An Accomplished Artist-Poet-Teacher-Writer/The Honorable Lady Ling-fu Yang," *Game & Gossip* (Monterey, CA) 18, no. 2 (November 15, 1972), 15–16. Yang Ling-fu, *Translations of My Art, Volume One: The Dragon Fights* (N.p.: Yang Ling-fu, 1939); see the introduction by Kiang Kang-Hu; this book may have been first published by the Mukden Museum in October 1927. See also Michael D. Brown, *Views from Asian America, 1920–1960: An Illustrated History* (San Francisco: Michael D. Brown, 1992), 67.

14 "Accomplished Artist-Poet-Teacher-Writer." See also the biographical entry on Yang Ling-fu in this volume.

15 Li Chu-tsing, "Tseng Yuho: Unusual Life, Unusual Art," in *Dsui hua* (Hong Kong: Hanart T. Z. Gallery, 1992), 15–19.

16 Kristine Kim, *A Process of Reflection: Paintings by Hisako Hibi*, exh. cat. (Los Angeles: Japanese American National Museum, 1999), 3.

17 Louise Turner, "A Japanese-American of the Cezanne School," *Southwest Profile*, September/October 1985, 20, 23.

18 Jade Snow Wong, "The Artist's Story," in *Jade Snow Wong: A Retrospective*, exh. cat. (San Francisco: Chinese Historical Society of America, 2002), 18.

19 Ibid., 20.

20 Dido Smith, "Three Potters from China," *Craft Horizons* 17, no. 2 (March/April 1957): 23.

21 Ruth Asawa, "Artist's Statement," *Ruth Asawa, Completing the Circle*, exh. booklet, Oakland Museum of California.

22 Kay Sekimachi, interview by Suzanne Baizerman, Berkeley, CA, July 26 and 30 and August 3 and 6, 2001; Archives of American Art, Smithsonian Institution, printout p. 13.

23 Bernice Bing, "Artist Statement," from Women Artists of the American West, Asian American Artists website: http://www.sla.purdue.edu/WAAW/AsianAmerican/ Artists/BINGStatement.HTM.

24 See Irene Poon, *Leading the Way: Asian American Artists of the Older Generation* (Wenham, MA: Gordon College, 2001), 12–13; see also Bing's "Artist Statement," ibid.

25 According to her obituary in the *Los Angeles Times*, Fujikawa "was briefly engaged to be married in 1929, but broke it off and spent a year in Japan at the urging of her mother, who found the thwarted nuptials too embarrassing"; *Los Angeles Times*, December 13, 1998.

26 Jade Snow Wong met Kitaōji Rosanjin on a State Department tour. When he learned that she was a potter, he roared with laughter and said, "Nonsense! No *woman* can be a potter!" See Jade Snow Wong, *No Chinese Stranger* (New York: Harper and Row, 1975), 114.

27 *San Francisco Chronicle*, January 8, 1928, D7.

28 "Accomplished Artist-Poet-Teacher-Writer," 17–18. Yang Ling-fu, who met Hitler at an exhibition tea in Berlin, gave him a painting of two quarreling birds with a poem of her composition. When he requested a translation, she mailed it from an outgoing train. Her poem "To the Warlords" warned: "Life is transient as a sun beam. / Why should you hate each other? / You are brothers of the same blood. / Why harm each other? Why bruise your wings? / You will need them for loftier flights. / Let there be Peace."

29 Mine Okubo, *Citizen 13660* (reprint, Seattle: University of Washington Press, 1983), 3.

30 Letter from Dean Mullavey, no date, Katherine Choy file, CAAABS collection, Asian American Art Project, Stanford University.

31 Betty Townsend, "Oakland Chinese Girl Scores as Gifted Artist," *Oakland Post-Enquirer*, September 26, 1941.

32 Nanying Stella Wong, interview by Irene Poon Andersen, August 19, 1997.

33 Norma Broude and Mary D. Garrard, "Introduction: Feminism and Art in the Twentieth Century," *The Power of Feminist Art: The American Movement of the 1970s, History and Impact*, ed. Norma Broude and Mary D. Garrard (New York: Harry N. Abrams, Inc., 1994), 23.

34 Judith Anderson, "Why Ruth Asawa Can't Avoid Controversy," *San Francisco Chronicle*, February 8, 1982, 16.

35 Sally Woodbridge, *Ruth Asawa's San Francisco Fountain, Hyatt on Union Square*, booklet (San Francisco: Sally B. Woodbridge, Ruth Asawa, and Lawrence Cuneo, 1973).

36 Mildred Hamilton, "A tour of Ruth Asawa's San Francisco," *San Francisco Sunday Examiner and Chronicle*, Scene/Arts, September 19, 1976.

37 Melissa Walt, "Tseng Yuho," *Tseng Yuho: Crossing the Line*, exh. cat. (San Francisco: Chinese Historical Society of America, 2004), 8–9.

38 Quoted in Kim, *A Process of Reflection*, 10.

39 Ibid.

40 Ibid.

41 Deborah Gesensway and Mindy Roseman, *Beyond Words: Images from America's Concentration Camps* (Ithaca, NY: Cornell University Press, 1987), 73. Okubo's drawings feature stocky figures that show the influence of Diego Rivera, with whom she had briefly worked.

42 "Gyo Fujikawa: An Illustrator Children Love," *Publishers Weekly*, January 4, 1971, 46.

43 Elaine Woo, "Children's Author Dared to Depict Multiracial World," *Los Angeles Times*, December 13, 1998.

44 Fong et al., "The People's Artist," 40.

45 For a moving portrayal of the Yashimas' prewar activism and imprisonment, see Taro Yashima's pictorial memoir in English and Japanese, *The New Sun* (New York: Henry Holt and Company, 1943).

46 Email message from Rich Tokeshi to Valerie Matsumoto, March 21, 2004.

47 Quoted in Fong et al., "The People's Artist," 42.

48 Ibid.

49 Tseng Yuho, "Dsui Hua," *Dsui hua, Tseng Yuho*, exh. cat. (Hong Kong: Hanart T. Z. Gallery, 1992), 35. As Tseng Yuho added regarding the history of art, the transnational traffic of ideas "began long ago and influenced Chinese art many times over."

50 Ibid.

51 Ibid., 34.

52 Ding Xiyuan, "The Art of Tseng Yuho," in ibid., 21.

53 Tseng Yuho, "Dsui Hua," in ibid., 26.

54 Ibid., 33. In addition to her art and scholarship, Tseng Yuho has envisioned building a cultural and art center revolving around Chinese tea practices. Although this project will not be built in Hawaii as originally planned, perhaps she will realize her dream with her move back to China. Regarding initial plans, see Beverly Creamer, "UH gets $600,000 gift for teahouse," *The Honolulu Advertiser*, February 19, 2004, B4.

55 Quoted in Woodbridge, *Ruth Asawa's San Francisco Fountain*, 5.

56 Quoted in Dido Smith, "Three Potters from China," *Craft Horizons* 17, no. 2 (March/April 1957): 24.

57 "Katherine Choy," Museum of Contemporary Crafts, New York, ca. 1961, Oakland Museum Artist File.

58 Ulysses Grant Dietz, "Biography: Katherine Choy—A Promise Unfulfilled," *Katherine Choy: Ceramics*, ed. Ron-

ald A. Kuchta (Newark, NJ: Newark Museum, 2000), 4. See also online Memorial Gallery of American Art at www.mgaa.net/Gallery/Choy/index.htm.

59 Eli Leon, *Putting the Pieces Together: American Quilts by 19th and 20th Century Migrants to California* (San Rafael, CA: Falkirk Cultural Center, 1993), n.p. Whether Tominaga learned to quilt in Japan or in the United States is not clear.

60 Yoshiko Wada, "Contemplative Geometry," *Portfolio Collection: Kay Sekimachi* (Bristol, Eng.: Telos Art Publishing, 2003), 20.

61 Signe Mayfield, "Kay Sekimachi: Threads of Memory," in ibid., 12.

62 Ibid., 12–13.

63 "Artist to Review Book," undated newspaper clipping, Nanying Stella Wong file, CAAABS collection, Asian American Art Project, Stanford University.

64 Townsend, "Oakland Chinese Girl Scores."

65 Jade Snow Wong, *Fifth Chinese Daughter* (reprint, Seattle: University of Washington Press, 1989), 244.

66 Maxine Hong Kingston, "Letter to My Friend, Jade Snow Wong," in *Jade Snow Wong: A Retrospective*, 2.

67 Quoted in Shirley Sun, *Mine Okubo: An American Experience*, exh. cat. (Oakland, CA: Oakland Museum, 1972), 12.

68 Turner, "A Japanese American of the Cezanne School," 19.

69 Ibid. Hayakawa did win scholarships at the School of the California Guild of Arts and Crafts and at the California School of Fine Arts.

70 Hisako Hibi, *Peaceful Painter: Memoirs of an Issei Woman Artist*, ed. Ibuki Hibi Lee (Berkeley: Heyday Books, 2004), 36.

71 Ibid., 40.

72 Karin Higa, "Some Notes on an Asian American Art History," in *With New Eyes: Toward an Asian American Art History in the West*, by Irene Poon Andersen, Mark Johnson, Dawn Nakanishi, and Diane Tani (San Francisco: Art Department Gallery, San Francisco State University, 1995), 13.

73 Nanying Stella Wong, interview by Irene Poon Andersen, August 19, 1997.

74 Miyoko Ito, interview by Dennis Barrie, July 20, 1978, Archives of American Art, Smithsonian Institution.

75 "Gyo Fujikawa," 46.

76 Virginia Scharff, "Introduction: Women Envision the West, 1890–1945," in *Independent Spirits: Women Painters of the American West, 1890–1945*, ed. Patricia Trenton (Berkeley: Autry Museum of Western Heritage in association with the University of California Press, 1995), 5.

77 Jade Snow Wong, "The Artist's Story," 17.

78 See Jade Snow Wong's second memoir, *No Chinese Stranger*.

79 Ruth Asawa, interview by Addie Lanier, "Artist Remembers Painful Days of Internment During World War II," *Noe Valley Voice*, December 1989/January 1990.

80 Because data on several artists is incomplete, it is difficult to ascertain their marital status and whether they had children. Of the fifteen women who had children, thirteen had from one to four children. Ruth Asawa had six children, and Chio Tominaga had eight.

81 Ito, interview, 1978.

82 Quoted in Shirley Sun, *Mine Okubo: An American Experience*, exh. cat. (Oakland, CA: Oakland Museum, 1972), 42.

83 Tseng Yuho, interview by Valerie Matsumoto, in Honolulu, Hawaii, August 4–5, 2003.

84 Ruth Asawa, interview by Valerie Matsumoto, in San Francisco, California, October 2002.

85 Broude and Garrard, "Introduction," in *Power of Feminist Art*, eds. Broude and Garrard, 21.

86 Jade Snow Wong, email message to Valerie Matsumoto, February 4, 2004.

87 Karin Higa, "Asian American Women Artists Association (AAWAA) Introduction," Women Artists of the American West website, http://www.sla.purdue.edu/WAAW/AsianAmerican/AAWAA.html.

88 *Noe Valley Voice*, June/July 1981.

89 Chiori Santiago, "The Armature of Family," *The Museum of California*, Spring 2002, 12.

90 CAAABS project interview, August 26, 1999.

91 Please see http://www.seattleschools.org/schools/hamilton/iac/callig/.

92 Please see http://mission.base.com/manzanar/history/origins.html. Although her grandparents and other relatives were interned during World War II, Midori Kono Thiel was not, because her family had moved to Hawaii in 1936.

Chinese Artists in the United States

A Chinese Perspective

Mayching Kao

While the awakening of an Asian American consciousness and the development of Asian American studies programs in universities in the last few decades has led to the recognition and examination of the artistic heritage of Asian Americans, the art world in Hong Kong, Taiwan, and mainland China has also started to focus on Chinese artists living and working in countries around the world. Since the early 1980s, major exhibitions of works by them, whether as individuals or in groups, have been presented and catalogs published. Some of these artists, collectively called "overseas artists of Chinese descent" (*haiwai Huayi yishujia*), have achieved international acclaim as modern artists, but many have simply been forgotten in the turbulent history of China in the past century. The surge of interest in their creative work, which has evolved outside of the geopolitical reality of China, underscores the many challenges facing Chinese artists of the twentieth century and raises questions about their relationship to mainstream developments in China and their host countries. The

Chao Chung-hsiang, *Love of the Cosmos,*
1956 (detail, fig. 180).

case of Chao Chung-hsiang (1910–1991) best illustrates this point. Chao died a lonely death in Taiwan in 1991, finding his final resting place at the end of a lifetime of wandering, from mainland China to Taiwan and from Europe to the United States. New York was his home for more than thirty years. His art also drifts from China to the West and back to a synthesis of the two. The exhibitions and symposia presented worldwide in the decade after his death generated a great deal of public interest and a massive amount of critical writings, in both Chinese and English, by prominent scholars.[1] He is hailed as an innovative master of the twentieth century, recognized for bringing about a new combination of Chinese and Western art. But Chao was only one of many Chinese artists who migrated to the United States in the last century. In studying Chinese artists in the United States, one needs to ask why Chao and other Chinese artists left their home country and what artistic aspirations motivated them to seek an uncertain future in a foreign land. What were their achievements and failures in shaping their artistic careers in the United States? Moreover, did their art evolve in response to a new artistic and cultural environment? What were

their perceptions of their own cultural heritage and their contributions to the multicultural diversity and complexity of the United States? Finally, will these overseas Chinese artists and their work ever find a place in the history of Chinese or American art?

The migration of Chinese artists is best understood in the historical context of modern China, its relationship with the United States, and American attitudes and policies toward the Chinese in the United States.[2] China in the mid-nineteenth century was simultaneously faced with domestic strife and Western imperialism, resulting in the collapse of the Qing empire and the founding of the Republic of China in 1911. The decades that followed were no less tumultuous; they included the May Fourth New Culture Movement, the rise of communism, the domination of warlords, and the Second Sino-Japanese War. Against this historical background China was undergoing a slow but tantalizing process of modernization and westernization in order to build a strong and prosperous modern nation. In 1872 the United States was the first nation to receive Chinese students under government sponsorship, sent to acquire Western learning and technical knowledge. Unfortunately, the Chinese Educational Commission was short-lived, with only four groups of about thirty young children being sent.[3] Instead, Japan and Europe took over as mentors of China's modernization during this period.

China has a long history of migration across the seas, but until the twentieth century the cause was mainly economic. With the discovery of gold in California in 1848, the young country offered opportunities of work and livelihood. The Chinese, mostly farmers or workers of low social strata from the coastal province of Guangdong in the south, came to the United States as a source of cheap labor (*Huagong*). They worked in California and on the rest of the West Coast, as well as in Hawaii. They were confronted with a harsh and discriminatory society in which there were frequent outbreaks of anti-Chinese violence and the passage of anti-Chinese state laws and local ordinances. The adoption of the Chinese Exclusion Act in 1882 effectively reduced the number of Chinese immigrants and forced many to return to their homeland.

Back in China in the first years of the twentieth century, a new generation of artists and intelligentsia became aware of the decline of Chinese art and its stagnant state. They advocated reforms through the introduction of Western art into China. Many went abroad to study as *liuxuesheng* (overseas students), and when they returned, they became the leading force for China's modernization in art. Their destinations were Japan and Europe, especially Paris, art capital of the world at that time. Almost all returned home after completing their courses of training in the art academies and studios overseas. As influential figures in art and education, they were responsible for introducing Western art theories, styles, and techniques, from academic realism to modernism, bringing forth a westernized New Art Movement in modern Chinese art history. Traditional painting continued to thrive but was given a loose term, *guohua* (national painting), to differentiate it from the imported *xihua* (Western-style painting).[4] At the same time, many artists initiated the reform of Chinese painting through the synthesis of the two traditions.[5] A number of these reformers are notable. Xu Beihong (1895–1953) went to study in Paris and became the strongest and most influential advocate of academic realism in China. His style of ink painting represents a fusion of expressive brushwork of the Chinese tradition with drawing techniques based on studies from life.[6] Lin Fengmian (1900–1991) also went to Paris. But he came under the influence of modernist trends such as fauvism, cubism, and expressionism. The spiritual leader of the modernist

movement in China, he achieved at the same time a highly personal style integrating the expressive colors and free forms of modern Western art with the lyrical content of his native tradition.[7] Gao Jianfu of the Lingnan school of painting, and many others, went to Japan to study Western and Japanese art. The Lingnan school incorporated elements of Western painting such as realism, linear perspective, and shading into Chinese painting.[8]

Compared to Japan and France, the United States can hardly claim any overseas Chinese students whose original intention was to study art. For the limited few who caught our attention, they mostly came from villages in Guangdong to join their families in the United States. Even if they eventually returned to their homeland, their impact on the art world was much less than those students returning from Japan and France. However, the United States played a part in the education of the first Chinese to study oil painting abroad. Li Tiefu (1869–1952) went from Guangdong to Canada to join his uncle

in 1885, but two years later he went on to study art at Arlington School of Art in England. By the time he returned to China in 1930, he had spent forty-five years abroad, of which about twenty-five were in New York, ranking him among the first generation of overseas Chinese artists in the United States. Because of the turbulent times in which he lived and worked, details of his life are not well documented.[9] He was known to have studied at the Academy of Fine Arts in New York in 1913 and the International Academy of Design in 1916. As a follower of William Merritt Chase and John Singer Sargent, Li was deeply rooted in American realism (fig. 164), setting him apart from other first-generation Chinese Western-style painters such as Xu Beihong. Li was highly respected for his patriotism and his friendship with Dr. Sun Yat-sen, founder of the Republic of China. Instrumental in the founding of the New York branch of the revolutionary Tongmenghui, Li supported its causes with proceeds from the sale of his paintings.

FIG. 165 Dong Kingman, *Chinatown San Francisco (corner of Washington and Grant)*, ca. 1950. Watercolor on paper, 14½ × 21½ in.

Another pioneer in the study of Western art in the United States is Feng Gangbo (1884–1984), also a native of Guangdong. He went to Mexico in 1905 and became the first Chinese student to enroll in the Royal Academy of Fine Arts there. In 1911 he left Mexico for the United States, where he studied painting in the art schools of San Francisco and Chicago and, finally, the Art Students League in New York. He returned to China in 1921 and contributed to the burgeoning movement for Western-style painting in art education as an advocate of American realism, particularly in portraiture.[10] Other Chinese artists who followed in the footsteps of Li and Feng include Wong Chiu Foon (1896–1971), who migrated to Boston to work with his uncle in 1910. He subsequently attended the Buffalo Fine Arts Academy of New York and the Pennsylvania Academy of the Fine Arts, where he received thorough training in the academic tradition of Western art. He won many awards in his student days, including a scholarship to tour Europe for the study of the works of old masters. Graduating in 1925, he returned to Guangdong a year later and became an active member of the flourishing Western-style art movement. Wong pursued a teaching career, settling in 1945 in Hong Kong, where he remained until his death in 1971.[11]

These pioneers of Western art, and others like them, returned to China to contribute their new knowledge to the modernization of Chinese art, a historical process often described as a "draw from the West to nourish China" (*yin Xi run Zhong*). Their first loyalty was to their motherland, and they felt little conflict in the confrontation of these great artistic traditions. Unfortunately, they were gradually forgotten in the political upheavals that brought the Communist regime into power in 1949, at the same time modern developments in art rendered their realistic style obsolete. Only since the 1980s, when China opened its doors to the West, have historians rediscovered them in their efforts to reconstruct the history of modern Chinese art.

The case of **Dong Kingman** represents another aspect of Chinese American artists. By the title of his 2001 commemorative exhibition, *Dong Kingman: An American Master*, it is evident that he belonged to mainstream American art and enjoyed a successful career of seven decades as a watercolorist. He was an "American-born Chinese" but received his early education and art training in Hong Kong. At the age of eighteen he returned to the United States and attended the Fox Morgan School in Oakland. His decision to specialize in watercolor painting was a happy turning point.[12] Even though he confessed that he had a difficult time "trying to reconcile my Chinese heritage with my American thinking" in his early career, he resolved to focus on the perfection of his painting skills and allowed his personality and temperament to shine through.[13] While some critics continue to appreciate his paintings as a cross between the Oriental and the Occidental, his popular appeal comes from vivid representations of cities and their people with masterful draftsmanship, fluent brushwork, and vibrant colors that capture the vitality of modern life (fig. 165).

Seong Moy (b. 1921) is another Chinese American artist who has found a place in mainstream American art, perhaps for the same reason as Dong Kingman: he works in a secondary medium, in Moy's case printmaking, though he is also active as a painter. A native of Guangdong, Moy moved to the United States in 1931 and worked in a Chinese restaurant prior to attending the St. Paul School of Art in Minnesota. He later went to New York, where he studied with Hans Hofmann and at Atelier 17 and the Art Students League. He taught art in various universities from 1951 on, overcoming many hardships to achieve success as a modern artist. His Chinese heritage plays a part in shaping his personal style, which has evolved from the stylization of human figures and the incorporation of themes from Chinese literature and plays into an abstract style that emphasizes the relationship of geometric shapes and vibrant colors

to convey Eastern philosophical thought. *Inscription of T'Chao Pae #II* (fig. 166) is an early woodcut of 1952 in which he explores at about the same time as Zao Wou-ki (b. 1919) in Paris the aesthetic potential of archaic Chinese calligraphy as abstract structure and expressive form, illustrating the artist's aim "to recreate in the abstract idiom of contemporary time some of the ideas of ancient Chinese art forms."[14]

Another modernist among Chinese American artists is **Yun Gee**, also a native of Guangdong. He went to join his father in California in 1921 and in 1924 decided to study art at the California School of Fine Arts, where he developed a keen interest in modernist styles, particularly cubism and synchromism. His early artistic career showed promise, and he was accepted by the artistic circles in San Francisco, and later in Paris and New York. However, after settling down in New York in 1939, he died there in 1963 in obscurity. Torn between his passion for modern art and his spiritual roots in Chinese culture that suffered in the discriminatory atmosphere of the United States, he encountered hardships, and his art received critical reviews. His later years were

plagued by alcoholism and ill health, and he was forgotten by the art world. Only after his death was he rediscovered and his achievement recognized with a series of exhibitions in the United States and Taiwan. Recent studies hail him as a Chinese, American, and modernist painter, as well as a pioneer in avant-garde art.[15] In *Where Is My Mother* (fig. 167), an early work dated 1926–1927, the young artist expresses his sorrow at leaving his mother behind in China, as many Chinese women were separated from their families in America, due to restrictive immigration laws. The painting may also be interpreted as symbolic of the motherland that Yun Gee left behind. It is inspired by his poem of the same title, which concludes:

> I dreamed that I could bring her close,
> Created the painter's art
> On the canvas
> Mother looking out of the door,
> By the mountain road a cart,
> A plane in the air,
> The ship on the sea.
> Could I find my mother again?[16]

Inscription of T'Chao Pae #II 26/225

that were considered useful in China's quest for modernization, Wen Yiduo (1899–1946) appears to be a solitary example of an art student. Between 1922 and 1925, Wen attended the Chicago Art Institute, Colorado University, and the Art Students League. He excelled in art courses but also expanded his interest in European and American literature.[18] His art shows a tendency for decorative design, as seen in *In Front of the Mirror* (fig. 168), a watercolor illustration for *Feng Xiaoqing* by Pan Guangdan in 1927. The artist has successfully portrayed a woman trapped in her own state of loneliness and self-preoccupation. The work also demonstrates the sinicizing process of a foreign medium, as seen in the calligraphic strokes of the drapery and overlapping planes that create a shallow space. After his return to China, Wen maintained ties with the art world, but his reputation as a poet, writer, and scholar eventually overshadowed his involvements in art. He developed a keen interest in calligraphy and seal carving and became quite proficient in these two branches of traditional arts a few years before his tragic death.

One other name worth mentioning is Wong Siu Ling (1909–1989), a native of Guangdong Province and a good friend of Xu Beihong. In 1938, to study Western art, Wong chose to go to the United States as an alternative to wartime Europe. By this time he was already an accomplished oil painter. Nevertheless, he undertook serious study at the California School of Fine Arts and Columbia University, firmly grounded in academic realism. He subsequently settled in New York, active as a teacher and exhibiting both as a painter and as a watercolorist.[19]

Chinese artists in the United States during the late nineteenth and early twentieth centuries often had to contend with difficult living conditions and almost daily encounters with racism. Many such instances were recorded in the lives of Li Tiefu and Yun Gee, while Wen Yiduo as a government-sponsored overseas student was not spared.[20] The growing concern over the fate of China in the face of Western and

With tears on his cheeks, the man in the portrait looks out with an expression of longing. All forms are rendered in color prisms of yellow, ochre, and green, creating a rhythmic correlation of shapes and tones that inject a sense of order into the emotionally charged painting.

While China was a source of cheap labor, it also sent thousands of students to the United States in the first three decades of the twentieth century under the Boxer Indemnity Scholarship and other government funds.[17] While almost all of these students majored in science, technology, and the humanities, subjects

FIG. 167 Yun Gee, *Where Is My Mother*, 1926–1927. Oil on canvas, 20⅛ × 16 in.

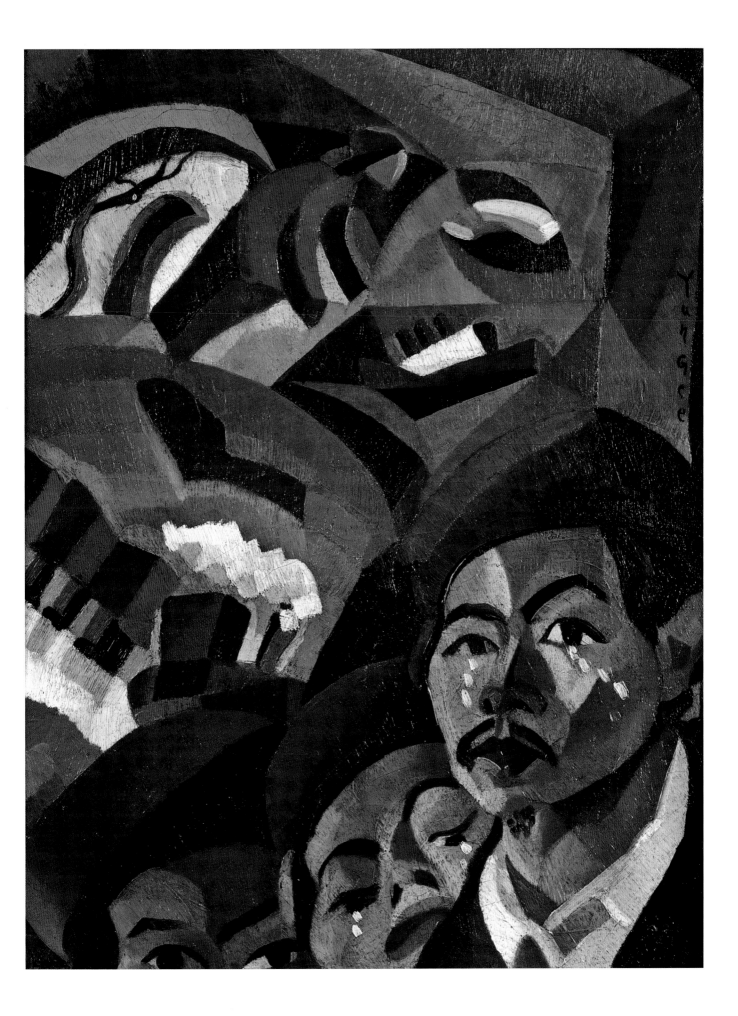

FIG. 168 Wen Yiduo, *In Front of the Mirror*, 1927.
Watercolor, dimensions unknown.

major exhibitions of Chinese art, both ancient and modern, were sent. Examples include the spectacular *International Exhibition of Chinese Art* held in London in 1935–1936 and the exhibitions of traditional and modern paintings that toured major European countries in 1933–1935, organized by Xu Beihong and Liu Haisu (1894–1994), respectively. These activities opened the eyes of other Westerners to the rich artistic heritage of China and found for the country a place in the international world of art.

Yang Ling-fu is perhaps a notable exception in promoting traditional Chinese painting in the United States. She was a symbol of women's liberation in the early twentieth century, traveling in China, North America, and Europe. Thrice she crossed the Pacific Ocean, the first time in 1926 to participate in the Philadelphia Exposition, where she displayed her paintings and conducted public demonstrations of her skills in painting, calligraphy, and poetry. In 1936, she was in Canada for the Vancouver Exposition, followed by touring exhibitions in the United States. She returned to California in 1938 to escape from the Second Sino-Japanese War and then devoted much of her time and energy to promote American awareness and understanding of Chinese art. She was a versatile artist of all traditional subjects of landscapes—figures and flowers and birds—and was equally adept at poetry, calligraphy, and painting, the three perfections of the literati tradition.[21] (See Valerie Matsumoto's essay, fig. 163.)

As the Second Sino-Japanese War continued, more Chinese artists traveled to the United States to increase American awareness of the plight of the Chinese people and to raise funds for the war efforts. As representatives of China and its culture, these artists almost all belonged to the traditional school. They accomplished their noble missions with exhibitions, lectures, and demonstration workshops held in major cities. The most famous among these artists was Chang Shanzi (1882–1940), elder brother of **Chang Dai-chien**. He toured France and the United

Japanese imperialism also stimulated artists' nationalistic spirit and transformed them into vanguards of China's modernization. An excellent example can be found in Li Tiefu, who was best known for his support of the revolutionary activities of Sun Yat-sen.

These few Chinese artists were further handicapped by the lack of understanding in the United States of the great achievements of Chinese culture and art, as both the Qing court and its successor, the Nationalist government, made little attempt to promote them as a means to change the American public's perception of China as a backward and vulnerable country. This stands in contrast to the situation in Japan and Europe, as well as in Russia, where

FIG. 169 Chang Shu-chi, *Eagle*, 1956. Mineral pigments and inks on paper, 24 × 36 in.

States from 1938 to 1940, arousing the sympathy of the American people and depicting China's determination to overcome its invaders by his naturalistically rendered roaring tigers. The new developments of the Lingnan school of painting, characterized by a revolutionary spirit and the assimilation of realistic elements of Western painting, were also offered to the American public by Zhang Kunyi (1895–1969) in 1938 and Fang Rending (1901–1975) in 1939–1940.

Last but not least of these cultural ambassadors, **Chang Shu-chi**—whose monumental painting *Messengers of Peace* (see Gordon Chang's essay, fig. 97) of 1940 was selected by the Nationalist government to be presented to President Franklin D. Roosevelt in honor of his third term in office—also toured the United States for five years between 1941 and 1946. His activities received extensive media coverage, establishing him as the best-known Chinese painter in America during this period. A native of Pujiang, Zhejiang Province, Chang was a student

of Liu Haisu in the Shanghai Art Academy and successfully built a dual career as an artist and teacher. He returned to the United States in 1949, earning a living by selling paintings and publishing note cards and stationery.[22] Chang mainly painted flowers and birds in a style that carried on the spirit of the reform of Chinese painting tradition in the 1920s: his work brings the ancient classical tradition of the Song dynasty (960–1279) to the modern period by enlivening it with spontaneous, expressive brushwork of the literati tradition of the Ming (1368–1644) and Qing (1644–1911) dynasties and revitalizing it with realism achieved by life studies borrowed from Western drawing. The result is a style that is decorative, realistic, expressive, and full of vitality. Chang was noted for his magical ability to capture the spirit of his subjects, such as birds (fig. 169),

FIG. 170

Chang Shu-chi in painting
demonstration, ca. 1942.

and his popularity was instrumental in shaping the American public's perception of Chinese painting (fig. 170).

THE WANDERING SOULS: 1943 AND THE FOLLOWING DECADES

The year 1943 signaled a new phase of the China-U.S. relationship, when the Chinese Exclusion Act of 1882 was relaxed in recognition of China as an indispensable ally in the fight against Japan in World War II. Two years later China finally won the Second Sino-Japanese War, but the country was soon embroiled in civil wars between the Nationalist government and the Communist troops, which ended in 1949 with the removal of the Nationalist government to the island of Taiwan. Despite the raging civil wars in China, study abroad and travel to the United States resumed at great speed in an effort to train capable professionals for China's postwar reconstruction and modernization. Several thousand Chinese with strong educational, professional, and commercial backgrounds were admitted into the United States, including many of the best and brightest graduate students sent over by the Nationalist government. Among these Chinese students and visitors are artists who will become major figures in the Sino-

U.S. artistic dialogue: **C. C. Wang** (Wang Chi-ch'ien), who toured museums to study their Chinese painting collections in 1947; Wang Ya-chen (1894–1983) and Chen Chi (1912–2005), both to study modern art in 1947; and Chen Chi-kwan (1921–2007), who came to study architecture in 1948.

The civil wars and the eventual Communist takeover of mainland China started an exodus of millions of Chinese migrating to Taiwan, Hong Kong, Southeast Asia, and all corners of the world. Dispossessed of their homes and families, detached from their roots, they found themselves in alien and not necessarily friendly environments. This historical process came to be called the Chinese diaspora.[23] On the one hand, the Cold War and the consequent hostile relations between the newly founded People's Republic of China and the United States abruptly terminated all ties and communications as China closed its doors to most of the countries in the world, especially the United States. The Chinese in the United States had to wait to resume communication with their homeland until 1972, when President Richard Nixon reversed the policy of containment of China after his historic visit to Beijing. On the other hand, a closed China was embroiled in political movements one after the other, culminating in the Great Pro-

210

letarian Cultural Revolution (1966–1976). The period was one of isolation and wandering for many Chinese, who saw little hope of returning to their homeland, forcing some to permanently plant their roots in American soil. Tang Junyi wrote eloquently of the tragic destiny of the modern Chinese, describing them as "flowers and fruits whirling and scattering" (huaguo piaoling) after the fall of a big tree in the garden. It was a time of war and destruction during which Chinese culture and art were devastated.[24] But these catastrophic changes also provided an ideal opportunity to reflect and to re-examine the cultural heritage in a quest for new life. Tang Junyi called it "self planting of spiritual roots" (linggen zizhi).[25] By settling down in their host countries, these artists created the historical phenomenon of "overseas artists of Chinese descent." It is characterized by the dual development of traditional painting on the one hand and a new synthesis of Chinese and modern Western art on the other, both developing outside of China proper.

As mentioned earlier, some Chinese artists were already in the United States prior to 1949. Many more followed in the subsequent years. Some came directly from China in the late 1940s and early 1950s, others came after a few years in Hong Kong or Taiwan, and a few arrived via Europe or other countries. Moreover, the relatively liberal policies toward foreign students also attracted highly qualified art students from Hong Kong, Taiwan, and Southeast Asia. Regardless of their place of origin and their routing to the United States, these new immigrants transformed the relatively homogeneous composition of the Chinese American artists of the earlier period. First of all, immigrants were of both sexes and various age groups at varying points of their artistic careers. They came from diverse geographic origins with different social backgrounds. Most importantly, they brought with them the full spectrum of artistic development in modern China and, to a certain extent, that of Hong Kong and Taiwan, reflecting

differing loyalties to traditional and modernist art. These loyalties, or artistic ideals, underscored their efforts to adapt their art to a new environment and to shape their cultural identity outside of China.

One may ask why these artists left their homeland and settled in the United States. The reasons are manifold; no doubt the overriding concern was political, whether driven by the political instability in China, Taiwan, and Hong Kong or to take voluntary exile from the Communist regime and the oppressive rule of the Nationalist government in Taiwan. In view of the massive destruction of China's cultural heritage, its preservation and continuous development outside of mainland China became paramount. Thus the idea of promoting Chinese art in an international arena could also be considered, while New York beckoned those artists under the influence of American modern art with its pursuit of the new. These modernists aimed for opportunities for personal advancement and were ambitious about competing on the same footing as American artists. The success of Zao Wou-ki and Chu Teh-chun (b. 1920) in Paris showed that such goals were achievable. The pursuit of creative freedom was important as well, particularly to artists from Taiwan.

Regardless of the artistic aspirations or backgrounds of these immigrant artists, they faced a harsh reality in the Eurocentric art world of America. Michael Sullivan offered his keen observation of the situation:

As long as the differences between Chinese and Western art were clear-cut, the Western public tended to be not merely critical but often positively hostile towards Chinese artists who painted in the Western idiom and judged their works harshly. Westerners dismissed Chinese painters who continued to work in the traditional style as conservative and uninteresting, yet if they detected the influence of Picasso or Klee they accused the painters of "copying," although they would applaud Oriental

influences on Western painters. For Zao Wou-ki to be stimulated by Jackson Pollock showed how derivative he was; for Mark Tobey to be influenced by Chinese calligraphy showed how receptive he was.[26]

Chinese Tradition Renewed and Transformed

The United States had never before been graced by the presence of so many Chinese artists with such profound knowledge of and skills in traditional painting. They provided the American public with an extraordinary introduction to a venerable tradition and its modern expressions. Their self-appointed mission was to promote, preserve, and develop the essence of traditional Chinese painting in the West. The sense of urgency was heightened as art in mainland China came under the influence of Russian socialist realism and traditional painting was suppressed and reformed according to political ideology.[27]

Traditional artists had a difficult task on their hands, because the essence of Chinese painting was not easily appreciated even by modern Chinese, least of all the American public. Dominated by the literati tradition that has developed since the eleventh century, traditional painting is the integration of the three perfections of poetry, calligraphy, and painting. It emphasizes the study of ancient masters as well as the cultivation of scholarship and moral character. Often done in monochrome ink, its styles are restrained and subtle. The images are appreciated not for their faithful representation of nature but for their nuances of ink and brush codified into a formal language of their own. In its degenerate state in the final decades of the Qing dynasty, traditional painting came to be criticized for its lifeless repetitions of casual ink play, far removed from reality. The reform movements of the early twentieth century therefore advocated its revitalization through the introduction of realistic Western art.[28]

From the 1940s on, a greater awareness and better understanding of the Chinese artistic tradition emerged in the United States, largely brought about by the presence and activities of such eminent traditional artists as C. C. Wang and Chang Dai-chien.[29] Another favorable factor was the many touring exhibitions of Chinese art from Taiwan, whose government claimed its orthodoxy as the rightful heir to Chinese tradition when mainland China was closed to most countries in the world. The most spectacular was the 1962 exhibition of Chinese art treasures from the Palace Museum in Taipei. The formation of major public and private collections of Chinese art was instrumental as well, including those taken outside of China by their refugee owners. The development of scholarship in Chinese art, along with the growth of Chinese studies programs at universities, all contributed to making Chinese art more accessible to and understandable by the American public.[30] No less important were the developments in modern American art, particularly in abstract expressionism, which has formal and philosophical goals akin to those of the cultural heritage of China. The popularity of Eastern mysticism, especially in California, played a part in increasing public awareness of Chinese culture and art.

The majority of traditional painters active in the United States were considered conservative, and they often confined their activities within the Chinatowns of major cities. In their agonizing experience of displacement in the West, they found their spiritual home in tradition, clinging to fading memories of their homeland and longing for the distant rivers and mountains in their dreams. They have been likened to wandering souls in forced exile and full of nostalgia for the past.[31] Yet these artists could not help but respond to the change in their cultural environment and living conditions. They had to try to adapt their traditional training to what they learned and saw in the West, so that Western influence became perceivable in varying degrees in their art, while others met the challenge of modernist aesthetic ideas and developed a synthesis of their own.

These Chinese artists not only were promoters and conservators of traditional art abroad but also contributed to the East-West artistic dialogue in a positive way.

Wang Chi-yuan (1893–1975) was already in the United States when the Chinese Exclusion Act was repealed. He recalled his emigration experience in a touching statement written in 1972:

> Thirty-two years ago I was in Hong Kong. I had come from Shanghai not only fleeing from the war within my country, but leaving the place where my kind of person and my kind of work were no longer of value or importance. In 1941 I landed in San Francisco. Summer of 1942 took me to the Yosemite area, that stupendous place of great vistas and tremendous beauty. In these mountains I found the qualities of peace and beauty to which I could respond, and in the great quiet and calm I could work again. In November of 1942 I came to New York which is indeed home for me. The Metropolitan Museum asked me to be part of their Modern Chinese Painting Exhibition that was just being formed. For the very first time the work of contemporary Chinese painters crossed this important threshold. Thereafter the American Federation of Art requested the loan of the paintings for one of their circulating shows. For three years this ancient painting art in its fresh new life crisscrossed the United States. The increased interest in Oriental art eventually brought me to a decision—I would establish a school where Chinese Brushwork could be taught. The school is the place where my beliefs are made evident, a new joining of eastern materials and western hands to form not just a mixture of old things, but a wholly new art—a language which both East and West understand—and to which both contribute.[32]

The statement is quoted at length because it gives strong testimony to the aspirations of the immi-grant artist in a new life in the United States. The words are all the more surprising when one realizes that Wang Chi-yuan, a native of Wujin, Jiangsu Province, was among the first generation of Western-style painters and a key figure in the New Art Movement to revolutionize tradition. His return to traditional painting was central to the formation of his Chinese cultural identity in the United States. Since he was unable to return home, his ashes were scattered over the Taiwan Straits after his death in 1975.

Wang Chi-yuan was equally proficient in oils, watercolors, and ink, but in New York he mainly painted in the latter two media and practiced calligraphy. He achieved a hybrid style ranging from classical Chinese to conservative realism enlivened by Chinese brushwork, as evident in *Old Pine Tree with Two Pigeons* (fig. 171), painted in 1958 in New York's Central Park. Wang Chi-yuan's ideals of a contemporary art that would bridge China and the West were brilliantly realized by his good friends Chang Dai-chien and C. C. Wang, with whom he often exhibited, notably their joint exhibition held at Seton Hall University in 1972. In addition, a traveling exhibition of works by Wang Chi-yuan and Chang Dai-chien entitled *Contemporary Chinese Brushwork* was presented by the Smithsonian Institution two years earlier.[33]

Wang Ya-chen was a fellow advocate of the New Art Movement and a first-generation Western-style painter. A native of Hangzhou, Zhejiang province, he studied Western painting in Japan and France, then returned home to become a major artist and influential teacher in the modern art academies in Shanghai, in addition to being a prolific writer on current issues in art.[34] Under government sponsorship, he toured the United States to study modern art in 1947 but was held up by the political disruptions in 1949. For thirty-three years he lived alone in the United States, separated from his wife and family in mainland China, until he returned to mainland China in 1980 and died three years later. He represents a typi-

FIG. 171
Wang Chi-yuan, *Old Pine Tree with Two Pigeons*, 1958. Ink on paper, dimensions unknown.

cal case of *luoye guigen* (fallen leaves returning to the roots), or the sojourner mentality of Chinese Americans.[35] He always maintained his Chinese identity in the long years of voluntary exile, leading a simple life by "finding consolation in art, resting the body and soul in learning," while he taught Chinese painting in American universities for a living. His painting style stays close to tradition and changes little, in strong contrast to his experimental works in oil of the 1930s.[36]

The influence of the Lingnan school of painting spread to the United States mainly through the exhibitions, lectures, demonstration workshops, and teaching activities of **Lui-sang Wong**. Wong, a native of Guangdong, emigrated from Hong Kong to San Francisco in 1960. He joined the faculty of the University of Chinese Culture in Taipei in 1983 but maintained close ties with American art associations and institutions. As a student of Chao Shao-an in Hong Kong, Lui-sang Wong integrates Chinese and Western styles by heightening the sense of realism as he captures the atmospheres and moods of monumental mountains and rivers and by adopting dynamic compositions, intense colors, and vibrant brushwork.[37] Perhaps because of his integrative style, or because of the general Western practice of grouping Chinese painting with watercolor paint-

ing, he is not only active among Chinese painters but also accepted by the circle of American watercolorists, winning honors and awards from relevant associations. Lui-sang Wong founded the East Wind Art Studio in San Francisco as a vehicle to promote Chinese art and as a means of livelihood. Many other traditional painters have been similarly engaged, including **Lim Tsing-ai**, **Cheng Yet-por**, Wang Chang-chieh (1910–1999), and **James Yeh-jau Liu**, all of whom arrived in the United States in the 1960s.

The most distinguished artist to leave China due to the 1949 political turnover was Chang Dai-chien, a native of Neijiang, Sichuan Province. For nearly three decades, he wandered all over the world, building homes in Argentina, Brazil, and California, before finally returning to Taiwan, seat of the Nationalist government, where his loyalty lay. A sojourner perpetually seeking the legendary Peach Blossom Spring,[38] Chang maintained a strong Chinese identity and re-created the ambience of a Chinese cultural environment in all his international homes. As early as the 1930s, he was hailed by Xu Beihong as the greatest painter in the last five hundred years. His status as an overseas Chinese artist was often overlooked, as he is about the only Chinese artist outside of China claimed by both sides of the Taiwan Straits and is featured prominently in the mainstream his-

FIG. 172

Chang Dai-chien,
Niagara Falls, late 1953/
early 1954. Rigid board
album leaf; ink and color
on silk, 20½ × 15 in.

tory of twentieth-century Chinese art. The ground-breaking exhibition *Chang Dai-chien in California*, curated by Professor Mark Johnson in 1999, documented for the first time Chang's dual identity as a great modern master and an overseas Chinese artist making new contributions to the art of America.[39]

When Chang Dai-chien first visited the United States in 1953, he was steeped in traditional painting, conversant in all styles and schools in the history of Chinese painting. When he painted Niagara Falls (fig. 172), he transformed the spectacular scen-

ery into a Chinese painting. Less than a decade later he evolved his late style of splashed ink and splashed color that is the convergence of various factors: exposure to modern art trends in the West, particularly abstract expressionism; re-examination of the unorthodox *pomo* tradition that dates back to the Tang dynasty (618–906); and failing eyesight, which no longer permitted him to work in a meticulous, detailed manner. Chang's late style is culminated in a monumental painting, *Wuxia Gorge and Sailboats Amidst Clouds* (fig. 173), dated 1968. With bold

splashes of color and ink flowing freely down the entire length of the painting, it captures the breathtaking grandeur of the artist's birthplace as well as the mystical moods of the Yangtze River. Beneath the towering cliffs of the gorge poises a lone cypress, its old and gnarled branches vividly recalling the wind-blown cypresses of Carmel, California, where Chang spent extended periods before settling there in 1968. The encounter of East and West in Chang Dai-chien's late paintings led to innovations that bring modern transformation to an ancient tradition.

C. C. Wang fled China in 1949 to make New York his permanent home. He continued to develop his multifaceted career as an artist, collector, connoisseur, and scholar and gradually became known internationally as an authority on Chinese painting. Just like his good friend Chang Dai-chien in the 1950s, he drew upon his encyclopedic knowledge of and insights into Chinese art traditions to paint in the orthodox literati style, regrettably considered by Michael Sullivan as "skillful, orthodox, conservative, and deservedly unregarded."[40] But Wang resolved the sharp contrast between the classical art that he was devoted to and the modern environment of New York in which he lived. He sought inspiration from modern art trends through studies at the Art Students League and visits to major museums. Recognizing the common ground between the Chinese painting tradition and abstract expressionism, he soon began to explore the latter. Those efforts culminated in his participation in the exhibition *The New Chinese Landscape: Six Contemporary Chinese Artists*, sponsored by the American Federation of Arts, which toured the United States in 1966–1968.[41]

The style that came out of Wang's dynamic fusion of Eastern, Western, classic, and contemporary elements is both innovative and personal. It integrates the elegant refinement of the Four Wangs of the early Qing dynasty, the grandeur and power of the landscapes of the Song and Yuan dynasties, and the technical experimentation and textural abstrac-

tion of modern art in the West. *Landscape* (fig. 174) of 1969 is an excellent example of his fully evolved modern style, in which he utilizes a new language of brushwork derived from textures impressed by crumpled paper and a fresh compositional structure, while at the same time capturing the grandeur of nature with allusions to the great ancient tradition. This innovative style is regarded by Joan Stanley-Baker as the rebirth of Chinese painting.

Tseng Yuho also has helped transform Chinese tradition through an innovative fusion of East and West. She was born in Beijing, where she received a solid grounding in traditional painting and calligraphy. She arrived in Honolulu in December 1949 and settled there with her German husband, Gustav Ecke, who accepted the post of curator at the Honolulu Academy of Arts after being driven from China by the Communists. Tseng forged a distinguished career as artist, art historian, scholar, professor, and curator, crossing the boundaries between tradition and modernity with a highly personal style.[42] *Silent Action* (fig. 175) of 1955 demonstrates the artist's response to her new environment and freedom gained through exposure to Western modernism. She successfully adapted her classical training to render with precision the exaggerated geological formation of the Hawaiian landscape, which is at the same time reminiscent of the panoramic landscapes of Jiang Sen of the Song dynasty. Direct communion with real nature is equally important in the formation of Tseng's style. She invented *dsui hua*,[43] a technique she developed from traditional scroll mounting methods of pasting paper on paper (she also may have been inspired by collage). Into her paintings she introduces various materials in addition to paper, including fibrous tissues, gold, and aluminum, building the surface of her work with patches and overlapping layers in conjunction with painted brushwork and color washes (fig. 176).

Tseng Yuho does not belong to the category of alienated, struggling Chinese artists in a foreign land.

She has been among the most successful Chinese artists in America, and fame came to her early. Though she maintains a strong Chinese identity, she is equally at ease in circles of Chinese and American artists. Therefore her recent decision to return to China to retire may surprise many. The move cannot be simply explained by the sojourner's desire to return to his or her homeland. Instead, Tseng Yuho

is concerned with the future of traditional crafts in a fast-changing social and economic situation; she wishes to contribute her experience and expertise in ensuring their sustained development. Moreover, her success in fusing East and West to create an innovative and personal style could serve as an example to the mainland artists who are now under new waves of influence from the West.

Chen Chi-kwan, also a native of Beijing, had a very different background and training from Tseng, but he was equally innovative in his artistic vision and techniques. He came to the United States for

FIG. 174 C. C. Wang (Wang Chi-ch'ien),
Landscape, 1969. Hanging scroll,
ink on paper, image: 18⅝ × 24⅝ in.

graduate study in architecture in 1948 but was cut off abruptly from China by the 1949 revolution. He built a successful career as an architect in the United States and later in Taiwan. He started painting out of a concern for the future of the ancient tradition and a desire to inject new life into it. His paintings became known through the Mi Chou Gallery in New York, which presented annual exhibitions of his work for ten years from 1957 on. He was one of the few Chinese artists who could depend on the sale of their art for a living. *Ball Game* (fig. 177) is an early work that registers his artistic response to a typical facet of American life—American football. One of a series of paintings, it does not depict the game or the players. Instead, with a succession of strokes and dots derived from calligraphy, the artist captures the essence of the game: the fierce and fleeting confusion of players as they battle from one end of the graded field to the other.[44] The delightful and witty "ink-play" is by someone not at all confined by the canons of traditional painting.

FIG. 175 Tseng Yuho, *Silent Action*, 1955. Ink on vintage Hawaiian tapa, 26⅜ × 35 in.

FIG. 176 Tseng Yuho, *Ascent of a Forest*, 1958.
 Ink, paper, and acrylics on Masonite,
 4 panels, 24 × 13 in. each.

Where Is Arcadia? (fig. 178) of 1962 deals with the perpetual theme of the Peach Blossom Spring in Chinese literature and art. It reflects the artist's concern for peace and harmony in a modern society and the vision of his own Utopia. Chen has constructed a bold composition of two confronting cliff faces, enriching it with interesting surface textures—built up by many layers of color applied with a special technique—and a wealth of fascinating details, such as fishermen on their boats. Unlike any traditional painting in composition and brushwork, the work nevertheless captures the spirit of Chinese art.

The Lure of the Modern West

For artists who looked toward the modern West for their creative models from the 1940s on, Paris and other major European cities presented more opportunities than America. Those few who chose to come to the United States, such as Chao Chung-hsiang and Walasse Ting (b. 1929), generally came in the late 1950s or early 1960s after spending some years in Europe. Unlike the Chinese artists of the traditional school, they came to America to learn the lat-est developments in modern art and to make a name for themselves in the international arena. Therefore they more actively attempted to integrate with and assimilate into the cultural environment of their adopted country. L. Ling-chi Wang has defined this type of Chinese American identity as *luodi sheng-gen*, or "planting seeds in foreign soil and allowing them to take root."[45] However, these artists described themselves as *guohe zuzi*, like a pawn in the chess game that only goes forward to cross the river. Their number was much smaller than that of their counterparts in Europe, and their place in American modernism has just recently begun to be recognized.

When Chao Chung-hsiang arrived in New York in 1958 after two years in Spain and other parts of Europe, abstract expressionism was at its height of popularity in the city. As noted earlier, abstract expressionism touched the creative efforts of traditional artists in their quest for a new art that was both Chinese and modern. It was even more attractive to the Chinese modernists who followed the art trends in the West, as they recognized that the qualities considered "advanced" in abstract expressionism were similar to various formal and technical expressions of traditional Chinese art evident for centuries. Jeffrey Wechsler succinctly summarized these qualities:

FIG. 177 Chen Chi-kwan, *Ball Game*, ca. 1952.
Ink on paper, approx. 47¼ × 9¾ in.

FIG. 178 Chen Chi-kwan, *Where Is Arcadia?*, 1962.
Ink and color on paper, 36⅜ × 9 in.

gestural methods,... frequent restriction of color range,... calligraphic imagery, free linearism, and aggressive or rapid brushwork, highly asymmetrical compositions, often with large areas of empty space; atmospheric or flat fields of color; a spontaneous approach to art-making that includes the acceptance of accidental effects, and the notion of the act of painting as a self-revelatory event, psychically and somatically charged and implicitly linked to the artist's emotions.[46]

The Chinese artists who embraced abstract expressionism were also persuaded by its links to Daoist metaphysics and the art of calligraphy. The movement spread to Asia in the 1950s, attracting many adherents among artists in Taiwan and Hong Kong. Some of these artists responded with an infusion of Chinese aesthetics, leading to the formation of the Modern Ink Painting Movement.[47]

Chen Chi is one of the Chinese artists who came under the influence of American abstract expressionism after settling in the United States. He came to the country in 1947 under the sponsorship of the Chinese Nationalist government to study the latest developments in modern art, but the 1949 revolution forced him to stay. At that time he was already a well-established watercolorist working in a realistic manner. He started to paint his new environment, gradually moving away from realism to experiments combining Chinese brush and *xun* paper with watercolor pigments. His personal style is lyrical and evocative, capturing moods with luminous colors, expansive washes, and fluid lines. *Flowing River* (fig. 179), dated 1956, borrows the horizontal-scroll format from Chinese painting, the engraved lines from archaic stone reliefs, and the rolling water and cloud patterns from traditional design. All these elements, combined with free splashes of color and ink, create a powerful visual symphony that is both Chinese and modern. Chen Chi enjoyed a successful career as a watercolorist in the United States and received recognition by mainland China as his work became better known through his many trips and exhibitions there since the opening of China in the late 1970s.[48]

Chao Chung-hsiang was also an accomplished modern artist with a secure teaching post in the

FIG. 179 Chen Chi, *Flowing River*, 1956.
Ink and color on paper, 16 × 60 in.

art department of a university in Taiwan prior to his arrival in America in 1958. During a visit to Paris while studying in Spain, he had discovered abstract expressionism, mainly through his former schoolmates at the National Academy in China, Zao Wou-ki and Chu Teh-chun, who were already involved in the trend. Chao Chun-hsiang recognized New York as the center of action for abstract expressionism, and he headed for the new art capital of the world, seeking his fortune and greater creative freedom in an international arena. He met with moderate success in the early 1960s. His circle of friends included Franz Kline, who reportedly told Chao that "the reason your work isn't getting into New York's top museums is not that your work isn't good—it's because you are a foreigner. You won't have your turn until they've collected enough of us."[49] Chao's misfortune, apart from being alone in an alien city away from his family, was in finding a satisfying style, albeit late in life, that soon came under attack in New York and fell from favor. In its place were pop art, photorealism, op art, and a variety of other trends. Chao decided not to follow any of them. Instead, he re-

turned to ink and paper, evolving a distinctive personal style that incorporated ideas and symbols of Chinese painting with visual elements from abstract expressionism and later trends. He remained isolated from mainstream American art, neglected in his time and only rediscovered after his death in Taiwan, a year after returning from decades of voluntary exile. In contrast to the traditionalists and modernists of his generation who aimed for a harmonious blending of East and West, Chao felt more acutely the contradictions of the two artistic traditions and the sufferings of a wandering soul. His individual style, evident in *Love of the Cosmos* (fig. 180), is charged with conflicting, fragmented forms and iridescent colors in unusual combinations that simultaneously expand and destroy spatial relationships.

After spending ten years in Paris, Walasse Ting arrived in New York in 1963. He also viewed the metropolis as a place for new art movements and for artists from all over the world. A self-taught art-

FIG. 180 Chao Chung-hsiang, *Love of the Cosmos*,
1956. Ink and acrylic on paper mounted
on canvas, 69 × 43½ in.

because of the underdeveloped college art education in the British colony. Among those who settled in the United States is Fay Ming-gi (b. 1943), who attended Columbia School of Art and Design in 1961 and then studied sculpture at the Kansas City Art Institute. In the 1970s, when photorealism was in vogue, he moved from abstract expressionism to realism. He uses simple still-life motifs such as fruits and vegetables familiar to Chinese or popular Chinese symbols (fig. 182), bringing forth the essence of life contained in these common objects.[51] Working in a style diametrically opposed to that of Fay is David Diao (b. 1945), who graduated from Kenyon College in 1964. Though his work continues to be abstract, *Made in USA* (fig. 183) of 1979 is representative of his style, which is dominated by hard-edged, geometrical forms filled with brilliant colors. While Fay Ming-gi's predominantly Western style still hints at his Chinese cultural roots, David Diao represents a group of Chinese artists whose works have become completely American; they contain no discernible Chinese quality.

CONCLUDING REMARKS

In studying the developments of Chinese artists in the United States, one finds that the two periods demarcated by the repeal of the Chinese Exclusion Act in 1943 are very different in nature. During the first period, artistic choice was dictated by the urgent needs of China in turmoil and a desire to learn from the West in order to build a strong and prosperous modern nation. Realism, representing aesthetic values contrary to that of the native tradition, was considered the best antidote to cure the ills of a degenerate art and to make it relevant to society. The pioneers of the Sino-American artistic contact all studied the realistic school and returned to China to serve. Their primary loyalty was to their country, and the urgency of their responsibility transcended the conflicts of an artistic and cultural nature. Their relative lack of grounding in the classical tradition made

ist, Ting is not attached to any particular school or prevalent style, though his mature style reveals the influence of abstract expressionism, pop art, and Matisse's fauvism (fig. 181). In the 1970s, he shifted from abstraction to representational female figures in scenes echoing with sensuous joys and instinctive desires, depicted with brilliant colors and flowing lines—a style and subject matter that have won for him fame and fortune in the international art world.[50]

The 1960s saw a number of individuals from Hong Kong going to the United States to study art

FIG. 181 Walasse Ting, Untitled illustration for pp. 124–125 in the book *1¢ Life* (Bern: E. W. Kornfeld, 1964). Color lithograph, object: 16⅜ × 12 × 1⅜ in.

their defection to Western art a lesser burden to bear. Their numbers were small and their names long forgotten in the turbulent history of twentieth-century China. Only since China opened its doors in the late 1970s and early 1980s have they been rediscovered in a new wave of East-West dialogue. Art historians also came to rescue them from obscurity in an attempt to reconstruct a more balanced narrative of modern Chinese art, taking into account the achievements and contributions of Western-style painters in the nation's quest for new art.[52] Their proficiency in mastering a foreign artistic medium was praiseworthy, even though they developed outside of mainstream American art and were unlikely to be given a place in its history. But the few Chinese artists who both embraced modern movements and made the decision to settle in America had a much more tortuous path. They felt deeply the tension of East-West

FIG. 182

Fay Ming-gi, *Hot Peppers and Snow Peas*, 1980. Acrylic on canvas, 55 × 64 in.

FIG. 183
David Diao, *Made in USA*, 1979. Acrylic on canvas, 72 × 66 in.

confrontation in art and culture in a discriminatory social environment. The art they created documents their struggles as well as their efforts to bring the two artistic traditions together. They will take their place in the history of twentieth-century Chinese art as pioneers in the Chinese response to modern art.

In the post-1943 era, Chinese artists in the United States were characterized by a strong sense of loss and displacement because most of them left China abruptly and found themselves cut off from their homeland with no hope of returning. As they settled in their host country with their vast knowledge of Chinese art and comprehensive expertise in traditional ink painting, the United States provided them with a fertile ground for the interaction of Chi-

nese and Western art. They stood at the forefront of the East-West artistic dialogue, formulating personal styles that exemplify the essence of the Chinese tradition, meeting the challenge of modernist aesthetic ideas, and developing a synthesis of their own. Their contribution lies in linking the past and the present, at the same time building bridges between China and the West.[53] As their achievements become better known in China, their struggles and experiences in resolving the contradictions and conflicts in Chinese and Western art will be useful references for a new generation of artists who are again facing strong influence from the West. For those Chinese artists who dreamed of finding a place in international modern movements, their number was still small, and they were peripheral to mainstream developments in the

United States. Exceptions may be found in the case of watercolor artists who successfully integrated into the artistic circles and became central figures in this medium.

The Immigration and Nationality Act of 1965, which replaced the discriminatory, race-based quota system in existence since 1924, and subsequent liberalizing policies concerning immigration have resulted in a substantial increase in Chinese immigrants, particularly from China since 1979, the year that marked the normalization of relations between the United States and the People's Republic of China. The number of Chinese artists in North America also swelled, amounting to more than four hundred in the 1990s, representing an astonishing talent pool in a variety of styles and media.[54] Moreover, these Chinese artists face a different, or more sympathetic, critical climate in the United States. Described by Julia Andrews as a critical shift in the international art world in the 1980s,[55] Chinese artists in the post-Mao period were absorbed into the international art scene and featured prominently in important international exhibitions through the development of postmodernism and multiculturalism. New critical issues such as global/local have emerged that overshadow the East-West dichotomy of the previous century, while transnational developments of contemporary art are no longer narrowly defined by national boundaries.[56] Chinese American artists enter a new phase of diversity in which ideas about art and means of expression may take many forms. What they share with their predecessors is their deep feeling for China and its cultural heritage, a bond that brings Chinese together from different parts of the world and links them to China, past, present, and future.

Notes

1 The list is too long to be mentioned here. The latest publication is *Love of the Cosmos: The Art of Chao Chung-hsiang* (Hong Kong: Alisan Fine Arts Ltd., 2004), the catalog of an exhibition that toured Taipei, Beijing, Shanghai, Hong Kong, and Paris.

2 See Lorraine Dong and Marlon K. Hom, "A Brief Cultural History of the Chinese in California: From Early Beginnings to the 1970s," in *Asian Traditions/Modern Expressions: Asian American Artists and Abstraction, 1945–1970*, ed. Jeffrey Wechsler (New York: Abrams in association with the Jane Voorhees Zimmerli Art Museum, Rutgers, the State University of New Jersey, 1997), 194–198. This succinct study on the subject, though focusing on the Chinese in California, is a good general reference. See also Tu Wei-ming, ed., *The Living Tree: The Changing Meaning of Being Chinese Today* (Stanford, CA: Stanford University Press, 1994).

3 Qian Gang and Hu Jincao, *Da Qing liu Mei youtong ji* [Chinese Educational Mission Students] (Xianggang: Zhonghua shuju, 2003).

4 For a discussion of the problems of *guohua* terminology, see Mayching Kao, "From *Hua Guohua*: Issues in the Development of a Modern Language for Chinese Painting," in *Identity Problems in Art Terminology: Reception and Resettlement of Modern Language for Art in Korea, China and Japan* (Seoul: College of Fine Arts, Seoul National University, 1998), 5–16.

5 A good introduction to the history of twentieth-century art in China is Julia F. Andrews and Kuiyi Shen, *A Century in Crisis: Modernity and Tradition in the Art of Twentieth-Century China* (New York: Guggenheim Museum, 1998).

6 Examples of Xu Beihong's work can be seen in *Xu Beihong huaji* [Paintings by Xu Beihong], 6 vols. (Beijing: Beijing chubanshe, 1979–1988).

7 Examples of Lin Fengmian's work can be seen in *Lin Fengmian quanji* [The Collected Works of Lin Fengmian], 2 vols. (Tianjin: Renmin meishu chubanshe, 1994).

8 Examples of Gao Jianfu's works can be seen in Mayching Kao, *The Art of the Gao Brothers of the Lingnan School* (Hong Kong: Art Gallery, The Chinese University of Hong Kong, 1995).

9 See *The Art of Li Tiefu* (Hong Kong: Hong Kong Arts Centre, 1991).

10 A good example of Feng Gangbo's work can be seen in Liu Xin, ed., *Zhongguo youhua bainian tushi* [An Illustrated History of Oil Painting in China in the Last Hundred Years] (Nanning: Guangxi meishu chubanshe, 1996), 33.

11 Li Shizhuang and Zheng Wenhao, *Huang Chaokuan de huihua* [Paintings by Wong Chiu Foon] (Xianggang: Xianggang yishu lishi yanjiu hui, 2002), 9–15.

12 Dong Kingman tells his own life story in *Paint the Yellow Tiger* (New York: Sterling Publishing, 1991).

13 Dong Kingman and Helena Kuo Kingman, *Dong Kingman's Watercolors* (New York: Watson-Guptill Publications, 1980), 14.

14 Wechsler, ed., *Asian Traditions/Modern Expressions*, 163–164. See also Hong Kong Museum of Art, *The Chinese Response: Paintings by Leading Overseas Artists* (Hong Kong: The Urban Council, 1982), 50–53; and transcripts of an interview with Seong Moy conducted by Paul Cummings on January 18, 1971, Archives of American Art, Smithsonian Institution.

15 *The Art of Yun Gee* (Taipei, Taiwan: Taipei Fine Arts Museum, 1992), 53–58.

16 Ibid., 21.

17 Weili Ye, *Seeking Modernity in China's Name: Chinese Students in the United States, 1900–1927* (Stanford, CA: Stanford University Press, 2001), 8–11.

18 Wen Lipeng and Zhang Tongxia, eds., *Zhuixun zhimei: Wen Yiduo de meishu* [Seeking Aesthetic Perfection: The Art of Wen Yiduo] (Jinan: Shandong meishu chubanshe, 2001), 156–161.

19 A large body of his works has been donated to museums in Hong Kong and Guangzhou. See Hong Kong Museum of Art, *Wong Siu Ling* (Hong Kong: The Urban Council, 1994).

20 Weili Ye, *Seeking Modernity*, 171.

21 Yang Ling-fu's works can be seen in Yang Ling-fu, *Thrice Across the Pacific Ocean* (Taipei: National Palace Museum, 1976).

22 See Hong Rui, *Zhang Shuqi* [Chang Shu-chi] (Shanghai: Renmin meishu chubanshe, 1981).

23 Robin Cohen, *Global Diasporas: An Introduction* (London: UCL Press, 1997), 85–94.

24 Tang Junyi, *Shuo Zhonghua minzu zhi huaguo piaoling* [On Flowers and Fruits Whirling and Scattering] (Xianggang: Sanmin shuju, n.d.), 2.

25 Ibid., 30.

26 Michael Sullivan, *The Meeting of Eastern and Western Art*, 2nd ed. (Berkeley: University of California Press, 1989), 194–195.

27 Examples are *Steel Production* by Ya Ming, dated 1960, and *Chairman Mao* by Li Qi, dated 1960, in *Zhongguo meishu guan cangpin ji* [Collection of the China National Gallery], vol. 1 (Beijing: Renmin meishu chubanshe, 1988), plates 23 and 24.

28 See Michael Sullivan, "Traditional Painting," in *Art and Artists of Twentieth-Century China* (Berkeley: University of California Press, 1996), 5–26.

29 For the paintings of artists working in the Chinese medium, see *Beyond the Magic Mountains* (New York: Hanart Gallery, 1989). The exhibition was presented in New York and Taipei.

30 These issues are discussed in Jerome Silbergeld, "Chinese Painting Studies in the West: A State-of-the-Field Article," *Journal of Asian Studies* 40, no. 4 (November 1987): 849–897.

31 Ni Zaiqin, "Piaobo de linghun: yuedu Zhao Chunxiang you gan" [A Wandering Soul: Thoughts on Reading Zhao Chunxiang], unpublished 1999 article provided by the author.

32 Pamphlet published to coincide with a joint exhibition of works by Wang Chi-yuan, Chang Dai-chien, and Wang Chi-ch'ien at Seton University in 1972.

33 A pamphlet of the same title was published to accompany the exhibition.

34 Wang's writings are collected in Wang Zhen and Rong Junli, eds., *Wang Yachen yishu wenji* (Shanghai: Shanghai shuhua chubanshe, 1990).

35 L. Ling-chi Wang, "Roots and the Changing Identity of the Chinese in the United States," in Tu Wei-ming, ed., *The Living Tree*, 198–201.

36 An example of Wang Ya-chen's early oil paintings can be seen in Liu Xin, *Illustrated History of Oil Painting in China*, 122. In his Chinese paintings, Wang was best known for his goldfish, an example of which can be seen in *A Selection of Shanghai Art Museum's Painting Collections* (Shanghai: Renmin meishu chubanshe, 1994), plate 24.

37 Examples of paintings by Lui-sang Wong can be seen in *Lui-sang Wong's Paintings* (Taipei: Yishu tushu gongsi, 1993).

38 "Peach Blossom Spring" references an ancient poem

that describes a mythological place of idealized Chinese culture.

39 See Mark Johnson and Ba Tong, *Chang Dai-chien in California* (San Francisco: San Francisco State University, 1999).

40 Sullivan, *Art and Artists of Twentieth-Century China*, 208. An example of C. C. Wang's early paintings in the traditional style can be seen in *C. C. Wang's Painting and Calligraphy Works* (Shanghai: Shanghai shuhua chubanshe, 2003), plate 2.

41 Chu-tsing Li and Thomas Lawton, *New Chinese Landscape: Six Contemporary Chinese Artists* (New York: American Federation of Arts, 1966).

42 Ibid.

43 Tseng Yuho, "Dsui Hua," in *Dsui hua, Tseng Yuho* (Hong Kong: Hanart T. Z. Gallery, 1992), 24–35.

44 Hugh Moss, *The Experience of Art: Twentieth Century Chinese Paintings from the Shuisongshi Shanfang Collection* (Hong Kong: Andamans East International Ltd., 1983), 177–178.

45 L. Ling-chi Wang, "Roots and Changing Identity," 204–206.

46 Wechsler, ed., *Asian Traditions/Modern Expressions*, 13.

47 The development is discussed in *Xiandai shuimo hua* [Modern Ink Painting] (Taipei: Lishi Bowukuan, 1988).

48 Information about Chen Chi is included in Yuan Zhenzao, *Zhongguo shuicai hua shi* [History of Watercolor in China] (Shanghai: Shanghai huabao chubanshe, [1998]), 58–59.

49 Julia Andrews, "Chao Chung-hsiang and New York," in *Chao Chung-hsiang*, vol. 3 (Hong Kong: Alisan Fine Arts, 1999), 37.

50 Hong Kong Museum of Art, *The Chinese Response*, 62–65.

51 Ibid., 22–25.

52 A good example is Zhu Boxiong and Chen Ruilin, *Zhongguo xihua wushi nian* [Fifty Years of Western-Style Painting in China] (Beijing: Renmin meishu chubanshe, 1989).

53 Liu Changhan, *Bainian Huaren meishu tuxiang* [Chinese Overseas Artists of the Last Hundred Years] (Wuhan: Hubei meishu chubanshe, 2002), 23.

54 Zheng Sheng Tian and Charles Liu, *Artists of Chinese Origin in North America Directory* (N.p.: Point Gallery, Artists Magazine, and The International Institute for the Arts, 1993).

55 Andrews, "Chao Chung-hsiang and New York," 35.

56 Wu Hung, "Contesting Global/Local: Chinese Experimental Art in the 1990s," *Orientations* 33, no. 9 (November 2002): 62–67.

Postwar California

Asian American Modernism

Paul J. Karlstrom

Race and cultural identity declare themselves in any arena of human activity, including the making of art. They are the basis for selection of the artists included in this volume. But can we in a meaningful way talk about salient features of an Asian American modernism in terms of either individual or community expression? Is there an Asian American modernism that reflects—as in the multifaceted hall of mirrors to which modernism has been compared—shared experience?[1] Or are we finally obliged to consider individuals in terms of their participation within the broader modernist concept? That seems to be the key issue: the challenge of discovering a modernism that acknowledges established formal criteria and stylistic signals while at the same time respecting the more compelling expressive needs of life experience and identity.

Having thus acknowledged race as a common condition unifying these artists, the task is to determine the method through which to identify and describe individual responses to modernism within

Ruth Asawa, Woven wire sculptures,
ca. 1950s (detail, fig. 198).

the group. Oral history as a historical tool has served me well over the years, and I see no reason to abandon it in this study. As it happens, this selection of prominent Asian American modernists lends itself to storytelling. And their inclusion here in part is due to their availability as direct interview subjects, either to me or to others. Among these, for example, are **Carlos Villa**, **Ruth Asawa**, George Tsutakawa, **Masami Teraoka**, and **Kay Sekimachi**, with all of whom I have enjoyed some personal contact. In several cases I have also conducted formal interviews. For most of the artists, interviews exist and, for a few—as is the case with **Isamu Noguchi**, whom I visited in Japan shortly before his death—much has been written. With Noguchi, the question of race and identity invariably arises. Therefore, in addition to his preeminent position as an international modernist, Noguchi receives early and close attention in this essay as a prime example. Others for whom race and personal identity play useful, one might even say central, roles in our attempt to understand them through their work and in the modernist choices they make are **Matsumi Mike Kanemitsu**, **Hideo Date**, **Gary Woo**, and **Leo Valledor**. **Yasuo Kuniyo-**

FIG. 184
Yun Gee painting, ca. 1926.

shi, whom Tom Wolf discusses elsewhere in this volume, provides yet another reminder of the national scope and complexity of Asian American modernist practice.

Oral history as a method necessarily foregrounds personal experience and memory, both of which are subjective and notoriously fugitive. Nonetheless, when handled critically, it can provide insight into psychological and emotional factors, including the individual experience of race that can inflect artistic expression. Why, for example, are certain stylistic or formal choices made over other alternatives? And to what extent, and for what reasons, do they acknowledge or conceal Asian spirit and tradition and Asian American identity? Among these primarily abstract artists, Valledor, Villa, and Kanemitsu are most instructive in this respect. In each case, I have had contact either directly or through individuals close to them. For Valledor, his widow Mary and younger cousin Villa provided insights that literally could not have been gained from other sources. My interview with Nancy Uyemura, former student and long-time companion of Kanemitsu, similarly created a vivid and sensitive portrait of this important second-generation abstract expressionist. And it may well be that postwar abstraction itself is a productive focus for our investigation of race in modernist art. In any event, California offers an impressive array of such artists. Admittedly, their stories provide only one means of approach to the bigger subject. Nonetheless, the degree to which life experience influences creative production is a legitimate concern in any study of modernism.

In the effort to determine possible features of an Asian American relationship to modernism (ways in which the various shared experiences of these communities we have decided to treat as one in this book may be reflected in the art), the life and work of Chinese American **Yun Gee** offers an excellent starting point[2] (fig. 184). I view him as the touchstone for an investigation and discussion of Asian American

participation in the modernist endeavor that defines twentieth-century art. In addition, the retrospective lens of postmodernism helps identify earlier tendencies, legitimate aspects of modernism, that appear within an expanded notion of modernism itself.

Yun Gee functioned within a complex of identity-inflected forces that many white American artists were spared. Race is far from the only factor that informs work and career, but it surfaces in the art of Yun Gee as a dialogue between international modernism and a powerful inclination to give visual expression to personal life experience. Taking into account defining career features from a biographical as well as an art-historical perspective, we can see that modernist personalism, race, cosmopolitanism, and erotic longing, which appear as major themes in Yun Gee's art, prove enlightening not only to art historians but also to scholars in related fields, including Asian American studies.[3]

Just what is the role of racial identity in the broader picture of American art? How are we to untangle the threads that connect the individual to context in order to better understand the forces under-

lying creative activity and, ultimately, the art itself? Two other more or less contemporaneous American artists, George Tsutakawa in a specific sense and the African American Jacob Lawrence as a more generalized model, bring the issues of race into focus in a way that is useful in considering the experience of Yun Gee. Tsutakawa, a prominent Seattle sculptor, taught for years at the University of Washington but kept strong connections to family and friends in Japan. (See Kazuko Nakane's essay, figs. 66 and 67). He observed that in Japan his work looked American, but in the United States the same work struck many as very Asian. When asked whether he was a Japanese or an American artist, he responded, "I am neither, I am both."[4] Also a longtime professor at the University of Washington, but one whose heart remained with his community in Harlem, Jacob Lawrence provides a powerful example for a discussion of race in the United States as it affects creative activity. He faced a typical dilemma created by an identity largely determined by his place in a white-dominated world.[5] Simply put, the dilemma consisted of a sense of community solidarity (and, in Lawrence's case, obligation) set against the individualistic need to function as an independent creative spirit. Part of Lawrence's achievement was to create, through a uniquely personal modernism based on superficially simple ("primitive" or naïve) forms, a balance between these two competing forces.

From a strictly stylistic perspective, French-derived and American-modified cubism—as influentially practiced by Stanton Macdonald-Wright—forges a legitimate link between artists such as Yun Gee and Hideo Date, a Japanese American. But a second point of contact between these two artists may be even more telling in terms of the larger picture. For me, when the personal escapes the restrictive grasp of stylistic formula, we glimpse the individual-

ity of an alternative modernist expression. Among American artists, Marsden Hartley offers the most compelling precedent in this regard: his German expressionist–derived modernist paintings cannot be properly understood without reference to the events of his life and the deep longings, reaching back to childhood, that conditioned his relationship to the world.

In Yun Gee and Date we also encounter an insistent self-revelation, bubbling up from interior depths, which can release the work from stylistic conformity. With these two artists, eroticism and nature play significant roles, especially in works like Date's untitled pencil drawing of 1947 in which female sexuality merges seamlessly with nature in the form of an anthropomorphized tree (fig. 185). A third point of contact also emerges, one that has to do with "Ori-

FIG. 185 Hideo Date, *Untitled*, 1947.
Pencil on paper, 31¾ × 26 in.

entalizing," perhaps not for the legitimate goal of establishing racial identity but for what may be interpreted as a professional opportunism drawing upon that identity and the related stylistic trappings that appeal to a taste for the "exotic." This understandable tendency, one that is found in both artists but especially Date, adheres also to the great modernist sculptor Isamu Noguchi. Along with Yun Gee, Noguchi serves as an invaluable touchstone, and conveyor of background and context, for later Asian American modernists.

MARKERS OF HOME:
ISAMU NOGUCHI, MATSUMI KANEMITSU,
AND MASAMI TERAOKA

Isamu Noguchi is perhaps the best-known example of an artist who never seemed to find the acceptance as an American that he sought. His life and career in particular were qualified by a kind of melancholy, a longing and disappointment that dual residences in Japan and Long Island, the sites of his museums, never fully compensated or cured.[6] Noguchi's Shikoku Island residence on Japan's Inland Sea, which I visited in the company of George Tsutakawa in 1988, seemed to our party quintessentially Japanese. Lunch was served by a beautiful young woman who, to our delight as cultural tourists, appeared to be authentically geisha (she was not), and nothing in the decor or environment—except his sculpture carefully arranged around the grounds—hinted at a Western connection. Somehow a lingering sense of contrivance, an environment constructed to create the image of identity reconciliation, was what some of us took away from our otherwise idyllic afternoon in Noguchi's home.[7]

Noguchi's "Japaneseness" has been noted and remarked upon by others. Following the leads of biographers Dore Ashton and Sam Hunter, Elaine Kim discusses the phenomenon as central to understanding the role of race in Noguchi's life and art. Describing the farmhouse Noguchi restored and occupied with his Japanese actress wife, Yoshiko Yamaguchi, in 1952, Kim writes about the "exoticism" involved as an appeal to Western taste and ideas about Japan: "Whether they approved or not, the Japanese understood that Noguchi was performing Japaneseness."[8] "Exoticism" is a term and concept that needs to be picked up and handled carefully; it smacks of "Orientalism" and marginalization. Nonetheless, it appears to have been part of the image construction practiced, for various reasons including professional, by some Asian American artists. In fact, they were joined by a few role-playing westerners such as Stanton Macdonald-Wright, whose Caucasian wife was required to wear Japanese apparel and hide behind a shoji screen when visitors came to their Pacific Palisades home.[9]

Noguchi's embrace of Japaneseness may have been a defense or coping mechanism, a strategic response to his treatment and the reception of his art in his native country (Noguchi was born to a part-Irish mother and Japanese father in Los Angeles in 1904). There are two main ways to look at this "strategy" and what it was intended to accomplish. First, there was clearly a painful recognition of his ambiguous racial and national identity. Turning to an inauthentic Japanese identity was surely an effort to resolve this ambiguity. Second, Noguchi appears to have made an effort to legitimatize his art in terms of personal identity by introducing Japanese traditional forms and materials into the European modernism that actually defined him as an artist[10] (fig. 186).

The following anecdote from the world of modern dance speaks directly to modernism's embrace of Japanese minimalist aesthetics. The prominent Los Angeles theater director Gordon Davidson, stage manager for Martha Graham early in his career, recalls attending a meeting in 1962 to discuss a new work for an upcoming tour of the Middle and Far East. The great lighting designer Jean Rosenthal and Noguchi were also present at Graham's Sutton Place apartment. Davidson describes the meeting:

[The setting was] very Oriental in feeling. Mystic and magical. Martha began by saying, "I am thinking of a new ballet," *pause*, "based on the Phaedra legend," *pause*, and I thought something more was going to come. Instead she reached over and removed from the [Chinese-style] coffee table a stone, a rock that she obviously had picked out from amongst other rocks that were around in various floral displays in the living room. She handed it to Noguchi, Noguchi fingered it—its smoothness, its texture, its shape—and handed it to Jean Rosenthal, who did the same, and handed it to me. Martha too had begun by touching the stone, and running her fingers, her elegant fingers, over the surface of the

FIG. 186
Isamu Noguchi, *Sesshū*, 1959–1960. Aluminum, 99 × 45½ in.

rock before passing it on. I handed it back to Martha, and she looked at everyone, smiled, and put the rock down. And that was the end of the production meeting.[11]

Of the many meanings that can be drawn from Davidson's recollection, perhaps the most relevant is the attraction for avant-gardists such as Graham and Noguchi to the alternative modernist idea of Eastern ritual and Zen restraint, a different way of seeking answers to specific questions and the solution to problems. At this point, Western modernism and Eastern thought converge.

The phenomenon was most evident in San Francisco's Zen scene in and around North Beach in the 1950s. Defined more by poetry and jazz than by visual art, the Beat Era embraced a mystical Eastern perspective that provided the counterculture with a spiritual alternative to Western materialism. As a result, many artists from New York to Los Angeles shifted their gaze and attention from Europe to Asia. In this process, Asian American artists found validation in their own traditions. This may have been especially true in San Francisco where, according to longtime Art Institute dean Fred Martin, "there was a time in the 1950s when everything was Hasegawa"[12] (fig. 187). Painter **Saburo Hasegawa** was an influential presence in San Francisco cultural life largely due to the then-current enthusiasm for Eastern thought and aesthetics. Hasegawa introduced poet Gary Snyder to tea ceremony and had a close association with Alan Watts.[13] During this period, art-

FIG. 187 Saburo Hasegawa, *Rhapsody at the Fishing Village*, 1952. Ink on paper mounted as folding screen, approx. 96 × 66 in.

ists and poets sought out Zen priests as teachers, such as **Hodo Tobase** (fig. 188) in the early 1950s and **Shunryu Suzuki** a decade later. One might say that the American creative counterculture had become officially "Asianized" when Suzuki appeared onstage with Allen Ginsberg and Timothy Leary at the Human Be-In in Golden Gate Park on January 14, 1967.[14] Manuel Neri, Leo Valledor, **Bernice Bing** (see Valerie Matsumoto's essay, fig. 146), and **Noriko Yamamoto** (fig. 189) were among the younger Bay Area artists affected by Hasegawa and presumably Zen Buddhist ideas.

Asian Americans such as Hasegawa and Noguchi participated in the great modernist enterprise in what may appear to be an "authentic" way from the standpoint of race and cultural tradition. In this volume, Karin Higa discusses how modernist dancer Michio Ito collaborated with Noguchi in 1925 on the production of William Butler Yeats's drama *At the Hawk's Well* in New York, which blended aspects of Noh drama and Western modern dance.[15] Higa's es-

FIG. 188 Hodo Tobase, *Twelve Dragons*, ca. 1958. Ink on rice paper, 24 × 44 in.

FIG. 189
Noriko Yamamoto,
Untitled, 1961. Acrylic on canvas,
dimensions unknown.

say includes the reproduction of an earlier 1916 photograph by Alvin Langdon Coburn of Ito wearing a fox mask for a London production (see fig. 36, p. 41). The photograph suggests that Ito's performance represented nothing less than becoming one with nature through the specific animal. This merging of Asian artists and nature surfaces throughout the century, and the entire oeuvre of the Southern California fisherman artist **Shiro Ikegawa** may be seen in that light, especially in identification with nature in his famous *Trout Mask* (fig. 190) and in his elaborate sushi bar conceptual art performances in Los Angeles. These examples suggest that some Asian Americans artists embraced their perceived cultural roles as disciples of nature. Perhaps the extensive animal imagery in the work of such artists as **Toshio Aoki**, **George Matsusaburo Hibi** (fig. 191), and **Mine Okubo** suggests that anthropomorphization and the strong tradition of animal stories in Asian culture play a role in their iconography.

But one should also keep in mind that, where race and ethnicity are involved, the idea of home—and where it lies—remains forceful and compelling,

a key to at least a partial understanding of artists from Noguchi to Matsumi Kanemitsu. In the catalog foreword to a major 1998 retrospective in Osaka and Hiroshima, Matsumi Kanemitsu is described as "coming home."[16] As was the case with other prominent artists of his generation who were born in the United States but spent formative or otherwise influential years in Japan (a life history that has been given the name *kibei* in Japanese), the question of "home" for Kanemitsu becomes an inevitable factor in fully understanding the man and his art.

Although born in the United States to Japanese nationals, at age three Kanemitsu was taken to Japan

FIG. 190 Shiro Ikegawa wearing *Trout Mask*, ca. 1970s.

238

FIG. 191 George Matsusaburo Hibi, *Wings*, 1930. Oil on canvas, 56 × 46 in.

to be reared by his grandparents near Hiroshima, where he received his early education. Kanemitsu's early life in Japan and in the United States may have created confusion or ambivalence about identity and even national allegiance. Indeed, in one exhibition catalog interview he recalled that after first returning to the States, "I was ashamed of my Japanese accent and poor English.... I was a kind of scapegoat for other Japanese Americans." But in fact, those who knew him well report that he saw himself as an American, and this extended to his full identification with contemporary art in this country.[17] He was a realist and recognized that his experience in this country was to a degree racially impacted. Yet that hardly means that his modernism was a vehicle for expression of statements regarding race and identity. Kanemitsu's abstract-expressionist-inflected work displayed an artful union of Euro-American modernist framework and Japanese references. This structure seems to be especially true of the California-period paintings and the lithographs for which he was widely and justifiably admired. These works knit aspects of a life that included growing up in Japan; meeting Picasso, Matisse, and Léger in Europe; falling under the influence of Yasuo Kuniyoshi as a young artist in New York; and then maturing among the acclaimed modern artists associated with the New York school as well as those of the Gutai and Bokujin groups in Japan.

For all the legitimate locating of the influence traditional Japanese *sumi-e* technique and Zen painting has in his black-and-white paintings, the artist himself credited his New York experience for this crucial development in his art. When asked directly where he received his inspiration, he responded: "Well, sure. New York—we were involved with a new 'ism.' I work in black and white, so naturally, Franz Kline and [Robert] Motherwell."[18] Kanemitsu thought of himself not as an Asian artist, not even as an American artist, but as a *modern* artist.

Kanemitsu's California career began in 1965,

when he relocated to Los Angeles to accept a teaching position at the California Institute of the Arts (CalArts). However, his connections with Southern California go back to the late 1950s with exhibitions at the Dwan Gallery in Westwood near the UCLA campus. Even more important to the development of his art was a 1961 Ford Foundation grant to work at the Tamarind Lithography Workshop in Los Angeles, which led to a long exploration of lithography that has constituted what many critics consider his greatest achievement. As was the case with other Asian Americans—among them Ruth Asawa, Shiro Ikegawa, **George Miyasaki**, **Kenjilo Nanao**, Ben Sakoguchi, and Walasse Ting, who also worked at Tamarind—printmaking became an important and consistent part of Kanemitsu's art. The technique of drawing on stone was perfectly suited to Kanemitsu's *sumi-e* practice.

Revealingly, Kanemitsu cited Georgia O'Keeffe, especially her flower paintings, as influential, raising the tricky issue of sexual allusion and erotic imagery. He mentioned her work—"Where my roots (are)"[19]—after a discussion of the erotic series he did at Tamarind in the 1960s (fig. 192).

Of course, few artists are as direct in depicting explicit and exaggerated sexuality as is Masami Teraoka, whose *ukiyo-e*–derived style directly participates in the *shunga* woodblock print tradition. The similarity of works like Teraoka's *Wave Series/ Tattooed Woman at Kaneohe Bay I* (1984) (fig. 193) to Kanemitsu's *Salt and Lake* (1965) raises the possibility that, as a student in Los Angeles, Teraoka may have benefited from this example. There is no mistaking Teraoka's intentions in regards to erotic content and its importance in his work: "I'm interested in bringing out human nature and ... sexuality as positive and basic issues of life."[20] The sexual underpinnings of Teraoka's work are on full display in his early fiberglass sculpture (fig. 194). Its material shows his connection to the fetish finish style associated with the exciting Los Angeles art scene he encountered in

the 1960s. But in its biomorphic eroticism it is even closer to the sculptural concoctions of Hans Bellmer. The memory of Japanese *shunga* informs even this student work. And Teraoka's subsequent art simply cannot be understood outside of this tradition.

When Teraoka was asked recently whether he considered himself an American artist, his response was unequivocal:

Definitely yes. If I were living in Japan, I would not have been an artist. I would never have had the chance to appreciate my own culture and *ukiyo-e* art. It was a matter of the unexpected chance that I was able to detach myself from Japan physically and mentally. Freedom I felt in Los Angeles and California was the key to my work such as *ukiyo-e* [that] was well received and appreciated.[21]

FIG. 193
Masami Teraoka, *Wave Series/Tattooed Woman at Kaneohe Bay I*, 1984. Watercolor on paper, 14½ × 21½ in.

FIG. 194 Masami Teraoka, *Male and Female Form*,
ca. 1966–1970. Fiberglass, resin, metal, plastic,
and lacquer, approx. 8 × 24 × 8 in.

Teraoka retrospectively sees his pop art/ *ukiyo-e* work, influenced by Tom Wesselman nudes, and describes his *Hollywood Landscape* series first exhibited in 1973 at David Stuart Gallery in Los Angeles and the International Museum of Erotic Art in San Francisco as articulating his "cultural and personal identity...I intentionally used the ancient vocabulary and introduced it in a context of contemporary art."[22] However, like Roger Shimomura's work, Teraoka's signature blending of Asian iconography and style and Western pop sensibility may be less a personal acknowledgment of ethnic attachment or cultural identity than what appears to be something of the opposite: the appropriation of traditional style and form—and even subjects—as a means to declare full independence of vision and expression from the limitations of both tradition and modernism. In that respect, Teraoka's *ukiyo-e* paintings can be viewed as more subversive of tradition than the integrative strategies of artists like Kanemitsu.

To the end of his life, Matsumi Kanemitsu acknowledged and honored both poles of his dual heritage and interests as an artist, working in a studio adjacent to Little Tokyo, the symbolic center of Southern California Japanese life and culture. There he painted works that represented a reconciliation of

what at times must have seemed to him conflicting parts of his life in America. No doubt in part due to that struggle, Kanemitsu created some of the most lyrically beautiful examples of California modernist art (fig. 195).

In contrast, Masami Teraoka, by settling in Hawaii, physically chose a compromise between Japan, his country of birth, and the United States mainland, the acknowledged source of his freedom as an artist. With this independence came permission to cunningly appropriate the look while fundamentally transforming the cultural meaning of his Japanese sources. Nonetheless, despite the considerable gulf between their relationships to Japanese tradition and American modernism, the work of Kanemitsu and Teraoka demonstrates two divergent poles of what amounts to the same thing: acknowledgment and reconciliation of the sources that feed and inform much Asian American modernist art. Teraoka bril-

FIG. 195 Matsumi Mike Kanemitsu, *Santa Ana Wind*,
1970. Acrylic on canvas, 72 × 72 in.

liantly sets the two cultures in confrontation, while Kanemitsu finds a means, through abstraction, to create a tender embrace between East and West.

ASIAN-INFLECTED ABSTRACTION: GARY WOO AND SUNG-WOO CHUN

The same could be said about Gary Woo and **Sung-woo Chun**, as well as a number of others whose abstractions sensitively, often with great delicacy, create a similar cultural intermarriage between Eastern tradition and Western modernism. This singular achievement perhaps requires early preparation in non-Western methods and aesthetics. The role of Asian tradition in Asian American abstract painting has already been the subject of an important exhibition organized by Jeffrey Wechsler, who featured painters like Chun, whose abstracted mandalas (fig.

196) evoke spiritual traditions within a modernist idiom.[23] Artists who do not appear in that survey, such as Woo, also deserve recognition for their blending of traditional and innovative approaches to art.

Woo, who studied calligraphy in China, where such training was the accepted path to becoming an artist, expressed impatience in his response to a review by critic Thomas Albright in which his calligraphy-based abstraction is in effect legitimatized and rendered modern by association with Western modernists Mark Tobey, Paul Klee, and Mark Rothko. Published in *East West*, a San Francisco Asian American bilingual journal, Woo's expression of frustration makes several telling points, and his words are well worth quoting by way of calling attention to a central issue in the critical reception of Asian American artists in this country:

FIG. 196 Sung-woo Chun,
Lunar Mandala, 1962.
Oil on canvas,
39¾ × 30½ in.

He [Albright] states that I have "Orientalized early Mondrian" in my painting entitled "Climbing Vine." I had simply painted an asparagus fern which is growing in the next garden. I do not Orientalize Mondrian any more than Mr. Albright Orientalizes me in his title for this article.... By the same token, one could also say that the later works of Mondrian Occidentalize Japanese Shoji screens.... In respect to Tobey, he states "there are strong parallels to Tobey in 'Written Assignment' and 'Nubian Mood.'" This might possibly be true since Mark Tobey has Occidentalized Oriental calligraphy.[24]

In addition, some formalist critics such as Clement Greenberg nationalistically impugned the value of drawing inspiration from Asian art. Art historian Bert Winther-Tamaki has documented this attitude among artists—including Franz Kline, who initially embraced, then publicly disavowed interest in calligraphy.[25] Willem de Kooning's 1950 statement that "there is a train track in the history of art that goes way back to Mesopotamia. It skips the whole Orient"[26] suggests the extent to which some artists apparently felt it necessary to distance themselves from East Asian art. Although the situation on the West Coast is somewhat different, where preeminent artists like Mark Tobey in the Northwest and Stanton Macdonald-Wright in Southern California clearly identified Asian aesthetics as central to their own work, these mid-century modernist prejudices warrant bearing in mind.[27]

Among Asian American abstract painters, an-

FIG. 197 Gary Woo, *Moss Garden*, 1956.
Oil on canvas, 61 × 25 in.

other instructive example along these lines is the Korean Sung-woo Chun. Born in 1934 into a cultured Seoul family, Chun was encouraged by his father (a high school principal who founded the private Kansong Art Museum, where his son had the opportunity to study Korean art) at an early age to pursue art as a career. After several years of instruction in traditional painting techniques, Chun abandoned the ink and watercolor of his teachers and adopted the oil paints used by the European impressionists he admired and sought to emulate. Enrolled at the California School of Fine Arts (now San Francisco Art Institute) after two years at San Francisco State (he immigrated to the United States in 1953), he studied with Sam Tchakalian and Nathan Oliveira, who encouraged an individual vision drawing upon Asian themes and techniques. At that time the influential presence of Clyfford Still and abstract expressionism were still felt at the school, and Chun initially responded with the thick impasto typical of gestural painting. But increasingly he returned to the gentle, translucent color washes employed during his earlier training in Korea. The effect was that of symbolist or even color-field stain painting, a departure from the physicality of abstract expressionism and a return to the pseudo-impressionist manner he employed in his earlier work.

Like Woo, also a self-described abstract impressionist,[28] Chun arrived at a style more in step with the elegant reticence and relative subtlety of the Korean painting that had provided his formative aesthetic sense. Not surprisingly, both artists saw their paintings in close and intimate relationship with nature. Chun's claim that "my works do not exist outside of nature, they breathe deeply when they are free in nature"[29] suggests an anthropomorphism that underlies his abstract art. A sense of spirituality and "oneness" also was important to Woo, who actively sought "the mystery in the abstract."[30] In an interview, Woo provided a strong hint as to the source of his "modernist" abstraction and its ultimate meaning (fig. 197).

Attuned to the abstract and the mystery in nature, he seemed to regard the world philosophically in terms of experiencing the universal: "We are a small part of the universe. I am always thinking about that. I look at the wonder of nature itself, the true extraordinary mystery in the flowers, the plants and animals. . . . I look at it [nature] all the time and wonder 'how did this get here?'"[31] Judging from these remarks, and the attitudes they reveal, it does not seem fanciful to think of the paintings of Gary Woo and Sung-woo Chun—and even the California work of Matsumi Kanemitsu—not so much in terms of American abstract expressionist individuality but more as visual metaphors for an all-embracing nature and specifically observed (and, more to the point, felt) phenomena from which these artists draw their inspiration and imagery.

CRAFTS AND SOCIAL MODERNISM:
RUTH ASAWA, NOBUO KITAGAKI,
AND KAY SEKIMACHI

The Bauhaus-derived modernism of Ruth Asawa and **Nobuo Kitagaki**, San Francisco artists who probably never have been discussed together, unexpectedly invites what turns out to be an edifying comparison. Perhaps the personal aspect uncovered in Yun Gee and Hideo Date is here more restrained. But to the extent one builds a career around community and the stabilizing influence of tradition, an individual identity is thereby established. These two artists, particularly Asawa, suggest a specific quality once again reminiscent of Jacob Lawrence (whom Asawa met at Black Mountain) and his community-dedicated art. This element points to what could well be described as a social modernism, a branch or tributary of modernist expression that extends outward rather than inward. External rather than internal, social modernism is directed to neighborhood and embraces community.

Ruth Asawa trained at Black Mountain College, where she studied with Josef Albers and met her hus-

band, Albert Lanier. And Black Mountain lies at the heart of her unique modernist story. At first glance I would not necessarily have thought of Asawa and her work as leading exemplars of modernism, Asian American or otherwise. I expect that reservation had to do with the craft-based nature of her art. However, subsequent consideration has brought me to see her as among the most modernist of artists within the Asian American context (fig. 198). How did I come to that conclusion and on what is it based? During a 2002 interview with Asawa, my very first question went directly to the issue of modernism: her understanding of the term and her relationship to it. She paused, and then turned to her Black Mountain experience of 1946–1949 as the source for both her ideas about modernism and the basis for her subsequent life in art. It soon became apparent that Albers and the Bauhaus philosophy formed the direction her art was to take, including the communal aspect and social dimensions that distinguish it.[32]

However, there was another side of the Black Mountain experience under Albers, one that reflected his basic formalism and controlled, as opposed to emotional, approach. Interestingly, perhaps surprisingly, Asawa seems to have been attracted to that quality in her teacher:

> Well, for me. I liked the rigid[ity] and the things I learned from him. I wasn't very much one for feeling because I had come from a culture that didn't think very much of one's feelings.[33]

This may have been the case at the time, but her life and activities in San Francisco, and indeed the direction of her art—private as well as public—speaks for a depth of feeling and compassion that extends from immediate family to community and her adopted city that has benefited from the communal, social, and educational values she developed at Black Mountain.[34] Asawa's recognition of the individual and social importance of education under-

246

lies her much-admired work on behalf of children and art, notably in the Alvarado Arts Workshop she established in 1968 with art historian Sally Woodbridge. This interest has extended to her work on behalf of museum education and children's programs at the Fine Arts Museums of San Francisco, where she was a trustee. The lobby of the education tower at the new de Young Museum appropriately is filled with an installation of Asawa's hanging wire sculptures. Just how personal to her they are, and at the same time how modern, becomes clear when considering the insistence on craft as a legitimate form of expression and an understanding of the creative potential of materials used and combined in new ways. In this,

FIG. 198
Ruth Asawa, Woven wire sculptures, ca. 1950s. Dimensions variable.

Asawa's innovative work brings to mind the sculptures of her California contemporary Claire Falkenstein.

For more than thirty years Nobuo Kitagaki had a booth known as the "Teahouse in the Trees" at the San Francisco Art Festival and was honored for the quality of the displays that received admiring reviews from critic Alfred Frankenstein. But his fine-art work, notably the constructivist collages, appears to have taken a subordinate position to the crafts and design aspects in his commercial production of shoji screens and related functional/decorative objects. In retrospect, however, the distinguishing feature of Kitagaki's art career may have been his ability to integrate in individual works Western modernism with Eastern formal tradition, as in his application of the "rules" governing placement and measure of elements in tea ceremony. The geometric elements in his constructivist collages are based directly on such ideas, notably the placement and arrangement of tatami mats (fig. 199). Kitagaki no doubt understood that his commercial success would be best realized by assuming a creative identity that drew upon the decorative appeal of the Orient, to which he was connected more by race than by direct cultural experience. However, his bicultural aesthetic interests provided an opportunity for a subtle combination of modernist sensibility and traditional decorative forms.

As is the case with Asawa, Kitagaki's socially directed modernism grew directly from precepts of the Bauhaus. Kitagaki attended the avant-garde Chicago Institute of Design from 1947 to 1949, where László Moholy-Nagy and other teachers reflected a Bauhaus sensibility, providing a model beyond the formal concerns of constructivist-based art to communal and social applications. Kitagaki's modernist social activity was limited by circumstances that

FIG. 199 Nobuo Kitagaki, *Tatami Mat Abstraction*, 1968. Collage, 14 × 18 in.

also appear to have virtually derailed his career about midway, a story that is not at all clear and need not overly concern us here.[35] But it is worth noting that his main efforts, especially in the two decades or so after he abandoned his collage work, were directed to his Teahouse and the group that he chose to exhibit with him at the annual art festivals. Most of these artists were involved, as was Kitagaki, with craft and design, both important features of the Bauhaus program. Among the regulars at the Teahouse were photographer Leo Holub and his artist wife, Florence;[36] jewelers Merry Renk, Bob Winston, and Alice Jeung; ceramic sculptor **Win Ng**; potter Spaulding Taylor; abstract painter Bernice Bing; and weaver Kay Sekimachi.

Sekimachi is particularly illustrative of the close, and salubrious, connections between Asian craft tradition (and aesthetics) and Western modernism. Her greatly admired weavings achieve an impressive equilibrium between form and function, the past and the present (fig. 200). Like Asawa and Kitagaki, Sekimachi had a direct link to the Bauhaus through her studies with Trude Guermonprez, an influential Bauhaus weaver. Sekimachi's works perfectly express the fundamental difference between the "assault" of American fine-art crafts innovators such as Peter Voulkos in ceramics and those, often Asian American, artists

FIG. 200 Kay Sekimachi, *Nagare III*, 1968. Nylon monofilament, woven, 87 × 10 × 11 in.

who value tradition and seek to modernize it in their own work—two very different, and equally valid, modernist approaches. However, the well-crafted, possibly conservative, tendency is typically viewed as less authoritative in modernist terms.

The preponderance of work displayed in Kitagaki's pavilion falls in the areas of craft and design, including batik, jewelry, ceramics, and textiles. Kitagaki himself contributed one or two collages, but by the later years he had abandoned his geometric collage abstractions and turned his creative energies to set designs and costumes. Perhaps two lessons may be drawn from his example. First, for a number of his Asian American contemporaries, traditional Asian crafts may have provided a familiar and reassuring series of forms and materials with which to approach European modernist ideas. Certainly that was the case with Ruth Asawa, who has freely acknowledged the role of tradition in her modernist work. Asked about the possible influence of origami and hanging textiles on her woven sculpture, Ruth succinctly established her position in relationship to the past in terms of her use of forms and materials:

> If you go back, many of those things were [there] before...we think we are [all modern] but we aren't so. It goes back to an earlier time...and I think it's important to have a relationship with the past, not just be modern or old. It's good to be part of everything.[37]

In a similar and most specific manner, the senior Kitagaki's shoji screen shop with its various Japanese decorative objects—presumably including tatami mats —gave an orderly and disciplined context to the Bauhaus lessons of the Institute of Design. But beyond that felicitous connection was also the cooperative, social aspect of the arts in Japan as well as the Bauhaus ideal. For some Asian Americans this seems to have provided the most natural way to create a Western modernist expression that best reflected Eastern

FIG. 201
Carlos Villa, *Tat2*, 1969.
Ink on Itek photograph,
14 × 8½ in.

tradition. In this way identity is preserved, and ac-knowledged, while allowing the individual artist to freely engage the new art.

POLES OF ASIAN AMERICAN MODERNISM:
CARLOS VILLA AND LEO VALLEDOR

In a few noteworthy cases, social and political issues have emerged as appropriate, legitimate—even es-sential—components of individual expression. So it was with Carlos Villa, who early in his career discov-ered that his artistic identity was inextricably bound

to his identity as an Asian American of Filipino de-scent. This life-directing epiphany as an event within the process of art making, evidence for which ap-pears in the 1969 iconic self-portrait *Tat2* (fig. 201), is economically but fully described by Villa:

> There is a piece I did in which I took an Itek print of a photograph of myself, and drew patterns on it. Long before I was aware of the words and theo-ries as "recuperative strategy," or "reinvention," I was in the process of *becoming* [author's emphasis].

Before that, I was told who I was. From then until now, through the process of art, I became who I am. Somewhere between the enlarged image of an Asian face and the act of drawing, was space. At that time there existed a void, devoid of a knowledge of true national history or a specific and truer art history.[38]

Directly related to this revealing account, one that explains fully and succinctly the trajectory of a career dedicated to community "recuperation" through educational activism and art—activism *as* art—is an illuminating observation that explains the political direction Villa's artistic life was to take. Villa's journey in art, his decision to dedicate it and his energy to multiculturalism and community "retrieval," provides a loose parallel to the career focus of Jacob Lawrence, who painted the history of his people. In this respect, Villa may be the leading figure among Asian Americans of his generation. And it is of more than passing interest that he cites Yun Gee as a personal role model. One can see the points of contact and similarities of experience that attract Villa to his Chinese immigrant predecessor at the California School of Fine Arts. Villa described Yun Gee's response to the treatment he encountered in San Francisco as internalized feelings within "walls of prejudice-fermented self-loathing and frustration."[39] However, his sympathetic observation that Yun Gee kept "it all inside" is not entirely accurate: one has only to look again at his self-portraits, most notably *Where Is My Mother* (see Mayching Kao's essay, fig. 167), to be reminded of the personal presence and consistent self-revelation that underlie Yun Gee's oeuvre.

This tendency to strategic self-revelation is nowhere more present than in the work and career of Carlos Villa, for whom identity is to be found through and in art. In fact, Villa may well be the artist best suited to a productive discussion of social and political concerns—and identity issues—in Asian American art (or, for that matter, any art). In a 2003 interview, Villa described to me what he agreed was the "social aspect" of his modernist practice, and the deep personal rewards it has brought to him. He recounted with understandable pride how art historian Moira Roth and renowned scholar of race and feminism Angela Davis came to him after seeing his publication *Other Sources* and said, "You must continue this work."[40] However, Villa also continues his private studio practice. He concluded the interview by talking about his current art in terms of "simplification, reduction, abstraction." A few moments earlier he spoke of collaboration with people in the community as part of an expanded notion of art activity: "Extension of the studio is an artist's obligation." Moira Roth has described Villa's work in terms of "Dual Citizenship."[41] I would suggest that the dual citizenship is both national, as asserted by Villa himself, and located within the context of his artistic life. Modernist individualism cohabits in Villa's practice with a socially aware and community-directed modernism, as in the work of Asawa and, to a lesser degree, Kitagaki.

This apparent dichotomy is strikingly exemplified in the divergent career directions taken by Villa and his older cousin Leo Valledor, role model and mentor. It was Leo who encouraged Carlos to enroll at the California School of Fine Arts and his example, including a seven-year sojourn in New York, that exerted an important and lasting influence. Despite two years at CSFA, Valledor was largely self-taught,[42] but he was gifted and quickly developed a gestural abstract style that reflected the influence of Mark Tobey.[43] In addition to Tobey, his earliest influences were Paul Klee, Arshile Gorky, and Bradley Walker Tomlin. He exhibited his *Black and Blue* (reflecting his identification with black culture and music) series at Dilexi Gallery in 1959, and in 1961 he relocated to New York City, where his work underwent a rapid process of simplification under the influence of Rothko, Newman, and Zen meditation.

FIG. 202
Leo Valledor, *Becoming*, 1963.
Acrylic on canvas, 24 × 24 in.

Among the results of this impressive new minimalist direction is *Becoming* (1963), arguably Valledor's masterpiece of contemplative reduction (fig. 202). The painting is uniformly dark gray with a single point of light blue green at the center, a small dot that Carlos Villa describes as equal to the large color field it occupies. In this confrontation, the void supporting a single spot of light, Valledor seems to provide a Zen-derived metaphor for life. Perhaps the dot is a surrogate for the artist as he seeks to navigate the confusion and darkness—the emptiness—of the "void" that is human existence. This reading would take into account not just the emotional need Valledor sought to satisfy within his work and the art community, an antidote for the "anguish" with which he struggled,[44] but also the larger issue of personalism as a common feature in the work of many of the artists discussed here. In that case, the minimalism Valledor embraced and made his own is rich in human implications, a vehicle for his desire to bring order and meaning to his life. Not unlike Villa's characterization of the earlier CSFA student Yun Gee,

Valledor internalized his feelings and wrapped them in the forms of contemporaneous modernist art.

The big problem with seeking *direct* Asian influences in the American art of modernists such as Leo Valledor is that so many possible sources do not have references or connections to racial experience. On this important point Valledor may be the most instructive artist with whom to conclude our search for possible distinctive (Asian) qualities in the artists we have brought together. At the very least, identity may not be the determining factor after all. This important issue is put into useful perspective by the words of Valledor's widow, Mary Valledor, now married to Carlos Villa. Her statement eloquently suggests a balanced approach to the question of individuality and group identity in America:

> Leo was born in San Francisco, and he was raised in the Fillmore district where the Filipino and Asian population lived side-by-side with the African American community. When people asked if his work reflected Filipino culture, he responded

that he was more influenced by Black culture ... in his art and in his life. He did not like to be identified by race. And he did not want to be identified with, say, upper middle class Asian families. He did not want to be known as an Asian painter. He had never been to the Philippines. He loved his country. And so he felt very American, and that was important to him.[45]

CONCLUSION: ECHOES OF
ASIAN SENSIBILITY AND TRADITION

We can be fairly sure that few if any of the artists we have discussed—and the many other Asian Americans who participated in the great modernist adventure of the twentieth century—would accept being identified exclusively by race or ethnicity. Modernism is above all about individuality and expression of a unique vision both of the world and of art itself. No self-respecting modernist would willingly seek or permit such a limitation, especially one tied to a condition about which one has no choice. The whole point of "being modern" is the freedom to explore and invent, unencumbered by the unavoidable accidents of birth, race, and sex.

I would suggest that this search for and expression of individual identity, and a place in the world, underlies both the social aspect and the personalism we have encountered in the work of most of the artists discussed here. As for the elusive Asian American aspect we set out to discover, each artist seems to have either training in or knowledge of forms and themes that may be associated with Asian tradition.

But the American experience, the Western modernist imperative, seems to assert its presence. These artists, when all is said and done, are American modernists, despite inevitable echoes of and references to Asian backgrounds. This freedom to reinvent themselves artistically is precisely what their California creative environment encouraged.

Returning to the metaphor introduced at the beginning of this essay, we are reminded that as we wander through the halls of modernism, with doors opening into seemingly countless rooms waiting to be visited and described, the images reflected in the wall of mirrors are multiple and diverse. Each reflection provides only a fragmentary view of what the artists, and we through them, seek to know and understand. But as they look in one mirror after another, in addition to the new and exciting world that confronts them, they inevitably and unavoidably catch fleeting glimpses of themselves. The ongoing discovery of the nature and multiplicity of twentieth-century modernist creative expression is aided by the instructive examples provided by Asian American artists, including those discussed in these pages. These individual stories and shared experiences expand in specific and valuable ways our understanding of the great modernist enterprise, filling in missing pages. We learn as we watch these artists travel in search of personal expression, all the while negotiating the competing demands of creative individuality, shared social community, and universality within the modernist vocabulary they have freely chosen.

Notes

1 The mirror metaphor is particularly apt as employed by David Hollinger in "The Knower and the Artificer," *American Quarterly* 39 (1987): 37.

2 For a more complete picture of my personal view of Yun Gee, see "A Modernist Painter's Journey in America," in *Yun Gee: Poetry, Writings, Art, Memories*, ed. Anthony W.

Lee (Seattle: Pasadena Museum of California Art in association with University of Washington Press, 2003), 21–34.

3 The tendency has been to emphasize racialization as a *determining* rather than a *facilitating* factor, thereby potentially limiting the individual's scope of indepen-

dent vision. Increasingly, racism is also being viewed as contributing in a significant way to a distinctive pattern of "confluence" between modernist form and autobiography.

4 George Tsutakawa, interview by Mayumi Tsutakawa, Kyoto, Japan, 1988. Video produced by the author for the Smithsonian Archives of American Art.

5 See Paul J. Karlstrom, "Modernism, Race, and Community," in *Over the Line: The Art and Life of Jacob Lawrence*, ed. Peter T. Nesbett and Michelle DuBois (Seattle and London: University of Washington Press, 2000), 229–230.

6 The story of Noguchi's lifelong search for personal and national identity has not been better described than by Dore Ashton in her superbly sensitive account of the artist. See *Noguchi East and West* (New York: Knopf, 1992). "The life that he lived in the world was shadowed, Noguchi felt, by the duality of his origins. How much this entered into his life's work can never be measured, but even a skeletal outline of his childhood and adolescence reveals countless sources of chagrin" (11). See also Sam Hunter, *Isamu Noguchi* (Seattle: Bryan Ohno editions in association with the University of Washington Press, 2000).

7 The 1988 visit with Noguchi was occasioned by a Smithsonian video project devoted to George Tsutakawa and the installation of his *Lotus Fountain* sculpture at the new Fukuyama prefectural museum. Noguchi, who died several months later, was reciprocating the hospitality shown him by the Tsutakawas in Seattle. From the standpoint of video documentation goals, our welcome was not what we had hoped.

8 Elaine H. Kim, "Interstitial Subjects: Asian American Visual Art as a Site for New Cultural Conversations," in *Fresh Talk/Daring Gazes: Conversations on Asian American Art*, by Kim, Margo Machida, and Sharon Mizota (Berkeley and Los Angeles: University of California Press, 2003), 17. Bruce Altshuler describes the Japanese view of the house and lifestyle, in which he and his wife dressed in kimonos and zoris in a clichéd old Japanese manner, as a "bizarre exercise in exoticism"; *Isamu Noguchi* (New York: Abbeville Press, 1994), 62. These observations roughly match my own experience of visiting Noguchi in 1988 (see n. 7).

9 In 1973, I went with UCLA faculty artist Jan Stussy

to visit his mentor, Stanton Macdonald-Wright. The Pacific Palisades house was decorated in the Oriental manner. More surprising was the realization that Mrs. Macdonald-Wright, who was never introduced, was present but hidden from view behind a shoji screen. As she silently left the room in response to her husband's order, I briefly glimpsed her gliding away in a traditional kimono.

10 Elaine Kim makes this critical observation by quoting Bruce Altshuler, who, as she rightly states, "places him [Noguchi] squarely in the tradition of modernism"; Kim, "Interstitial Subjects," 17 (quoting Altshuler, *Isamu Noguchi*, 99).

11 Gordon Davidson, email to the author, June 18, 2004.

12 Fred Martin, in a conversation with Mark Johnson, December 1989; email statement by Mark Johnson forwarded to the author, April 8, 2004.

13 See Gary Snyder, *Mountains and Rivers Without End* (Washington, D.C.: Counterpoint, 1996), author's notes.

14 For an account of the Human Be-In, see Peter Coyote, *Sleeping Where I Fall* (Washington, D.C.: Counterpoint, 2004), 75. For information about Suzuki, including his presence and influence in San Francisco, see David Chadwick, *Crooked Cucumber: The Life and Zen Teaching of Shunryu Suzuki* (New York: Broadway Books, 1999).

15 For a discussion of Michio Ito, Noguchi, and Martha Graham, and the contemporary enthusiasm for Noh theater and other non-Western forms of expression, see Ashton, *Noguchi East and West*, 23–26. In connection with the Graham-Noguchi dance collaborations, it is interesting to note that Ito stimulated Graham's, and no doubt Noguchi's as well, interest in Oriental mythology (25). The theme of Ashton's perceptive study of Noguchi is personal reinvention through myth, specifically a personalization of the Orpheus myth as explanation of the artist/self, and draws upon Walter Benjamin's acceptance of myth alone as "the world" (6).

16 *Matsumi Kanemitsu, 1950–1990* (Osaka, Japan: Osaka Prefectural Government, 1998), 3.

17 According to Nancy Uyemura, Kanemitsu was "more American than I ever thought of a Japanese American being." Yet (like George Tsutakawa, who was "neither/both") he was simultaneously "*very* American and *very* Japanese." Interviewed in Los Angeles by the author, September 8, 2003 (transcription, 21–22).

18 Kanemitsu, interview by Marjorie Powers, *Los Angeles Art Community: Group Portrait*, UCLA Oral History Program, January 1, 1975–March 31, 1977, 141.

19 Ibid., 147.

20 Masami Teraoka, email correspondence to CAAABS project researcher, September 12, 2000, Asian American Art Project, Stanford University.

21 Ibid., 3.

22 Teraoka, email to author, June 10, 2003. Also see Howard A. Link and Masami Teraoka, *Waves and Plagues: The Art of Masami Teraoka* (San Francisco: Chronicle Books, 1988), 13–15.

23 See Jeffrey Wechsler, ed., *Asian Traditions/Modern Expressions: Asian American Artists and Abstraction, 1945–1970* (New York: Abrams in association with the Jane Voorhees Zimmerli Art Museum, Rutgers, the State University of New Jersey, 1997), for an illuminating discussion of Asian tradition in abstract painting.

24 Gary Woo, "Artist Answers Critic," Forum, *East West*, November 21, 1967. Albright's review of Woo's exhibition at John Bolles Gallery (*Paintings and Drawings*, October 30–November 30, 1967) appeared in the *San Francisco Chronicle*.

25 Bert Winther-Tamaki, *Art in the Encounter of Nations: Japanese and American Artists in the Early Postwar Years* (Honolulu: University of Hawai'i Press, 2001), 58.

26 Herschel B. Chipp, *Theories of Modern Art: A Source Book by Artists and Critics* (Berkeley and Los Angeles: University of California Press, 1968), 555.

27 Winther-Tamaki documents New York criticism that denigrates Tobey's Asian-inspired work as "effeminate"; Winther-Tamaki, *Encounter of Nations*, 52.

28 Remarks from "Conversations with Gary and Yolanda Garfias Woo: Artists in the Community," an interactive discussion hosted by the Chinese Historical Society of America, San Francisco, May 23, 2004. Woo described calligraphy and gardens as art on the same level as painting, and he spoke of his own abstract work in terms of "calm and repose, like clouds in the sky."

29 Ho Jae Lee, *Sung-woo Chun* (Korea: Gana Art Gallery, 1992), 56.

30 Gary Woo, CAAABS project interview, December 16, 2003, San Francisco, CA.

31 Ibid.

32 Ruth Asawa and Albert Lanier, interview by Paul Karlstrom, San Francisco, June 21 and July 5, 2002. Archives of American Art, Smithsonian Institution, www.archivesofamericanart.si.edu; hereafter cited as Interview.

33 Interview (draft), 14.

34 Interview (draft), 57–59.

35 See Kitagaki's biographical entry in this volume.

36 I owe a debt of gratitude to Leo and Florence Holub, who called my attention to their friend Nobuo Kitagaki. The Holubs, with his photographs and her drawings, participated in many of the Kitagaki annual exhibitions. Leo shared with me materials Kitagaki gave him that describe the measurement ratios of tatami mats as incorporated into his constructivist collages.

37 Interview (draft), 32–33.

38 Carlos Villa, *(60 Forms of) UTANG/Payback and Tribute (In Filipino)*, no. 13, unpublished manuscript, Asian American Art Project, Stanford University.

39 Ibid., no. 22.

40 Carlos Villa, interview by Paul Karlstrom, May 23, 2003, Archives of American Art, Smithsonian Institution.

41 Moira Roth, "The Dual Citizenship Art of Carlos Villa," *Visions Art Quarterly* 3, no. 4 (Fall 1989): 20–23.

42 Wally Hedrick was an early mentor who, in the words of Carlos Villa, took Valledor "under his wing." According to Villa, after Valledor's first year at the California School of Fine Arts, Hedrick told him his teachers had "nothing more to give him." Conversation with Carlos Villa, July 14, 2004.

43 Mary Valledor, interview by Paul Karlstrom, July 24, 2003, Asian American Art Project, Stanford University. Leo's interest in Zen and meditation attracted him to Tobey, as did the white writing (3, 5–7). He also admired the "contemplative" qualities in the work of Mark Rothko and Barnett Newman (4, 7).

44 Ibid., 21–25. Mary Valledor, Leo's widow, was joined by Carlos Villa to conclude the interview. The issue of minimalism as a means to bring order to a disorderly and perhaps "unraveling" life was the final subject of discussion.

45 Ibid., 2–3.

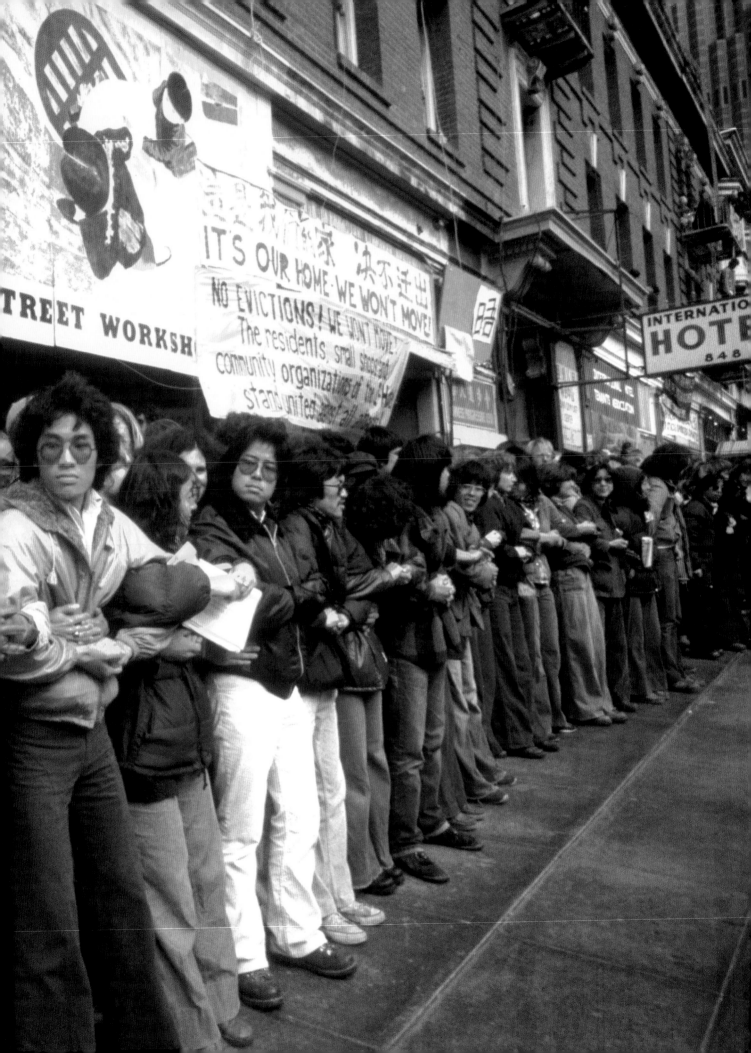

Art and Social Consciousness

Asian American and Pacific Islander Artists in San Francisco, 1965–1980

Margo Machida

The decades of the 1960s and 1970s were a watershed time for the United States. It was an extraordinarily combative era, with profound consequences that, for good or ill, continue to shape present-day discourse and expectations. With the rise of broad-based protest and identity movements—antiwar, Black Power, Chicano, Asian American, Native American, Third World Liberation, feminist, gay and lesbian—it was a heady moment that witnessed a potent convergence of heightened ethnic awareness, cultural activism, and politically inspired cultural production. For Asians in the United States, the power of art and visual culture to help frame and articulate a sense of place in the contemporary world was increasingly conceived as a means of projecting a distinctly Asian American culture and sensibility. This conviction arose out of a perception that, despite differences in background, Asian groups shared common struggles to establish themselves in this nation, in the face of histories too often marked by discrimination, racism, and economic exploitation. The post-1965 period, therefore, is distinguished by the emergence of a heightened *Asian American* cultural conscious-

ness among many visual artists. Indeed, the deliberate quest to construct a pan-ethnic, Asian American space, a kind of community of the imagination, makes much work from this era distinctive.

Beginning in the 1970s, paralleling efforts in the Chicano, Native American, and African American arts communities, a significant body of foundational scholarship and critical writing on Asian American visual artists and issues was generated by community-based and ethnic-specific cultural organizations (as well as by activist scholars and documentarians in and outside of the academy). Besides acting as incubators for new generations of artists, those institutions have typically served as an interface with the majority culture, making the art and ideas visible and intelligible to wider audiences. This intellectual and political legacy has strongly shaped the ways that Asian American art continues to be framed, presented, and interpreted. For instance, during the 1990s, an unprecedented number of museum and university gallery exhibitions highlighted "Asian American" visual art as a distinct entity. Among them were many exhibitions centered on sociopolitical and identity issues or on particular historical events, such as the Vietnam War, the Ko-

Jim Dong, *I-Hotel Protest*, ca. 1976 (detail, fig. 209).

rean War, the U.S. colonization of the Philippines, and the Japanese American internment. Equally notable is the fact that most of those thematic group exhibitions were organized by Asian Americans; many were artist-activist-scholars who continue to play a generative role in developing the field.

The 1970s therefore constitute a critical turning point in Asian American scholarship and artistic production, as matters of identity, and self and collective representation, increasingly came to the forefront. To understand how this cultural transformation unfolded, it is useful to examine not only the institutions that arose in this period and the confluence of historical factors involved but also the work and thinking of the practitioners themselves—those artist-activists whose efforts made it possible. Although these developments occurred across the United States, this essay primarily focuses on a particular place: San Francisco in the late 1960s and 1970s. Given the city's position as a long-established center of Asian settlement and a hub of cultural activity, it provides an important touchstone to the genesis of the Asian American arts movement.

This essay will, I hope, generate further conversations aimed at constructing more inclusive accounts of contemporary Asian and Pacific Islander artistic production in the San Francisco Bay Area and beyond—for instance, developments in major centers of artistic activity such as Los Angeles and New York deserve focused attention. Clearly, this examination is not exhaustive, as many significant artists, curators, writers, and cultural activists could not be included in this brief text. Nor is it intended to be a prescriptive "reading" of Asian American art and visual culture from this period. As is true for their non-Asian peers, not every Asian American artist is concerned with social issues and questions of identity and identification, or seeks to address them in her or his work. Moreover, an abiding concern with issues of identity and heritage is not in itself unique to this generation of artists and intellectuals; rather,

their work and ideas should be understood as part of a broader continuum. Indeed, as other contributors to this book aptly demonstrate, many Asian artists in the United States seek to incorporate iconographies, motifs, and art-making practices associated with Asian art traditions in their work. Such interests may denote formal concerns with traditional Asian idioms and conventions, or with seeking visual strategies aimed at bridging the sometimes uneasy divide between "East and West." They are not, however, necessarily engaged in conceiving a distinctly "Asian American" culture. Consequently, this is a selective and necessarily partial view of a more complex and far larger history.

A GLOBAL AND LOCAL CONTEXT

The post–World War II period was a time of worldwide social upheaval and far-reaching change. Following the war, anticolonial resistance in Asia, Africa, the Caribbean, and the Pacific grew in intensity, leading to the collapse of centuries-old Western empires. These transformations occurred against a backdrop of continual global conflict, and the ever-present threat of nuclear annihilation, as the United States and the Soviet Union emerged as mutually antagonistic superpowers. In the perilous atmosphere of the Cold War, the success of national independence movements was often followed by decades of chronic postcolonial instability, and the reopening of long-dormant ethnic and religious conflicts. Aided and abetted by the United States and the Soviet Union, unrest and harsh struggle affecting whole regions ensued, characterized by successive revolutions and coups, prolonged civil wars, social disintegration, and episodes of direct military intervention by the superpowers and their surrogates. Yet in the United States these times were also witness to growing economic prosperity, the rise of a large suburban middle class, and the birth of the first generation of "baby boomers," who came of age in the 1960s, swelling enrollments at colleges and univer-

sities. One of the by-products of this era of domestic prosperity was President Lyndon Johnson's "Great Society" (1964–1968), a sweeping reform program that vastly expanded spending for social programs, including the arts.

By the mid-1960s, the United States was experiencing a groundswell of social and cultural unrest, with a growing civil rights movement and serious division over the country's involvement in the Vietnam War. By 1968, a mounting frustration with the glacial pace of social change, exacerbated by the assassination of Reverend Martin Luther King Jr., led to a series of major race riots. Often requiring military intervention to suppress, these clashes served to focus further attention on the problems of the inner cities, where the "minority" community arts movement was emerging. Among the government's responses to this unrest was the decision to fund inner-city art programs through the newly established National Endowment for the Arts (NEA). In addition, the President's Council on Youth Opportunity made grants to sixteen cities—San Francisco among them—for summer arts programs. During this period, moreover, the Department of Housing and Urban Development (HUD) and the Office of Economic Opportunity (OEO) were created; federal funding through OEO later provided seed money for many community-based organizations.

With the passage of the Immigration Act of 1965, these years also were a remarkable time for Asians in the United States. Although the U.S. presence in Asia had rapidly expanded following World War II, with the postwar occupation of Japan, the establishment of numerous military bases around the Pacific Rim, and U.S. involvement in the Korean and Vietnam Wars, the presence of Asians in this country continued to be severely restricted. The Immigration Act of 1965 finally abolished the discriminatory national origins quota system, removing those long-standing legal barriers to Asian immigration and resulting in explosive growth in new immigration from all parts

of Asia. In addition, the 1975 Communist victory in Vietnam, accompanied by the triumph of parallel Communist insurgencies in Laos and Cambodia (soon renamed Kampuchea), would lead to a massive exodus of Southeast Asians, the majority of whom resettled in the United States. In response, the U.S. Congress approved millions for Vietnamese refugee aid, and the establishment of resettlement programs intended to evenly spread the rising tide of refugees across the country. Yet California ultimately became the major destination for more than 40 percent of all refugees and their families,[1] many of whom settled in metropolitan centers such as San Francisco and Los Angeles.

CULTURE, ART, AND POLITICS IN SAN FRANCISCO

Located on the Pacific Rim, with historic ties to Asia and the wider Pacific world, as well as to Mexico, Central America, and South America, San Francisco and the Bay Area embrace a distinctive cosmopolitanism. Shaped by a history of conquest, migration, and trade, San Francisco has become one of the world's great port cities, home to a continuously evolving "port culture,"[2] where peoples from cultures around the globe mingle. This site is also an entry point and home for numerous Asians, many of whom once passed through Angel Island, the West Coast equivalent of New York City's Ellis Island.

Following World War II, San Francisco acquired a romantic mystique as the local center of a flourishing Bohemian subculture, in which Asian Americans participated. From the early 1950s to the 1960s, when some of its central figures moved on, the North Beach neighborhood in Little Italy became a gathering place for artists, musicians, and writers of the Beat Generation. One of the currents that marked the era was a fascination with Eastern religions, cultures, and philosophies. Among this enclave's residents in the 1930s and 1940s was **Dong Kingman**,[3] an Asian American painter and designer, who gained

FIG. 203 Martin Wong, Stage set for
The Angels of Light performance
of *Paris Sights Under the Bourgeois
Sea*, ca. 1971.

FIG. 204 Martin Wong, Stage set for
The Angels of Light performance,
ca. 1971.

considerable recognition later for his set and title designs on major Hollywood films, including the musical *Flower Drum Song*. (Other artists living in North Beach in the 1950s and 1960s included **Wing Kwong Tse** and **Victor Duena**.)

Whereas the Beats were largely a literary movement, by the 1960s they were superceded by the emergent hippie and psychedelic drug cultures. With its profound impact on the popular imagination, hippie culture was strongly associated with graphic design, colorful clothing, rock music, and mass outdoor spectacles like the historic 1966 San Francisco Trips Festival. San Francisco also became a major center for underground comics, a deliberately anticommercial use of the medium, which presented frequently salacious and often highly satiric views of daily life and human foibles. According to scholar Timothy Drescher, these "comix" would influence younger

Bay Area muralists, such as the Chicano artist Michael Rios, who collaborated with Asian and Pacific Islander artists including Sekio Fuapopo.[4]

In the populist and anarchistic spirit of the times, street performance and political theater proliferated. Among these groups was a street theater collective called The Angels of Light in which **Martin Wong**, a Chinese American who would become a nationally acclaimed painter, was a well-known personality. Art historian Mark Johnson describes the Angels as "gender-bending and drug culture-visionary," as their outrageous and campy drag performances blended "multiple religious narratives, Asian performance and dance styles, with glitter, face paint and chiffon."[5] Freely combining Asian cultural motifs with psychedelia, Wong produced elaborate set designs for the collective's musical productions (figs. 203 and 204), making extensive use of the lo-

FIG. 205 Martin Wong, *Tibetan Porky Pig Eating Watermelon*,
1975. Acrylic on canvas, 40 × 34 in.

cal Asian Art Museum to do research and produce
sketches for his sets, and related paintings that ef-
fortlessly mingle elements of contemporary Ameri-
can pop culture with ancient Asian mythological
motifs (fig. 205).

The Bay Area also became the nexus of an in-
creasingly politicized youth counterculture in the
1960s, and a site for radical activism in the U.S. acad-
emy that would pose foundational challenges to
long-held conceptions of American culture and his-
tory. Like their counterparts across the nation, local
university students militated for greater academic
freedom and control over curricula, faculty hires,

and institutional policies. Influenced by Third World anticolonial struggles and by the Black Power movement (the Black Panther Party was formed in Oakland in 1966), more radical students began to view the oppression of people of color, in this country and abroad, as having a common source in U.S. imperialism and racism. Under the banner of collective liberation and self-determination, Asian American students joined multiethnic coalitions such as the Third World Liberation Front, participating in now-historic student strikes at San Francisco State College (now San Francisco State University [SFSU]) in 1968, and at the University of California, Berkeley. In 1969, Asian American studies was formally instituted at both schools, soon to be followed by other California institutions. Notably, literary scholar and artist **Kai-yu Hsu** played a central role in conceiving a department of Asian American studies and a College of Ethnic Studies at SFSU. In this period, historian and community activist Yuji Ichioka, a founder of the UCLA Asian American Studies Center, is widely credited with coining the term "Asian American" to frame what has been termed a "new self-defining political lexicon."[6] Indeed, it was in the universities that many from this generation of Asian American artists first encountered ideas of ethnic pride and Third World solidarity. Those visions of social transformation would continue to guide the course of their creative and private lives.

For visual artists in the Bay Area, the 1970s were generally a time of expanding opportunity and change. Beginning in the late 1960s, the Asian Art Museum in San Francisco (1966), the Oakland Museum (1969), and the University Art Museum in Berkeley (1970) would open to become venues for contemporary art and regional artists. Newly available government funding supported the formation of nonprofit alternate art spaces, including community-based organizations, and teaching jobs were created in response to larger student enrollments in local uni-

versities and art schools. In the Bay Area, due to the relative absence of an extensive art infrastructure, especially when compared to cities like New York, such institutions have historically been of central importance. As art historian Paul Karlstrom points out, in an "art world traditionally disadvantaged in terms of galleries, market, and criticism...discourse has typically taken place in California almost exclusively in the state's educational institutions."[7] Among the area's art schools, two are often cited as having been especially influential in the post–World War II period for their impact on local intellectual activity, including the development of critical discourse: the San Francisco Art Institute (formerly the California School of Fine Arts), which is strongly associated with 1950s abstract expressionism and the rise of the Bay Area figurative style, and the California College of Arts and Crafts (CCAC, now California College of the Arts). Artists associated with these schools include UC Berkeley student Theresa Hak Kyung Cha, who premiered work at the San Francisco Art Institute and other Bay Area venues (fig. 206); **George Miyasaki**, who taught at CCAC and later at UC Berkeley; and **Arthur Shinji Okamura**, who also taught for many decades at CCAC.

ASIAN AMERICANS AND THE MURAL MOVEMENT

Public murals are a distinctive feature of Bay Area visual culture.[8] Since they are typically painted outdoors, their outsize scale and undeniable presence make them a prime visual medium for mass communication. San Francisco's community murals first appeared in the 1960s, alongside similar developments in Chicago, Los Angeles, and New York. In response to the challenges of the period, many visual artists devoted themselves to political causes, using murals to address paramount social issues. Their bold, graphic styles, heroic figures, and politically charged subject matter owe a considerable

FIG. 206 Theresa Hak Kyung Cha during
performance of *Aveugle Voix*, 1975.

debt to the earlier Mexican mural movement, and
to the many federal Works Progress Administration
(WPA) murals that adorn buildings around the city,
such as the famous cycle on California history at
Coit Tower in downtown San Francisco. During the
1930s, the Depression-era WPA hired local artists
to produce hundreds of public works. The Mexican
painter Diego Rivera was also a prominent presence
in San Francisco, where he executed several major
commissions, including a large piece for the 1940
Golden Gate International Exposition on Treasure
Island. As art historian Anthony Lee points out, sev-
eral Asian Americans were among Rivera's assistants
on the Treasure Island project, including painters
Mine Okubo and **Peter Lowe** (see Mark Johnson's
essay for more information about Bay Area mural
artists from this period). Okubo would later publish
Citizen 13660, a book of drawings that chronicled her
experiences in the Japanese American internment
camps during World War II. Lee posits that these
artists emerged from a largely unrecognized "tradi-
tion of radicalism"[9] within California Asian Ameri-
can art, whose lineage can be traced to groups such

as the Chinese Revolutionary Artists Club, founded
in San Francisco's Chinatown in 1926 by the painter
Yun Gee.

An important stimulus for the contemporary
mural movement came from the NEA, with the cre-
ation of its Expansion Arts Program in 1971 to aid
"professionally directed community arts groups"
with activities involving ethnic and rural minorities.
Additional NEA funding was targeted to programs
with a mural component, including San Francisco's
Neighborhood Arts Program. Asian American and
Pacific Islander artists have been an active force
in this movement, for which figures such as **Ruth
Asawa** were passionate advocates. Among the art-
ists actively involved in the creation of public art
in the Asian American communities is Johanna Po-
ethig, a Philippine-raised muralist, installation artist,
and performance artist who is known for her works
in diverse communities throughout the Bay Area.
Although not of Filipino descent, Poethig spent her
formative years in the Philippines, and after moving
to San Francisco in the late 1970s, she sought out
the Filipino community in the Mission District. Sur-
prised to find no murals about that community, Po-
ethig—working in collaboration with Filipino poet
Presco Tabios and Vicente Clemente, a former politi-
cal prisoner of the dictatorial Marcos regime—exe-
cuted *Descendants of Lapu-Lapu* (1984), depicting the
origin legends of the Filipino peoples (fig. 207).

Jointly painted in 1977 by Sekio Fuapopo and
Leo Maalona, both of Samoan descent, and Chicano
artist Mike Rios, *Tradewinds* (fig. 208) was a distinc-
tive interior mural located in the Paradise Hawaii
Restaurant, a dinner theater and Polynesian review
then housed in the site of the former Kabuki The-
ater in San Francisco. This collaboration, grounded
in each artist's deep appreciation of the other's cul-
ture, exemplifies the common bonds that can be
formed around a shared conception of indigenism.
Tradewinds is a mythic depiction of the seafaring his-

FIG. 207 Johanna Poethig, Vicente Clemente, and
Presco Tabios, *Descendants of Lapu-Lapu/Ang Lipi
ni Lapu-Lapu*, 1984. Mural, 90 × 25 ft.

tory of the Pacific Island peoples, centered on a mon-
umental figure rising like a colossus from the ocean,
which for Fuapopo represents both a powerful chief-
tain and Maui, the great Polynesian god of the sea.
Interwoven throughout the mural are bold designs,
suggestive of body tattoos worn by Polynesians, and
tapa patterns based on the stars and constellations
they used to navigate the Pacific Ocean.

Opposition to urban renewal and gentrification
was also a major theme in public art of the period.
During that time, the San Francisco Bay area wit-
nessed escalating battles over development, typically
resulting in the displacement of ethnic minority,
poor, and working people. Beginning as early as the
1950s, a plan known as the Golden Gateway project
was already in process to construct hotels and offices
on downtown blocks that targeted parts of China-
town and Manilatown for demolition. The local real
estate market began to heat up significantly in the
1960s, and by the 1970s, one of the biggest hotel own-
ers in San Francisco had laid out a plan for a major
downtown project in Yerba Buena, an area occupied
by many single-room-occupancy hotels and small
businesses. Another building slated to be torn down
was the International Hotel (known as the I-Hotel)
on Kearny Street. This block-long structure had for
years been home to elderly Filipino and other work-
ing men, as well as to a number of Asian American
political and cultural organizations, including the
pioneering Kearny Street Workshop and the Jackson
Street Gallery. In the process of contesting this evic-
tion, many young Asian American artists, writers,
and activists were thrust into local politics (fig. 209).
The protracted protests leading up to the eviction of
the building's tenants and demolition in 1977 endure
in the memories of local Asian American artists as a
major event that brought them together. It has also

FIG. 208 Sekio Fuapopo with Mike Rios
and Leo Maalona, *Tradewinds*, 1977.
Oil on plaster, 30 × 58 ft.

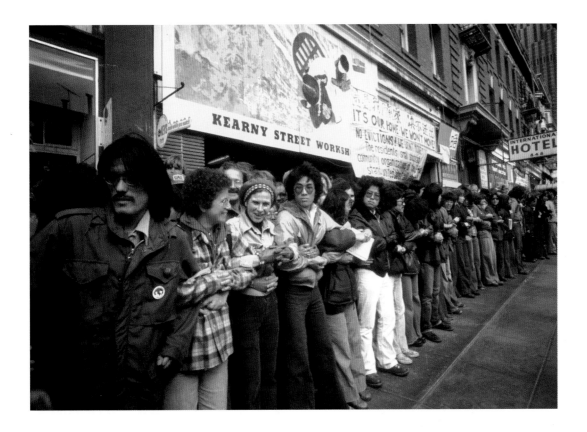

FIG. 209 Jim Dong, *I-Hotel Protest*, ca. 1976. Photograph.

served as the touchstone for a significant body of visual art, photography, and a 1983 documentary film by Curtis Choy, *The Fall of the I-Hotel*.

MULTICULTURALISM AND THE VISUAL ARTS

Reflecting the emergent ethnic consciousness and activism of the period, by the 1970s the San Francisco Art Institute had become an important venue for wide-ranging dialogues on multiculturalism in the arts. This initiative can largely be credited to the vision of Filipino American artist and faculty member **Carlos Villa**, who, along with many collaborators, organized the landmark 1976 exhibition, *Other Sources: An American Essay*. Featuring three hundred participants in the show and related programs, this was the first of a series of ambitious projects Villa mounted at the institute.[10] His goal was to create an "interface between the Third World community and mainstream community"[11] by presenting a spectrum of works by artists of color in the San Francisco Bay Area, including a large number of Asian American and Pacific Islander artists. *Other Sources* (figs. 210

and 211) followed closely on the historic *Third World Painting/Sculpture Exhibition* organized in 1974 for the San Francisco Museum of Modern Art by curator Rolando Castellón, along with Raymond Saunders and Ruth Tamura, which featured sixty Bay Area artists of color.[12]

Villa entitled his project *Other Sources* because he believed that works and cultures framed under the "Third World" rubric are often perceived in highly circumscribed, stereotypic ways by the artgoing public. In his view, rather than attempting to inquire into their meanings, many mainstream viewers typically reduce such work to a single message of "protest." To make the alternate sources of meaning in the exhibited works more legible, Villa regarded the accompanying catalog as crucial in articulating the artists' underlying concerns, through its "documentation of first voice statements."[13] Another significant facet of the project was to place minority artists and their work in a broader comparative context that not only brought different communities together but also engaged with issues of art criticism and dominant conceptions of art history.[14] Using the art school as a platform for public conversations,

Jack Loo, *Angel Island*,
1975. Woodblock print,
8 × 10½ in.

Carlos Carvajal Sr., *Idols—
Cannibalistic Witchcraft by
the Agents of Terror and
Merchants of Death*, 1970.
Oil on Masonite, 20 × 32 in.

Other Sources was highly influential for other Bay Area schools and arts institutions in opening an expanding discursive space around matters of identity, difference, culture, and the arts.

Cultural activism grounded in a sense of Third World consciousness powerfully infused politics in the late 1960s and early 1970s.[15] According to Rupert García, a Chicano printmaker, poster artist, and influential teacher, events like the 1968 Third World

student strike at San Francisco State College (now San Francisco State University) were momentous for many in the Bay Area, awakening a potent sense that all people of color ultimately share a common relationship, whether they reside in this nation or abroad. García recalls, "It's where the notion of a Third World Liberation Front became solid for me—learning about the international thrust of politics and cultural exchange within the context of social change [and] a certain kind of consciousness of how people become oppressed."[16] As he observes, many of these connections, including the joint projects between Kearny Street and Galería de la Raza (of which he was a member) were based not so much on formal institutional ties as on individuals who sought to work across communities.

Based on conceptions of Third World and ethnic consciousness, new writers' collectives and literary journals were formed during this period. Among them was *Liwanag: Literary and Graphic Expressions by Filipinos in America* (1975),[17] which included full-page graphics, photographs, and reproductions of works by local Filipino visual artists intertwined with prose and poetry by writers such as Al Robles, Jessica Hagedorn, Oscar Peñaranda, Serafin Syquia, and Presco Tabios. Artists and photographers featured in *Liwanag* included Dan Begonia, Dan Gonzales, Lorena Cabeñero, Reggie Macabasco, Joe Ramos, Tony Remington, Carlos Villa, and **Leo Valledor**. *Ting: The Caldron, Chinese Art and Identity in San Francisco*, published by Glide Urban Center in 1970,[18] brought together works by writers and artists—Chinese and non-Chinese alike—who shared an affinity with Chinese culture.[19] Visual artists highlighted in this publication included **Kem Lee**, **Lui-sang Wong**, **Irene Poon**, and Kai-yu Hsu. In San Francisco's Mission District—building on the earlier Pocho-Che Collective of Chicano and Latino writers who sought to connect "strong international histories and social movements throughout the Americas into the Mission *consciencia* (consciousness)"[20]—Third World

Communications Collective emerged in 1973. Asian American writers such as Janice Mirikitani, Jessica Tarahata Hagedorn, Serafin Syquia, and George Leong were among its new members. Soon thereafter, they published the literary anthology *Time to Greez! Incantations from the Third World* (1975), which is noteworthy for its interdisciplinary as well as multiethnic character. With Jim Dong and Rupert García serving as its graphic editors, it featured work by Asian American, African American, Native American, and Chicano artists.

The early 1970s was also a time of growth for ethnic community–based arts organizations. A key development was the San Francisco Arts Commission's inauguration of its Neighborhood Arts Program (NAP), an initiative to "bring art to the neighborhoods." Here, too, Asian Americans would play an important role, as Chinese American artist **Bernice Bing** was appointed district organizer for Chinatown and North Beach in 1970. Among the Asian American cultural organizations to emerge in this period were the Chinese Culture Foundation of San Francisco (1965), Kearny Street Workshop (1972), Asian American Theater Company (1973), Japantown Art and Media Workshop (1977), and National Asian American Telecommunications Association/ NAATA (1980). Their core constituencies reflected the demographics of the Bay Area at the time, in which Chinese, Filipinos, and Japanese were the largest Asian groups.

Two of these organizations played a particularly foundational role in the Asian American community arts movement: Kearny Street Workshop and Japantown Art and Media Workshop. Kearny Street has the distinction of being one of the few Asian American arts organizations from the period to remain active, and to have maintained its political legacy, as evidenced by *War and Silence* (2003), a recent art exhibition whose antiwar theme speaks to present-day U.S. military involvement in Iraq and the Muslim world. Located on the International Hotel block,

Kearny Street was founded by Jim Dong, Lora Foo, and Mike Chin in 1972. Combining cultural activism and grassroots politics, Kearny Street provided a drop-in center for artists, neighborhood youth, and members of the local community, even as it championed housing struggles in the immigrant communities, strikes by local garment and electrical union workers, and the battle waged by the International Hotel's tenants against threats of eviction. Kearny Street also nurtured a small press, producing publications such as *Texas Long Grain: Photographs by the Kearny Street Workshop* (1982)[21] that showcased works by Jim Dong, Zand Gee, Robert Hsiang, Crystal K. D. Huie, Jerry Jew, Corky Lee, Peter Man, Gene Moy, Greg Soone, Leland Wong, Doug Yamamoto, Norman Yee, and Janet Yoshii. It would later be followed by *Pursuing Wild Bamboo: Portraits of Asian American Artists* (1992),[22] which provides rare documentation by and about artists active in the period. It is composed of a series of photo-essays by four Asian American photographers focused on the work and lives of their contemporaries: Zand Gee writing on artist Chester Yoshida; Bob Hsiang on Mt. Shasta Taiko; Crystal K. D. Huie on Leland Wong; and Lenny Limjoco on performance artist Brenda Wong Aoki. Kearny Street Workshop likewise sponsored a Writers' Workshop that was associated with many prominent figures, including poets such as Al Robles and George Leong, and playwright and poet Genny Lim.

From its inception, Kearny Street Workshop actively functioned as a multidisciplinary arts organization, providing classes in silkscreening, photography, video, crafts, music, and dance; an Asian American jazz program; silkscreen poster projects; and mural projects in Chinatown. Throughout, the visual arts and exhibition projects were a focal point of the group's activities, in its efforts to highlight often-unrecognized Asian American artists and to make the arts accessible to the community at large. In this, Kearny Street Workshop became a site for the creation of a visual culture intended to respond di-

rectly to its times, and to changing conditions in the Asian American communities. In 1974 Kearny Street opened the nearby Jackson Street Gallery, the site of a series of collectively organized projects.

Among the gallery's memorable offerings was *Angel Island: An Exhibition of the Chinese Experience at the Immigration Station* (1976) (fig. 212). Angel Island was a federally run immigration and detention center located in San Francisco Bay, through which thousands of Chinese immigrants passed during the first half of the twentieth century. This collaboratively developed exhibition is particularly notable for its incorporation of rubbings and plaster casts of the inscriptions made by detainees on

the barracks walls, chronicling their harsh experiences of passage and incarceration. According to Crystal Huie,[23] a photography instructor at Kearny Street who played an active role in initiating this project, members of the workshop—along with students and community volunteers—participated in both documenting the inscriptions and subsequently designing the multimedia exhibition that featured archival and contemporary images (as well as poetry) inspired by their trips to the site. Among the visual works were silkscreens by Leland Wong, Zand Gee, and Lori Chan; photographs by Jim Dong, Crystal Huie, and Bob Hsiang; and a clay figure by Dennis Taniguchi depicting a detainee in the act of carving a poem.[24] By establishing potent visual and tactile connections to a local site that is deeply associated with Chinese American history in the Bay Area, the exhibition had an opening that drew large crowds from the surrounding communities and elicited testimonies from former detainees. Subsequent to the show, these efforts contributed to the book *Island: Poetry and History of Chinese Immigrants on Angel Island, 1910–1940* by Him Mark Lai, Genny Lim, and Judy Yung (1980). This collaboration with scholars and writers also exemplifies the multifaceted ways in which artistic projects can be integrated with larger historical and interpretive efforts.

Alongside their Asian American focus, the activities at Kearny Street Workshop and Jackson Street Gallery demonstrated a firm commitment to maintaining ongoing connections with other communities of color. This is evident in collaborations with members of the Chicano arts organization Galería de la Raza, which included an early two-person exhibition featuring work by Rupert García and Juan Fuentes that took place at Jackson Street Gallery.[25] Like-

FIG. 212 Leland Wong, *Angel Island Exhibit: Portrait of My Father at Twelve Years Old*, 1976. Silkscreen poster, woodcut, and serigraph, 20 × 13 in.

wise, Kearny Street–affiliated artists participated with other Asian Americans and Pacific Islanders in group exhibitions at the Galería. As its former director, René Yáñez, recalls, "People call it diversity now, but back then we were talking about Third World communities, and felt that the only way we were going to survive was [by] sticking together."[26] The production of political posters and graphic art provided an important connection between the members of Kearny Street and Chicano arts organizations, both on ideological grounds and through a common interest in allied visual traditions (such as Cuban poster art and the Mexican mural movement).

Japantown Art and Media Workshop (JAM) was founded in 1977 under the direction of Dennis Taniguchi, a Denver-born Japanese American silkscreen artist and potter. Growing up in Berkeley in a largely African American community, Taniguchi began his process of radicalization in the mid-1960s, after contact with the Black Panther Party at a rally at Oakland City College. As he recalls: "It was an eye-opener.... The Blacks were the first to even bring up the idea that whites were oppressing them and you don't have to take it anymore. You can stand up and fight."[27] Loosely modeled after Kearny Street, JAM[28] was created under the aegis of the Japantown Art Movement, an umbrella organization comprising eight cultural and social service groups that included the Nihonmachi (Japantown) Street Fair, Asian American Dance Collective, and Oshogatsu Festival. Reflecting the politics of its day, JAM sought to combine entrepreneurialism with expressions of the experiences and struggles of Japanese Americans through art and literature. In its efforts to promote a greater awareness of Japanese American history and experience, JAM published the collection *Ayumi: A Japanese American Anthology* (1980). This cross-generational, bilingual anthology featured graphic works, literature, and historical documents that extend from accounts of early immigration through the World War II internment of Japanese Americans

to the present.[29] *Ayumi* is especially noteworthy because it reproduced so many works by elder artists—such as **Mitsu Yashima** (an influential teacher and activist affiliated with JAM), **Taro Yashima**, **Sueo Serisawa**, **Teikichi Hikoyama**, **Tokio Ueyama**, and **Eitaro Ishigaki**—and therefore is regarded as one of the earliest documents historicizing that generation of Bay Area artists.

At the core of JAM's activities were graphic arts training programs for neighborhood youth, and the visual design services it furnished to local businesses and community groups, involving local artists like Leland Wong, Jim Dong, and the late Wes Senzaki. For Taniguchi, the most valuable aspect of JAM's legacy was the teaching it provided for a new generation of artists and designers; as he relates, "We cranked [out] hundreds of artists. That's what I am most proud of."[30] Impressive evidence of this legacy is to be found in the collection of the Japanese American Historical Society in San Francisco.

CONSTRUCTING AN ASIAN AMERICAN VISUAL CULTURE: FIVE ARTISTS

To give a sense of how artists have conceived and projected aspects of Asian American consciousness through their work, the following discussion highlights five prominent individuals whose efforts overlapped in this historic moment. They come to the visual arts from different trajectories, yet all share a common trait: their work emerged as an organic response to the world around them, and in particular to the conditions and influences they encountered during the 1970s. For this discussion, the work is viewed as reflecting contrasting ways of thinking about how art and visual culture should function, and about reasons for invoking identity and heritage.

Represented by Jim Dong, Leland Wong, and Nancy Hom, the first approach is socially directed, often overtly political, and pragmatic in its intention, which is to impart messages that are readily apprehended by the broadest possible audience. Tak-

ing the form of public murals, silkscreened posters, prints, and book illustrations, and seeking to convey a staunch sense of community and solidarity, its content is typically inspired by figures, places, and events of significance to the Asian American movement. The orientation of Sekio Fuapopo and Carlos Villa, by comparison, is primarily introspective and associative, their relation to ethnicity and heritage envisioned through a far more personal, idiosyncratic lens. Even as Fuapopo and Villa are cognizant of contemporary art world concerns, including Western modernism and its formalist legacy, in their paintings and mixed media pieces they also seek to make conscious use of materials, idioms, systems of meaning, and art-making practices associated with non-Western cultures.

Images of Community

Jim Dong's sensibilities and concerns as a graphic artist, painter, muralist, and photographer are steeped in his experience of place, San Francisco's Chinatown, where he was raised. Dong's 1976 "portable mural," *The Struggle for Low Income Housing* (fig. 213) (produced in collaboration with Nancy Hom), is one of the most frequently reproduced images of Asian American public art from this period. Focused on the local community's intense opposition to the demolition of the International Hotel, the painting is dominated by the defiant image of one of the hotel's elderly Filipino residents. Brandishing a menacing cane overhead, the enraged man darts forward like a comic book superhero to seize the wrecking ball about to demolish his home. According to Dong, its central motif of a hand grasping a sphere echoes Diego Rivera's use of a similar device in *Man at the Crossroads*,[31] a controversial 1933–1934 mural made for New York's Rockefeller Center and subsequently destroyed.

Like Jim Dong, graphic artist, photographer, and illustrator Leland Wong has artistic interests rooted in an organic assimilation of the distinctive material and commercial culture of San Francisco's Chinatown, where he was born and raised. Wong's family owned a gift shop filled with Chinese and Japanese wares. Because his parents were immersed in the business and social life of the community, the artist was well aware of the effects of anti-Asian discrimination and racism, and of the struggles faced by new immigrants for their economic and psychic survival. The social consciousness sparked by the injustices he saw around him, and by his subsequent involvement with activism, amplified the artist's interest in expressing his heritage. In the late 1970s, Wong began designing elaborate bilingual posters for local community events that draw loosely on formal elements and motifs associated with Japanese *ukiyo-e* woodblock prints. Yet they are also rendered in a more elaborate decorative style that, according to the artist, seemed "very Chinese" to certain viewers. In one early example, *Ten Thousand Turtles* (fig. 214), a pair of dragon-headed turtles—powerful Chinese symbols of longevity and prosperity—ride the crest of a wave about to wash over the roofs of Japantown. While perhaps Wong was unconsciously affected by the variety of Asian influences to which he was exposed as a child, his willingness to freely conflate references to different East Asian cultures can also be viewed as an example of the emergence of a distinct Asian American hybrid cultural sensibility. This orientation is characterized by a new, generalized sense of "Asianness," rather than being identified with specific Asian national artistic traditions.

For nearly three decades, Chinese-born graphic artist and poet Nancy Hom has devoted much of her art to political and social causes. Raised in New York City's Chinatown, Hom became involved in the emerging East Coast Asian American movement, and with her growing attachment to cultural activism, she increasingly looked for ways to have her art serve larger social purposes. In 1974, Hom moved to San Francisco and soon joined Kearny Street Workshop, eventually to become its director. Influenced

FIG. 213 Jim Dong (with Nancy Hom), *The Struggle for Low Income Housing*
(aka *International Hotel Victory Mural, San Francisco*), 1976. Acrylic on plywood, 14 × 24 ft.

by the poster art and prints she saw in the Mission District, a largely Latino neighborhood, Hom began to produce works whose bold hues, strong patterns, and sharply delineated forms drew on both Chicano and Cuban revolutionary graphics. A noteworthy piece from this period is *Cinco de Mayo* (1978) (fig. 215), an oversized silkscreen poster promoting the popular festival that celebrates Mexican independence. This striking image, with its joyous visage of a brown-skinned woman framed by a mane of flowing black hair, is based on Adele Chu, a dancer, choreographer, and musician of Chinese Panamanian heritage who had initiated the first Brazilian Carnaval in San Francisco. It points to the hybrid nature of Latino cultures, in which people of Asian heritage in the Western Hemisphere have long played a part.

Cultural Identities in Conversation with Modernism

Samoan-born artist Sekio Fuapopo studied painting at the San Francisco Art Institute in the early 1970s. While there, he encountered two Filipino American instructors, Carlos Villa and Leo Valledor, who encouraged him to explore his cultural roots and identity through art. Taking this advice to heart, Fuapopo began to combine the lessons he had gleaned from abstract expressionism with motifs associated with Samoan culture, such as the geometric designs of tapa (a woven bark cloth used for both ritual and everyday purposes). As an Americanized Samoan, Fuapopo makes no claims to cultural "authenticity"; instead, he is fully aware of his position as a diasporic and Western-educated artist trying to access and reconfigure elements of tradition on his own, very personal terms. Among Fuapopo's works from the early 1970s is *"Mali'e"—Shark* (1972) (fig. 216), which is inspired by the shape of a shark's gaping jaws with their rows of dagger-like teeth. In this large-scale painting, dominated by three conjoined elliptical forms in acid yellows and reds, the artist draws upon a motif common among Pacific Island cultures, in-

FIG. 214 Leland Wong, *Ten Thousand Turtles*, 1980. Silkscreen, 26 × 20 in.

cluding the tattoos and tapa patterns of his Samoan heritage. As the shark is a powerful guardian figure, its inherent strength and fierce resilience are invoked to confer protection on Samoans, both in their homeland and wherever they may be. Whereas Dong, Hom, and Wong rely on images that denote in culturally or politically recognizable ways, Fuapopo employs images that connote a connection to his heritage through color and design.

As an artist and educator active in the mainstream art world who is also a cultural activist, Carlos Villa has had a career distinguished by a rare ability to bridge different communities. Although he primarily considers himself a studio artist, since the late 1960s "community actions" aimed at "bringing people together or bringing cultures together"[32] have been integral to his practice. Born in San Francisco's Tenderloin District in 1936, Villa was raised in an immigrant working-class family in a small enclave of

FIG. 215

Nancy Hom, *Cinco de Mayo*, 1978. Silkscreen, 18 × 22 in.

274

FIG. 216 Sekio Fuapopo, *"Mali'e"—Shark*, 1972.
Enamels on canvas, 54 × 96 in.

Filipinos. After achieving significant recognition in New York, in the late 1960s Villa returned to the Bay Area, where he increasingly began to delve into his Filipino heritage as a source of material for his art. Recognizing that Filipino culture is fundamentally syncretic, due to the mingling of indigenous Pacific cultures and the centuries-old legacy of circulation within a Spanish colonial empire that brought in peoples and influences from around the world, Villa drew upon many different cultural streams in constituting a vision of Filipino identity he could find meaningful.

Among his early works is *Where It Is Hidden* (1970), a large, object-like painting on unstretched canvas, in which mirror slivers and animal blood—a material Villa loosely associates with non-Western ritual practices—are densely layered with acrylic pigments laid down with the gestural energy of abstract expressionism. The artist conceived the work as a violation of Western formal conventions of visual presentation, as well as a material means of synthesizing different cultural and artistic streams. Villa's use of

blood is also strongly connected to childhood memories of celebratory family meals in which animals were butchered and cooked, their fresh blood serving as an integral ingredient in the accompanying sauces. By introducing an organic material with deep personal resonance, Villa found a means of directly imprinting his own heritage on postwar American modernism. He recalls, "I finally did it in my own way. I may have looked at Jackson Pollock or Morris Louis or [Helen] Frankenthaler with a sense of awe. But to be able to put blood in there and paint with it made it my own."[33]

Villa began using unstretched canvas following his exposure to tapa cloths. These bark cloths, typically used in many Pacific Island cultures as clothing and for household functions, commonly serve as decorative wall hangings as well. Moreover, while traditional cloths contain repetitive geometric patterns, those produced since the late twentieth cen-

tury may also feature designs and images that reference contemporary culture. Seemingly channeling the spirit of modern tapa, in 1972 the artist produced *Traffic Island Tapa* (fig. 217), a piece whose frenetically crisscrossing geometric patterns, rendered in dense layers of beading, conjure aerial views of the California urban highway system. Noting that "I wasn't born in the islands [the Philippines]—[but] I spent a lot of time on traffic islands,"[34] Villa gave the work a title that is a wry pun on the artist's upbringing in urban America.

FIG. 217 Carlos Villa, *Traffic Island Tapa*, 1972.
Acrylic and beads on canvas, 69 × 71 in.

What these artists, works, and collaborations make plain are the continuities (rather than the ruptures) between the polycentric ideas that informed "multiculturalist" art of the 1970s and present-day cultural production that deals with questions of positionality, identity, and place in the context of postcolonialism, imperialism, and transnational circulations of people, images, goods, ideas, and capital. Although such work is strongly grounded in particular communities and locations, it also looks beyond local and national borders to engage with peoples and societies around the world with whom these artists perceive cultural and historical connections. In this, one

can see the powerful effects of Third World solidarity movements (as well as of more informal interpersonal networks) on the developing consciousness of many Asian American and Pacific Islander artists of that period.

The multiple practices of the artists discussed in this essay, moreover, posit a more integrative way of thinking about the role of the artist, as both an individual creator and a social actor. They suggest how visual art can add to a modern society's deep repertoire of responses to its time by providing what I would term "expressive capital." This idea builds on French sociologist Pierre Bourdieu's notion of "cultural capital," referring to noneconomic resources such as education and social status that enable in-dividuals to function effectively within a culture. In light of the West's legacy of efforts to dominate and control others, the concept of a group possessing its own "expressive capital" can be extraordinarily meaningful to those historically denied access to adequate means of self- and collective representation. Each group entering the social and political space of this nation recasts and contests its public culture on various levels, from the smallest details of daily encounters between peoples and lifeways to the larger intellectual and political realms. In a continuously evolving and heterogeneous society, concerns articulated by artists of non-Western heritage are integral to enlarging this country's most fundamental visions of itself, its ethos, and its collective character.

Notes

1 Sucheng Chan, *Asian Americans: An Interpretive History* (New York: Twayne Publishers, 1991), 157.

2 For a discussion of the concept of "port culture," see John Kuo Wei Tchen, *New York Before Chinatown: Orientalism and the Shaping of American Culture, 1776–1882* (Baltimore: The Johns Hopkins University Press, 1999). Tchen theorizes about port cultures as zones of cross-cultural interaction and creolization, and examines the historical formation of multicultural districts in international port cities like New York.

3 Dong Kingman's recollections of that Bohemian enclave are chronicled in his illustrated autobiography. See Dong Kingman, *Paint the Yellow Tiger* (New York: Sterling Publishing, 1991), 56.

4 Timothy W. Drescher, *San Francisco Bay Area Murals: Communities Create Their Muses, 1904–1997* (St. Paul: Pogo Press, Inc., 1998), 19. Comic book art has been influential for many artists of color, in part because of the ubiquitous presence of comics and graphic novels in Asia, Latin America, South America, and other places of origin. However, the iconographies of 1970s political murals, with their stalwart figures, seem to have more in common with mainstream action comics' muscular superheroes, and their Manichean struggles between the forces of good and evil, than with the legacy of the countercultural underground "comix" movement.

5 Mark Dean Johnson, unpublished notes on "The Angels of Light San Francisco, Circa 1970: Photographs and Drawings by Martin Wong," 1999.

6 K. Connie Kang, "Yuji Ichioka, 66: Led Way in Studying Lives of Asian Americans," *Los Angeles Times*, September 7, 2002.

7 Paul Karlstrom, "Art School Sketches: Notes on the Central Role of Schools in California Art and Culture," in *Reading California: Art, Image, and Identity, 1900–2000*, ed. Stephanie Barron, Sheri Bernstein, and Ilene Susan Fort (Los Angeles: Los Angeles County Museum of Art and Berkeley: University of California Press, 2000), 85.

8 According to Timothy Drescher, by the late 1990s there were more than seven hundred murals in the San Francisco area alone. See Drescher, *San Francisco Bay Area Murals*, 7.

9 Anthony Lee, *Painting on the Left: Diego Rivera, Radical Politics, and San Francisco's Public Murals* (Berkeley: University of California Press, 1999), 193–194.

10 See Carlos Villa, *Other Sources: An American Essay* (San Francisco: San Francisco Art Institute, 1976). Villa's ex-

ploration of local artistic production that began with *Other Sources* would later be extended in the Worlds in Collision courses he designed, and in a series of symposia, "Sources of a Distinct Majority" (1989–1994), on multiculturalism, identity, and cultural politics. Those proceedings were later published in Carlos Villa, *Worlds in Collision: Dialogues on Multicultural Art Issues* (San Francisco: International Scholars Publications and San Francisco Art Institute, 1994). This work would be followed in 2001 by another major symposium, "Worlds in Collision 2: Call & Response," which convened artists, curators, and writers to discuss the changes that had taken place in cultural discourses and politics during the intervening decades.

11 Carlos Villa, interview with the author, June 3, 2003.

12 Rolando Castellón, formerly the director of Galería de la Raza, was the curator of the San Francisco Museum of Art's M.I.X. (Museum Intercommunity Exchange) department during the mid-1970s. His initiatives brought unprecedented numbers of artists of color into the museum. This 1974 exhibition featured artists of African American, Latino, Asian, and Middle Eastern descent.

13 Carlos Villa, interview with the author, June 3, 2003.

14 In order to situate this work in a larger context, *Other Sources* features pungent essays on Third World art, politics, and aesthetics by cultural activist Paul Kagawa and artist Rupert García placed in dialogue with writings by art historian Allan Gordon and influential Bay Area critic Thomas Albright, among others. Additionally, the text of a conversation between Rolando Castellón and Carlos Villa provides insights into the cultural politics of this period, and how artists of color were located both within the wider discourse and in a local institutional context.

15 The term "Third World" emerged in the late 1940s and originally referred to nations that were not aligned with either the "Free World" (the United States and its allies) or the "Communist World" (the Soviet Union and allied Communist countries). Since then, the definition of the term has become very elastic. In vernacular usage, it often referred to nations in Africa, Latin and Central America, the Caribbean, and parts of Asia that were poverty stricken, minimally industrialized, and economically "underdeveloped." By the 1960s, it was adopted by U.S. political activists to speak of solidarity among groups that had suffered oppression and exploitation by capitalism, imperialism, and colonialism—including impoverished whites as well as peoples of non-European origin throughout the world.

16 Rupert García, interview with the author, January 10, 2004.

17 See *Liwanag: Literary and Graphic Expressions by Filipinos in America* (San Francisco: Liwanag Publications, Inc., 1975).

18 See Nick Harvey, ed., *Ting: The Caldron, Chinese Art and Identity in San Francisco* (San Francisco: Glide Urban Center, 1970).

19 Ibid., Foreword, n.p.

20 Juan Felipe Herrera, "Riffs on Mission District Raza Writers," in *Reclaiming San Francisco: History, Politics, Culture*, ed. James Brooks, Chris Carlsson, and Nancy J. Peters (San Francisco: City Lights Books, 1998), 219.

21 Jim Dong, Zand Gee, and Crystal K. D. Huie, eds., *Texas Long Grain: Photographs by the Kearny Street Workshop* (San Francisco: Kearny Street Workshop Press, 1982).

22 Zand Gee, Bob Hsiang, Crystal K. D. Huie, and Lenny Limjoco, *Pursuing Wild Bamboo: Portraits of Asian American Artists* (San Francisco: Kearny Street Workshop Press, 1992).

23 Crystal K. D. Huie, telephone interview with the author, January 12, 2004.

24 Description provided by Nancy Hom, correspondence with the author, September 15, 2005.

25 The legacy of collaboration between Kearny Street Workshop and Galería de la Raza continues. At this writing, according to René Yáñez, these organizations are planning a joint "Asian American/Chicano" art exhibition to be mounted at the SomArts cultural complex in downtown San Francisco; René Yáñez, interview with the author, January 10, 2004.

26 Ibid.

27 Dennis Taniguchi, interview with the author, August 8, 2003.

28 Taniguchi recalls that among its members were Geraldine Kutaka, Richard Wada, Oku Kodama, Gail Oratani, Wes Nibei, Richard Tokeshi, Mitsu Yashima, Sheryl Hayashino, and Paul Kagawa.

29 The anthology *Ayumi* included personal journals, works from out-of-print newspapers, books, concentration camp magazines and periodicals, and graphics from

personal collections. The editorial board included Janice Mirikitani, Hiroshi Kashiwagi, Richard Wada, Doug Yamamoto, and Mitsu Yashima.

30 Dennis Taniguchi, interview with the author, August 8, 2003. Japantown Arts and Media Workshop closed its doors in 2000 when Taniguchi moved to Hawaii.

31 Diego Rivera's *Man at the Crossroads* (1933–1934) portrayed workers at the crossroads of science, industry, capitalism, and socialism. For a detailed description of this mural, see Desmond Rochfort, *Mexican Muralists: Orozco, Rivera, Siquieros* (New York: Universe Publishing, 1993), 130–132.

32 Carlos Villa, interview with the author, June 3, 2003.

33 Ibid.

34 Carlos Villa, correspondence with the author, March 7, 2004.

Biographies

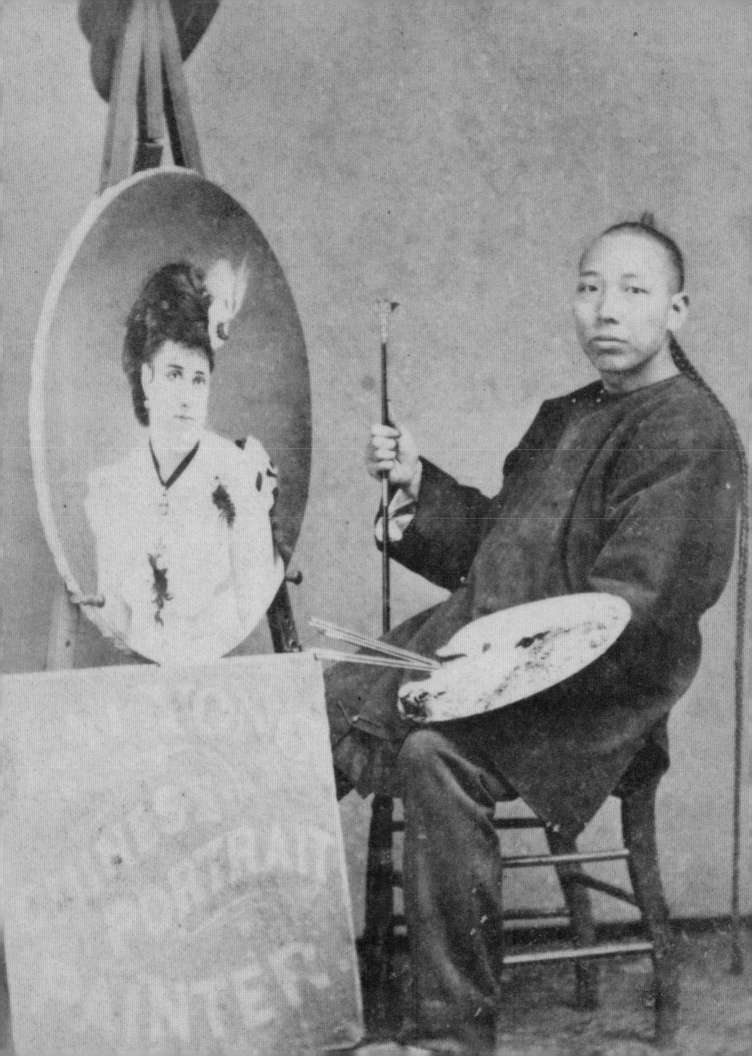

Introduction to
Biographies of California Asian American Artists, 1850–1965

Sharon Spain

The biographical entries found here document artists of Asian ancestry active in California from 1850 to 1965 and are the result of more than ten years of work by dozens of researchers. Known as the "California Asian American Artists Biographical Survey" (CAAABS),[1] this distinct research initiative, funded by the National Endowment for the Humanities, had a goal of recording information on 100 artists, but at this writing we have documented more than 1,000 artists. While for a majority of these artists information is limited and may consist of a listing in an exhibition catalog, a mention in a newspaper, or a record in an enrollment document for an art school, we were able to amass significant information on 159 artists.

While the term *Asian American* is used to describe these artists, a quick reading of any of these biographies will illustrate how complex and varied the lives of these individuals are, and how ill-suited in some cases this term is. Some artists were born in the United States, some immigrated and became citizens (if or when it was possible to do so), some spent extended periods of time here, and others were recurrent visitors, traveling back and forth between

Lai Yong, *Self-Portrait*, ca. 1871 (detail, p. 469).

cities and countries. Their selection for inclusion here has to do not only with their physical presence in California, but also with their influence, engagement, and dialogue with other artists, and with the California culture at large. Therefore artists such as C. C. Wang and Isamu Noguchi, usually associated with New York, appear here. Tseng Yuho's lengthy stays and extensive exhibition history in the state prompt her listing here; Miyoko Ito, known as a Chicago artist, was born and had her earliest training in the San Francisco Bay Area and is included here for these reasons. Kamesuke Hiraga, who was born in Japan and who spent the majority of his career in France, is included because of his early, pivotal art training in the state, as are Eitaro Ishigaki and Takeo Edward Terada, who both returned to and died in Japan. In the hope of retrieving a neglected art history, it is important to not repeat the narrow definitions of nationality or residency that may have contributed to the exclusion of these artists from previous histories.

Because of the date range of this biographical research project (1850–1965) and the nature of immigration during those years, artists of Chinese and Japanese ancestry predominate in these biographies,

with artists of Filipino and Korean ancestry being fewer in number. No substantial information regarding artists of South Asian or Southeast Asian descent was identified for inclusion in this directory. (Please refer to the Chronology for information regarding immigration legislation history.)

With 1965 as the cutoff date for this project, we have used the criteria that artists must have been actively studying or exhibiting by this time. Therefore artists such as Martin Wong and Masami Teraoka, better known for their careers in the 1970s and 1980s, are included here. Martin Wong, although only nineteen in 1965, had studied with Dorr Bothwell in Mendocino the previous year, and his prodigious talents were already noted; Masami Teraoka, who came to California in 1961 to study art, had been an exhibiting artist in Japan.

Many artists that we wish could be included here are not, either because of limited information or because of project time constraints. Not appearing are numerous nineteenth-century photographers active in San Francisco, such as Ann Ting Gock and Kai Suck; Chinese Art Association members including Longsum Chan, Wahso Chan, Sui Chan, Sam Fong, and Suey B. Wong; the many Japanese pictorialist photographers active in the 1920s and 1930s, such as Kiyoshi Asaishi, Riso Itano, Hiseo E. Kimura, Kentaro Nakamura, F. Y. Sato, Harry Shigeta, and Kaye Shimojima; Hojin Miyoshi, cofounder of Shaku-do-sha association in Los Angeles; Violet Nakashima, who participated in WPA art projects in the San Francisco Bay Area; photographer and painter Kango Takamura; Henry Okamoto, who studied ceramics at Mills College at the same time as Katherine Choy, and who founded the Clay Art Center with her in Port Chester, New York; and many, many others. As with any such study, new information is constantly appearing, and it is our hope that others will continue this research.

Sources consulted were primarily in English. Books, exhibition catalogs, and other published materials regarding specific artists in other languages were translated when possible. There is a signifi-

cant body of research in Japan regarding Japanese artists in the United States, and these resources were consulted and translated in many cases. English-language sections of Japanese newspapers published in California were another source of information, and various Chinese- and Japanese-language papers were translated when they contained specific information regarding artists. *The Chinese Digest*, a San Francisco English-language publication, was also an important source. However, the thorough research of non-English papers published in California has yet to be completed and remains an important area for future research.

A majority of the research for these biographies was conducted by students, many of whom wrote initial drafts of entries. Researchers included students at San Francisco State University; the University of California, Berkeley; the University of California, Los Angeles; Sacramento State University; and Stanford University (the acknowledgments contain a complete list of student researchers). Mark Johnson directed this research initiative since its inception. Paul Karlstrom played an instrumental role in the crafting of the biographical entries and artist interview formats, and he worked closely with students in both Northern and Southern California as principal advisor during the research phase. Cecile Whiting and Valerie Matsumoto at UCLA were also centrally involved in supporting student research, as was Karin Higa at the Japanese American National Museum. At SFSU Darlene Tong played an important advisory role, and Irene Poon has been at the core of this project since it began. Her untiring efforts to contact, interview, and photograph elder artists resulted in the inclusion of many individuals. Without the knowledge and methodical work of Marian Yoshiki-Kovinick, the Southern California portion of this project would not have been possible. The author of this introduction has also overseen and conducted research, and managed this archive for nearly a decade. As a result of this collaborative, multiyear study, stylistic differences in the biographies reflect the many authors involved.

Our deepest appreciation goes to the families of artists and to the artists themselves. The most important and meaningful information has come from them, and we are proud to be able to include quotes from many artists—either taken directly from personal interviews or culled from written sources. While the research process has been an incredibly rewarding experience, especially for those researchers who had the opportunity to meet and interview artists and artists' family members, it has also been fraught with sadness, as many of the elder artists interviewed have passed away during the course of our project. We hope that this directory serves as a document of their lives and work and that it will inspire others to continue research in this important area of American art history.

The notes below serve as a guide for reading the artists' biographical entries and explain the research methodology.

ARTISTS' NAMES

The issue of artists' names is complicated, and over time it has contributed to confusion or errors in the documentation of their careers. While the practice of family names preceding given names is common in Asia, this ordering often was not understood in the United States. In addition, spelling and pronunciation were frequently difficult for those not of Asian ancestry. Artists and their families chose different ways to deal with name order and spelling, including eventually accepting misinterpretations of their names. Therefore Dong Kingman became known as Mr. Kingman despite this being his given name; Yoshida Sekido, who apparently tried to maintain the surname-first name order, was also commonly known as Sekido Yoshida; and Chee Chin S. Cheung Lee's name appears in a variety of ways. Phonetic spellings have resulted in Sekishun Masuzo Uyeno's name also being spelled as Ueno, and Noboru Foujioka's spelled as Fujioka; Hu Wai Kee's name also appears as Key in exhibition records. Yoshio Markino (formerly Makino) chose to add an "r" to make pronunciation eas-

ier for English speakers, and Julia Suski's father similarly changed their family name from Susuki to aid pronunciation. The family name of nineteenth-century artist Tameya Kagi today probably would be spelled and pronounced Kaji, but as well as being listed in exhibition records as Kagi, he also signed artwork with that name. Often individuals were given Western names in addition to their Japanese or Chinese names either by their parents or in some cases by non–family members, and some artists have been known by alternate names at different points in their careers. Sadamitsu Fujita received the name Neil from a grade school teacher, and Eiko Asawa became Ruth Asawa under similar circumstances; Noriko Yamamoto is sometimes listed as Nora Yamamoto in exhibitions in the 1950s, and Matsumi Kanemitsu is alternately known as Mike Kanemitsu.

In deciding how to represent artists in this survey, we have tried to determine how artists themselves identified during their artistic careers in the United States, either gathering this information from the artists, their friends, or family members or relying on exhibition records or other written sources for the most common representations of names. For artists of Chinese ancestry included in this study, as well as for other Chinese artists mentioned in the narratives, who are not clearly known by a specific name format in the United States and whose Chinese names may alternately be spelled in Wade-Giles or pinyin, we use the pinyin. The names of Japanese Americans and artists from Japan who lived and worked in the United States and who are included in this study are provided principally as given name first, family name second, following the usage of the individuals themselves. For Japanese artists, curators, authors, and others mentioned here, their names appear in the Japanese order of family name first, given name second, with elongated vowels indicated with macrons. We have done our best to represent Japanese-language words and terminology with macrons; we also include appropriate accents on names and words in other languages. Japa-

nese words that have entered the English dictionary and vernacular, such as ikebana and shoji, appear in their English-language forms. An artist's name in boldface indicates that the artist also has a biographical entry.

RESIDENCES AND PLACE-NAMES
Place-names in China appear in the pinyin format, with the exception of commonly known cities such as Hong Kong and Taipei. Japanese place-names are primarily listed with city only, but in the case of smaller locations in Japan, prefecture names are also provided. Japanese place-names do not appear with macrons.

DATES
Birth, death, and residency dates and locations come from information supplied by artists and artists' family members as well as from such sources as federal census records, internment records, immigration records, school enrollment records, newspaper citations, the social security death index, and the California death index. Since individuals' recollections or personal written records of dates, such as when an exhibition took place or when someone attended school, sometimes differed from other recorded documentation, we have cross-checked information to provide the most accurate dates possible. For some artists, such as Isamu Noguchi, who traveled widely and lived in multiple cities, chronological residency dates reflect a summary of complex international lives.

MEDIA
Practitioners of art forms such as ikebana and tea ceremony are not included in this survey despite the importance of these practices as art forms in Asia. Calligraphy is placed within the rubric of "ink painting," and "ink painting" is differentiated from "watercolor painting" to denote watercolor's typical use of gum arabic as a binder. In special cases more detailed media are provided when the use of other types of pigment binders is of importance (see Chang Dai-chien

and Chang Shu-chi). In general, film is not included as a medium. However, director (and actor) Sessue Hayakawa is included because he was known as a painter as well. James Wong Howe is also included because of his work as a photographer (in addition to his long career as an Academy Award–winning cinematographer). Several animators and illustrators, most notably some who worked for the Walt Disney Studios, are also included here, since animation and illustration span fine and commercial art.

ART EDUCATION
This information pertains only to formal institutional art education. Details of non-art academic study and non-formal art education, such as that with private tutors, can be found in the narrative portion of the entries. It is not our intention to give private study, which is more common in Asia than in the United States, a lesser value. Instead, the narrative provides a greater opportunity to explain the nature of private study. Some information regarding school enrollment during the early 1900s, such as exact attendance dates, could not be confirmed with institutions and is dependent on the accuracy of secondary sources. Names of academic institutions appear as they were known during the time of the artist's attendance. Below are current names of institutions followed by their former names:

California College of the Arts
> School of the California Guild of Arts
> > and Crafts
> California School of Arts and Crafts
> California College of Arts and Crafts

California Institute of the Arts (CalArts)
> Chouinard Art Institute

Otis College of Art and Design
> Otis Art Institute of the Los Angeles
> > Museum of History, Science and Art
> Otis Art Institute
> Los Angeles County Art Institute
> Otis Art Institute of Los Angeles County

Otis Art Institute of Parsons School
of Design
Otis School of Art and Design

San Francisco Art Institute
San Francisco Art Association
California School of Design
Mark Hopkins Institute of Art
San Francisco Institute of Art
California School of Fine Arts

Pacific Northwest College of Art (Portland, OR)
Museum Art School

EXHIBITIONS

When possible, exhibition title, location (institution and city), and date are provided. Dates for single exhibitions that continued over two years are listed with a solidus between the years—for example, "1949/50." Dates for consecutive annual exhibitions (such as art association annuals) appear in full—for example, "1949–1950." Institution names, like school names, appear as the institution was known during the year of exhibition. Below are current names of institutions followed by their former names:

Los Angeles County Museum of Art
Los Angeles Museum of History,
Science and Art
Los Angeles Museum
Los Angeles County Museum
San Francisco Museum of Modern Art
San Francisco Museum of Art

COLLECTIONS

Although at one time many museums owned works by artists included here, intervening years have seen the deaccessioning of important works, as the result of changing interests of curators and collectors. We have made every effort to confirm the current status of collections.

BIBLIOGRAPHY

The bibliographical listings for each artist serve two purposes—to provide resources for expanded information on the artist and to give references for information cited in th e narratives. CAAABS project interview citations appear in many biographies, and any available transcripts or tapes of interviews are noted. The CAAABS artist files, housed at Stanford University, are the repository for much of the cited materials; these files contain copies of newspaper articles, artists' résumés, museum records, and documentation from consulted archives. While every source consulted has not been listed, this bibliographical information is provided to support the narratives for those artists about whom little is known. Such sources are also provided when information in the biographical narratives differs from other published information.

Consulted Records

San Francisco Museum of Modern Art exhibition records, pre-1965; San Francisco Art Institute enrollment records, 1907–1950, awards, 1888–1891; California State Fair records, 1954–1956, 1958–1964, 1967–1968; Crocker Kingsley Exhibitions, Crocker Art Museum, Sacramento, 1930–1991; Ferdinand Perret Research Materials on California Art and Artists, 1769–1942 (Archives of American Art microfilm); Fine Arts Museum of San Francisco (de Young Museum and California Palace of the Legion of Honor) exhibition files, 1926–1965; Los Angeles County Museum of Art artist files; Los Angeles Area and Vicinity exhibitions, 1948, 1950–1959, 1961; Los Angeles County Fair records, 1928–1930, 1933–1941, 1951; *Los Angeles Times* Index, 1930–1945/Publications in Southern California Art; Chinatown Artists Club records (de Young Museum); San Diego Museum of Art artist files and exhibition records; San Diego City Directories, 1916–1948, 1951–1965; Peter Palmquist's "Preliminary Checklist of Asian and Asian American Photographers and Related Trades, Active in California/Oregon/Washington, 1850–1930" (from Andersen et al., *With New Eyes*); California Art Research, San Francisco, 1936–1937 (Bancroft Library); Internment camp newspapers: *Heart Mountain Sentinel, Manzanar Free Press, Granada Pioneer, Denson (Jerome) Tribune, Gila News-Courier, Poston Chronicle, Poston*

Press Bulletin, Rohwer Outpost, Santa Anita Pacemaker, Topaz Times, Tulean Dispatch; San Francisco Art Association records: Painting annuals, 1916, 1919–1921, 1923–1925, 1927–1933, 1937–1942, 1944–1946, 1948–1960. Drawing annuals, 1935, 1937–1939, 1941–1954, 1956–1958, 1960–1961. Watercolor annuals, 1936–1937, 1939–1953, 1955–1958; *Chinese Digest* (San Francisco), 1935–1940; records housed at the National Archives, including the United States Federal Population Census, the Japanese American Internee Data File, and Passenger Lists of Vessels Arriving at San Francisco, 1893–1953; *Rafu Shimpo (Los Angeles Japanese Daily News)*, ca. 1930s; *Kashu Mainichi (The Japan-California Daily News)* (Los Angeles), ca. 1930s; *Nichi Bei (The Japanese American News)* (San Francisco), ca. 1920s; *Shin Sekai (The New World)* (San Francisco), ca. 1920s.

General Bibliography

Andersen, Irene Poon, Mark Johnson, Dawn Nakanishi, and Diane Tani. *With New Eyes: Toward an Asian American Art History in the West*. San Francisco: Art Department Gallery, San Francisco State University, 1995.

Brown, Michael D. *Views from Asian California, 1920–1965*. San Francisco: Michael D. Brown, 1992.

California Arts and Architecture 56, no. 4 (October 1939).

Catalogue of the Second Jury Free Exhibition of the Works by Members of the East West Art Society. San Francisco: East West Art Society, 1922.

Dicker, Laverne Mau. *The Chinese in San Francisco: A Pictorial History*. New York: Dover, 1979.

Eaton, Allen Hendershott. *Beauty Behind Barbed Wire: The Art of the Japanese in Our War Relocation Camps*. New York: Harper, 1952.

Geijutsu Shinchō (Tokyo), no. 10 (October 1995).

Gesensway, Deborah, and Mindy Roseman. *Beyond Words: Images from America's Concentration Camps*. Ithaca, NY: Cornell University Press, 1987.

Halteman, Ellen Louise. *Publications in [Southern] California Art 7: Exhibition Records of the San Francisco Art Association, 1872–1915; Mechanics' Institute, 1857–1899; California State Agricultural Society, 1856–1902*. Los Angeles: Dustin Publications, 2000.

Harvey, Nick, ed. *Ting: The Caldron, Chinese Art and Identity in San Francisco*. San Francisco: Glide Urban Center, 1970.

Higa, Karin M. *The View from Within: Japanese American Art from the Internment Camps, 1942–1945*. Los Angeles: Japanese American National Museum, 1992.

Hughes, Edan Milton. *Artists in California, 1786–1940*. San Francisco: Hughes Publishing Company, 1989.

Japanese and Japanese American Painters in the United States: A Half Century of Hope and Suffering, 1896–1945. Tokyo: Tokyo Metropolitan Teien Art Museum and Nippon Television Network Corporation, 1995.

Japanese Artists Who Studied in U.S.A. and the American Scene (Amerika ni Mananda Nihon no gaka-tachi: Kuniyoshi, Shimizu, Ishigaki, Noda). Tokyo: National Museum of Modern Art, 1982.

Japanese Artists Who Studied in U.S.A., 1875–1960 (Taiheiyō o koeta Nihon no gakatachi ten). Wakayama, Japan: Museum of Modern Art, Wakayama, 1987.

Japan in America: Eitaro Ishigaki and Other Japanese Artists in the Pre–World War II United States. Wakayama, Japan: Museum of Modern Art, Wakayama, 1997.

Jarrett, Mary. *The Otis Story: Of Otis Art Institute Since 1918*. Los Angeles: The Alumni Association, 1975.

Kim, Elaine. *Fresh Talk/Daring Gazes: Conversations on Asian American Art* (with Margo Machida and Sharon Mizota). Berkeley and Los Angeles: University of California Press, 2003.

Kovinick, Phil, and Marian Yoshiki Kovinick. *An Encyclopedia of Women Artists of the American West*. Austin: University of Texas Press, 1998.

Lee, Anthony. *Picturing Chinatown: Art and Orientalism in San Francisco*. Berkeley: University of California Press, 2001.

——, ed. *Yun Gee: Poetry, Writings, Art, Memories*. Seattle: University of Washington Press, 2003.

Mirikitani, Janice, ed. *Ayumi: A Japanese American Anthology*. San Francisco: Japanese American Anthology Committee, 1980.

Moure, Nancy Dustin Wall. *Publications in Southern California Art 1, 2 & 3*. Los Angeles: Dustin Publications, 1984.

——. *Publications in Southern California Art 4, 5 & 6*. Los Angeles: Dustin Publications, 1999.

Okutsu, James K. *Expressions from Exile, 1942–1945: Japanese American Art from the Concentration Camps*. San Francisco: San Francisco State University, Asian American Studies Department, 1979.

Palmquist, Peter E. *Facing the Camera: Photographs from the Daniel K. E. Ching Collection*. San Francisco: Chinese Historical Society of America in joint sponsorship with Asian American Studies Department, San Francisco State University, 2001.

Poon, Irene. *Leading the Way: Asian American Artists of the Older Generation*. Wenham, MA: Gordon College, 2001.

Reed, Dennis. *Japanese Photography in America, 1920–1940*. Los Angeles: George J. Doizaki Gallery, Japanese American Cultural and Community Center, 1985.

Sullivan, Michael. *Art and Artists of Twentieth-Century China*. Berkeley: University of California Press, 1996.

——. *The Meeting of Eastern and Western Art*. New York: New York Graphics Society, 1973.

Tsutakawa, Mayumi, ed. *They Painted from Their Hearts: Pioneer Asian American Artists*. Seattle: Wing Luke Asian Museum/University of Washington Press, 1994.

Wechsler, Jeffrey, ed. *Asian Traditions/Modern Expressions: Asian American Artists and Abstraction, 1945–1970*. New York: Abrams in association with the Jane Voorhees Zimmerli Art Museum, Rutgers, the State University of New Jersey, 1997.

Wilson, Michael G., and Dennis Reed. *Pictorialism in California: Photographs 1900–1940*. Malibu, CA, and San Marino, CA: J. Paul Getty Museum and Henry E. Huntington Library and Art Gallery, 1994.

Winther-Tamaki, Bert. *Art in the Encounter of Nations: Japanese and American Artists in the Early Postwar Years*. Honolulu: University of Hawai'i Press, 2001.

Note

1 The project served to continue the work begun by the Northwest Asian American Art Project, Archives of American Art, Smithsonian Institution. That initiative's "Directory of Asian American Artists in Washington and Oregon (1900–1975)" appeared in Tsutakawa, *They Painted from Their Hearts: Pioneer Asian American Artists*.

Self-portrait by Ricardo Alvarado

Alvarado, Ricardo Ocreto

BORN: February 7, 1914, Urdaneta, Pangasinan, Philippines

DIED: April 11, 1976, San Francisco, CA

RESIDENCES: 1914–1928, Urdaneta, Pangasinan, Philippines § 1928–1976, San Francisco, CA

MEDIA: photography

SELECTED SOLO EXHIBITION: *Through My Father's Eyes*, Jewett Gallery, San Francisco Public Library, 1998, and National Museum of American History, Smithsonian Institution, 2002 (fourteen-city national tour)

SELECTED GROUP EXHIBITION: *Harlem of the West—The Fillmore Jazz Archives*, San Francisco Arts Commission Gallery, 1998

SELECTED BIBLIOGRAPHY: Mandel, Susan. "Memories of the Manong." *The Washington Post*, January 26, 2003, G7. § Myers, Holly. "With Eyes All American: Ricardo Ocreto Alvarado's Pictures of Filipinos in the U.S." *Los Angeles Times*, July 8, 2004, E4. § Sagullo, Monica. "A Journey Back in Time: Photographer's Daughter Shares History 'Through Her Father's Eyes.'" *Philippine News*, May 1, 1999, B8, B9. § Taylor, Robert. "Photos Capture Era of Filipino Culture: exhibit highlights details of everyday life." *Contra Costa Times*, July 16, 2005, D1.

THE SCOPE AND IMPORTANCE of Ricardo Alvarado's work as a photographer recording the burgeoning Filipino community in Northern California was not recognized until after his death. Alvarado came to California as part of the first wave of immigrants from the Philippines, known as the Manong generation. Arriving in San Francisco in 1928, he worked as a houseboy and janitor—two of the few jobs available to Filipino immigrants. Following the entry of the United States into World War II, Alvarado enlisted in the army, and as part of the highly decorated United States Army First Filipino Infantry Regiment he served in combat as a medical technician in the Pacific.

Upon his return to San Francisco and civilian life, Alvarado began working as a cook at the Letterman Army Hospital in the Presidio, where he was employed for the next twenty years. The stability of the Letterman Hospital job enabled him to pursue his work as a photographer. Alvarado used his camera to document the lives of Filipinos, both in San Francisco and in surrounding rural areas. Capturing community activities such as dances, banquets, cock fights, and funerals, Alvarado's photographs not only present a vivid history of the Filipino community in Northern California in the 1940s and 1950s but also are evocative of everyday life of an earlier era.

In addition to his photographs of the Filipino community, Alvarado also took many pictures of happenings in the Fillmore and Western Addition districts of San Francisco. Many of his friends and fellow workers at the Letterman Hospital lived in the primarily African American neighborhoods, and Alvarado captured the community events, parties, and thriving jazz scene found there.

Alvarado married in 1959 and raised two children, Janet and Joseph, with his wife, Norberta. His photographic production declined, and it was not until after his death that his daughter found his camera equipment and nearly three thousand photographs in the family basement and learned of her father's earlier career. Now seen as one of the largest archives documenting the early Filipino community in the United States, the work of Ricardo Alvarado has garnered national attention through a multicity tour sponsored by the Smithsonian Institution.

Aoki, Toshio

BORN: 1854, Yokohama, Japan

DIED: June 26, 1912, San Diego, CA

RESIDENCES: 1854–ca. 1880, Japan § ca. 1880–1895, San Francisco, CA § 1895–1912, Pasadena, CA

MEDIA: ink, watercolor, and oil painting

SELECTED GROUP EXHIBITIONS: Big Trees Winery exhibit at the California Pavilion of World's Columbian Exposition, Chicago, 1893 § Blanchard Gallery, Los Angeles, 1908 § *Fourth Annual International Watercolor Exhibition*, Art Institute of Chicago, 1924

SELECTED COLLECTIONS: Los Angeles County Museum of Art § Orange County Museum of Art, Newport Beach, CA § Pasadena Museum of History, Pasadena, CA

SELECTED BIBLIOGRAPHY: "Cherry Blossom Dinner Tonight." *Pasadena Daily News*, March 7, 1903, 5. § "Death Calls T. Aoki." *Pasadena Daily News*, June 27, 1912, 1. § "Hand Painted Rooms Fad of Society Women." *Pasadena Daily News*, February 9, 1907, 15, 22. § "To See Yourselves as Aoki Sees You." *Los Angeles Herald*, February 17, 1895, 17.

A CELEBRATED ARTIST at the turn of the twentieth century whose work was embraced by America's most wealthy and powerful, Toshio Aoki deftly used his talents to both promote Japanese culture and succeed financially in an era rife with hostility toward Asian immigrants. Aoki came to California in approximately 1880 with Deakin Brothers of San Francisco, a store that, like others of the period, brought artists and artisans from Japan to create works for sale. How long Aoki worked in this capacity is unclear, as he reportedly also served for a time as a cartoonist for a San Francisco newspaper.

In 1895 Aoki moved to Pasadena and was affiliated with the G. T. Marsh and Company store, where he held painting demonstrations. By this time he had already achieved prominence as an artist, so much so that the *Los Angeles Herald* ran a full-page article entitled "To See Yourselves as Aoki Sees You," in which the "famous Japanese artist" rendered Los Angeles's rich and famous in traditional Japanese clothing, accompanied by Aoki's commentary on his sketches. Aoki had also begun creating "painted rooms"—designs on leather, often floral, which were installed not only in the homes of the wealthy of Pasadena, but also in affluent residences across the United States.

Little is known about Aoki's marriage and subsequent divorce to a Caucasian woman, which may have occurred during his early years in California, but far more is known about his adopted daughter, Tsuru. The seven-year-old girl arrived in San Francisco in 1898 with her aunt and uncle, reported to be prominent actors in Japan who were beginning a theatrical tour of the United States. Although based in Pasadena at that time, Aoki maintained a studio in San Francisco until 1901, and there he met Tsuru and her guardians. The actors apparently encountered financial difficulty while in California and left Tsuru with Aoki. The artist raised the girl as his daughter, and his successful career enabled him to provide well for her.

Toshio Aoki, ca. 1907

As Aoki's fame as an artist grew, he frequently traveled to the East Coast for part of each year to work on commissions, stopping in Colorado Springs, where Tsuru attended boarding school. Aoki also hosted his own social gatherings. In 1903 Aoki, accompanied by Tsuru, held an elaborate cherry blossom dinner at his studio in Pasadena, and the lavish event was described in great detail in the local press. Guests, who reportedly included J. Pierpont Morgan and John D. Rockefeller, dined on Japanese delicacies at tables centered around a large cherry tree covered with thousands of artificial blossoms brought from Japan. By 1907 Aoki's creations, including hand-painted parasols, scarves, and gowns, were sought after by the wives of both the governor of Colorado and the vice president of the United States.

In addition to his decorative work, Aoki also created highly skilled paintings. He occasionally worked in oil on canvas, but more often he created finely detailed paintings using curvilinear composition in traditional Japanese water-soluble media. Imagery typically included maidens in elegant Japanese kimonos in mythological settings and exemplified iconography associated with the *nihonga* movement.

Aoki continued to work until his death of heart failure in 1912. Shortly thereafter, Tsuru began her own successful career as a silent-film actress. She married actor and film producer **Sessue Hayakawa** and led a dramatic life often documented in newspaper headlines until her death in 1961.

Asawa, Ruth

BORN: January 24, 1926, Norwalk, CA

RESIDENCES: 1926–1942, Norwalk, CA § 1942–1943, Santa Anita Assembly Center, Santa Anita, CA; Rohwer Relocation Center, Rohwer, AR § 1943–1946, Milwaukee, WI § 1946–1949, Asheville, NC § 1949–present, San Francisco, CA

MEDIA: sculpture, painting, printmaking, drawing, and public art

ART EDUCATION: 1943–1946, Milwaukee State Teachers College, Milwaukee, WI § 1946–1949, Black Mountain College, Asheville, NC

SELECTED SOLO EXHIBITIONS: Design Research, Cambridge, MA, 1946 § Peridot Gallery, New York, 1954, 1956, 1958 § de Young Museum, San Francisco, 1960 § *Ruth Asawa: A Retrospective View*, San Francisco Museum of Art, 1973 § *The Sculpture of Ruth Asawa: Contours in the Air*, de Young Museum, San Francisco, 2006/7

SELECTED GROUP EXHIBITIONS: Tin Angel Night Club (with Jean Varda), San Francisco, 1953 § *San Francisco Art Association*, San Francisco Museum of Art, 1953, 1956, 1959–1961 § *Four Artists* (with Ida Dean, Merry Renk, and

Ruth Asawa kneeling on the floor of her dining room with tied-wire sculptures, 1963. Photo by Imogen Cunningham

Marguerite Wildenhain), San Francisco Museum of Art, 1954 § São Paulo Biennial Exhibition, Brazil, 1955 § *The Whitney Sculpture Annual*, Whitney Museum of American Art, New York, 1956, 1958 § *Made in California: Art, Image, and Identity, 1900–2000*, Los Angeles County Museum of Art, 2000

SELECTED COLLECTIONS: Fine Arts Museums of San Francisco § Guggenheim Museum, New York § Oakland Museum of California § Whitney Museum of American Art, New York

SELECTED BIBLIOGRAPHY: Cornell, Daniell. *The Sculpture of Ruth Asawa: Contours in the Air*. San Francisco: Fine Arts Museums of San Francisco and Berkeley: University of California Press, 2006. § Harris, Mary Emma. *The Arts at Black Mountain College*. Cambridge, MA: MIT Press, 1987. § Rubenstein, Charlotte Streifer. *American Women Sculptors*. Boston: G. K. Hall & Co., 1990. § *Ruth Asawa: A Retrospective View*. San Francisco: San Francisco Museum of Art, 1973.

I like wire because it's so transparent. You can see right through it and it makes shadows and it defines the sculpture better than the sculpture itself when you get a shadow on it. And I like the quality of the transparency. It's sort of like insect wings and bubbles—you know, soap bubbles. I like that lightness and the kind of fragility of it and I'm pleased with how it looks.

RUTH ASAWA
Interview, *Sundays on 7*,
KGO-TV, October 1995

ACCLAIMED FOR HER innovative biomorphic sculptures in wire as well as her activism in arts education, Ruth Asawa was encouraged as a child by a grade school teacher to pursue art. Her dream of attending either the Chouinard Art Institute or the Otis Art Institute, both in Los Angeles, was derailed by Executive Order 9066, as she was forced to finish high school while interned at the relocation center in Rohwer, Arkansas. However, during those years she was able to apply to college at any school not on the West Coast, and she was admitted to

Milwaukee State Teachers College. There, she studied draw-
ing, painting, printmaking, and jewelry. Her plans to become
a teacher were discouraged by anti-Japanese sentiments of the
period, resulting in her decision to attend the experimental
Black Mountain College. The three years at Black Mountain
transformed Asawa's life. She was especially challenged by
the process orientation of former Bauhaus teacher Josef Al-
bers and inspired by the ideas of architect Buckminster Fuller.
Black Mountain's democratic structure also influenced Asawa's
thinking about art education.

In 1949, Asawa moved to San Francisco, where she mar-
ried fellow Black Mountain student Albert Lanier. While La-
nier established himself as an architect and they raised six chil-
dren, Asawa experimented with wire sculpture. In the early
1950s, she used a simple coil weaving technique to "draw"
both simple and complex forms and volumes inspired by na-
ture. Although some critics felt this work did not constitute
sculpture because it was not rigid, Asawa found support in
the Northern California textile arts community. Her hang-
ing sculptures, which sometimes measured eighteen feet in
length, were exhibited internationally. In retrospect, these works
can be related to later process-oriented suspended artworks
by Eva Hesse, another Albers student, as well as to the paper-
sculpture *tanabata* and origami traditions of Japanese art.

In the early 1960s, Asawa began a new series of wire works
recalling tree branches and roots. She also created a series of
public works, including fountains, for which she is well known
in the San Francisco Bay Area, and which sometimes incorpo-
rated human figuration. After a high-profile retrospective in
1973, she worked increasingly in collaboration with schoolchil-
dren, who sometimes modeled complex imagery from bread
dough cast in bronze. Her ceramic tile mural at the Alvarado
School in San Francisco has become an important model of
collaboration for artists in the schools. Asawa often speaks
publicly on behalf of the role of art in enriching the lives of
children in the public schools and the larger community. She
has received numerous honors and has been acknowledged in
local press as "San Francisco's best-loved artist."

Bae, Yoong

BORN: November 19, 1928, Seoul, Korea

DIED: November 14, 1992, Oakland, CA

RESIDENCES: 1928–1974, Seoul, Korea § 1974–1992,
San Francisco Bay Area, principally Oakland, CA

MEDIA: painting, printmaking, and sculpture

SELECTED SOLO EXHIBITIONS: Soker-Kaseman Gallery,
San Francisco, 1983 § Total Museum of Contemporary
Art, Seoul, Korea, 1993 § *Yoong Bae: Late Works*, Asian
Art Museum, San Francisco, 1996

SELECTED GROUP EXHIBITIONS: International Graphic
Art Exhibition, Cincinnati Art Museum, Cincinnati,
1960 § East West Gallery, Hong Kong, 1979 § World
Print Gallery, San Francisco, 1983

SELECTED COLLECTIONS: Asian Art Museum, San Francisco
§ The National Museum of Contemporary Art, Seoul,
Korea

SELECTED BIBLIOGRAPHY: Kim, Kumja Paik, and Margaret
Juhae Lee. *Yoong Bae: Late Works*. San Francisco: Asian Art
Museum, 1996. § *Yoong Bae (1928–1992)*. Seoul: Myrung
Lip, 1993.

*I feel that the artist has an obligation to preserve and even
reinterpret the traditional arts. I don't prefer to change them,
I learn from them and then use them as I adopt them to
my needs.*
<div align="right">YOONG BAE
Kim and Lee, Yoong Bae: Late Works, 9</div>

IN 1963, YOONG BAE spent four months in the United States
through the Ford Foundation's Young Artists Program. After
visiting the San Francisco Bay Area, he resolved to return to
make the area his home. By the time he moved to Oakland's

Yoong Bae, ca. 1961

Montclair district in 1974, he was already recognized in Korea as an accomplished printmaker, graphic artist, and painter noted for his interest in American art developments, including pop art and the use of printing techniques previously unknown in Korea.

Yoong Bae was born into a privileged Seoul family; his father was a traditional ink painter who also directed a Confucian academy. After he moved to the United States, Yoong Bae's paintings incorporated Confucian concepts and visual motifs related to Zen meditation as well as a compositional simplicity of repeated forms that can be related to minimalism. He utilized Korean rice-paper *hanji* and traditional inks as media. His work is noted for an atmospheric softness and innovative printing techniques, which together create an ethereal quality that reflects the artist's interests in Asian philosophy and spirituality. He exhibited consistently in both San Francisco and Seoul during the 1970s and 1980s. Bae also volunteered at the Asian Art Museum in San Francisco, helping with the production of posters and public programs; this institution hosted a memorial exhibition of his work after his death from cancer.

Bing, Bernice

BORN: April 10, 1936, San Francisco, CA

DIED: August 17, 1998, Philo, CA

RESIDENCES: 1936–1963, San Francisco, CA § 1963–1966, Mayacamas, CA § 1966–1985, San Francisco, CA § 1985–1998, Philo, CA

MEDIA: oil, acrylic, and watercolor painting

ART EDUCATION: 1957–1958, California College of Arts and Crafts, Oakland, CA § 1958–1961, California School of Fine Arts, San Francisco

SELECTED SOLO EXHIBITIONS: Batman Gallery, San Francisco, 1961 § California College of Arts and Crafts Gallery, Oakland, CA, 1968 § South of Market Cultural Center Gallery, San Francisco, 1991

SELECTED GROUP EXHIBITIONS: *San Francisco Art Association*, San Francisco Museum of Art, 1961, 1966 § *Other Sources*, San Francisco Art Institute, 1976 § *Completing the Circle*, Triton Museum of Art, Santa Clara, CA, 1992 § *Milieu: Part I*, Asian American Arts Center, New York, 1995

SELECTED COLLECTION: Fine Arts Museums of San Francisco

SELECTED BIBLIOGRAPHY: Albright, Thomas. *Art in the San Francisco Bay Area, 1945–1980*. Berkeley: University of California Press, 1985. § Roth, Moira, and Diane Tani, eds. *Bernice Bing*. Berkeley/San Francisco: Visibility Press, 1991. § Wechsler, Jeffrey, ed. *Asian Traditions/ Modern Expressions: Asian American Artists and Abstrac-*

tion, 1945–1970. New York: Abrams in association with the Jane Voorhees Zimmerli Art Museum, Rutgers, the State University of New Jersey, 1997.

When I was an art student . . . I was totally naive about my own cultural heritage. I was living in and reacting to parallel worlds—one, the rational, conscious world of the West; the other, the intuitive, unconscious world of the East. This duality caused me to explore the differences and samenesses in art forms.

BERNICE BING
Florence Wong and George Rivera, eds.
Completing the Circle: Six Artists. Mountain View, CA:
Asian Heritage Council, 1990, 8.

BERNICE BING, a third-generation Chinese American, was born in San Francisco's Chinatown. She received a scholarship to attend the California College of Arts and Crafts, where she studied painting with Richard Diebenkorn and Nathan Oliveira. Inspired by abstract expressionism and existentialist philosophy, she employed large gestural brushstrokes, thick areas of impasto, and vivid colors to record her response to the natural world. While at the California College of Arts and Crafts, she also studied under **Saburo Hasegawa**, who served as a mentor and exposed her for the first time to Asian art, religion, and philosophy.

In 1958, Bing transferred to the California School of Fine Arts, studying under Frank Lobdell, Elmer Bischoff, and Clyfford Still. She received her B.F.A. in 1959 and her M.F.A. in 1961. Many of her fellow students would later become well-known Bay Area artists, including Joan Brown, Jay DeFeo, Manuel Neri, **Leo Valledor**, and William T. Wiley. With Beat culture flourishing and Bay Area funk art just emerging, this period of creativity informed much of Bing's artistic development. Her works aspired to synthesize a Zen-inspired, calligraphic aesthetic with a Western, modernist vocabulary.

In the early 1960s, Bing's paintings began to be exhibited and received favorable critical attention. During this time she moved to the countryside, living for three years as a caretaker at Mayacamas Vineyards. During a nine-month stay at the Esalen Institute, she explored art-making in the context of parapsychological, mystical, and spiritual practices.

In San Francisco in the 1970s, Bing organized street fairs, exhibitions, and art workshops for the Neighborhood Arts Program in Chinatown. In 1980, she was appointed the director of the South of Market Cultural Center (SOMAR), a nonprofit artists' organization and gallery space that she helped to establish. Her tenure at SOMAR left her little time to paint, and she exhibited sporadically throughout much of the 1980s.

In 1984, Bing traveled extensively in Korea, Japan, and China, studying calligraphy and painting at the Zhejiang Academy of Fine Arts in Hangzhou. She credited these studies as a pivotal influence on her later works that focus on the exploration of landscape and light and their expression through the

Bernice Bing, ca. 1958. Photo by Jerry Burchard

calligraphic brushstroke. From the late 1980s until her death, she exhibited frequently throughout California and received several prestigious awards, including the Asian Heritage Council Art Award in 1990 and the National Women's Caucus for the Arts Award in 1996.

Carvajal, Carlos, Sr.

BORN: March 15, 1893, Manila, Philippines

DIED: August 20, 1973, San Francisco, CA

RESIDENCES: 1893–1924, Manila, Philippines § 1924–1973, San Francisco, CA

MEDIA: oil painting

ART EDUCATION: Ateneo de Manila University, Manila, Philippines

SELECTED GROUP EXHIBITION: *American Primitive and Native Art*, San Francisco Art Institute Gallery, 1970

SELECTED BIBLIOGRAPHY: Albright, Thomas. "Doggedly Individual Art." *San Francisco Chronicle*, July 2, 1970, 41. § Bloomfield, Arthur. "Set 'Em Up in the Next Gallery." *San Francisco Examiner*, July 1, 1970, 62. § Brown, Michael D. *Views from Asian California, 1920–1965*. San Francisco: Michael D. Brown, 1992. § Carvajal, Carlos, Jr. CAAABS project interview. April 1998. San Francisco, CA.

CARLOS CARVAJAL WAS born into a theatrical and political family. His mother, Patrocinio "Patro" Tagaroma, was a famed Filipina mestiza soprano who, with his father, Don Pepe Carvajal, performed in operas and zarzuelas (a form of Spanish opera) in Manila. Carvajal's father was also involved in the Philippines independence movement and was a close friend of the national hero and author José Rizal. Growing up in a family of financially struggling artists, Carvajal learned to be practical and enrolled in one of the country's most prestigious universities, Ateneo de Manila, to study commerce and business. He also studied art at this time. Carvajal raised his tuition through various odd jobs, working primarily as a magician and as a hypnotist, and briefly as a priest's assistant.

In 1924, Carvajal immigrated to San Francisco, where he found work as a furniture finisher and decorator and eventually owned his own business. He was particularly adept at faux wood graining and marbling, and painting floral motifs. Carvajal devoted his spare time to oil painting, frequently taking an easel and brushes to paint city scenes on outings with his son. He was a friend of fellow Filipino American painter **Joaquin Legaspi**. His early work addressed a range of subjects—floral still lifes, genre scenes of San Francisco and the Philippines, and portraits of family members. These works are characterized by a use of bright colors and a uniform attention to detail.

In the 1960s, the artist's work became increasingly complex. Paintings were often satirical and anti-religious, attacking the perceived hypocrisy of the Catholic church. Late in Carvajal's life, his art gained local recognition, and work from this period was exhibited at several San Francisco galleries. In 1970, the San Francisco Art Institute featured his work in a group exhibition after Filipino American activist and poet Al Robles brought it to the attention of the institute's director.

Self-portrait
by Eva Fong Chan

Chan, Eva Fong

BORN: April 1, 1897, Sacramento, CA

DIED: June 26, 1991, San Francisco, CA

RESIDENCES: 1897–ca. 1901, Sacramento, CA § ca. 1901–1906, San Francisco, CA § 1906, Emeryville, CA § ca. 1906–ca. 1916, Oakland, CA § ca. 1916–ca. 1918, Sacramento, CA § ca. 1918–ca. 1921, Guangzhou, China § ca. 1921–ca. 1924, Shanghai, China § ca. 1924–1991, San Francisco, CA

MEDIA: oil and watercolor painting

ART EDUCATION: 1930–1932, California School of Fine Arts, San Francisco

SELECTED GROUP EXHIBITIONS: *San Francisco Art Association*, California Palace of the Legion of Honor, 1932 § *Chinese Art Association of America*, de Young Museum, San Francisco, 1935/36

SELECTED BIBLIOGRAPHY: Chan, Eva Fong. Interview by Genny Lim. August 8, 1982. Chinese Women of America Research Project, San Francisco, CA. § "Oriental Art Group Is Developing New Technique: Club of Revolutionaries Try to Express Fusion of East and West." *San Francisco Examiner*, 1931. In Yun Gee Biographical Folder. Oakland Museum of California. § Wong, Rosalind, and Mei Ping Wong. CAAABS project interview. Ca. 2001.

EVA FONG CHAN was among the first Asian American women to actively paint and exhibit in the United States. Chan, the second of thirteen children born to a Chinese father and a mother who may have been a Shoshone Native American, spent her very early years in Sacramento. Her family then moved briefly to San Francisco until the 1906 earthquake caused them, like many San Franciscans, to relocate to temporary housing erected in Emeryville. They later moved to Oakland, where Chan attended high school and won an art competition, which led to her design being produced on Christmas cards. Chan is also noted at this time for being the Bay Area's first Miss Chinatown, and she received as a prize a piano, which she taught herself to play. These early successes in art and music marked the beginning of lifelong interests for Chan.

Following her graduation from high school, Chan moved with her family to Sacramento. She attended Sacramento Junior College briefly but left school to help her mother. Chan became reacquainted with Bo Kay Chan, whom she knew as a child in Sacramento, and when he returned to China to work in his family's business, Chan joined him and they married in Guangzhou. Chan studied piano and possibly art during the six and a half years she lived in Guangzhou and Shanghai. With servants to help with household chores, Chan had time to devote to her creative endeavors.

The couple returned to San Francisco and lived above the Mandarin Theater. In 1930, at the age of thirty-three, Chan be-

gan studying at the California School of Fine Arts. Soon after, she joined the Chinese Revolutionary Artists Club, originally founded by **Yun Gee** (who by this time was in Paris). In an article from the period she is described as a new member of the group and the club's only female participant. Although Chan left the California School of Fine Arts in 1932 to devote time to her studies at the Arrillaga Music College, she continued to be active as an artist. In 1935, she exhibited with the Chinese Art Association at their de Young Museum exhibition and served as the group's secretary. A photo of the Parilia, the Artists' Ball of the San Francisco Art Association, from the same year shows Chan with fellow artist **Nanying Stella Wong** as a striking pair in Aztec-inspired costumes. Many of Chan's fellow artists in the Chinese Art Association had been her classmates three years earlier at the California School of Fine Arts and also may have been members of the earlier Chinese Revolutionary Artists Club. This overlap in membership between the Chinese Revolutionary Artists Club in the early 1930s and the Chinese Art Association in mid-decade suggests that the earlier club evolved into the later association.

Although works in watercolor with floral motifs survive from the 1910s, Chan's most productive period of painting was the early 1930s. During this time she created oil paintings moderate in scale and stylistically conservative. Although she exhibited landscapes in museum exhibitions, Chan also created portraits depicting Chinese American women with contemporary American hairstyles dressed in traditional garments, including cheongsams and robes. One painting entitled *Bo Kay Chan Golfing, Thomas Kwan Watching* shows Chan's husband clad in golf pants teeing off with a friend and suggests the upward mobility of the Chinese middle class of the time.

The birth of a daughter in 1940 greatly curtailed Chan's work as a painter. She played the organ for the Chinese Congregational Church and maintained a successful career as a piano teacher throughout her life.

Chang Dai-chien (Zhang Daqian)

BORN: May 10, 1899, Neijiang, Sichuan, China

DIED: April 2, 1983, Taipei, Taiwan

RESIDENCES: 1899–1949, China § 1949–1950, Hong Kong § 1950–1951, Darjeeling, India § 1952–1953, Argentina § 1954–1967, Brazil § 1967–1978, Carmel, CA § 1978–1983, Taipei, Taiwan

MEDIA: ink painting, distemper on paper, board, and silk, and printmaking

SELECTED SOLO EXHIBITIONS: Musée de l'Art Moderne, Paris, 1956 § *Paintings: Chang Dai-chien*, Stanford University Art Museum, 1967 § *Chang Dai-chien: A Retrospective Exhibition*, Center for Asian Art and Culture, San Francisco, 1972 § Santa Barbara Museum of Art, Santa Barbara, CA, 1974 § *Challenging the Past: The Paintings of Chang Dai-chien*, Sackler Gallery, Smithsonian Institution, Washington, D.C., 1991 § *Chang Dai-chien in California*, Fine Arts Gallery, San Francisco State University, 1999

SELECTED GROUP EXHIBITIONS: *Contemporary Chinese Paintings*, de Young Museum, San Francisco, 1947 § Chinese Art Gallery, San Francisco, 1965/66 § *A Century in Crisis: Modernity and Tradition in the Art of Twentieth-Century China*, Guggenheim Museum, New York, 1998

SELECTED COLLECTIONS: Asian Art Museum, San Francisco § Los Angeles County Museum of Art § National Museum of History, Taipei § National Palace Museum, Taipei

SELECTED BIBLIOGRAPHY: d'Argencé, René-Yvon Lefebvre. *Chang Dai-chien: A Retrospective Exhibition*. San Francisco: Center of Asian Art and Culture, 1972. § Fu Shen. *Challenging the Past: The Paintings of Chang Dai-chien*. Seattle: University of Washington Press, 1991. § Johnson, Mark, and Ba Tong. *Chang Dai-chien in California*. San Francisco: San Francisco State University, 1999.

Chang Dai-chien at Stanford University, 1967. Photo by Leo Holub

To study tradition is the single most important thing.
The history of traditions in Chinese painting is truly lengthy.
We should try to master all of these rich experiences ourselves
and apply them directly to our art; thus we can develop
from each study we make [of the past]. Gradually you will
build an individual style, which is a lifetime business and,
if undertaken without a willingness to accept the bitter
struggles that will ensue, cannot succeed.

<div align="right">

CHANG DAI-CHIEN
Xiao Jianchu, "Zhigen chuantong buduan chuangxin,"
in *Bao Limin, Chang Dai-chien de yishu*, 52.
Quoted in Fu Shen, *Challenging the Past*, 45.

</div>

CHANG DAI-CHIEN IS regarded as the most important Chinese ink painter to have worked in twentieth-century California. His earliest art teachers were his mother and brother, and he later studied with Shanghai teachers Zeng Xi and Li Ruiqing. The artist established a major reputation during the 1920s and 1930s in the Chinese art capitals of Beijing and Shanghai for his encyclopedic referencing of Chinese art history. His reputation expanded in the 1940s after he created an influential body of work referencing Tang dynasty murals located in the Dunhuang caves in the Gobi Desert. The artist left China after the Communist takeover and traveled widely before moving to Brazil, where he lived after 1953. In 1956, he visited Picasso in France and mounted the first exhibition of Chinese painting held in a museum of modern art in Paris.

Chang Dai-chien began annual visits to California in 1954, often staying for a few days in Berkeley during international travel stopovers. He had established a more significant presence by the mid-1960s, leading to invitations for several exhibitions in 1967, including a major retrospective at the Stanford University Art Museum. Exhibitions were also presented at other museums specializing in Asian art in California, as well as at galleries in Carmel (Laky Gallery, 1967, 1970, 1972, 1974) and Los Angeles (Cowie Gallery, 1969; Ankrum Gallery, 1973, 1979). In addition, the artist presented several high-profile ink painting demonstrations; occasionally lectured, using a translator; and received an honorary doctorate from the University of the Pacific in 1974. He produced two series of lithographs in 1973 and 1975.

In 1968, Chang Dai-chien purchased a home in Carmel and then moved in 1971 to a larger home on the exclusive 17-Mile Drive in Pebble Beach. He was acquainted with significant California artists and teachers, including Ansel Adams and Rudolph Schaeffer, as well as such scholars as Michael Sullivan, James Cahill, and René-Yvon d'Argencé. However, since he spoke Chinese, his primary circle of friends were members of the Chinese community. American artists, including **C. C. Wang** and Diana Kan, visited the Monterey Peninsula to see Chang Dai-chien, as did important Chinese artists, such as the noted photographer Long Ching-san.

The artist's move to California coincided with the most experimental and Western-looking period in his work. Beginning in his Brazil studio in 1962, Chang Dai-chien produced nearly abstract works that resemble concurrent developments in post-painterly abstraction. The artist linked these to Tang dynasty *pomo*, or splashed ink and color paintings. He attributed these abstract pieces to his failing eyesight, but detailed work from the same period mitigates that assertion. Starting in 1970, the artist produced several paintings reminiscent of the California landscape; he even stated his intention to paint Carmel "in a Chinese manner." Paintings created later in the 1970s blended this style with more traditional Chinese painting themes and compositional structures.

Although he did not talk publicly about politics, Chang Dai-chien was distressed by U.S. political overtures to the People's Republic of China in the early 1970s, which contributed to his move to Taipei later that decade. He never returned to California after 1979 and died four years later.

Chang Shu-chi (Zhang Shuqi)

BORN: July 12, 1900, Pujiang, Zhejiang, China

DIED: August 18, 1957, Piedmont, CA

RESIDENCES: 1900–1941, China § 1941–1946, United States, principally San Francisco, CA § 1946–1949, Nanjing, China § 1949–1957, San Francisco Bay Area, principally Piedmont, CA

MEDIA: ink painting; distemper on paper, silk, and board; and printmaking

ART EDUCATION: 1922–1924, Shanghai Art Academy, Shanghai, China

SELECTED SOLO EXHIBITIONS: Siesta Club, Los Angeles, 1941 § Art Institute of Chicago, 1943 § William Rockhill Nelson Gallery of the Atkins Museum of Fine Arts, Kansas City, MO, 1943 § de Young Museum, San Francisco, 1943, 1944, 1949 § Los Angeles County Museum, 1944 § National Palace Museum, Taipei, Taiwan, 1970

SELECTED GROUP EXHIBITIONS: Metropolitan Museum of Art, New York, 1943, 1948 § *Chinatown Artists Club*, de Young Museum, San Francisco, 1944, 1945 § *Society of Western Artists*, de Young Museum, San Francisco, 1951–1957 § *Society of Western Painters*, Laguna Beach Art Museum, CA, 1957

SELECTED COLLECTIONS: Fine Arts Museums of San Francisco § Franklin Delano Roosevelt Library, Hyde Park, NY § Metropolitan Museum of Art, New York § The Royal Ontario Museum, Toronto

SELECTED BIBLIOGRAPHY: Chang, Gordon. CAAABS project interview. October 26, 1998. Audiotape, Asian American Art Project, Stanford University. § Chang, Shu-chi, and Helen Chang. *Painting in the Chinese Manner*. New York:

Chang Shu-chi, ca. 1943

The Vintage Press, 1960. § Chang Shu-chi Archives. Hoover Institution, Stanford University. § "Chinese Painting: Professor Chang shows how he does it in eight minutes flat." *Life,* March 15, 1943, 65–66. § Frankenstein, Alfred. "The Chinese Send Us Chang Shu-Chi." *San Francisco Chronicle,* This World, November 14, 1943, 12. § Jewell, Edward Alden. "Art in Review." *New York Times,* May 12, 1942, 23. § Sullivan, Michael. *Chinese Art and Artists of the Twentieth Century.* Berkeley: University of California Press, 1996.

The occidental artist is primarily objective in his natural and acquired artistic dispositions, whereas the oriental artist is fundamentally subjective. This being so, the Western artist strives to copy nature as much as the Chinese endeavors to consult his own ideals and imaginations. Which is right, the West or the East?... Essentially there is no difference. The purpose of painting ... is to recreate

beauty. It makes little significance as to the ways and means of attaining beauty. Happily, the present tendency seems to foretell a union between the East and the West. Oriental artists realize the necessity of borrowing more from nature to supplement their imagination, while occidental artists are beginning to pay attention to design by the mind much more than before.

CHANG SHU-CHI
"On Occidental and Oriental Painting."
Unpublished manuscript,
ca. 1943, family collection.

DURING THE YEARS of World War II and the 1950s, Chang Shu-chi presented dozens of solo exhibitions and painting demonstrations across the United States and Canada, and his work was the subject of films, a national radio broadcast narrated by Pearl Buck, and a feature in *Life* magazine. This unparalleled visibility established the artist as the most widely known Chinese painter of the time in America.

At the age of eight, Chang began to study Chinese painting with his uncle. After graduating as the valedictorian of his high school class, in 1922 he entered the Shanghai Art Academy, where he studied both Western art techniques, using charcoal and oil paint, and Chinese media of ink and distemper on silk, paper, and board. Upon graduation in 1924, he taught high school, and in 1930 he began teaching at the National Central University in Nanjing, where he was promoted to professor in 1935. In the period that followed, Chang published several books and also developed innovative technical approaches to traditional Chinese painting, including the use of white paint on colored silk and painting with multiple colors loaded onto the brush. In his signature paintings of birds and flowers, he intended a modern integration of the distinct Chinese painting styles of meticulous rendering and literati free brushwork. His work can be related to the Lingnan school of painting during this period.

In 1940, Chang created a huge silk painting (64 × 140 in.) of one hundred doves, entitled *Messengers of Peace,* for presentation to Franklin Delano Roosevelt on the occasion of his third presidential inauguration on behalf of the Chinese government. A colophon from Chiang Kai-shek was mounted alongside the painting's right edge, and the work was displayed at Hyde Park and, reportedly, the White House. Although the artist had friends in both Nationalist and Communist circles, he was selected to travel to North America in 1941 as the "Chinese government's ambassador of art." On a grueling exhibition and demonstration tour of the American eastern seaboard, the Midwest, the West Coast, and Canada, he raised significant funds for the United China Relief effort. During these years, the artist established a home and circle of friends in San Francisco and participated in the group exhibitions of the Chinatown Artists Club.

In 1946, Chang returned to his teaching position in China and subsequently presented several exhibitions there. Later

that year, an associate from San Francisco, Helen Fong (1912–1992), visited China, and the two were married in 1947. During the Chinese civil war, first Helen and later her husband returned to the Bay Area. In Oakland they established the Chang Art Studio, which reproduced his paintings on both greeting cards and fine stationery that were widely distributed. (Chang had started the business during his first stay in the country.) He actively exhibited and taught privately at this studio; he also lectured widely and taught a summer session at the University of California, Berkeley.

Significant stylistic changes appear in Chang's work of the 1950s, including a shift of imagery to recognizable California landscapes of Carmel and Yosemite, and the development of a more rugged brushwork style. Some of these paintings appeared in group exhibitions. Unfortunately, the artist became seriously ill with stomach cancer and died in 1957. After his death, his widow—an amateur painter and the sister of noted California educator Alice Fong Yu—opened a memorial gallery in Oakland for Chang's work, for which she designed a moon gate. She also arranged for the posthumous publication of a book of his work, entitled *Painting in the Chinese Manner*.

Chang, Wah Ming

BORN: August 2, 1917, Honolulu, HI

DIED: December 22, 2003, Carmel, CA

RESIDENCES: 1917–1918, Honolulu, HI § ca. 1919–ca. 1935, Oakland, San Francisco, and Palo Alto, CA § 1936–1938, Los Angeles, CA; Dallas, TX; Honolulu, HI; and San Francisco, CA § 1939–1970, Altadena and Los Angeles, CA § 1970–2003, Carmel, CA

MEDIA: printmaking, puppetry, set design, painting, illustration, and sculpture

SELECTED SOLO EXHIBITIONS: East West Gallery, San Francisco, 1928 § Carmel Art Association, Carmel, CA, 1981, 1989, 1993 § *The Imaginative World of Wah Ming Chang*, Monterey Museum of Art, Monterey, CA, 2000 § *Wah Ming Chang & Tyrus Wong: Two Behind the Scenes*, Chinese Historical Society of America, San Francisco, 2003

SELECTED GROUP EXHIBITIONS: City of Paris Department Store Gallery, San Francisco, 1925 § Brooklyn Society of Etchers, 1927 § Honolulu Academy of Arts, 1928 § Carmel Art Association, Carmel, CA, 1983–1987 § *Made in California: Art, Image, and Identity, 1900–2000*, Los Angeles County Museum of Art, 2000

SELECTED COLLECTIONS: Carmel Art Association, Carmel, CA § Chinese Historical Society of America, San Francisco

SELECTED BIBLIOGRAPHY: Barrows, David, and Glen Chang. *The Life and Sculpture of Wah Ming Chang*. Carmel, CA: Wah Ming Chang, 1989. § Kistler, Aline. "Work Done by Chinese Boy Is Discussed." *San Francisco Chronicle*, July 29, 1928, D7. § Poon, Irene. *Leading the Way: Asian American Artists of the Older Generation*. Wenham, MA: Gordon College Press, 2001. § Poon, Irene, Roger Garcia, Webster Colcord, Leslee See Leong, and Lisa See. *Wah Ming Chang & Tyrus Wong: Two Behind the Scenes*. San Francisco: Chinese Historical Society of America, 2003. § Riley, Gail Blasser. *Wah Ming Chang: Artist and Master of Special Effects*. Springfield, NJ: Enslow Publishers, 1995.

I am happy to participate in anything that would show the advancement or acknowledgment of Chinese in this culture. I actually believe being Chinese has helped me because I stand out, although my work will become neither historical nor legendary until I do.

WAH MING CHANG
"Oscar-winning local artist Wah Ming Chang dies."
Monterey Herald, December 23, 2003.

WITH THE EARLY support from his creative parents and the artistic influence of mentor Blanding Sloan, child prodigy Wah Ming Chang forged a unique career that spanned almost eight decades. Chang was born in Honolulu and moved to the San Francisco Bay Area with his parents when he was about two years old. His mother, Fai Sue Chang, was a graduate of the California College of Arts and Crafts in Oakland and was an accomplished commercial artist, actress, and costume designer; the interests of his father, Dai Song Chang, included architecture and etching. The family moved to San Francisco in the early 1920s and took over the management of the Ho Ho Tearoom at 315 Sutter Street, which became a gathering place for local artists and writers, many of whom attributed its popularity to the warmth and kindness of the Chang family.

Artist Blanding Sloan became aware of Chang's talents as he watched the young artist, who had begun drawing at the age of two, sketching on the back of the tearoom menus. Sloan encouraged Chang to visit him at his studio, where he and his wife, writer and East West Gallery founding member Mildred Taylor, held regular gatherings, and the young boy and his parents became frequent guests. Chang spent time at the studio after school and regularly participated in the life drawing classes held there. At only seven years old, Chang was accepted into the circle of working artists that included Ralph Stackpole and Maynard Dixon, and he was encouraged by Sloan to pursue etching and oil painting. Soon, Chang was exhibiting his work and offering demonstrations in galleries and stores and was the frequent subject of newspaper articles. His work was shown in national exhibitions, including a 1927 Brooklyn Society of Etchers show where his print was exhibited alongside a work by James McNeill Whistler.

Wah Ming Chang, ca. 1925

In 1928, following the sudden death of Chang's mother, the young boy's distraught father asked Sloan and Taylor if they would serve as Chang's guardians. Chang attended the progressive Peninsula School of Creative Education in Menlo Park on scholarship and, after leaving the school, joined Sloan and Taylor in Hollywood, where Sloan was designing sets for productions at the Hollywood Bowl. Chang worked on set designs and a WPA puppet project and in 1936 accompanied Sloan to Texas to work on publicity art for the large-scale historical pageant Sloan was directing for the state's centennial celebration. While in Texas, Chang met Glenella (Glen) Taylor, whom he would later marry.

After a short period of teaching art in Hawaii, Chang returned in 1939 to California, where he was the youngest person on staff at the special effects and model department at Walt Disney Studios. He made articulated models for *Bambi* and *Fantasia*, and props for *Pinocchio*. This work was interrupted in 1940 when Chang contracted polio and spent a year recovering. He then went to work as the head of the model department for the George Pal Puppetoons Studios, where he produced animated shorts. In 1945, Chang opened his own East-West Studios and collaborated with Blanding Sloan on a film about folksinger Huddie Leadbetter (Leadbelly), which was later re-edited by Pete Seeger. Chang and Sloan also produced the award-winning film *The Way of Peace*, a commentary on the atomic age.

In the 1950s and 1960s, Chang began creating set and costume designs for such movies as *The King and I* and *Can-Can*. Chang and partner Gene Warren created special effects, masks, and animation for the television series *The Outer Limits* and the movies *The Seven Faces of Dr. Lao*, *Spartacus*, and *Cleopatra*; they won an Academy Award for special effects for

The Time Machine. Chang also worked on the television series *Star Trek*, where he designed masks, costumes, and props.

In 1970, Chang and his wife, Glen, moved to Carmel Valley and began making educational films that focused on environmental issues. Prompted by the plight of endangered wildlife, Chang also started to create small animal sculptures in bronze. Chang was accepted in the Carmel Art Association as a sculptor in 1975. In 2000, the Monterey Museum of Art honored Chang with a retrospective exhibition.

Chann, George (Chen Yinpi)

BORN: January 1, 1913, Guangzhou, China

DIED: May 26, 1995, Los Angeles, CA

RESIDENCES: 1913–1922, Guangzhou, China § 1922–1925, Stockton, CA § 1925–1927, San Francisco, CA § 1927–1932, Guangzhou, China § 1932–1933, San Mateo, CA § 1933–1946, Los Angeles, CA § 1946–1949, Guangzhou, China § 1949–1953, San Francisco, CA § 1953–1995, Los Angeles, CA

MEDIA: oil, acrylic, and watercolor painting

ART EDUCATION: 1927–1932, Sun Yat-sen College, Guangzhou, China § 1933–1941, Otis Art Institute, Los Angeles

SELECTED SOLO EXHIBITIONS: California Palace of the Legion of Honor, San Francisco, 1942 § Los Angeles Museum, 1942 § de Young Museum, San Francisco, 1944, 1951 § *George Chann: Recent Paintings*, Ankrum Gallery, Los Angeles, CA, 1968 § *George Chann*, Lin & Keng Gallery, Taipei, 2000 § *George Chann*, Shanghai Art Museum, China, 2005

SELECTED GROUP EXHIBITIONS: Foundation of Western Art, Los Angeles, 1941 § *Artists of Los Angeles and Vicinity*, Los Angeles Museum, 1941–1945 § Chinatown Artists Club, de Young Museum, San Francisco, 1944 § *Contemporary Chinese American Artists*, Los Angeles County Art Institute, 1959

SELECTED COLLECTIONS: Hirshhorn Museum and Sculpture Garden, Washington, D.C. § Palm Springs Desert Museum, Palm Springs, CA

SELECTED BIBLIOGRAPHY: Chen, Odile, ed. *George Chann*. Taipei: Lin and Keng Gallery, 2005. § Ferdinand Perret Files, Archives of American Art, Smithsonian Institution, reel 3854, frames 940–941. § "George Chann Works at Ankrum Gallery." *Los Angeles Times*, February 26, 1968, 12. § Lee, Vico. "Forgotten Artists." *Taipei Times*, May 18, 2003, 19. § Millier, Arthur. "Youthful Chinese Artist Displays Outstanding Ability." *Los Angeles Times*, December 13, 1942, part 3, 5. § Wang, Chia Chi Jason. *George Chann*. Taipei: Lin & Keng Gallery, 2000.

Art is the expression of the unknown.

GEORGE CHANN
Janet Chann, email correspondence,
June 7, 2005

GEORGE CHANN CAME to the United States at the age of nine, joining his U.S.-born father in Stockton. He returned to Guangzhou at fourteen to study at the Sun Yat-sen College. In 1932, when he finished his studies in China, Chann again traveled to California and taught for a year at the Elmer A. Jones Orphanage in San Mateo.

In 1933, Chann moved to Los Angeles and on scholarship attended the Otis Art Institute, where he studied with Edouard Vysekal and Alexander Brooks. While a student, Chann taught Chinese at the Chinese Congregational Church, and following his graduation, he taught at Otis and began to exhibit frequently. In 1942 alone, he presented solo exhibitions at the California Palace of the Legion of Honor, the San Diego Gallery of Fine Arts, the Guymaye Gallery in New York, and the Los Angeles Museum. By the age of thirty-eight Chann had had twenty one-person shows. Although he exhibited some still lifes and landscapes, his work was predominantly portraits and figurative oil paintings, and his subjects often were children and people of color. Contemporary reviews describe Chann's work as "sensitive," "sympathetic," and "emotional," recurring terms that suggest that the Latino, African American, and Asian children Chann depicted were not frequently the subjects of artwork in museums and galleries at the time.

Between 1947 and 1949 Chann traveled in China. He married in 1949, and he and his wife returned to California, first living in San Francisco and then relocating to Los Angeles. In Los Angeles Chann opened the Farmers Market Art Gallery in the city's Farmers Market complex. His gallery became a mainstay in the market, which was a major tourist destination, and the artist continued to operate the business until his death in 1995. The shop featured jewelry, traditional Chinese art and antiquities, and Chann's own work. Although he was not exhibiting as widely as he once had, Chann painted every day in the small studio he maintained in the back of the gallery.

During the 1950s Chann's work began to change stylistically. Perhaps affected by abstract expressionism and the three years he had spent in China, Chann created increasingly abstract works in oils, incorporating calligraphy and rubbings from oracle bones, bronze vessels, and other Chinese antiquities he sold in his shop. After making the rubbings, Chann would soak them in water, tear them and step on them, and then collage the worn pieces onto the canvas. Using the collage as his base, he then applied multiple layers of oil paint, sometimes adding his own calligraphy. However, he did not confine himself solely to abstract work. Chann also created a series of paintings based on Bible stories, which he worked on for approximately ten years. In the 1960s, Chann started a relationship with the Ankrum Gallery in Los Angeles and showed fre-

George Chann

quently there, exhibiting both Chinese-landscape watercolor paintings and the dense, abstract, calligraphic work with rich surface treatments that he had begun the previous decade.

Paintings by Chann have increased in popularity since his death. A retrospective of his work in 2000 in Taipei was described as an effort to recognize the work of this forgotten artist.

Cheng Yet-por (Bu Dou)

BORN: 1907, Malaysia

DIED: April 5, 1991, San Jose, CA

RESIDENCES: 1907–1927, Malaysia § 1928–1948, Hangzhou, Shanghai, and Yantai, China § 1948–1960, Kaohsiung and Taipei, Taiwan § 1960–1961, Hong Kong § 1961–1964, Taipei, Taiwan § 1964–1967, San Francisco, CA § 1967–1975, Carmel, CA § 1975–1991, San Jose, CA, and Taipei, Taiwan

MEDIA: ink and oil painting

ART EDUCATION: 1928–1933, National Academy of Fine Arts, Hangzhou, China

SELECTED SOLO EXHIBITIONS: Laky Gallery, Carmel, CA, 1964 § University of Tennessee, Knoxville, 1965 § Stanford International Center, Stanford University, 1965 § Chinese Art Gallery, San Francisco, 1966 § Triton Museum of Art, Santa Clara, CA, 1976

SELECTED GROUP EXHIBITIONS: San Francisco State College, 1964–1965 § National Museum of History, Taipei, Taiwan, 1963, 1964, 1985

SELECTED BIBLIOGRAPHY: Cheng, Jasmine. CAAABS project interview. April 16, 2001. Milpitas, CA. § Cheng, Yet-Por. *Chinese Finger Painting by Prof. Yet-Por Cheng.* Carmel: Chinese Art Gallery, 1979. § *Chinese World*, January 28, 1965, n.p. § "Yet-Por Cheng, artist, teacher" (obituary). *San Jose Mercury News.* April 13, 1991, B6. § Poindexter, Anne. "Art and Mr. Cheng." *Game and Gossip* (Carmel, CA), November 15, 1970, 4, 28.

My animals are all alive; they all have skin and flesh and bone.

CHENG YET-POR
Jasmine Cheng, CAAABS project interview

BU DOU, MEANING "always continue to strive," not only was the adopted name of Cheng Yet-por but also describes the artist's creative attitude. Cheng was the son of a poor farmer. His artistic talent was noted when he was fifteen and laboring in the tin mines of Ipoh, Malaysia. Cheng would paint pictures of animals during his breaks, earning the other miners' admiration and their encouragement to seek artistic training.

In 1928, Cheng traveled to China and entered the Western art department of the National Academy of Fine Arts in Hangzhou. He studied with Lin Fengmian and Liu Haisu, who had both studied for extended periods in Europe, worked in oils, and were exploring new concepts of Chinese painting. Their influence on Cheng was profound, and he worked in a similar style, combining Chinese and Western techniques.

After graduating in 1933, Cheng began a long teaching career, first working at the Shanghai Academy of Fine Arts and later at such institutions as the Shanghai New China Art College, National Taiwan Normal University, Hong Kong New Asia College, and the National Taiwan Fine Arts College. According to his family, despite Cheng's success as a teacher, his Western-influenced art style almost cost him his life. In 1941, while he was teaching in Japanese-occupied Yantai, a Japanese officer insisted that Cheng create a Chinese ink painting for him. The artist shook his head to indicate that he did not know how to create such a work. The officer, however, thought Cheng was refusing to paint, and he pulled out his knife. In fear, Cheng made a quick study of ink-painting techniques and produced the requested work. The experience prompted him to begin a deeper study of traditional brush painting, a style he continued to utilize for the rest of his life.

Cheng's favorite subjects were animals. He depicted them in ink on paper, sometimes with bold color and dramatic gesture, and often on scrolls. His horses and cats are especially well known, and his painting *Love and Protect Animals* won an international competition in 1931.

Following an invitation in 1964 to serve as a guest lecturer at San Francisco State College (now University), Cheng relocated to the Bay Area. In 1967 he moved to Carmel and opened the Chinese Art Gallery there. He taught in Carmel and San Francisco and lectured frequently on Chinese art at West Coast associations and schools. Spending time in Taiwan as well as California, Cheng moved to San Jose in 1975 and fulfilled a lifelong dream of opening a Chinese restaurant shortly before his death in 1991.

Cheng Yet-por

Chinn, Benjamen

BORN: April 30, 1921, San Francisco, CA

RESIDENCES: 1921–1942, San Francisco, CA § 1942–1946, Honolulu, HI (U.S. military service) § 1946–1949, San Francisco, CA § 1949–1950, Paris, France § 1950–present, San Francisco, CA

MEDIA: photography

ART EDUCATION: 1946–1949, California School of Fine Arts, San Francisco § 1949–1950, Académie Julian, Paris

SELECTED SOLO EXHIBITIONS: *Benjamen Chinn at Home in San Francisco*, Chinese Historical Society of America, San Francisco, 2003 § *Benjamen Chinn: Photographs of Paris, 1949–1950*, Scott Nichols Gallery, San Francisco, 2005/6

SELECTED GROUP EXHIBITIONS: *Mendocino*, San Francisco Museum of Art, 1948 § *Perceptions*, San Francisco Museum of Art, 1954 § Mt. Angel College, Mt. Angel, OR, 1964 § *Alumni Exhibition, San Francisco Art Institute, Anniversary Exhibition*, Focus Gallery, San Francisco, 1981 § *San Francisco Art Institute: Fifty Years of Photography*, Transamerica Pyramid Gallery, San Francisco, 1998

Benjamen Chinn, 1997.
Photo by Irene Poon

SELECTED COLLECTIONS: Center for Creative Photography, University of Arizona, Tucson § Chinese Historical Society of America, San Francisco

SELECTED BIBLIOGRAPHY: *Aperture* 1, no. 2 (1952): cover. § Chinn, Benjamen. CAAABS project interview. August 14, 1998. San Francisco, CA. Transcript, Asian American Art Project, Stanford University. § Davis, Keith. *An American Century of Photography: From Dry-Plate to Digital/The Hallmark Photographic Collection.* 2nd ed. Kansas City, MO: Hallmark Cards, in association with H. N. Abrams, 1999. § Klochko, Deborah. *Ten Photographers, 1946–54, The Legacy of Minor White: California School of Fine Arts, The Exhibition Perceptions.* San Francisco: Paul M. Hertzmann, Inc., 2004. § Martine, Lord. "Focus: Chinatown. Photographer studied with greats, traveled the world, but kept his sights on his neighborhood." *San Francisco Chronicle,* January 31, 2003, E1, E6. § Poon, Irene, Dennis Reed, and Paul Caponigro. *Benjamen Chinn at Home in San Francisco.* San Francisco: Chinese Historical Society of America, 2003.

I've never considered myself an artist, I still don't. I've always been pretty much of a loner.
 BENJAMEN CHINN
 CAAABS project interview

ALTHOUGH HE HAS traveled widely and studied with internationally acclaimed artists, Benjamen Chinn chooses to live on Commercial Street in San Francisco's Chinatown, the same street where he was born and the neighborhood that was the inspiration for many of his early photographs. One of twelve children, Chinn was taught by his older brother how to take pictures and develop prints when he was only ten years old. His first camera was a ninety-nine-cent Univex that used ten-cent rolls of film. He was fascinated by the development process, and worked in the darkroom in the family's basement. Soon, Chinn was acting as his junior high school's staff photographer, a role that continued through high school.

Following graduation, during World War II, Chinn served in the U.S. Army Air Corps as a photographer at Hickman Air Force Base in Hawaii. He was one of five members of the aerial crew, photographing reconnaissance and performing mapping, and traveled in modified B-26 bombers whose bomb bays had been replaced with gas tanks.

Upon returning to San Francisco after being discharged in 1946, Chinn enrolled at the California School of Fine Arts and was selected to participate in the first class of the new photography program established by Ansel Adams. Adams, and later Minor White, taught the class, and lecturers included Ruth Bernhard, Dorothea Lange, Lisette Model, and Imogen Cunningham. While at the California School of Fine Arts, Chinn also took painting and sculpture classes, and painting instructors Dorr Bothwell and Richard Diebenkorn were particularly influential. Chinn credits Bothwell with teaching him how to structure his vision, to see shapes and tones and how they recede and advance in space. Since he had his own darkroom at home, Chinn interacted little with his fellow students. How-

ever, he was very much a part of the social circle of prominent photographers who gathered in the Bay Area. He attended the monthly parties that Adams hosted for which each guest brought multiple copies of a print to exchange. Once, Chinn surprised aspiring photographer Paul Caponigro by taking him to a party at Adams's home, where he introduced his nineteen-year-old friend to such notables as Brett Weston, Minor White, Imogen Cunningham, and Dorothea Lange, which left a lasting impression on the young photographer.

After graduating in 1949, Chinn moved to Paris and studied at the Académie Julian with Alberto Giacometti. Chinn also attended the Sorbonne, studying geography and philosophy. Returning to San Francisco, he worked as the assistant to the chief of engineers at the U.S. Pipe and Steel Company. During this time, one of Chinn's Paris photographs appeared on the cover of the second issue of *Aperture* magazine, he served on the West Coast screening committee for Edward Steichen's *Family of Man* exhibition, and his work was included in the *Perceptions* exhibition in San Francisco. In 1953, Chinn was hired as chief of photographic services by the Department of Defense with the Sixth Army, and he later served as chief of training aids division until his retirement in 1984.

Chinn's richly toned black-and-white photographs of the 1940s and 1950s often feature figures and forms that convey a nuanced specificity of place. Chinn traveled widely in China, Israel, and Mexico.

Choy, Katherine (Choy Po-yu)

BORN: August 17, 1929, Hong Kong

DIED: February 23, 1958, Rye, NY

RESIDENCES: 1929–1946, Hong Kong § 1946–1948, Macon, GA § 1948–1951, Oakland, CA § 1951–1952, Bloomfield Hills, MI § 1952–1957, New Orleans, LA § 1957–1958, Port Chester, NY

MEDIA: ceramics, textiles, metal work, and painting

ART EDUCATION: 1946–1948, Wesleyan College, Macon, GA § 1948–1951, Mills College, Oakland, CA § 1951–1952, Cranbrook Academy, Bloomfield Hills, MI

SELECTED SOLO EXHIBITIONS: Mi Chou Gallery, New York, 1957 § Museum of Contemporary Crafts, New York, 1961 § *Katherine Choy: A Promise Unfulfilled*, Newark Museum, Newark, NJ, 2000/2001

SELECTED GROUP EXHIBITIONS: *4th Annual of the Association of San Francisco Potters*, de Young Museum, San Francisco, 1950 § *International Exhibition of Ceramic Art*, Smithsonian Institution, Washington, D.C., 1952 § *Designer Craftsmen U.S.A.*, San Francisco Museum of Art, 1954 § *Five Chinese American Ceramists*, Mi Chou Gallery, New York, 1955 § *The Potter's Art in California, 1885–1955*, Oakland Museum of California, 1978 § *Great Pots: Contemporary Ceramics from Function to Fantasy*, Newark Museum, Newark, NJ, 2003

Katherine Choy, late 1950s

SELECTED COLLECTIONS: Museum of Art and Design, New York § Newark Museum, Newark, NJ

SELECTED BIBLIOGRAPHY: "Clay Is Her Calling." *Dixie Times Picayune States Roto Magazine*, September 14, 1952. § Kuchta, Ronald A., ed. *Katherine Choy: Ceramics.* Newark, NJ: Newark Museum, 2000. § Smith, Dido. "Three Potters from China." *Craft Horizons* 17, no. 2 (March/April 1957): 23–32.

There is one point on which pottery must be considered as a fine art rather than a craft or industry. You have to think deeply—as in sculpture or any creative work—to achieve a synthesis of the technical and the esthetic.

KATHERINE CHOY

Smith, "Three Potters from China," 24

BEFORE HER DEATH at twenty-nine, Katherine Choy studied with leading international artists, headed a major university ceramics department, and fulfilled her dream to establish a working center for advanced study in ceramics, all while creating a body of work that consistently challenged the definitions of ceramics. Choy was born to a wealthy Shanghai family that moved to Hong Kong following the 1911 revolution. She came to the United States at seventeen to study literature at Wesleyan College, but two years later she transferred to Mills College to pursue her growing interest in art. While at Mills, she took a variety of classes, including painting, sculpture, weaving, enameling, and metalwork. However, ceramics began to take precedence, and she studied with F. Carlton Ball and Antonio Prieto. From them Choy received both a sound technical grounding and a conceptual framework with which to explore ceramics. Following the completion of her M.A. in 1951, she spent the summer at the Jade Snow Wong studio in San Francisco doing research and experimental work. She then moved to Bloomfield Hills, Michigan, where she was on scholarship for a year at the Cranbrook Academy. There, she studied ceramics with Maija Grotell and Bernard Leach and painting with Max Beckmann, adding further to her artistic foundation. Her work was exhibited widely in many group shows and national competitions, including the Ceramic National exhibitions at Syracuse from 1949 to 1956.

In 1952, Choy was hired to head the ceramics department at Newcomb College, Tulane University, which had a long and established ceramics tradition. In addition to expanding classes and updating facilities, Choy was also able to explore in depth the chemistry of pottery, creating her own unique glazes and setting standards that are still used today. As a result of her innovative approach to glazing, the Good Earth Company, a commercial manufacturer located in Port Chester, New York, hired her as a consultant. Becoming aware of the financial instability of the Good Earth Company, the visionary Choy contacted her friend and Mills classmate Henry Okamoto about

opening a ceramic art center at the Good Earth site. Okamoto, who was living in Connecticut, arranged for the purchase of the facility, and shortly thereafter, with the financial support of Choy's backers in New Orleans, the partners opened the Clay Art Center in 1957.

The mission of the Clay Art Center was to provide a work facility for advanced potters from around the world. Participants created art in a communal atmosphere where everyone was required to help in the studio and teach classes. The exchange of ideas was as valued as the production of ceramics, and collaborative projects were encouraged. Viola Frey and Cleo Bell, both former students of Choy's at Newcomb, were two of the founding members.

Choy produced more than two hundred works during the first year of the Clay Art Center while on sabbatical from Newcomb. While her earlier pieces were characterized by organic, often asymmetrical forms utilizing calligraphic surface decoration and innovative glazes, the work produced in the last year of her life evidenced an increasingly progressive approach. Her pieces became larger, more sculptural, with broken contours and sgraffito markings. As one of the few artists at that time to create such radically innovative forms, she—like her contemporaries Peter Voulkos and John Mason—was redefining ceramics. Following Choy's sudden death in 1958, Henry Okamoto headed the Clay Art Studio and dedicated his life to realizing Choy's dream. The center continues today as a vital center for ceramic arts.

Chun, David P.

BORN: February 17, 1898, Honolulu, HI

DIED: October 24, 1989, San Francisco, CA

RESIDENCES: 1898–1905, Honolulu, HI § 1905–ca. 1920, Guangzhou, China § ca. 1920–1924, Honolulu, HI § 1924–1989, San Francisco, CA

MEDIA: oil painting and printmaking

SELECTED SOLO EXHIBITION: San Francisco Museum of Art, 1939, 1940/41

SELECTED GROUP EXHIBITIONS: American Federation of Arts, Washington, D.C., 1932 § California State Fair, Sacramento, 1933 § *San Francisco Art Association*, San Francisco Museum of Art, 1935 (inaugural), 1937–1942 § *Chinese Art Association of America*, de Young Museum, San Francisco, 1935/36 § Oakland Art Gallery, Oakland, CA, 1936, 1939 § *California Art Today*, Golden Gate International Exposition, San Francisco, 1940 § *Chinatown Artists Club*, de Young Museum, San Francisco, 1942–1945 § *Made in California: Art, Image, and Identity, 1900–2000*, Los Angeles County Museum of Art, 2000

SELECTED COLLECTIONS: Fine Arts Museums of San Francisco § Monterey Museum of Art, Monterey, CA § San Francisco Museum of Modern Art

SELECTED BIBLIOGRAPHY: Brown, Michael D. *Views from Asian California, 1920–1965*. San Francisco: Michael D. Brown, 1992. § "Chinese Argue in Tong Rooms, Quote Sages, Over Proposals to Orientalize Chinatown." *The San Francisco News*, July 17, 1935. § Chun, David. Biographical Folder. Oakland Museum of California.

The value of the art work not only expresses the inspiration and spirit of the artist himself or herself, but ... will be able to lead to human good (and) understanding toward the peaceful world.

<div align="right">

DAVID CHUN
Biographical Folder,
Oakland Museum of California

</div>

AN ARTIST WHOSE social conscience guided much of his work, David Chun exhibited widely in the Bay Area during the 1930s and 1940s. Born in Hawaii, Chun moved to China with his family when he was seven years old. While he was in China, Chun's interest in art developed, and he began to take lessons in painting. After returning briefly to Hawaii, the artist came to San Francisco in the early 1920s. During his first years in the city, Chun studied at the San Francisco Continuation School, where his design for a school bookplate won first prize. More awards followed as his work began to appear in national competitions.

Chun was the first president of the Chinese Art Association (later known as the Chinatown Artists Club), whose members included **Chee Chin S. Cheung Lee**, **Dong Kingman**, and **Nanying Stella Wong**, and he participated in the group's five exhibitions at the de Young Museum. Both a printmaker and a painter, Chun also worked as a professional lithographer and illustrator throughout his life. His friendship with both Grace McCann Morley and Albert Bender of the San Francisco Museum of Art resulted in the museum's acquisition of several of the artist's woodcut prints in 1938.

Involved with both the WPA and a 1935 project of the Downtown Association, Chun gained publicity when he became the principal advocate for the beautification of Chinatown through a return to traditional Chinese aesthetics. Chun explained that he was not interested in turning the community into "a Hollywood set designer's conception of Chinatown" but instead wanted to create designs that would be Chinese in every way, replacing ugly trash cans with colorful incense burners and creating a tea garden in what is today Portsmouth Square. Chun created design sketches for the well-known arch that today marks the Grant Avenue entrance to Chinatown.

Although the artist created still lifes, landscapes, and cityscapes, many of Chun's paintings and prints address important social issues. Depression-era poverty is the subject of *Breadline*, and the dramatic *War Toll* is an articulate pacifist statement. The artist was deeply affected by the Japanese invasion of China and its impact on his own family. The invasion was the subject of several of his paintings and prints, including *A Shortcut to Destruction*, in which soldiers march past a crying Buddhist statue. Chun is distinguished as being the only Chinese artist to have work included in the *Art in Action* section of the 1939 Golden Gate International Exposition, but despite his active career in the 1930s and 1940s, little is known of his work following a two-person exhibit in Berkeley in 1949.

Chun, Sung-woo

BORN: June 2, 1934, Seoul, Korea

RESIDENCES: 1934–1953, Seoul, Korea § 1953–1958, San Francisco, CA § 1959–1960, Oakland, CA § 1961–1964, Columbus, OH § 1964–1965, San Francisco, CA § 1966–present, Seoul, Korea

MEDIA: oil and acrylic painting, printmaking, and mixed media

ART EDUCATION: 1953, Seoul National University, Fine Arts College § 1953–1955, San Francisco State College § 1955–1958, California School of Fine Arts, San Francisco § 1959–1960, Mills College, Oakland, CA § 1961–1964, Ohio State University, Columbus

SELECTED SOLO EXHIBITIONS: Six Gallery, San Francisco, 1956 § Lucien Labaudt Gallery, San Francisco, 1958 § Mi Chou Gallery, New York, 1958, 1961 § Bolles Gallery, San Francisco, 1961–1965 § *Ernie Kim and Sungwoo Chun,*

David Chun, ca. 1935

Richmond Art Center, Richmond, CA, 1965 § Gana Art Gallery, Seoul, 1994

SELECTED GROUP EXHIBITIONS: *San Francisco Art Association*, San Francisco Museum of Art, 1956–1959 § *Young America*; Whitney Museum of American Art, New York, 1960 § São Paulo Biennial Exhibition, Brazil, 1972 § *Postwar Abstract Art in Korea and the West: Passion and Expression*, Hoam Art Gallery, Seoul, 2000

SELECTED COLLECTIONS: Fine Arts Museums of San Francisco § Korean National Museum of Contemporary Art, Seoul § Whitney Museum of American Art, New York

SELECTED BIBLIOGRAPHY: Chun, Sung-woo. CAAABS project interview. September 14, 2000. Seoul. § Chung, Yang-Mo. *Chun Sung-woo*. Korea: Insa Art Center, 2000. § Goodrich, Lloyd, and John I. H. Baur. *Young America 1960: Thirty American Painters Under Thirty-Six*. New York: Whitney Museum of American Art, 1960. § Lee, Ho Jae. *Sung-woo Chun*. Korea: Gana Art Gallery, 1992. § Wechsler, Jeffrey, ed. *Asian Traditions/Modern Expressions: Asian American Artists and Abstraction, 1945–1970*. New York: Abrams in association with the Jane Voorhees Zimmerli Art Museum, Rutgers, the State University of New Jersey, 1997.

Sung-woo Chun

308

I consider myself to be an American artist because I learned how to paint in America. If I was taught in Korea, I would consider myself a Korean artist.

<div align="right">SUNG-WOO CHUN
CAAABS project interview</div>

BORN IN SEOUL to an affluent family, Sung-woo Chun began to create art at the age of nine, studying with traditional Korean painters. His father, who owned one of the largest collections of art in Korea, supported and nurtured Chun's artistic career. At the Kansong Art Museum, founded by his father, Chun was exposed to the ancient traditions of Korean art, which he later acknowledged strongly influenced his work. In 1946, at age twelve, Chun abandoned the inks and watercolors of his Korean instructors for the European oil paints used by the impressionist artists he admired. He was accepted to Korea's prestigious Seoul National University, Fine Arts College, in 1953. However, he left for the United States later that same year to avoid being drafted to fight in the Korean War.

Chun attended San Francisco State College (now University), where he was introduced to abstract painting, and in 1955 transferred to the California School of Fine Arts, where he received his B.F.A. There, studying with Sam Tchakalian and Nathan Oliveira, he began to experiment with painting techniques, developing the method that would later become his signature style. Although still working in oils, Chun returned to the gentle washes of color characteristic of Korean ink paintings. He removed figures from his work and created highly abstract landscapes, atmospheric color-field paintings that often incorporated mandala motifs. He achieved the strikingly luminescent quality found in his work by diluting the paint with turpentine and applying multiple layers of the color washes onto a canvas laid flat on the floor. He said, "To paint pigments on canvas hung up on the easel is running counter to the providence of nature. My works do not exist outside of nature, they breathe deeply when they are free in nature."

Chun followed Ralph DuCasse, a former professor at the California School of Fine Arts, to Mills College in Oakland, where he received his M.F.A. In 1960, Chun was selected to participate in the Whitney Museum's prestigious *Young America* exhibition. After teaching briefly at Mills, Chun undertook a six-month lecture tour of Midwest universities. In 1961, he returned to San Francisco as a contractual artist with the Bolles Gallery, but he was feeling pressure to return to Korea now that his studies were completed. Soon after, he began the only doctoral program in painting in the United States at Ohio State University. Following the completion of his Ph.D., Chun taught at the Richmond Art Center in 1965, during **Ernie Kim**'s tenure there as director.

After learning of his father's death, Chun returned to Seoul in 1966 and taught painting, first at Ewha University and then in 1968 at Seoul National University, Fine Arts College. When his older brother died in 1971, he fulfilled his responsibilities as eldest son, assuming both his father's former roles as

principal at Posung High School (also founded by his father) and as director of the Kansong Art Museum. He continued in these positions for the next twenty-five years.

Although Chun claims he never stopped being a painter after he returned to Korea, he was unable to devote much time to his artwork until he retired in 1996. Today he continues to paint in thin washes, often applying eighty diluted layers of pigment; nature, spirituality, and the mandala still figure prominently in his work.

Date, Hideo

BORN: January 3, 1907, Osaka, Japan

DIED: January 6, 2005, Flushing, New York

RESIDENCES: 1907–1923, Osaka, Japan § 1923–1925, Fresno, CA § 1925–1929, Los Angeles, CA § 1929–1930, Tokyo, Japan § 1930–1942, Los Angeles, CA § 1942–1945, Santa Anita Assembly Center, Santa Anita, CA; Heart Mountain Relocation Center, Heart Mountain, WY § 1945–1952, New York, NY § 1952–2005, Flushing, NY

MEDIA: watercolor and oil painting, drawing, and murals

ART EDUCATION: 1928, Otis Art Institute of the Los Angeles Museum of History, Science and Art § 1928, 1930–ca. 1941, Art Students League, Los Angeles § 1929, Kawabata Gakkō, Tokyo, Japan

SELECTED SOLO EXHIBITIONS: Art Center School, Los Angeles, 1947 § Creative Galleries, New York, 1954 § Living in Color: The Art of Hideo Date, Japanese American National Museum, Los Angeles, 2001/2

SELECTED GROUP EXHIBITIONS: Japanese Artists of Los Angeles (Second Annual), Little Tokyo, 1930 § The Contemporary Oriental Artists, Foundation of Western Art, Los Angeles, 1934 § Exhibition of Oriental Artists, Foundation of Western Art, Los Angeles, 1935 § Exhibition of California Oriental Artists, Los Angeles Museum, 1936 § Exhibition of California Oriental Painters, Foundation of Western Art, 1937 § Federal Arts Project, Stendahl Art Galleries, Los Angeles, 1937 § Artists of Southern California, Los Angeles Art Association, 1941 § Half Century of Japanese Artists in New York, 1910–1950, Azuma Gallery, New York, 1977 § On Gold Mountain: A Chinese American Experience, Autry Museum of Western Heritage, Los Angeles, 2000

SELECTED COLLECTIONS: Japanese American National Museum, Los Angeles § Los Angeles County Museum of Art § Smithsonian American Art Museum, Washington, D.C. § State Museum Resource Center, California State Parks, Sacramento

SELECTED BIBLIOGRAPHY: Cheng, Scarlet. "A Painter Ready to Claim His Place." Los Angeles Times, October 28, 2001, Calendar sec., 61–62. § Higa, Karin. Living in Color: The Art of Hideo Date. Los Angeles: Japanese American National Museum, 2001. § Pagel, David. "The Delicate Contours of a Life in the Shadows." Los Angeles Times, November 28, 2001, F2.

I have never [been] interested in the so called general public art culture and the public had no interest of or knowledge of me.

HIDEO DATE
Higa, *Living in Color*, 57

SHORTLY AFTER HIDEO DATE's birth in Osaka, Japan, his father left to find work in California, and slowly the family reunited in Fresno. Date arrived in 1923 and worked in orchards to help support the family while studying English. After the failure of his father's hardware store, the family moved to the Little Tokyo community of Los Angeles.

In 1925, Date attended Polytechnic High School, where he became interested in drawing. He received a scholarship to the Otis Art Institute in 1928 and became friends with fellow students **Benji Okubo** and **Tyrus Wong**. Although Date received accolades for his work, Otis's director said it was a tragedy that he painted in an "Oriental manner." In response, Date decided to return to Japan to study the art he knew little about, yet with which he seemed destined to always be identified.

Date attended the Kawabata Gakkō in Tokyo for a year, where he studied *nihonga*. Founded by Kawabata Gyokushō, the school embraced Japanese, Chinese, and Indian classical art, their influence on modern European art, and the circular nature of these relationships.

Back in Los Angeles in 1930, Date joined the Art Students League. He had studied with the league's director, Stanton Macdonald-Wright, in 1928, and Macdonald-Wright's Synchromism blended well with Date's recent *nihonga* training.

Hideo Date, ca. 1920s

Macdonald-Wright's connections to European and American modernist painters made him a unique proponent of the vanguard in Los Angeles, and through the exhibitions he organized and his influential teaching he played a pivotal role in the formation of many young artists. Date absorbed Macdonald-Wright's approach to figuration in the solid, often asexual bodies that dominate his work in the 1930s. And Macdonald-Wright's approach to color theory is evident throughout Date's career (with the exclusion of his work during internment) in his use of strong, vivid colors.

In 1932, Date left his job at his brothers' flower shop and moved into the Art Students League's studios, where he led a sparse but focused existence, with the support of many close artist friends. Date exhibited widely in the 1930s in many important group shows and was commissioned to paint a mural in an Oriental-themed room in Pickfair, the home of Mary Pickford and Douglas Fairbanks. Date began work on a WPA mural commission for the school at Terminal Island, a community with a large Japanese population, and chose the Japanese legend of the goddess of light as his subject matter. However, he was unable to complete the project, as he was interned following the bombing of Pearl Harbor. Date was first held at Santa Anita, then transferred to the Heart Mountain Relocation Center in Wyoming.

Along with Benji Okubo, also an internee at Heart Mountain, Date formed an art school, calling it the Art Students League. The school boasted 250 members, and teachers included Date, Okubo, **Robert Kuwahara**, Shingo Nishiura, and **Riyo Sato.** Date organized exhibitions and created a mural at the camp. Because of the lack of supplies, Date's own work during the period was primarily pencil drawings, and his subject matter was dominated by representations of cats—some fierce, some docile—perhaps a metaphor for the artist's anger about and possible resignment to his captivity.

In 1945, Date was released to work on a mural in Buffalo, New York, and later moved to New York City. Unlike many other artists, whose work was destroyed during internment, Date was fortunate to have left his paintings with good friends who looked after them during the war years. Date returned to Los Angeles in 1947 to retrieve his work and held a one-person show at the gallery at the Art Center School before returning to New York. He married the same year, and began to create increasingly abstract works in oils. Federal legislation in the early 1950s allowed Date to become a naturalized citizen, enabling him to receive a passport and fulfill a lifelong dream of traveling to Europe. He returned frequently to Europe over the following decades to paint. The Japanese American National Museum held a major retrospective of his work in 2001–2002.

Duena, Victor

BORN: April 16, 1888, Philippines

DIED: April 12, 1966, San Francisco, CA

RESIDENCES: 1888–1912, Philippines § 1912–1930, California § 1930, Pittsburg, CA § 1931–1954, California § ca. 1955–1966, San Francisco, CA

MEDIA: oil and watercolor painting

SELECTED SOLO EXHIBITION: Vesuvio Café, San Francisco, ca. 1957–1966

SELECTED GROUP EXHIBITIONS: Museum of Modern Art Rental Gallery, New York, ca. 1965 § *Art-Naif*, San Francisco Museum of Art, 1974

SELECTED COLLECTION: Los Angeles County Museum of Art

SELECTED BIBLIOGRAPHY: Aronson, Steven. "Naive Melody in Manhattan: A Collector's Eye for Singular American Folk Art." *Architectural Digest*, October 1990, 144–149+. § Brown, Michael D. *Views from Asian California, 1920–1965.* San Francisco: Michael D. Brown, 1992. § Maresca, Frank, and Roger Ricco. *American Self-Taught: Paintings and Drawings from Outsider Artists.* New York: Knopf, 1993. § 1930 Federal Population Census. Pittsburg, Contra Costa, California. Roll 114, Page 11A, Enumeration District 17, Image 83.0. National Archives, Washington, D.C.

ONCE HE BEGAN to paint in his sixties, Victor Duena became a prolific artist, creating hundreds of works within a period of less than ten years; today very few of his paintings survive.

Duena arrived in California in 1912, among the first wave of primarily male immigrants from the Philippines. His life in the United States probably was like that of many Filipino bachelors, who were restricted by discriminatory immigration laws and social discrimination and subsequently worked as transient migrant laborers. The 1930 federal census shows that Duena was living in Pittsburg, California, and working in the canning industry. He later settled in the Justice Hotel located in San Francisco's Manilatown, adjacent to Chinatown and North Beach.

What prompted Duena to start painting is unclear. Subject matter that inspired the self-taught artist included San Francisco scenes and his memories of life in the Philippines. His renderings range from the 1950s San Francisco café scene to wild animals in jungle environments. Naive in style, the works are composed of simple lines, lush colors, and intricate patterning with a flattened perspective. These characteristics caught the eye of art dealer and Vesuvio Café owner Henri Lenoir when he saw Duena's work in a San Francisco Filipino barbershop. Lenoir sought out the artist and encouraged him to exhibit his work in the Vesuvio Café, which, like its nearby

neighbor City Lights Bookstore, was a gathering place for North Beach Beat writers and artists. Many of Duena's paintings were bought by café patrons who appreciated the artist's unique sensibility.

Fong, Wallace H., Sr.

BORN: July 6, 1905, Dutch Flat, CA

DIED: June 24, 1980, Rancho Palos Verdes, CA

RESIDENCES: 1905–ca. 1915, Dutch Flat, CA. § ca. 1915–ca. 1968, San Francisco, CA § ca. 1968–1980, Rancho Palos Verdes, CA

MEDIA: photography

SELECTED COLLECTION: William Hoy Collection, Chinese Historical Society of America, San Francisco

SELECTED BIBLIOGRAPHY: *Chinese Digest* (San Francisco), January 1938, cover. § *Chinese Digest* (San Francisco), January 1939, cover. § 1930 Federal Population Census. San Francisco, San Francisco, California. Roll 209, Page 35A, Enumeration District 392, Image 746.0. National Archives, Washington, D.C. § Wong, H. K. "Roaming 'Round." *Chinese Digest* (San Francisco), August 1938, 14.

THE PHOTOGRAPHS WALLACE H. FONG SR. took during his years with the *Chinese Digest* can be seen today both as documents of life in the Chinatown of 1930s San Francisco and as poetic images typifying the goals of a new generation of Chinese San Franciscans engaged in exploring the arts and culture of their community.

Fong was born to a China-born father and California-born mother who were merchants in Dutch Flat, California, where the transcontinental railroad crosses the Sierra Nevada. The family later moved to San Francisco, where Fong became active in the cultural life of the city's Chinese community and played saxophone for the Cathay Club, recognized as the first all-Chinese dance band in the United States. Fong married in 1925, and the artist, his wife, Pearl, and their four-year-old son, Wallace Jr., are recorded as living in San Francisco in the 1930 federal census. Fong Sr. worked as the staff photographer for the *Chinese Digest* from 1936 to 1940. However, the listing of his profession as "photographer" in the 1930 federal census indicates that he was actively working as a photographer before his tenure with the publication. It appears that Fong was not the proprietor of his own photography studio; most likely he was employed at a local studio, such as **May's Photo Studio**, before and possibly during his time at the *Chinese Digest*.

The *Chinese Digest* was a monthly publication founded by Thomas W. Chinn and Chingwah Lee, dedicated to presenting information about the cultural life of San Francisco's Chinatown, as well as general news. Printed in English, it was emblematic of a new generation of middle- and upper-middle-class Chinese men and women who sought to cultivate the

Wallace H. Fong Sr., ca. 1936

artistic and cultural components of their community. Wallace Fong Sr.'s photographs for the *Chinese Digest* are not typical photojournalism. They are often highly poetic and include formal still lifes, shots with carefully controlled lighting, and double exposures. Fong's pictures often appeared on the cover of the publication, as did *A Pagan Altar to a Monkey God*, which shows a man praying at an altar. Photographed from behind in a darkened room, the man is positioned partially cropped out of the picture frame, and a dramatic spot of light appears almost in the center of the frame. Fong's photographs present images of Chinatown radically different from the often-seen voyeuristic images taken by non-Chinese photographers, both in their familiarity with the subject matter and in their formalistic approach to picture making.

Like his father, Wallace Fong Jr. became a photographer and in the 1940s was employed by the San Francisco office of the Associated Press (AP). He recommended his father for a photojournalist-technician position, and the two became the first father-and-son team at the San Francisco AP offices. Wallace Fong Sr. seems to have spent the remainder of his career at the San Francisco AP, while he still often volunteered his services to the Chinatown community, photographing special events and judging contests. His son later moved to the Los Angeles area, working in the AP offices there. Later, likely after retirement, the elder photographer joined his son in Rancho Palos Verdes and died there in 1980.

Fong, Wy Log

BORN: February 22, 1894, San Francisco, CA

DIED: September 5, 1974, Los Angeles, CA

RESIDENCES: 1894–ca. 1914, San Francisco, CA § ca. 1914–ca. 1930, Portland, OR § ca. 1930–ca. 1954, San Francisco and Los Angeles, CA § ca. 1954–1974, Los Angeles, CA

MEDIA: oil and watercolor painting, and illustration

ART EDUCATION: 1917–1920, Museum Art School, Portland, OR

SELECTED GROUP EXHIBITIONS: Juried Exhibition, Portland

Art Museum, Portland, OR, 1920, 1922 § Group Exhibition, Portland Art Museum, Portland, OR, 1959

SELECTED COLLECTION: Daniel K. E. Ching Collection, Chinese Historical Society of America, San Francisco

SELECTED BIBLIOGRAPHY: Allen, Ginny, and Jody Klevit. *Oregon Painters*. Portland: Oregon Historical Society, 1999. § Rice, Clyde. *A Heaven in the Eye*. New York, NY: Breitenbush Books, 1984. § Tsutakawa, Mayumi, ed. *They Painted from Their Hearts: Pioneer Asian American Artists*. Seattle: Wing Luke Asian Museum/University of Washington Press, 1994.

WY LOG FONG was a successful painter and illustrator in the 1920s and 1930s. Many of his works survive today, including original paintings, plus prints produced by the West Coast Engraving Company of Portland, Oregon, to which he was under contract in the 1920s. After moving from San Francisco, Fong attended high school in Portland, where he later studied art at the Museum Art School. Fong is listed in the 1928 Portland city directory; however, it is unclear how long he remained in the Portland area. He later moved back to San Francisco and then to Los Angeles, where he attended the Art Students League. He was described as a sidewalk pastel portrait artist in Los Angeles's Chinatown.

Fong created genre portraits of Chinese men, women, and children, similar in style to the work of early-twentieth-century painter Esther Hunt. Fong's paintings sometimes contained stereotypes of his subjects, perhaps to appeal to non-Chinese audiences. One interesting aspect of his career are the works he painted on velvet from the teens to the 1930s. While velvet paintings date back to the eighteenth century, the origination of the modern kitsch form in the United States has been attributed to Edgar Leeteg, who was active in the 1930s and 1940s. The earlier dates of Fong's work may mean that he was the first artist in the United States to work on velvet.

Foujioka, Noboru

BORN: January 10, 1896, Hiroshima, Japan

DIED: unknown

RESIDENCES: 1896–ca. 1910, Hiroshima, Japan § ca. 1910–ca. 1915, Tokyo, Japan § ca. 1915–1916, Portland, OR § 1916–1919, New York, NY § 1919–1921, Paris, France § 1921–1932, New York, NY (with stays in San Francisco, CA; Seattle, WA; Los Angeles, CA; and Paris, France) § 1932–1933, Los Angeles, CA § 1934–unknown, Tokyo, Japan

MEDIA: oil and ink painting

ART EDUCATION: 1915–1916, Museum Art School, Portland, OR § ca. 1916–ca. 1919, Art Students League, New York

SELECTED SOLO EXHIBITIONS: *Special Exhibition of Works by Noboru Foujioka*, The Nippon Club, New York,

1924 § *Exhibition of Paintings by Noboru Foujioka*, California Palace of the Legion of Honor, San Francisco, 1927 § California Palace of the Legion of Honor, San Francisco, 1932 § Los Angeles Museum, 1933 § Seijusha Art Galleries, Tokyo, 1936

SELECTED GROUP EXHIBITIONS: Salon d'Automne, Paris, 1920 § *The First Annual Exhibition of Paintings and Sculpture by Japanese Artists in New York*, The Art Center, New York, 1927 § *Flower Show*, California Palace of the Legion of Honor, San Francisco, 1931

SELECTED COLLECTIONS: Fine Arts Museums of San Francisco § Japanese American National Museum, Los Angeles

SELECTED BIBLIOGRAPHY: "Foujioka Arts Go on Exhibit at L.A. Gallery." *Kashu Mainichi* (Los Angeles), January 4, 1933, 1. § "Foujioka Former Resident of L.A." *Rafu Shimpo* (Los Angeles), December 24, 1936, 28. § "Noboru Foujioka." *Kashu Mainichi* (Los Angeles), January 8, 1933, 3. § "Three Exhibitions Scheduled for July Opening at Palace." *San Francisco Chronicle*, June 26, 1932, D3. § "Whistler and Japanese Art." *Kashu Mainichi* (Los Angeles), April 2, 1933.

NOBORU FOUJIOKA, who studied in Paris and at the Art Students League in New York, had some of his greatest artistic successes during his years in California, including two solo exhibitions at the California Palace of the Legion of Honor. Foujioka was born in Hiroshima and spent his youth in a mountain village. He studied graphic arts for five years in Tokyo, where his artistic talent was noted and encouraged. He continued his studies in Portland, Oregon, at the city's Museum Art School and subsequently moved to New York to study at the Art Students League with John Sloan and Frank Vincent DuMond. While he was in New York, his work came to the attention of the Japanese consul general of New York, who helped the artist travel to Paris to further his studies. There, Foujioka studied with Othon Friesz and Charles Guérin and was part of the artists' community in Montparnasse.

After two years in Paris, Foujioka returned to New York and held a solo exhibition at the Nippon Club. Other solo exhibitions followed, including a 1927 show at the California Palace of the Legion of Honor in San Francisco that later traveled to San Diego, Portland, and the University of Washington in Seattle. The artist spent a great deal of time on the West Coast, accompanying his work to various venues. He also spent time again in Paris, as **Henry Sugimoto** tells of meeting him there in 1929. A second solo show of paintings at the California Palace of the Legion of Honor in 1932 coincided with the artist's relocation to Los Angeles. While in Los Angeles, the artist was associated with the *Kashu Mainichi* newspaper and wrote an article about the influence of Japanese art on James McNeill Whistler's work.

Foujioka combined the line and brushstrokes of ink painting with French impressionistic colors to create portraits, genre paintings, and still lifes. Work exhibited by Foujioka in the 1920s and 1930s was frequently described as satirical and humorous. However, some reviewers found the artist's paintings not amusing but rather an indictment of modern American life. In 1933, in response to such comments, a writer for the *Kashu Mainichi* stated, "The artist paints with no idea of condemning or of pointing out any lesson. He is only immensely amused. You can imagine him as a youth approaching with amorous intentions, Life, which seemed to him a grand dame and when Life turned to him her sordid side, instead of recoiling or feeling rebuffed, he stepped up and embraced her, sordidness and all." Two works that prompted such discussions were *Strap Hanger* and *American Spirit*, described in the *Rafu Shimpo* newspaper as the "two most acrid sarcasms in oil ever painted of contemporary American life." *American Spirit* was purchased by Herbert Fleishhacker, then a bank president and head of the San Francisco school board, an indication that affluent art collectors appreciated the sensibility of Foujioka's work.

Foujioka returned to Japan in 1934, where his work was received with great acclaim. Reportedly, he married an heiress, but beyond this minor information that appeared in Los Angeles Japanese papers, little is known about the artist's later life.

Fujikawa, Gyo

Gyo Fujikawa, ca. 1934

BORN: November 4, 1908, Berkeley, CA

DIED: November 26, 1998, New York, NY

RESIDENCES: 1908–1926, Berkeley, San Pedro, and Wilmington, CA § 1926–1931, Los Angeles, CA § 1932–1933, Japan § 1933–1941, Los Angeles, CA § 1941–1998, New York, NY

MEDIA: watercolor painting, drawing, and illustration

ART EDUCATION: 1926–1931, Chouinard Art Institute, Los Angeles

SELECTED BIBLIOGRAPHY: Fujikawa, Gyo. *Babies*. New York: Grosset and Dunlap, 1963. § "Gyo Fujikawa: An Illustrator Children Love." *Publishers Weekly,* January 4, 1971, 45–48. § "Gyo Fujikawa, 90, Creator of Children's Books." *New York Times,* December 7, 1998, B10. § Metzl, Ervine. "Gyo Fujikawa." *American Artist,* 18, no. 5 (May 1954): 32–35.

I am flattered when people ask me how I know so much about how children think and feel. Although I have never had children

of my own, and cannot say I had a particularly marvelous childhood, perhaps I can say I am still like a child myself. Part of me, I guess, never grew up.
GYO FUJIKAWA
"Gyo Fujikawa," *New York Times,*
December 7, 1998, B10

GYO FUJIKAWA, THE DAUGHTER of Hikozo and Yu Fujikawa, was named by her father for a Chinese emperor. Brought up in the Bay Area, San Pedro, and Wilmington, California, she showed such promise in art that, thanks to the efforts of a high school teacher, she received a scholarship in 1926 to study at the Chouinard Art Institute in Los Angeles. She also studied dance with Michio Ito during this time and was friends with others active in the Japanese American art community, including **Julia Suski**. Following graduation and a year spent in Japan, Fujikawa taught at Chouinard from 1933 to 1937 before accepting a position at Walt Disney Studios to design promotional materials that included programs and brochures for *Fantasia*. Transferring to the company's New York studios, she designed many twenty-five-cent Disney books. After leaving Disney she worked briefly for the Fox Film Company and later served as art director for William Douglas McAdams, a New York pharmaceutical agency. Because she was living on the East Coast during World War II, Fujikawa avoided being interned, although her family was forced to spend the war years at the Rohwer Relocation Center in Arkansas.

While Fujikawa continued to work on a variety of commercial projects, her composite of Disney characters in *McCall's Magazine* caught the eye of Doris Dunewald, editor at Grosset and Dunlap. Dunewald asked Fujikawa to illustrate a new edition of Robert Louis Stevenson's *A Child's Garden of Verses*, which was published in 1957. After this success, she provided pictures for other children's books by various writers, including *The Night Before Christmas* (1961) and *Mother Goose* (1968), and eventually produced more than forty of her own books, two of which, *Babies* (1963) and *Baby Animals* (1963), were best-sellers. The popularity of Fujikawa's books is noteworthy not only because the general public appreciated her illustrative style but also because she represented children of different ethnicities in her stories, which was unusual for children's books of the time. During her long career, she also designed six postage stamps, one of which, commemorating Lady Bird Johnson's beautification program, prompted the president and first lady to invite her to the White House.

Fujikawa's illustrations are distinctive for their attention to detail, and the artist attributed this precision to her experience working with Walt Disney. In addition, she felt that children responded to details in illustrations and looked for visuals to correspond to the text that was read to them. Whether representing children, adults, animals, or even objects, the artist maintained a balance between realism and stylized fantasy. Done in soft watercolors or distinctive black-and-white line

drawings, Fujikawa's work has had continuing appeal, and the frequent republication of her books attests to the enduring nature of her work.

Fujita, Sadamitsu Neil

BORN: May 16, 1921, Waimea, Kauai, HI

RESIDENCES: 1921–1939, Waimea, Kauai, HI § 1939–1942, Los Angeles, CA § 1942–1943, Pomona Assembly Center, Pomona, CA; Heart Mountain Relocation Center, Heart Mountain, WY § 1943–1947, Italy, France, and Japan (U.S. military service) § 1947–1949, Los Angeles, CA § 1949–1954, Philadelphia, PA § 1954–present, New York, NY

MEDIA: watercolor and oil painting, and drawing

ART EDUCATION: 1940–1942, 1947–1949, Chouinard Art Institute, Los Angeles § 1957–1960, Columbia University, New York

SELECTED SOLO EXHIBITIONS: Philadelphia Art Alliance, 1953 § Wellon Gallery, New York, 1956 § *Eden Before the Apple*, Benson Gallery, Bridgehampton, NY, 1985 § *Seeing Is Feeling: American Faces in the North Fork*, Floyd Memorial Library, Greenport, NY, 1999

SELECTED GROUP EXHIBITIONS: California Watercolor Society, Los Angeles, 1948–1951 § Philadelphia Academy of Fine Arts, Philadelphia, 1955 § Santa Barbara Museum of Art, Santa Barbara, CA, 1956

SELECTED COLLECTIONS: Atwater Kent Museum, Philadelphia § Floyd Memorial Library, Greenport, NY § Los Angeles County Museum of Art

SELECTED BIBLIOGRAPHY: "Fujita Design Inc.: They Know What They are Doing and Why." *Idea* 23, no. 130 (May 1975): 10–21. § Fujita, Sadamitsu Neil. CAAABS project interview. October 30, 2000. Transcript, Asian American Art Project, Stanford University. § "S. Neil Fujita." *CA Magazine* 4, no. 9/10 (September/October 1962): 60–67. § Thomajan, P. K. "S. Neil Fujita: cogent communicator with the pr touch." *Graphics Today*, May/June 1976, 14–20.

The subject of my work can be defined in two parts but not necessarily so: the fine and commercial art aspects of my work have become almost an entirety in itself, an embodiment of my social, cultural, intellectual and structural self.... The subjects in all cases blended into a harmonious creative whole whether it is for an advertising piece or a painting done abstractly or realistically for my personal satisfaction and fulfillment.

SADAMITSU NEIL FUJITA
Undated correspondence to CAAABS researcher, ca. 2000. Asian American Art Project, Stanford University.

Sadamitsu Neil Fujita,
1948. Photo by
Robert Perine

RENOWNED AS A commercial artist, Sadamitsu Neil Fujita has created imagery of international visibility. Fujita was born in Waimea on the island of Kauai and received the name "Neil" from a first-grade teacher. Fujita's father was a blacksmith for a sugar plantation, and as a youth Fujita worked in the sugarcane fields. The family lived in the sugar plantation camps; Fujita noted that although they lived there during the 1930s, the idea of "the Depression" did not have much resonance for the family, since life was already very difficult. A shift to a better school in Honolulu for the last two years of high school resulted in Fujita's first art education, and following graduation, as he assessed the limited options available to him in Hawaii, Fujita decided to travel to California in hopes of greater opportunities.

Working at a fruit and vegetable market in Los Angeles, Fujita again saw how limited his life might become, and he decided to apply to art school. A customer from the fruit stand provided him room and board in exchange for housework, and Fujita was able to enroll in the Chouinard Art Institute, where the smells of oil paints and kilns reminded him of his father's blacksmith shop. Fujita studied at the school for two years, until Executive Order 9066 forced him to move to the Heart Mountain Relocation Center in Wyoming. He served as the camp newspaper's art editor and was interned at Heart Mountain until he joined the U.S. Army in 1943.

After four years in the army, Fujita returned to Los Angeles and his studies at Chouinard. He became active in the California Watercolor Society and exhibited with the group for four years. Although he studied fine arts at Chouinard and was influenced by teachers Millard Sheets and Rex Brandt, he began to take graphic design courses in his last year of school, anticipating a need to support himself and a family following graduation.

Fujita married fellow Chouinard student Aiko Tamaki, and the couple moved to Philadelphia. Fujita was hired by N. W. Ayer & Son, the largest advertising firm in the United States at the time, and began a long and successful career. Despite his work as a commercial artist, Fujita continued to paint, and in 1953 he had his first one-man show in Philadelphia, in which all his work sold. Fujita applied for and received a Fulbright scholarship to study design and architecture in Italy, but at the same time he was offered the job of director of design and packaging at Columbia Records, and he accepted the position. The couple moved to New York, and Fujita worked for Columbia Records for six years. He was the first to feature original artwork on record album covers and is acknowledged as having revolutionized the industry. His own abstract painting appears on the cover of Dave Brubeck's *Time Out*. Fujita later ran his own design studio, and his distinctive bold graphic style can be seen in the many book covers he designed, such as Mario Puzo's *The Godfather* and Truman Capote's *In Cold Blood*, and in other logo and design work. Fujita also taught throughout his life, first at the Philadelphia Museum School of Art and then at the Pratt Institute, the New School for Social Research, and the Parsons School of Design, where he served on the faculty for eleven years.

Fujita has described his work as abstract derivations of nature. His paintings are characterized by a sophisticated use of geometric shapes and lines, and often the two-dimensional aspects of the composition are emphasized. The artist has frequently worked in opaque water-based media, utilizing muted colors in mottled fields. His later work includes detailed, anthropomorphized studies of fruits and vegetables.

Fukuhara, Henry K.

BORN: April 25, 1913, Los Angeles, CA

RESIDENCES: 1913–1942, Los Angeles and Santa Monica, CA § 1942–1943, Manzanar Relocation Center, Manzanar, CA § 1943–1944, Idaho and Farmingdale, NY § 1945–1987, Deer Park, NY § 1987–present, Santa Monica, CA

MEDIA: watercolor and acrylic painting, printmaking, and mixed media

ART EDUCATION: 1931, Otis Art Institute of the Los Angeles Museum of History, Science and Art

SELECTED SOLO EXHIBITIONS: Los Angeles Public Library, 1936 § Santa Monica Public Library, 1936 § Los Angeles Museum of History, Science and Art, 1936

SELECTED GROUP EXHIBITIONS: Los Angeles Museum, 1931 § Nassau Community College, Garden City, NY, 1976 § Elaine Benson Gallery, Bridgehampton, NY, 1979, 1983 § Setagaya Museum of Art, Tokyo, 1989 § *The View from Within*, Wight Art Gallery, University of California, Los Angeles, 1992 § *Living Legends Exhibit*, Mira Mesa College, Mira Mesa, CA, 1994

SELECTED COLLECTIONS: Heckscher Museum, Huntington, NY § Japanese American National Museum, Los Angeles § Los Angeles County Museum of Art § San Bernardino County Museum of Art, Redlands, CA

SELECTED BIBLIOGRAPHY: Fukuhara, Henry. CAAABS project interview. November 12, 1999. § *Hollywood Citizen News*, August 15, 1936. § Lovoos, Janice. "Working with Abandoned Control." *American Artist*, May 1993, 50–53. § "Magical Vistas in Linoleum Imprints." *Westways* 28, no. 6 (June 1936): 12–13. § Millier, Arthur. "Nurseryman's Art." *Los Angeles Times*, August 16, 1936, C5.

My goal is an innovative painting that's more interesting than the subject. If you're going to paint it the way it is, you might as well take a photograph.

HENRY FUKUHARA

http://www.watercolormagic.com/wcm_galleryarchive .asp?id=1603. Downloaded October 23, 2003.

LOS ANGELES–BORN Henry Fukuhara, eldest son of Ichisuke and Ume Fukuhara, grew up in the Pacific Palisades district of the city and Santa Monica. While he attended Santa Monica High School, Fukuhara's artistic ability was noted by his art teacher, Lucille Brown Greene, who encouraged him to pursue a career in painting. After graduating, he took her advice and attended the Otis Art Institute. However, after only two months he was forced to leave school and return to work due to hardships brought on by the Depression.

Never losing his interest in art, Fukuhara created a group of linoleum block prints that came to the attention of the Automobile Club of Southern California, who published four of them in their June 1936 edition of *Westways*. That same year, the prints were exhibited at the Los Angeles Public Library, the Santa Monica Public Library, and, most notably, the Los Angeles Museum of History, Science and Art, prompting favorable comments from leading art critics of Los Angeles. Arthur Miller of the *Los Angeles Times* said that Fukuhara's prints "have a classical feel, real character and poetry."

In April 1942, Fukuhara and his wife, daughter, and extended family were interned at the Manzanar Relocation Center. After being released to pick sugar beets in Idaho in 1943, he decided to find a place to start a new life. He and his family finally settled in Deer Park, on Long Island. Envisioning a series of sketches documenting life in the camps, Fukuhara gained permission from the authorities and visited the Topaz, Rohwer, and Jerome Relocation Centers to make pencil drawings. The portfolio of fifty sketches that resulted from these camp visits, along with drawings he had previously completed at Manzanar, was published in 1944 and offered for sale in the camps. Despite his efforts, sales of the portfolios were limited, as many internees did not want reminders of their years of internment. Today, however, Fukuhara's portfolio remains an important visual record of this experience.

Fukuhara started a wholesale flower business with his father and brother in Deer Park. Unfortunately, the demands of work prevented him from continuing to make art, and he did not resume painting until 1972, while recuperating from an operation. He began attending classes taught by Ed Whitney and workshops led by Robert E. Wood, and during a visit with his daughter in California, he studied with Rex Brandt and George Post. Fukuhara credits most of his subsequent success, however, to the influence of his last instructor, Carl Molno, who introduced him to modern art and encouraged him to work more loosely. Fukuhara developed a new approach to painting, which he has described as "abandoned control of the watercolor medium." Rapidly gaining recognition, he received invitations to juried shows, won awards, and obtained gallery representation.

Fukuhara's work is characterized by a sense of motion and energy, with a strong graphic foundation. Although primarily known for his watercolors, Fukuhara has also worked in acrylics and created mixed-media collages. His paintings, which are often landscapes or cityscapes, combine a loose and imaginative sketching style with compositionally faceted shapes of color.

In 1987, Fukuhara retired and returned to Santa Monica, where he has been able to devote his time to painting and teaching. He is a nationally respected watercolor teacher and has held numerous seminars and workshops throughout the United States.

Gee, Yun (Zhu Yuanzhi)

BORN: February 22, 1906, Kaiping, Guangdong, China

DIED: June 5, 1963, New York, NY

RESIDENCES: 1906–1921, Guangdong, China § 1921–1927, San Francisco, CA § 1927–1930, Paris, France § 1930–1936, New York, NY § 1936–1939, Paris, France § 1939–1963, New York, NY

MEDIA: oil painting on canvas, paperboard, and silk, and drawing

ART EDUCATION: 1924–1927, California School of Fine Arts, San Francisco

SELECTED SOLO EXHIBITIONS: Modern Gallery, San Francisco, 1926 § Galerie à Reine Margot, Paris, 1936, 1939 § *The Paintings of Yun Gee*, William Benton Museum of Art, University of Connecticut, 1979 (traveled to the Oakland Museum of California; Bowdoin College Museum of Art, Brunswick, ME; Art Gallery, University of North Carolina at Greensboro) § *The Art of Yun Gee*, Taipei Fine Arts Museum, 1992 § *The Art and Poetry of Yun Gee*, Pasadena Museum of California Art, 2003

SELECTED GROUP EXHIBITIONS: *Painting, Sculpture and Drawings by American and Foreign Artists*, Brooklyn Museum, 1931 § *The Social Viewpoint in Art*, John Reed Club, New York, 1932 § *Murals by American Painters and Photographers*, Museum of Modern Art, New York, 1932 § *Made in California: Art, Image, and Identity, 1900–2000*, Los Angeles County Museum of Art, 2000

SELECTED COLLECTIONS: Hirshhorn Museum and Sculpture Garden, Washington, D.C. § Los Angeles County Museum of Art § Oakland Museum of California § Whitney Museum of American Art, New York

SELECTED BIBLIOGRAPHY: *The Art of Yun Gee*. Taipei, Taiwan: Taipei Fine Arts Museum, 1992. § Brodsky, Joyce. *The Paintings of Yun Gee*. Storrs, CT: William Benton Museum of Art, University of Connecticut, 1979. § Lee, Anthony W., ed. *Yun Gee: Poetry, Writings, Art, Memories*. Seattle: Pasadena Museum of California Art in association with University of Washington Press, 2003.

While I attended the California School of Fine Arts I met Mr. Otis Oldfield, an inspiring Modern Artist. It was through him that I discovered the broad scope of creativity in painting. Then I discovered Diamondism which happily set San Francisco on its ear and attracted the patronage of Prince and Princess Murat. These two invited me to go to Paris . . . ah, the ultimate dream of the artist.

<div align="right">

YUN GEE
"Yun Gee Speaks His Mind,"
ca. 1954, in Lee, ed., *Yun Gee*

</div>

AMONG THE MOST advanced modernist painters active in California during the 1920s, Yun Gee forged an international career that began in his native China, included two sojourns in Paris, and ended in New York City with his death in 1963. As a teenage student at the California School of Fine Arts, he was already a prominent exponent of modernism, arguably the most accomplished in San Francisco. His brief California career of only six years saw the precocious development of a personal cubist-derived style.

Yun Gee's father, Gee Quong On, was a merchant in San Francisco who, like other Chinese Americans, took advantage of the destruction of records during the 1906 earthquake and fire and claimed American citizenship, thereby securing entry to the country for his children. Under those circumstances, Yun Gee immigrated to the United States in 1921 at age fifteen after receiving some art training in China, possibly at the progressive Gao brothers studio. Gee settled in Chinatown and enrolled at the California School of Fine Arts, where he studied with various modernist-inclined artists, chief among them Otis Oldfield, who had recently returned from Paris. From Oldfield, Gee learned the coloristic cubist-derived style that determined the development of his painting. His work attracted attention and support from other artists and intellectuals, among them the politically radical poet Kenneth Rexroth and leftist painter Victor Arnautoff, and Gee presented a one-person show at the new Modern Gallery that launched a promising career before his twentieth birthday. During his six years in San Francisco he founded the Chinese Revolutionary Artists Club, which would continue after his departure from the city.

With the success of the exhibition and the encouragement of his new patrons, Prince and Princess Achille Murat, he sailed in 1927 for Paris, where he soon established himself within the bohemian modernist circle that included poet Paul Valéry (whose portrait he painted), Gertrude Stein, and several of the leading artists. In 1930 he married the poet Princess Paula de Reuss, who remained in Paris when he returned to the United States; they divorced in 1932. Despite the attention he and his work received in France, he decided to pursue his career in New York, expecting his Parisian experience to advance his professional fortunes in America. That was not to be the case, and he returned one more time to Paris in 1936, remaining until 1939, when events in Germany and

disappointing reception of his work sent him back to New York.

During his final two decades in New York, Gee's fortunes declined, as did his emotional state and health. He became increasingly isolated and eccentric, with limited opportunities to show his work. From 1942 to 1947 he was married to Helen Wimmer, with whom he had his only child. From 1950 until his death, Yun Gee lived with Velma Aydelott. During these later years he managed to attract a few students, including his daughter, Li-lan, and practiced a style of realism that he imagined would regain him favor in the art world. Instead, critics found it difficult to write about his new work and focused on his Chinese origins. Yun Gee expressed his dismay in some of his writings, most notably in "Yun Gee Speaks His Mind" (1954): "[In New York] it was not the subject of my art but my race [that critics wrote about]." Discouraged and depressed, he turned increasingly to alcohol. Yun Gee died of stomach cancer in 1963.

Harada, Taneyuki Dan

BORN: June 17, 1923, Los Angeles, CA

RESIDENCES: 1923–1931, Los Angeles, CA § 1931–1938, Japan § 1938–1941, Oakland, CA § 1942–1943, Tanforan Assembly Center, San Bruno, CA; Topaz Relocation Center, Topaz, UT; Leupp Isolation Center, Leupp, AZ § 1943–1946, Tule Lake Segregation Center, Newell, CA § 1946–1952, Richmond, CA § 1952–present, Berkeley, CA

MEDIA: oil painting

ART EDUCATION: 1947–1949, California College of Arts and Crafts, Oakland, CA

SELECTED SOLO EXHIBITIONS: Block 5, Tule Lake Segregation Center, Newell, CA, 1945 § KPFA-FM Station, Berkeley, CA, ca. 1950

SELECTED GROUP EXHIBITIONS: Oakland Art Gallery, Oakland, CA, 1948–1949 § San Francisco Museum of Art, 1948–1949 § California Palace of the Legion of Honor, San Francisco, 1948 § *The View from Within*, Wight Art Gallery, University of California, Los Angeles, 1992 § *Art After Incarceration*, Pro Arts Gallery, Oakland, CA, 1998

SELECTED COLLECTIONS: Fine Arts Museums of San Francisco § Japanese American National Museum, Los Angeles § Los Angeles County Museum of Art

SELECTED BIBLIOGRAPHY: Harada, Taneyuki Dan. CAAABS project interview. July 13, 1998. Transcript, Asian American Art Project, Stanford University. § Higa, Karin M. *The View from Within: Japanese American Art from the Internment Camps, 1942–1945*. Los Angeles: Japanese American

Dan Harada, 1996. Photo by Irene Poon

National Museum, 1992. § *Japanese and Japanese American Painters in the United States: A Half Century of Hope and Suffering, 1896–1945*. Tokyo: Tokyo Metropolitan Teien Art Museum and Nippon Television Network Corporation, 1995.

I just turned twenty [when I created the sketch for the painting Barracks] ... I remember it was an extremely hot day ... The sun was setting—casting dark long shadows on the hot desert ground. The setting sun stained the side of the barracks with orange hue. There was a pile of coals by the mess hall— so forlorn ... The barracks no longer were barracks for me but symbols of incarceration.
TANEYUKI DAN HARADA
Letter to Irene Poon, July 5, 1997

DAN HARADA WAS born in Los Angeles's Little Tokyo, but he moved to Japan with his mother when he was seven, following the death of his father. The Harada family remained in Japan for seven years and then moved to Oakland after Harada's mother remarried.

Four years later, when Harada was eighteen, the family was interned at the Tanforan Assembly Center. Harada first started painting while at Tanforan and later recalled that the Tanforan art school, founded by artists including **Chiura Obata** and **George Matsusaburo Hibi**, "was really an exciting place [with] teachers like **Mine Okubo**, **Frank Taira**, and others ... there were so many students the place was really packed every day."

After being moved to the Topaz Relocation Center, Harada continued studying art at the school there, where teaching was directed toward older students. Harada furthered his education with Obata, **Byron Takashi Tsuzuki**, and especially Hibi, whose attitude toward art most influenced his development. Harada continued to paint in camp after being transferred to the Leupp Isolation Center in Arizona, and later to the Tule Lake Segregation Center in California. His first one-person exhibition was held in the ironing room of Tule Lake's Block 5 in 1945. Harada experimented stylistically during his internment education and found particular inspiration in Albert Pinkham Ryder's dark, atmospheric works, which seemed to parallel his own environment of black tar barracks in the desert.

Following his release, Harada enrolled at the California College of Arts and Crafts, where he studied commercial design and illustration with Spencer Macky and others and was influenced by the work of Ben Shahn. During these years he supported himself by working as a fruit picker and gardener's helper. He exhibited in prestigious Bay Area juried exhibitions and received the James D. Phelan Award for his work in 1949. After presenting two solo exhibitions of new work in 1950, Harada eventually turned to a career in computer programming and worked for the federal government. He returned to painting after retirement.

Hartmann, Sadakichi

BORN: November 8, 1867, Nagasaki, Japan

DIED: November 21, 1944, St. Petersburg, FL

RESIDENCES: 1867–1871, Nagasaki, Japan § 1871–1882, Hamburg, Germany § 1882–1886, Philadelphia, PA (1885, 1886, extended stays in Europe) § 1887–1889, Boston, MA (and travels to Europe) § 1889–1892, New York, NY § 1892–1894, Boston, MA (1892, Europe) § 1894–ca. 1915, New York, NY § ca. 1915–1921, San Mateo and San Francisco, CA § 1921–1923, various (including NY, FL, NC, and NM) § 1923–1938, Los Angeles and Beaumont, CA § 1938–1944, Banning, CA

MEDIA: pastels

SELECTED SOLO EXHIBITIONS: *Impressions of an Amateur*, B. Kramer Studio, New York, 1894 § Art Gallery, Hollywood Library, Los Angeles, 1934 § University of California, Riverside, 1970

SELECTED GROUP EXHIBITION: Allen Gallery, New York, 1900

SELECTED COLLECTION: University of California, Riverside

SELECTED BIBLIOGRAPHY: Albers, Patricia. *Shadows, Fire, Snow: The Life of Tina Modotti*. New York: Clarkson Potter, 1999. § Batchelor, John, comp. *The Sadakichi Hartmann Papers: a descriptive inventory of the collection*

Sadakichi Hartmann reading the *California Demokrat*, 1910

in the University of California, Riverside, Library. Edited by Clifford Wurfel. Riverside, CA: University of California Library, 1980. § *The Life and Times of Sadakichi Hartmann, 1867–1944: An Exhibition Presented and Co-Sponsored by the University Library and the Riverside Press–Enterprise Co. at the University of California, Riverside, May 1 to May 31, 1970*. Riverside, CA: The University, 1970. § Pound, Ezra. *Guide to Kulchur*. 1938. Reprint, New York: New Directions, 1970, 309–310. § "Sadakichi's Pastels." *Los Angeles Times*, November 18, 1934, 2, 6. § Weaver, Jane Calhoun, ed. *Sadakichi Hartmann: Critical Modernist*. Berkeley: University of California Press, 1990.

Let us belong if we will to different creeds, entertain different political and moral views, different ideals for our mental, emotional and physical nature, but let us be united in the one effort to render our national life richer, purer, and more powerful, by giving to it a National Art.

SADAKICHI HARTMANN
Weaver, ed., *Sadakichi Hartmann:*
Critical Modernist, 14

EZRA POUND ONCE wrote, "If one had not been oneself, it would have been worth while being Sadakichi." Today Sadakichi Hartmann is regarded as one of the foremost art critics, thinkers, and writers of the late nineteenth and early twentieth centuries in the United States, and a prescient voice of an emerging international modernism. Hartmann was born in 1867 on Dejima, an island in the harbor of Nagasaki; his Japanese mother, Osada, died within months of his birth. Hartmann and his elder brother Taru were taken by their father,

a German government official, to live in Hamburg with their grandmother. There they received a privileged education in aristocratic surroundings. In 1882, Hartmann was sent to military boarding school, but within months he ran away and was subsequently sent to the United States to live with an uncle in Philadelphia. Hartmann worked in printing and engraving shops and began his "self-education" at the Mercantile Library of Philadelphia. He visited Walt Whitman regularly in Camden, New Jersey, beginning in 1884, sometimes translating German correspondence for the poet, and later documented these encounters in *Conversations with Walt Whitman* (1895).

During frequent stays in Europe—studying in Munich, Berlin, Paris, and London—Hartmann expanded his knowledge of literature, theater, and visual arts. In 1892, Hartmann traveled throughout Europe as a foreign correspondent, interviewing the most prominent writers and artists of the day. His association with Stéphane Mallarmé and other symbolist poets informed his own work as a playwright in such works as *Christ* (for which he was jailed for obscenity) and *Buddha* and would influence the art criticism he wrote in the 1890s.

Hartmann began writing essays on art for Philadelphia newspapers in the 1880s and in 1893, while living in Boston, founded the magazine *Art Critic*. However, this publication was short-lived, as his appreciation of European painters and dramatists was a step ahead of his American audience, and Hartmann moved from Boston to New York in 1894. To support himself, Hartmann turned to writing journalistic articles for various publications. He also lectured widely on art and was himself an artist, working primarily in pastels. Hartmann felt that pastels allowed him to work in a subjective manner

contrary to the "tameness of the photographic tendency in art." By 1896 Hartmann had sold almost one hundred of his pastels and given many others to friends. Very few of these early works survive. His pastels were described as having a strange, luminous quality and often depicted figures in dream-like nature scenes.

Hartmann published a second art journal called *Art News* in 1896, the same year Alfred Stieglitz launched *Camera Notes*. Although Hartmann's venture failed, he became close friends with Stieglitz and a regular contributor to *Camera Notes* and later to *Camera Work*, contributing important essays on art, photography, and an emerging modernism. Many of his most innovative essays were published under the pen name of Sidney Allan. Hartmann's first book on art, *Shakespeare in Art*, was published in 1900, and his 1901 two-volume publication, *History of American Art*, was used as a standard textbook for many years. Subsequent books included *Japanese Art* (1903) and *The Whistler Book* (1910). Hartmann wrote insightfully on photographers Edward Steichen, Alfred Stieglitz, Frank Eugene, Edward Curtis, and Paul Strand and was an early champion of such painters as Winslow Homer, Thomas Eakins, Marsden Hartley, Max Weber, Thomas Hart Benton, and Grant Wood. Hartmann himself served as a subject for many artists, and although his interests lay foremost in art and literature, not politics, he cofounded *Mother Earth* with Emma Goldman, Edwin Bjorkman, and John R. Coryell.

After living for several years in the San Francisco Bay Area, where he held court for visitors like the young Tina Modotti, severe asthma prompted Hartmann to search for a more hospitable environment, and he eventually settled in Southern California in 1923. Although some people remembered Hartmann for his writing and contribution to art history, he was increasingly identified as a colorful member of John Barrymore's circle in Hollywood and appeared as a court magician in Douglas Fairbanks's film *The Thief of Baghdad*. Although his writing declined, Hartmann's *The Last Thirty Days of Christ* (1920) was praised by Ezra Pound.

In 1938, Hartmann moved to the Morongo Indian Reservation in Banning, California, and lived in a shack he built adjacent to his daughter's home. He spent the last six years of his life there, creating pastels of the desert and writing. How Hartmann avoided internment during World War II is unclear; he may have lived outside of the exclusion zone, but townspeople periodically contacted the sheriff, convinced Hartmann was signaling Japanese planes from the top of Mount San Jacinto. He died while visiting his daughter Dorothea Gilliland in Florida in 1944.

Hasegawa, Saburo

BORN: September 6, 1906, Yamaguchi, Japan

DIED: March 11, 1957, San Francisco, CA

RESIDENCES: 1906–1929, Japan (including Kobe, Ashiya, Osaka, and Tokyo) § 1929–1932, France, United States, England, and Italy § 1932–1954, Japan (including Ashiya, Tokyo, Nagahama, and Fujisawa) § 1954, New York, NY § 1955, Japan § 1955–1957, San Francisco, CA

MEDIA: ink and oil painting, and printmaking

ART EDUCATION: 1926–1929, Tokyo Imperial University

SELECTED SOLO EXHIBITIONS: New Gallery, New York, 1953 § Oakland Museum of California, 1957 § Rose Rabow Gallery, San Francisco, 1959, 1976

SELECTED GROUP EXHIBITIONS: *Salon d'Automne*, Paris, 1930 § *Contemporary Art Exhibition of Japan*, San Francisco Museum of Art, 1952 (touring exhibition) § First and Second Tokyo Biennial Exhibitions, 1952, 1953 § Rose Fried Gallery, New York, 1955 § *Forerunners of Vanguard Painting in Japan*, Kyoto, Japan, 1965

SELECTED COLLECTIONS: Japan Society, New York § National Museum of Modern Art, Kyoto, Japan § National Museum of Modern Art, Tokyo § Oakland Museum of California § San Francisco Museum of Modern Art

SELECTED BIBLIOGRAPHY: Hasegawa, Saburo. "Five Calligraphic Drawings." In *New World Writing: Sixth Mentor Selection*. New York: The New American Library, 1954, 51–56. § Hasegawa, Saburo, and Inui Yoshiaki. *Ga, Ron* [Paintings, Treatise]. 2 vols. Tokyo: Sansai Sha, 1977. § Munroe, Alexandra. *Japanese Art After 1945: Scream Against the Sky*. New York: Harry N. Abrams, Inc., 1994. § Watts, Alan, ed. "Saburo Hasegawa: Artist of the Controlled Accident." Typescript, 1957. Biographical Folder. Oakland Museum of California.

To be / consciously unconscious / and unconsciously conscious / both / physically / and / mentally / is / not impossible / when through enlightenment one could conceive / that / spontaneity is evanescent / and / evanescence is spontaneous / in / man / nature / and / art / My / work / consists of / controlled accidents / as much as / my life / does
 SABURO HASEGAWA
 "Five Calligraphic Drawings," 52

SABURO HASEGAWA WAS a painter, printmaker, critic, and educator who is remembered in Japan as an influential, avant-garde artist. He cofounded the Jiyū Bijutsu Kyōkai (Free Artists Association) in 1937 and later authored books on art education. Hasegawa's mature work synthesized Western abstract painting, which he had observed during his international travel between 1929 and 1932, and Asian ideas about art. During World

War II, he began to intensively practice Zen Buddhism and tea ceremony and was arrested in 1944 for refusing to create art for propaganda purposes. In 1950, he met and became friends with **Isamu Noguchi**, who encouraged his interest in abstraction and traditional Japanese art. At about this time, Hasegawa turned away from oil painting, the medium in which he primarily worked, and began a new body of work consisting of prints, calligraphy, and rubbings. His reintroduction of traditional materials such as *sumi-e* ink and rice paper was considered anachronistic by some in the Japanese art world. In the United States, however, his works were highly praised, and his thinking about abstraction was extremely influential.

When Zen and other Eastern philosophies attracted interest in the United States in the early 1950s, the works of Hasegawa were exhibited in several major U.S. cities, including San Francisco and Los Angeles, as well as museums and galleries in New York. His woodblock prints and *sumi-e* ink works were acquired by leading American museums and private collections. He also gained prominence in New York as a writer for *Art News*, as a lecturer—among those in attendance at his New York lectures were Franz Kline and Willem de Kooning—and as an advisor to museums, including the Museum of Modern Art. During this time, Hasegawa met California scholar and teacher Alan Watts, who invited him to

lecture in the Bay Area. Hasegawa lectured at Watts's American Academy of Asian Studies in San Francisco, and he began teaching at the California College of Arts and Crafts in 1955. His lectures focused on Eastern ideas, Asian art history, and drawing and painting. He also demonstrated tea ceremony and ikebana. Widely known in the Bay Area artistic and literary communities at the time of his death from cancer, he influenced many students, including painter **Bernice Bing** and poet Gary Snyder.

Hashimoto, Michi

BORN: July 10, 1887, Fukushima, Japan

DIED: April 17, 1972, Los Angeles, CA

RESIDENCES: 1887–1911, Fukushima and Miyagi, Japan § 1911–1920, Oakland, CA § 1920–1942, Los Angeles, CA § 1942–1944, Tokyo, Japan § 1944–1950, Fukushima, Japan § 1950–1957, Pacoima, CA § 1957–1972, Los Angeles, CA

MEDIA: oil and watercolor painting, and decorative screens

ART EDUCATION: ca. 1921–1924, University of California, Los Angeles

Saburo Hasegawa, ca. 1956

Michi Hashimoto and her husband
on their anniversary, 1937

SELECTED SOLO EXHIBITIONS: Los Angeles Museum,
1924 § Frances Webb Gallery, Los Angeles, 1940

SELECTED GROUP EXHIBITIONS: California Watercolor
Society, Los Angeles, 1925, 1926, 1929 § *Artists of
Southern California*, San Diego Art Gallery, 1926 §
Laguna Beach Art Association, Laguna Beach, CA,
1926 § *Painters and Sculptors of Southern California*,
Los Angeles Museum, 1929 § California State Fair,
Sacramento, 1931 § Olympic Competition and Exhibition,
Los Angeles, 1932 § Wilshire Art Gallery, Los Angeles,
1934

SELECTED BIBLIOGRAPHY: Asaka, Alice. "Fujin-Kwai to Give
Farewell Banquet." *Rafu Shimpo* (Los Angeles), March
14, 1930, 1. § "Art Parade Reviewed," *Los Angeles Times*,
July 7, 1940, part 3, 8. § "Michi Hashimoto." *Los Angeles
Times*, January 20, 1924, part 3, 30. § Moure, Nancy
Dustin Wall. *Publications in Southern California Art 1, 2 & 3*.
Los Angeles: Dustin Publications, 1984. § 1930 Federal
Population Census. Los Angeles, Los Angeles, Califor-
nia. Roll 135, Page 7A, Enumeration District 84, Image
491.0. National Archives, Washington, D.C. § Obituary
of Michi Hashimoto. *Los Angeles Times*, April 19, 1972,
part 1, 26. § "Young Nisei Artists to Exhibit at Wilshire
Art Gallery Showing." *Rafu Shimpo* (Los Angeles), April 4,
1934, 1.

AT THE AGE of twenty-four, Michi Hashimoto (born Michi
Yoshida) emigrated from Japan to Oakland, California. Nine

years later she moved to Los Angeles and began attending
UCLA. She married Masahiko Hashimoto in 1922, and the
couple settled in West Los Angeles, where Masahiko ran a suc-
cessful plant nursery with his brothers.

Hashimoto's first solo show was held at the Los Angeles
Museum in 1924. Work exhibited included watercolors and
painted screens. A review of the show in the *Los Angeles Times*
focused on the "decidedly oriental" nature of her work; it
serves as an example of how issues of oriental versus occiden-
tal style likely played out in Hashimoto's professional life. The
article states that despite Hashimoto's desire to work in the
manner of Western artists, teachers at UCLA "encouraged her
to keep to the occidental oriental spirit in her work, and she
soon came to a place in her study where she wished to express
herself in the Japanese manner."

Hashimoto exhibited widely in the 1920s and early 1930s,
showing landscapes, still lifes, and work with religious or mys-
tical themes. A 1940 solo exhibition at the Frances Webb Gal-
lery featured portraits of her friends and relatives, and this
time she was described as working in "a direct Western style,"
in a *Los Angeles Times* review. Extant paintings include stylized
portraits, landscapes with elements of fantasy, and work utiliz-
ing gold metallic paint.

Hashimoto and her husband were recognized as promi-
nent West Los Angeles residents and important members of
the Japanese community. She served as the first president of
the Fujin-kai, a women's group, and news of the couple's depar-
ture for and return from a six-month trip to Japan in 1930 was
covered extensively in the *Rafu Shimpo*. In 1942, the couple
moved to Japan and lived in Tokyo. Their home was destroyed
by an accidental fire (not a result of U.S. fire bombings of the
cities), in which much of her work was lost, and in 1944 they
moved to Fukushima. They moved back to California in 1950
and settled in Pacoima, and in 1957 they returned to West Los
Angeles. Michi Hashimoto ran the Hashimoto Nursery until
1970.

Hayakawa, Miki

BORN: June 7, 1899, Nemuro, Hokkaido, Japan

DIED: March 6, 1953, Santa Fe, NM

RESIDENCES: 1899–1908, Nemuro, Hokkaido, Japan §
1908–1929, Oakland and Alameda, CA § 1929–1937, San
Francisco, CA § 1937–1940, Pacific Grove, CA § 1940–
1942, Monterey, CA § 1942, Stockton, CA § 1942–1953,
Santa Fe, NM

MEDIA: oil painting and printmaking

ART EDUCATION: 1922, School of the California Guild of Arts
and Crafts, Berkeley, CA § 1923–1929, California School
of Fine Arts, San Francisco

SELECTED SOLO EXHIBITIONS: Kinmon Gakuen,
San Francisco, 1929 § Santa Fe East Gallery,
Santa Fe, NM, 1985

SELECTED GROUP EXHIBITIONS: *San Francisco Art Associa-
tion*, California Palace of the Legion of Honor, 1924, 1925,
1931 § *San Francisco Art Association*, California School of
Fine Arts, 1927–1929 § *Painters and Sculptors of Southern
California*, Los Angeles Museum, 1927, 1936 § *San
Francisco Art Association*, San Francisco Museum of
Art, 1935 (inaugural), 1938 § *Exhibition of California
Oriental Painters*, Foundation of Western Art, Los Angeles,
1937 § *38th Annual Exhibition for New Mexico Artists*, San
Francisco Museum of Art, 1951 § *Made in California:
Art, Image, and Identity, 1900–2000*, Los Angeles County
Museum of Art, 2000

SELECTED COLLECTIONS: Japanese American National
Museum, Los Angeles § Los Angeles County Museum
of Art § Museum of New Mexico, Santa Fe

SELECTED BIBLIOGRAPHY: Brown, Michael D. *Views from
Asian California, 1920–1965*. San Francisco: Michael D.
Brown, 1992. § *Japanese and Japanese American Painters
in the United States: A Half Century of Hope and Suffer-
ing, 1896–1945*. Tokyo: Tokyo Metropolitan Teien Art
Museum and Nippon Television Network Corporation,
1995. § Kovinick, Phil, and Marian Yoshiki-Kovinick. *An
Encyclopedia of Women Artists of the American West*. Austin:
University of Texas Press, 1998, 131–132. § Turner, Louise.
"A Japanese-American of the Cezanne School." *Southwest
Profile*, September–October 1985, 19–24.

*Painting is a mirror of one's own self.... If I have any unkindness
in my heart, I don't dare to take a brush and paint. One must
approach a canvas feeling, in a way, pure.*

MIKI HAYAKAWA
Turner, "A Japanese-American
of the Cezanne School," 23

NOTED FOR HER rich color and modernist experimentation
with form, Miki Hayakawa was a prominent painter in Cal-
ifornia throughout the 1920s and 1930s. Born in Japan, Ha-
yakawa moved to the Oakland area with her mother in 1908,
joining her father who had arrived the year before. As a teen-
ager, she became determined to study art, but her father, a
minister, strongly disapproved of his daughter's decision, and
she was forced to leave the house and live on her own. She sub-
sequently supported herself by housecleaning and designing
costumes. Already recognized as a talented artist, Hayakawa
received scholarships to study at the School of the California
Guild of Arts and Crafts, then located in Berkeley, and at the
California School of Fine Arts in San Francisco. During her
time at the California School of Fine Arts she befriended class-
mates **Yun Gee** and **George Matsusaburo Hibi**, who became
mentors. She worked alongside Gee in classes at the school, as
evidenced by their portraits of the same subject; Gee's painting
included Hayakawa at work. Hayakawa's adventurous paint-
ings from the late 1920s reflect the fauvist color and cubist
broken form associated with Gee, but her work encompasses
more solid, classical portraits as well, and she exhibited at pre-
miere California museums from the mid-1920s throughout the
1930s.

In 1937, Hayakawa moved to the Monterey Peninsula,

Miki Hayakawa (center)
with Hisako Shimizu (Hibi)
and George Matsusaburo
Hibi, late 1920s

where she exhibited regionally as well as continued to exhibit in San Francisco. After moving to Stockton at the beginning of 1942, she and her family were assigned to the Santa Fe Justice Department Camp, although the artist was permitted to live in the Santa Fe community at large, released on her own recognizance. She became involved with the artists of Santa Fe, including John Sloan and Foster Jewell, and married artist Preston McCrossen in 1947. During this period, she espoused the influence of Cézanne, creating Santa Fe–inspired landscapes as well as portraits. She died from cancer at the age of fifty-three.

Hayakawa, Sessue

BORN: June 10, 1890, Nanaura, Chiba Prefecture, Japan

DIED: November 23, 1973, Tokyo, Japan

RESIDENCES: 1890–1909, Nanaura, Chiba Prefecture, Japan § 1909–1913, Chicago, IL § 1913–1922, Los Angeles, CA § 1922, Tokyo, Japan § 1923–1926, Paris, France § 1926–1931, New York, NY § 1931–1934, Tokyo, Japan, and Los Angeles, CA § 1934–1937, Tokyo, Japan § 1937–1949, Paris, France § 1949–1973, Los Angeles, CA, and Tokyo, Japan

MEDIA: oil and watercolor painting

SELECTED SOLO EXHIBITIONS: Galérie Roux-Hentschel, Paris, 1948 § Frances Webb Galleries, Los Angeles, 1949

Sessue Hayakawa, ca. 1924

SELECTED BIBLIOGRAPHY: Hayakawa, Sessue. *Zen Showed Me the Way…to Peace, Happiness and Tranquility*. Indianapolis: Bobbs-Merrill, 1960. § "Hayakawa Can Use the Brush Like Any Real, Regular Artist." *Los Angeles Express*, August 23, 1919, sec. 3, 4. § "Oriental-Style Works Shown by Hayakawa." *Los Angeles Times*, February 27, 1949, 4. § "Sessue Hayakawa." *Arts, Beaux-Arts, Littérature, Spectacles*, June 25, 1948, 4.

Destiny has brought me much. She has been kind. But it has been left to me to fashion the acumen of deeds in the pattern destiny has drawn, to solve the great koan *of life for myself.*

SESSUE HAYAKAWA
Zen Showed Me the Way…, 256

KINTARO HAYAKAWA (who later changed his name to Sessue) was the youngest son of the governor of Chiba Prefecture. He attended naval prep school, but his military career ended before he could enter the naval academy when he ruptured an eardrum while diving. His resulting depression led to an attempt at suicide. In his autobiography, *Zen Showed Me the Way*, he explained how he retreated to an abandoned mountaintop temple, where he practiced meditation and studied Zen Buddhism for the first time. In May 1909, Hayakawa helped passengers from an American ship that was grounded in Tokyo Bay, and he attributed this encounter as the impetus for his desire to study in the United States. He enrolled at the University of Chicago later that year and graduated in 1913 with a B.A. in political science.

Hayakawa stopped in Los Angeles during his journey back to Tokyo, where a career in government awaited him. While in Los Angeles he became involved with the community of actors in Little Tokyo. Hayakawa produced the play *Typhoon*, which came to the attention of silent film director Thomas Ince. Ince subsequently made a film version of the story, with the newly named "Sessue" Hayakawa as the lead. In 1914, Hayakawa married actress Tsuru Aoki, the adopted daughter of artist **Toshio Aoki**, and the film careers of both Hayakawa and Aoki flourished in the following years.

Hayakawa's role as an art dealer in Cecil B. DeMille's *The Cheat* (1916) established the actor as one of the most popular film stars of the era. He was lauded for his measured performances, which were influenced by the Zen concept of *muga*, or "absence of doing," a welcomed contrast to the overwrought emotions and broad gestures of other silent film actors. However, despite his status as a handsome leading man, anti-Japanese prejudice meant that Hayakawa's roles were limited to villains or exotic lovers. In 1918, in response to this stereotyping, Hayakawa started his own film company, Haworth Pictures, and produced twenty-three movies in four years, including the 1919 production of *The Dragon Painter*, which was filmed in Yosemite and starred Hayakawa in the title role,

with Aoki as his muse. Hayakawa played another painter in *The Gray Horizon*, also in 1919, and an article in the *Los Angeles Express* detailed how Hayakawa had studied painting at the University of Chicago and was himself a talented artist.

Hayakawa and Aoki hosted elaborate parties at their Hollywood mansion, known as "Argyle Castle." The parties were reminiscent of the galas Aoki had hosted as a child with her adopted father almost two decades earlier in Pasadena. In the increasingly anti-Japanese climate Hayakawa explained that he "was determined to show the Americans who surrounded me that I, a Japanese, could live up to their lavish standards." During the filming of *The Vermilion Pencil*, a film Hayakawa made in collaboration with the Robertson-Cole Company, the actor was almost killed when a set collapsed. He later discovered that members of Robertson-Cole were active in the growing anti-Japanese movement. These events prompted Hayakawa and Aoki to give up their Hollywood lives and move to Japan. Ironically, their stay in Tokyo was cut short when they received death threats by those who felt their films presented unflattering depictions of Japanese. The couple finally settled in Paris, where they lived until 1926.

While in Paris, Hayakawa wrote a novel, acted in films, performed for British royalty, and was a celebrated performer in Parisian nightclubs. The couple then moved to New York, where Hayakawa acted in theater and vaudeville and in 1927 established a Zen temple and study center in a converted apartment.

Between 1931 and 1933, Hayakawa and Aoki spent time in Tokyo and Los Angeles, and in 1934 they settled in Tokyo. In 1937, Hayakawa traveled to Paris to make a movie and became trapped in Europe at the outbreak of World War II. He remained in France, separated from his family for eleven years, and turned to painting to support himself during the German occupation. His war-era watercolors on silk depicting landscapes and animals were said to fuse traditional brush painting with impressionism; they were shown in a 1948 solo exhibition in Paris just prior to his departure from Europe. Before returning to Japan, Hayakawa stopped in Hollywood, where he made the film *Tokyo Joe* with Humphrey Bogart and held another solo show of his artwork. He was reunited with his family in Tokyo later that year.

Hayakawa's return to Japan marked the actor's further immersion in Zen Buddhism, culminating in his ordination as a Zen priest. Hayakawa continued to occasionally act in films, and in 1957 he received an Academy Award nomination as best supporting actor in *The Bridge on the River Kwai*. Following his wife's death in 1961, Hayakawa continued to act sporadically but increasingly devoted his energy to his Zen practice.

Hee, Hon Chew

BORN: January 24, 1906, Kahului, Maui, HI

DIED: May 17, 1993, Kaneohe, Oahu, HI

RESIDENCES: 1906–1911, Kahului, Maui, HI § 1911–1920, Guangzhou, China § 1920–1929, Honolulu, HI § 1929–1932, San Francisco, CA § 1932–1933, Guangzhou, China § 1933–1948, Honolulu, HI § 1948–1951, New York, NY § 1951–1953, Paris, France § 1953–1960, Berkeley, CA § 1960–1993, Kaneohe, Oahu, HI

MEDIA: oil and watercolor painting, printmaking, and murals

ART EDUCATION: 1929–1932, California School of Fine Arts, San Francisco § 1948–1951, Art Students League, New York

SELECTED SOLO EXHIBITIONS: Honolulu Academy of Arts, 1935, 1983 § *Hon Chew Hee: A Lifelong Art Expression*, Kuakini Medical Center, Honolulu, 1987

SELECTED GROUP EXHIBITIONS: *San Francisco Art Association*, California Palace of the Legion of Honor, San Francisco, 1931, 1932 § *Chinese Art Association of America*, de Young Museum, San Francisco, 1935/36 § *San Francisco Art Association*, de Young Museum, San Francisco, 1959, 1962

SELECTED COLLECTIONS: Honolulu Academy of Arts § National Museum of History, Taipei § Nelson-Atkins Museum of Art, Kansas City, MO

SELECTED BIBLIOGRAPHY: Haar, Francis, and Prithwish Neogy. *Artists of Hawaii: Nineteen Painters and Sculptors*. Honolulu: University of Hawaii Press, 1974. § Hee, Hon-Chew. *Serigraphs*. Honolulu: Hon-Chew Hee Studio, 1973. § Ronch, Ronn. "Hon Chew Hee's Life with Color." *Honolulu Advertiser*, October 1, 1987, B1, B3. § Taylor, Lois. "The True Artist." *Honolulu Star Bulletin*, August 21, 1983, C1.

I always wondered how I would be able to combine the East and the West. And I never could do it. Then when I dropped Chinese art altogether, went to Western art, I found Western art lacked culture. So when I studied with Lhote and Léger I was interested only in their theories, their principles, their ideas. When I returned from Europe I found out that I had to go back to the Oriental thinking. I began to use the Oriental as a base and used Occidental as the surface, working on it. And now I feel that I know what I am doing. Today I try to go into the combination of the East and the West.

HON CHEW HEE
Haar and Neogy, *Artists of Hawaii*, 69

AMONG HAWAII'S BEST-KNOWN artists, Hon Chew Hee spent important formative years in China, California, and France. Hee was born in Maui, where his father was a well-known edu-

cator and Cantonese interpreter for Queen Liliʻuokalani. Hee was sent to China when he was five to receive a formal education, including training in brush painting. He remained in Guangzhou until he was fourteen, when he returned to Hawaii to finish his American education. Hee's interest in art continued to grow, and the young artist was even expelled from high school for drawing during English class. Hee worked in the pineapple fields and eventually saved enough money to travel to San Francisco to study at the California School of Fine Arts.

During his three years at the California School of Fine Arts, Hee received the Virgil Williams Scholarship and worked with Diego Rivera on the mural *The Making of a Fresco Showing the Building of a City*. Rivera asked the young artist to join him in Mexico, but Hee was unable to accept the offer.

After graduation, Hee went to China and taught art for a year and then returned to Hawaii in 1933. While in Honolulu, he taught at the YMCA with Isami Doi, who showed Hee how to make wood carvings. Hee, along with Doi, Madge Tennent, and Marguerite Louis Blasingame, founded the Hawaiian Mural Arts Guild in 1934, and the following year, Hee had his first one-person show at the Honolulu Academy of Arts. Hee was employed at the Pearl Harbor Naval Base in the sign shop and was present during the December 1941 bombing, which occurred five days after he began working there. While at the naval base, Hee taught himself serigraphy (silkscreen) printing, which would later become a preferred medium for the artist.

In 1948, Hee and his wife, Marjorie, moved to New York. While she pursued a master's degree in education, Hee studied English at Columbia University in the mornings and watercolor painting with George Grosz at the Art Students League in the afternoons. When his wife completed her degree and returned to Hawaii, Hee decided to travel instead to Paris, where he stayed for eighteen months, studying with André Lhote and Fernand Léger. In Paris, Hee was greatly influenced by modern art and was especially interested in the move from impressionism to abstraction by artists such as Cézanne and Picasso, seeing parallels in abstract European art and Chinese art. Ultimately he credited a synthesis of both Western and Asian art traditions for the development of his personal style.

After he returned from Europe, Hee and his wife lived in Berkeley for seven years. During this time Hee exhibited with the San Francisco Art Association; he also completed a mural for the Oakland Naval Supply Center. Returning to Hawaii in 1960, Hee soon established himself as one of the state's most respected artists. He taught at the University of Hawaii and often gave private lessons, including private instruction in brush painting to Jacqueline Kennedy. He founded both the Hawaii Watercolor Serigraph Society and the Ten Bamboo Studio of Hawaii and had several exhibitions in Taiwan, where he also taught. He continued to work and exhibit until shortly before his death.

Hee's work varied stylistically depending on the medium he used. His watercolors are generally impressionistic and draw on traditions of brush painting, later oils are often geometric and abstract, and serigraphs frequently demonstrate the influence of Léger. In addition to reflecting his various artistic influences and training, many of Hee's paintings illustrate dual Chinese and native Hawaiian cultural histories. Such works include the serigraph *Chinese Meets Hawaiian*, which depicts a historical exchange of gifts, and the enamel-on-steel abstract mural *Under the Pacific*, located at Kauai Community College.

Hibi, George Matsusaburo

BORN: June 21, 1886, Iimura, Shiga Prefecture, Japan

DIED: June 30, 1947, New York, NY

RESIDENCES: 1886–1906, Japan § 1906–1918, Seattle, WA § 1918, San Diego, CA § 1919–1933, San Francisco, CA § 1933–1942, Mt. Eden and Hayward, CA § 1942–1945, Tanforan Assembly Center, San Bruno, CA; Topaz Relocation Center, Topaz, UT § 1945–1947, New York, NY

MEDIA: oil painting and printmaking

ART EDUCATION: ca. 1905, Hōsei College, Kyoto (now Ritsumeikan University) § 1919–1930, California School of Fine Arts, San Francisco

SELECTED SOLO EXHIBITIONS: Hayward Union High School, CA, 1937 § *Matsusaburo Hibi Retrospective*, Lucien Labaudt Gallery, San Francisco, 1962

SELECTED GROUP EXHIBITIONS: *East West Art Society*, San Francisco Museum of Art, 1922 § *San Francisco Art Association*, California Palace of the Legion of Honor, 1925, 1931 § California State Fair, Sacramento, 1938 § *San Francisco Art Association*, San Francisco Museum of Art, 1939, 1940, 1945, 1946 § Oakland Art Gallery, 1943, 1944 § Associated American Artists, New York, 1945 § *The View from Within*, Wight Art Gallery, University of California, Los Angeles, 1992 § *Made in California: Art, Image, and Identity, 1900–2000*, Los Angeles County Museum of Art, 2000

SELECTED COLLECTIONS: Fine Arts Museums of San Francisco § Hayward Historical Society, Hayward, CA § Japanese American History Archives, San Francisco § Japanese American National Museum, Los Angeles § UCLA University Research Library, Special Collections

SELECTED BIBLIOGRAPHY: Hibi, George Matsusaburo. Artist File. Archives of the San Francisco Art Institute. § Higa, Karin M. *The View from Within: Japanese American Art from the Internment Camps, 1942–1945*. Los Angeles: Japanese

American National Museum, 1992. § "Japanese Artist Leaves All Paintings to Hayward Groups." *Hayward Review*, April 8, 1942, 3. § Lee, Ibuki. CAAABS project interview. April 25, 1995. San Francisco.

I am now inside of barbed wires but still sticking in Art—
I seek no dirt of the earth—but the light in the star of the sky.

GEORGE MATSUSABURO HIBI
Letter dated December 9, 1944.
Quoted in Grace L. McCann Morley, "Foreword,"
Ninth Annual Drawing and Print Exhibition,
San Francisco Art Association, January 31–February 25, 1945.

GEORGE MATSUSABURO HIBI was a central figure in both the development of important art associations in pre–World War II Northern California and the creation of influential art schools at Tanforan and Topaz during internment. He was nicknamed "George" upon his arrival in the United States, and the artist used both nickname and given name during his professional career.

After beginning an education in law, Hibi moved at the

Hisako and George Matsusaburo Hibi, 1931

age of twenty to Seattle, where he studied English. He subsequently relocated to San Francisco and drew cartoons for several California newspapers and Japanese publications in the United States. In 1919, he began a long relationship with the California School of Fine Arts, first as a student and later as a staff member. At that time, the influence of Cézanne was strong in the teaching of Gottardo Piazzoni and other faculty, and Hibi's regular, broad brushwork reflected this. Hibi worked at the school in a variety of capacities, including as a gardener, custodian, and store clerk. He also was a teaching assistant who gave demonstrations and provided technical information about materials and processes, including batik.

Hibi was instrumental in the founding of the East West Art Society in 1921, and he was the lead contact in arranging the group's 1922 exhibition at the San Francisco Museum of Art. In that exhibition, Hibi displayed ten works. By that time he had developed his signature imagery of mountain lions, wolves, and other California wildlife, often depicted in moments of dramatic struggle for survival.

Hibi participated in important group exhibitions during the 1920s and 1930s, including many exhibitions at the Kinmon Gakuen (Golden Gate Institute), in San Francisco. He also founded another artists' association in 1927, the Amateur and Professional Artist Society. In 1930, he married Hisako Shimizu (**Hisako Hibi**), who had also been a student at the California School of Fine Arts. In 1933 the couple moved to the Hayward area, where Hibi began a Japanese-language school for Nisei children and continued to hold exhibitions, including a 1937 solo show in which he presented ninety works.

Anticipating internment, Hibi donated fifty paintings to community venues in Hayward, stating, "There is no boundary in art. This is the only way I can show my appreciation to my many American friends here." Regrettably, only a handful of pre-1942 works have survived. The 1942 relocation of the Hibi family to the Tanforan Assembly Center is recorded in photographs by Dorothea Lange, underscoring the couple's stature in the Bay Area arts community. There, and at the Topaz Relocation Center, Hibi helped organize important art schools, with sequential curriculum structured in part on the model of the California School of Fine Arts. At Topaz, Hibi's teaching emphasized Cézanne, and his paintings and small wood-block prints include imagery of snowy barracks and threatening wolves. After the medical release of **Chiura Obata** from Topaz in 1943, Hibi served as director of the art school for more than two years and organized important exhibitions of the art produced there.

At the end of the war in 1945, Hibi and his family moved to New York City, where he exhibited and hoped to make a fresh start as an artist. Unfortunately, his health deteriorated, and he died of cancer in 1947 a few days after his sixty-first birthday.

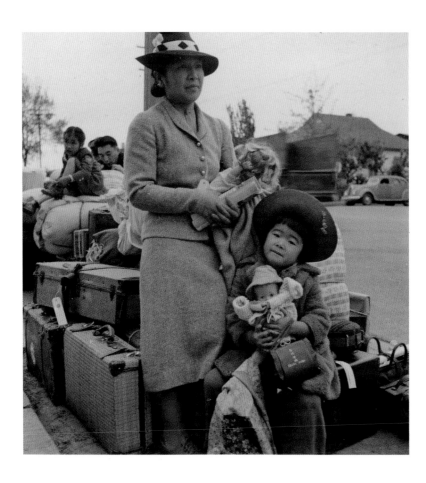

Hisako Hibi and
daughter Ibuki leaving
for internment, 1942.
Photo by Dorothea Lange

Hibi, Hisako

BORN: May 14, 1907, Torihama, Fukui Prefecture, Japan

DIED: October 25, 1991, San Francisco, CA

RESIDENCES: 1907–1920, Torihama, Fukui Prefecture,
Japan § 1920–1933, San Francisco, CA § 1933–1942, Mt.
Eden and Hayward, CA § 1942–1945, Tanforan Assembly
Center, San Bruno, CA; Topaz Relocation Center, Topaz,
UT § 1945–1954, New York, NY § 1954–1991, San
Francisco, CA

MEDIA: oil painting and printmaking

ART EDUCATION: 1926–1929, California School of Fine Arts,
San Francisco § 1952–1953, Museum of Modern Art, New
York

SELECTED SOLO EXHIBITIONS: Lucien Labaudt Gallery, San
Francisco, 1970 § *Retrospective*, Perception Gallery, San
Francisco, 1977 § *Hisako Hibi, Her Path*, Somar Gallery,
San Francisco, 1985 § National Japanese Historical
Society, San Francisco, 1986 § *A Process of Reflection:
Paintings by Hisako Hibi*, Japanese American National
Museum, Los Angeles, 1999

SELECTED GROUP EXHIBITIONS: *California Art Today*, Golden
Gate International Exposition, San Francisco, 1940 § *San
Francisco Art Association*, San Francisco Museum of Art,
1941, 1944, 1946 § *Strength and Diversity: Japanese
American Women, 1885–1990*, Oakland Museum of Califor-
nia, 1990 § *The View from Within*, Wight Art Gallery,
University of California, Los Angeles, 1992 § *Asian
Traditions/Modern Expressions*, Jane Voorhees Zimmerli Art
Museum, Rutgers State University, New Brunswick, NJ,
1997 § *Made in California: Art, Image, and Identity, 1900–
2000*, Los Angeles County Museum of Art, 2000

SELECTED COLLECTIONS: Fine Arts Museums of San
Francisco § Japanese American National Museum,
Los Angeles § Los Angeles County Museum of Art

SELECTED BIBLIOGRAPHY: Brown, Michael D. *Views from
Asian California, 1920–1965*. San Francisco: Michael D.
Brown, 1992. § Hibi, Hisako. *Peaceful Painter: Memoirs of
an Issei Woman Artist*. Ed. Ibuki Hibi Lee. Berkeley: Heyday
Books, 2004. § Kano, Betty. "Four Northern California
Artists: Hisako Hibi, Norine Nishimura, Yong Soon Min,
and Miran Ahn." *Feminist Studies* 19, no. 3 (Fall 1993):
628–642. § Taylor, Sandra C. *Jewel in the Desert: Japanese
American Internment at Topaz*. Berkeley: University of
California Press, 1993.

*This life is transitory / Time to bloom, time to fall /
as Spring comes and goes / art continues in timeless time.*

HISAKO HIBI

Kristine Kim. *A Process of Reflection: Paintings by
Hisako Hibi*. Exhibition catalog. Los Angeles:
Japanese American National Museum, 1999, 17.

DURING HER LONG CAREER, which spanned nearly eight decades, Hisako Hibi created paintings that recorded her personal history. While her images of internment and the dark period that followed are among the most powerful documents of that experience, the artist was also acclaimed for her exuberant later works, which demonstrated her survival and resilience.

Born in 1907 to Buddhist parents in Japan, Hisako Shimizu immigrated to San Francisco with her parents as a young teen. After graduating from Lowell High School, she decided to remain in San Francisco although her parents returned to Japan in 1925. She studied at the California School of Fine Arts, where her teachers included Spencer Macky, Otis Oldfield, and Gottardo Piazzoni. While at the school, she met fellow student **George Matsusaburo Hibi**, who was more than twenty years her senior, and the two were married in 1930. In 1933, they moved to Mt. Eden, and later to Hayward, where they raised their two children.

In 1942, immediately before internment, Hisako Hibi and her husband distributed their paintings to members of the Hayward community, knowing they would be unable to take the works with them to camp. The Hibi family was held at the Tanforan Assembly Center and then at the Topaz Relocation Center. Friend Dorothea Lange documented the family's evacuation in a photograph of Hisako Hibi and daughter Ibuki standing with their baggage. While at Topaz, Hibi created more than seventy oil paintings of life in the camp and lectured at the Topaz school. Her intimate pictures include depictions of the back-breaking work performed by women at camp, images of mothers bathing children, and atmospheric landscapes. In 1943 she received a prize for her painting of sunflowers exhibited in a show of work by interned artists that took place at the Friends Center in Cambridge, Massachusetts.

Following their release from camp in 1945, the Hibis moved to a small apartment in New York. After George Matsusaburo Hibi's death in 1947, Hisako Hibi worked as a seamstress in a garment factory to support her children. Hibi's semi-abstract, dark, and sometimes hauntingly bleak works from the late 1940s record her emotional pain. Later, Hibi returned to school, studying at the Museum of Modern Art with teachers including Victor D'Amico, and her imagery became increasingly abstract. She became a U.S. citizen in 1953 after the McCarran-Walter Act made citizenship possible for U.S. resident aliens from Japan.

In 1954, Hibi returned to San Francisco; she joined the San Francisco Society of Women Artists in 1961. She worked as a dressmaker for Lilli Ann and Betty Clyne. Marcelle Labaudt presented solo exhibitions of the work of George Matsusaburo Hibi in 1962 and Hisako Hibi in 1970 at the Lucien Labaudt gallery. During these years a new generation of Asian American artists emerged in San Francisco, and Hibi participated in this arts renaissance, exhibiting in noncommercial, alternative galleries. She traveled to Japan in 1973–1974, record-

ing the experience in paintings. Although largely abstract, her work from the 1970s and 1980s often referenced Buddhism and antiwar themes; they were painted in thin washes of color with a tangle of smaller marks that sometimes suggested figurative or religious iconography. In 1985, the San Francisco Arts Commission presented Hibi with an Award of Honor, and she mounted an important related solo exhibition. She was an early member of the Asian American Women Artists Association and hosted a 1990 group meeting at the Kimochi Senior Center, where she was then living at the age of eighty-three.

Hikoyama, Teikichi

BORN: 1884, Shizuoka, Japan

DIED: ca. 1957, Tokyo, Japan

RESIDENCES: 1884–1901, Japan § 1901–1933, San Francisco, CA § 1933–1957, Japan

MEDIA: printmaking and oil and ink painting

SELECTED SOLO EXHIBITION: Kinmon Gakuen (Golden Gate Institute), San Francisco, 1926, 1927, 1932

SELECTED GROUP EXHIBITIONS: *San Francisco Art Association*, Palace of Fine Arts, 1921 § *East West Art Society*,

Teikichi Hikoyama (left) with Takehisa Yumeji, ca. 1920s

San Francisco Museum of Art, 1922 § *San Francisco Art Association*, California Palace of the Legion of Honor, 1925 § *Sangenshoku Ga Kai, First Annual Exhibition*, Kinmon Gakuen, San Francisco, 1926 § *Sangenshoku Ga Kai, Second Annual Exhibition*, Kinmon Gakuen, San Francisco, 1927 § *Sangenshoku Ga Kai and Shaku-do-sha Association Joint Exhibition*, Kinmon Gakuen, San Francisco, and Central Art Gallery, Los Angeles, 1927 § *With New Eyes: Toward an Asian American Art History in the West*, Art Department Gallery, San Francisco State University, 1995

SELECTED COLLECTION: Japanese American National Museum, Los Angeles

SELECTED BIBLIOGRAPHY: Endo, Chiyuki. "Hiko San." *Nippon & America* (in Japanese), February 1957, 13. § Hikoyama, Manabu. Correspondence (in Japanese) to CAAABS researcher. June 28, 1998. Asian American Art Project, Stanford University. § Hiyane, Teruo. "Rafu No Jidai: Miyagi Yotoku To Nanka Seishun Gunzo" [The Period in Rafu: Miyagi Yotoku and Young People's Life in Southern California]. *Shin Okinawa Bungaku Magazine* 89 (1991): 148–152. § Moromisato, Michihiro. "Yotoku To Yumeji." *Okinawa Times*, June 19, 1997. § Nomoto, Ippei. *Yotoku Miyagi: Imin Seinen Gaka No Hikari To Kage* [Yotoku Miyagi: Light and Shade of an Immigrant Artist]. Okinawa, Japan: Okinawa Taimususha, 1997.

A VISIONARY PAINTER and printmaker, Teikichi Hikoyama is credited as the first Japanese woodblock printing artist to be active in California. Arriving in San Francisco in 1901, Hikoyama lived in the homes of various friends during his California residency. He often stayed with publisher Shigeki Oka during the teens and 1920s, creating works in a basement studio, and later stayed with the Inouye family in Stockton, where he also painted. The artist is remembered as an eccentric, a characterization sometimes linked to the published account of his experimentation with poisonous mushrooms gathered in Golden Gate Park. Nevertheless, he worked with friends **Chiura Obata** and **George Matsusaburo Hibi** to organize the East West Art Society in 1921. In the second exhibition of that group, Hikoyama exhibited a dozen works; only Obata exhibited more. Hikoyama's 1920s paintings display a magical realism, and his woodblock prints incorporated bold patterns that sometimes suggested elemental forces. Although most of his works were small, he occasionally created overscale paintings that were too large for home display.

During the 1920s, a number of artists and socialists formed a group to assist Hikoyama in mounting a Los Angeles exhibition. The group, deriving its name from one of his prints, called itself Kokuen Kai (Black Flame Society). Although many of his friends and supporters were socialists, Hikoyama was not personally involved with politics. One of the Kokuen Kai

organizers, artist **Yotoku Miyagi**, wrote, "Hikoyama's works… consist of an expression of passion that burns like a flame. It's a flame that does not stop until it burns everything." Hikoyama was the senior artist of the Sangenshoku Ga Kai (Three Primary Colors Art Group), which organized exhibitions in San Francisco in the late 1920s, including a joint show with the Los Angeles Shaku-do-sha group in 1927.

In 1932 Hikoyama exhibited seventy-three oil paintings in San Francisco, his last documented exhibition before leaving the United States. Hikoyama returned to Japan in 1933 and wandered widely, never establishing a permanent address. Although he was financially destitute late in life, a family member remembers his vigor and passion when talking about art.

Hiraga, Kamesuke

BORN: September 25, 1889, Mie, Japan

DIED: November 5, 1971, Paris, France

RESIDENCES: 1889–1906, Mie, Japan § 1906–ca. 1916, San Francisco, CA (1914, 1915, trips to Paris) § ca. 1916–1925, Los Angeles, CA § 1925–1926 France, Netherlands, and Spain § 1926, Los Angeles, CA § 1927–1971, Paris, France (with extended stays in Japan, New York, and Los Angeles)

MEDIA: oil, watercolor and ink painting, drawing, and printmaking

ART EDUCATION: 1909–1915, San Francisco Institute of Art § 1914, 1915, Académie Julian, Paris

SELECTED SOLO EXHIBITIONS: Little Tokyo, Los Angeles, 1926 § Milch Gallery, New York, 1930 § Prefectural Merchandise and Engineering Complex, Mie, Japan, 1935 § *Recent Works by Hiraga Kamesuke*, Ishibashi Museum of Art, Fukuoka, Japan, 1960 § Ise Jingu Chokokan, Ise, Japan, 1972, 1988

SELECTED GROUP EXHIBITIONS: Salon de la Société Nationale, Paris, 1926–1932 § *Annual Exhibition of Contemporary American Painters*, Rhode Island School of Design, Providence, 1930 § Pasadena Art Institute, Pasadena, CA, 1931 § Sears Roebuck Gallery, Washington, D.C., 1933

SELECTED COLLECTIONS: Ise Jingū Chōkokan, Ise, Japan § National Museum of Modern Art, Tokyo

SELECTED BIBLIOGRAPHY: "Charges Cruelty." *Los Angeles Times*, December 2, 1923, part 2, 5. § Halteman, Ellen Louise. *Publications in [Southern] California Art 7: Exhibition Records of the San Francisco Art Association, 1872–1915; Mechanics' Institute, 1857–1899; California State Agricultural Society, 1856–1902*. Los Angeles: Dustin Publications,

2000. § *Japanese and Japanese American Painters in the United States: A Half Century of Hope and Suffering, 1896–1945.* Tokyo: Tokyo Metropolitan Teien Art Museum and Nippon Television Network Corporation, 1995. § Millier, Arthur. "Japanese Artist Paints in Occident." *Los Angeles Times*, November 21, 1926, C36. § Millier, Arthur. "Japanese Artist Returns." *Los Angeles Times*, November 7, 1926, C32. § 1920 Federal Population Census. Los Angeles, Los Angeles, California. Roll T625 111, Page 9B, Enumeration District 308, Image 837. National Archives, Washington, D.C. § "Pasadena's Shows Varied." *Los Angeles Times*, April 19, 1931, B10. § *Seitan Hyaku–nen Kinen Hiraga Kamesuke Ten* [Kamesuke Hiraga Exhibition: One Hundredth Anniversary of His Birth]. Mie, Japan: Jingu Choko Kan, 1988.

KAMESUKE HIRAGA WAS BORN in Mie, Japan, to parents who separated when he was three years old. Hiraga was raised at his mother's family home and later lived with his father. As a child, he enjoyed drawing, and his desire to become a painter led him to the United States. Hiraga arrived in San Francisco in 1906 and is reported to have been present for the earthquake, living temporarily across the bay in Oakland following the cataclysmic event. In 1909, Hiraga began taking classes at the San Francisco Institute of Art (he may have taken art classes elsewhere prior to this training), where he became friends with **Henry Yoshitaka Kiyama** and **Kazuo Matsubara**. Hiraga received the Julian Prize in 1914 and 1915 to study in Paris. In 1915, after graduating from the San Francisco Institute of Art, he married Canadian-born Marie Catherine McLeod in Vancouver, Washington. The couple moved to Los Angeles, where Hiraga worked as a fisherman and a watch repairman and saved money for tuition to study again in Paris. Hiraga and his wife divorced in 1923 after a year-long separation. Despite being robbed in 1925, Hiraga still made his way to Paris later that year.

In Paris, Hiraga studied with Lucien Simon, who encouraged him to travel to Brittany to paint, and Hiraga created numerous landscape works during his travels in the region. During this time Hiraga also created skilled portraits, such as *Woman with Fan*, for which he received praise in France and the United States.

Returning in the fall of 1926 to Los Angeles, Hiraga exhibited more than two hundred paintings in a solo show in Little Tokyo. Arthur Millier praised the artist's work in the *Los Angeles Times* and noted that Hiraga planned to return to Paris in the spring. While in Los Angeles, Hiraga took it upon himself to find approximately thirty paintings he had made and sold prior to his trip to France. He reportedly exchanged them for new paintings he had created in Europe and burned the earlier Los Angeles–era works.

In the years just prior to World War II, Hiraga lived in Paris, married again, and participated in many exhibitions in both Europe and the United States. His first solo exhibition in Japan took place in 1935. Hiraga was in Paris during the war and was jailed for seven months, falsely accused of right-wing political affiliations. In the 1950s, Hiraga continued to receive accolades for his work in France and Japan. He returned to Japan for the first time in 1955, and in 1960 a major exhibition of his work was held at the Ishibashi Museum of Art. In the 1960s and 1970s Hiraga donated many paintings to the Ise Jingū Chōkokan, a museum in his home prefecture of Mie. He also published an autobiography, continued to exhibit widely, and received honors from the French and Japanese governments. After his death in 1971, his ashes were divided between Paris and Mie. Major retrospectives of his work were held at the Ise Jingū Chōkokan in 1972 and 1988.

Hodo Tobase

BORN: 1895, Japan

DIED: February 24, 1982, Kumamoto Prefecture, Japan

RESIDENCES: 1895–1951, Japan § 1951–1958, San Francisco, CA § 1958–1982, Japan

MEDIA: calligraphy

SELECTED SOLO EXHIBITIONS: *Calligraphy by Hodo Tobase*, San Francisco Museum of Art, 1958 § *Hodo Tobase Calligraphy*, California Institute of Integral Studies, San Francisco, 1992

SELECTED GROUP EXHIBITIONS: *With New Eyes: Toward an Asian American Art History in the West*, Art Department Gallery, San Francisco State University, 1995 § *Beat Culture and the New America: 1950–1965*, de Young Museum, San Francisco, 1996

SELECTED COLLECTIONS: Lucid Art Foundation, Inverness, CA § San Francisco Museum of Modern Art § San Francisco Zen Center

SELECTED BIBLIOGRAPHY: Brotherton, Joseph. Interviewed by Paul J. Karlstrom. March 5, 1999, and January 23, 2001, San Francisco, 18–22. Transcript, Archives of American Art, Smithsonian Institution. § Wenger, Michael. *Wind Bells: Teachings from the San Francisco Zen Center, 1968–2001.* Berkeley, CA: North Atlantic Books, 2001.

SAID ARTIST JOSEPH BROTHERTON of Hodo Tobase, "He was a superb teacher. He would work very hard composing these sort of Zen homilies, that would be the week's study. He would write a profound statement in four or five Japanese characters which would translate into something like 'Daily Life is Important.'... Then we would write these statements with a big broad brush.... He'd use a fat red brush to correct everything you'd written and I loved it. To me, it was so liberating

because I wasn't using a pencil between my thumb and forefinger anymore, I was using the lively brush."

Zen priest Hodo Tobase was sent to California by the Japanese government to give comfort to Japanese American farmers whose land was lost during their wartime internment. Knowing little English, he ministered primarily to members of the Japanese community, serving as the priest at the San Francisco Zen temple Sokoji. However, the growing interest in Zen Buddhism among poets and artists in San Francisco brought Hodo to the attention of this wider audience.

In a 2001 Archives of American Art interview, Brotherton described how Hodo had contacted Alan Watts, who wanted to have calligraphy taught at the American Academy of Asian Studies (later to be called the California Institute of Integral Studies) in San Francisco. The class took place every Monday night, and students included Brotherton, Gordon Onslow Ford, **Ruth Asawa**, and **Saburo Hasegawa** (who also taught at the academy). Hodo's experimental calligraphy would prove to be very influential for these artists, and Onslow Ford credited his study with Hodo as having an enormous impact on not only his art but also his way of life. Brotherton said that the two years he studied with Hodo transformed his work as a painter; calligraphy provided freedom, yet it also taught him organizational skills, as Hodo's unorthodox approach to the practice required each calligraphic character to lie within a nine-section square.

Hodo's own work, such as *Twelve Dragons*, uses calligraphic strokes to suggest the sinewy bodies of dragons, with the initial splash of the ink's impact on the paper evoking their heads.

Following Hodo Tobase's departure, **Shunryu Suzuki** was assigned to the Sokoji Zen temple and would have an even more influential tenure at the institution.

Howe, James Wong

BORN: August 28, 1899, Yong'an Village, Taishan, Guangdong, China

DIED: July 12, 1976, Los Angeles, CA

RESIDENCES: 1899–1904, Yong'an Village, Taishan, Guangdong, China § 1904–ca. 1914, Pasco, WA § ca. 1914–ca. 1915, Portland, OR § 1916–1929, Los Angeles, CA § 1929, China § 1930–1976, Los Angeles, CA

MEDIA: photography and cinematography

SELECTED SOLO EXHIBITIONS: *James Wong Howe*, The Museum of Chinese American History, Los Angeles, 1992 § *High Drama, Low Key: The Cinematography of James Wong Howe*, Museum of Modern Art, New York, 2001 (film series)

SELECTED BIBLIOGRAPHY: "Chinatown, San Francisco: James Wong Howe focuses his searching lens on his people in

America," *Look*, December 26, 1944, 22–27. § James Wong Howe Papers. Margaret Herrick Library, Academy of Motion Picture Arts and Sciences, Beverly Hills, CA. § Rainsberger, Todd. *James Wong Howe, Cinematographer*. San Diego: A. S. Barnes, 1981.

When I was a kid I was forever sketching, painting and drawing. I wanted very much to do something with it. And I played around with a camera a lot, and experimented. I always loved the grace and simplicity of Chinese designs and paintings. Even where there is much ornamentation, Chinese designs are harmonious and subtle.

JAMES WONG HOWE
Elizabeth Borton, "Hollywood from the Inside,"
undated article from unknown newspaper, ca. 1930,
from artist's scrapbook. In James Wong Howe Papers.

ONE OF AMERICA'S most innovative and influential cinematographers, James Wong Howe made nearly 125 movies from 1922 to 1974, was nominated for sixteen Academy Awards, and helped define the look of Hollywood films. Born Wong Tung Jim in China, Howe immigrated with his family to the United States when he was almost five years old. His father worked on the Northern Pacific Railroad and later opened a general store in Pasco, Washington. Howe's early years were difficult, as he faced blatant racism from residents of the small community. He left home at the age of fifteen and traveled to Portland, Oregon, where he worked as a professional boxer. At just over five feet tall and weighing only one hundred pounds, he successfully boxed in the flyweight division, winning many matches.

Howe made his way to Los Angeles and began working as a camera-room handyman for Lasky Studios in 1917, where he cleaned the cutting room, since he was considered too small to carry the heavy cameras. In 1919, during the filming of Cecil B. DeMille's *Male and Female*, he was called to help when a com-

James Wong Howe, ca. 1937

plicated scene required multiple cameras and there were not enough people to hold the slates. Howe's work as the "fourth assistant cameraman" endeared him to the director.

Howe also began taking still pictures, and in 1922 popular actress Mary Miles Minter asked if he would photograph her. During the shoot, some nearby black fabric cast a dark reflection on her light blue eyes, which would appear almost white on early film. Minter was so pleased with the result that she asked Howe to serve as the cameraman on her next film, and only later did he realize what had caused the effect. Soon other actresses requested that he work on their films, and Howe quickly gained a reputation for providing a look of natural glamour to the women he filmed.

Howe spent 1929 in China shooting locations for a film he hoped to direct, and he subsequently returned to Hollywood and a new world of "talking pictures." He adapted quickly and became known and respected for his innovative, realistic style and low-contrast lighting. Howe pioneered the use of deep focus and ceilinged sets in the 1931 film *Transatlantic*, techniques Gregg Toland would use in *Citizen Kane* ten years later. In 1933, his complete name, "James Wong Howe," appeared in film credits for the first time instead of the ethnically vague "James Howe," as studios sought to capitalize on the growing popularity of the Chinese cinematographer. However, an anti-Asian climate still prevailed in the country, and anti-miscegenation laws forced Howe and writer Sanora Babb, who was Caucasian, to travel to Paris to marry in 1937. Their marriage was not legal in the United States until 1948.

Howe received his first Academy Award nomination in 1938 for *Algiers* and was as much a celebrity as the actors and actresses he filmed. He continued to be a pioneer, working with infrared film in the 1940s and using Technicolor in a subtle way in *The Adventures of Tom Sawyer* (1937). During the filming he battled to bring a realistic look to Twain's story, shunning gaudy colors for costumes and sets in favor of warm earth tones. His vision prevailed, but the Technicolor company refused to work with him on another film until 1949. His handheld camera work (on roller skates and in a wheelchair) became legendary and much imitated.

In 1948 Howe went to China to produce Lao She's *Rickshaw Boy*, but political instability prevented completion of the project. When he returned home, he was graylisted by the House Un-American Activities Committee due to his willingness to work with those affiliated with the Communist Party. Other causes may have been Babb's own blacklisting and the couple's progressive politics and friendship with blacklisted writers such as Carlos Bulosan. During this period Howe made several low-budget, artistically interesting films, including the 1953 documentary *The World of Dong Kingman*. In 1955 he received his first Academy Award for *The Rose Tattoo*, and he eventually began working again on major films in Hollywood. Throughout the 1960s and 1970s he worked with young directors such as Martin Ritt (*Hud*, 1963, for which he won a second Academy Award) and John Frankenheimer (*Seconds*, 1966) and helped define the look of movies for a new generation of filmmakers.

Hsu, Kai-yu

BORN: July 5, 1922, China

DIED: January 4, 1982, Tiburon, CA

RESIDENCES: 1922–1945, China § 1945–1946, various locations in Europe § 1947–1948, Eugene, OR § 1948–1952, San Francisco, CA § 1952–1955, Monterey and Palo Alto, CA § 1956–1969, Palo Alto, CA § 1969–1982, Tiburon, CA

MEDIA: ink painting and photography

SELECTED SOLO EXHIBITIONS: San Francisco State University, 1974 § Seton Hall University, South Orange, NJ, 1975

SELECTED COLLECTION: San Francisco State University

SELECTED BIBLIOGRAPHY: Hsu, Kai-yu. *Asian American Authors*. Boston: Houghton Mifflin, 1976. § Hsu, Kai-yu. *Chou En-lai, China's Gray Eminence*. Garden City, NY: Doubleday, 1968. § Hsu, Kai-yu. Personnel File. San Francisco State University. § Hsu, Kai-yu. *Twentieth Century Chinese Poetry*. Garden City, NY: Doubleday, 1963. § Hsu, Kai-yu, and Fang-yu Wang. *Ch'i Pai-shih's Paintings*. Taipei: The Art Book Co., 1979.

The house [in Taipei] where I am writing this note belongs to my brother, a college president, and is a leftover from the Japanese occupation days. The greenery beyond the sho-ji screened window, and the dusty traffic only a few feet away from the wall in this population swollen city, create a sense of cultural unreality heightened by the presence of an electric fan on the tatamied floor. The three manuscripts of Chinese texts lie on my sweaty desk top, all staring at me with tropical indolence, while I dream of a story of this unreal life.

KAI-YU HSU
Letter to James Wilson,
Dean of Humanities. June 15, 1968.
San Francisco State University Personnel Files.

KNOWN PRIMARILY AS a teacher and scholar of twentieth-century Chinese poetry, literature, and linguistics, Kai-yu Hsu was also a painter, art historian, and critic. His life and work were tragically swept away by a deadly mud slide in 1982.

After pursuing an education in China in foreign language and literature with an emphasis in English, Kai-yu Hsu served in the Chinese Air Force during 1944–1945. In 1945–1946, he traveled to six countries in Europe as a military aide at Chinese embassies. In 1947, he moved to Oregon to begin a two-year master's program in journalism, after which he moved

Kai-yu Hsu, ca. 1975

to San Francisco to work as a reporter for the *Chinese World* (1948–1952). He then became an instructor in the Chinese/Mandarin Department of the Army Language School in Monterey and worked as a research assistant for the China Project at Stanford University (1952–1956). He became a naturalized citizen in 1955. In 1956, he began his doctoral studies at Stanford in the Department of Asian Studies, where he also taught Mandarin as a lecturer. He completed his dissertation on poet Wen Yiduo and received his Ph.D. in Chinese literature and thought in 1959.

Also in 1959, Hsu began teaching full time at San Francisco State College (now University). Although his courses focused on contemporary Chinese literature, he also taught Chinese painting and aesthetics. Almost immediately after being hired, he organized several exhibitions of Chinese painting at the school, and his invitations to artists in Taiwan, including **James Yeh-jau Liu** and **Cheng Yet-por**, led to their relocation to the Bay Area. Hsu was a leading faculty member at San Francisco State College, serving as chair of the Department of Foreign Languages (1960–1965) and the Department of World and Comparative Literature (1974–1979); he also strategized after the important 1968 student strike and promoted the formation of the College of Ethnic Studies. Hsu was active in the new discipline of Asian American studies and published important anthologies of Asian American writers in the early 1970s. He returned to China to visit in 1973 and received a National Endowment for the Humanities summer stipend in 1977.

Hsu's work as an artist was intertwined with his teaching; he frequently gave painting and calligraphy demonstrations, and he exhibited his work at his lectures nationwide. His calligraphy was bold and rounded, and his ink-painted landscapes sometimes recalled Bay Area scenes of harbors and fog. He coauthored books on Qi Baishi, painting technique, and philosophy. Although he was warned to leave his Tiburon home following heavy rains, Hsu made an ill-fated decision to return in an attempt to save items from his extensive library and personal art collection, and he was killed in a sudden major mud slide.

Ikegawa, Shiro

BORN: July 15, 1933, Tokyo, Japan

RESIDENCES: 1933–1956, Tokyo, Japan § 1956–1971, Los Angeles and Altadena, CA § 1972–1973, San Anselmo, CA § 1973–1989, Altadena, CA § 1989, Davis, CA § 1990–present, Los Angeles and Altadena, CA

MEDIA: painting, printmaking, sculpture, and performance

ART EDUCATION: 1954–1956, Tokyo University of Arts, Japan § 1957–1961, Los Angeles County Art Institute

SELECTED SOLO EXHIBITIONS: Comara Gallery, Los Angeles, 1961, 1963–1965, 1968 § Crocker Art Museum, Sacramento, CA, 1965 § Santa Barbara Museum of Art, Santa Barbara, CA, 1966/67 § Beni Gallery, Kyoto, Japan, 1967 § Comsky Gallery, Los Angeles, 1970 § Long Beach Museum of Art, Long Beach, CA, 1971

SELECTED GROUP EXHIBITIONS: *International Print Show*, Seattle Art Museum, 1963–1965, 1967, 1968 § *National Print Exhibition*, Brooklyn Art Museum, 1964, 1966 § *American Prints 60's*, Smithsonian Institution, Washington, D.C., 1965 § *Exhibition of Japanese Artists Abroad, Europe and America*, Tokyo Modern Art Museum, 1965 § *Addictions*, Santa Barbara Contemporary Arts Forum, Santa Barbara, CA, 1991

SELECTED COLLECTIONS: Fine Arts Museums of San Francisco § Los Angeles County Museum of Art § Seattle Art Museum § Smithsonian American Art Museum, Washington, D.C.

SELECTED BIBLIOGRAPHY: Brown, Michael D. *Views from Asian California, 1920–1965*. San Francisco: Michael D. Brown, 1992. § Destiny, Diane. CAAABS project interview. July 14, 2001. Altadena, CA. § Seldis, Henry. "Art Walk." *Los Angeles Times*, November 13, 1970, part 4, 9. § Shiro Ikegawa Papers, [ca. 1950–1998]. Archives of American Art, Smithsonian Institution.

Painting for myself all comes from the inside…problems come from the inside, and the artist has to solve them.

SHIRO IKEGAWA
Brown, *Views from Asian California*, 31

AS AN ABSTRACT and conceptual artist, Shiro Ikegawa advanced an innovative approach to printmaking, often incorporating Buddhist concepts either obliquely or overtly in his work. Ikegawa was born in Tokyo and attended the Tokyo University of Arts, where he studied drawing and received his early formal training. Seeing the work of New York abstract expressionists reproduced in Japanese magazines had a great impact on the young artist, and he decided to continue his studies in the United States and explore abstraction. Arriving

in Los Angeles, Ikegawa studied English and enrolled at the Los Angeles County Art Institute, where he remained for four years and received an M.F.A. Following graduation, Ikegawa began as an instructor at Pasadena City College, marking the beginning of a successful teaching career. His abstract paintings and unique colored and embossed etchings brought him early recognition.

In 1966 Ikegawa visited Japan, where he was confronted by the increasing commercialization of the country. Temples with souvenir shops and Buddhas on advertising billboards prompted Ikegawa, upon his return to California, to create works that both incorporated a pop art approach to Buddhist iconography and addressed his own profound reintroduction to religious and cultural traditions in Japan. Mudras, Buddhas, and other religious imagery appeared prominently in his pieces, and he exhibited these and other works widely in the late 1960s and early 1970s. His thirty-two-foot-long color etching, *The Tale of Genji*, was commissioned by the *Los Angeles Times* in 1973. During this period Ikegawa also taught at several schools, including California State University, Los Angeles; Otis School of Art and Design; the California School of Fine Arts; and San Francisco State University.

Although he was also a painter and sculptor (his bronzes were included in the 1965 New York World's Fair), Ikegawa's

greatest achievements were in printmaking. He incorporated photographic printmaking into his pieces, worked with heavy embossing techniques, and created monumental-scale prints. Henry J. Seldis in a 1970 review in the *Los Angeles Times* said that "several 8-foot-wide print relief sculptures combine an amazing sense of symbolism with extraordinary technical virtuosity." And in the 1971 Long Beach Museum of Art exhibition catalog, Seldis explained that Ikegawa's large wall reliefs had turned into actual "environmental experiments."

Although Ikegawa was primarily an abstract artist, his work became more conceptual in the 1970s. He found inspiration in the natural environment and went on frequent camping and fishing trips in the Sierra Nevada Mountains. The artist combined resulting photographs and journals with postimpressions of the trip to make mixed-media pieces. His red VW bus, likely the transportation for his journeys, appears as subject matter for several works, floating in a sky of clouds as if navigating its own magical route. Ikegawa's fascination with fish, particularly with rainbow trout, can also be seen throughout his work. Prints include detailed stories about the fish and its possible thoughts. He once cast a real fish in plaster, creating a mold he would often use.

An automobile accident in the late 1970s left Ikegawa in a coma for several months, but he was later able to resume making art and teaching. He continued to exhibit in the 1980s and taught at the University of California, Davis. However, a second accident in the 1990s curtailed his activities, and he has since exhibited sporadically in shows, such as the 1991 *Addictions* at the Santa Barbara Contemporary Arts Forum.

Shiro Ikegawa

Inukai, Kyohei

BORN: 1886, Okayama, Japan

DIED: June 2, 1954, New York, NY

RESIDENCES: 1886–1900, Japan § 1900–ca. 1903, Hawaii § ca. 1903–ca. 1906, San Francisco, CA § ca. 1906–ca. 1917, Chicago, IL § ca. 1917–1954, New York, NY

MEDIA: oil painting

ART EDUCATION: ca. 1903–ca. 1906, Mark Hopkins Institute of Art § ca. 1906–ca. 1916, School of the Art Institute of Chicago

SELECTED SOLO EXHIBITIONS: Arlington Galleries, New York, 1922 § Grand Central Art Galleries, New York, 1934

SELECTED GROUP EXHIBITIONS: *The First Annual Exhibition of Paintings and Sculpture by Japanese Artists in New York*, The Art Center, New York, NY, 1927 § *Annual Founders Exhibition*, Grand Central Art Galleries, New York, 1931, 1932, 1941 § Union League Club, New York, 1936 § *The Japanese American Artists Group*, The Riverside Museum, New York, NY, 1947

SELECTED COLLECTION: National Museum of Modern Art, Tokyo

SELECTED BIBLIOGRAPHY: "Art Notes." *New York Times*, January 25, 1922, 13. § DeVree, Howard. "A Reviewer's Notebook." *New York Times*, May 13, 1934, sec. 10, 7. § *Geijutsu Shinchō* (Tokyo), no. 10 (October 1995). § *Japanese and Japanese American Painters in the United States: A Half Century of Hope and Suffering, 1896–1945*. Tokyo: Tokyo Metropolitan Teien Art Museum and Nippon Television Network Corporation, 1995. § "Japanese Artist Dead." *New York Times*, June 4, 1954, 23. § *Japan in America: Eitaro Ishigaki and Other Japanese Artists in the Pre–World War II United States*. Wakayama, Japan: Museum of Modern Art, Wakayama, 1997. § "Kyohei Inukai: Grand Central Galleries." *Art News*, May 12, 1934, 8. § "Prize Winners Variously Significant." *New York Times*, March 28, 1926, SM10.

KYOHEI INUKAI LEFT JAPAN for Hawaii in 1900 and lived there for three years before moving to San Francisco. In San Francisco, he attended the Mark Hopkins Institute of Art, but following the 1906 earthquake he left the city and moved to Chicago. According to his obituary, Inukai attended the School of the Art Institute of Chicago for ten years. The 1910 census shows Inukai married to a woman named Lucille, and other sources have described Inukai's marriage to a wealthy, Caucasian classmate as having been scandalous at the time.

Inukai moved to New York in approximately 1917 and married Althea Willa Kirk. The couple had a son in 1921, and it was later reported that Inukai had three children. In New York, Inukai was associated with the National Academy of Design, winning the academy's Isaac N. Maynard Portrait Prize in 1926, which was voted on by fellow artists. The self-portrait featured the artist in his studio, working at an easel, and was one of many intense self-portraits he created.

Inukai was an active artist-member of the Grand Central Art Galleries and exhibited frequently in their annual shows. His works reflect a carefully composed academic realism, and Inukai's reputation as a skilled portraitist was well known, resulting in many commissioned works for wealthy New Yorkers. He was noted for his elegant depictions of women, and a solo show at the Grand Central Galleries in 1934 featured several of these paintings. While many of Inukai's portraits are formal, one work in which the artist incorporates himself into the painting via a mirror demonstrates a clever stylistic reference to Velázquez's *Las Meninas*.

Ishida, Nitten

BORN: April 3, 1901, Hiroshima, Japan

DIED: April 23, 1996, San Francisco, CA

RESIDENCES: 1901–1931, Hiroshima and Tokyo, Japan; Taiwan § 1931–1941, San Francisco, CA § 1941–1942, Fort Missoula Justice Department Camp, Fort Missoula, MT § 1942–1944, Fort Sill, U.S. Army Facility, Lawton, OK; Fort Livingston, U.S. Army Facility, Alexandria, LA; Santa Fe Justice Department Camp, Santa Fe, NM § 1944–1946, Crystal City Justice Department Camp, Crystal City, TX § 1946–1947, Richmond, CA § 1947–1996, San Francisco, CA

MEDIA: ink painting

SELECTED COLLECTIONS: Japanese American National Museum, Los Angeles § Nichiren Buddhist Temple, San Francisco

SELECTED BIBLIOGRAPHY: Ishida, Helen. CAAABS project interview. November 2003. Videotape, Asian American Art Project, Stanford University. § Mart, David. "The Calligraphic Class of the Sensai." *San Francisco Chronicle*, October 14, 1962, 10.

Happiness and a sense of inner peace come through giving one's self freely and completely to causes which are meaningful and satisfying to one's self. I consider myself a happy man.

NITTEN ISHIDA
Helen Ishida. "Case History" (unpublished paper). August 4, 1975, 13. Collection Asian American Art Project, Stanford University.

THE SEVENTH AND YOUNGEST son of a landowner-farmer, Nitten Ishida graduated from grammar school with honors and continued his education in Tokyo. He studied at Myōjuji Temple, where his brother was the chief priest, and had an austere, focused existence. While attending high school, he was a temple apprentice disciple and woke at 3 AM to participate in morning prayers and temple responsibilities before going to school. At this time he took his initial vows to the priesthood. Ishida believed that being a priest did not mean leading a sequestered life but instead could mean providing service to individuals and the community—beliefs that informed the rest of his life.

In 1923, Ishida entered Waseda University; in 1925, he graduated with a degree in political science and economics, but he decided to continue his religious studies and entered a graduate theological institute. He fulfilled his required military service, becoming an army officer. He then returned to his brother's temple, which sent him to Taiwan, where he established three churches. Deciding that he wanted to travel more before settling down, Ishida arrived in San Francisco in 1931. With a letter of introduction from the president of Waseda University, he met with fellow alumni and gave lectures, traveling to other West Coast cities. He returned to San Francisco and was asked to start a temple at 2016 Pine Street, where he began teaching calligraphy classes to community members. Ishida married later that year.

As a former army officer, he and others in the community collected money for Japan at the onset of the Sino-Japanese War. Ishida was in Sacramento when Pearl Harbor was bombed and was stunned by the attack. The FBI came to his home in San Francisco, where they questioned his wife, took personal papers and belongings, and later detained him. A week later, on December 11, 1941, he was sent to the Department of Justice camp in Fort Missoula, Montana, where he was not allowed to communicate with his family. On April 10, 1942, Ishida was moved to Fort Sill, Oklahoma, then to Fort Livingston, Louisiana, where he remained for a year. He then was moved to a federal facility in Santa Fe, New Mexico, for six months, and finally was reunited with his family in Crystal City, Texas, on February 26, 1944. At the various camps where Ishida was interned, he taught calligraphy classes attended by fellow internees.

Once the war was over, Ishida was not released but was instead on a list for deportation. Because his children were American citizens, he was able to avoid being deported, and he became a naturalized citizen in 1952, the first year it was possible to do so. Life was difficult for the Ishidas following the

war. They lived in a government housing project in Richmond, California, and Ishida worked briefly as a gardener, and then as a soy sauce salesman. In July 1947 the Ishidas returned to San Francisco and worked to rebuild the Pine Street temple, which had been looted and damaged during the war.

Ishida worked with his brother, who was then chief abbot, to establish a relief organization to send donations of food and clothes to Japan. He also sponsored young farmers from Japan to study farming in the United States in hopes of promoting goodwill between the countries. In 1952 Ishida became the Nichiren archbishop for the United States. In the 1970s he served as president of the Japanese American Religious Federation, worked on issues such as housing for the aged and poor, and helped to establish the Nihonmachi Terrace housing complex in San Francisco's Japantown. He was honored in Japan for fostering Japanese cultural arts, and in San Francisco for his religious and community work.

Ishida taught calligraphy until he was ninety years old. In San Francisco some students attended his weekly Friday night classes for more than twenty-five years. Ishida's own work, characterized by strong, simple yet elegant lines, is primarily

Nitten Ishida, ca. 1962. Photo by Nathan Zabarsky

calligraphic, although he occasionally incorporated symbolic imagery in what were unique, experimental pieces. His work includes hanging scrolls and small paintings that he exhibited at temples and community centers. His calligraphy appears in many stone memorials, including at the Nihonmachi Terrace in San Francisco and at his grammar school in Hiroshima.

Ishigaki, Eitaro

BORN: December 1, 1893, Taiji, Wakayama Prefecture, Japan

DIED: January 23, 1958, Tokyo, Japan

RESIDENCES: 1893–1909, Taiji, Wakayama Prefecture, Japan § 1909, Seattle, WA § 1910–1912, Bakersfield, CA § 1912–1915, San Francisco, CA § 1915–1951, New York, NY § 1951–1958, Tokyo, Japan

MEDIA: oil and ink painting, drawing, and murals

ART EDUCATION: 1913, William Best School of Art, San Francisco § 1914, San Francisco Institute of Art § 1915–1918, Art Students League, New York

SELECTED SOLO EXHIBITIONS: ACA Gallery, New York, 1936, 1940 § *Eitaro Ishigaki Retrospective*, Bungei Shunjū Gallery, Tokyo, 1959

SELECTED GROUP EXHIBITIONS: *Exhibition of Paintings and Sculptures by the Japanese Artists Society of New York City*, The Civic Club, New York, 1922 § *The First Annual Exhibition of Paintings and Sculpture by Japanese Artists in New York*, The Art Center, New York, 1927 § American Artists Congress, New York, 1936–1940 § *Exhibition by Japanese Artists in New York*, ACA Gallery, New York, 1936 § *The Japanese American Artists Group*, The Riverside Museum, New York, 1947 § Ten Ten Kai, Tokyo, Japan, 1955–1958

SELECTED COLLECTIONS: Ishigaki Eitaro Memorial Museum, Wakayama, Japan § The Museum of Modern Art, Wakayama, Japan

Eitaro Ishigaki, ca. 1925

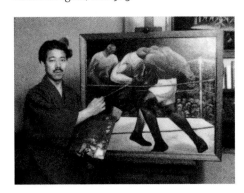

SELECTED BIBLIOGRAPHY: *Japanese Artists Who Studied in U.S.A. and the American Scene (Amerika ni Mananda Nihon no gaka-tachi: Kuniyoshi, Shimizu, Ishigaki, Noda)*. Tokyo: National Museum of Modern Art, 1982. § *Japan in America: Eitaro Ishigaki and Other Japanese Artists in the Pre–World War II United States*. Wakayama, Japan: Museum of Modern Art, Wakayama, 1997. § "Leftist Tint Led to Exile, Shaped Social Themes." *The Nikkei Weekly*, January 31, 1994, 25. § Tateishi, Tetsuomi. *Ishigaki Eitaro*. Tokyo: Bijutsu Shuppan Sha, 1959.

I can characterize it in no other way than as another slander against the WPA by opponents of the present administration. They slander the murals also because a Japanese artist painted these scenes of early American history. "How can an alien understand the American struggle?" they ask.

EITARO ISHIGAKI
Louise Mitchell. "The Fight for Negro Liberation,"
Daily Worker, April 5, 1938, 7.

IN 1909, AT THE AGE of sixteen, Eitaro Ishigaki moved from Japan to Seattle to join his father, who had lived there for eight years. They moved together the following year to Bakersfield, California, where the young Ishigaki was introduced to socialism during English classes offered at a local church. In 1912, Ishigaki moved to San Francisco, where he met the poet Takeshi Kanno and his wife, the sculptor Gertrude Boyle. Through these friends, Ishigaki had the opportunity to meet many artists, including writer Joaquin Miller. He attended classes at William Best School of Art and at the San Francisco Institute of Art.

Ishigaki moved with Boyle to New York in 1915 and continued studying art at the Art Students League, taking night classes with John Sloan. He also became involved in a communist group organized by Sen Katayama, a Japanese union worker and missionary, whom Ishigaki had met in San Francisco. Ishigaki was a founding member of the John Reed Club in 1929, a communist organization whose membership included Ernest Hemingway and John Dos Passos. During this time, Ishigaki became friends with Mexican artists Diego Rivera, José Clemente Orozco, and Rufino Tamayo, and his paintings—which had long reflected social concerns—started to reflect the sculptural modeling of forms associated with Rivera's murals. Ishigaki was actively involved in the Artists Congress and various WPA projects in the 1930s and in 1938 completed a two-panel mural in Harlem depicting American Independence and the Freeing of the Slaves. Ishigaki came under fire for the then-controversial nature of the murals and was even accused of making Abraham Lincoln's skin tone too dark. As a result, the murals were destroyed three years later by the Municipal Art Commission.

Ishigaki produced numerous political paintings that fo-

cused on workers' rights and struggles, as well as images of racism in the United States, which were exhibited regularly during the 1920s and sporadically during the 1930s and 1940s. In 1951, during the McCarthy era, Ishigaki was threatened with deportation by the FBI for communist activity and left the country before legal proceedings were begun. He was unwelcome in Tokyo, and his wife Ayako recalled that "he became isolated and lost enthusiasm for painting."

Ishii, Chris

BORN: August 11, 1919, Fresno, CA

DIED: November 6, 2001, Dobbs Ferry, NY

RESIDENCES: 1919, Fresno, CA § 1920–1936, Caruthers, CA § 1936–1942, Los Angeles, CA § 1942, Santa Anita Assembly Center, Santa Anita, CA; Granada Relocation Center, Amache, CO § 1943, Camp Savage, MN; Camp Shelby, MS (U.S. military service) § 1943–1946, India, Burma, and China (U.S. military service) § 1946–1949, Los Angeles, CA § 1949–1951, New York, NY § 1951, Paris, France § 1952–1955, New York, NY § 1955–2001, Dobbs Ferry, NY

MEDIA: oil and watercolor painting, drawing, illustration, and animation

ART EDUCATION: 1936–1940, Chouinard Art Institute, Los Angeles § 1951, Académie Julian, Paris

SELECTED BIBLIOGRAPHY: Ishii, Christopher. Written correspondence. October 12, 2000. Asian American Art Project, Stanford University. § Ishii, Naka. "Day of Remembrance" speech (notes), 1995. § Nakagawa, Martha. "Rebels with a Just Cause." *Rafu Shimpo* (Los Angeles), December 11, 1997, 1, 4. § Wakiji, George. "An Uncommon Man—Not Typical Nisei." *Rafu Shimpo* (Los Angeles), December 1964, 5, 20.

As people get older, they often become more conservative, less open to new ideas. I resist that tendency and try to keep an open mind about new forms of art, new ways of seeing the world. The only thing that is constant is change, and we need to stay flexible in order to understand what is happening both in the world of art and the world at large.

CHRIS ISHII
Email correspondence, October 22, 2000

CHRIS ISHII GREW UP in Caruthers, California, where his family owned a small farm. His artistic talent was noted in high school, and he was encouraged to continue his studies after graduation. He decided to attend the Chouinard Art Institute because family friends knew **Gyo Fujikawa**, who taught at the school. Art school in Los Angeles was a big change from his rural life in Caruthers. Knowing nothing about the history of art, or even about how to use a telephone, Ishii had to quickly adjust to his new environment. While at Chouinard, Ishii excelled at watercolor painting and commercial art, and teachers who were particularly influential included Phil Paradise, Gyo Fujikawa, Carl Beetz, and Ed Northridge. During his time at the school he also began an enduring friendship with **Ken Nishi**.

Following graduation, Ishii was hired by Walt Disney Studios, where he worked on *Fantasia*, *The Reluctant Dragon*, *Dumbo*, and Donald Duck and Mickey Mouse shorts. Ishii participated in a three-month strike at the studios that resulted in employees receiving the right to unionize. Ishii credited this experience as having helped form his ideas about politics and the labor movement.

The bombing of Pearl Harbor occurred three months after Ishii returned to work following the resolution of the strike. Two months later he was forced to leave Disney and was interned at the Santa Anita Assembly Center. While at Santa Anita, he created a cartoon featuring a young Nisei boy for the camp newspaper, the *Pacemaker*. A contest was held to name the character, and Li'l Neebo (a contraction of "Little Nisei Boy") was born. Illustrating the trials and tribulation of life in camp, Li'l Neebo became a beloved character. When Ishii was transferred to the Granada Relocation Center in Colorado, the character went with him, appearing in that camp's newspaper, the *Granada Pioneer*, where it was expanded into a comic strip. When it became possible, Ishii voluntarily joined the army; after basic training he worked for the Military Intelligence Service for three years in China, Burma, and India. He served as an artist for the Psychological Warfare Unit, drawing propaganda leaflets that were dropped both on civilians in China to warn them of impending danger and on Japanese soldiers in an attempt to shake their morale.

While in Hong Kong, Ishii met and married his wife, Ada, and at the conclusion of the war the couple settled in Los Angeles. Ishii returned to the Disney Studios for a year, and then he and a partner started a commercial art studio in Hollywood. Eventually he turned to freelance work, which he continued until 1949, when the Ishiis moved to New York. During his years in Los Angeles, Ishii became involved with the Nisei Progressive Party, a group later targeted by the House Un-American Activities Committee. Ishii did layouts and illustrations for the group's publication, *The Independent*.

In New York, Ishii covered the trial of Iva Toguri (accused of treason for being "Tokyo Rose") for *The Independent*, and later Ishii was investigated by the FBI for his association with the Nisei Progressive Party. He worked for the Tempo Productions animation studio in New York, but a lifelong desire to study painting in Paris prompted the couple, along with their young son, to move to France. Ishii studied at the Académie Julian, and Ada gave birth to their second child. The family re-

turned to New York, and Ishii returned to work in various film production houses in the city, producing animated and live-action TV commercials. In 1965 Ishii started Focus Productions, with two partners, and worked as director of live action and animation. From 1975 to 1985, he worked on various freelance assignments, such as collaborating with Woody Allen on the short animation sequences for *Annie Hall* (1977).

Ito, Miyoko

BORN: April 27, 1918, Berkeley, CA

DIED: August 18, 1983, Chicago, IL

RESIDENCES: 1918–1923, Berkeley, CA § 1923–1928, Nagoya, Japan § 1928–1942, Berkeley, CA § 1942–1943, Tanforan Assembly Center, San Bruno, CA; Topaz Relocation Center, Topaz, UT § 1943–1944, Northampton, MA § 1944–1983, Chicago, IL

MEDIA: watercolor and oil painting, and printmaking

ART EDUCATION: 1937–1942, University of California, Berkeley § 1943–1944, Smith College, Northampton, MA § 1944–1945, School of the Art Institute of Chicago

SELECTED SOLO EXHIBITIONS: Smith College Museum of Art, Northampton, MA, 1943 § The Hyde Park Art Center, Chicago, 1971 § Phyllis Kind Gallery, New York, 1973, 1978, 1992 § *Miyoko Ito: Mistress of the Sea*, Thomas McCormick Gallery, Chicago, 2000

SELECTED GROUP EXHIBITIONS: *San Francisco Art Association*, San Francisco Museum of Art, 1941, 1943, 1946–1953 § *The Japanese American Artists Group*, The Riverside Museum, New York, 1947 § *Six Illinois Painters 67/69*, Illinois Arts Council, 1967 (touring exhibition) § *Biennial Exhibition*, Whitney Museum of American Art, New York, 1975 § *The Chicago Connection*, Crocker Art Museum, Sacramento, CA, 1977

SELECTED COLLECTIONS: Art Institute of Chicago § Pennsylvania Academy of the Fine Arts, Philadelphia § Smithsonian American Art Museum, Washington, D.C.

SELECTED BIBLIOGRAPHY: Adrian, Dennis. *Miyoko Ito: A Review; The Renaissance Society at the University of Chicago, October 5–November 9, 1980*. Chicago: The Society, 1980. § Brandt, Michelle, and Tom McCormick. *Miyoko Ito: Mistress of the Sea*. Chicago: Thomas McCormick Gallery, 2000. § Ito, Miyoko. Interviewed by Dennis Barrie. July, 20, 1978. Saugatuck, MI. Transcript in Archives of American Art, Smithsonian Institution.

Miyoko Ito, ca. 1970

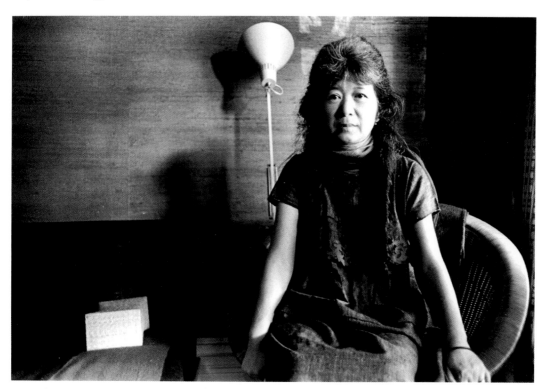

In my more recent paintings I have come to notice a completely unconscious and natural relation to the general feeling and attitude of the orient. Academically I know little about their art and up to now I have been indifferent to their painting in particular. Perhaps I arrived at this very natural state in a roundabout way—by way of the French moderns whose influence has been very important in all the years that I have been painting.

MIYOKO ITO
David Shapiro Papers, 1942–1987.
Reel 3759, frame 136. Archives of
American Art, Smithsonian Institution.

MIYOKO ITO WAS BORN in Berkeley, California, and at the age of five moved to Japan with her family. Prone to sickness as a child, Ito found confidence in the calligraphic work in which she excelled. She credited an art-infused school curriculum that included landscape painting outings for second graders with her decision to become an artist. Prompted by the fear that the frail Ito might contract tuberculosis, the family returned to California when she was ten. Once back in Berkeley, Ito had difficulty with English, and in order to successfully learn the language, she completely suppressed her knowledge of Japanese. She later explained that her trouble with verbal communication contributed to her becoming a visual artist.

Ito attended Berkeley High School, where she took as many painting and music courses as possible. She attended the California College of Arts and Crafts one summer, and despite wanting to attend an art school, she ultimately enrolled at the University of California, Berkeley, at the urging of her parents. As a painting major she studied with Worth Ryder, John Haley, and Erle Loran and was greatly influenced by the Bay Area school, which combined elements of Cézanne and cubism with the influence of Hans Hofmann. Her work from this period is described as representational cubism. Like the paintings of her closest mentor, John Haley, her work was structured in form, yet reminiscent of Raoul Dufy in the combination of gouache whites and transparent watercolors.

Ito married Harry Ichiyasu in April 1942 in a hurried ceremony to ensure they would not be separated during internment. The couple was detained first at the Tanforan Assembly Center and then at the Topaz Relocation Center. Ito applied for a graduate school scholarship release from camp and was accepted at Smith College. After a year there, she left to attend the School of the Art Institute of Chicago. Her husband joined her in Chicago after his release from camp in 1945.

During the late 1940s, Ito began to work with lithography, moving away from watercolors. Working primarily monochromatically, Ito gained a command of the subtle range of values available from one color. Simultaneously beginning to explore oil painting, Ito applied what she learned from lithography to these works and became known for her masterful modulation of color. Ito received a John Hay Whitney Opportunity Fellowship in the late 1940s and regularly attended the Oxbow Summer School. During the early 1950s Ito's children were born, and although she produced fewer works, she worked daily in her home studio, which she would continue to do for the rest of her career.

Through the 1950s, Ito developed the style that would define her painting. Working in an increasingly abstract manner, she created images that were distinguished by her unique use of form, color, and brushwork. Ito used a small sable brush to create short, regular strokes of paint, which gave her works a velvet-like nap and created an overall luminous effect. Her palette during this period was composed primarily of earthy browns, ochres, and dark greens. The geometric, angular shapes prevalent in her work of the early 1950s gave way to more tubular and biomorphic forms toward the end of the decade. Throughout the rest of her career she fluctuated between using a hotter palette of colors and a color scheme of soft pinks and yellows. She received a Guggenheim Foundation Fellowship in 1977.

Ito rarely discussed the meaning of any of her paintings beyond the vague references to landscapes or objects found in her enigmatic titles. An aura of mystery surrounded the artist and her work, and her paintings have continued to prompt speculation since her death in 1983.

Iwata, Jack Masaki

BORN: October 1, 1912, Seattle, WA

DIED: July 13, 1992, Monterey Park, CA

RESIDENCES: 1912–1916, Seattle, WA § 1916–1928, Hiroshima, Japan § 1928–1942, Los Angeles, CA § 1942–1946, Manzanar Relocation Center, Manzanar, CA; Tule Lake Relocation Center, Newell, CA § 1946–1961, Los Angeles, CA § 1961–1992, Monterey Park, CA

Jack Iwata

MEDIA: photography

SELECTED COLLECTION: Japanese American National
Museum, Los Angeles

SELECTED BIBLIOGRAPHY: Iwata, Jack, and Nagaharu
Yodogawa. *Wan Moa Shotto/One More Shot.* Tokyo: Bungei
Shunjū, 1991.

ALTHOUGH BORN IN Seattle, Jack Iwata was sent to Japan for his education, like many children of his generation. He began attending school at age four in Hiroshima, and while in middle school he received a camera from his father as a reward for good grades. Cameras were not commonly owned in Japan at that time, so Iwata taught himself to use the unusual gift. Iwata returned to the United States, joining his family in Los Angeles, where he finished high school and later attended Whittier College. Iwata would go on photographic outings with his father to the ocean or mountains and worked to perfect his skills as a photographer.

In 1937, **Toyo Miyatake** became aware of Iwata's skills and asked the young photographer to join him at his successful studio. Iwata photographed wedding ceremonies, taking not only formal portraits but also candid shots, which were unusual for the time. As head photographer at the studio he also photographed festivals, funerals, and portraits. Iwata began an association with the *Rafu Shimpo* newspaper; using one of the first flash synch units, he was able to more easily cover news events spontaneously, especially those at night. He photographed the first national Japanese American Citizens League (JACL) convention, and in 1937 he was among the last people to photograph Amelia Earhart. His 1942 bird's-eye-view photo of Los Angeles's Little Tokyo residents boarding buses bound for relocation centers is one of the most recognized images of the internment experience.

During World War II, Iwata and his wife, Peggy, were interned at Manzanar, as was Toyo Miyatake, and in early 1943 Iwata and Miyatake established a photo studio there. However, soon after, Iwata moved from Manzanar to Tule Lake to be with his father, who was in ill health and was being held at Tule Lake because of his prewar involvement with a Japanese veterans' group. Initially unable to continue his photography, Iwata was later asked in 1945 by Tule Lake administrators to create photographic documentation of the camp. He worked there as a photographer until his release.

Following the war, Iwata returned to Los Angeles and resumed his job at Toyo Miyatake's studio. A desire to be self-employed prompted him to briefly run his own film lab, but news service jobs defined the rest of his professional career. He was asked to join the Kyodo News Service, the wire service of Japan, and covered all U.S./Japan-related news. His first job was to photograph the 1949 U.S. national swim meet in which Furuhashi Hironoshin broke a world record, a symbolic event for postwar Japan. Iwata covered visits by the Japanese crown prince and the royal emperor and empress, and he was known in Japan for his reporting of the Golden Globe Awards and Academy Awards and for his interviews with Hollywood celebrities such as Alfred Hitchcock, which appeared in Japanese publications. Iwata's photographs ran in major magazines and newspapers in Japan, making him something of a celebrity in the country. In 1986 he helped Kyodo News Service start their affiliate company, Kyodo News California, where he served as general manager. He continued to be active as a photographer and news executive until his death in 1992.

Jayo, Federico Dukoy

BORN: July 1, 1907, Misamis Occidental, Mindanao, Philippines

DIED: July 30, 1978, Loma Linda, CA

RESIDENCES: 1907–1923, Misamis Occidental, Mindanao, Philippines § 1923–1942, Long Beach and Los Angeles, CA § 1942–1945, Europe (U.S. military service) § 1945–1957, Los Angeles, CA § 1957–1978, Banning, CA

MEDIA: oil and watercolor painting, and pastels

ART EDUCATION: ca. 1927–1928, Chouinard Art Institute, Los Angeles

SELECTED BIBLIOGRAPHY: Hughes, Edan Milton. *Artists of California, 1786–1940 II.* San Francisco: Hughes Publishing Company, 1989. § Jayo, Norman. CAAABS project interview. August 12, 2004. Emeryville, CA. Transcript, Asian American Art Project, Stanford University.

AT THE AGE of sixteen Federico Jayo came to California from Mindanao wishing to study architecture. He arrived in Los Angeles in 1923 and began to take classes. However, teachers soon steered Jayo into art classes, seeing his aspirations as "too ambitious" for a young Filipino. Despite never formally studying the architecture and engineering he loved, he continued throughout his life to work on his own projects and was seen as a visionary inventor by many who knew him.

His artistic talents encouraged, Jayo enrolled at the Chouinard Art Institute in the late 1920s. By 1930 he was a working artist, supporting himself with the portrait work that would sustain him and his family throughout the course of his life. Since he lived in Los Angeles, Jayo became involved with the film industry, creating artwork that appeared on posters for Bela Lugosi's *Dracula* (1931) and making portraits of film stars. Jayo frequently worked by the wishing well at Olivera Street, where friends would gather, including publisher and labor activist Stanley Garibay and poet and novelist Carlos Bulosan.

As a portraitist, Jayo traveled the circuit of fairs and festivals that took place in California. From the 1930s until his death in 1978, Jayo regularly attended the California State Fair

in Sacramento. In the early years of his participation, he organized a group of fellow artists into the fair's "artists' colony," and his Depression-era labor organizing of these artist-workers mirrored the labor movement his friends and peers were involved with in the Central Valley agricultural community. The artists' colony was beneficial to the artists as well as an attraction for fair visitors. Jayo organized similar colonies at the seasonal gatherings at Catalina Island and the Pomona State Fair, and he worked as a portraitist at Disneyland in its early years, unsuccessfully attempting to organize an artists' colony there as well.

While Jayo continued to travel the fair circuit throughout his life, World War II was a break in this career. Volunteering for the army, he served in Eisenhower's Supreme Command. He made propaganda posters and flyers for the war effort, participated in the liberation of Paris, and created maps of Normandy for use by the GIs. The D-Day experience was so moving for Jayo that he later named one of his sons Norman.

After the war Jayo returned to Los Angeles and to his portrait work. He married and began a family. Seasonal work at El Mirador Hotel in Palm Springs prompted the Jayos to move in 1957 to the nearby town of Banning, where they lived on the border of the Morongo Indian Reservation. Jayo supported a family of eight children on his earnings as a professional portraitist. But although he was a skilled artist admired by his peers, Jayo created little noncommissioned artwork in his off-hours, instead spending his free time working on his countless ideas and inventions. Described as a Renaissance man interested in philosophy, science, religion, quantum physics, and math, Jayo created designs for a 3-D television set and for an original photo booth for the Keystone company, which produced four photos for a quarter as an amusement for the California State Fair.

While Ramon Magsaysay was the president of the Philippines in the mid-1950s, Jayo was commissioned by the consulate to create a painting of the leader. This larger-than-life-size portrait was one of the few oil paintings he made. Although he considered the commission a great honor, Jayo did not pursue similar work and was not motivated by a desire for success or prestige. Over his lifetime Jayo likely created thousands of pastel and sepia portraits, many of which may still hang in homes in California today.

Joe, Dale

BORN: August 28, 1928, San Bernardino, CA

DIED: February 23, 2001, New York, NY

RESIDENCES: 1928–1946, San Bernardino, CA § 1947–1953, Berkeley, CA § 1953–1956, New York, NY § 1956–1957, France § 1958–2001, New York, NY

MEDIA: painting, printmaking, and set design

Federico Jayo with Dorothy Lamour and Robert Preston, ca. 1940

ART EDUCATION: 1946–1950, University of California, Berkeley § ca. 1950–1951, California College of Arts and Crafts, Oakland, CA

SELECTED SOLO EXHIBITIONS: Urban Gallery, New York, 1954–1963 § Mi Chou Gallery, New York, 1954–1963 § *Dale Joe: Paintings*, The University of Iowa Museum of Art, Iowa City, 1999

SELECTED GROUP EXHIBITIONS: *San Francisco Art Association*, San Francisco Museum of Art, 1951–1953 § *Bokujin Group*, Japan, 1954, 1955 § *Fulbright Painters*, Smithsonian Institution, Washington, D.C., 1958 (traveling exhibition) § *Contemporary Chinese American Artists*, Los Angeles County Museum, 1959 § *Young America*, Whitney Museum of American Art, New York, 1960

SELECTED COLLECTIONS: Grey Art Gallery and Study Center, New York University, New York § Newark Museum of Art, Newark, NJ

SELECTED BIBLIOGRAPHY: *Dale Joe: Paintings*. Iowa City, IA: The University of Iowa Museum of Art, 1999. § Joe, Dale. CAAABS project interview. June 25, 1998. New York, NY. § O'Hara, Frank. "Dale Joe." *Art News* 53 (October 1954): 58. § Wechsler, Jeffrey, ed. *Asian Traditions/Modern Expressions: Asian American Artists and Abstraction, 1945–1970*. New York: Abrams in association with the Jane Voorhees Zimmerli Art Museum, Rutgers, the State University of New Jersey, 1997.

I've been moved and influenced by many artists and art movements from cave paintings to present-day art—much of this may not be evidenced on the surface of my work. I've painted who I am, caught up in the currents of Chinese and American cultures. I paint landscapes and nature from the traditions of Abstract-Expressionist action painting and calligraphic flung-paint accidental art.

DALE JOE
Dale Joe: Paintings

Dale Joe, 1998. Photo by Irene Poon

DALE JOE BEGAN studying art as a teenager in San Bernardino. He received his B.A. in creative writing and English literature at the University of California, Berkeley, and while pursuing an M.A. in the same field started to take art classes with **Mine Okubo** and Felix Ruvolo. They urged him to go on working in the visual arts, which he did through expanded study with Bay Area artists at the California College of Arts and Crafts in Oakland.

Joe studied painting with Ruvolo and printmaking with Leon Goldin at the college, and both there and at other schools he attended classes and lectures by Okubo, Richards Ruben, Sybil Moholy-Nagy, and Claire Falkenstein. Joe began to enter his work in competitions, including the San Francisco Art Association's annual exhibitions, where in 1951 he won two first prize purchase awards. His success continued as he participated in juried shows both locally and nationally, including at the de Young Museum, the Oakland Museum, the Brooklyn Museum print annuals, the Metropolitan Museum of Art print annuals, and the Chicago Art Institute print shows. In San Francisco, Joe designed sets for the Inter-players' production of *Dear Judas* by Robinson Jeffers as well as August Strindberg's *Miss Julie*. For Strindberg's play, Joe later recalled, "The theater reviewers noticed the sets utilizing banners in the splash paint technique more than the play."

In 1953, Joe moved to New York City after receiving a John Hay Whitney Opportunity Fellowship to study there. Joe had arranged to work as an assistant to Bradley Walker Tomlin because he admired Tomlin's calligraphic approach to painting, but a month before Joe arrived Tomlin died. His original plan thwarted, Joe introduced himself to other artists, including Jack Tworkov, Allan Kaprow, and Wolf Kahn. Joe also began an independent study of the handwriting of Western authors at the Pierpont Morgan Library as well as calligraphic study with **C. C. Wang** in his studio at Carnegie Hall.

Between 1954 and 1963 Joe had several one-person shows at the Urban Gallery in New York, known for exhibiting work by such artists as Kaprow, Leon Golub, and Felix Pasilis. During this same period, Joe also exhibited frequently at the Mi Chou Gallery, which featured modern paintings by Asian and Asian American artists like **Noriko Yamamoto**, **Bernice Bing**, and Chen Chi-kwan. Joe's work from the early 1950s is characterized by delicate markings—influenced by his study of handwriting and calligraphy—utilizing water-based media presented in horizontal scroll-like orientations. In paintings from the late 1950s, the markings appear on impastoed surfaces more square in format. Joe defined his work as incorporating action painting, abstract expressionism, and the direct ink writing of the Asian avant-garde.

In 1956–1957, Joe was awarded a Fulbright scholarship to study in France. While there, he studied the drawings of Degas as well as the Lascaux cave paintings. Upon his return to New York in 1958, his work was chosen for a national traveling exhibition of Fulbright artists that originated at the Smithsonian Institution, and in 1960, his paintings were included in the *Young America* exhibition at the Whitney Museum.

In the 1970s, Joe's fortune as a painter plateaued due to the closure of the Mi Chou and Urban galleries, as interest in abstract expressionism declined. Despite knowing Andy Warhol and participating in events at Warhol's first factory, Joe chose not to embrace pop art and turned to freelance design work to support himself. Joe had a successful career as a home projects designer for magazines such as *Family Circle, Woman's Day*, and *McCall's*, which enabled him to also continue creating his own work. His later paintings are characterized by fluid paint handling that suggests abstract atmospheric environments.

Kagi, Tameya

BORN: 1851, Japan

DIED: 1894, Japan

RESIDENCES: 1851–1875, Japan § 1875–1885, San Francisco, CA § 1885–1889, Berlin, Germany § 1889–1894, Japan

MEDIA: oil painting

SELECTED GROUP EXHIBITIONS: *Dai Ni Kai Naikoku Kangyou Hakurankai* (Second Domestic Industrial Exposition), Japan, 1881 § *Mechanics' Institute Exhibition*, San Francisco, 1883, 1884 § *San Francisco Art Association*, 1884

SELECTED COLLECTION: Miyagi Museum of Art, Sendai, Japan

SELECTED BIBLIOGRAPHY: 1880 Federal Population Census. San Francisco, San Francisco, California. Roll T9_73, Page 490D, Enumeration District 38, Image 0718. National Archives, Washington, D.C. § Halteman, Ellen Louise. *Publications in [Southern] California Art 7: Exhibition Records of the San Francisco Art Association, 1872–1915; Mechanics' Institute, 1857–1899; California State Agricultural Society, 1856–1902.* Los Angeles: Dustin Publications, 2000. § *Japanese Artists Who Studied in U.S.A. 1875–1960 (Taiheiyō o koeta Nihon no gakatachi ten)*. Wakayama, Japan: Museum of Modern Art, Wakayama, 1987.

TAMEYA KAGI IS the first artist of Japanese ancestry documented to have worked in California. He came from a samurai family in Wakayama and moved to the United States in 1875. In San Francisco he worked to save money to study art, while he painted in his free time. Hired as an assistant to a measurement technician for a survey of the Pacific Coast, he took the opportunity to improve his drawing skills. When his art began to receive attention, he left the survey team to return to San Francisco with his small savings in order to attend art school. He may have taken classes at the newly formed California School of Design.

In San Francisco Kagi worked under a German artist, creating architectural drawings. An accident that disabled his leg

Tameya Kagi

prevented him from doing physical work, and although many suggested that he return to Japan because of limitations resulting from his disability, Kagi remained in San Francisco, relying on his skills as an artist to make a living. In the 1880 U.S. census he reported "portrait painter" as his profession.

Kagi became the apprentice to Juan (James) Buckingham Wandesforde in 1878, studying oil painting. Wandesforde, an English artist who came to California in 1862, had been the first president of the San Francisco Art Association in 1872. That Kagi was the assistant to one of the most prominent painters in the city suggests his profile during this period.

Three works by Kagi were exhibited in 1881 in Japan's *Dai Ni Kai Naikoku Kangyou Hakurankai* (Second Domestic Industrial Exposition). In the 1883 *Mechanics' Institute Exhibition* in San Francisco, Kagi showed five works, including *The Morning Drink, Azalea*, and *Golden Gate*. In the 1884 Mechanics' Institute show, four works by Kagi were included: *The Turtle Who Wanted to Fly, A Faun, Vicinity of Tokio*, and *San Francisco Night Scene*.

Kagi moved to Berlin by way of London in 1885 and is reported to have studied painting at the Berlin University. He returned to Japan in 1889 and participated in the Meiji Bijutsu Kai, Japan's first Western painting group.

Kagi served as a juror for the *Dai San Kai Naikoku Kangyou Hakurankai* (Third Domestic Industrial Exposition) in 1890, and he exhibited his *Head of a Horse* in the Meiji Bijutsu Kai's third exhibition in 1891. Kagi taught at a school that the Meiji Bijutsu Kai started in 1892, but he died two years later.

Kaneko, Jun

BORN: 1942, Nagoya, Japan

RESIDENCES: 1942–1963, Nagoya, Japan § 1963–1967, Los Angeles, CA § 1967, Berkeley, CA, and Helena, MT § 1968–1972, Los Angeles, CA (with extended trip to Japan in 1971) § 1972–1973, Durham, NH § 1973–1975, Providence, RI § 1975–1979, Nagura, Japan § 1979–1986, Bloomfield Hills, MI § 1986–present, Omaha, NE

MEDIA: sculpture, ceramics, painting, and textiles

ART EDUCATION: 1964, California Institute of the Arts, Los Angeles § 1966, University of California, Berkeley § 1970, Claremont Graduate School, Claremont, CA

SELECTED SOLO EXHIBITIONS: David Stuart Galleries, Los Angeles, 1968 (two-person show with Peter Voulkos) § Woods-Gerry Gallery, Rhode Island School of Design, Providence, 1975 § Clayworks Studio Workshop, New York, 1979 § *Parallel Sounds*, Contemporary Art Museum, Houston, 1981 § *Jun Kaneko: Dangos in the Garden*, Longhouse Reserve, East Hampton, NY, 2001

SELECTED GROUP EXHIBITIONS: *Zaiya Invitational Painting Show*, Nagoya, Japan, 1963 § *23rd Ceramic National Exhibition*, Everson Museum of Art, Syracuse, NY, 1964 § *Craftsman USA '66*, Museum of Contemporary Crafts, New York, 1966 § *Directions in Contemporary American Ceramics*, Museum of Fine Arts, Boston, 1984 § *Color and Fire*, Los Angeles County Museum of Art, 2000

SELECTED COLLECTIONS: American Crafts Museum, New York § Los Angeles County Museum of Art § Philadelphia Museum of Art § Shigaraki Ceramic Museum, Shigaraki, Japan § Smithsonian American Art Museum, Washington, D.C.

SELECTED BIBLIOGRAPHY: Davis MacNaughton, Mary. *Revolution in Clay: The Marer Collection of Contemporary Ceramics*. Seattle: University of Washington Press, 1994. § Interview With Jun Kaneko, November 1998. http://www.kleinart.com/html/kaneko-articles-1998b.html. Downloaded March 14, 2001. § Kaneko, Jun. CAAABS project interview. March 19, 2001. Transcript, Asian American Art Project, Stanford University. § Peterson, Susan. *Jun Kaneko*. Trumbull, CT: Laurence King, 2001. § Silberman, Robert. "Jun Kaneko." *American Craft*, October/November 2000.

I am not offended if somebody calls me an American artist. This is a really interesting thing. About 90 percent of my activities are in this country, so from that point of view this may be true. But when I go to Asian countries to judge [ceramic] competitions, the Asian judges always ask if I mind being considered an American judge. Many people in Japan say my work has a lot of strong American influences. Many people in the U.S. see a lot of Japanese influence in my art. It depends where you stand, what environment you are in.

JUN KANEKO
CAAABS project interview

TODAY JUN KANEKO is known for his monumental ceramic sculptures he calls *dango* (Japanese for "dumpling"), but when he arrived in the United States in 1963, the artist planned to study painting and had little interest in ceramics. From an

Jun Kaneko, 1969

early age Kaneko was interested in the work of the Catalan artist Antoni Tàpies, whose paintings combine surface features of earth and glue with bold markings influenced by Asian calligraphy. Kaneko began his own artistic study in the studio of the painter Ogawa Satoshi in 1961, and after winning several awards for his paintings in Japan, he decided that he wanted to pursue a career in art. Concerned that the Japanese school system would not offer him enough creative freedom, Kaneko believed his choice was between studying alone outside of the Japanese school system or studying at an institution abroad. So, at the recommendation of his painting tutor, Kaneko, twenty-one years old and speaking no English, boarded a plane and flew to Los Angeles.

Kaneko was met at the Los Angeles airport by Jerry Rothman, a friend of his tutor. Rothman had recently graduated from the Otis Art Institute, where he had studied with Peter Voulkos. Rothman introduced Kaneko to Fred and Mary Marer, important collectors of contemporary West Coast ceramics, and Kaneko house-sat for them while they were in Europe. During the three months he lived at the Marer house, Kaneko became intimately familiar with the collection that included work by Voulkos, **Henry Takemoto**, John Mason, and Kenneth Price. By the time the Marers returned, Kaneko had decided to change his focus and pursue ceramics.

Kaneko attended the California Institute of the Arts in 1964, but not until later that summer, when he lived and worked with Rothman in Paramount, California, did Kaneko begin making objects that he felt were successful. He made flat shapes and used glazes to create abstract images and symbols, much like painting on canvas. He also began to produce large forms, later explaining that creating a four-foot-tall ceramic piece did not seem unusual, as the ceramic artists he had been exposed to at that time were all making large-scale works. Kaneko continued his studies with Peter Voulkos at Berkeley, and later with Paul Soldner at the Claremont Graduate School.

While Kaneko has commented that he did not experience racism during his early years in California, he did experience culture shock. Moving to America, Kaneko said, was a very drastic but positive experience. He felt his body and mind slow down so that he could investigate visually what others learned easily from oral communication.

Kaneko has taught at such schools as the Rhode Island School of Design (1973–1975) and the Cranbrook Academy of Art (1979–1986). He began to work in Omaha, Nebraska, in 1983 when he starting using a commercial kiln in the city to produce monumental-sized ceramics. Today Kaneko and his wife, Ree Schonlau, continue to live and work in Omaha. Kaneko exhibits widely, and his public art commissions can be found at the Salt Palace Convention Center in Salt Lake City, the Toronto International Airport, and San Jose Symphony Hall in San Jose, California.

Kanemitsu, Matsumi Mike

BORN: May 28, 1922, Ogden, UT

DIED: May 11, 1992, Los Angeles, CA

RESIDENCES: 1922–1925, Ogden, UT § 1925–1937, Hiroshima, Japan § 1937–1938, Ogden, UT, and Ruth, NV § 1938–1940, Hiroshima, Japan § 1940–1941, Los Angeles, CA; Salt Lake City, UT; and McGill, NV § 1941–1946, Fort Douglas, UT; and Fort Riley, KS (U.S. military service) § 1946, Nice, France (U.S. military service) § 1946–1950, Baltimore, MD § 1950–1951, Paris, France § 1951–1965, New York, NY § 1965–1992, Los Angeles, CA

MEDIA: oil, acrylic, watercolor and ink painting, and printmaking

ART EDUCATION: ca. 1950s, Art Students League, New York § 1961, 1965, 1969, Tamarind Lithography Workshop, Los Angeles

SELECTED SOLO EXHIBITIONS: *Drawings*, Baltimore Museum of Art, 1954 § Honolulu Academy of Arts, Honolulu, 1967 § *Selected Works, 1968–1978*, Los Angeles Municipal Art Gallery, 1978 § Japanese American Cultural Center, Los Angeles, 1988 § *Matsumi Kanemitsu, 1950–90*, The National Museum of Art, Osaka/Hiroshima City Museum of Contemporary Art, Japan, 1998

SELECTED GROUP EXHIBITIONS: *Annual Exhibition*, Baltimore Museum of Art, 1948 § *Whitney Annual*, Whitney Museum of American Art, New York, 1956 § *14 Americans*, Museum of Modern Art, New York, 1962 § *Japanese Artists Who Studied in USA, 1875–1960*, Hiroshima Museum of Modern Art, Hiroshima, 1986 § *Asian Traditions/Modern Expressions*, Jane Voorhees Zimmerli Art Museum, Rutgers State University, New Brunswick, NJ, 1997 § *Made in California: Art, Image, and Identity, 1900–2000*. Los Angeles County Museum of Art, 2000

SELECTED COLLECTIONS: Corcoran Gallery of Art, Washington, D.C. § Los Angeles County Museum of Art § Metropolitan Museum of Art, New York § Museum of Modern Art, New York § San Francisco Museum of Modern Art § Smithsonian American Art Museum, Washington, D.C.

SELECTED BIBLIOGRAPHY: Foster, James. *Matsumi Kanemitsu.* Honolulu: Honolulu Academy of Arts, 1967. § Kanemitsu, Matsumi. Interview by Marjorie Rogers. 1977. "Los Angeles Art Community: Group Portrait," UCLA Oral History Program. § *Kanemitsu Selected Works, 1968–1978.* Los Angeles: Los Angeles Municipal Art Gallery, 1978. § *Matsumi Kanemitsu, 1950–1990.* Osaka, Japan: Osaka Prefectural Government, 1998. § *Matsumi Kanemitsu Lithographs, 1961–1990.* Osaka: Yamaki Art Gallery, 1990.

To me, I want my work to be like life—everything that is different or opposite to be in balance, like yin and yang, negative and positive, day and night. I want to be just like sunshine, like moon.

MATSUMI MIKE KANEMITSU
Quoted by Nancy Uyemura in
Matsumi Kanemitsu, 1950–1990

BORN IN OGDEN, UTAH, Matsumi Kanemitsu was taken to Japan at age three to be reared by his grandparents in a suburb of Hiroshima. He did not return to the United States for thirteen years, when as a teenager he attended school briefly in Ogden before working on the railroad and in copper mines in Nevada. Back in Japan in 1938 to finish high school, he eventually convinced his father to let him return to his country of birth, and he worked briefly as a gardener in Los Angeles before enlisting in the U.S. Army, thereby forfeiting his Japanese citizenship. Following the attack on Pearl Harbor, Kanemitsu was arrested, interrogated, and released. He spent much of his military career detained in several army camps in the Midwest, ending up at Fort Riley, Kansas, where, with art materials provided by the Red Cross, he drew portraits and decorated officers' clubs. He later said, "That was the beginning of my [art] career." At the end of hostilities, he volunteered for overseas service and was stationed in France as a hospital assistant.

While in France, Kanemitsu established connections with the bohemian art world, meeting intellectuals and artists—among them Pablo Picasso—who introduced him to modernist art and reinforced his decision to pursue formal study, first on the GI Bill with sculptor Karl Metzler in Baltimore, then with Fernand Léger in Paris, and finally at New York's Art Students League. There his work was initially representational, reflecting the influence of **Yasuo Kuniyoshi** and the social realism of Harry Sternberg. Until Kuniyoshi's death in 1953, Kanemitsu worked in the surrealist-inflected figurative style of his famous teacher. Abandoning study at the League, he became immersed in the world of the abstract expressionists, aligning himself with some of the movement's leading members, notably Ad Reinhardt, and imbibing the spirit and ideals of what became known as the New York school.

In 1961, Kanemitsu received a Ford Foundation grant to work at the Tamarind Lithography Workshop in Los Angeles. His collaboration with June Wayne provided the opportunity to explore lithography, the medium that constituted what many critics consider his greatest achievement. In 1965, Kanemitsu accepted a teaching position at the California Institute of the Arts (formerly the Chouinard Art Institute), where he taught until 1970. He became a familiar figure in the Los Angeles art

Matsumi Kanemitsu, 1958

Taizo Kato, ca. 1920

world and was particularly admired by his students at the institute and at the Otis Art Institute, where he taught from 1971 to 1983. His art underwent several transformations, but he often worked with *sumi-e* brush and ink-based techniques. In 1964 he visited Japan and established ongoing contact with the avant-garde Gutai Group and Bokujin Group.

Kanemitsu's gestural painting of the New York years ultimately gave way to a sensual, coloristic post–painterly abstraction, as seen in the *Pacific* and *Wave Series* of the early 1980s. These lyrically decorative paintings are typical of his California work and may be in part a response to the emphasis on the shifting atmospheric color effects characteristic of the Southern California light-and-space movement. Throughout these changes Kanemitsu remained dedicated to preserving qualities that he believed to be inherent in the Asian tradi-

tion, including the use of black-and-white *sumi-e* painting. This aspect of his work was typically emphasized by critics. In August 1991 he was diagnosed with inoperable lung cancer. Kanemitsu died in May of the following year in his downtown Los Angeles studio/residence, just blocks from Little Tokyo.

Kato, Taizo

BORN: 1888, Japan

DIED: January 4, 1924, Los Angeles, CA

RESIDENCES: 1888–1906, Japan § 1906–1924, Los Angeles, CA

MEDIA: photography

SELECTED SOLO EXHIBITION: *Taizo Kato: The Modernist Eye*, White Room Gallery, Los Angeles, 2004

SELECTED GROUP EXHIBITIONS: *Made in California: Art, Image, and Identity, 1900–2000*, Los Angeles County Museum of Art, 2000 § *Ansel Adams and the Development of Landscape Photography in America*, Sheldon Art Galleries, St. Louis, MO, 2003 § *California Dreaming: Camera Clubs and the Pictorial Photography Tradition*, Boston University Art Gallery, 2004

SELECTED COLLECTIONS: Bancroft Library, University of California, Berkeley § Japanese American National Museum, Los Angeles § National Gallery of Canada, Ottawa, Ontario, Canada

SELECTED BIBLIOGRAPHY: 1920 Federal Population Census. Los Angeles, Los Angeles, California. Roll T625 108, Page 8A, Enumeration District 212, Image 293. National Archives, Washington, D.C. § Howe, Percy Y., ed. *1923 American Annual of Photography*, vol. 37. New York: Tennant and Ward, 55, 199. § Howe, Percy Y., ed. *1924 American Annual of Photography*, vol. 38. New York: Tennant and Ward, 271. § Howe, Percy Y., ed. *1925 American Annual of Photography*, vol. 39. New York: Tennant and Ward, 165. § Kato, Taizo. "The Records of an Unbroken Friendship but the Mortal Severance, 1907–1924." Collection of the Bancroft Library, University of California, Berkeley. § *Photograms of the Year 1921: the annual review of the world's pictorial photographic work*. London: Iliffe & Sons Ltd.; Boston: American Photographic Pub. Co., 1921.

TAIZO KATO ARRIVED in the United States in 1906 at the age of eighteen. Although it is not known where he spent his first few years in the country, by 1910 he was living in Los Angeles. Kato worked as a photographer and ran the Korin, a Kodak store and art shop located first at 408 West Sixth and later at 522 S. Hill Street.

Much of what is known of Kato comes from the album *The Records of an Unbroken Friendship but the Mortal Severance, 1907–1924*, a collection of photographs likely assembled by his friend Kamejiro Sawa after Kato's death. The 1920 federal census lists Kato and Sawa living at the same residence, and both list 1906 as their date of immigration to the United States. The 1907 date cited in the album's title indicates that they likely met and began their friendship the year after they both arrived in the United States, and it appears they ran the Korin together. Besides containing photographs by Kato, the album documents Kato's travels throughout California (and perhaps abroad), includes pictures of the Korin, and has many photographs of Kato and his friends (including Sawa), some of whom were artists and photographers. Concluding photographs are from Kato's funeral, held January 9, 1924.

Kato was a prolific photographer who primarily made elegantly composed, soft-focus, pictorialist landscapes and still lifes. He also created portraits, and a photograph of actor **Sessue Hayakawa** found in *The Records of an Unbroken Friendship* is likely by the artist. A 1917 photograph by Kato in the National Gallery of Canada in Ottawa is of Cristel Gang, who would later work as a secretary for Edward Weston and **Sadakichi Hartmann**. Kato's photographs are skilled interpretations of the pictorialist style popular at the time. He probably knew other Little Tokyo photographers, who formed the Japanese Camera Pictorialists of California and whose pictorial work would grow more modern and influential in the mid to late 1920s and the 1930s. The Japanese Camera Pictorialists held their first exhibition in 1924, just months after Kato's death.

Kee, Hu Wai (Hu Wai Key)

BORN: May 21, 1890, Honolulu, HI

DIED: September 8, 1965, San Francisco, CA

RESIDENCES: 1890–1921, Honolulu, HI § 1921–1965, San Francisco, CA

MEDIA: ink, oil and watercolor painting, and pastels

ART EDUCATION: 1930–1931, California School of Fine Arts, San Francisco

SELECTED GROUP EXHIBITIONS: *Chinese Art Association of America*, de Young Museum, San Francisco, 1935/36 §

Hu Wai Kee, 1949

California State Fair, Sacramento, 1936 § Oakland Art
Gallery, Oakland, CA, 1937, 1938 § *Chinatown Artists
Club*, de Young Museum, San Francisco, 1942–1945 §
San Francisco Art Association, San Francisco Museum of
Art, 1943 § *5th Annual Art Festival*, Palace of Fine Arts,
San Francisco, 1951 § *7th Annual Union Square Festival*,
San Francisco, 1953

SELECTED BIBLIOGRAPHY: Hu, Sandria. CAAABS project
interview. April 28, 2002. Audiotape, Asian American Art
Project, Stanford University. § Hughes, Edan Milton.
Artists in California, 1786–1940. San Francisco: Hughes
Publishing Company, 1989.

HU WAI KEE may have studied art in Honolulu as a young man
prior to moving to San Francisco in 1921 at the age of thirty-
one. Kee traveled to the city with his brother, the only two
siblings of a large family to leave Hawaii, and worked in San
Francisco as an insurance agent. He married in 1926.

The first indication of Kee's artistic activities is from en-
rollment records at the California School of Fine Arts for the
1930–1931 academic year. There he likely attended classes
with **Eva Fong Chan**, Wahso Chan, Sam Fong, **Hon Chew
Hee**, and Longsum Chan, who were also enrolled then. These
individuals would all become members of what would be
known first as the Chinese Art Association and later as the
Chinatown Artists Club, whose membership consisted of both
academically trained artists and amateur or hobbyist painters.
The Chinese Art Association held its first exhibition at the de
Young Museum in 1935. Kee contributed five oil paintings, in-
cluding *Telegraph Hill, Still Life, Cigar and Wine*, and *Makapuu
Point*, the latter title a reference to the location on the eastern
side of Oahu, the island of his birth.

In 1941, Kee served as the secretary of what was then the
Chinatown Artists Club. He wrote to the de Young Museum
requesting another exhibition for the group, preferably in Feb-
ruary, to coincide with Chinese New Year. This 1942 show,
as well as the subsequent exhibitions of the group in the fol-
lowing three years, all took place in February. In 1942, Kee
exhibited three oil paintings and one watercolor, a mixture of
portraits, still lifes, and landscapes. The biography of Kee that
appears with the 1942 exhibition records notes that he studied
with Nelson Poole, Hal Heath, John Garth, Otis Oldfield, and
R. Jerome Jones.

In 1943 Kee exhibited eight works in the de Young show:
*Sunset at Sacramento River, Key Haven at Hunter's Point, Volcano
at Kilauea, Barn House, High Sierra, My Home at Hunter's Point,
Portsmouth Square*, and *Still Life*. He exhibited again with the
group in 1944, and in the 1945 exhibition he contributed six
watercolors and one oil painting. In addition to the oil and wa-
tercolor work represented in these exhibitions, Kee was also a
skilled calligrapher and created ink paintings of Chinese imag-
ery. Throughout the 1950s Hu continued to exhibit in San Fran-
cisco at outdoor shows in locations such as Union Square.

Ernie Kim, ca. 1950s

Kim, Ernie

BORN: September 2, 1918, Manteca, CA

DIED: May 10, 1997, Sonoma, CA

RESIDENCES: 1918–ca. 1936, Manteca, CA § ca. 1936–1942,
Los Angeles, CA § 1942–1947, Europe (U.S. military
service) § 1947–1949, Fort Lewis, WA, and Los Angeles,
CA § 1949–1997, San Francisco Bay Area (including Palo
Alto, Richmond, San Francisco, and Sonoma)

MEDIA: ceramics and sculpture

SELECTED SOLO EXHIBITIONS: Richmond Art Center,
Richmond, CA, 1964 § *Ernie Kim and Sungwoo Chun*,
Richmond Art Center, Richmond, CA, 1965

SELECTED GROUP EXHIBITIONS: *Association of San Francisco
Potters*, de Young Museum, San Francisco, 1954, 1956,
1958 § California State Fair, Sacramento, 1955, 1956,
1958, 1960, 1961 § *6th Annual Exhibition of Ceramic Arts*,
Smithsonian Institution, Washington, D.C., 1957

SELECTED COLLECTIONS: Everson Museum of Art, Syracuse,
NY § St. Paul Art Center, St. Paul, MN

SELECTED BIBLIOGRAPHY: Meisel, Alan. "Letter from San
Francisco." *Craft Horizon*, January 25, 1965, 41. § Sanders,
Dr. Herbert. *Sunset Ceramics Book*. Menlo Park, CA: Lane
Publishing, 1953.

*[In 1946] I encountered a fascinating experience with a
medium I was particularly adapted to. It was then that I
realized I could serve myself and the community by becoming
a ceramic artist.*
ERNIE KIM
Career Statement and Biography. N.d., ca. 1960.
Collection Asian American Art Project,
Stanford University.

AN ACCLAIMED CERAMICIST during the 1950s, and later an influential teacher and art center director, Ernie Kim was first introduced to ceramics while recovering from injuries incurred at the Battle of the Bulge during World War II. A parachute lieutenant in the U.S. Army, Kim was the sole survivor of his unit and had been left to die in the snow but was subsequently captured. At the German POW camp in Heppenheim, he received no medical care and very little food. When he was finally rescued, Kim weighed only sixty-five pounds and suffered from severe depression.

Kim spent several years in army hospitals, where he began to work with clay as occupational therapy. After he was discharged, he completed a course in ceramics sponsored by the Veterans Administration. In 1949, he moved to the Bay Area, where he worked as a teacher at Nixon's Craft Studio and attended a design class taught by Marian Hartwell. In 1952, Kim was hired as an instructor in the Palo Alto Unified School District and began exhibiting his work widely. He was awarded many prizes both regionally and nationally in the 1950s and 1960s. During this period, his work incorporated powerful surface design and unusual variations of pottery forms. He was appointed head of the ceramics department at the California School of Fine Arts in 1956. In 1962, he began teaching at the Richmond Art Center and served as the center's director from 1970 to 1980. In 1998, the Richmond Art Center instituted an annual prize for artists in craft media that bears his name.

Although Kim expressed an interest in pursuing pure sculpture, he generally focused on creating functional forms. His ceramic work is characterized by a combination of earth colors obtained from slips and oxides and by his use of oxidation, sgraffito, calligraphic markings, and wax-resist techniques for surface designs. During the 1980s, the artist also experimented with creating bronze wall reliefs.

Kingman, Dong (Dong Moy Chu)

BORN: April 1, 1911, Oakland, CA

DIED: May 12, 2000, New York, NY

RESIDENCES: 1911–ca. 1916, Oakland, CA § ca. 1916–1929, Hong Kong § 1929–1933, Oakland, CA § 1933–1946, San Francisco, CA § 1946–2000, New York, NY

MEDIA: watercolor painting

ART EDUCATION: 1931, Fox Morgan School, Oakland, CA

SELECTED SOLO EXHIBITIONS: Art Center, San Francisco, 1936 § de Young Museum, San Francisco, 1945 § Midtown Gallery, New York, 1945 § Taipei Museum, Taiwan, 1996 § Brewster Gallery, New York, 1997

SELECTED GROUP EXHIBITIONS: *San Francisco Art Association*, San Francisco Museum of Art, 1935 (inaugural), 1936, 1937,

1939–1943 § *California Art Today*, Golden Gate International Exposition, San Francisco, 1940 § Taipei Art Gallery, New York, 1997 § *Made in California: Art, Image, and Identity, 1900–2000*, Los Angeles County Museum of Art, 2000

SELECTED COLLECTIONS: de Young Museum, San Francisco § Hirshhorn Museum and Sculpture Garden, Washington, D.C. § Metropolitan Museum of Art, New York § San Francisco Museum of Modern Art § Whitney Museum of American Art, New York

SELECTED BIBLIOGRAPHY: Caen, Herb, and Dong Kingman. *San Francisco: City on Golden Hills*. Garden City, NY: Doubleday & Company, 1967. § "Dong Kingman." *California Art Research*. San Francisco: WPA, 1937. § Gruskin, Alan D., and William Saroyan. *The Watercolors of Dong Kingman, and How the Artist Works*. New York: Studio Publications, 1958. § Kingman, Dong. CAAABS project interview. New York, NY. July 3–4, 1996. Transcript, Asian American Art Project, Stanford University. § Kingman, Dong. *Paint the Yellow Tiger*. New York: Sterling Publishing, 1991. § Kingman, Dong. *Portraits of Cities*. New York: 22 Century Film Corp., 1997. § "Official Dispatch: Artist records his mission on 40-foot painted scroll." *Life*, February 14, 1955, 66–70. § Watson, Ernest W. "Dong Kingman: An Interview." *American Artist Magazine* 7 (February 1943): 12.

In the old tradition of China, Chinese artists often painted their pictures from memory. First, [he] would go to a mountain… for a sketch trip…. Back in the studio he developed his picture, his memory aided by the scanty scribbles he may have brought back in his sketchbook. All of this, to my understanding, produced some very satisfactory results and I very often follow the same procedure.

DONG KINGMAN
Watson, "Dong Kingman: An Interview," 12

OFTEN ACCLAIMED AS America's most popular watercolor artist, Dong Kingman was born in Oakland, California. In 1916, at the age of five, he moved with his family to Hong Kong, where he studied painting—both plein-air oil painting with his Paris-trained teacher Szetu Wei and classical Chinese painting at a private school, which instructed through copying. In 1929, Kingman returned to Oakland with his first wife, and in 1931, he continued his art training at the nearby Fox Morgan School, where he received recognition for his watercolor painting. He moved with his wife and son to San Francisco in 1933, and there he joined the Chinese Art Association. Although Kingman later complained that association members were overly interested in playing mahjong, he participated in several of their exhibitions.

In 1935, Kingman participated in group shows at major San Francisco museums and worked for the WPA. His first

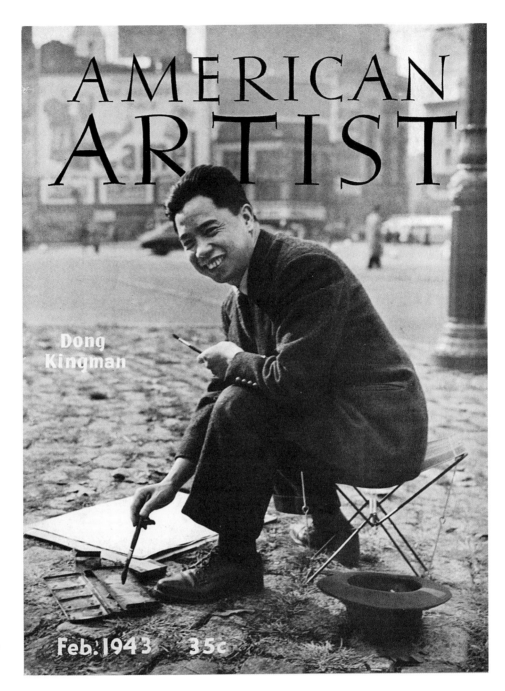

Dong Kingman, 1943

major solo exhibition at the Art Center in 1936 received a rave review, which brought increased recognition. In that same year he was awarded the First Purchase Prize of the San Francisco Art Association and began teaching. His works were acquired by important collectors, including William Gerstle and Albert Bender, who donated works to several U.S. museums. Kingman's North Beach studio at 15 Hotaling Place was around the corner from the noted Black Cat Café, a gathering place for such artists and writers as Matthew Barnes, Beniamino Bufano, Raymond Pucinelli, John Steinbeck, and William Saroyan—all of whom Kingman knew.

In 1942–1944, Kingman received a two-year Guggenheim Fellowship, which enabled him to paint throughout the United States. He was drafted into the army in 1944, but Eleanor Roosevelt, an admirer of his work, arranged for his transfer to the O.S.S. Art Department, where he drew maps. In 1945, the de Young Museum mounted a major exhibition of his work, which was reviewed in *Time* magazine, and the artist attended the opening in uniform. Later that year, Kingman's first New York exhibition was held at the Midtown Gallery, and he received his first magazine assignment to illustrate a story on China for *Fortune*. Kingman moved permanently to New York in 1946.

In 1953, Kingman was the subject of a short documentary by **James Wong Howe**, which was screened during Kingman's goodwill trips on behalf of the U.S. State Department. One such trip was also documented in a 1955 issue of *Life* magazine. In the 1960s, Kingman was hired to create opening titles for such Hollywood films as *55 Days at Peking*, *The World of Susie Wong*, and *Flower Drum Song*. He also was a juror for twenty consecutive years for the televised Miss Universe pageant. Beginning in the 1960s, he exhibited and traveled internationally, received many awards, illustrated dozens of magazine covers, and published several books of his works. Although his mobility was impaired by a stroke in his later years, he remained active until his death.

Kira, Hiromu

BORN: April 5, 1898, Waipahu, Oahu, HI

DIED: July 19, 1991, Los Angeles, CA

RESIDENCES: 1898–1902, Oahu, HI § 1902–1914, Kumamoto Prefecture, Japan § 1914–1916, Vancouver, Canada § 1916–1926, Seattle, WA § 1926–1942, Los Angeles, CA § 1942–1944, Santa Anita Assembly Center, Santa Anita, CA; Gila River Relocation Center, Rivers, AZ § 1944–1946, Cleveland, OH § 1946–1991, Los Angeles, CA

MEDIA: photography

SELECTED GROUP EXHIBITIONS: *International Photography Salon*, Prague, Czechoslovakia, 1928 § *Pittsburgh Photography Salon*, Pittsburgh, PA, 1931 § *25th Annual International Salon of the Camera Pictorialists of Los Angeles*, 1942 § *Japanese Photography in America: 1920–1940*, Japanese American Cultural and Community Center, Los Angeles, 1985 (toured to venues including Oakland Museum of California; Whitney Museum of American Art, New York; and Corcoran Gallery of Art, Washington, D.C.) § *Painted with Light: Photographs by the Seattle Camera Club*, Seattle Art Museum, 1999–2000 § *Made in California: Art, Image and Identity, 1900–2000*, Los Angeles County Museum of Art, 2000 § *California Dreaming: Camera Clubs and the Pictorial Photography Tradition*, Boston University Art Gallery, 2004

SELECTED COLLECTIONS: The Cleveland Museum of Art § Japanese American National Museum, Los Angeles § Los Angeles County Museum of Art § Polk Museum of Art, Lakeland, FL

SELECTED BIBLIOGRAPHY: Blumann, Sigismund. "Hiromu Kira, A Japanese Artist Who Has Poetized Paper." *Camera Craft* 35, no. 8 (August 1928). § Kira, Hiromu. "Why I Am a Pictorial Photographer." *Photo Era Magazine* 64, no. 5 (May 1930): 231–232. § Monroe, Robert. "Light and Shade: Pictorial Photography in Seattle, 1920–1940, and the Seattle Camera Club." In *Turning Shadows into Light*, edited by Mayumi Tsutakawa and Alan C. Lau. Seattle: Young Pine Press, 1982. § Reed, Dennis. *Japanese Photography in America: 1920–1940*. Los Angeles: Japanese American Cultural and Community Center, 1985. § *Vanity Fair* 36, no. 1 (March 1931): 42. § Wilson, Michael G., and Dennis Reed. *Pictorialism in California: Photographs 1900–1940*. Malibu and San Marino, CA: J. Paul Getty Museum and Henry E. Huntington Library and Art Gallery, 1994.

Truly speaking, it was more or less incidental that I became a pictorialist: first, mere curiosity in the camera itself, then the interest in the souvenirs of the occasions; and, finally, the sublime pleasure in reproducing the creative expression of the things that appeal to our artistic nature.

HIROMU KIRA
"Why I Am a Pictorial Photographer," 231–232

AMONG THE BEST-KNOWN and best-documented pictorialist photographers in Los Angeles, Hiromu Kira began his photography career in Seattle. Born in Hawaii, Kira was sent to Japan for his education and eventually moved to Seattle when he was eighteen. There he first became interested in photography after borrowing a camera from a friend. He subsequently bought his own Kodak camera and taught himself how to develop and print film in his bathroom. After experiencing frustration with

Hiromu Kira

developing film, and with unsatisfactory results from professional photo finishers, Kira stopped pursuing photography for two years. In 1922, he was inspired to pick up the camera again after being impressed by images he saw in a local exhibition. In 1923, he submitted prints to the Seattle Photography Salon, and two were accepted. The following year his work was accepted in the Pittsburgh Salon and the Annual Competition of American Photography. Kira began to work in the camera department of a local pharmacy and met other photographers, such as Kyo Koike, and joined the Seattle Camera Club. Kira's work from this period includes images of street scenes, Mount Baker, and fishermen, all common subject matter for club members at the time.

In June 1926, Kira moved to Los Angeles with his wife and two young children after a friend wrote to him about the city's good climate and employment opportunities. Although never a member of the Japanese Camera Pictorialists of California, a group that was active in Los Angeles at the time, he did become close friends with club members K. Asaishi and T. K. Shindo. These new associations may have contributed to developments in Kira's work, as he began creating photographs that differed dramatically from the images he made in Seattle. He saw the 1927 and 1931 Edward Weston exhibitions sponsored by the Shaku-do-sha group and, like Weston, began concentrating on still lifes and avoided retouching negatives and prints.

By late 1927, Kira was working on a series of photographs of origami cranes placed on geometric backgrounds. Elegant in composition, these photos evidenced a decidedly modern approach, as Koike, Kira's friend and mentor in Seattle, noted in a review in the July 13, 1928, issue of *Notan*. "Mr. Hiromu Kira well represents his technical skill in 'Study—Paper Work.' I have a different opinion about calling such kind of picture a pictorial work, but I should never reject it." The year 1928 marked the beginning of a series of photographs Kira made of glass vials, continuing his play with geometric forms and composition. This period was both highly productive and successful for Kira. In 1928 he was named an associate of the Royal Photography Society, and the following year he was made full fellow. In 1929 alone Kira exhibited ninety-six works in twenty-five different national and international shows. During this time Kira was also employed at T. Iwata's art store, and his photograph *The Thinker* was made on an outing to show a customer how to use his newly purchased camera. This photograph would appear in the March 1931 issue of *Vanity Fair* magazine.

In 1941, two days before Pearl Harbor, Kira's work was jurored into the *25th Annual International Salon of the Camera Pictorialists of Los Angeles*. A few months later Kira began to burn many family belongings in anticipation of internment. He stored his camera, photography books, and prints in the basement of the Nishi Hongwanji Buddhist Temple while he and his family were interned at Gila River. After release he lived briefly in Chicago before returning to Los Angeles. There, Kira worked as a photo retoucher and printer for the Disney, RKO, and Columbia Pictures studios and never returned to the successful career he had established before the war.

Kishi, Masatoyo

BORN: March 11, 1924, Osaka, Japan

RESIDENCES: 1924–1960, Osaka and Tokyo, Japan § 1960–1988, San Francisco, CA § 1988–present, Grass Valley, CA

MEDIA: sculpture and oil and ink painting

SELECTED SOLO EXHIBITIONS: Bolles Gallery, San Francisco, 1962 § Nicholas Wilder Gallery, Los Angeles, 1965 § Richmond Art Center, Richmond, CA, 1970 § Gregory Ghent Gallery, San Francisco, 1986

SELECTED GROUP EXHIBITIONS: *Winter Invitational*, California Palace of the Legion of Honor, San Francisco, 1962, 1964 § *New Image of San Francisco*, de Young Museum, San Francisco, 1963 § *Art of San Francisco*, San Francisco Museum of Art, 1964 § Triangle Gallery, San Francisco, 1970, 1972–1976 § Taipei Fine Arts Museum, Taipei, Taiwan, 1999

SELECTED COLLECTIONS: Kyoto National Museum of Modern Art § Oakland Museum of California

SELECTED BIBLIOGRAPHY: Frankenstein, Alfred. "A Classic Retrospective." *San Francisco Chronicle*, May 23, 1974, 44. § Kishi, Masatoyo. CAAABS project interview. August 12, 1998. Grass Valley, CA. § Martin, Therese. "Masatoyo Kishi." Unpublished essay. Asian American Art Project, Stanford University. § Wechsler, Jeffrey, ed. *Asian Traditions/Modern Expressions: Asian American Artists and Abstraction, 1945–1970*. New York: Abrams in association with the Jane Voorhees Zimmerli Art Museum, Rutgers, the State University of New Jersey, 1997.

Visual artists should work individually, not within groups. I am very isolated and have enjoyed my isolation for forty years. I don't realize myself as Japanese, I'm just Kishi.

MASATOYO KISHI
CAAABS project interview

EDUCATED IN JAPAN, Masatoyo Kishi received a degree in physics and mathematics from the Tokyo University of Science in 1953. Although interested in art as a child, he worked as a high school mathematics teacher, and it was not until the late 1950s that the self-taught artist began participating in the exhibitions of the abstract painters' group Tekkei Kai, held at the Kyoto Museum of Art.

Masatoyo Kishi on the
roof of the Japanese Art
Center, Bush Street,
San Francisco, 1961

In 1960, Kishi traveled to San Francisco on a cargo boat with twenty rolled abstract paintings and almost immediately established a relationship with the Bolles Gallery. His early abstract expressionist works were characterized by the interaction of strong shapes and marks against a monochromatic field, and were generally painted using pours with the canvas on the floor. In making his work, Kishi was inspired by philosophies including Zen Buddhism, Taoism, and existentialism, as well as a personal interest in Western classical music and seventeenth-century Japanese temple structures. His paintings were exhibited at prestigious San Francisco museums and galleries during the early 1960s. Kishi taught at both Holy Names College in

Oakland (1965–1966) and Dominican College in San Rafael (1964–1974), where he also served as art department chair.

By the early 1970s, Kishi had abandoned painting altogether for sculpture. His reductive, organic forms initially resembled figures but became increasingly geometric. These meticulously crafted works sometimes incorporated large sheets of fiberglass and plastics, and the artist later explored clay and metal sculpture. Commissions followed to create public sculptures in Washington, D.C., as well as in Walnut Creek and Union City, California. In 1988, the artist moved to Grass Valley, California; he continues to present regular exhibitions of his work.

Kitagaki, Nobuo

BORN: February 10, 1918, Oakland, CA

DIED: September 22, 1984, Portland, OR

RESIDENCES: 1918–1941, Oakland, CA § 1941–1943,
Tanforan Assembly Center, San Bruno, CA; Topaz
Relocation Center, Topaz, UT § 1943–1944, Chicago,
IL § 1944–1946, U.S. military service § 1946–1947,
New York, NY § 1947–1949, Chicago, IL § 1949–1981,
San Francisco, CA § 1981–1984, Portland, OR

MEDIA: paper collage, wood, shoji screen, and costume
design

ART EDUCATION: 1946–1947, Cooper Union, New York §
1947–1949, Chicago Institute of Design, Chicago §
1951–1952, California School of Fine Arts, San Francisco §
1958–1959, San Francisco State College, San Francisco

SELECTED SOLO EXHIBITIONS: *Abstract Collages by Nabuo
Kitagaki*, Lucien Labaudt Gallery, San Francisco,
1950 § *Abstract Collages by Nabuo Kitagaki*, Califor-
nia Palace of the Legion of Honor, San Francisco,
1953 § *Collages: Nobuo Kitagaki*, Eric Locke Gallery, San
Francisco, 1957 § *Collages by Nobuo Kitagaki*, Maxwell
Galleries, San Francisco, 1963

SELECTED GROUP EXHIBITIONS: *San Francisco Art Association*,
San Francisco Museum of Art, 1948, 1951 § *Third World
Painting/Sculpture Exhibition*, San Francisco Museum of
Art, 1974 § *Transcendent Blossoms*, Syntex Gallery, Palo
Alto, CA, 1975

SELECTED BIBLIOGRAPHY: Kitagaki, Robin. *An Interview with
a Japanese American Artist, Nobuo Kitagaki*. San Francisco
State University Asian American Studies/Artist Project,
May 1982. § "Louis Macouillard, Nobuo Kitagaki,
Gerolamo Albavera, Maxwell Galleries." *Artforum*,
July 1963, 12. § Renouf, Renee. "A Tribute for Nobuo
Kitagaki." *Hokubei Mainichi* (San Francisco), October 17,
1984.

*As a Japanese American I have observed and absorbed not only
that which is Euro-American but which is also Asian American
or Eurasian. In my basic art expression I reflect not only the
"form follows function" precepts of the Bauhaus but also the
abstract purity of things Japanese, be it [sic] architectural,
art forms, crafts, or culinary.*
 NOBUO KITAGAKI
 Robin Kitagaki, *An Interview*

BORN IN OAKLAND, CALIFORNIA, to parents from Kumamoto
who reared their five children in both American and Japanese
traditions, Nobuo Kitagaki focused on an art career at an early
age. Following internment and service in the army, he went
to New York, where he enrolled on the GI Bill at the Cooper
Union art school, after which he studied at the avant-garde

Nobuo Kitagaki. Photo by Leo Holub

Chicago Institute of Design, where László Moholy-Nagy was
teaching. Kitagaki then returned to the Bay Area and attended
the California School of Fine Arts and concluded his formal
education at San Francisco State College (now University),
where he received a B.A. in fine arts and planned to get an
M.F.A. with a teaching career in mind. Kitagaki's education
provided him with strong credentials, and he established a
reputation for his collages. Later, he gave lectures on his in-
ternment experience (at California State Universities, Hay-
ward and San Francisco) and art and collage at San Francisco
State.

During internment Kitagaki applied his literary and ar-
tistic interests to camp publications, including the *Tanforan
Totalizer* in San Bruno and, with his supportive friends and
co-editors **Mine Okubo** and Toku Okubo, *Trek* at the Topaz
Relocation Center. He also established the library at Topaz. Af-
ter being cleared for service in the U.S. Army Special Services,
Military Intelligence, Kitagaki spent the remaining war years
in uniform, being honorably discharged in 1946 (he is buried
at Golden Gate National Cemetery).

Kitagaki's San Francisco career was built upon an artful
integration of Japanese design techniques and reductive and
geometric formalism. He made his living by designing and
constructing shoji screens that he sold from his shop on Grant
Avenue. His work was acknowledged by ten design awards
from the jury of the San Francisco Art Festival. And his design
talents were also employed on behalf of the Oshogatsu Festival
and the Nihonmachi Fair in Japantown.

The loss of sight in one eye from a mugging may have im-
pacted the scope of Kitagaki's professional ambitions, and he
eventually made his living by typing and working as a tran-
scriber, skills he learned years earlier at business school in Oak-

land. Nonetheless, Kitagaki continued his annual Teahouse in the Trees at the San Francisco Art Festival, where he exhibited his own work and that of friends. The social focus of his creative life is further evidenced in his work with the Kimochi program for elderly Japanese in Japantown as well as ongoing efforts to encourage art activity in the broader Asian American community.

Kiyama, Henry Yoshitaka

BORN: January 9, 1885, Neu, Tottori Prefecture, Japan

DIED: April 24, 1951, Neu, Tottori Prefecture, Japan

RESIDENCES: 1885–1904, Tottori Prefecture, Japan § 1904–1922, San Francisco, CA § 1922–1924, Tottori Prefecture, Japan § 1924–1927, San Francisco, CA § 1927–1931, Tottori Prefecture, Japan § 1931–1937, San Francisco, CA § 1937–1951, Tottori Prefecture, Japan

MEDIA: illustration, oil painting, and drawing

ART EDUCATION: 1910–1911, 1913–1917, 1919, San Francisco Institute of Art

SELECTED SOLO EXHIBITIONS: Kinmon Gakuen, San Francisco, 1927 § Yonago City Art Museum, Tottori Prefecture, Japan, 1993

SELECTED GROUP EXHIBITIONS: *San Francisco Art Association*, Palace of Fine Arts, 1920 § *California Artists*, Palace of Fine Arts, San Francisco, 1921 § *San Francisco Art Association*, California Palace of the Legion of Honor, 1925

Henry Yoshitaka Kiyama in front of a San Francisco laundry, probably on Gough Street

SELECTED COLLECTION: Yonago City Art Museum, Tottori Prefecture, Japan

SELECTED BIBLIOGRAPHY: Hughes, Edan Milton. *Artists in California, 1786–1940*. San Francisco, CA: Hughes Publishing, 1989. § Kiyama, Henry (Yoshitaka). *The Four Immigrants Manga*. Translated and with introduction by Frederik L. Schodt. Berkeley, CA: Stone Bridge Press, 1999. § Kiyama, Henry (Yoshitaka). *Manga Yonin Shosei (The Four Students Comic)*. San Francisco: Yoshitaka Kiyama Studios, 1931.

RECOGNIZED TODAY AS the author of the first autobiographical, serialized comic book, or *manga*, Henry Yoshitaka Kiyama arrived in San Francisco in 1904 at the age of nineteen. In 1910, Kiyama began taking classes at the San Francisco Institute of Art, where his friends included **Kazuo Matsubara** and **Kamesuke Hiraga**. Kiyama attended classes taught by Pedro Lemos in 1914 and Spencer Macky in 1919, and won several awards between 1915 and 1920 for his skilled depictions of architecture and portraits. Kiyama was awarded a scholarship to attend the New York Art Students League, but instead he returned to Japan for two years, during which he married and fathered a daughter. Returning to San Francisco alone in 1924, Kiyama established his own art studio, where he specialized in realistic portraits.

Kiyama's February 1927 exhibition at the Kinmon Gakuen (Golden Gate Institute) was sponsored by the Sangenshoku Ga Kai (Three Primary Colors Art Group) and premiered his serialized comic strips. Initially intended for weekly publication over a year in a newspaper, the fifty-two strips were published in San Francisco in 1931 as a book entitled *Manga Yonin Shosei (The Four Students Comic)*. They depicted Japanese immigrant life in San Francisco during the 1920s as well as historical events, including the 1906 earthquake, the 1915 Panama-Pacific International Exposition, World War I, 1918's influenza epidemic, Prohibition, and the 1921 Turlock Incident. Using backdrops of recognizable locations and a humorous approach incorporating both Japanese and English, Kiyama provided a rare, firsthand account of living and working conditions and aspirations of Japanese immigrants. The books were printed in Tokyo during Kiyama's second return to Japan in 1927 and included a foreword by Kaname Wakasugi, the Japanese consul general in San Francisco. Also included were a collaborative frontispiece featuring a caricature created by **Chiura Obata** of Kiyama wielding an oversized pen, brief remarks by the *Nichi Bei* columnist Shunshuro, and an inscription by artist Perham Nahl, who wrote in English, "Orient and Occident laugh together at the playful pen of Kiyama." Comics scholar Frederik Schodt, who arranged for the republication with full English translation of this remarkable work in 1999, has linked Kiyama's style to American cartoonist George McManus, the creator of the serial *Bringing Up Father*, and points out that Ki-

yama employed a Western left-to-right layout, the reversal of traditional right-to-left Japanese book design.

Despite his desire to go to Paris to further his artistic opportunities, Kiyama returned permanently to Japan in 1937. There he taught art at a local girls' high school, continued to paint and draw satirical cartoons, and occasionally exhibited work in his hometown. After World War II, he drew a sequel to his San Francisco series, depicting two Japanese Americans who experience culture shock when they visit Japan, but this sequel was never printed or published.

Kobashigawa, Hideo

BORN: February 22, 1917, Phoenix, AZ

DIED: April 14, 2001, Los Angeles, CA

RESIDENCES: 1917–1921, Phoenix, AZ § 1921–1932, Izumi, Okinawa Prefecture, Japan § 1932–1934, Phoenix, AZ § 1934–1941, Stanton and Los Angeles area, CA § 1941, Texas (U.S. military service) § 1942–1945, Manzanar Relocation Center, Manzanar, CA; Tule Lake Relocation Center, Newell, CA § 1945–1999, New York, NY § 1999–2001, Los Angeles, CA

MEDIA: oil, ink, and watercolor painting, and printmaking

ART EDUCATION: 1940–1941, Otis Art Institute, Los Angeles § ca. 1950–1951, Art Students League, New York

SELECTED SOLO EXHIBITION: *Hideo Kobashigawa, a Retrospective—A Kibei Nisei Artist's Life and Dream*, Naha Shimin Gallery and Motobu Chōmin Gallery, Okinawa Prefecture, Japan, 2000

SELECTED GROUP EXHIBITIONS: *The View from Within*, Wight Art Gallery, University of California, Los Angeles, 1992 § *With New Eyes: Toward an Asian American Art History in the West*, Art Department Gallery, San Francisco State University, 1995 § *Art After Incarceration*, ProArts Gallery, Oakland, CA, 1998

SELECTED COLLECTIONS: Japanese American National Museum, Los Angeles § Okinawa Prefectural Museum, Naha, Japan

SELECTED BIBLIOGRAPHY: *Hideo Kobashigawa, A Retrospective: A Kibei Nisei Artist's Life and Dream*. Okinawa, Japan: Okinawa Prefecture, 2000. § Higa, Karin M. *The View from Within: Japanese American Art from the Internment Camps, 1942–1945*. Los Angeles: Japanese American National Museum, 1992. § Kobashigawa, Ben. "In Remembrance of Hideo Kobashigawa, An Okinawan American Artist." *Nichi Bei Times*, April 28, 2001, 1–2. § Kobashigawa, Ben, and Dick Jiro Kobashigawa. CAAABS project interview. October 20, 2000. San Francisco. Audiotapes, Asian American Art Project, Stanford University.

Some period about thirty years ago, I had many dreams in which I was always lost in a city unknown to me.... Probably this was a reflection of me. I am like a traveler always lost in this society of America.

HIDEO KOBASHIGAWA
Hideo Kobashigawa, A Retrospective, 102

ALTHOUGH HIS WORK was not recognized until he was in his seventies, Hideo Kobashigawa began his career as an artist when he was a young man and dedicated himself exclusively to making art for more than fifty years. Kobashigawa was born in Phoenix, Arizona, but moved with his family to Okinawa when he was four years old. His father, who came to Arizona through Mexico in 1906, was a successful farmer and brought his family back to his home community in Okinawa when his young boys became school-age. Kobashigawa's interest in art, which began when he was a young child in Arizona, grew during his time in Okinawa, and he decided to become a professional artist. However, life became increasingly difficult for the family. Due to financial necessity, Kobashigawa followed his older brother, Jiro, to Arizona to find farmwork that would enable them to send money back to the family. They eventually moved to the Los Angeles area, where Jiro began working as a gardener's assistant in West Los Angeles; soon Hideo was doing gardening work there as well. In Los Angeles Kobashigawa met artist **Jack Chikamichi Yamasaki**, who would become a lifelong friend. With the help of his brothers, Kobashigawa enrolled at the Otis Art Institute, where he took classes for a year. He made still lifes and figure paintings in oils, and his working process from this period was recorded in a short film made by Jiro.

Self-portrait by Hideo Kobashigawa, ca. 1945

Drafted into the service in the spring of 1941, Kobashigawa was sent to Texas for basic training, but he refused to handle a gun. This refusal, combined with his constant sketching of the camp and fellow soldiers, was seen as suspicious behavior following the bombing of Pearl Harbor, and it prompted his release from the military. After briefly returning to Los Angeles, Kobashigawa was sent to the Manzanar Relocation Camp. He initially professed that the available time for art making was "paradise," but his experience changed once he was categorized as a "no-no boy" for answering "no" to politicized loyalty questions asked by the United States government. He subsequently was sent to the Tule Lake Relocation Camp, where he endured hardships along with the others the government wanted to isolate. In Manzanar, Kobashigawa began to create a series of images of the mountains above the camp, often including written notations of his thoughts. He later bound these large sheets together in book format and added written commentary about his recollections of his experiences. He also created woodcut prints, but his intention to present a print to every family in Manzanar was blocked by his transfer. His paintings from Tule Lake generally reflect a darker mood.

Following his release, Kobashigawa moved to New York and was affiliated with the group of artists who gathered at the studio of **Taro Yashima**. In New York he pursued art study at the Art Students League and married fellow artist Masako Yamamoto, who had studied with **Chiura Obata** at the Topaz Relocation Center. However, their marriage ended, as Kobashigawa's single-minded determination to focus on art began to eclipse his personal relationships. He moved to Brooklyn public housing, where he lived for forty-three years, and remained a reclusive artist for the rest of his life.

Kobashigawa worked primarily in oils, watercolors, and ink, and he supported himself through the small wages he earned at a Japanese restaurant. He created stark, abstracted images of the natural world, paintings of his childhood memories of Arizona and Okinawa, and depicted the isolated and homeless in the city. The artist eschewed exhibitions of his work and chose not to sell his paintings. However, following the 1992 survey exhibition of art from internment, *The View from Within*, Kobashigawa's work began to receive attention. The Prefecture of Okinawa mounted a major retrospective in 2000, just prior to the artist's death in 2001.

Kobayashi, Senko

BORN: February 3, 1870, Hiroshima, Japan

DIED: October 10, 1911, Hiroshima, Japan

RESIDENCES: 1870–1888, Hiroshima, Japan § 1888–1898, San Francisco, CA § 1898, Hiroshima, Japan § 1898–1900, Hawaii § 1900–1902, Paris, London, and various locations in Italy § 1902–1903, Hawaii § 1903–1905,

Hiroshima, Japan § 1905–1908, Tokyo, Japan § 1908–1911, Hiroshima, Japan

MEDIA: oil and watercolor painting, and drawing

ART EDUCATION: 1893–1897, Mark Hopkins Institute of Art, San Francisco

SELECTED GROUP EXHIBITIONS: *San Francisco Art Association*, 1896 § California State Fair, Sacramento, 1896 § Hiroshima Shoko Kaigisho (Hiroshima Chamber of Commerce and Industry), Hiroshima, Japan, 1898 § *10th Annual Hakuba Kai Exhibition*, Tokyo, Japan, 1905 § *Tokyo Kangyo Hakurankai* (Tokyo Industrial Exposition), 1907

SELECTED COLLECTION: Hiroshima Municipal Museum, Hiroshima, Japan

SELECTED BIBLIOGRAPHY: Halteman, Ellen Louise. *Publications in [Southern] California Art 7: Exhibition Records of the San Francisco Art Association, 1872–1915; Mechanics' Institute, 1857–1899; California State Agricultural Society, 1856–1902.* Los Angeles: Dustin Publications, 2000. § *Japanese and Japanese American Painters in the United States: A Half Century of Hope and Suffering, 1896–1945.* Tokyo: Tokyo Metropolitan Teien Art Museum and Nippon Television Network Corporation, 1995. § *Japanese Artists Who Studied in U.S.A. 1875–1960 (Taiheiyo o koeta Nihon no gakatachi ten).* Wakayama, Japan: Museum of Modern Art, Wakayama, 1987.

BORN HANAKICHI KOBAYASHI, the artist was the third son of Tokusaemon and Waki Kobayashi. His father sold fishing supplies to support the family. Kobayashi studied Chinese literature from 1886 to 1888 in private school, and in 1888 he traveled to San Francisco to attend the Nihon Fukuin Kai (Japanese Gospel Society), where he studied English for three years while also working. In San Francisco he decided to study art, and he was accepted to the Mark Hopkins Institute of Art in September 1893.

Senko Kobayashi

Kobayashi received the W. E. Brown Medal for life drawing in 1896. That same year he opened his own studio on Larkin Street and started an association for Japanese artists living in San Francisco. He became friends with **Yoshio Markino**, who studied at the Mark Hopkins Institute of Art from 1896 to 1897, and met poet Yone Noguchi, father of **Isamu Noguchi**, during this time. In 1897, Kobayashi graduated from the Mark Hopkins Institute of Art and received the Avery Gold Medal for oil painting.

In 1898, Kobayashi returned to Japan to take care of his elderly mother. He exhibited his work while there, but after five months in Japan he decided to travel to Europe. His first stop was in Hawaii, and he remained there for a year, earning money for his trip to Europe. While in Hawaii he started an art school and painted portraits of Sanford Dole and Princess Ka'iulani, who was also a skilled artist.

Kobayashi arrived in Paris in December 1900 after stopping in San Francisco, New York, and London. In Paris he was befriended by other Japanese artists; he also spent time in Italy. He left Europe in 1902 and lived for another year in Hawaii before finally returning to Japan. He opened an art school in Hiroshima in 1904, and in May 1905 he moved to Tokyo, where he exhibited eighteen oil paintings and four pastels in the 10th Annual Hakuba Kai Exhibition.

In 1906, Kobayashi became a lecturer at the Gakushūin Women's College in Tokyo and was made assistant professor the next year. His work *Yūwaku* (*Temptation*) caused a sensation when it was exhibited in the Tokyo Kangyō Hakurankai in 1907. In poor health, Kobayashi retired in 1908 and returned to Hiroshima, where he died three years later at the age of forty-one.

Kotoku, Shiyei (Yukie Kotoku)

BORN: January 17, 1890, Kochi, Japan

DIED: February 18, 1933, Osaka, Japan

RESIDENCES: 1890–1905, Kochi and Tokyo, Japan § 1905, Seattle, WA § 1905–1907, San Francisco, Oakland, and Berkeley, CA § 1907–1927, Los Angeles, CA § 1927–1929, Paris, France § 1929–1933, Japan

MEDIA: oil and watercolor painting, and printmaking

ART EDUCATION: ca. 1907, University of California, Berkeley § ca. 1908, Los Angeles School of Illustration and Painting

SELECTED SOLO EXHIBITIONS: *Paintings by Conrad Buff and Shiyei Y. Kotoku and Sculpture by A. P. Proctor and Harold Swartz*, Los Angeles Museum, 1923/24 (described as four one-person exhibitions) § Kinmon Gakuen, San Francisco, 1927 § Central Art Hall, Los Angeles, 1927

SELECTED GROUP EXHIBITIONS: *Southern California Japanese Art Club*, Nippon Club, Los Angeles, 1916 § *Painting and Sculpture, California Liberty Fair*, 1918 § *Annual Exhibition of Painters and Sculptors of Southern California*, Los Angeles Museum of History, Science and Art, 1920–1924 § *Annual Exhibition, California Art Club*, Los Angeles Museum of History, Science and Art, 1920–1922, 1924 § *San Francisco Art Association*, California Palace of the Legion of Honor, 1921, 1925 § *East West Art Society*, San Francisco Museum of Art, 1922 § *Shaku-do-sha Association Exhibition*, Union Church, Little Tokyo, Los Angeles, 1923

SELECTED COLLECTIONS: Japanese American History Archives, San Francisco § Sonoma County Museum, Santa Rosa, CA

SELECTED BIBLIOGRAPHY: "Exhibitions by A. Phimister Proctor, N. A., Harold Swartz, Conrad Buff and Sheyei [*sic*] Kotoku." *Bulletin of the Los Angeles Museum Department of Fine and Applied Arts*, January 5, 1924, 142. § "Japanese Exhibit Art: Nippon Club Displays Excellent Work of Native Artists and Pictures by Well-known Americans." *Los Angeles Times*, April 23, 1916, L1. § "Program Given to Help Artist Study in France," *Rafu Shimpo* (Los Angeles), March 7, 1927, 3. § "A Son of Nippon with Originality." *Los Angeles Times*, December 16, 1923, part 3, 24.

FOLLOWING THE DEATH of his father, fifteen-year-old Yukie Kotoku (later to be known as Shiyei) traveled to Seattle with his uncle, renowned Japanese Socialist leader Kōtoku Shūsui.

Shiyei Kotoku, ca. 1920s

After moving to the San Francisco Bay Area, Kotoku studied art briefly at the University of California, Berkeley, while working as a houseboy. He subsequently moved to Los Angeles, where he studied at the Los Angeles School of Illustration and Painting. The artist changed his name to Shiyei (meaning "shadow/death") after his uncle returned to Japan in 1911 and was seized and executed for his political activity.

Although Shiyei Kotoku maintained a significant presence in Northern and Central California, he lived primarily in Los Angeles, and in the 1920s he married and had two children there. He participated in eleven exhibitions between 1918 and 1923 at the Los Angeles Museum, and his work received strong reviews in the *Los Angeles Times*, which in 1923 described it as combining "some of the fine decorative qualities found in many Japanese prints, together with the realism which oil paint gives and which is the Occidental point of view." The article noted of one piece, "This makes a strange and interesting painting and we are led to wonder if Kotoku will bring to us something we have always wished to see from the Japanese artist, works of art which take what is good from Japanese life and art and combine it with what is of value in our own. This canvas seems to point the way."

Japanese-language newspapers in both Los Angeles and San Francisco followed Kotoku's career closely. He participated in the San Francisco East West Art Society exhibition in 1922 and the Los Angeles Shaku-do-sha exhibition of 1923. Kotoku created highly skilled figurative work as well as representations of urban life in San Francisco and Los Angeles, the latter evincing a greater connection to realistic depictions of New York's Lower East Side than to more traditional California imagery. Some of his most innovative work appears in his landscapes. Sometimes using a palette of vivid colors and repeated, curvilinear shapes, he depicts such locations as the Grand Canyon and the cliffs of Carmel.

With financial support from casino owner Nagaharu Itani and a Los Angeles Japanese community fund-raiser, Kotoku traveled to France, where he painted and exhibited Paris street scenes in the 1927 *Salon d'Automne*. He also spent time in the south of France and Italy. This period marked the beginning of Kotoku's chronic alcoholism, which led to a divorce from his wife and separation from his children, who remained in Los Angeles. Friend and mentor **Kamesuke Hiraga**, then living in France, arranged for Kotoku's return to Japan from Paris.

In Japan, Kotoku received support from his mother and family friends in his hometown and ultimately mounted several solo exhibitions there. In spite of this support, Kotoku's physical condition deteriorated. He died at the age of forty-three from an infection following an accident.

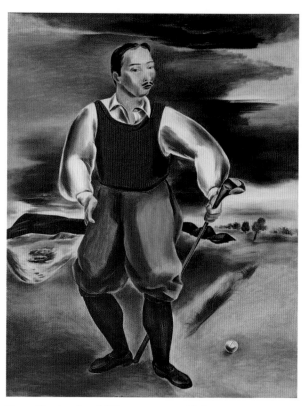

Yasuo Kuniyoshi, *Self-Portrait as a Golf Player*, 1927. Art © Estate of Yasuo Kuniyoshi/Licensed by VAGA, New York, NY

Kuniyoshi, Yasuo

BORN: September 1, 1889, Okayama, Japan

DIED: May 14, 1953, New York, NY

RESIDENCES: 1889–1906, Okayama, Japan § 1906–1907, Seattle and Spokane, WA § 1907–1910, Los Angeles, CA § 1910–1924, New York, NY (summers in Ogunquit, ME) § 1925, Paris, France § 1926–1928, New York, NY § 1928, Paris, France § 1929–1953, New York, NY (summers in Woodstock, NY; trip to Japan, 1931)

MEDIA: oil, ink, and casein painting, photography, printmaking, and drawing

ART EDUCATION: 1907–1910, California School of Art and Design, Los Angeles § 1914–1916, Independent School, New York § 1916–1920, Art Students League, New York

SELECTED SOLO EXHIBITIONS: *Yasuo Kuniyoshi*, Whitney Museum of American Art, New York, 1948 § National Museum of Modern Art, Tokyo, 1954 § *Yasuo Kuniyoshi, 1889–1953: A Retrospective Exhibition*, University Art Museum, University of Texas at Austin, 1975 § *The Shores of a Dream: Yasuo Kuniyoshi's Early Work in America*, Amon Carter Museum, Fort Worth, TX, 1996

SELECTED GROUP EXHIBITIONS: *Exhibition of Paintings and Sculptures by the Japanese Artists Society of New York City*, The Civic Club, New York, 1922 § *Nineteen*

Living Americans, Museum of Modern Art, New York, 1929 § *San Francisco Art Association*, California Palace of the Legion of Honor, 1931, 1932 § *American Painting*, Golden Gate International Exposition, San Francisco, 1940 § *Advancing American Art*, Metropolitan Museum of Art, New York, 1946 § Venice Biennale Exhibition, Venice, Italy, 1952

SELECTED COLLECTIONS: Fine Arts Museums of San Francisco § Metropolitan Museum of Art, New York § Museum of Modern Art, New York § Santa Barbara Museum of Art, Santa Barbara, CA § Yasuo Kuniyoshi Museum, Okayama, Japan

SELECTED BIBLIOGRAPHY: Davis, Richard A. *Yasuo Kuniyoshi: The Complete Graphic Work*. San Francisco: Alan Wofsy Fine Arts, 1991. § Goodrich, Lloyd. *Yasuo Kuniyoshi*. New York: Whitney Museum of American Art, 1948. § Kuniyoshi, Yasuo. *Yasuo Kuniyoshi*. New York: American Artists Group, 1945. § Myers, Jane, and Tom Wolf. *The Shores of a Dream: Yasuo Kuniyoshi's Early Work in America*. Fort Worth, TX: Amon Carter Museum, 1996. § Wolf, Tom. *Yasuo Kuniyoshi's Women*. San Francisco: Pomegranate Artbooks, 1993. § *Yasuo Kuniyoshi*. Okayama: The Yasuo Kuniyoshi Museum, Fukutake Publishing Co. Ltd., 1991.

I have often obtained in painting directly from the object that which appears to be real results at the very first shot, but when that does happen, I purposely destroy what I have accomplished and re-do it again and again. In other words that which comes easily I distrust. When I have condensed and simplified sufficiently I know then that I have something more than reality.

YASUO KUNIYOSHI
Yasuo Kuniyoshi, n.p.

YASUO KUNIYOSHI WAS the most esteemed Japanese American artist in the United States in the years between the two world wars. He was born in Okayama and came to the United States alone when he was barely seventeen years old. He had no thought of becoming an artist, and he worked at menial jobs in Seattle before attending high school in Los Angeles, where a teacher encouraged his talent for art.

Kuniyoshi enrolled in art classes at the California School of Art and Design in Los Angeles. He studied there for three years and then moved to New York, where he tried several art schools before settling on the Art Students League, the school with which he would be associated for the rest of his career, first as student and then as teacher. There he studied with figurative painter Kenneth Hayes Miller and found a circle of sympathetic friends, including Katherine Schmidt, who in 1919 lost her American citizenship when she married Kuniyoshi, an alien ineligible for U.S. citizenship.

During the 1910s and early 1920s Kuniyoshi developed his first distinctive style, characterized by warm, earthy col-

ors and flattened spaces related to those in American folk art, Japanese prints, and European modernism. He began showing regularly, and critics remarked on the subtle humor in his art, the product of his slightly naive style and his eccentric subjects—such as *Sisters Frightened by a Whale* and *Self-Portrait as a Golf Player*.

Kuniyoshi and Schmidt took two extended trips to Europe, in 1925 and 1928. There he made his major series of lithographs. The example of school of Paris artists, especially his friend Jules Pascin, encouraged Kuniyoshi to paint from the figure instead of from his imagination, which resulted in his most famous series of paintings, those of sultry, semi-nude women in interiors, a series that continued through the 1930s.

Over the years the women he portrayed became increasingly melancholy, a projection of the artist's unease about world politics. Kuniyoshi was alarmed by the Japanese invasion of China in 1937 and quickly became an active opponent of Japanese militarism. After the bombing of Pearl Harbor he was declared an "enemy alien": his bank account was impounded, his camera was confiscated, and he was subjected to various other harassments. Nevertheless, he felt strongly supportive of American democracy and worked with the Office of War Information to help propaganda efforts on behalf of the Allies, making radio broadcasts to Japanese audiences for the Voice of America and working on savage drawings that denounced Japanese militarism.

He and Katherine Schmidt divorced in 1932, and in 1935 he married Sara Mazo, a dance student with Martha Graham. For their honeymoon they drove through the Southwest to Mexico, and Kuniyoshi's experience of the Western landscape entered his pictorial vocabulary in the coming years. In 1941 he separated from Mazo, and he again traveled through the Southwest, this time to Los Angeles. Paintings of spacious, empty landscapes often occupied by architectural ruins resulted, mirroring the desolation the war was wreaking in Europe.

In 1944, near the war's end, Kuniyoshi reunited with Mazo. In the postwar years he would occupy a position of prominence in the American art world, receiving many awards and serving as the first president of Artists Equity. In 1948 Kuniyoshi had a retrospective exhibition at the Whitney Museum—the first ever given to a living artist by that institution. The next year he traveled west again, to serve a stint as guest instructor at Mills College in Oakland in the summer of 1949.

Following his retrospective, Kuniyoshi adopted a color scheme of jarringly bright colors, employing it in emotionally complicated paintings of cynical circus performers and bereft women. In the early 1950s, ill with cancer, he ended his artistic career with a series of powerful black-and-white drawings, heavily worked in *sumi-e* ink. The somber depths of emotion plumbed in these works, which take clownish military figures, crows, or insects as their subjects, make a powerful

end for an illustrious career. Kuniyoshi also left a legacy as a teacher, with students renowned in their own right including **Matsumi Mike Kanemitsu** and **Sueo Serisawa**.

Kuraoka, David

BORN: July 7, 1946, Hanamaulu, Kauai, HI

RESIDENCES: 1946–1956, Hanamaulu, Kauai, HI § 1956–1964, Lihue, Kauai, HI § 1964–1971, San Jose, CA § 1971–present, San Francisco, CA (seasonal, Wainiha Valley, Kauai)

MEDIA: ceramics

ART EDUCATION: 1964–1967, San Jose City College, San Jose, CA § 1967–1971, San Jose State College, San Jose, CA

SELECTED SOLO EXHIBITIONS: *David Kuraoka: Raku Forms*, Richmond Art Center, Richmond, CA, 1975 § *Kuaoka in '82*, Redding Museum and Art Center, Redding, CA, 1982 § *David Kuraoka Ceramics*, Kauai Museum, Lihue, Kauai, HI 1983 § *Kuraoka: Recent Pitfire and Celadon*, Stones Gallery, Kauai, HI, 1992 § *Recent Work by David Kuraoka*, The Contemporary Museum, Honolulu, 2002/3

David Kuraoka

SELECTED GROUP EXHIBITIONS: *The Japanese Artist in Hawaii, '79*, The Japanese Chamber of Commerce, Honolulu, 1979 § *One Man's Vision: Herbert Sanders and Former Students*, Contemporary Artisans, San Francisco, 1980 § *California Clay*, College of the Siskiyous, Weed, CA, 1981 § *With New Eyes: Toward an Asian American Art History in the West*, Art Department Gallery, San Francisco State University, 1995

SELECTED COLLECTIONS: The Contemporary Museum, Honolulu § Honolulu Academy of Arts, Honolulu § Kauai Museum, Lihue, Kauai § Rotterdam Modern Museum of Art § Utah State University, Logan

SELECTED BIBLIOGRAPHY: Kuraoka, David. CAAABS project interview. March 30, 2001. San Francisco. Transcript, Asian American Art Project, Stanford University. § Kuraoka, David. *David Kuraoka*. Maui, HI: Maui Arts & Culture Center, 2001. § Smyser, A. A. "Hawaii's Living Treasure." *Honolulu Star Bulletin*, December 12, 2000.

Pit-firing, my primary chosen form of ceramic firing, is a confrontation and a transformation, for me and for the clay. And the struggle always makes my life a little bit better than it was when I started. My forms are my canvases for ideas that sometimes exist only vaguely in my mind, visual possibilities full of the mystery of the fire. I am endlessly excited and curious to learn what we can create together. Every pit is different and every one exciting.

DAVID KURAOKA

http://www.hawaiicraftsmen/org/raku2001info/ the%20guest%20artists.htm. Downloaded March 14, 2001.

ALTHOUGH DAVID KURAOKA has lived in the San Francisco Bay Area for more than forty years, his work reflects his deep connection to his Hawaiian birthplace. With titles that reference island locations, and surface treatments that are evocative of the topography and plant life of Hawaii, his ceramics combine a nostalgia for the islands with the serendipity of the pit-firing techniques he uses to create his works. Kuraoka grew up in rural Kauai, a third-generation Japanese Hawaiian. A love for Hawaiian landscape and nature came early, and his summers as a youth were spent working in the pineapple and sugarcane fields. A fascination with Hawaiian rock formations and gravestones, and how they erode and change color over time, has also informed his work. Kuraoka's father was a newspaper photographer, and his mother was a watercolor artist and arts and crafts teacher, and from them Kuraoka gained an appreciation for art.

In 1964, Kuraoka moved to San Jose, California, where he enrolled at San Jose City College, intending to study architecture. In an art class required for architecture majors, Kuraoka discovered ceramics. He has explained that the actual contact with the clay persuaded him to pursue a career in art. Life in San Jose was difficult for Kuraoka because it was so unlike

the close-knit society of his island community. Feeling at odds with mainland California culture, he spent much of his free time working in the ceramics studio.

In 1967, Kuraoka was accepted to the M.F.A. program at San Jose State College. There, he began working with raku techniques. Like that of many other California ceramic artists of the time, Kuraoka's work leaned less toward traditional ceramics and more toward an abstract sculptural form. He found inspiration in the energy and attitude of California artists such as Peter Voulkos, instead of in the work of respected Japanese craftsmen such as Hamada Shōji. This aesthetic put Kuraoka at odds with his San Jose State professor Herbert Sanders, an expert in raku techniques. Sanders felt that Kuraoka was disrespectful of the past and was in effect "bastardizing" raku. However, Kuraoka found traditional raku stifling. Because of this break with traditional raku, Sanders encouraged Kuraoka to use the term "American flash fire" instead. Presently, Kuraoka describes his work as "pit-fired."

Kuraoka has spent many years as an educator in the Bay Area teaching ceramics at San Francisco State University. He was instrumental in founding the Pescadero Beach Firings in the late 1960s. This tradition started at Waddell Creek Beach, where Kuraoka organized all of the Northern California state and community college ceramic artists to take part in weekend-long clay-firing sessions. The last two events at Pescadero Beach, which took place in the late 1970s, brought together roughly nine hundred people, who camped out and fired for three straight days. This event later moved to Hawaii, where it still takes place annually. In Hawaii, Kuraoka has installed several public murals of both glazed and pit-fired forms and tiles. He is most widely known for his abstracted vessel forms, elegantly glazed with celadon or covered with the rich coloration of natural pit firing.

In 1987 Kuraoka was named a "Hawaii Living Treasure" by Honpa Hongwanji Mission of Hawaii, which acknowledges those who have made a significant contribution to the spirit of multiculturalism in Hawaii. At forty-one, Kuraoka was one of the youngest recipients of this award. Kuraoka currently divides his time between his homes in San Francisco and Kauai.

Kuwahara, Robert

BORN: August 12, 1901, Tokyo, Japan

DIED: December 10, 1964, Larchmont, NY

RESIDENCES: 1901–1910, Tokyo, Japan § 1910–1914, Santa Barbara, CA § 1914–1929, Los Angeles, CA § 1929–1931, New York, NY § 1931–1942, Los Angeles, CA § 1942–1943, Santa Anita Assembly Center, Santa Anita, CA; Heart Mountain Relocation Center, Heart Mountain, WY § 1943–1945, Chicago, IL § 1945–1950, New Rochelle, NY § 1950–1964, Larchmont, NY

MEDIA: animation, illustration, oil and watercolor painting, and drawing

ART EDUCATION: 1921–1926, Otis Art Institute of the Los Angeles Museum of History, Science and Art

SELECTED SOLO EXHIBITIONS: Olympic Hotel, Los Angeles, 1929 § American Friends Service Committee, Chicago, 1943

SELECTED BIBLIOGRAPHY: Aoyama, Hiyuki. "Former Studio Artist Now Supervises Art Classes." *Santa Anita Pacemaker*, July 1, 1942, 5. § "Ex-Local Artist Holds Exhibit." *Heart Mountain Sentinel*, November 6, 1943, 8. § "Japanese Follows Art of Occident." *San Francisco Chronicle*, July 26, 1931, D8. § Kumai, Alan. "He Makes Cartoons." *Kashu Mainichi* (Los Angeles), 1962 (Christmas edition), 4. § Kuwahara, Michel. CAAABS project interview. November 11, 2000. § "Successful Exhibit Held by Kuwahara." *Rafu Shimpo* (Los Angeles), March 18, 1929, 3.

Art is not only cultural, but practical as well. It is a natural part of our existence.

ROBERT KUWAHARA
Aoyama, "Former Studio Artist Now
Supervises Art Classes," 5

ROBERT KUWAHARA WAS a highly accomplished commercial artist whose career highlights included animation work for Walt Disney, MGM Studios, and CBS Terrytoons. Displaying an interest and talent in art soon after moving to Southern California from Japan, Kuwahara became an editor and cartoonist for the *Poly Optimist*, the newspaper for Polytechnic High School in Los Angeles, where he was a student.

During the 1920s, Kuwahara attended the Otis Art Institute in Los Angeles and worked as an editor of the English section of the *Rafu Nichi-Bei* newspaper. After resigning from the *Rafu Nichi-Bei* in 1929, Kuwahara held a successful solo exhibition of pastel portraits and pen sketches at the Olympic Hotel in Los Angeles and sold thirty-two pieces. The *Rafu Shimpo* newspaper reproduced two of Kuwahara's sketches, *A Product of the Desert* and *Portrait of a Fox*, with a review of the show. The reviewer wrote, "By selling so many of his works, the exhibit proved to be the most successful ever held by a Japanese artist in this city." Shortly after this success, Kuwahara moved to New York City to work as a freelance portraitist and artist for various book publishers. His time in New York coincided with the New York Stock Market crash, and unable to find steady employment, he returned to Los Angeles after two years.

Upon his return to California in 1931, Kuwahara was interviewed in the *San Francisco Chronicle* about his work. In the article, Kuwahara stated, "To a Japanese of the Orient, my work would undoubtedly look quite Occidental.... I admire the native art of my own land. Its elimination of inessential

details is always impressive to me, and its feeling for decorative effect is also striking." Throughout the 1930s, Kuwahara lived in Los Angeles. He married **Julia Suski**, a musician and graphic designer for the *Rafu Shimpo*. During this period, Kuwahara gained recognition as a Disney animator. He worked for Disney from 1932 to 1936 and then moved to MGM Studios.

During internment, Kuwahara and his family were held first at the Santa Anita Assembly Center and then at the Heart Mountain Relocation Center in Wyoming. Kuwahara's accomplishments were well known to camp supervisors. While at Santa Anita, Kuwahara was allowed to teach art classes twice a week. After being relocated to Heart Mountain, Kuwahara joined a group of well-established Nisei artists that included **Hideo Date**, **Riyo Sato**, and **Benji Okubo**. Together, they practiced their craft, taught art classes to the residents, and displayed their works in shows organized by Heart Mountain staff. In 1943, Kuwahara exhibited a collection of watercolors at the Chicago branch of the American Friends Service Committee.

After his release from Heart Mountain in 1943, Kuwahara sought work in Chicago as a commercial artist. In 1945, Kuwahara created *Miki*, an award-winning comic strip that was purchased and syndicated; he worked on the strip for the next five years. After leaving *Miki*, Kuwahara worked for Terrytoons in New Rochelle, New York. He created the Hashimoto Mouse character that appeared in the theatrical release *Hashimoto-san* (1959) and directed episodes of the animated television cartoon series *Hashimoto Mouse* (1959–1963). He also directed episodes of *Deputy Dawg*. Kuwahara continued working for Terrytoons until his death in Larchmont on December 10, 1964.

Kwok, John

BORN: March 21, 1920, Shanghai, China

DIED: June 16, 1983, Los Angeles, CA

RESIDENCES: 1920, Shanghai, China § 1920–1927, Stockton, CA § 1927–1940, Sacramento, CA § 1940–1942, Los Angeles, CA § 1942–1945, Florida (U.S. military service) § 1945–1983, Los Angeles, CA

MEDIA: watercolor and oil painting, drawing, and printmaking

ART EDUCATION: 1938–1940, Sacramento Junior College, Sacramento, CA § 1940–1942, Chouinard Art Institute, Los Angeles

SELECTED SOLO EXHIBITIONS: Fraymart Gallery, Los Angeles, 1952 § *John Kwok: Line and Color*, Chinese American Museum, Los Angeles, 2004/5

SELECTED GROUP EXHIBITIONS: California Watercolor

Society Annual Exhibitions, 1947–1955, 1958–1966 § *Annual Exhibition of Artists of Los Angeles and Vicinity*, Los Angeles County Museum of Art, 1948 § *New Paintings by Los Angeles Artists*, San Francisco Museum of Art, 1949 § *Contemporary Chinese American Artists*, Los Angeles County Art Institute, 1959 § Laguna Beach Art Association, 1966, 1969–1972, 1980, 1983 § California National Watercolor Society Annual Exhibitions, 1967–1973 § California State Fair, 1967, 1968

SELECTED BIBLIOGRAPHY: "Art News from Los Angeles." *Art News* 50, no. 10 (February 1952): 46. § Kwok, Katherine. CAAABS project interview. November 26, 2000. Audiotape, Asian American Art Project, Stanford University. § McClelland, Gordon T., and Jay T. Last. *The California Style: California Watercolor Artists, 1925–1955*. Beverly Hills: Hillcrest Press, 1985. § McClelland, Gordon T., and Jay T. Last. *California Watercolors, 1850–1970: An Illustrated History & Biographical Dictionary*. Santa Ana, CA: Hillcrest Press, 2002.

All my compositions are made inside the studio and without reasons as to the subject matter, making it difficult to give titles to my paintings. I think I am more engrossed in the sensations that a few jars of the tempera can manufacture in my mind manipulating with different shapes and intensity of color on a white piece of paper.

JOHN KWOK
Letter to Mr. William Wallett,
California Watercolor Society, n.d. Collection Asian
American Art Project, Stanford University.

JOHN KWOK IMMIGRATED with his family to the United States when he was less than a year old. They eventually settled in Sacramento, where his father was a minister and where both his parents taught Chinese. From an early age Kwok enjoyed drawing, and he began taking art classes at Sacramento Junior College. In 1940, Kwok applied for and received one of the two annual full scholarships given by the Chouinard Art Institute in Los Angeles, and he started attending the school that fall.

The two years Kwok spent at Chouinard were instrumental in shaping his professional life. He studied with California watercolorists Millard Sheets and Phil Paradise and began close friendships with fellow artists that would last for years. World War II temporarily derailed Kwok's artistic career, and he served as a radioman in the U.S. Air Force in Florida, sometimes making pen-and-ink sketches of his fellow soldiers. Once back in Los Angeles, Kwok worked at I. Magnin, at that time one of the most elegant department stores in the country, creating window displays and signage. Kwok also began to exhibit his paintings in the postwar years, becoming a prolific member of the California Watercolor Society, where his works were frequent winners of awards. Although Kwok married and started a family during this time, he continued to paint, often

receiving critical praise. A 1952 review of his solo show at the Fraymart Gallery described his paintings as containing the energy of a Dubuffet or Tamayo, but with a style all his own, and the review anticipated success for Kwok.

Kwok worked full time at I. Magnin until 1954, when he turned to freelance commercial work for the store as well as for Bullocks Wilshire, the Santa Fe Railway, and Max Factor. He continued freelance work for the remainder of his life. He also painted commissioned portraits, and in the 1970s, he began serving as a juror for local exhibitions such as the 1971 Long Beach Museum of Art's Art Association Annual.

While family, social, and professional responsibilities precluded his complete commitment to painting, he was extremely prolific and made time almost daily to paint. Kwok worked primarily in opaque water-based media. He often created works based on still lifes, and his interpretations of these subjects grew increasingly abstract throughout his life. Early work often represented objects or the human form in an abstract, personal style, using for the most part bright or deep colors. In the 1960s Kwok reduced his use of the human form and focused on line, pattern, and movement, utilizing intense, brighter colors. His work was sometimes compared to that of Paul Klee, whom Kwok admired. Kwok's final phase is characterized by muted tones and subtle shading of organic forms that fill the picture plane.

John Kwok, ca. 1950s

Lee, Chee Chin S. Cheung

BORN: June 18, 1896, Kaiping, Guangdong, China

DIED: January 31, 1966, San Francisco, CA

RESIDENCES: 1896–1914, China § 1914–1925, San Francisco, CA § 1925–1926, China § 1926–1966, San Francisco, CA

MEDIA: oil and watercolor painting, and printmaking

ART EDUCATION: 1918–1923, California School of Fine Arts, San Francisco

SELECTED SOLO EXHIBITION: California Palace of the Legion of Honor, San Francisco, 1943

SELECTED GROUP EXHIBITIONS: *East West Art Society*, San Francisco Museum of Art, 1922 § California State Fair, Sacramento, 1923 § *1st Annual Exhibition of Western Watercolor Painting*, California Palace of the Legion of Honor, San Francisco, 1932 § Oakland Art Gallery, Oakland, CA, 1932, 1939 § Foundation of Western Art, Los Angeles, 1933, 1937, 1939–1941 § *Chinese Art Association of America*, de Young Museum, San Francisco, 1935/36 § Federal Arts Project, Stendahl Gallery, Los Angeles, 1937 § *San Francisco Art Association*, San Francisco Museum of Art, 1937–1943 § *California Art Today*, Golden Gate International Exposition, San Francisco, 1940 § *Chinatown Artists Club*, de Young Museum, San Francisco, 1942–1945

SELECTED COLLECTION: California Historical Society, San Francisco

SELECTED BIBLIOGRAPHY: "Chin Chee." *California Art Research*. San Francisco: WPA, 1937. § Frankenstein, Alfred. "Around the Galleries." *San Francisco Chronicle*, This World, May 15, 1938, 17. § Hughes, Edan Milton. *Artists in California, 1786–1940*. San Francisco: Hughes Publishing, 1989, 329. § MacDonald Wright, S. "Chinese Artists in California." *California Arts and Architecture* 56, no. 4 (October 1939): 20–21. § Millier, Arthur. "Our Orientals, Mr. Sheets and Chicagoans Exhibit Art." *Los Angeles Times*, May 6, 1934, A8.

These paintings have been my life's enjoyment. They represent fleeting moments of my inner self. I visualize a time that will come in my life when I will want to push back the "Hands of Time." With these momentos of these "fleeting moments" before me, the reversal of time will be a pleasure and a solace. To dispose of them would be to sell myself.
CHEE CHIN S. CHEUNG LEE
"Chin Chee," *California Art Research*, 26

AN IMPORTANT REGIONALIST PAINTER who exhibited in California for more than twenty years, Chee Chin S. Cheung Lee used name variations that have confused his professional record. His

Chee Chin S. Cheung Lee, ca. 1935. Lithograph by Pauline Vinson

family name was Chee, and his given name was Chin. However, the artist often added or used instead his Chinese high school student name, Cheung Lee.

Born in Kaiping, Guangzhou, in 1896, Lee was summoned in 1914 to join his father, who had moved to San Francisco in 1902 and who had established a successful career as an herbalist. Lee assisted his father and studied English at the Congregational School. In 1918 he decided to pursue art and enrolled in the summer session of the California School of Fine Arts. Working with both Spencer Macky and Gottardo Piazzoni, Lee was awarded several school prizes during 1921–1923 for his carefully rendered oil paintings. In 1922, Lee exhibited a portrait in the second exhibition of the East West Art Society. Soon after, his visionary masterpiece, *Mountain Fantasy*, appeared in the California State Fair. He subsequently painted several commissions for Chinese fraternal and district associations and supported himself as a hotel manager and, later, as a sales clerk.

In 1925, the artist returned to China, briefly studying Chinese art. He married, but he returned to San Francisco alone in less than a year. In spite of financial hardships during the years that followed, he resumed an active career, exhibiting both oil paintings and watercolors. While Arthur Millier wrote in the *Los Angeles Times* in 1934, "Cheung Lee seems a convert of the Hopper style," the solid forms of his figurative work during the

1930s reflect the influence of Diego Rivera. In spite of being identified with Western art influences, Lee's work sometimes included inscriptions in Chinese and often referenced Chinese themes. In the mid-1930s, the artist joined the Chinese Art Association (later the Chinatown Artists Club) and participated in their 1935 exhibition at the de Young Museum, where Lee's depictions of the waterfront were singled out as outstanding in several reviews. He also worked for the WPA and participated in related group shows. A ca. 1935 WPA portrait of the artist by Pauline Vinson shows him in vest and bow tie working on a watercolor, holding his brush in the Chinese manner. Beginning in 1937, Lee exhibited in the annual exhibitions of the San Francisco Art Association. He also participated in Foundation of Western Artists and California Watercolor Society exhibitions during the 1930s and early 1940s.

A highlight of the artist's professional career was his solo exhibition at the California Palace of the Legion of Honor in September 1943, where forty objects filled two galleries. Beginning in 1942, he participated annually in the de Young Museum exhibitions of the Chinatown Artists Club, which occurred through 1945. Despite this activity, Lee stopped exhibiting after World War II. Following his death in January 1966, his personal collection of works, which included a mural-scale battle scene and a portrait of Chiang Kai-shek, were auctioned for a few dollars and widely dispersed or lost.

Lee, Chingwah

BORN: June 28, 1901, San Francisco, CA

DIED: January 2, 1980, San Francisco, CA

RESIDENCE: 1901–1980, San Francisco, CA

MEDIA: illustration

SELECTED BIBLIOGRAPHY: Chinn, Thomas. *Bridging the Pacific: San Francisco Chinatown and Its People*. San Francisco: Chinese Historical Society of America, 1989, 220–227. § Lee, Chingwah. "Art and Culture." *Chinese Digest*, August 1938, 11. § Lee, Chingwah. "Remember When?" *Chinese Digest*, November 20, 1936, 9, 14. § Lee, Chingwah. "Seven Steps to Fame" (1930). Reprinted in *Chinese Digest*, December 6, 1935, 8.

We are Chinese, and will always be. Our cultural life is something to look up to, a heritage not common in America. Let us turn to any other field of endeavor, and see how many of us can find employment outside of Chinatown.... Therefore, let us keep and develop Chinatown into a distinctive town— again a world-famous town!

CHINGWAH LEE
"Seven Steps to Fame" (1930)

THOUGH HE HAD an acting career in Hollywood movies, Chingwah Lee was an important figure in the art community of San Francisco's Chinatown from the 1920s until his death in 1980. Born in San Francisco to a family of nine children, Lee participated in and later wrote about ceremonial parades, religious festivals, and other Chinatown activities that took place

after the 1906 earthquake and fire. He attended the University of California, Berkeley, and worked at the Chinatown YMCA as a counselor and Boy Scout leader in the 1920s. While at the YMCA, he produced three small mimeographed journals, *Tri-Termly Toot* (1921), *Scout Wig Wag* (1927), and *Y-World* (1929). In September 1930, he proposed the "Seven Steps to Fame," which included the adoption of Chinese fashion, architecture, and pageantry as a way to transform Chinatown from a "slum" into a "tourist magnet." In 1935, he cofounded with Thomas Chinn and others the *Chinese Digest* magazine, which documented and advocated Chinese American art, culture, and history. This important English-language journal included an ongoing series of articles that Lee wrote about Chinese ceramics and Chinese inventions, and it contained as well many of his witty illustrations and cartoons. Lee became the principal editor of the *Chinese Digest* in 1939 and experimented with different formats for the journal during the year before it ceased operation.

During this period Lee also operated the Chinese Art Studio and Chinese Trade and Travel Association at 868 Washington Street (the *Chinese Digest* was produced in the back room). Here, Lee was an appraiser and dealer of Chinese fine arts, including paintings and especially ceramics. He credited dealer Otto Bentz as his mentor in this endeavor. The front door of the Chinese Art Studio, which Lee designed, was in the form of a moon gate, and the studio was the site of an NBC national radio broadcast in 1937. Also in that year, Lee was selected to help identify Chinese actors for the Hollywood production of Pearl Buck's epic, *The Good Earth*. Although the film featured Caucasian actors in the roles of Chinese, Lee was

Chingwah Lee, 1937

the principal Chinese American actor, in the role of Ching. In 1937 he also appeared uncredited as Quan Lin in the film *Daughter of Shanghai*. During World War II, Lee enlisted as an interpreter and served at the Army Language School in Monterey. He continued to act in other film productions, playing Chang Teh in *China* (1943) and Guerrilla Charlie in *Thirty Seconds Over Tokyo* (1944). Later, he appeared as the Professor in *Flower Drum Song* (1961) and briefly was an actual professor when he taught at the innovative Rudolph Schaeffer School of Design in San Francisco.

In 1963, Chingwah Lee cofounded the Chinese Historical Society with five other leaders of the Chinatown community, including Thomas Chinn. In the early 1970s he was also involved in founding the Chinese Culture Center, a community organization that presented both historical and contemporary art exhibitions. After his death in 1980, his important collection of Chinese antiques was auctioned by Sotheby's.

Lee, George

BORN: December 19, 1922, San Francisco, CA

DIED: July 22, 1998, Santa Cruz, CA

RESIDENCES: 1922–1925, San Francisco, CA § 1925–1942, Santa Cruz, CA § 1942–1945, South Pacific (U.S. military service) § 1946–1949, Santa Cruz, CA § 1950–

Self-portrait by George Lee, ca. 1949

1953, Korea (U.S. military service) § 1954–1998, Santa Cruz, CA

MEDIA: photography

ART EDUCATION: ca. 1940–1942, Salinas Junior College, Salinas, CA

SELECTED SOLO EXHIBITION: *Chinatown Dreams: The Photography of George Lee*, Museum of Art and History, Santa Cruz, CA, 2000

SELECTED COLLECTIONS: Chulalongkorn University, Bangkok § Museum of Art and History, Santa Cruz, CA

SELECTED BIBLIOGRAPHY: Dunn, Geoffrey. *Chinatown Dreams: The Life and Photographs of George Lee*. Capitola, CA: Capitola Book Co., 2002. § Lydon, Sandy. *Chinese Gold: The Chinese of the Monterey Bay Region*. Capitola, CA: Capitola Book Co., 1985.

I knew back then that my photos would be of historical value.... I knew they were worth saving. I just didn't know it would all fly by so quickly.

GEORGE LEE
Dunn, *Chinatown Dreams*, 11

GEORGE LEE'S PORTRAITS of Santa Cruz Chinatown residents from the 1940s document a part of California history that has largely been forgotten. Lee was born in San Francisco in 1922. His father came to California from Guangzhou at the turn of the century, and his mother immigrated from a village near Macao shortly after World War I. When Lee was three, his family moved briefly to Tracy, California, and ultimately settled in Santa Cruz. Lee's father was employed as a cook at the Wilder Dairy Ranch, living and working at the ranch six days a week and returning home on Sundays for dinner. The family, which grew to seven children, lived in the Santa Cruz Chinese community known as "Birkenseer's Chinatown," which was adjacent to a hotel where working-class Italian immigrants lived. Many of Lee's childhood friends were Italian, and he was introduced to photography as a teenager by his friend Frank Del Bianco. Lee was skilled with the camera by the time he attended high school, and he served as the photographer for the school's newspaper and yearbook, while working after school for the local camera shop.

As a nineteen-year-old student at Salinas Junior College, Lee began a series of portraits of aging men in his Santa Cruz Chinatown community. The men portrayed were the last of the generation who had come to California in the nineteenth century in search of a better life, only to encounter harsh working conditions, racism, and loneliness. These were the men Lee had grown up surrounded by, and whom he knew well. Images by photographers such as Walker Evans and Dorothea Lange for the Farm Security Administration began to appear in magazines and newspapers at this time, and Lee later acknowledged

their influence on his work. However, Lee brought a unique perspective to his pictures that differentiated his work from that of other photographers. Since he worked within his own community, his images reflect a deeper personal relationship with his subjects.

Lee enlisted in the U.S. Navy at the age of twenty, and worked as a military photographer throughout World War II, serving in combat zones in the Pacific (he would again serve as a combat photographer during the Korean War). Once back in Santa Cruz, Lee married and began working at his friend Eddy Webber's photography store, where he continued to be employed for the next forty years. His photographs began appearing regularly in local papers such as the *Santa Cruz Sentinel*, and several images were picked up by the Associated Press. Lee also began a long teaching career at schools including Cabrillo Junior College, Harbor High, and Santa Cruz Adult School, where he established darkrooms and influenced hundreds of students.

In addition to his pictures of the Chinese community in Santa Cruz, Lee also created many landscape images, photographing the Sierra Nevada in winter and capturing the San Lorenzo River near Santa Cruz. Lee cited Ansel Adams and Edward Steichen, as well as Edward Weston, who worked in nearby Point Lobos, as influences. A retrospective of Lee's work in 2000 documented his six-decade-long career and included additional images from his world travels and personal family photographs.

Lee, Jake

BORN: October 23, 1915, Monterey, CA

DIED: September 13, 1991, Los Angeles, CA

RESIDENCES: 1915–ca. 1933, Monterey, CA § ca. 1933– ca. 1937, San Jose, CA § ca. 1937–ca. 1942, San Francisco, CA § ca. 1942–1991, Los Angeles, CA

MEDIA: watercolor and oil painting, and murals

ART EDUCATION: ca. 1930s, San Jose State College, San Jose, CA § ca. 1940s, Otis Art Institute, Los Angeles

SELECTED SOLO EXHIBITION: Chinese American Museum, Los Angeles, 2007

SELECTED GROUP EXHIBITIONS: *California Watercolor Society*, various locations, 1944, 1947–1951, 1953, 1954/55 § *San Francisco Art Association*, San Francisco Museum of Art, 1946, 1947 § *15th Annual Society of Western Artists*, de Young Museum, San Francisco, 1954 § *Contemporary Chinese American Artists*, Los Angeles County Museum, 1959

SELECTED COLLECTIONS: Carnegie Art Museum, Oxnard, CA § U.S. Air Force Art Collection

SELECTED BIBLIOGRAPHY: Brown, Michael D. *Views from Asian California, 1920–1965*. San Francisco: Michael D. Brown, 1992. § "Four Who Express the Oriental Flavor." *Los Angeles Times*, home supplement, August 21, 1955, 12, 13, 42. § Frankenstein, Alfred. "World of Art and Music." *San Francisco Chronicle*, This World, August 22, 1943, 12. § Jarrett, Mary. *The Otis Story: Of Otis Art Institute Since 1918*. Los Angeles: The Alumni Association of Otis Art Institute, 1975, 59. § Kan, Johnny, and Charles L. Leong. *Eight Immortal Flavors*. Berkeley, CA: Howell-North Books, 1964. § McClelland, Gordon T., and Jay T. Last. *The California Style: California Watercolor Artists, 1925–1955*. Beverly Hills: Hillcrest Press, 1985, 233. § *Westways* 46, no. 10 (1954, part 1): cover.

FOR MORE THAN forty years Jake Lee worked as a successful commercial artist while also finding time to create and exhibit his fine-art watercolors. Lee was born in Monterey, California, and grew up watching the artists who worked near the Monterey Wharf and fishing docks. Lee studied art and philosophy at San Jose State College (now University) and then took a job as a commercial artist for a San Francisco newspaper in the late 1930s. During this time he became friends with **Dong Kingman**, and the two would often go on sketching outings together. Kingman was a strong influence on Lee, and Lee's work would often be compared with that of his famous friend. However, a 1943 review of Lee's work described his watercolor technique as being much tighter, with more exact drawing and less free color than Kingman's.

In the early 1940s, Lee moved to Los Angeles, where he studied at the Otis Art Institute. He continued to live in Southern California for the remainder of his life and worked as a sketch artist at Paramount Studios. He also did illustration and cover designs for magazines, worked on advertising art, and designed book jackets, album covers, and Christmas cards. Lee worked primarily in watercolors or gouache on illustration board for these commercial assignments. His series of paintings for the *Ford Times* and *Lincoln-Mercury* magazines depicting the American panorama were also published in Germany and France. The twelve murals Lee created for Kan's Restaurant in San Francisco's Chinatown were reproduced in *Westways* magazine, but they are no longer extant.

In the 1960s, the U.S. Air Force flew Lee to various bases to make paintings of the sites, and today the air force has eleven pieces by Lee in its permanent collection. Lee was an active member of the American Watercolor Society, the California Watercolor Society, the Society of Illustrators of Los Angeles, the California Art Club, and Watercolor West, and he exhibited regularly with these groups. Lee also taught throughout his career and was an influential art instructor in Southern California.

Kem Lee

Lee, Kem (Lee Siu Yum)

BORN: October 1, 1910, Taishan, Guangdong, China

DIED: October 2, 1986, Berkeley, CA

RESIDENCES: 1910–1928, Taishan, Guangdong, China §
1928–ca. 1936, San Mateo, CA § ca. 1936–1986, San
Francisco and Berkeley, CA

MEDIA: photography and painting

ART EDUCATION: ca. 1934–ca. 1935, San Mateo Junior
College, San Mateo, CA

SELECTED SOLO EXHIBITION: *Chinatown Stories (1940–1980):
Photography by Kem Lee*, Ethnic Studies Library, University
of California, Berkeley, 1997

SELECTED GROUP EXHIBITION: *With New Eyes: Toward an
Asian American Art History in the West*, Art Department
Gallery, San Francisco State University, 1995

SELECTED COLLECTION: Ethnic Studies Library, University of
California, Berkeley

SELECTED BIBLIOGRAPHY: Harvey, Nick, ed. *Ting: The
Caldron, Chinese Art and Identity in San Francisco*. San
Francisco: Glide Urban Center, 1970. § Wong, Ken.
"The Dean of Chinatown Photogs." *San Francisco
Examiner*, September 26, 1979, B2. § Wong, Nanying
Stella. CAAABS project interview. March 2001. Berkeley,
CA. § Woon, Henry. "An Imagist Dies." *Asian Week*,
November 21, 1986.

LEE SIU YUM, otherwise known as Kem Lee, has often been re-
ferred to as "the official photographer" of San Francisco's Chi-
natown. For more than forty years, Lee created photographs
of bachelors, newlyweds, pageants, and news events that ap-
peared in the pages of local Chinese publications. Lee came to
the United States at the age of eighteen, leaving behind a wife
and son. After a two-month stay at the Angel Island Immigra-
tion Station, Lee was employed by Richard Amphlett of San
Mateo, who published *The San Mateo Times*. Lee, hired as a
houseboy for the widower, became his friend. Amphlett used
his influence in the community to help Lee enter the segre-
gated Peninsular Avenue Grammar School in the early 1930s,
at the age of twenty. Later, after attending a few semesters at
San Mateo Union High School, Lee enrolled at San Mateo Ju-
nior College. During his three semesters in college, Lee stud-
ied painting.

In the following years, Lee tried different business ven-
tures that capitalized on his artistic interests. In 1938, he
opened the Chinese Art Guild on Stockton Street in San Fran-
cisco, which provided graphic design services to the commu-
nity, including signage design and layout. However, this busi-
ness lasted only two years, as most Chinese businesses could
not afford such services and white business owners would not
patronize a Chinese establishment. Understanding the limi-
tations of the community, yet wanting to work in a creative
field, Lee turned to photography. Over time, he opened several
photography studios, including T. K. Lee Studios at 431 Jackson
Street and Kem Lee Studios at 653 Pacific Avenue, which later

relocated to 768 Clay Street. The main source of his business came from clients seeking portrait or wedding photographs. While Lee spent the majority of his career as a photographer, his skill as a painter is evidenced by his mural commissioned by the Alta-California Building Society for the 1939 Golden Gate International Exposition on Treasure Island.

While maintaining his photo studio business, Lee also served as the primary photographer for San Francisco Chinese newspapers beginning in the late 1940s. He captured local events for papers such as *Young China, The Chinese Times*, and the *Chinese Pacific Weekly*. These local publications could not afford full-time reporters or photographers, so despite his reputation as the community's premier photojournalist, Lee was never paid for his work. Until Lee's images of San Francisco's Chinatown appeared in papers, few people in Chinatown had seen positive images of their community in print. Lee made it possible for local papers to offer a fuller view of Chinatown, including images not only of weddings and beauty queens but also of day-to-day life in the neighborhood.

Lee's pictures appeared in print until the 1960s, when many newspapers from Hong Kong and Taiwan replaced local Chinese publications. Lee married artist and poet **Nanying Stella Wong**; like his wife, he also composed poetry, especially in the later years of his life. Lee was honored by President Lyndon Johnson in a White House ceremony celebrating Asian American journalists.

Legaspi, Joaquin

BORN: August 18, 1896, Iloilo, Philippines

DIED: September 18, 1975, San Francisco, CA

RESIDENCES: 1896–ca. 1916, Iloilo, Philippines § ca. 1916–1917, Honolulu, HI § 1917–ca. 1928, San Francisco, CA § ca. 1928–1939, New York, NY § 1939, San Francisco, CA § ca. 1940s, New York, New Jersey, and Washington (U.S. military service) § ca. 1950s–1975, San Francisco, CA

MEDIA: painting, drawing, and sculpture

ART EDUCATION: 1918, California School of Fine Arts, San Francisco

SELECTED GROUP EXHIBITIONS: Montgomery Street Studios, San Francisco, ca. 1925 § Prospect Park, Brooklyn, 1930 § *First Filipino American Art Exposition*, Yerba Buena Center for the Arts, San Francisco, 1994

SELECTED BIBLIOGRAPHY: "Legazpi, the Poet." *Kalayaan International* (San Francisco) 1, no. 1 (June 1971): 15. § Navarro, Jovina, ed. *Manong Legaspi: Joaquin Legaspi, Poet, Artist, Community Worker*. El Verano, CA: Pilnachi Printers, 1976. § 1930 Federal Population Census. Bronx, Bronx, New York. Roll 1486, Page 15A, Enumeration

District 601, Image 493.0. National Archives, Washington, D.C. § Passenger Lists of Vessels Arriving at San Francisco, 1893–1953. Roll 100, Page 7. National Archives, Washington, D.C.

Controversy // The saying / West and East / shall never meet— // As like / Secret Lovers / Seemingly apart // Facing // The turbulent Watery Main, / their feet— / Wedded in the deep / At the very start. // So have We / To revive / Life's buried love // Therein / Our misunderstanding / To Quarrel— / In blind defiance / to Antique rules // Struggle... // As Indians on / Wounded Knee / made strangers / of their land— // How much less... How much less... // MUST / The Naturalized Asians / Demand?

JOAQUIN LEGASPI
Navarro, ed., *Manong Legaspi*, n.p.

A PAINTER, SCULPTOR, and poet, Joaquin Legaspi is perhaps best known as a community activist and organizer. Originally from the Philippines, Legaspi came to the United States by way of Hawaii in 1917 with thousands of other Filipino bachelors who gained work as contract laborers in Californian agriculture, Hawaiian sugar plantations, or Alaskan fish canneries. During his stay in Hawaii, he was deeply affected by the harsh working conditions endured by immigrant laborers. His efforts to organize a group of Filipino workers in order to voice their grievances resulted in his blacklisting and forced him to move to the mainland.

Settling in San Francisco, Legaspi studied with Spencer Macky in 1918 at the California School of Fine Arts and be-

Joaquin Legaspi, ca. 1972. Photo by Dan Begonia

came friends with the group of artists who gathered at the Montgomery Block, including puppeteer Perry Dilley and his wife, Grace Dilley. Legaspi held an exhibition of his work at the Montgomery Block in approximately 1925. Other friends included the writer Ethel Duffy Turner, a Mexican Revolution historian, and the sculptor Beniamino Bufano. Legaspi moved to New York in the late 1920s and met his wife, Anna, in a Catskills Mountain resort where he was painting children's portraits. Anna, originally from Denmark, and Legaspi found it difficult to find a place to live in New York due to discrimination. However, the 1930 census shows them living in the Bronx, with Legaspi's profession listed as "artist."

The couple moved to San Francisco in 1939. Legaspi, who was a knowledgeable electrician, served both during and after World War II in the signal corps of the army. He installed and repaired electronic equipment, working in the mountains of Washington state, New Jersey, and New York. Legaspi and his wife separated in the mid-1950s, and Legaspi focused his energies on improving living and employment conditions for Filipinos. He and four others organized the United Filipino Association (UFA), which would become active in the political struggle to retain San Francisco's International Hotel in 1968. Upon the eviction of the "I-Hotel" tenants, Legaspi established the Manilatown Multipurpose Center, an office serving the needs of elderly Filipinos in the Kearny Street area; he also served as director of the Chinese Senior Citizens Center.

Legaspi's creative talents in art and poetry matched his humanitarianism. Jovina Navarro describes Legaspi's art as interpreting "the aspirations, conflicts, contradictions and sentiments of the Filipino people." Artistically, his early work may have been influenced by Fernando Amorsolo, who was a friend and classmate in the Philippines, and a renowned painter. Later, Legaspi also explored abstract painting. Examples of his artwork are difficult to locate, but many of the poems he wrote throughout his life under the name "El Pasig" were published in *Manong Legaspi: Joaquin Legaspi, Poet, Artist, Community Worker*.

Leong, Gilbert

BORN: May 9, 1911, Los Angeles, CA

DIED: August 23, 1996, Pasadena, CA

RESIDENCES: 1911–1942, Los Angeles, CA § 1942–1946, Memphis, TN (U.S. military service) § 1946–1975, Los Angeles, CA § 1975–1996, Pasadena, CA

MEDIA: sculpture and watercolor painting

ART EDUCATION: 1931–1932, Chouinard Art Institute, Los Angeles

SELECTED GROUP EXHIBITIONS: *8th Annual Southern California Exhibition*, San Diego, CA, 1934 § Los Angeles County Fair, 1934, 1935, 1937, 1940 § *Exhibition of*

California Oriental Painters, Foundation of Western Art, Los Angeles, 1937 § *Los Angeles Art Association International Show*, 1937 § Fine Arts Gallery, San Diego, CA, 1938 § *Brushstrokes of Old Chinatown*, El Pueblo Gallery, Los Angeles, 1994 § *On Gold Mountain*, Autry Museum of Western Heritage, Los Angeles, 2000

SELECTED BIBLIOGRAPHY: *California Arts and Architecture* 56, no. 4 (October 1939): 8, 15. § Leong, Leslie. CAAABS project interview. October 11, 2000. Audiotapes, Asian American Art Project, Stanford University. § Lew, Alvina. "Historical Society Looks at Its Own History." *Asian Week*, January 24, 1986, 13. § McCall Head, Ethel. "Home's Heart Is a Secret Thing." *Los Angeles Times Home Magazine*, September 23, 1951, cover, 4, 5, 12. § See, Lisa. *On Gold Mountain*. New York: St. Martin's Press, 1995.

Now a parting word to your sons and to your daughters: be proud of your heritage from wherever it may come. We all have something to give. Share it. I am proud to be Chinese. I'm proud to be an ABC—that's American-Born Chinese.

GILBERT LEONG
Lew, "Historical Society
Looks at Its Own History," 13

ALTHOUGH A TALENTED painter and sculptor, Gilbert Leong is best remembered for his long career as a Los Angeles architect. He was one of the first American architects of Chinese descent. Leong was born in Los Angeles to Chinese immigrant parents, and as a youth he worked in his family's restaurant. His interest in art led to his enrollment at the Chouinard Art Institute, where he studied painting with Millard Sheets and sculpture with Merrill Gage.

Leong exhibited his sculptural pieces in juried exhibitions and received prizes for his work. In 1937, at the Los Angeles County Fair, Leong exhibited *The Good Earth*, which depicted a young woman modeled from terra cotta, gracefully holding a tall lotus flower executed in brass. *The Good Earth* refers to the book by Pearl S. Buck that was made into a major motion picture that same year. The Fine Arts Gallery of San Diego expressed interest in purchasing *The Good Earth* for their permanent collection, and although the institution never bought the sculpture, it was on long-term loan in its rotunda. Recognition of Leong's work continued in 1939 when he was one of several artists featured in the October issue of *California Arts, and Architecture*, dedicated to artists of Chinese descent who were active in the state. The magazine reproduced both *The Good Earth* and *Kwan Yin*, another figurative sculpture. Of the latter piece, Stanton Macdonald-Wright stated, "It is difficult for a young Chinese whose art education has been almost exclusively occidental to catch the spirit of Kwan Yin in stone or clay. . . . For this fountain that graces China City, Gilbert Leung [sic] has done an excellent job in translating the physiognomy of Kwan Yin into a classical-modern vernacular."

Although Leong experienced success as a sculptor, he realized it would be difficult to make a living exclusively through this work. He enrolled in the University of Southern California's architecture program and became one of its top students. After graduating, Leong worked with two well-known Los Angeles architects, Harwell Harris and Paul Williams, and during World War II served in the army, stationed in Memphis, Tennessee.

Back in Los Angeles in 1950, Leong began an architectural practice with his associate Schwen Wei Ma, establishing one of the first Chinese American architecture firms in the country. Leong became a prominent figure in the community, designing both public and private buildings, and was an active member of many Chinese American organizations.

In 1951, Leong's firm designed a modernist house that was featured on the front cover of the *Los Angeles Times Home Magazine*. In 1954 he established a private practice, which he continued until his retirement in 1987. Leong's business flourished, and he designed numerous homes for other members of the Chinese community in the Silver Lake/Los Feliz area. At the same time, the Chinese business community called upon Leong to design buildings in Chinatown and elsewhere for banks, churches, and commercial enterprises. In 1980, Leong redesigned the center courtyard garden for the Pacific-Asia Museum, located in Pasadena, where his plan called for an irregular rock formation reminiscent of the scholars' rocks associated with Daoism.

Gilbert Leong with unknown sitter, ca. 1930s

Leong, James

BORN: November 27, 1929, San Francisco, CA

RESIDENCES: 1929–1955, San Francisco, CA § 1955–1956, New York, NY § 1956–1958, Norway § 1958–1990, Rome, Italy § 1990–present, Seattle, WA

MEDIA: oil painting, mixed media, and murals

ART EDUCATION: 1947–1953, California College of Arts and Crafts, Oakland, CA

SELECTED SOLO EXHIBITIONS: American Gallery, Los Angeles, 1955 § Retrospective touring exhibition organized by the United States Information Service (USIS), 1976 (various locations in Turkey and Scandinavia) § Lasater Gallery, Seattle, 1994

SELECTED GROUP EXHIBITIONS: Museum of Modern Art, New York, 1955 § Whitney Museum of American Art, New York, 1955 § San Francisco Museum of Art, 1962 § *Asian Traditions/Modern Expressions*, Jane Voorhees Zimmerli Art Museum, Rutgers State University, New Brunswick, NJ, 1997

SELECTED COLLECTIONS: Chinese Historical Society of America, San Francisco § Dallas Museum of Fine Arts § Indianapolis Museum of Art § Princeton University Art Museum

SELECTED BIBLIOGRAPHY: Findlay, Ian. "In From Exile." *Asian Art News* 4, no. 6 (November/December 1994): 88–92. § Leong, James. CAAABS project interview. August 13, 1997. Seattle. § Leong, James. "James Leong." Unpublished essay. § Luna, Deni. "Work of Seattle Artist Shows His Intense Reactions to World Affairs." *Northwest Asian Weekly* (Seattle), January 11, 1997, 11+. § "The Non-Beatniks." *Time*, June 8, 1955, 66.

By choice the artist is a marginal person, a kind of outsider. I think that my personal experiences have given me the ability to cope with being a marginal person. It is something that few people can understand. Most people want to belong.

JAMES LEONG
Findlay, "In From Exile"

JAMES LEONG'S CAREER includes the production of early figurative paintings, landscapes created during a thirty-four-year residency in Europe, and, more recently, abstractions. The partial loss of sight in one eye resulting from a discriminatory attack as a child left Leong with a challenging visual impairment. Leong has noted, "It's because of my visual impairment that I try to produce more than most people try to do.... I was a very angry person but that anger was harnessed and expressed in painting." Leong received a scholarship to attend the California College of Arts and Crafts, and he completed a B.F.A. in 1951 and an M.F.A. in 1953. He later recalled that

James Leong, 1996. Photo by Irene Poon

visiting faculty Walt Kuhn and **Yasuo Kuniyoshi** left indelible impressions on him. The young artist also drew inspiration from the career of **Dong Kingman**. In the early 1950s, Leong created the nation's first mural portraying the history of the Chinese in the Americas. However, some people thought the mural embodied anti-American sentiments and controversial depictions of early Chinese immigrants. For these reasons, the artist was investigated by the FBI and became distanced from the Chinese-American community.

During the Korean War, Leong worked as an illustrator and political cartoonist. He received a John Hay Whitney Opportunity Fellowship and left California for New York in 1955, although he exhibited in Los Angeles at the American Gallery later that year. Leong's association with René d'Harnoncourt, director of the Museum of Modern Art, and Edith Halpert of the Downtown Gallery led to a series of four solo exhibitions at New York's Barone Gallery.

Leong left New York in 1956, traveling on a Fulbright scholarship to Norway, where his interest in the landscape prompted a change of subject in his painting. In 1958, the artist received a Guggenheim Fellowship and traveled to Rome. He stayed in Rome for more than thirty years, converting the fifteenth-century Palazzo Pio in the heart of the city into studios where artists, including Cy Twombly and Warrington Colescott, sublet spaces.

Leong's interest in the theories of mathematics and Roman architecture resulted in a body of abstract, architectonic works. These works were featured in solo and group exhibitions throughout Europe and further established his interna-tional reputation. His ten-year retrospective organized by the USIS for the U.S. bicentennial traveled through Turkey and Scandinavia. But the 1989 Tiananmen Square massacre shifted the artist's attention to creating more emotional works.

In 1990, Leong returned to the United States and settled in Seattle, impressed by its multiracial climate and political openness. A family trip to China and a three-year battle with cancer affected the artist's later work. Leong currently lives in Seattle and continues an active career.

Lim Tsing-ai (Lin Ching-ni)

BORN: 1914, Taishan, Guangdong, China

DIED: ca. 1985, San Francisco Bay Area, CA

RESIDENCES: 1914–1962, Guangdong, China; Hong Kong; Taipei; Manila § 1962–ca. 1985, San Francisco Bay Area, CA

MEDIA: ink painting

ART EDUCATION: Sun Yat-sen University, Taipei, Taiwan

SELECTED SOLO EXHIBITIONS: de Young Museum, San Francisco, 1963 § Stanford Museum, Stanford, CA, 1964 § Park's Gallery, San Jose, CA, 1965

SELECTED GROUP EXHIBITIONS: Chinese Art Exhibit, London, 1943 § International Art Exhibition, New York, 1944 § Guomindang Office, San Francisco, 1964 § Chinese Art Gallery, San Francisco, 1965

SELECTED COLLECTIONS: Asian Art Museum, San Francisco
§ Huagang Museum, Taipei, Taiwan

SELECTED BIBLIOGRAPHY: *The Chinese World* (San Francisco),
March 2, 1964. § *The Chinese World* (San Francisco),
August 6, 1965. § Yeh, George K. C. "Chinese Painting
and Prof. Tsing-ai Lim." *Chinese Art Gallery Anniversary
Special Issue* (San Francisco), 1966.

*Chinese culture is looked upon today by the West as a sedative
for tranquilizing the spirit. Hence, we, who are overseas and
active in the field of culture, must proceed with our energies
and time in the proper direction, so that we may be able to
save ourselves, our people, and all mankind. If we do so, our
traditional culture will shine as an eternal flame in the world.
My establishment of the Chinese Art Gallery here is based
on that idea.*

LIM TSING-AI
Yeh, "Chinese Painting and Prof. Tsing-ai Lim"

LIM TSING-AI BEGAN to study art as a teenager and trained in
the style of ancient Chinese art, copying works by noted mas-
ters and becoming skilled in all aspects of Chinese painting. In
his early years as an artist in China, he had more than twenty
exhibitions throughout the country. He also became known
internationally, and in 1953 he was invited by a Japanese paint-
ers' guild to exhibit his work in cities including Tokyo, Osaka,
Nagoya, and Kobe. In 1956 Lim had a series of successful ex-
hibitions throughout Southeast Asia. King Suramarit of Cam-
bodia awarded Lim a gold medal in recognition of his cultural
accomplishments and efforts toward international goodwill.
Lim taught at the Overseas Chinese College of Technology and
Commerce in Hong Kong, the College of Fine Arts at the Uni-
versity of the Philippines, and the Hue University in South
Vietnam. In 1962 the Education Ministry of the Republic of
China (Taiwan) cited Lim for his work and services, and later
that year he began a goodwill and study tour of the United
States. During this time he held several exhibitions, including
solo shows at the de Young Museum in San Francisco and the
Stanford Art Museum. Eventually he moved permanently to
the Bay Area.

In 1963 Lim began his association with the Rudolph
Schaeffer School of Design in San Francisco, where he taught
for the next several years. Two years later, in May 1965, he
opened the Chinese Art Gallery at 30 Waverly Place in San
Francisco's Chinatown, where he gave lessons and presented
exhibitions. An important venue for Chinese painting and
arts, the gallery hosted exhibitions of work by both historic
and contemporary artists. In 1965 and 1966 alone, exhibitions
included work by **Chang Dai-chien**, Huang Chun-pi, and Qi
Baishi. The Chinese Art Gallery was instrumental in provid-
ing a venue for such work and was a nexus for Chinese art in
Northern California.

Liu, James Yeh-jau

BORN: September 23, 1910, Changsha, Hunan, China

DIED: July 24, 2003, Tiburon, CA

RESIDENCES: 1910–1935, China § 1935–1938, Japan
§ 1938–1944, China § 1944–1946, international
travel § 1946–1949, China § 1949–1962, Taiwan
§ 1962–1967, San Francisco, CA § 1967–2003,
Tiburon, CA

MEDIA: ink painting

ART EDUCATION: 1929–1935, National Academy of Fine Art,
Hangzhou, China

SELECTED SOLO EXHIBITIONS: San Francisco State College,
1960 § National Museum of History, Taipei, Taiwan, 1992

SELECTED GROUP EXHIBITIONS: Laky Gallery, Carmel, CA,
1965 § *World Journal*, Millbrae, CA, 2000

SELECTED COLLECTIONS: Bishop Library, Tiburon, CA §
de Saisset Museum, University of Santa Clara, CA

SELECTED BIBLIOGRAPHY: Hsu, Kai-yu. "It Is All in the Mind
and in the Hand." *The Gallery: Carmel-by-the-Sea* (Laky
Gallery, Carmel, CA), May 1965, 1, 2, 5. § *The Paintings
of Yeh-Jau Liu*. Taipei: National Museum of History,
1992. § *The Paintings of James Yeh-jau Liu*. Self-published,
in association with National Museum of History 1992
catalog. § Whiting, Sam. "The Art of Living: At 93, Jimmy
Liu Still Paints Every Day." *San Francisco Chronicle*, June 1,
2001, 4.

*I paint every day, early in the morning for about three hours;
if I paint a lot of landscapes, sometimes it's up to six or seven
hours . . . I never stop because I enjoy it so.*

JAMES YEH-JAU LIU
Marilyn Olson, "A Glorious Painter of Feelings,"
in *The Paintings of James Yeh-jau Liu*

RAISED IN A FAMILY of seventeen children, James Yeh-jau Liu
became interested in art as a child. He pursued his education
at the prestigious Hangzhou National Academy of Fine Art,
first studying Western media and techniques for three years
with Lin Fengmian, who had trained in Paris, and then focus-
ing on Chinese classical painting for an additional three years
with renowned artist-teacher Pan Tianshou. After graduation,
he continued his education in Japan but returned to China af-
ter the invasion of Manchuria. He was then drafted and later
worked for the Department of Education and Culture in Nan-
jing. In 1944, Liu and four others were sent abroad on a two-
year research tour of the West, which took them to Egypt, Eu-
rope, and, in 1946, California. Liu remembers then resolving
to return to the state.

Liu moved to Taiwan in 1949 and resumed art making. He

James Yeh-jau Liu, 1998. Photo by Irene Poon

Lowe, Peter

BORN: July 4, 1913, Los Angeles, CA

DIED: February 27, 1989, Alameda, CA

RESIDENCES: 1913–1914, Los Angeles, CA § 1914–ca. 1930, China § ca. 1930–1989, San Francisco and Oakland, CA

MEDIA: oil, watercolor and ink painting, printmaking, murals, and mosaics

SELECTED GROUP EXHIBITIONS: *San Francisco Art Association*, San Francisco Museum of Art, 1939–1942, 1945, 1946, 1948 § *Chinatown Artists Club*, de Young Museum, San Francisco, 1942, 1943, 1945 § *Federal Arts Project: Prints*, de Young Museum, San Francisco, 1943

SELECTED COLLECTIONS: Baltimore Museum of Art § Fine Arts Museums of San Francisco § Frederick R. Weisman Art Museum, University of Minnesota § Philadelphia Museum of Art

SELECTED BIBLIOGRAPHY: Brown, Michael D. *Views from Asian California, 1920–1965.* San Francisco: Michael D. Brown, 1992. § Lowe, Peter. Interviewed by Mary Fuller McChesney. March 2, 1965. Oakland, CA. Transcript, Archives of American Art, Smithsonian Institution. § McChesney, Robert. *Robert McChesney: An American Painter.* Petaluma, CA: Sonoma Mountain Publishing, 1996, 72, 104. § Volz, Herman. Interviewed by Mary Fuller McChesney. June 27, 1964. Mill Valley, CA. Transcript, Archives of American Art, Smithsonian Institution.

I think it was a wonderful thing and I'm glad that they allowed a good thing in this country, the federal art project. We turned out beautiful things for the easel project and the mural project and mosaic and lithograph[y]. Everything was outstanding in art.

> PETER LOWE
> Interviewed by Mary Fuller McChesney.
> March 2, 1965. Oakland, CA. Transcript, Archives of
> American Art, Smithsonian Institution.

later taught painting at the Taiwan Fine Arts Academy, and his work during this period included classical imagery in ink of plum branches and bamboo. Liu was invited by Professor **Kai-yu Hsu** to exhibit and teach at San Francisco State College (now University) in 1960, and he permanently moved to California in 1962. Although Liu only taught at San Francisco State for two and a half years, he helped arrange for two other Chinese artists' relocation to California, painter and teacher **Cheng Yet-por** and painter and designer Wang Chang-chieh (also known as C. C. Wang, but not to be confused with **Wang Chi-ch'ien**). Liu's work became more broadly painted and richly colored, and it was exhibited at the Laky Gallery in Carmel.

In 1967, Kai-yu Hsu helped Liu locate a storefront on Main Street in Tiburon, a North Bay community with ferry service to San Francisco. There, Liu established the Han Syi Studio, a small, personal gallery where he earned a significant reputation for his freely painted coastal scenes in colored ink, which reflected aspects of the Bay Area and California landscape. He was named Tiburon's Citizen of the Year in 1987, and he mounted a solo exhibition in Tiburon Town Hall in 2000 at the age of ninety. He exhibited in innumerable exhibitions, including those at the *World Journal* newspaper headquarters in Millbrae, California, and at the Sun Yat-sen Memorial Hall in San Francisco's Chinatown. He was very active until his death following an automobile accident.

BORN IN LOS ANGELES, Peter Lowe at the age of one moved to China with his parents. As a child of six or seven, he had his first art instruction there, learning calligraphy and how to sculpt under the supervision of Buddhist monks. When he returned to the United States, he settled in San Francisco and briefly attended the California School of Fine Arts, taking night courses. In a 1965 interview with Mary Fuller McChesney and Robert McChesney, Lowe recalled how he became friends with a group of Chinese artists who rented space in the Carpenters' Hall on Montgomery Street behind Rinaldo Cuneo's apartment. Lowe also described how the group hired Otis Oldfield to teach. Members of this group would later hold exhibitions at the de Young Museum as the Chinese Art Association and Chinatown Artists Club.

While pursuing art, Lowe owned a garment factory with a friend for a time, but the business was not financially successful. Friend **Dong Kingman**, seeing Lowe's situation, recommended that he try to get work on a WPA art project. After first being sent out on gardening projects after telling WPA administrators that he was a landscape painter, Lowe finally was assigned to work on murals for Treasure Island under Herman Volz. Volz later said that Lowe was "a most talented guy. He was much more talented than I ever was." Lowe also worked on the mosaic mural at San Francisco City College, often doing his own work after hours, and created lithographs during his time with the WPA. Lowe became friends with Robert McChesney when the two worked together at Treasure Island, and their friendship continued even after Lowe gave up painting. Lowe also worked at Treasure Island with Diego Rivera on the mural *Pan American Unity* (now at San Francisco City College), and Rivera asked him to mix his colors because of Lowe's experience with color grinding and mixing in China.

Lowe, who later remembered this WPA period fondly, served in World War II and stopped painting not long afterward. During an interview with Herman Volz in 1964, Lowe's friends Robert McChesney and Mary Fuller McChesney offered insight into why Lowe stopped painting. Lowe fought for approximately fifteen years to have his wife admitted to the United States. This struggle, combined with the prejudice he encountered while serving in the U.S. Navy during World War II, caused him to suffer an emotional breakdown while on leave in San Francisco, and he set fire to his paintings, which had been stored by friends. Reflecting on Lowe's work for the WPA, Herman Volz also remembered similar difficulties and pressures Lowe faced that likely were the result of racism. "He was fantastic, this guy. He was marvelous. But he was a guy who had no talent, according to the supervisors, you know, the

bureaucratic supervisors. They didn't like him and I saved him many times from being fired. They didn't like his personality. I don't know what there was they didn't like about him.... He was a marvelous painter." Lowe exhibited his work into the late 1940s but by the 1950s had stopped painting. He later owned and ran a grocery store in Oakland.

Peter Lowe,
ca. 1940s

Luke, Keye

BORN: June 18, 1904, Guangdong, China

DIED: January 12, 1991, Los Angeles, CA

RESIDENCES: 1904–1908, Guangdong, China § 1908–1927, Seattle, WA § 1927–1991, Los Angeles, CA

MEDIA: oil painting, murals, illustration, and drawing

ART EDUCATION: 1938, Chouinard Art Institute, Los Angeles

SELECTED SOLO EXHIBITIONS: Frederick Nelson Gallery, Seattle, 1933 § Assistance League Art Gallery, Los Angeles, 1936

SELECTED GROUP EXHIBITION: *Exhibition of California Oriental Painters*, Foundation of Western Art, Los Angeles, 1937

SELECTED BIBLIOGRAPHY: *California Arts and Architecture* 56, no. 4 (October 1939): 8, 21. § "Keye Luke Art Expert at Chinese." *Los Angeles Evening Herald*, December 30, 1929, B9. § Pease, Frank. "A Seattle Beardsley." *The Town Crier* (Seattle), September 22, 1933. § Perine, Robert. *Chouinard: An Art Vision Betrayed*. Encinitas, CA: Artra Publishing, 1985. § Tsutakawa, Mayumi, ed. *They Painted from Their Hearts: Pioneer Asian American Artists*. Seattle: Wing Luke Asian Museum/University of Washington Press, 1994. § Wolfson, Sonia. "Work of Chinese Artist Wins Praise: Orient and Occident Meet in Fascinating Symbolism." *Saturday Night* (Los Angeles), January 11, 1936. Ferdinand Perret Research Materials on California Art and Artists, 1769–1942. Reel 3859, frame 1349. Archives of American Art, Smithsonian Institution.

BEST KNOWN AS a successful Hollywood actor who portrayed Charlie Chan's number-one son in films of the 1930s, Keye Luke was also an accomplished artist. His father, Lee Luke, was a noted merchant and art dealer in San Francisco in the late nineteenth century, and he returned to China to marry and start a family. When Luke was three years old, the family moved from China to Seattle. There, Luke attended Pacific Grammar School and Franklin High School. He was the art editor of his high school's yearbook, and his black-and-white illustrations for the publication, with subject matter that included the story of Beowulf, garnered attention for their skillful composition that blended occidental and oriental influences in a style reminiscent of Aubrey Beardsley. Luke began studying

Keye Luke with instructor
Richard Munsell, ca. 1939

architecture at the University of Washington, but when his father died he left school to support his mother and four younger siblings. Luke created sketches and layouts for theatrical ads in Seattle newspapers, and in 1926–1927 he painted a six-panel mural in oils for the Bon Marche department store. The mural depicted the Chinese story of Xi Wangmu and the peaches of immortality, and in an accompanying brochure for store visitors, Luke explained the mural's story and related symbolism. Frank Pease, in a review of a later Seattle solo exhibition of Luke's work, said, "Keye Luke's more than any other contemporary American artist's work I have seen is the most intriguing with impending possibilities."

Luke moved to Los Angeles and began working as an artist for Fox West Coast Theaters, where he created posters and caricatures for movie promotion. He was also employed as a consultant for the newly opened Grauman's Chinese Theater. Luke created publicity artwork in association with several of the early Charlie Chan films and also produced newspaper graphics for the RKO Studio. Luke was promised a role in an RKO picture starring Anna Mae Wong that ultimately was not produced, but eventually he made his film debut in the 1934 Greta Garbo picture, *The Painted Veil*, playing the role of a doctor. In 1935, Luke was featured as Lee Chan, son of Charlie Chan, in the film *Charlie Chan in Paris*. He reprised this role in seven more films opposite Swedish-born Warner Oland as Charlie Chan, and in several additional films in subsequent years opposite other actors.

Luke continued to produce and exhibit artwork, and notable was a 1936 Los Angeles solo exhibition that featured his black-and-white work along with paintings and portraits of motion picture actors including Anna May Wong, Warner Oland, and Katharine Hepburn. Subject matter for the black-and-white work included both Western and Eastern mythic characters and allegorical stories. One work entitled *Four Beautiful Women of Antiquity* featured Helen of Troy, Semiramis of Babylon, Lady Guinevere, and Yang Guifei. Luke took night classes at the Chouinard Art Institute and exhibited with such artists as **Tyrus Wong**, **Miki Hayakawa**, **Mine Okubo**, and **Hideo Date** in the *California Oriental Painters* exhibition in 1937. But, as his career as an actor grew, Luke exhibited less frequently. He married Ethel Davis in 1942 and in the early 1950s illustrated several books, including *The Unfinished Song of Achmed Mohammed* (1951) and the children's books *Blessed Mother Goose* (1951) and *Lost Dove* (1953). Luke had prominent roles in films and television for more than five decades, appearing in *Love Is a Many Splendored Thing* (1955), *Around the World in Eighty Days* (1956), the TV series *Kung Fu* (playing Master Po), *Gremlins* (1984), and Woody Allen's *Alice* (1990). A founding member of the Screen Actors Guild, Luke is honored with a star on the Hollywood Walk of Fame.

Mancao, Frank A.

BORN: November 22, 1901, Cebu Island, Philippines

DIED: December 16, 1984, Reedley, CA

RESIDENCES: 1901–1918, Cebu Island, Philippines § 1918–1926, San Francisco, Oakland, and Elkhorn, CA § 1926–1927, Philippines § 1927–1933, San Francisco, CA § 1933–1984, Reedley, CA

MEDIA: photography

SELECTED BIBLIOGRAPHY: Alta Elementary School. "Chapter VI: The Filipinos." Reedley, CA. http://www.kc.usd.k12.ca.us/alta/c-6.pdf. Downloaded October 2004. § Cordova, Fred. *Filipinos: Forgotten Asian Americans*. Dubuque, IA:

Kendall/Hunt Publishing, 1983. § 1920 Federal Population Census. Elkhorn, San Joaquin, California. Roll T625 143, Page 18A, Enumeration District 148, Image 0411. National Archives, Washington, D.C. § 1930 Federal Population Census. San Francisco, San Francisco, California. Roll 207, Page 11B, Enumeration District 345, Image 802.0. National Archives, Washington, D.C. § Passenger Lists of Vessels Arriving at San Francisco, 1893–1953. Roll 209, Page 106. National Archives, Washington, D.C.

FRANK MANCAO CAME to the United States in 1918 and by 1920 was living in Elkhorn, California. According to the federal census of that year, he worked as a waiter in a restaurant. He returned to the Philippines in 1926 to marry, and he and his wife and newborn daughter returned to California in 1927. The family settled in San Francisco, where Mancao worked

Frank Mancao (left) working as a chauffeur in the San Francisco Bay Area, mid-1920s

as a chauffeur for a wealthy family. The Mancaos lived in San Francisco for almost six years and had a second daughter.

In the Philippines Mancao had worked as a photographer, but he could not find similar employment in California. However, after the family moved to Reedley, California, Mancao began taking photographs of the town's Filipino community, often selling the images he printed. The pictures he took, especially those from the 1930s and 1940s, are a unique body of work that documents the early history of one Filipino community in California. Mancao's photos capture family scenes, picnics and parties, golf and gambling, as well as the many Filipino-owned small businesses, and community events such as weddings and funerals. The elegance of his compositions may reflect his training in photography in the Philippines.

The Mancao family invested in a restaurant and pool hall, located at 1305 I Street in Reedley, and later Mancao worked as a farmworker labor contractor, often acting as a negotiator between workers and farmers during labor disputes. In 1944 Mancao sold the restaurant and pool hall and purchased five acres of land for vegetable farming. Later sold to the city, this land is now the town's C. F. Mueller Park.

Mancao was an important leader in the Reedley community and an advocate for the rights of the city's Filipino residents. In 1946, in celebration of the independence of the Philippines, Mancao helped raise funds and organized a major celebration and parade in Reedley, witnessed by many dignitaries, including state Senator Hugh Burns. In 1950 Mancao began work as an agent for the Woodmen Accident and Life Insurance Company and was employed there for the next twenty years.

Markino, Yoshio

BORN: December 25, 1869, Toyota, Aichi Prefecture, Japan

DIED: October 18, 1956, Kamakura, Kanagawa Prefecture, Japan

RESIDENCES: 1869–1893, Toyota and Nagoya, Japan § 1893–1897, San Francisco, CA § 1897–1923, London, England § 1923–1927, New York, NY, and Boston, MA § 1927–1942, London, England § 1942–1956, Kamakura, Japan

MEDIA: oil, ink and watercolor painting, and drawing

ART EDUCATION: 1896–1897, Mark Hopkins Institute of Art § ca. 1897–ca. 1899, Goldsmith Art Institute, London § ca. 1899–ca. 1900, London Central Industrial Arts School

SELECTED SOLO EXHIBITIONS: Clifford House (Gallery Haymarket), London, 1907 § *Watercolor Paintings by Yoshio Markino*, Art Center, New York, 1925 § New Studio Gallery, London, 1929

Yoshio Markino

SELECTED GROUP EXHIBITIONS: Grosvenor Gallery, International Society, London, ca. 1904–ca. 1928 § *Japan and Britain: An Aesthetic Dialogue, 1850–1930*, Barbican Art Gallery, London, 1991

SELECTED BIBLIOGRAPHY: *Japanese and Japanese American Painters in the United States: A Half Century of Hope and Suffering, 1896–1945*. Tokyo: Tokyo Metropolitan Teien Art Museum and Nippon Television Network Corporation, 1995. § Markino, Yoshio. *A Japanese Artist in London*. Philadelphia: George W. Jacobs & Co., 1910. § Markino, Yoshio, Ikuo Tsunematsu, and Betty Shephard. *Alone in This World: Recollections of Yoshio Markino and Mamoru Shigemitsu*. Brighton, U.K.: In Print, 1993. § Noguchi, Yone. "Yoshio Markino." *Japan Times*, March 4, 1917. http://www.media.kyoto-u.ac.jp/edu/lec/edmarx/Noguchi/ma. Downloaded May 2004. § Price, Clair. "A Talk with Yoshio Markino in His Attic Studio," *New York Times*, August 5, 1928, 102. § Wechsler, Jeffrey, ed. *Asian Traditions/Modern Expressions: Asian American Artists and Abstraction, 1945–1970*. New York: Abrams in association with the Jane Voorhees Zimmerli Art Museum, Rutgers, the State University of New Jersey, 1997, 173.

One day I was in a great hurry to wrap up my pictures, and by mistake I took one of Jennings'. . . . A manager looked so unpleasant with my works because they were "too Japanese." He picked up that picture by Jennings and said, "Look here, it is too Japanese. English publics [sic] would not understand such design." I said very politely, "Pardon me, but it is done by my English friend." He was rather perplexed. "Oh, I am afraid your friend is too much influenced by you!"

YOSHIO MARKINO
A Japanese Artist in London.
Philadelphia: George W. Jacobs & Co., 1910, 60.

BORN THE SECOND SON of a samurai, Yoshio Markino was initially educated by his father, then attended school in 1886 in Nagoya, where he studied Western painting and English. After failing an army exam in 1889, Markino continued his studies in English literature and decided to travel to the United States to become a poet or writer. In July 1893, Markino moved to San Francisco. Friends who felt he would have a difficult time be-

coming a successful writer in English encouraged him to study art instead, and he enrolled at the Mark Hopkins Institute of Art. The artist changed his name from Makino to Markino to simplify pronunciation for English speakers. In his 1910 autobiography, *A Japanese Artist in London*, Markino provided a shocking account of the late-nineteenth-century racism in San Francisco that prompted him to leave the city.

Markino initially traveled to Paris but eventually settled in London in 1897 and was surprised by Londoners' kindness and generosity. Employed during the day with the Japanese naval attaché, Markino continued his education in various art school night courses. He described his early years in London as extremely impoverished, and financial instability would plague him throughout his life. Poet Yone Noguchi stayed with Markino on his first trip to London in 1903 and later reminisced about their spartan existence; the two remained good friends throughout their lives.

Despite criticism that his art was "too Japanese," Markino's illustrations were published in books and magazines, and he soon was invited to write and illustrate his first book, *The Colour of London* (1910). The book was translated into several languages and generated international recognition for Markino and his work. *The Colour of Paris* and *The Colour of Rome* followed. Markino used water-based media to create atmospheric representations of city scenes, especially London streets shrouded in fog in a style influenced by Turner.

In 1923, on his way to Tokyo for a solo exhibition of his work, Markino was stranded in New York when one of the most devastating earthquakes in modern history hit Tokyo. His artwork had already reached Japan and was destroyed, and Markino remained in the United States for the next four years, living in New York and Boston. He returned to London, where he continued to paint and publish, but was forced to move into the Japanese embassy in 1939 at the onset of World War II. He returned to Japan in 1942 after war was declared between England and Japan.

Following the war, Markino gave private art lessons to students, including **James (Jimi) H. Suzuki**. Suzuki recalled that Markino encouraged him to continue his artistic training in the West, which Suzuki did in 1952.

In addition to being an accomplished artist, Markino was also a respected writer in both English and Japanese. His books include *When I Was a Child* (1912), *My Recollections & Reflections* (1913), *Thinkers and Thoughts of East and West* (1936), and *My Forty Years in England* (1940, in Japanese).

Mateo, Sylvester P.

BORN: December 31, 1909, Morong, Rizal, Philippines

DIED: August 5, 2001, San Francisco, CA

RESIDENCES: 1909–1928, Morong, Rizal, and Manila, Philippines § 1928–1929, San Francisco, CA § 1929, Minneap-

Sylvester Mateo (center) with friends, ca. 1930

olis, MN § 1930–1931, San Francisco and Salinas, CA § 1931–2001, San Francisco, CA

MEDIA: oil painting and drawing

ART EDUCATION: 1924–1927, University of the Philippines, Manila § 1928, University of California, Berkeley § 1929, Federal School of Illustration, Minneapolis

SELECTED GROUP EXHIBITIONS: *San Francisco Art Association*, San Francisco Museum of Art, 1941, 1946 § *Society of Western Artists*, de Young Museum, San Francisco, 1949, 1951 § *5th Annual Palace of Fine Arts Exhibition*, San Francisco, 1951 § *Fisherman's Wharf, 11th Annual Exhibition*, San Francisco, 1958

SELECTED COLLECTIONS: Malacanan Palace, Manila, Philippines § Morong Church, Morong, Rizal, Philippines

SELECTED BIBLIOGRAPHY: *Liwanag: Literary and Graphic Expressions by Filipinos in America*. San Francisco: Liwanag Publishing, 1975. § Sceny, Evora H. "Sylvestre P. Mateo." Unpublished paper, California State University, Sacramento, Spring 1983. Collection Asian American Art Project, Stanford University.

We had to work from memory alone—no photos, sketches or even notes were permitted. We lived with the studies of our subjects until we would not forget a feature—I chose to do a portrait of our national hero, Dr. Jose Rizal....I will never forget a detail of his appearance.

SYLVESTER P. MATEO
Sceny, "Sylvestre P. Mateo"

BORN TO A PROMINENT Filipino family in the town of Morong, Sylvester Mateo became interested in art and illustration at an early age. Mateo later recalled that the highlight of his week was when the *Saturday Evening Post* arrived with news of the United States and illustrations by Norman Rockwell. His father, also an artist, supported his son's interest and sent him to Manila when he was fifteen to attend the University of

the Philippines. There, he studied with noted artist Fernando Amorsolo, received a foundation in art history, and learned to paint from memory, an important component of his training. After three years at the school, his father asked if he would like to study in the United States. Mateo traveled to San Francisco in 1928 to attend the University of California, Berkeley. While there, he received a scholarship to study at the Federal School of Illustration in Minneapolis, which he attended briefly, but the 1929 stock market crash's impact on the Philippines economy affected his family's ability to support him. He had to return to California to find a job.

In the early 1930s Mateo performed seasonal agricultural work, was employed at a hotel in San Francisco, and later worked for the WPA on public construction projects in San Francisco. During World War II Mateo worked at the San Francisco Naval Shipyard, first as a laborer and later as an outfitter, and continued this work into the postwar years. Mateo continued to paint during this time, creating work such as *The Black Vase* (1938), an asymmetrical still life, and *The Wrong Catch* (1940), a painting of a tiger shark that was a prize winner at the San Francisco Art Association's annual exhibition in 1941. Mateo's work tended to be large-scale landscapes, seascapes, and genre scenes. His early training, which required that he paint from memory, served him later in life, as he was able to easily recall and depict scenes from the Philippines. He also represented scenes from his daily life, such as his 1946 *Docking the Ship*, an image of the USS *Missouri* on which Mateo once worked. Mateo also made portraits of friends and family members. He was the first Filipino to be a member of the Society of Western Artists.

In 1975, accompanied by his wife, Mary, Mateo returned to the Philippines for the first time in nearly fifty years by invitation of Ferdinand Marcos for the installation of Mateo's painting of the country's national hero, Dr. José Rizal, in the presidential Malacañan Palace. In 1978, Mateo returned again when his *Christ of Morong* was installed at the sixteenth-century Morong Church in his hometown.

Matsubara, Kazuo

BORN: June 1, 1895, Honolulu, HI

DIED: unknown

RESIDENCES: 1895–1912, Honolulu, HI § 1912–ca. 1916, San Francisco, CA § ca. 1916–ca. 1919, Paris, France § ca. 1919–ca. 1932, San Francisco and Los Angeles, CA

MEDIA: oil painting and printmaking

ART EDUCATION: 1913–1916, San Francisco Institute of Art

SELECTED SOLO EXHIBITION: Olympic Building, Los Angeles, 1929

SELECTED GROUP EXHIBITIONS: *California Society of Etchers,* 1919, 1920 § *San Francisco Art Association,* Palace of Fine Arts, 1921, 1923, 1924 § *International Printmakers Exhibition,* Los Angeles Museum of Art, 1921, 1924, 1925 § *East West Art Society,* San Francisco Museum of Art, 1922 § *San Francisco Art Association,* California Palace of the Legion of Honor, 1925 § *Chicago Society of Etchers,* 1925 § *Japanese Artists of Los Angeles* (First Annual), Little Tokyo, 1929

SELECTED COLLECTIONS: Japanese American National Museum, Los Angeles § Smithsonian American Art Museum, Washington, D. C.

SELECTED BIBLIOGRAPHY: "Critics Praise Matsubara's Art Exhibit in LA." *Nichi Bei* (San Francisco), February 14, 1929. § Ferdinand Perret Research Materials on California Art and Artists, 1769–1942. Reels Cal 1, Cal 2. Archives of American Art, Smithsonian Institution. § Millier, Arthur. "City's Japanese Show Art." *Los Angeles Times,* December 29, 1929, part 3, 9.

KAZUO MATSUBARA STUDIED at the San Francisco Institute of Art between 1913 and 1916 with John Stanton, Frank Van Sloan, and Lee Randolph. His fellow students included **Kamesuke Hiraga** and **Henry Yoshitaka Kiyama**. Matsubara traveled to Paris sometime between 1916 and 1919 and returned to San Francisco by 1920. He exhibited widely in San Francisco and Los Angeles in the 1920s and early 1930s, showing both oil paintings and etchings. He depicted many California locales, and titles of exhibited works reference Pescadero, San Luis Obispo, Morro Bay, Golden Gate Park, and Lake Merritt.

In the 1921 second international printmakers' show at the Los Angeles Museum, he showed three pieces entitled *Spring, Summer,* and *Autumn.* The 1922 East West Art Society exhibition catalog reproduced his *Nude,* an oil portrait of a reclining woman wrapped in a Spanish shawl and holding a fan. His illustrations for Natsume Sōseki's book *I Am a Cat* were published that same year by the Japanese American Press in San Francisco.

His fine-art etchings display an elegant line and depict subjects that include bird-on-a-branch imagery. *Los Angeles Times* art critic Arthur Millier wrote of Matsubara's sophisticated and glowing landscape paintings exhibited in the 1929 *Japanese Artists of Los Angeles* exhibition: "Matsubara is probably the artist who would most quickly catch the popular eye, and he would deserve it for he has a keen feeling for dramatic value in nature. . . . In the smaller 'Mountains of San Luis Obispo' he gives us an altogether delightful work attaining fine tonality with earth reds and browns lit by turquoise blues. Several of his small pictures done in the Morro Bay district have delicious atmospheric quality, a matter again of tonality rather than color."

In 1929 the Los Angeles Japanese newspaper *Rafu Shimpo* referred to Matsubara as "one of the best known artists in the

Southland." Matsubara is listed as residing on Grant Avenue in San Francisco in 1932. He may have returned to Europe or Hawaii after this date, since despite his high profile, his name suddenly vanishes from the historical record.

May's Photo Studio

Yai S. Lee (Leo Chan Lee, Leo Y. Lee)

BORN: June 26, 1893, China

DIED: August 6, 1976, San Francisco, CA

Isabelle May Lee

BORN: February 12, 1889, San Francisco, CA

DIED: December 15, 1968, San Francisco, CA

RESIDENCES: YAI S. LEE: 1893–ca. 1911, China §
ca. 1911–1976, San Francisco, CA

ISABELLE MAY LEE: 1889–1968, San Francisco, CA

MEDIA: photography

SELECTED GROUP EXHIBITIONS: *The Pear Garden in the West*,
Concourse Gallery, Bank of America, San Francisco, 1983
(touring exhibition, with venues including Wing Luke

Museum, Seattle; and Asian American Art Center, New York) § *With New Eyes: Toward an Asian American Art History in the West*, Art Department Gallery, San Francisco State University, 1995

SELECTED COLLECTIONS: Bancroft Library, University of California, Berkeley § California Historical Society, San Francisco § Performing Arts Library and Museum, San Francisco

SELECTED BIBLIOGRAPHY: Chen, Jack. *The Pear Garden in the West: America's Chinese Theatre, 1852–1982.* San Francisco: Strawberry Hill Press, 1983. § Dicker, Laverne Mau. *The Chinese in San Francisco: A Pictorial History.* New York: Dover, 1979. § Lee, Stanford. CAAABS project interview. October 1995. § State of California, *California Death Index, 1940–1997.* Sacramento, CA: State of California Department of Health Services, Center for Health Statistics.

THE PICTURES CREATED by May's Photo Studio were nearly lost after the deaths of the creative husband-and-wife team that founded and ran this community business. Today, these images serve as important photographic documents of Bay Area Chinese American social life from the 1920s to 1950s.

Yai S. Lee (known as Leo Chan Lee) immigrated to San Francisco after the 1911 Chinese revolution and met and mar-

Self-portrait of Leo and Isabelle Lee with their son, Stanford, ca. 1935

ried San Franciscan Isabelle May, the daughter of a prominent Chinese family involved in producing Chinese opera locally. Isabelle May worked for charitable causes, including the Red Cross, the Needlework Guild, and the first Chinese women's club, and acted on stage to raise funds for flood victims in China, possibly then establishing personal relationships with members of the theatrical community who would later appear in many studio photographs. The Lees initially worked with W. W. Swadley, one of the city's most successful photographers of the period, and then opened their own May's Photo Studio on Waverly Place in Chinatown in 1923. Early portraits, often intended to be mailed to relatives in China, featured men in Western suits and women dressed in Chinese traditional clothes; others depicted men in Chinese dress and women in highly fashionable Western clothes. Subjects were often photographed against large-scale canvas backdrops that were painted by Chinese opera set designer Mok Huk Ming. Backdrop images included idyllic river views, Chinese locations (sometimes rendered in Western one-point perspective), and various interior scenes. During this period May's Photo Studio was reportedly the only shop in Chinatown equipped with large-format and panoramic cameras.

In addition to creating portraits of San Francisco Chinese community members, the Lees created hundreds of photographs during the 1920s and 1930s of Cantonese opera companies that regularly traveled from China to perform in San Francisco. Examples of this work include candid photos of Mei Lanfang from 1930, images of singers that were used on handbills, and exquisite large-format portraits, often hand-colored and embellished with glitter, created for theater marquees. The couple also took countless pictures of Chinatown social events, such as weddings, graduations, New Year's parades, association banquets, picnics, and store openings. Photographs document the activities of the San Francisco Chinese community during the Sino-Japanese War, including Guomindang rallies; others show several mayors and various political figures during their visits to Chinatown. While the Lees photographed important cultural and political activities, they also created warm, often humorous portraits of their own family. By 1931 the studio had moved to larger quarters at 770 Sacramento Street and was open seven days a week, including holidays.

After World War II, May's Photo Studio encountered increasing competition from new Chinatown photographers, and Leo Chan Lee complained to his son that he felt harassed by immigration officials, who sometimes requested his negatives. The studio is listed in San Francisco city directories through the 1950s and 1960s. But in 1969, a year after Isabelle May Lee's death, it is listed as selling picture frames, not as a photography studio, and continued to be listed in this manner until Leo's death in 1976.

In 1978, the archive of glass negatives and original prints from May's Photo Studio was discarded in a dumpster. A local collector retrieved approximately eight hundred images, and later at a flea market, studio equipment, three hundred additional photographs, and several of the painted backdrops were also saved. Selections from this recovered archive have appeared in several exhibitions.

Miyagi, Yotoku

BORN: February 10, 1903, Kunigami, Okinawa, Japan

DIED: August 2, 1943, Tokyo, Japan

RESIDENCES: 1903–1919, Kunigami, Okinawa, Japan § 1919–1920, Baldwin Park and Brawley, CA § 1920–ca. 1923, San Francisco, CA § ca. 1923– ca. 1925, San Diego, CA § ca. 1925–ca. 1926, Brawley, CA § ca. 1926–ca. 1930, Los Angeles, CA § ca.1930–1933, West Los Angeles, CA § 1933–1943, Tokyo, Japan

MEDIA: oil painting

ART EDUCATION: 1920–1921, 1923, California School of Fine Arts, San Francisco § 1923–1925, San Diego Public Art School

SELECTED SOLO EXHIBITION: Olympic Hotel, Los Angeles, 1932

SELECTED GROUP EXHIBITIONS: *Sangenshoku Ga Kai and Shaku-do-sha Association Joint Exhibition*, Kinmon Gakuen, San Francisco, and Central Art Gallery, Los Angeles, 1927 § Olympic Hotel, Los Angeles, 1928 § *Japanese Artists of Los Angeles* (First and Second Annual Exhibitions), Little Tokyo, 1929, 1930 § *Artists' Fiesta*, Los Angeles, 1931

SELECTED BIBLIOGRAPHY: Johnson, Chalmers. *An Instance of Treason: Ozaki Hotsumi and the Sorge Spy Ring*. Stanford, CA: Stanford University Press, 1964. § Millier, Arthur. "City's Japanese Show Art: Exhibit Here Revealed Several Fine Talents and Wide Interest in Local Colony." *Los Angeles Times*, December 29, 1929, part 3, 9. § Nomoto,

Yotoku Miyagi

Ippei. *Miyagi Yotoku: imin seinen gaka no hikari to kage* [Yotoku Miyagi: Light and Shade of an Immigrant Artist]. Naha, Japan: Okinawa Taimususha, 1997. § Willoughby, Charles. *Shanghai Conspiracy: The Sorge Spy Ring*. New York: E. P. Dutton and Co., 1952.

AS A PAINTER in Los Angeles, Yotoku Miyagi received praise for his work and might have had a career as a successful artist. However, his involvement with radical politics, which ultimately led to his imprisonment and death in Tokyo's Sugamo Prison, cut short this promising future.

Born on the island of Okinawa, Miyagi lived with his grandparents as a child, while his parents farmed to support the family. His father traveled first to the Philippines and later to Hawaii and California for work; his mother worked in Japan. At the age of twelve, influenced by a teacher, Miyagi became interested in art and began carrying a sketchbook whenever he went out. Miyagi also was affected by the ideas of his grandfather, who believed that "one should not oppress the weak"; these views were to help inform his later political philosophy. Miyagi contracted tuberculosis but still traveled to the United States in 1919, passing through Seattle. He first stayed with his father in Baldwin Park, east of Los Angeles, and then joined his older brother and father, who had moved to the town of Brawley, near the Mexican border. Miyagi studied English in the local high school, and his health benefited from the warm climate.

Miyagi attended the California School of Fine Arts and studied under Spencer Macky intermittently in 1920 and 1921. He was enrolled again at the school in 1923, possibly after working in Alaska. Following his time in San Francisco, he returned to the San Diego area, where he continued his studies. He married in 1925 and by 1926 was living in Los Angeles's Little Tokyo neighborhood, where he ran the Owl Restaurant with three friends. Miyagi's work was included in several exhibitions, including a 1929 show that was reviewed by *Los Angeles Times* critic Arthur Millier. Millier wrote:

> He provides, in my opinion, the "clou" of the show. He cannot be classified in any school—as can so many of the Japanese painters of today, with the heavy impress of the great Cezanne on their canvases. Perhaps his finest work is a landscape showing the red and gray buildings of an Alaskan fish cannery in a landscape of luminous grays under a northern twilight.... It is unusually personal in its quality and would be a gem of art in any company.... Here is an artist for whom we confidently predict an important future.

Running parallel with his interest in art was Miyagi's interest in politics, which was provoked by the racism and contradictions he saw in American capitalism. He participated in political reading groups and officially joined the American Communist Party in 1931. In 1933 he was persuaded to travel to Japan, joining what would be known as the Sorge spy ring, a Soviet-sponsored espionage group. He lived in Tokyo for eight years, but his contributions to the spy ring are somewhat unclear. He was arrested in 1941 and died in prison in 1943 of complications from tuberculosis and torture. Following his death, community members prohibited his mother from burying his ashes in his hometown in Okinawa, and after her death his remains were sent to his brother, then living in Mexicali, Mexico. Finally, in 1965, Miyagi's ashes were retrieved from Mexico and buried in the Tama Cemetery in Tokyo alongside fellow Sorge spy ring members.

Miyasaki, George

BORN: March 24, 1935, Kalopa, HI

RESIDENCES: 1935–1953, Kalopa, HI § 1953–1959, Oakland, CA § 1959–present, Berkeley, CA

MEDIA: oil, watercolor and ink painting, and printmaking

ART EDUCATION: 1953–1958, California College of Arts and Crafts, Oakland, CA

SELECTED SOLO EXHIBITIONS: Achenbach Foundation for Graphic Arts, California Palace of the Legion of Honor, San Francisco, 1963 § San Francisco Museum of Art, 1967 § Honolulu Academy of Arts, 1980 § Portland Art Museum, Portland, OR, 1983 § Mary Ryan Gallery, New York, 1993

SELECTED GROUP EXHIBITIONS: San Francisco Museum of Art, 1955–1964, 1970, 1971, 1974, 1983–1985 § *One Hundred Prints of the Year*, The Society of American Graphic Artists, New York, 1963 § *Paper Art*, Crocker Art Museum, Sacramento, CA, 1981 § *CCAC: Past, Present, Future*, Oliver Art Gallery, California College of Arts and Crafts, Oakland, CA, 1996

SELECTED COLLECTIONS: British Museum, London § Fine Arts Museums of San Francisco § Metropolitan Museum of Art, New York § Museum of Modern Art, New York § National Gallery, Washington, D.C. § San Francisco Museum of Modern Art

SELECTED BIBLIOGRAPHY: Adams, Clinton, and June Wayne. *Tamarind: 25 Years, 1960–1985*. Albuquerque: University of New Mexico, 1985. § Albright, Thomas. *Art in the San Francisco Bay Area, 1945–1980*. Berkeley: University of California Press, 1992. § *George Miyasaki: The Early Prints*. Text by David Acton. San Francisco: Stephen Wirtz Gallery, 1992. § Graham, Lanier. *The Spontaneous Gesture*. Canberra: Australian National Gallery, 1987. § Landauer, Susan. *The San Francisco School of Abstract Expressionism*. Berkeley: University of California Press, 1996. § Miyasaki, George. CAAABS project interview. April 9, 1998. Berkeley, CA. Transcript, Asian American Art Project, Stanford University.

What I am searching for in the process of doing each picture is another set of options; a particular unknown, that unique something to appear and require a definition in color, form, relationship.

GEORGE MIYASAKI
CAAABS project interview

GEORGE MIYASAKI MOVED to Oakland, California, from his family home on the island of Hawaii after graduating from high school. He had been encouraged to attend the California College of Arts and Crafts by a high school teacher who had graduated from the school. Miyasaki initially studied advertising design, but he changed his focus to fine arts after being introduced to lithography in a course taught by Leon Goldin. Miyasaki also studied lithography with Nathan Oliveira, whom he considered his most influential mentor, and studied painting with Richard Diebenkorn. Miyasaki received a B.F.A. in 1957, and a John Hay Whitney Opportunity Fellowship enabled him to pursue an M.F.A. from the school, which he received in 1958. During this time, his work was frequently exhibited and recognized: he was awarded the William Gerstle Purchase Prize for Painting by the San Francisco Museum of Art in 1956, and the Purchase Prize for the National Print Exhibition at the Brooklyn Museum in 1958.

Miyasaki began teaching at the California College of Arts and Crafts immediately after receiving his graduate degree. While he continued to create paintings, he became increasingly associated with printmaking in Northern California. His early abstract lithographs demonstrate a range of forms, including aggressive marks related to action painting and block-like shapes. Along with Oliveira, he was instrumental in Willem de Kooning's introduction to lithography when they pulled two small editions for de Kooning in Berkeley in 1960. In 1961, Miyasaki worked at the Tamarind Lithography Workshop, where he was considered as skilled as the workshop's master printers.

After teaching briefly at Stanford in 1963, and a Paris sojourn in 1964 enabled by a John Simon Guggenheim Fellowship, Miyasaki began a long teaching career at the University of California, Berkeley. Solo exhibitions of his work have been mounted at several major museums, including the San Francisco Museum of Art, the Honolulu Academy of Arts, and the Portland Art Museum. His works have also been included in many national and international surveys of contemporary printmaking. By the 1970s, Miyasaki had developed an innovative format of large-scale works using handmade, delicately colored paper arranged in monumental collages that recalled the formalist abstractions of Hans Hofmann. These were shown widely in gallery and museum exhibitions. The artist received National Endowment for the Arts fellowships in both 1980–1981 and 1985–1986. Miyasaki retired from teaching in 1994, by which time he had achieved a reputation as one of California's leading artists associated with art utilizing handmade paper.

Miyatake, Toyo

BORN: October 28, 1895, Takashino, Kagawa Prefecture, Japan

DIED: February 22, 1979, Los Angeles, CA

RESIDENCES: 1895–1909, Takashino, Kagawa Prefecture, Japan § 1909–1911, Los Angeles and Fresno, CA §

George Miyasaki at
California College of Arts
and Crafts studio, 1958

Self-portrait by Toyo Miyatake, ca. 1933

1911–1932, Los Angeles, CA § 1932–1933, Japan § 1934–1942, Los Angeles, CA § 1942–1945, Manzanar Relocation Center, Manzanar, CA § 1945–1979, Los Angeles, CA

MEDIA: photography, oil painting, and drawing

SELECTED SOLO EXHIBITIONS: California Art Club, Los Angeles, 1929 § *Dance Photographs and Sketches*, San Francisco Museum of Art, 1938 § *Two Views of Manzanar* (with Ansel Adams), Wight Art Gallery, University of California, Los Angeles, 1978 § *Toyo Miyatake: View from*

Glass Eye, Japanese American Cultural and Community Center, Los Angeles, 2005

SELECTED GROUP EXHIBITIONS: *London International Photography Exhibition*, 1926 § *14th Annual Japanese Camera Pictorialists of California*, Los Angeles, 1940 § *Japanese Photography in America: 1920–1940*, George J. Doizaki Gallery, Los Angeles, 1986 § *The View from Within*, Wight Art Gallery, University of California, Los Angeles, 1992 § *Made in California: Art, Image, and Identity, 1900–2000*, Los Angeles County Museum of Art, 2000

SELECTED COLLECTION: Japanese American National Museum, Los Angeles

SELECTED BIBLIOGRAPHY: Miyatake, Atsufumi, Taisuke Fujishima, and Eikoh Hosoe, eds. *Toyo Miyatake Behind the Camera 1923–1979.* Special English edition of *Miyatake Toyo no shashin.* Translated by Paul Petite. Tokyo: Bungeishunjū Co. Ltd., 1984. § Miyatake, Toyo, with Enid H. Douglas. *A Life in Photography: The Recollections of Toyo Miyatake.* Claremont, CA: Oral History Program, Claremont Graduate School, 1978. § Reed, Dennis. *Japanese Photography in America: 1920–1940.* Los Angeles: Japanese American Cultural and Community Center, 1985. § *Toyo Miyatake: Infinite Shades of Gray.* Directed by Robert A. Nakamura. Film. 2001.

This opportunity will never come again. It mustn't come again. But as a photographer, I cannot allow it to pass.

TOYO MIYATAKE (commenting on
photographing during internment)
Miyatake, Fujishima, and Hosoe, eds.,
Toyo Miyatake Behind the Camera

DURING A CAREER that spanned six decades, Toyo Miyatake was revered as a modernist, documentary, and community photographer. While still in high school, he followed his father to Los Angeles from Japan after first arriving in Seattle. Rather than enter his father's candy-store business, Miyatake decided instead to follow his dream of becoming an artist by pursuing photography. After studying in a night class held in a nearby hotel taught by Harry Shigeta, Miyatake began to make portrait photographs, first developing film in his own bathroom. He opened Toyo Studio in 1923 (later to be known as Toyo Miyatake Studio) and frequently created portraits for free. A rare opportunity to create a series of unusual portraits of the acclaimed modernist dancer Michio Ito, who performed at the Hollywood Bowl during the mid-1920s, expanded his clientele and reputation, and expanded as well Miyatake's experimental approach to lighting. Miyatake also documented the 1932 Los Angeles Olympics for Japanese media and created portraits of a number of Japanese and Japanese American celebrities, including **Sessue Hayakawa**. Miyatake credits Edward Weston, who exhibited in Little Tokyo at the invitation of the Shaku-do-sha association during the 1920s, as a formative mentor. Weston encouraged Miyatake to closely study *ukiyo-e* woodblock prints to glean the geometry at the foundation of their composition. Miyatake's pictorialist photography, which was exhibited widely, remained among California's most abstract for decades.

Miyatake's internment experience was unique. He reported being given a choice of camps for relocation and chose Manzanar. Miyatake smuggled in a camera lens, because cameras were contraband, and immediately constructed makeshift equipment using scrap wood. Soon he was able to bring and use his personal equipment, however, and established a full darkroom and studio, after outside advocates including Ansel Adams and Weston helped convince camp director Ralph Merrit to let him do so.

After his release from camp, Miyatake returned to his Little Tokyo home and studio, which had been rented out during his internment. His portrait studio, for which his son Archie took increasing responsibility, flourished and became the principal family photography studio in the Southern California Japanese American community. Late in life, Toyo Miyatake received several awards, including a Los Angeles City Council Resolution in 1974, and was named Japanese Artist of the Year by the Little Tokyo Bijutsu-no Tomo Association in 1978. Other family members later achieved important positions in the Los Angeles photography community.

Miyazaki, Shiro

BORN: May 24, 1910, Nara, Japan

DIED: October 7, 1940, San Francisco, CA

RESIDENCES: 1910–1929, Nara, Japan § 1929–ca. 1932,

Self-portrait by Shiro Miyazaki

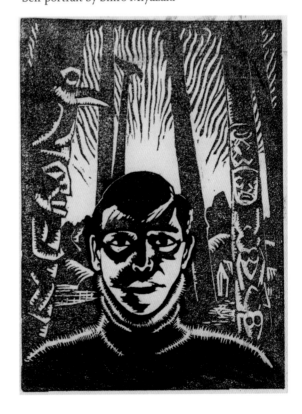

Seattle, WA § ca. 1932–1933, San Francisco, CA § 1933–1940, Sacramento Valley, San Francisco, and Los Angeles, CA § 1940, San Francisco, CA

MEDIA: oil and watercolor painting, woodblock prints, and linoleum prints

ART EDUCATION: 1932–1933, California School of Fine Arts, San Francisco

SELECTED SOLO EXHIBITION: Seattle Art Museum, 1939

SELECTED GROUP EXHIBITIONS: *National Scholastic Exhibition*, 1931 § *San Francisco Art Association*, California Palace of the Legion of Honor, San Francisco, 1932 § *Annual Exhibition of Northwest Artists*, Seattle Art Museum, 1932, 1936–1938 § *Northwest Printmakers Annual*, Seattle Art Museum, 1939, 1940

SELECTED COLLECTION: Seattle Art Museum

SELECTED BIBLIOGRAPHY: 1930 Federal Population Census. Seattle, King, Washington. Roll 2501, Page 10A, Enumeration District 178. National Archives, Washington, D.C. § Mirikitani, Janice. *Ayumi: Japanese American Anthology*. San Francisco: The Japanese American Anthology Committee, 1980. § Tsutakawa, George. Interviewed by Martha Kingsbury. September 8, 12, 14, 19, 1983. Seattle, WA. Transcript, Archives of American Art, Smithsonian Institution. § Tsutakawa, Mayumi, and Alan Chong, eds. *Turning Shadows into Light: Art and Culture of the Northwest's Early Asian/Pacific Community*. Seattle: Young Pine Press, 1982, 72, 75.

SHIRO MIYAZAKI'S FATHER left Japan when Miyazaki was six years old to work as the foreign correspondent for a major Japanese newspaper in Seattle. Miyazaki's mother joined his father when Miyazaki was eleven. Eight years later, Miyazaki was reunited with his family in Seattle, where two younger siblings had been born; the 1930 census shows the family living together on Twenty-fourth Avenue South.

Miyazaki attended Garfield High School and became close friends with artist George Tsutakawa shortly after arriving in Seattle. Tsutakawa recounted that Miyazaki was already interested in painting before coming to the United States. Miyazaki studied French postimpressionism and was a great admirer of van Gogh, Gauguin, Bonnard, pointillist painters, and American Ashcan school artists. Tsutakawa, Miyazaki, and other artists such as Kenjiro Nomura and Kamekichi Tokita would often go on painting outings on Sundays to the Duwamish River and Tukwila areas.

According to Tsutakawa, Miyazaki was also influenced by Orozco, Siqueiros, and other Mexican painters with revolutionary aims, and he himself made political prints and posters. As a committed Communist, Miyazaki held beliefs that were in strong opposition to those of his father. Eventually Miyazaki moved to California, where he briefly attended the

California School of Fine Arts and was active in the farming communities of the Sacramento Valley, often making propaganda materials. In addition to painting, Miyazaki reportedly wrote novels about Japanese immigrants and farmers (they were never published).

Miyazaki exhibited in Seattle and the San Francisco Bay Area in the 1930s, often showing still lifes, and won several awards. Although he took a few art courses, Miyazaki was largely self-taught, and his work is representational.

Miyazaki died at the age of thirty of tuberculosis and other ailments. Tsutakawa, who frequently sent money to Miyazaki, said the artist died impoverished and disowned by his family, and described him as a talented artist who was misunderstood by both the Japanese community and the art community of the Pacific Northwest.

Morimoto, Charles Isamu

BORN: 1903, Southern Honshu, Japan

DIED: November 8, 1953, Hiroshima, Japan

RESIDENCES: 1903–1916, Southern Honshu, Japan § 1916–1942, Long Beach and Los Angeles, CA § 1942–ca. 1945, Manzanar Relocation Center, Manzanar, CA; Tule Lake Relocation Center, Newell, CA § 1946–1953, Kure and Hiroshima, Japan

MEDIA: watercolor and oil painting

ART EDUCATION: 1926–1930, Otis Art Institute of the Los Angeles Museum of History, Science and Art

SELECTED GROUP EXHIBITIONS: *Young Painters of Los Angeles*, Los Angeles Museum, 1929 § *Young Painters of Los Angeles*, Santa Monica Public Library, 1930 § *Exhibition of California Oriental Painters*, Foundation of Western Art, Los Angeles, 1937

SELECTED BIBLIOGRAPHY: "Art Center Reopens." *Manzanar Free Press*, April 10, 1943, 4. § Carr, Harry. "The Lancer." *Los Angeles Times*, June 29, 1930, A1. § "Clicking off the Day's News With the Cameraman's Shutter." *Los Angeles Times*, August 17, 1927, A12. § Jarrett, Mary. *The Otis Story of Otis Art Institute Since 1918*. Los Angeles: Alumni Association of Otis Art Institute, 1975. § Millier, Arthur. "Our Young Painters." *Los Angeles Times*, December 15, 1929, 24. § "Models Wanted." *Manzanar Free Press*, July 7, 1942, 4. § 1930 Federal Population Census. Los Angeles, Los Angeles, California. Roll 141, Page 12B, Enumeration District 200, Image 24.0. National Archives, Washington, D.C. § "Young Painters at the Beach." *Los Angeles Times*, May 11, 1930, B13.

THE SON OF A Japanese gardener, Charles Morimoto came to the United States at the age of thirteen, and ten years later he

began attending the Otis Art Institute, where he majored in fine arts and decorative arts. He was a frequent award winner during his time at the school, and a photograph of him receiving a prize for a poster design from the National Conference of Catholic Charities appeared in the *Los Angeles Times* in 1927. In 1928, Otis students published *El Dorado, Land of Gold*, which featured illustrations by Morimoto, **Hideo Date**, Kiyoshi Ito, and Ryuichi Dohi, with a cover designed by **Benji Okubo**. Morimoto won the Huntington Assistance Prize at Otis in 1929.

Morimoto exhibited with the Young Painters of Los Angeles, a group whose members included Millard Sheets and Paul Sample. In a review of the 1929 show, Arthur Millier wrote that Morimoto "goes the furthest toward abstraction with his three designs evolved from figures." Morimoto also exhibited in the 1937 *California Oriental Painters* show with such artists as Hideo Date, **Jade Fon Woo**, **Tyrus Wong**, and **Miki Hayakawa**.

Morimoto married in approximately 1931 and had two children. The family was interned at the Manzanar Relocation Center and relocated to the Tule Lake Relocation Center in February 1944. While at Manzanar, Morimoto taught portrait and life painting classes at the Art Center with other artists, in-

Charles Morimoto with classmates, ca. 1928

cluding Takeo Itokawa, Masasuke Kumano, and Yasuko Hori; he continued to teach and paint at Tule Lake. Morimoto returned to Japan in January 1946 and worked for the occupation forces in Kure, near Hiroshima, as an interpreter, remaining in this position for approximately five years. During this time he also taught art to U.S. military officers' wives and children. When the Cultural Center opened in the city of Hiroshima, he went to work there as a commercial artist. Morimoto continued to create abstract paintings and at the time of his death in 1953 was preparing work to be exhibited in Hiroshima.

Nakanishi, Kinichi

BORN: March 2, 1892, Tokyo, Japan

DIED: September 23, 1964, Los Angeles, CA

RESIDENCES: 1892–1914, Tokyo, Japan § 1914–1942 Los Angeles, CA § 1942–ca. 1945, Santa Anita Assembly Center, Santa Anita, CA; Jerome Relocation Center, Denson, AR § ca. 1945–1964, Los Angeles, CA

MEDIA: oil painting

SELECTED GROUP EXHIBITIONS: California Art Club, Los Angeles Museum, 1920, 1921, 1924 § San Diego Gallery of Fine Arts, 1920 § *Painters and Sculptors of Southern California*, Los Angeles Museum, 1921 § *East West Art Society*, San Francisco Museum of Art, 1922 § Group of Independents, Los Angeles, 1923

SELECTED BIBLIOGRAPHY: Hughes, Edan Milton. *Artists in California, 1786–1940*. San Francisco: Hughes Publishing Company, 1989. § Japanese-American Internee Data File, 1942–1946. File number 951026. Records of the War Relocation Authority. National Archives, Washington, D.C. § "Night School Art Show Set." *Denson Tribune*, August 13, 1943, 4. § 1930 Federal Population Census. Los Angeles, Los Angeles, California. Roll 164, Page 16A, Enumeration District 734, Image 264.0. National Archives, Washington, D.C.

KINICHI NAKANISHI arrived in Los Angeles by way of San Francisco in 1914. Reportedly, he had graduated from horticultural college in Japan, and once in Los Angeles he studied painting with Dana Bartlett and Henry W. Cannon.

Nakanishi exhibited widely in the 1920s. He showed *Five P.M.* and *Poetry of the Trees* first at the California Art Club exhibition at the Los Angeles Museum in 1920 and again at the San Diego Gallery of Fine Arts the same year. His *Bathers* was reproduced in the 1922 *East West Art Society* exhibition catalog. Nakanishi created landscapes and portraits in a California impressionist style, with loose, gestural brushwork.

The 1930 census shows Nakanishi as unmarried and living on San Pedro Street. His occupation is listed as a salesman

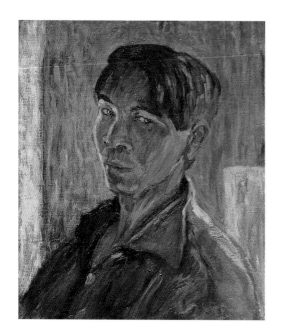

Self-portrait by Kinichi Nakanishi

in an art store, and a fellow lodger at the same address, Terasu Tanaka, is described as a photographer at an art store, so most likely they worked together. Despite his successes in the 1920s, Nakanishi did not continue to exhibit his work in the 1930s. By the time of World War II, Nakanishi was married, and during his internment at the Jerome Relocation Center, he taught at the camp's art school. In camp records he is listed as a skilled photographic processor.

It appears that after internment Nakanishi and his wife, Chiyo, returned to Los Angeles and changed their last name to Machikawa.

Nakano, Emiko

BORN: July 4, 1925, Sacramento, CA

DIED: March 7, 1990, Richmond, CA

RESIDENCES: 1925–1942, Sacramento and Chico, CA §
1942–ca. 1945, Merced Assembly Center, Merced, CA;
Granada Relocation Center, Amache, CO § ca. 1945–ca.
1947, Richmond, CA § ca. 1947–ca. 1951, San Francisco,
CA § ca. 1951–1990, Richmond, CA

MEDIA: oil and watercolor painting, printmaking, and drawing

ART EDUCATION: 1947–1951, California School of Fine
Arts, San Francisco § 1949, University of California,
Berkeley (summer) § 1952, Mills College, Oakland,
CA (summer)

SELECTED SOLO EXHIBITION: Richmond Art Center,
Richmond, CA, 1955 (two-person exhibition with Clayton Pinkerton)

SELECTED GROUP EXHIBITIONS: *San Francisco Art Association*,
San Francisco Museum of Art, 1951–1959, 1966 § *Annual
Oil and Sculpture, Annual Watercolor and Prints*, Richmond
Art Center, Richmond, CA, 1951–1956 § *American Drawing, Watercolors, and Prints*, Metropolitan Museum of Art,
New York, 1952 § São Paulo Biennial Exhibition, Brazil,
1955 § *30th Anniversary Exhibition*, Richmond Art Center,
Richmond, CA, 1966 § *San Francisco and the Second
Wave: The Blair Collection of Bay Area Abstract Expressionism*, Crocker Art Museum, Sacramento, CA, 2004

SELECTED BIBLIOGRAPHY: Japanese-American Internee
Data File, 1942–1946. File number 801745. Records of
the War Relocation Authority. National Archives, Washington, D.C. § Nakano, Emiko. Biographical Folder. Oakland
Museum of California. § 1930 Federal Population Census.
Chico, Butte, California. Roll 112, Page 2A, Enumeration
District 3, Image 822.0. National Archives, Washington,
D.C. § Shields, Scott A. *San Francisco and the Second
Wave: The Blair Collection of Bay Area Abstract Expressionism*.
Sacramento: Crocker Art Museum, 2004. § Wechsler,
Jeffrey, ed. *Asian Traditions/Modern Expressions: Asian
American Artists and Abstraction, 1945–1970*. New York:
Abrams in association with the Jane Voorhees Zimmerli Art Museum, Rutgers, the State University of
New Jersey, 1997.

EMIKO NAKANO WAS a successful painter and printmaker who exhibited widely in the San Francisco Bay Area in the 1950s. Nakano was born in Sacramento and grew up in Chico, California. The 1930 census lists her father's occupation as a retail merchant at a vegetable store. Nakano was a high school student when the United States entered World War II; with her family, she was interned first at the Merced Assembly Center and later at the Granada Relocation Center. At this time she was already interested in art, as internment records list a "potential occupation" as "artist, sculptor or teacher of art."

Following her release from internment, Nakano moved to Richmond with family members. She enrolled at the California School of Fine Arts in the fall of 1947 and attended classes through the summer of 1951. While there, she studied under Clyfford Still, James Budd Dixon, Edward Corbett, Richard Diebenkorn, Hassel Smith, and Elmer Bischoff.

Nakano participated in San Francisco Art Association oil painting, drawing/print, and watercolor annual exhibitions from 1951 to 1959. Her works from the early 1950s are often landscapes, with abstracted geometric compositions. By the mid-1950s Nakano moved to more complex geometric abstraction, and her pieces ranged from bright yellow and green oils on canvas to black *sumi-e* ink on paper. She won prizes in the San Francisco Women Artists shows held at the San Francisco Museum of Art in 1953 and 1956, as well as in the

Kenjilo Nanao, 1961

San Francisco Art Association annuals in 1953, 1954, and 1957. Throughout the 1950s Nakano worked as a freelance fashion illustrator in San Francisco. She stopped painting in the early 1960s.

Nanao, Kenjilo

BORN: July 26, 1929, Aomori, Japan

RESIDENCES: 1929–1955, Aomori and Tokyo, Japan § 1955–1960, Tokyo, Japan § 1960–1963, San Francisco, CA § 1963–1964, New York, NY § 1964–1965, Tokyo, Japan § 1965–1967, San Francisco, CA § 1967–1972, Marin County, CA § 1972–present, Berkeley, CA

MEDIA: printmaking and painting

ART EDUCATION: 1948–1951, Asagaya Art Academy, Tokyo § 1960–1963, 1968–1969, San Francisco Art Institute § 1963–1964, Brooklyn Museum Art School

SELECTED SOLO EXHIBITIONS: Brooklyn Museum Art School, 1964 § Santa Barbara Museum of Art, Santa Barbara, CA, 1972 § San Francisco Museum of Modern Art Rental Gallery, 1998 § *Kenjilo Nanao*, Aomori Prefectural Museum, Aomori, Japan, 2004

SELECTED GROUP EXHIBITIONS: The Printer's Art, San Francisco Museum of Art, 1967 § Northwest Printmakers' 39th International Exhibition, Seattle Art Museum, 1968 § California Printmakers, California Palace of the Legion of Honor, San Francisco, 1971 § *Eight West Coast Printmakers*, Brooklyn Museum, Brooklyn, NY, 1978 § *Beyond Words*, San Jose Institute of Contemporary Art, San Jose, CA, 1981 § American Academy of Arts and Letters Invitational Exhibition, New York, NY, 2003

SELECTED COLLECTIONS: Brooklyn Museum § Fine Arts Museums of San Francisco § Los Angeles County Museum of Art § Museum of Modern Art, New York § Oakland Museum of California

SELECTED BIBLIOGRAPHY: Baro, Gene. *30 Years of American Printmaking*. Brooklyn: Brooklyn Museum, 1976. § *Kenjilo Nanao*. Aomori, Japan: Aomori Prefectural Museum, 2004. § Nanao, Kenjilo. *Kenjilo Nanao*. Santa Barbara, CA: Santa Barbara Museum of Art, 1972. § Nanao, Kenjilo. CAAABS project interview. January 29, 2006. Berkeley, CA. § Secrist, Sally W., and N. Ann Howard. *4th International Exhibition of Botanical Art and Illustration*. Pittsburgh: The Hunt Institute for Botanical Documentation, Carnegie Mellon University, 1977.

Even though I had been dealing with a figurative subject (in the prints), my concern was with an abstract message.

KENJILO NANAO
Art Now West Coast Gallery Guide 10 (October 1999)

AN ARTIST SINCE his youth, Kenjilo Nanao came to San Francisco at the age of thirty-one to attend the San Francisco Art Institute. While there, he studied with James Weeks, Elmer Bischoff, and William Brown, but Nathan Oliveira proved to be his biggest influence. Nanao, a painter, began to explore printmaking under the guidance of Oliveira, who encouraged exploration and experimentation within the medium. As a result, Nanao for the next twenty-five years worked primarily in printmaking, establishing a reputation for his skilled lithographic works.

In 1963 Nanao went to New York, attending the Brooklyn Museum Art School. At the time, many students from Japan were studying at the school, and he often served as an impromptu translator in class. While in New York, he used the printmaking workshop at the Pratt Institute and gained an appreciation for the freedom he had experienced at the San Francisco Art Institute, as instruction in New York was more rigid and technically inclined. After returning briefly to Tokyo,

Nanao and his wife, Gail Chadell, returned to the Bay Area in 1965. Nanao received a Ford Foundation grant for study at the Tamarind Lithography Workshop in 1968 and received an M.F.A. from the San Francisco Art Institute in 1969. In 1970, he began twenty-one years of teaching at California State University, Hayward, developing an impressive printmaking program there while continuing to make and exhibit his own work. Nanao received a National Endowment for the Arts Individual Fellowship in 1980.

Nanao's lithographs are characterized by delicate gradations of color and are often surreal or erotic, which leads to comparisons with Japanese *shunga* prints. In the mid-1980s, Nanao shifted his focus from printmaking to oil painting, both to relieve himself of the taxing physical nature of lithography and to make a mental shift in his work. He also moved from figuration to abstraction, and his abstract paintings with geometric references often employ gold and silver leaf as underpainting beneath vivid hues of blues, yellows, or reds. A career retrospective was held in Nanao's hometown of Aomori, Japan, in 2004.

Ng, Win

BORN: April 13, 1936, San Francisco, CA

DIED: September 6, 1991, San Francisco, CA

RESIDENCE: 1936–1991, San Francisco, CA

MEDIA: sculpture, ceramics, metalwork, and painting

Win Ng, 1961. Photo by Eddie Murphy

ART EDUCATION: ca. 1956–1959, California School of Fine Arts, San Francisco § 1959–1960, Mills College, Oakland, CA

SELECTED SOLO EXHIBITION: *The Art of Win Ng*, Chinese Historical Society of America, San Francisco, 2005

SELECTED GROUP EXHIBITIONS: San Francisco Museum of Art, 1959, 1961, 1963, 1964, 1966 § *8th Annual Exhibition of Ceramic Arts*, Smithsonian Institution, Washington, D.C., 1961 § *California Sculptures*, Oakland Museum of California, 1963 § La Jolla Museum, La Jolla, CA, 1965 § *American Potters Today*, Victoria and Albert Museum, London, 1986 § Pacific Asia Museum, Pasadena, CA, 1989

SELECTED COLLECTIONS: Museum of Arts and Design, New York § Oakland Museum of California

SELECTED BIBLIOGRAPHY: Hicks, Allen R., ed. *The Art of Win Ng*. San Francisco: Chinese Historical Society of America, in association with the Win Ng Trust and Allen R. Hicks, 2005. § Riegger, Hal. "The Pottery of Win Ng." *Ceramics Monthly* 11 (April 1963): 15–17. § Wechsler, Jeffrey, ed. *Asian Traditions/Modern Expressions: Asian American Artists and Abstraction, 1945–1970*. New York: Abrams in association with the Jane Voorhees Zimmerli Art Museum, Rutgers, the State University of New Jersey, 1997.

In looking into the work of antiquity and into history, I feel into it—how those people worked, their social environment and their problems.

WIN NG
Riegger, "The Pottery of Win Ng"

WIN NG WAS ONE of eight children born to Cantonese-speaking immigrants in San Francisco's Chinatown. His first art studio, where he explored painting and stoneware ceramics, was set up in the basement of his parents' home, an indication of his family's support for his art making. An early influence was **Jade Snow Wong**, who employed Ng when he was in high school.

Ng studied briefly at San Francisco City College and San Francisco State College (now University) before serving in the U.S. Army as a construction drafter, which enabled him to visit and exhibit in Europe. During the late 1950s after his discharge, he resumed his studies at the California School of Fine Arts and began to exhibit his work nationally. He interacted with a variety of artists during this period, including Peter Voulkos, who visited Ng's studio. After graduating in 1959, he pursued a graduate degree from Mills College, receiving an M.F.A. in 1960.

Ng often worked in series, repeating a shape or theme many times in order to perfect its expression. His pieces included large-scale, abstract forms as well as vessels and sculpture recalling Chinese lamps, which innovatively incorporated abstract expressionism's dynamic gestures in their rich surface

designs and glazes. These works were pivotal in the development of ceramics as sculpture in this era, leading to international exhibitions for Ng and his critical acclaim as an artist "in the top ranks of contemporary American ceramics."

Ng was also a successful businessman, cofounding the San Francisco retail company Taylor and Ng in 1961. The store began as a small pottery shop where artists could sell their handcrafted wares. One of the first of its kind, Taylor and Ng was an early manifestation of the growing arts and crafts movement revival in Northern California, and sold utilitarian, unique artworks. The store later evolved into an influential gourmet cookware store, paving the way for the development of San Francisco's burgeoning food culture.

During the 1970s, Ng experimented with both abstract and figurative painting. These works were well received and led to public commissions throughout the Bay Area, including an acrylic mural for the Bay Area Rapid Transit District's Orinda station and ceramic murals for the Westside Health Center in San Francisco. After being diagnosed with HIV in 1981, Ng left his business interests and concentrated on creating ceramics that refined forms he had explored earlier in his career.

Nishi, Ken

BORN: June 7, 1916, Salinas, CA

DIED: December 9, 2001, Tappan, NY

RESIDENCES: 1916–1936, Salinas, CA § 1937–1942, Los Angeles, CA § 1942–1946, various locations (U.S. military service) § 1946–1952, Chicago, IL § 1952–2001, Tappan, NY § 1949–2001, Mabou, Cape Breton Island, Nova Scotia (seasonal)

MEDIA: watercolor and oil painting, sculpture, and murals

ART EDUCATION: 1937–1941, Chouinard Art Institute, Los Angeles

SELECTED SOLO EXHIBITIONS: Ozark Arts and Crafts Gallery, Springfield, MO, 1942 § St. Louis Public Library, St. Louis, MO, 1943 § Ruth Dickens Gallery, Chicago, 1950 § Rockland Center for the Arts, West Nyack, NY, 1963, 1970–1978 § *Ken Nishi: Reflections in Time*, Art Gallery of Nova Scotia, Halifax, 1999

SELECTED GROUP EXHIBITIONS: *California Art Today*, Golden Gate International Exposition, San Francisco, 1940 § Stanford University, 1940 § *Fourth Annual Missouri Show*, City Art Museum of St. Louis, 1944 § Merrick Gallery, Merrick, Long Island, 1964 § Edward Hopper House Gallery, Nyack, NY, 1983

SELECTED COLLECTIONS: Art Gallery of Nova Scotia, Halifax, Canada § National Museum of Mexico City § Springfield Museum, Springfield, MO

SELECTED BIBLIOGRAPHY: "Ken Nishi Memorial Exhibition." *Rafu Shimpo* (Los Angeles), May 15, 2004, 5. § *Ken Nishi: Reflections in Time*. Halifax: Art Gallery of Nova Scotia, 1999. § "Library Mural Completed." *Fort Wood News* 3, no. 5 (April 9, 1943): 4.

BORN IN CALIFORNIA, Ken Nishi was a prolific artist who exhibited widely and whose later work was strongly influenced by his adoptive home of Nova Scotia. Nishi grew up in Salinas, where his father was a pioneer in the modernization of farming and his mother was an accomplished *tanka* (an ancient Japanese poetry form) poet. With the encouragement of his family, Nishi began studying art at Salinas Junior College and in 1937 moved to Los Angeles to attend the Chouinard Art Institute, where he studied with Millard Sheets and graduated with honors. His oil painting *Street Scene* was included in the Golden Gate International Exposition's contemporary California painting show held on San Francisco's Treasure Island in 1940.

Nishi served in the U.S. Army during World War II. His family was interned during the war years and as a result lost their farmland in Salinas. While stationed at Fort Leonard Wood in Missouri, Nishi painted murals in recreation facilities; a newspaper photograph shows his forty-foot mural in the library of the Service Club depicting a rural Missouri scene with an African American farmer. During this time Nishi exhibited in shows in St. Louis and Springfield, Missouri. After leaving the army, Nishi continued to exhibit, first in the Chicago area and then in Tappan, New York, where he and his family settled in 1952. There he worked as a printer, sculptor, furniture maker, educator, and art director at the Rockland Center for the Arts.

Starting in 1949, Nishi and his family lived seasonally in Nova Scotia, and his work began to be informed by the natural landscape and people of the area. Nishi's 1999 solo exhibition at the Art Gallery of Nova Scotia featured work in a wide range of media, including watercolor, oil, gouache, wood, and stone. His landscape paintings were described as depicting "not a scary world of tumultuous water and angry skies but rather a place of contemplation, reflection, and involvement." Horizon lines figure prominently, illustrating the meeting of sea and land to sky, and fields of color turn landscapes into glowing atmospheric environments.

Nobuyuki, Kiyoo Harry

BORN: September 21, 1904, Kurume, Fukuoka Prefecture, Japan

DIED: June 9, 1990, Los Angeles, CA

RESIDENCES: 1904–1923, Japan § 1923–ca. 1940, San Francisco, CA (1936–1937, Japan) § ca. 1940–1942, Los Angeles, CA § 1942–ca. 1945, Turlock Assembly

396

Center, Turlock, CA; Gila River Relocation Center, Rivers, AZ § ca. 1945–1990, Los Angeles, CA

MEDIA: oil painting

ART EDUCATION: 1926–1927, California School of Fine Arts, San Francisco

SELECTED GROUP EXHIBITIONS: *Sangenshoku Ga Kai, First Annual Exhibition*, Kinmon Gakuen, San Francisco, 1926 § *Sangenshoku Ga Kai, Second Annual Exhibition*, Kinmon Gakuen, San Francisco, 1927 § *Sangenshoku Ga Kai and Shaku-do-sha Association Joint Exhibition*, Kinmon Gakuen, San Francisco, and Central Art Gallery, Los Angeles, 1927 § *San Francisco Art Association*, California School of Fine Arts, 1928 § *San Francisco Art Association*, California Palace of the Legion of Honor, 1932 § *San Francisco Art Association*, San Francisco Museum of Art, 1935 (inaugural), 1937–1940, 1944

SELECTED BIBLIOGRAPHY: Japanese-American Internee Data File, 1942–1946. File number 311042. Records of the War Relocation Authority. National Archives, Washington, D.C. § 1930 Federal Population Census. San Francisco, San Francisco, California. Roll 206, Page 14B, Enumeration District 320, Image 840.0. National Archives, Washington, D.C. § *Shin Sekai* [New World] (San Francisco), August 9, 21, 23, 1926. Japanese American History Archives, San Francisco.

KIYOO NOBUYUKI STUDIED at the California School of Fine Arts with Spencer Macky and Lee Randolph in the fall of 1926. He exhibited *Suburb Landscape* in the 1926 show of the Sangenshoku Ga Kai (Three Primary Colors Art Group); a reviewer for the Japanese-language newspaper *Shin Sekai* (New World) noted Nobuyuki's skill and accomplishment and described the painting as having broad brushwork and utilizing bright colors. Nobuyuki exhibited landscapes depicting the Sacramento area in the 1927 joint show of work by members of the San Francisco Sangenshoku Ga Kai and the Los Angeles–based Shaku-do-sha group.

Nobuyuki exhibited regularly with the San Francisco Art Association, and in the 1935 inaugural show of the San Francisco Museum of Art he exhibited *Alley, Houses of Russian Hill*, and *Winter*. He traveled back to Japan in 1936, returning to the United States in 1937, and listed "artist" as his profession on the ship's passenger list. He moved to Los Angeles in approximately 1940. Nobuyuki was interned at the Gila River Relocation Center in Arizona with his wife and sons, and while there he continued to paint. A surviving example of his painting from this period recalls more a French countryside than the Arizona desert of his confinement. After internment Nobuyuki returned to Los Angeles, but it appears that he did not exhibit in the years that followed.

Noda, Hideo Benjamin

BORN: July 15, 1908, Santa Clara, CA

DIED: January 12, 1939, Tokyo, Japan

RESIDENCES: 1908–1911, Santa Clara, CA § 1911–1926, Kumamoto, Japan § 1926–1931, Oakland and San Francisco, CA § 1931–1932, New York and Woodstock, NY; San Francisco, CA § 1933, New York, NY § 1934–1935, Tokyo, Japan, and New York, NY § 1936, New York, NY § 1937, San Francisco, CA § 1937–1939, Tokyo, Japan

MEDIA: oil and watercolor painting, and murals

ART EDUCATION: 1929–1931, California School of Fine Arts, San Francisco § ca. 1931–ca. 1932, Art Students League (summer sessions), Woodstock, NY

SELECTED SOLO EXHIBITIONS: Nichidō Gallery, Tokyo, 1938 § Memorial Exhibit, *Shin Seisaku Ha Kyōkai* (4th Annual New Wave Art Association), Tokyo, 1939 § *Hideo Noda*, Kumamoto Prefectural Museum, Japan, 1979 § Kumamoto Prefectural Museum of Art, Japan, 1992 (two-person show with Chuzo Tamotsu)

SELECTED GROUP EXHIBITIONS: Amateur and Professional Art Exhibition, San Francisco, 1929 § San Francisco Japanese Art Association, 1929 § *San Francisco Art Association*, California Palace of the Legion of Honor, 1931, 1932 § *2nd Biennial of Contemporary American Painting*, Whitney Museum of American Art, New York, 1934 § Society of Independent Artists, New York, 1934 § *22nd Annual Nika Kai Art Exhibit*, Tokyo, 1935 § *Posthumous Exhibition of Four Artists*, National Museum of Modern Art, Tokyo, 1962 § *Half Century of Japanese Artists in New York, 1910–1950*, Azuma Gallery, New York, 1977

SELECTED COLLECTIONS: Kumamoto Prefectural Museum of Art, Kumamoto, Japan § National Museum of Modern Art, Tokyo § Noda Memorial Museum, Woodstock, NY § Okawa Museum of Art, Kiryu, Japan

Hideo Noda

SELECTED BIBLIOGRAPHY: *Japanese and Japanese American Painters in the United States: A Half Century of Hope and Suffering, 1896–1945.* Tokyo: Tokyo Metropolitan Teien Art Museum and Nippon Television Network Corporation, 1995. § *Japanese Artists Who Studied in U.S.A. and the American Scene (Amerika ni Mananda Nihon no gakatachi: Kuniyoshi, Shimizu, Ishigaki, Noda).* Tokyo: National Museum of Modern Art, 1982. § *Japanese Artists Who Studied in U.S.A. 1875–1960 (Taiheiyō o koeta Nihon no gakatachi ten).* Wakayama, Japan: Museum of Modern Art, Wakayama, 1987. § *Japan in America: Eitaro Ishigaki and Other Japanese Artists in the Pre–World War II United States.* Wakayama, Japan: Museum of Modern Art, Wakayama, 1997. § "Leftist tint led to exile, shaped social themes." *The Nikkei Weekly,* January 31, 1994, 25.

When we paint, we should not be satisfied with depicting only a part of the phenomenal world. The complex world within a picture, that is to say, the literary content, the formative structure and the poetic sentiment should also be drawn.

HIDEO BENJAMIN NODA
Japanese Artists Who Studied in U.S.A. 1875–1960, 187

BORN IN SANTA CLARA, California, Hideo Noda was taken by his parents at the age of three to live with his uncle in Japan in order to receive a Japanese education. His interest in art began in middle school, when he would sketch during class in the margins of his papers and return home to draw in the evenings. Knowing he wanted to become an artist and realizing he would lose his American citizenship if he stayed in Japan beyond the age of eighteen, Noda convinced his uncle to let him return to California after he finished school. To complete his American education, he attended Piedmont High School, where he began to paint in oils for the first time. Noda served as salutatorian of his graduating class. Following graduation, he enrolled at the California School of Fine Arts in San Francisco, where he studied with Ralph Stackpole and was greatly influenced by visiting instructor Arnold Blanch. While there, he began a lifelong friendship with classmate **Takeo Edward Terada** and was friends with other students, including **Miki Hayakawa** and **Henry Sugimoto**. Diego Rivera's visit to the school was pivotal for Noda, and he learned fresco technique and served as an assistant to Rivera on the mural the artist created at the school.

At the invitation of Arnold Blanch, who had returned to the East Coast, Noda traveled to New York and attended classes at the Art Students League summer sessions in Woodstock, where he shared a house with **Sakari Suzuki** and **Jack Chikamichi Yamasaki**. Despite having little money, Noda was happy in Woodstock and found the artist community supportive and intellectually engaging. His summer-term teachers included John Sloan, George Grosz, and **Yasuo Kuniyoshi**, and

Noda was influenced by the social realism underlying their artwork. During this time Noda also met **Eitaro Ishigaki** and became active in radical politics, joining the John Reed Club. Noda's own social concerns are evident in his gouache painting *Scottsboro Boys* (1933), which depicts events surrounding the 1930s trial of nine African American teens falsely accused of raping two white women in Scottsboro, Alabama.

Noda met Ruth Kates in 1931 and soon married her, and in 1932 he received the Woodstock Art Association award. Later that year he returned to San Francisco and exhibited with the San Francisco Art Association, receiving a prize for his work. He returned to New York in early 1933 and was one of a small group of artists, which included Ben Shahn, that assisted Diego Rivera on the Rockefeller Center mural. The next year Noda's *Street Scene* was included in the Whitney Museum's *2nd Biennial of Contemporary American Painting* and purchased by the museum for its collection. Noda also created his own murals for the WPA during his New York years. In December 1934, he returned to Japan for the first time since leaving at eighteen. There he held his first solo exhibition at the Ginza Seijusha Gallery, was included in the 1935 Nika Kai exhibition, and worked with his friend Takeo Edward Terada on a mural for a bar in Tokyo. Noda returned to New York briefly the following year, but by 1937 he was back in San Francisco, where he completed a mural at his alma mater, Piedmont High School. Returning to Japan by way of Europe in the fall of 1937, Noda settled in an artists' colony in Toshima Ku in Tokyo and continued to exhibit. His wife, Ruth, joined him in May 1938, and the couple traveled to Lake Nojiri. While there, Noda began having difficulty with his eyesight and resorted to taping his eyelids open in order to work. Although the couple planned on returning to New York together in the fall, Noda remained in Japan due to his health, intending to join Ruth later. In December he was diagnosed with a cerebral tumor. He died in January 1939 at the age of thirty. His entire career spanned less than ten years.

Noda utilized pastel colors, line drawings, and soft textures in his work and sometimes employed a sgraffito or scratching technique to draw into wet paint. He often used a distinctive style to tell stories in montage format, which is especially evident in his visually complex urban scenes. Manmade structures such as walls and bridges appear frequently in these works and serve as metaphors for contact and isolation in city life.

Noguchi, Isamu

BORN: November 17, 1904, Los Angeles, CA

DIED: December 30, 1988, New York, NY

RESIDENCES: 1904–1906, Los Angeles, CA § 1906–1918, Tokyo, Omori, Chigasaki, and Yokahama, Japan §

1918–1922, Rolling Prairie and La Porte, IN § 1922–1935, New York (1927–1929, Paris; 1930, Paris and Beijing) § 1935–1936, Los Angeles, CA, and Mexico § 1937–1941, New York, NY § 1941, Los Angeles, CA § 1942, Colorado River Relocation Center, Poston, AZ; New York, NY § 1943–1950, New York, NY § 1950–1957, Tokyo, Hiroshima, and Kita Kamakura, Japan; New York, NY § 1958–1961, primarily New York, NY § 1961–1969, primarily Long Island City, NY (1962–1972, extended stays in Rome) § 1969–1988, primarily Long Island City, NY, and Mure, Japan

MEDIA: sculpture, painting, furniture design, and set and garden design

ART EDUCATION: 1922–1925, Leonardo da Vinci Art School, New York

SELECTED SOLO EXHIBITIONS: California Palace of the Legion of Honor, San Francisco, 1932 § *Isamu Noguchi*, San Francisco Museum of Art, 1942 § *Isamu Noguchi Retrospective*, Whitney Museum of American Art, New York, 1968 § Venice Biennale Exhibition, 1986

Isamu Noguchi with *Metamorphosis* and *The Queen*, ca. 1946

SELECTED GROUP EXHIBITIONS: *Fourteen Americans*, Museum of Modern Art, New York, 1946 § *American Art at Mid-Century*, National Gallery of Art, Washington, D.C., 1974 § *Twenty American Artists*, San Francisco Museum of Modern Art, 1982 § *Viewpoints: Postwar Painting and Sculpture*, Guggenheim Museum, New York, 1989

SELECTED COLLECTIONS: Guggenheim Museum, New York § Isamu Noguchi Garden Museum, Long Island City, NY § Los Angeles County Museum of Art § National Museum of American Art, Smithsonian Institution § National Museum of Modern Art, Tokyo

SELECTED BIBLIOGRAPHY: Altshuler, Bruce. *Isamu Noguchi.* New York: Abbeville Press, 1994. § Ashton, Dore. *Noguchi East and West.* New York: Knopf, 1992. § Duus, Masayo. *The Life of Isamu Noguchi: Journey Without Borders.* Translated by Peter Duus. Princeton: Princeton University Press, 2004. § Noguchi, Isamu. *The Isamu Noguchi Garden Museum.* New York: Abrams, 1987. § Noguchi, Isamu. *A Sculptor's World.* New York: Harper and Row, 1968.

For my part, I kept telling the people that to be modern really only meant to be themselves alive—to be and function in their own world.

ISAMU NOGUCHI
"The Artist and Japan:
A Report of 1950." Unpublished manuscript.
Copy provided by Saburo Hasegawa family.
Asian American Art Project, Stanford University.

BORN IN LOS ANGELES to Leonie Gilmour, an Irish-American teacher and editor, and Yone Noguchi, a renowned Japanese poet, Isamu Noguchi had a dual heritage that would become central to his seventy years of art making, as well as to the international modernism that he helped define. When Noguchi was a child, his mother took him to Japan, where he attended Japanese and Jesuit schools. He returned to the United States for high school and attended a progressive boarding school in Indiana that his mother had read about in a magazine. After a few months, though, the school closed, and Noguchi was eventually taken in by a family affiliated with the school and completed his secondary education.

The summer after graduation, Noguchi served as an apprentice to the sculptor Gutzon Borglum, best known as the creator of Mount Rushmore. Noguchi then attended Columbia University in New York as a pre-med student, but he soon dropped out to attend art classes and eventually secured his own studio space. He received praise for his academic figurative sculpture in plaster and terra cotta. He frequented Alfred Stieglitz's gallery, made masks for a performance by dancer Michio Ito, and saw the abstract works of Constantin Brancusi for the first time. In 1927 Noguchi received a John Simon

Guggenheim Fellowship and traveled to Paris to study stone and wood cutting.

In Paris, Noguchi worked as Brancusi's assistant for several months and through Michio Ito met artists Jules Pascin and Alexander Calder. He sculpted abstract works in wood, stone, and bent metal, and when his fellowship was not renewed in 1929, Noguchi returned to New York, where he exhibited these new sculptures in his first one-man show at the Eugene Schoen Gallery in New York.

Not finding wide acceptance for his abstract work, Noguchi turned to commissioned portrait busts of noted individuals such as George Gershwin and friends Buckminster Fuller and Martha Graham. These sculptures proved to be very successful, and he continued to create them throughout his career, often to support himself financially. In 1930, Noguchi traveled to Asia, studying painting and calligraphy with Qi Baishi in China and ceramics with Uno Jinmatsu in Japan. Upon returning to the United States, he exhibited his large figurative brush paintings and sculptures inspired by *haniwa* (cylindrical ceramics from ancient Japan) and began a three-decade-long collaborative relationship with Martha Graham, designing sets for her productions. Important acquisitions of his work were made by major U.S. museums. However, although he submitted proposals for public projects and monuments to the Federal Art Project, all were rejected as too nontraditional. Noguchi moved to Hollywood in 1935, designing a pool (unrealized) at the request of Richard Neutra, and the following year traveled to Mexico, where he fulfilled his desire to work in large scale, creating a seventy-two-foot-long sculptural relief mural, *History Mexico*, his most political work to date.

Returning again to New York, Noguchi created his first fountain for the Ford Motor Company building and designed his first mass-produced object (*Radio Nurse* intercom for Zenith Radio). In 1941, he drove to California with his good friend Arshile Gorky and was living in Hollywood when Pearl Harbor was bombed. The following year, Noguchi dedicated his efforts to political organizing and formed the Nisei Writers and Artists Mobilization for Democracy. He traveled to Washington, D.C., to speak out on behalf of Japanese Americans enduring hardships in internment camps, and in an act of solidarity, he voluntarily interned himself for seven months at the Relocation Center in Poston, Arizona, where he taught briefly.

Noguchi spent the balance of the 1940s in New York, where he began his designs of lamps and furniture for Knoll and Herman Miller and created the sets for Graham's *Appalachian Spring* and sets and costumes for both George Balanchine's *Orpheus* and the John Cage/Merce Cunningham work, *The Seasons*.

In 1949, Noguchi received a Bollingen Foundation Fellowship, enabling him to spend extended periods in Asia and Europe. While in Tokyo in the early 1950s, he designed the two bridges for Hiroshima's Peace Park and became friends with artist **Saburo Hasegawa**. In 1952, he married actress Shirley

Yamaguchi and established a house and studio on property belonging to noted ceramicist Kitaōji Rosanjin, splitting his time between there and New York. In 1961, Noguchi established a studio in Long Island City, New York, which in 1985 became the Isamu Noguchi Garden Museum. In the decades that followed, as the preeminent postwar American sculptor, Noguchi designed and completed major public works, including gardens, social spaces, playgrounds, and museum parks in the United States and Japan. He represented the United States at the Venice Biennale in 1986.

Nomiyama, Koichi

BORN: September 14, 1900, Kyushu, Japan

DIED: September 1984, Japan

RESIDENCES: 1900–1920, Kyushu, Japan § 1920–1942, San Francisco, CA § 1942–1945, Merced Assembly Center, Merced, CA; Granada Relocation Center, Amache, CO § ca. 1945–ca. 1974, New York, NY § ca. 1974–1984, Japan (possibly returning to live in the United States during this time)

MEDIA: oil painting

ART EDUCATION: 1926, California School of Fine Arts, San Francisco

SELECTED GROUP EXHIBITIONS: *Sangenshoku Ga Kai, Second Annual Exhibition,* Kinmon Gakuen, San Francisco, 1927 § *Sangenshoku Ga Kai and Shaku-do-sha Association Joint Exhibition,* Kinmon Gakuen, San Francisco, and Central Art Gallery, Los Angeles, 1927 § *San Francisco Art Association,* California School of Fine Arts, 1927, 1928 § *San Francisco Art Association,* California Palace of the Legion of Honor, 1929–1932 § *San Francisco Art Association,* San Francisco Museum of Art, 1935 (inaugural), 1938 § *The Japanese American Artists Group,* The Riverside Museum, New York, 1947 § *Society of Western Artists,* de Young Museum, San Francisco, 1952

SELECTED BIBLIOGRAPHY: "Art Class Will Hold Exhibition." *Nichi Bei* (San Francisco), October 28, 1927 (English section). § Japanese-American Internee Data File, 1942–1946. File number 801365. Records of the War Relocation Authority. National Archives, Washington, D.C. § Mirikitani, Janice, ed. *Ayumi: A Japanese American Anthology.* San Francisco: Japanese American Anthology Committee, 1980. § "Rec Art Class." *Granada Pioneer,* November 12, 1942, 4.

ALTHOUGH HIS EXACT place of birth is unknown, Koichi Nomiyama came from Kyushu, one of the largest southern islands that comprise Japan. He arrived in California at the age of twenty and studied at the California School of Fine Arts in 1926. He participated in Sangenshoku Ga Kai exhibitions

with artists **Teikichi Hikoyama** and **Kiyoo Harry Nobuyuki** in 1927 and that same year began exhibiting regularly with the San Francisco Art Association, including in the 1935 inaugural exhibition at the San Francisco Museum of Art. Nomiyama worked in oils, and his *Man Holding Mandolin* is reproduced in *Ayumi: A Japanese American Anthology* and was exhibited in the 1929 San Francisco Art Association exhibition.

Records indicate that at the time of his internment in 1942, Nomiyama was married, and he listed his occupation as artist. With **Tokio Ueyama**, he supervised the art department at the Granada Relocation Center, and they established a program that gave classes three times a day, three days a week. Following the war, he lived in New York. It is unclear whether he lived again in San Francisco before returning to Japan in 1974. In *Ayumi*, published in 1980, he is described as having recently moved back to San Francisco from Japan. However, death records indicate that he died in Japan in 1984.

Nong (Robert Han)

BORN: October 10, 1930, Seoul, Korea

RESIDENCES: 1930–1951, Seoul, Korea § 1952–1955, Ann Arbor, MI § 1955–1963, Monterey and Carmel, CA (including U.S. military service) § 1963–1965, Oakland, CA § 1965–1969, San Francisco, CA § 1969–1971, Paris, France § 1971–1984, San Francisco, CA § 1984–1986, Seoul, Korea § 1987, Barcelona and Madrid, Spain § 1987–present, Reva, VA

MEDIA: sculpture and painting

SELECTED SOLO EXHIBITIONS: Hidden Valley Gallery, Monterey, CA, 1962 § Santa Barbara Museum of Art, Santa Barbara, CA, 1965 § Crocker Art Museum, Sacramento, CA, 1965 § National Museum of Modern Art, Seoul, 1975 § Union de Arte, Barcelona, Spain, 1987 § Cultural Center, Korean Embassy, Washington, D.C., 1997

SELECTED GROUP EXHIBITIONS: National Collection of Fine Arts, Smithsonian Institution, Washington, D.C., 1961 § *Salon d'Automne*, Grand Palais, Paris, 1969–1971 § Oakland Museum of California, 1971 § San Francisco Museum of Modern Art, 1972

SELECTED COLLECTIONS: Asian Art Museum, San Francisco § Crocker Art Museum, Sacramento, CA § National Museum of Modern Art, Seoul § Oakland Museum of California § Santa Barbara Museum of Art, Santa Barbara, CA

SELECTED BIBLIOGRAPHY: Nong. CAAABS project interview. December 1, 2000. § Nong. E-mail correspondences to CAAABS researcher. October 20–November 18, 2000. Asian American Art Project, Stanford University. § Stewart, Marion C. "Maturity Through Understanding." *Southwest Art* 10, no. 1 (June 1980): 72–79. § Wechsler, Jeffrey, ed. *Asian Traditions/Modern Expressions: Asian American Artists and Abstraction, 1945–1970*. New York: Abrams in

Nong (Robert Han)

association with the Jane Voorhees Zimmerli Art Museum, Rutgers, the State University of New Jersey, 1997.

All subject matter has been exhausted.... There is nothing new. Composition, however, is the most important thing. It is based on the artist's individuality. When I create a new composition, it is very exciting. —NONG

Stewart, "Maturity Through Understanding," 73

THE ARTIST KNOWN AS Nong was born Han Ki Suk in Seoul. From a privileged family, he received a classical Korean education and was tutored by a Chinese scholar. He began to draw and work with clay when he was five years old, but his interest in art was not cultivated by his family. Instead, his father encouraged him to study law, which he did, earning a bachelor's degree. He became fluent in Chinese, Japanese, and English and also learned conversational French and German. Nong worked for the American embassy in South Korea when he was twenty years old and at that time adopted the American first name Robert. He would later take the name Nong (meaning "farmer" in Korean) as his professional artistic name. After a year at the embassy, he decided to immigrate to the United States, and in 1952, at the height of the Korean War, he moved to Ann Arbor, Michigan.

Nong began graduate study in international public law at the University of Michigan, working for a year at the law school as a research assistant and for two years in the political science department. In 1955, he accepted a teaching position as a civilian instructor at the U.S. Defense Language Institute in Monterey, California. He taught there for two years until he was drafted into the U.S. Army, for which he served in the Monterey area for six years.

In 1958, Nong received his United States citizenship and began to pursue the interest in art he had maintained since childhood. Self-taught, he created work primarily for himself and was initially rejected by galleries because he was unknown. In response, he opened the Nong Gallery, first in Oakland in 1963 and later in San Francisco. The gallery served as both his studio space and a showplace for his and other artists' work. His calligraphic renderings recalled his traditional education, while his paintings and sculptures were fundamentally inspired by his Taoist beliefs that prompted him to seek "colorless color, shapeless shape, and useful place as an empty space." His paintings often had a sculptural, three-dimensional quality that came from the mixed-media technique he developed, which combined layers of polyester, resin, ink, gesso, and tempera. The resultant interaction of materials created surprising effects and surface textures. His work alternates between abstract and representational imagery, and recurrent subjects include cats, dragonflies, mountains, moons, and female figures. Nong's interest in the *I Ching* can be seen in painting and sculptural work that incorporate abstract mark-

ings; poetry and calligraphy inform other nonrepresentational work. Nong moved to Virginia in 1987, where he continues to work and teach.

Obata, Chiura

BORN: November 18, 1885, Okayama, Japan

DIED: October 6, 1975, Berkeley, CA

RESIDENCES: 1885–ca. 1890, Okayama, Japan § ca. 1890–1899, Sendai, Japan § 1899–1903, Tokyo, Japan § 1903–1928, San Francisco, CA (summer 1927, Yosemite) § 1928–1930, Japan § 1930–1942, Berkeley, CA § 1942–1943, Tanforan Assembly Center, San Bruno, CA; Topaz Relocation Center, Topaz, UT § 1943–1945, St. Louis, MO § 1945–1975, Berkeley, CA

MEDIA: ink, and watercolor and oil painting

SELECTED SOLO EXHIBITIONS: East West Gallery, San Francisco, 1928 § California Palace of the Legion of Honor, San Francisco, 1931 § *Chiura Obata: A California Journey*, Oakland Museum of California, 1977 § *Great Nature: The Transcendent Landscapes of Chiura Obata*, de Young Museum, San Francisco, 2000

SELECTED GROUP EXHIBITIONS: *East West Art Society*, San Francisco Museum of Art, 1922 § *San Francisco Art Association*, California Palace of the Legion of Honor, San Francisco, 1925 § *San Francisco Art Association*, San Francisco Museum of Art, 1935, 1939, 1941, 1947 § *A More Perfect Union: Japanese Americans and the Constitution*, National Museum of American History, Smithsonian Institution, 1987 § *The View from Within*, Wight Art Gallery, University of California, Los Angeles, 1992 § *Made in California: Art, Image, and Identity, 1900–2000*, Los Angeles County Museum of Art, 2000

SELECTED COLLECTIONS: Crocker Art Museum, Sacramento, CA § Fine Arts Museums of San Francisco § Japanese American National Museum, Los Angeles § Oakland Museum of California § Smithsonian American Art Museum, Washington, D.C.

SELECTED BIBLIOGRAPHY: "California Japanese." *Time* 31, no. 17 (April 25, 1938): 36. § "Chiura Obata." *California Art Research*. San Francisco: WPA, 1937. § *Chiura Obata: A California Journey*. Oakland, CA: Oakland Museum, 1977. § Higa, Karin M. *The View from Within: Japanese American Art from the Internment Camps, 1942–1945*. Los Angeles: Japanese American National Museum, 1992. § Obata, Chiura. *Obata's Yosemite: The Art and Letters of Chiura Obata from His Trip to the High Sierra in 1927*. Essays by Janice T. Driesbach and Susan Landauer. Yosemite National Park, CA: Yosemite Association, 1993.

Chiura Obata
at Yosemite, 1927

*I dedicate my paintings, first, to the grand nature of California,
which, over the long years, in sad as well as in delightful times,
has always given me great lessons, comfort, and nourishment.
Second, to the people who share the same thoughts, as though
drawing water from one river under one tree.*

CHIURA OBATA
Obata's Yosemite: The Art and Letters

CHIURA OBATA WAS recognized by *Time* magazine in 1938 as "one of the most accomplished artists in the West." By that time, he had exhibited at many of Northern California's prestigious museums, designed sets for the San Francisco Opera (*Madame Butterfly*, 1924), and cofounded the exhibiting collective, the East West Art Society. He also became the first artist of Japanese ancestry to become faculty at a premier California university (University of California, Berkeley, 1932).

Raised and educated in Japan by his brother Rokuichi, a Meiji artist versed in both Japanese and Western traditions and aesthetics, Chiura Obata pursued additional *nihonga* training in Japan before immigrating to the United States. First arriving in Seattle, he immediately moved to San Francisco in 1903. His journal includes his sketches of post-1906 San Francisco earthquake devastation. In 1912, he married Haruko Kohashi, an important ikebana artist who displayed work at the 1915 Panama-Pacific International Exposition. Obata's dramatic, life-size *Mother Earth* nude portrait of his wife is an early masterpiece, synthesizing references to Japanese art and California landscape.

This synthesis of media and style in depicting California landscape appears in many of Obata's works. He sometimes painted on a large scale in traditional media of mineral pig-ment and animal glue on silk or paper, and subject matter included such famous California locations as Point Lobos and the Monterey Peninsula, as well as Yosemite and the Sacramento Valley. Obata's ambitious vision helped establish him as the leading artist in San Francisco's Japanese American community. After the death of his father in 1928, Obata returned with his family to Japan, where, at the renowned Takamizawa Print Works, he produced a major series of thirty-five color woodblock prints inspired by his 1927 backpacking trip to Yosemite with artists Worth Ryder and Robert Boardman Howard. One of these works received first prize in a 1930 Tokyo exhibition, and the series was exhibited widely upon his return to California in the same year. His full-time teaching appointment at the University of California, Berkeley, soon followed. Obata's teaching style included discussion of his Zen-inspired philosophy of nature as well as instruction in *sumi-e* painting techniques and was highly influential.

Obata documented his experiences during the period following the bombing of Pearl Harbor in a large number of important paintings and sketches. His cofounding of art schools at both the Tanforan Assembly Center and the Topaz Relocation Center with **George Matsusaburo Hibi** and others is among the most inspiring aspects of internment history. Obata was released from Topaz in 1943 after being beaten by another internee who disagreed with Obata's pro-American politics, and he moved with his family to St. Louis, where his son Gyo was living. After the war, Obata returned to Berkeley and resumed teaching. He became a naturalized citizen in 1954. After retiring in 1955, Obata led a successful series of tours to Japan to promote understanding between his adopted home and his country of birth.

Okamoto, Yajiro

BORN: May 13, 1891, Hiroshima, Japan

DIED: August 27, 1963, San Francisco, CA

RESIDENCES: 1891–1917, Japan § 1917–ca. 1922, Hawaii
(and U.S. military service, location unknown) § ca.
1922–1942, San Francisco, CA § 1942–ca. 1945, Tanforan
Assembly Center, San Bruno, CA; Topaz Relocation
Center, Topaz, UT § ca. 1945–1963, San Francisco, CA

MEDIA: oil painting

SELECTED GROUP EXHIBITIONS: *Second Annual California
Figure Painters*, Foundation of Western Art, Los Angeles,
1935 § *Bay Region Artists/20 Local Artists*, San Francisco
Museum of Art, 1935 § *San Francisco Art Association*, San
Francisco Museum of Art, 1935 (inaugural), 1936, 1937

SELECTED COLLECTION: Nichiren Buddhist Church, San
Francisco

SELECTED BIBLIOGRAPHY: Brown, Michael D. *Views from
Asian California, 1920–1965*. San Francisco: Michael D.
Brown, 1992. § 1930 Federal Population Census. San
Francisco, San Francisco, California. Roll 209, Page 1B,
Enumeration District 392, Image 679.0. National Archives,
Washington, D.C. § "17 Paintings by Nippon Artist in
Exhibition." *Kashu Mainichi* (Los Angeles), January 27,
1935, 1.

PRIMARILY A SELF-TAUGHT ARTIST, Yajiro Okamoto moved
from Japan to Hawaii in 1917. He joined the U.S. Army soon
after and served in World War I. Following the war, Okamoto
moved to San Francisco and by 1930 was married and living
at 1195 Stockton Street, in San Francisco's Chinatown. Oka-
moto worked as a barber, but he continued painting, and he
exhibited several times with the San Francisco Art Associa-
tion. An article in the Los Angeles Japanese newspaper, *Kashu
Mainichi*, detailing the 1935 San Francisco Art Association ex-
hibition that inaugurated the San Francisco Museum of Art,
stated, "A still life by Yajiro Okamoto, local barber-artist, won
high commendation from the jury of selection for his sincer-
ity and uncolored artists efforts." Titles of works exhibited in
the 1930s included *Bridge, Apartment House*, and *Still Life*. He
mainly created landscapes, floral still lifes, and figure studies,
and the work was sometimes described as having fantastical
or spiritual motifs.

During World War II Okamoto and his wife were interned
first at the Tanforan Assembly Center and then at the Topaz
Relocation Center. After the war, they returned to San Fran-
cisco, where Okamoto resumed his work as a barber.

Arthur Okamura, 1998. Photo by Irene Poon

Okamura, Arthur Shinji

BORN: February 24, 1932, Long Beach, CA

RESIDENCES: 1932–1938, Long Beach, CA § 1938–1942,
Compton, CA § 1942–1945, Santa Anita Assembly
Center, Santa Anita, CA; Granada Relocation Center,
Amache, CO § 1945–1957, Chicago, IL (1954, Majorca)
§ 1957–1959, San Francisco, CA § 1959–present,
Bolinas, CA

MEDIA: oil, acrylic and watercolor painting, sculpture, and
mixed media

ART EDUCATION: 1950–1954, Art Institute of
Chicago § 1954, Yale University Summer Art Seminar,
New Haven, CT § 1951, 1953, 1957, University of Chicago

SELECTED SOLO EXHIBITIONS: Santa Barbara Museum
of Art, Santa Barbara, CA, 1958 § California Palace of the
Legion of Honor, San Francisco, 1962 § *Arthur Okamura /
Matt Glavin: Drawings*, San Francisco Museum of Art,
1968 § Honolulu Academy of Arts, 1973

SELECTED GROUP EXHIBITIONS: Museum of Modern Art,
New York, 1954 § *Contemporary American Painting*, Art
Institute of Chicago, 1957 § *San Francisco Art Association*,
San Francisco Museum of Art, 1958–1961 § Whitney

Museum of American Art, New York, 1960, 1962, 1963, 1964 § *10th Annual SECA Awards*, San Francisco Museum of Art, 1966

SELECTED COLLECTIONS: Oakland Museum of California § San Francisco Museum of Modern Art § Santa Barbara Museum of Art § Smithsonian American Art Museum, Washington, D.C. § Whitney Museum of American Art, New York

SELECTED BIBLIOGRAPHY: Okamura, Arthur. CAAABS project interview. March 20, 1998. Bolinas, CA. § Poon, Irene. *Leading the Way: Asian American Artists of the Older Generation.* Wenham, MA: Gordon College, 2001. § Wechsler, Jeffrey, ed. *Asian Traditions/Modern Expressions: Asian American Artists and Abstraction, 1945–1970.* New York: Abrams in association with the Jane Voorhees Zimmerli Art Museum, Rutgers, the State University of New Jersey, 1997.

I would paint and see where they [my paintings] seemed to be like other kinds of Asian art that I had seen—the clouds, the mountains, the states. These concepts and forms from that period of my work made me realize the racial unconsciousness I felt or even kind of saw in my inner vision. Somehow they came forth . . . it's the kind of feeling that I like. I'm always surprised by it. I like it when I'm surprised. It's unexpected, it's not planned. It's magic.
ARTHUR SHINJI OKAMURA
CAAABS project interview

ARTHUR OKAMURA spent his childhood in Long Beach and Compton, California, and his interest in art began when he was in kindergarten. However, when he was ten years old, at the onset of World War II, his life abruptly changed, and his family was interned, first at the Santa Anita Assembly Center in California and then at the Granada Relocation Center in Colorado. Following their release from camp, the family moved to Chicago, where Okamura finished his public schooling. While he was in high school, his art teacher referred him to a Chicago friend who had a silkscreen poster studio. Okamura worked there for twelve years and learned by watching, ultimately becoming the studio's artist.

Beginning in 1950, Okamura attended the Art Institute of Chicago, where he studied not only art but also art history, learning from the museum's collection. Although influenced by the impressionists and painters like van Gogh and Gauguin, he was increasingly drawn to the work of contemporary American abstraction after seeing work such as Willem de Kooning's *Excavation.* Following graduation, Okamura was awarded an Edward L. Ryerson Foreign Travel Fellowship and went to the island of Majorca. There he started to paint abstractly and began writing poetry. Okamura was influenced by other Americans living in Majorca at the time, including the poet Robert Creeley and the painter John Altoon. Okamura later recalled, "They just kind of opened a lot of doors to me about what's

happening out there in painting, what's happening with poetry, music, and art," and Okamura and Altoon remained close friends until Altoon's death in 1969.

Returning to California in 1957, Okamura settled in the Bay Area, becoming a professor at the California College of Arts and Crafts, where he taught from 1958 to 1959 and 1966 to 1983. His works from the period were primarily abstract landscapes, and many took the form of long verticals, reminiscent of hanging scrolls. Okamura exhibited widely, holding solo shows at premier West Coast museums as well as exhibiting regularly at the Ruth Braunstein Gallery (later Braunstein/Quay Gallery) in San Francisco.

Although he shared studio space in Berkeley with fellow artists such as Peter Voulkos, **George Miyasaki**, and Don Potts, Okamura has made Bolinas, California, his primary residence since 1959. The coastal environment has strongly influenced Okamura's work, which includes representational paintings of animals and landscapes as well as sculptural forms.

Okubo, Benji

BORN: October 27, 1904, Riverside, CA

DIED: April 15, 1975, Los Angeles, CA

RESIDENCES: 1904–ca. 1926, Riverside, CA § ca. 1926–1942, Los Angeles, CA § 1942–1945, Pomona Assembly Center, Pomona, CA; Heart Mountain Relocation Center, Heart Mountain, WY § 1945–1975, Los Angeles, CA

MEDIA: oil and watercolor painting, drawing, illustration, and murals

ART EDUCATION: ca. 1927–ca. 1930, Otis Art Institute of the Los Angeles Museum of History, Science and Art § ca. 1930s, Art Students League of Los Angeles

SELECTED SOLO EXHIBITIONS: Mission Inn, Riverside, CA, 1933 § See Gallery, Plaza Hotel, Los Angeles, 1933 § *Exhibition of Paintings, Sponsored by the Rafu Shimpo and Kashu Mainichi*, Olympic Hotel, Los Angeles, 1933 (two-person show with Hideo Date)

SELECTED GROUP EXHIBITIONS: *The Contemporary Oriental Artists*, Foundation of Western Art, Los Angeles, 1934 § *Los Angeles Oriental Artists' Group*, Los Angeles Museum, 1936 § *Exhibition of California Oriental Artists*, Los Angeles Museum, 1936. § *Painters and Sculptors of Southern California*, Los Angeles Museum, 1936 § *Exhibition of California Oriental Painters*, Foundation of Western Art, Los Angeles, 1937 § *Touring Exhibition of Issei and Nisei Artists*, New Jersey College for Women, New Brunswick, NJ, 1945 § *On Gold Mountain: A Chinese American Experience*, Autry Museum of Western Heritage, Los Angeles, 2000

Benji Okubo teaching art
at Heart Mountain, ca. 1943.
Photo by Tom Parker

SELECTED COLLECTION: Japanese American National
Museum, Los Angeles

SELECTED BIBLIOGRAPHY: "Art Exhibit Hailed Success."
Heart Mountain Sentinel, January 22, 1944, 8. § Lenox,
Barbara. "2,020-ft. of Living on a 35-ft. Lot." *Los Angeles
Times*, March 26, 1961, J12. § "Models Sought to Pose
for Adult Evening Art Classes." *Heart Mountain Sentinel*,
April 17, 1943, 6. § Moure, Nancy Dustin Wall. *Publica-
tions in Southern California Art, Volumes I, II, III.* Glendale,
CA: Dustin Publications, 1975. § Totten, Donald Cecil.
Interviewed by Betty Hoag. May 28, 1964. Los Angeles.
Transcript, Archives of American Art, Smithsonian
Institution. § "Winners in Garden Poster Contest:
Students at Otis Awarded First Prize." *Los Angeles Times*,
March 16, 1928, A1.

AN ACCOMPLISHED PAINTER, illustrator, and landscape archi-
tect, Benji Okubo was raised in a family of seven children in
Riverside, California. His mother was a calligrapher, painter,
and graduate of the Tokyo Art Institute who encouraged her
children to develop their artistic sensibilities. His younger sis-
ter, **Mine Okubo**, would go on to become a prominent illus-
trator and painter.

In his early twenties, Okubo attended the Otis Art In-
stitute in Los Angeles with fellow students **Charles Isamu
Morimoto**, **Hideo Date**, Kiyoshi Ito, and **Tyrus Wong**. He was
an award and scholarship winner and designed the front cover

for *El Dorado, Land of Gold*, a book about the history of Califor-
nia illustrated by Otis students. He also took classes at the Art
Students League of Los Angeles, studying with influential syn-
chromist Stanton Macdonald-Wright, and taught there as well
as served as the league's director before the war. At this time
Okubo also became friends with Eddy See, who in Los Ange-
les's Chinatown in 1935 opened the Dragon's Den Restaurant,
a popular gathering place for artists and members of the Holly-
wood community. Together with artists Marian Blanchard and
Tyrus Wong, Okubo painted a mural of the Eight Immortals
and a dancing dragon in the restaurant.

Okubo participated in many group exhibitions, including
the second and third annual California modernists exhibitions
(1934 and 1935) and several exhibitions featuring the work of
artists of Asian ancestry. Some of the Oriental Artists Group
exhibitions were four-person shows featuring work by Okubo,
Date, Wong, and **Gilbert Leong**, and one exhibition catalog in-
cluded a foreword by Stanton Macdonald-Wright. Okubo often
depicted figures in fantastic or dreamlike environments and
employed the symbolic use of color characteristic of synchro-
mism. Titles of exhibited works included *On the Island of the
Moon, Valley of the Golden Mist*, and *Vision of the Blue Lily*.

The 1930s were an exciting time for Okubo and his con-
temporaries, as much interest was paid to their work, and op-
portunities to exhibit were plentiful. However, the successful
momentum that characterized Okubo's career in the 1930s
was halted by the onset of World War II. He was interned at

the Heart Mountain Relocation Center, where he, along with Hideo Date, **Robert Kuwahara**, and Shingo Nishiura, began teaching art to internees, poignantly naming the camp art school the Art Students League. A reporter for the *Heart Mountain Sentinel* wrote: "There is a bit of Los Angeles and yes, a bit of Paris at Heart Mountain. The Art Students League of Heart Mountain is a branch of the Los Angeles League which is a direct 'import' from the Art Students League of Paris. Poor in everything but talent, and in its modest surroundings, this center group is a far cry from its pretentious parent leagues." Okubo and his colleagues exhibited their work in a group show at Heart Mountain in January 1944.

After his release from the Heart Mountain Relocation Center on October 9, 1945, Okubo returned to Los Angeles, where he worked as a landscape architect. His work in this field is featured in a 1961 *Los Angeles Times* article.

Okubo, Mine

BORN: June 27, 1912, Riverside, CA

DIED: February 10, 2001, New York, NY

RESIDENCES: 1912–1934, Riverside, CA § 1934–1938, Berkeley, CA § 1938–1939, Europe § 1939–1942, San Francisco Bay Area, various locations § 1942–1944, Tanforan Assembly Center, San Bruno, CA; Topaz Relocation Center, Topaz, UT § 1944–1950, New York, NY § 1950–1952, Berkeley, CA § 1952–2001, New York, NY

MEDIA: oil, ink, and watercolor painting, drawing, printmaking, and murals

ART EDUCATION: 1933–1934, Riverside Junior College, Riverside, CA § 1934–1936, University of California, Berkeley

SELECTED SOLO EXHIBITIONS: San Francisco Museum of Art, 1940, 1941 § Riverside Fine Arts Guild, Riverside Public Library, Riverside CA, 1945 § Mortimer Levitt Gallery, New York, 1951 § *Mine Okubo: An American Experience*, Oakland Museum of California, 1972

SELECTED GROUP EXHIBITIONS: *San Francisco Art Association*, San Francisco Museum of Art, 1937–1938, 1940–1943, 1945–1953 § *California Art Today*, Golden Gate International Exposition, San Francisco, 1940 § *The Japanese American Artists Group*, The Riverside Museum, New York, 1947 § California Historical Society, San Francisco, 1972 § National Museum of Women in the Arts, Washington, D.C., 1991 § *The View from Within*, Wight Art Gallery, University of California, Los Angeles, 1992

SELECTED COLLECTIONS: Fine Arts Museums of San Francisco § Oakland Museum of California § San Francisco Museum of Modern Art

SELECTED BIBLIOGRAPHY: LaDuke, Betty. *Women Artists: Multi-Cultural Visions*. Trenton, NJ: Red Sea Press, 1992,

Mine Okubo, 1945. Photo by Toge Fujihira

113–126. § Okubo, Mine. *Citizen 13660*. New York: Columbia University Press, 1946. § Sun, Shirley. *Mine Okubo: An American Experience*. Oakland, CA: Oakland Museum, 1972. § "A Tribute to Mine Okubo." *Amerasia Journal* 30, no. 2 (2004).

"Why are you not bitter?" is one question often asked of me now. For one thing, life moves on. There is not time enough to sit back and worry about an event of the past. It is human nature to look ahead and to hope and to strive for a better tomorrow.

MINE OKUBO
Sun, *Mine Okubo: An American Experience*, 11

ALTHOUGH MOST WIDELY KNOWN for the artwork she created during internment, Mine Okubo had a successful career that spanned more than sixty years. Born and raised as the middle child in a family of seven children in Riverside, California, Okubo and several siblings were encouraged by their mother (who was a calligrapher, painter, and honor graduate of the Tokyo Art Institute) to become artists. Okubo completed her M.F.A. at the University of California, Berkeley, where she studied fresco and mural painting with John Haley, working in a figurative style with rounded forms reminiscent of that of Diego Rivera. The university awarded her the Bertha Taussig Traveling Scholarship in 1938, providing Okubo an extended stay in Europe during which she incorporated brilliant color and freer paint handling in her work. After the outbreak of

World War II in Europe, Okubo returned to California, where she worked for the Federal Art Project creating fresco and mosaic murals for the U.S. Army at Fort Ord and at the Servicemen's Hospitality House in Oakland. In 1940, in addition to having her own work in the *California Art Today* section of the Golden Gate International Exposition on Treasure Island, she demonstrated fresco technique in the *Art in Action* portion of the exposition, interacting with visitors while Diego Rivera completed his masterpiece *Pan American Unity* on scaffolding overhead.

In 1942, Okubo and her younger brother were interned first at the Tanforan Assembly Center and subsequently at the Topaz Relocation Center; other members of her family were dispersed to camps in Montana and Wyoming (including brother Benji at Heart Mountain), and another brother was drafted. She recorded her experiences in documentary ink drawings and powerful gouache and charcoal images, often working all night with a "quarantined" sign posted on her door to ensure uninterrupted work time. In her powerful visual diary, which took its name from her camp identification number, Citizen 13660, she recalled, "We were in shock. You'd be in shock. You'd be bewildered. You'd be humiliated. You can't believe this is happening to you. To think this could happen in the United States. We were citizens. We did nothing. It was only because of our race."

Okubo's career during internment was distinguished by the many major museum shows in which she continued to exhibit, her teaching of Western traditions of art making in the art schools at Tanforan and Topaz, and her participation in the founding of the camp publication *Trek*, for which she provided three cover illustrations. These illustrations came to the attention of the editors of *Fortune* magazine, who invited Okubo to New York to illustrate a feature article about Japan in the April 1944 issue. She continued a successful career in illustration for the next ten years, then returned to the Bay Area for a teaching appointment at the University of California, Berkeley, from 1950 to 1952. Although she experimented with formalist abstraction, by the late 1950s Okubo developed a personal vocabulary in painting based on traditional Japanese folk art. These paintings were characterized by brilliant color and simplified figurative forms of children, animals, and landscapes. Her work from the late 1980s and 1990s alternated between geometric figurative compositions and more expressively painted landscape abstractions.

Park, Charles (Pak Youngjik)

BORN: 1893, Pyongyang, Korea

DIED: 1959, Korea

RESIDENCES: 1893–1914, Pyongyang, Korea § 1914–ca. 1935, San Francisco, Chicago, and Los Angeles § ca. 1935–1959, Korea

MEDIA: painting

ART EDUCATION: 1924–1929, Otis Art Institute of the Los Angeles Museum of History, Science and Art, Los Angeles

SELECTED GROUP EXHIBITIONS: *Young Painters of Los Angeles*, Los Angeles Museum, 1929 § *Young Painters of Los Angeles*, Santa Monica Public Library, 1930

SELECTED BIBLIOGRAPHY: http://www.icasinc.org/bios/pak_jacq.html. Downloaded May 20, 2005. § http://koreaweb.ws/ks/ksr/pakjphd.htm. Downloaded May 20, 2005. § Millier, Arthur. "Our Young Painters." *Los Angeles Times*, December 15, 1929, 24. § Moure, Nancy Dustin Wall. *Dictionary of Art and Artists in Southern California Before 1930*. Glendale, CA: Dustin Publications, 1975. § Pak, Jacqueline. Email correspondence to CAAABS researcher. November 1, 2000. § Passenger Lists of Vessels Arriving at San Francisco, 1893–1953. Roll 76, Page 11. National Archives, Washington, D.C. § "Young Painters at the Beach." *Los Angeles Times*, May 11, 1930, B13.

BORN IN PYONGYANG to one of the wealthiest families in the city, Charles Park traveled to the United States as a student in 1914. He arrived in San Francisco having possibly already studied art in Pyongyang and is believed to have later attended the Art Institute of Chicago.

Charles Park at Otis Art Institute, ca. 1927

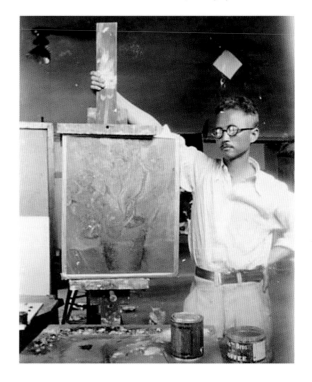

By 1924 Park was living in Los Angeles and was a student at the Otis Art Institute, where he was enrolled until 1929. While at Otis, Park studied with Stanton Macdonald-Wright, and a picture from his time at the school shows Park working at the easel. He participated in the *Young Painters of Los Angeles* exhibition in 1929, which also included work by fellow Otis student **Charles Isamu Morimoto**. *Los Angeles Times* art critic Arthur Millier noted, "Charles Park contributed a brilliant colored still life and an amusing 'Sunday Afternoon' of people in the country."

Park supported the aims of famous Korean nationalist An Ch'angho and was one of the earliest members of the Hungsadan (Young Korean Academy), an organization founded by An Ch'angho in San Francisco in 1913. Park lived with An Ch'angho and his family at the Hungsadan headquarters in Los Angeles for more than fifteen years.

Park admired the work of Cézanne and created figure studies, landscapes, still lifes, and portraits in an impressionistic style. Despite his involvement in Korean progressive politics, his work was not overly political. Much of his California work was confiscated by Japanese colonial police when he returned to Korea as a result of his ties to An Ch'angho. In Korea, Park became one of the country's earliest impressionist painters and served as professor of Western painting at Seoul National University.

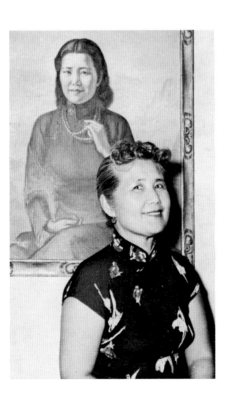

Lanhei
Kim Park

Park, Lanhei Kim

BORN: May 25, 1902, Pyongyang, Korea

DIED: October 18, 1996, San Diego County, CA

RESIDENCES: 1902–1914, Pyongyang, Korea § 1914–1918, Manchuria, China § 1918–1920, Seoul, Korea; and Manchuria, China § 1921–1923, Kobe, Japan § 1923–1928, Seoul, Korea § 1928–1934, Los Angeles, CA § 1934–1935, New York, NY, and Chicago, IL § 1936–1940, Chicago, IL § 1940–1947, Kirksville, MO § 1947–1996, Oceanside, CA

MEDIA: oil and watercolor painting, printmaking, and sculpture

ART EDUCATION: 1928–1934, University of California, Los Angeles § 1934, Art Institute of Chicago § 1935, National Academy of Design, New York

SELECTED COLLECTION: Seoul National University

SELECTED BIBLIOGRAPHY: Park, Lanhei Kim. *Facing Four Ways: The Autobiography of Lanhei Kim Park (Mrs. No-Yong Park)*, ed. Chinn Callan. Oceanside, CA: Orchid Park Press, 1984.

My Big Grandmother spoke to me frequently about Taoism. She explained the meaning of Taoist symbols we see everywhere in nature, in the forms of dishes and furniture around our home, and in the beautiful paintings of Taoist fairy tales. She influenced me greatly from childhood, and from her I inherited my keen interest in the symbolic art of religion and the folk art of oriental cultures.

LANHEI KIM PARK
Facing Four Ways, 13

THE QUEST FOR education shaped the life of Lanhei Kim Park, who was the first recorded woman of Korean ancestry to be active as an artist in California. Park was raised in an affluent home in Pyongyang and was greatly influenced by her grandmothers. Despite their own lack of formal education, they were smart, progressive thinkers who encouraged Park in her studies and taught her "the ethics of Confucianism and the symbolic representation of nature in the design of oriental paintings and art objects." Because of her father's resistance to the occupation of Korea by Japan, the family was forced to flee to Manchuria. Park dreamed of becoming a diplomat and traveling to the United States. In Manchuria she began her formal education, attending a girls' school and studying English with Canadian Presbyterian missionaries.

Park continued her studies at Ewha University, an all-women's school in Seoul, and spent two years at Kobe College, an American Congregational missionary women's school in Japan. In 1928, Park traveled to Los Angeles, where her sister was already living, and enrolled at UCLA. At the university, she majored in fine arts and furthered her English studies. In August 1932, she met Harvard-educated scholar and writer Dr.

No-Yong Park, who was giving a lecture in Los Angeles. The two stayed in contact, and in 1934, when Dr. Park was teaching at the New School for Social Research in New York, he persuaded her to visit. The couple was engaged soon after. During a semester when No-Yong Park taught in Cleveland, Lanhei enrolled at the school of the Art Institute of Chicago, where she studied sculpture, etching, lithography, and oil painting. She would arrive early in the morning before the other students to explore the museum and was particularly inspired by a Sung dynasty painted screen. When the couple returned to New York, she was accepted at the National Academy of Design. Her work at the academy was recognized, and she was quickly promoted through class levels. While there, she studied with Charles Hinton. Although she did not exhibit her art often, she did receive a first prize award in a 1935 student show. In New York Park also studied under Ching-chih Yee, who was known for creating designs to use on china and pottery, and who taught Park formal brush painting.

After marrying, Park accompanied her husband on his many lecture tours, often making landscape paintings of the places they visited. In 1940 they settled in Kirksville, Missouri, where her husband taught a course in Far Eastern affairs at Northeast Missouri State College, and where their two daughters were born. Park's art production declined as she raised her children, and the family later moved to Oceanside, California. There Park taught an Asian art and culture course through the University of California, San Diego, extension program, and she wrote *The Heavenly Pomegranate* as well as her autobiography, *Facing Four Ways*.

Poon, Irene

BORN: July 19, 1941, San Francisco, CA

RESIDENCE: 1941–present, San Francisco, CA

MEDIA: photography

ART EDUCATION: 1959–1967, San Francisco State College

SELECTED SOLO EXHIBITIONS: *Photographs by Irene Poon*, Crocker Art Museum, Sacramento, CA, 1967 § *Photographs by Irene Poon*, de Young Museum, San Francisco, 1968 § *Photographs: Chris Enos, Joanne Leonard, Irene Poon*, San Francisco Museum of Art, 1971 § *Leading the Way: Asian American Artists of the Older Generation*, Gordon College, Wenham, MA, 2001

SELECTED GROUP EXHIBITIONS: *A Variety Show of Photographs Selected by Margery Mann*, Humboldt State College, Arcata, CA, 1971 § *Interior Spaces*, University of California, Davis, 1978 § *Meniscus Portfolio*, Focus Art Gallery, San Francisco, 1985 § *With New Eyes: Toward an Asian American Art History in the West*, Art Department Gallery, San Francisco State University, 1995

Irene Poon, ca. 1972

SELECTED COLLECTION: San Francisco Museum of Modern Art

SELECTED BIBLIOGRAPHY: Bloomfield, Arthur. "Photo Poems of Chinatown." *San Francisco Examiner*, April 16, 1971, 31. § Frankenstein, Albert. "The Color Sense of Irene Poon." *San Francisco Chronicle*, September 24, 1968, 42. § Harvey, Nick, ed. *Ting: The Caldron, Chinese Art and Identity in San Francisco*. San Francisco: Glide Urban Center, 1970. § Mann, Margery. "Revolutions in Medium—But What About Message?" *Popular Photography* 67, no. 2 (August 1970): 25–26. § Poon, Irene. *Leading the Way: Asian American Artists of the Older Generation*. Wenham, MA: Gordon College, 2001.

Artists like Jade Snow Wong and Dong Kingman were my role models when I was growing up in San Francisco's Chinatown in the forties. They showed me that they could do something that was different from the traditional job-security models of teacher, engineer, doctor, and lawyer. They showed that a life in art was possible and respectable, though a living was [not] easy without some other source of income.

IRENE POON

David Chesanow. "Leading the Way:
Asian American Artists of the Older Generation."
In *Asian American Journal: International Examiner*,
May 16–June 5, 2001, 22.

IRENE POON, who grew up in San Francisco's Chinatown, frequently has taken the community and its people as a departure point for her photographic portrait studies. Poon's parents were first-generation immigrants from Guangzhou. Her father was an herbalist with a store on Grant Avenue; her mother assisted him. Poon was first exposed to photography by her father, an avid amateur photographer, who developed his own film and made prints in the family's basement. Poon gravitated

to photography in college, after experimenting with painting and sculpture. She received both her B.A. (in 1964) and her M.A. (in 1967) from San Francisco State College (now University); while there, she studied with Don Worth.

Following graduation, Poon began to exhibit frequently in the Bay Area and won a Phelan Award for her work in 1967. In the years that followed, she held solo exhibitions at many important Northern California museums. Her color photographs were lauded for their ability to convey atmosphere and emotion without becoming overly sentimental or dramatic. Art critic Alfred Frankenstein, who called her exhibition at the de Young "one of the great photography shows of the year," described Poon's use of color as "beholden to the subject but glancing off it to create somewhat somber photographic color compositions of great integrity and power." Others who admired Poon's work included Imogen Cunningham and John Gutmann, and Poon became friends with both noted artists.

Throughout her career, Poon primarily has created portraits, and while her early work focused on candid images of people in urban environments, her later photographs are more formal, posed studies. Her book, *Leading the Way: Asian American Artists of the Older Generation*, served as the catalog for her exhibition of portraits of elder artists of Asian ancestry working in the United States. Not only a photographer, but also a community activist and historian, Poon saw the important need to document the careers of these artists. As a board member and art curator of the Chinese Historical Society of America, based in San Francisco, Poon has organized or made possible many important exhibitions since the museum reopened in 2001, including career surveys for distinguished artists, including **Jade Snow Wong**, **Benjamen Chinn**, **Nanying Stella Wong**, **Tyrus Wong**, **C. C. Wang**, **Tseng Yuho**, **Wah Ming Chang**, **Win Ng**, and **Martin Wong**.

Poon continues to exhibit her photographs and organize exhibitions. In 1983 her work was included in the Meniscus Portfolio, an independent project featuring the work of fifteen photographers of local, national, and international reputation, and the portfolio circulated as an exhibition to San Francisco; Corvallis, Oregon; Tucson, Arizona; and Bath, England.

Quon, Milton

BORN: August 22, 1913, Los Angeles, CA

RESIDENCE: 1913–present, Los Angeles, CA

MEDIA: watercolor, ink and acrylic painting, mixed media, animation, and illustration

ART EDUCATION: 1936–1939, Chouinard Art Institute, Los Angeles

SELECTED SOLO EXHIBITION: *Impressions: Milton Quon's Los Angeles*, Chinese American Museum, Los Angeles, 2005/6

SELECTED GROUP EXHIBITIONS: Pacific Art Guild, Los Angeles, 1985–1991, 1998 § Santa Monica Public Library, Santa Monica, CA, 1989 § Ocean House, Santa Monica, CA, 1990 § *Inspiring Lines: Chinese American Pioneers in the Commercial Arts*, Chinese American Museum, Los Angeles, 2002

SELECTED BIBLIOGRAPHY: *California Arts and Architecture* 56, no. 4 (October 1939): cover, 20, 36. § Peschiutta, Claudia. "Chinatown First—The Roving Eye—Chinese-American art exhibit," *Los Angeles Business Journal*, January 21, 2002. § Quon, Milton. CAAABS project interview. May 14, 2000. Transcript, Asian American Art Project, Stanford University.

I believe that when people tell me they like my paintings, I believe they are complimenting or mentioning the fact that what you are inside—your feelings and emotions and the life you live—comes through an artist's hand and brush, and emotions and feelings are transferred to the viewer. You feel what I try to give you and in enjoying that feeling I have been successful.

MILTON QUON
CAAABS project interview

MILTON QUON GREW UP in Los Angeles's Chinatown as the only boy in a family of eight children. His father owned a stall in the produce market on San Pedro Street. While Quon was in junior high school, his drafting teacher noted his drawing ability and recommended that he attend an honors school, which he did, eventually graduating with a focus in architecture. At Los Angeles Junior College, he had a double major of art and engineering, and his mother hoped he would become an airplane or architectural engineer. Quon's uncle, seeing his nephew's dilemma—whether to focus on art or engineering—encouraged Quon's mother to let her son take the courses he wanted. Quon graduated from junior college with a degree in art and won a scholarship to the Chouinard Art Institute, where he studied for three years.

Quon walked five miles round-trip to Chouinard until his last year, when he was unable to carry his art supplies and had to travel by streetcar. While at Chouinard, he studied with many of the best-known California watercolorists, including Rex Brandt, Millard Sheets, and Phil Paradise. Quon did graphic work for restaurants, created window displays for Bullock's, and did a variety of graphic work for the Ice Follies, Sardi's, and the *Los Angeles Examiner*. He designed the first Chinese-frozen-food package in the early 1940s. Quon did the lettering that accompanied a drawing by **Tyrus Wong** on the front of the October 1939 *California Arts and Architecture* magazine issue that focused on artists of Chinese ancestry working in the state. His portrait of a mother and child was also reproduced within the magazine. He won the Latham Foundation International Poster Contest in 1939.

Quon started working at Walt Disney Studios in 1939 and worked on *Fantasia*. For the film *Dumbo*, he served as first assistant animator. When the United States entered World War II, Quon left Disney to work at Douglas Aircraft illustrating parts catalogs and doing other graphic work for the war effort. He returned to Disney in 1946 and worked in the publicity department. In 1951, he became an art director at a Los Angeles advertising agency that won many awards during his time there. In 1964 he began working as a senior design artist at a packaging design firm, where he remained until his retirement in 1980. Quon has also had a successful career as a teacher, beginning in 1974, when he taught part-time at Los Angeles Trade Tech College. He has also taught at Santa Monica College.

Quon has participated in many local Los Angeles watercolor exhibitions and has been a frequent award winner. He has been a member of the Pacific Art Guild, the Gardena Valley Art Club, and the Watercolor West Society. His frequent postretirement trips have resulted in more than sixty sketchbooks of locations, including China, Mexico, the Panama Canal, and Canada.

A 2002 exhibition at the Los Angeles Chinese American Museum featured work by Quon and fellow artists Fred Gong, Bill Jong, Leland Lee, Monroe Leung, and **Tyrus Wong**, all of whom at that time were between the ages of seventy-nine and ninety-two. The show presented both their commercial work and their fine-art painting.

Sato, Riyo

BORN: June 4, 1913, Palo Alto, CA

RESIDENCES: 1913–ca. 1934, Palo Alto, CA § ca. 1934–ca. 1940, Oakland, CA § ca. 1940–1942, Palo Alto, CA § 1942–1943, Heart Mountain, WY § 1943–1945, Buffalo, NY § 1945–present, Chicago, IL

MEDIA: watercolor, sketching, and lithography

EDUCATION: 1940, California College of Arts and Crafts, Oakland, CA § 1950s, Illinois Institute of Technology, Chicago

SELECTED GROUP EXHIBITIONS: *Oakland Sketch Club*, San Francisco Museum of Art, 1936 § *San Francisco Art Association*, San Francisco Museum of Art, 1942 § *Watercolors Allocated by Federal Art Project to the de Young*, de Young Museum, San Francisco, 1943

SELECTED COLLECTION: Fine Arts Museums of San Francisco

SELECTED BIBLIOGRAPHY: "Models Sought to Pose for Adults Evening Art Classes." *Heart Mountain Sentinel*, November 21, 1942, 6. § Sato Riyo. Biographical Information. Provided by family to Louise Siddons, Achenbach Foundation for Graphic Arts, Fine Arts Museums of San Francisco. March 29, 2004.

BORN IN PALO ALTO, Riyo Sato studied at the California College of Arts and Crafts in Oakland, where her teachers included Frederick Meyer. Following her time at the school, Sato moved back to Palo Alto and worked in San Francisco with the WPA, assisting mural artists and creating her own watercolor and lithograph work. Her watercolor *Good Old Summertime* was exhibited along with work by **Mine Okubo**, Shizu Utsunomiya, and **Dong Kingman** at the de Young Museum in February 1943 as part of an allocation of artwork made to the museum by the Federal Arts Project.

During World War II, Sato was relocated to Santa Anita and interned at Heart Mountain, Wyoming. For a year, she taught art classes in the camp along with **Hideo Date**, **Robert Kuwahara**, Shingo Nishiura, and **Benji Okubo**. Sponsored by the YMCA, Sato was able to move to Buffalo, New York, in December 1943. There, she worked at the Curtis-Wright Aircraft Manufacturing plant in the engineering design division; at night, she was a counselor with junior high school groups at the YMCA.

After World War II, Sato moved to Chicago. She worked for ten years as a commercial artist at Bielefeld Studios, and during the 1950s, she earned an M.A. in design and art education at the Illinois Institute of Technology. From 1955 to 1984 she was an art teacher at Garfield Elementary School and Roosevelt High School in East Chicago, Indiana. As a member of the Chicago Geographic Society, Sato traveled extensively to destinations including South America, Russia, Tibet, India, Vietnam, Antarctica, and the Artic Circle. After retiring, Sato continued to work, serving as a photographer and historian for her local church and Montgomery Place, an independent living facility for retired persons.

Sekimachi, Kay

BORN: September 30, 1926, San Francisco, CA

RESIDENCES: 1926–1929, San Francisco, CA § 1929–1930, Japan § 1930–1942, Berkeley, CA § 1942–1944, Tanforan Assembly Center, San Bruno, CA; Topaz Relocation Center, Topaz, UT § 1944–1945, Cincinnati, OH § 1945–present, Berkeley, CA

MEDIA: textiles

ART EDUCATION: 1946–1949, 1954, 1955, California College of Arts and Crafts, Oakland, CA § Summer 1956, Haystack Mountain School of Crafts, Liberty, ME

SELECTED SOLO EXHIBITIONS: Oakland Museum of California, 1962 (two-person show with Herbert Sanders) § Richmond Art Center, Richmond, CA, 1965 § Pacific Basin Textile Arts, Berkeley, CA, 1974 § *Marriage in Form: Kay Sekimachi and Bob Stocksdale*, touring exhibition, with venues including American

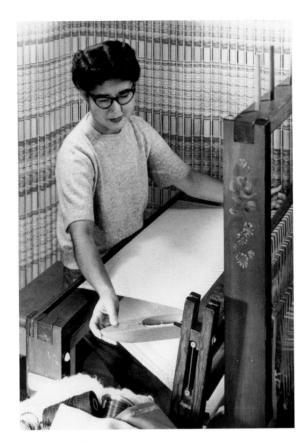

Kay Sekimachi, ca. 1953

Craft Museum, New York, NY; and Renwick Gallery, Smithsonian American Art Museum, Washington, D.C., 1993/95 § *Kay Sekimachi, An Intimate Eye: Woven and Paper Objects*, Mingei International Museum, San Diego, CA, 2001

SELECTED GROUP EXHIBITIONS: Richmond Art Center, Richmond, CA, 1954–1958, 1960–1962 § *Modern American Wall Hangings*, Victoria and Albert Museum, London, 1962 § *Wall Hangings*, Museum of Modern Art, New York, 1969 § *Deliberate Entanglements*, UCLA Art Galleries, 1971 § *Fiber Art: Americas and Japan*, National Museum of Modern Art, Kyoto, and National Museum of Modern Art, Tokyo, 1977 § *Made in California: Art, Image, and Identity, 1900–2000*, Los Angeles County Museum of Art, 2000

SELECTED COLLECTIONS: Fine Arts Museums of San Francisco § Museum of Arts & Design, New York § Oakland Museum of California § Renwick Gallery, Smithsonian Institution

SELECTED BIBLIOGRAPHY: Constantine, Mildred, and Jack Lenor Larsen. *Beyond Craft: The Art Fabric*. New York: Van Nostrand Reinhold Company, 1973. § Gedeon, Lucinda H. *Fiber Concepts*. Tempe, AZ: Arizona State University, 1989. § Larsen, Jack Lenor. *Kay Sekimachi*. Winchester, Eng.: Telos Art Publishing, 2003. § Mayfield, Signe.

Marriage in Form: Kay Sekimachi & Bob Stocksdale. Palo Alto, CA: Palo Alto Cultural Center, 1993. § Sekimachi, Kay. CAAABS project interview. April 27, 2000. Audiotapes, Asian American Art Project, Stanford University. § Sekimachi, Kay. *Intimate Views: The Books of Kay Sekimachi*. San Francisco: San Francisco Craft & Folk Art Museum, 2000.

The contrast in [my] books and boxes expresses duality in the Japanese character; as life is itself, these works are strong and fragile at the same time. I like to think that my work is honest and direct and maintains that quality of mystery that brings the viewer back to it, again and again, intrigued.

KAY SEKIMACHI
Parallel Views. Palo Alto: California Crafts Museum, Palo Alto Cultural Center, 1982.

LONG RECOGNIZED AS one of the premier American fiber and paper artists, Kay Sekimachi was first exposed to art-making while growing up in Berkeley, California. After returning from a year-long stay in Japan as a young child, she attended after-school programs to study calligraphy. At the age of sixteen, Sekimachi was interned, along with her family, first at the Tanforan Assembly Center and then at the Topaz Relocation Center. While at Topaz, Sekimachi studied painting and origami at the art school founded by **Chiura Obata**. She later recalled being especially inspired by the determination of her teacher, **Mine Okubo**.

In 1944, Sekimachi and her family were permitted to relocate to Ohio, where they lived at a Quaker hostel, and she worked glazing pottery. In 1945, the family returned to Berkeley, and Sekimachi enrolled in the California College of Arts and Crafts the following year. She left the school to pursue her interests in weaving in 1949, attending the Berkeley Adult School for basic lessons. A pivotal experience occurred in 1951 when Sekimachi attended renowned Bauhaus weaver Trude Guermonprez's first lecture at Pond Farm, a craft community and school in Guerneville, California. Sekimachi later returned to the California College of Arts and Crafts to study with Guermonprez during summer sessions in 1954 and 1955; she even finished Guermonprez's session as a substitute teacher in 1955. Guermonprez encouraged a more experimental approach to weaving, and Sekimachi began to pursue translucency in a series of room dividers, culminating in a series of works woven with monofilament during the late 1960s. Her large-scale, suspended sculptural forms have been compared to traditional Japanese motifs, including temple bell pulls and *tanabata* ceremonial paper hangings, and were enormously influential in the burgeoning development of the contemporary fiber art movement of that period.

In 1972, Sekimachi married craftsman Bob Stocksdale, renowned for his lathe-turned wooden bowls, who had himself been confined in camps during World War II as a conscien-

tious objector. In 1975, Sekimachi was awarded a grant from the National Endowment for the Arts and traveled to Japan. In 1997, she was honored by the Women's Caucus for Art of the College Art Association. She worked as a teacher, both at the Berkeley Adult School (1964–1972) and at San Francisco Community College (1965–1986). Her work is distinguished by a mastery of different techniques including tapestry, card weaving, double weaving, split-ply twining, and folding. Later work, often smaller in scale, explores vessel and book formats in media including linen, *washi* paper, and even paper from hornet's nests, sometimes with quiet patterning that recalls ikat.

Serisawa, Sueo

BORN: April 10, 1910, Yokohama, Japan

DIED: September 7, 2004, San Diego, CA

RESIDENCES: 1910–1918, Yokohama, Japan § 1918–1921, Seattle, WA § 1921–1941, Long Beach, CA § 1941–1942, Los Angeles, CA § 1942, Colorado Springs, CO § 1942–1943, Chicago, IL § 1943–1947, New York, NY § 1947–1975, Los Angeles, CA § 1975–2004, Idyllwild, CA

MEDIA: oil, watercolor and ink painting, and printmaking

ART EDUCATION: 1932–1933, Otis Art Institute of the Los Angeles Museum of History, Science and Art § 1942, Art Institute of Chicago

Sueo Serisawa, 1949.
Photo by Lou Jacobs Jr.

SELECTED SOLO EXHIBITIONS: Los Angeles Museum, 1941 § Dalzell Hatfield Gallery, Los Angeles, 1948 § Felix Landau Gallery, Los Angeles, 1959 § Laguna Beach Museum of Art, 1964 § Japanese American Cultural and Community Center, Los Angeles, 2000 § *Sueo Serisawa: Poetry in Painting*, Mingei International Museum, San Diego, 2004

SELECTED GROUP EXHIBITIONS: Corcoran Biennial, Washington, D.C., 1948 § Los Angeles County Museum, 1950, 1951 § Metropolitan Museum of Art, New York, 1950 § Tokyo International Exhibit, Tokyo, 1953 § Whitney Museum of American Art, New York, 1960 § Scripps College, Claremont, CA, 1991

SELECTED COLLECTIONS: Joslyn Art Museum, Omaha, NE § Metropolitan Museum of Art, New York § Santa Barbara Museum of Art, Santa Barbara, CA

SELECTED BIBLIOGRAPHY: Davis, Judson. *Sueo Serisawa Retrospective Exhibition Catalogue.* Los Angeles: Japanese American Cultural and Community Center, 2000. § Millier, Arthur. "Sueo Serisawa: An Account of the Inner Development of a Young American Painter." *American Artist* (June 1950): 33–37, 84–86. § Serisawa, Sueo, and Marsha Serisawa. CAAABS project interview. May 17, 2000. Idyllwild, CA. Transcript, Asian American Art Project, Stanford University. § Wechsler, Jeffrey, ed. *Asian Traditions/Modern Expressions: Asian American Artists and Abstraction, 1945–1970.* New York: Abrams in association with the Jane Voorhees Zimmerli Art Museum, Rutgers, the State University of New Jersey, 1997. § *Wind in the Pines: Serisawa's Poetry in Painting.* Film. Los Angeles: Japanese American Cultural and Community Center and Naljoropa Productions, 2000.

I'd like to share something with others through my painting—and that is the inexhaustible spirit of nature. By losing myself in nature's mystery, I become a channel for the creative energy and art becomes a medium for self-discovery.

SUEO SERISAWA

Wind in the Pines: Serisawa's Poetry in Painting. Film.
Los Angeles: Japanese American Cultural and
Community Center and Naljoropa Productions, 2000.

IN A CAREER THAT spanned nearly eight decades, painter Sueo Serisawa explored multiple styles and techniques. Born in Yokohama in 1910, Serisawa studied from an early age with his father, calligrapher and commercial artist Yoichi Serisawa. By the time the family moved to Long Beach, California, Serisawa had received his father's permission to pursue a career in art as well. At Long Beach Polytechnical High School, he studied with George Barker, a Thomas Eakins enthusiast, and developed a style of landscape, still life, and figure painting that mixed European impressionism with California landscape school ideals. He began winning prizes and recognition around Southern California. His dramatic *Nine O'Clock*

News—painted in 1939 on the day Germany invaded Poland and foreshadowing the impact World War II would have on his own life—was deemed "a young man's masterpiece" by *Los Angeles Times* art critic Arthur Millier. That same year, his first one-man show was presented at a small gallery on the Sunset Strip, and by 1941 he was a featured artist-of-the-month with a solo show at the Los Angeles Museum. The latter exhibition opened on December 7, 1941, the day Japan bombed Pearl Harbor. Within months, despite an increasingly successful career in Los Angeles, Serisawa and his wife Mary left the city, fleeing east to avoid internment.

The Serisawas lived for nearly a year in Colorado (where they had a daughter, Margaret) and a year in Chicago before settling in Greenwich Village in New York City. In New York—and during a summer in Woodstock—Serisawa developed friendships with **Yasuo Kuniyoshi**, Herman Cherry, and Fletcher Martin. Particularly inspired by a showing of Max Beckmann's work, Serisawa set out to develop a new expressionist painting style that dug beneath surface appearances to reveal an inner life and spirit. His figure studies of his wife and daughter—and, after returning to Los Angeles in 1947, of various friends and celebrities—became increasingly impressionistic, seeking to convey emotions and psychology. Broken lines, blocks of rich color, and geometric treatments of space began to dominate paintings like *Mary, 1949* and *Hobby Horse* as Serisawa moved steadily toward abstraction.

In 1955, Serisawa, joined by watercolorist Millard Sheets, returned to Japan for the first time. While Serisawa had already been exploring Japanese elements in his work, the month-long immersion in Japanese aesthetics proved a profound inspiration. Classic Japanese architecture, rock gardens, gold-leaf screen paintings, and especially the simplicity of the tea ceremony all moved the artist deeply. "I connected both end[s] of the electricity and made a connection, as though up to then I was only having one energy of some kind." Upon his return to the United States, the painter began to merge his efforts at abstraction with Japanese forms, cultivating what he called "Zen painting." His goal was to bring a powerful demonstration of "spirit changing into material form." In the 1960s and 1970s, he increasingly explored traditional Japanese forms, creating calligraphic works, woodblock prints, and his own gold and silver leaf *sumi-e* paintings. His work was recognized as a stirring interpolation of Eastern and Western expressionist traditions, and he developed a strong following as a teacher.

In the mid-1970s, Serisawa remarried and moved to the small town of Idyllwild, California, located in the mountains east of Los Angeles. Living away from the urban commotion with his new wife, Marsha, the artist began to explore nature and natural forms. Influenced by the teachings of J. Krishnamurti and desiring to escape the force of his own ego, he blended *sumi-e* ink and watercolor techniques, developing what he referred to as his own "humanistic expressionism."

Shibata, Yayoi Ailene

BORN: March 12, 1931, Mt. Eden, CA

RESIDENCES: 1931–1942, Mt. Eden, CA § 1942–1945, Tule Lake Relocation Center, Newell, CA § 1945–1950, Mt. Eden, CA § 1950–1952, Berkeley, CA § 1952–1960, Los Angeles, CA § 1960–1962, Tokyo, Japan § 1962–ca. 1980, Los Angeles, CA § ca. 1980–present, Redondo Beach, CA

MEDIA: oil and acrylic painting, mixed media, and ceramics

ART EDUCATION: 1950–1952, University of California, Berkeley § 1952–1955, University of California, Los Angeles

SELECTED SOLO EXHIBITIONS: California State University, Hayward, 1960 § Paul Rivas Gallery, Los Angeles, 1960, 1965 § Japanese American Cultural and Community Center, Los Angeles, 1991 § 871 Fine Arts, San Francisco, 1992 § *Passages*, Angels Gate Cultural Center, San Pedro, CA, 1997

SELECTED GROUP EXHIBITIONS: *Annual Nika Kai Art Exhibit*, Metropolitan Museum of Art, Tokyo, 1957 § Pasadena Art Museum, Pasadena, CA, 1958 § *San Francisco Art Association*, San Francisco Museum of Art, 1959 § Laguna Beach Art Association, Laguna Beach, CA, 1972 § Angels Gate Cultural Center, San Pedro, CA, 1992 § *Reshaping L.A.: In Praise of Diversity*, Angels Gate Cultural Center, San Pedro, CA, 1993

SELECTED BIBLIOGRAPHY: *Los Angeles Times*, December 4, 1992, B4. § "Shibata Named 'Featured Artist of the Month' in San Pedro." *Rafu Shimpo* (Los Angeles), April 8, 1997. § Wilson, William. "In the Galleries." *Los Angeles Times*, July 19, 1965, part 4, 8.

As an artist and as a Japanese-American who experienced the internment, recalling the years of confinement behind barbed wire was, and still is, a deeply painful and traumatic process.... I pray it never happens again in America.

YAYOI AILENE SHIBATA
Los Angeles Times, December 4, 1992, B4

YAYOI AILENE SHIBATA's parents emigrated from Japan, settling in Mt. Eden (now part of Hayward), a community south of Oakland, California, where they lived on a ten-hectare farm. There, they grew flowers commercially and created a Japanese garden and pond that would later be the subject of a March 1989 *Reader's Digest* article. Shibata's parents worked long hours to make the family business successful, often with the help of their five children. Yet Shibata's mother's found time late at night to write articles and poetry that were published in local Japanese newspapers, becoming a role model for her daughter in her own creative pursuits. Shibata was eleven years old at the onset of World War II when the family was interned at Tule Lake. When they finally returned to Mt. Eden, they found their home, greenhouse, and gardens had been vandalized, but they worked to recover them. Shibata completed high school and for two years attended the University of California, Berkeley, where she received an associate of arts degree. She then moved to Los Angeles and attended UCLA, where she studied painting with William Brice, Gordon Nunes, and Dorothy Brown and received her B.A. in fine arts. Shibata later received an M.A. in fine arts from UCLA with a focus in ceramics and during this time studied with Laura Anderson. Shibata also taught at UCLA for one year. In 1960, she moved to Tokyo, where she lived and painted for two years.

Shibata's work from the 1950s is primarily large-format

Yayoi Ailene Shibata, ca. 1955

nonobjective oils. A 1965 show at the Paul Rivas Gallery featured paintings of abstracted plant forms employing minimal colors with slight variations in hues, described as "poetic and delicate." More recent work has included smaller-scale acrylic, or collage with acrylic, paintings that deal with themes of personal identity and family history. A 1992 exhibition at the Angels Gate Cultural Center featured a series of works entitled *By Executive Order*, addressing her internment experience.

Sogioka, Gene I.

BORN: December 21, 1914, Irwindale, CA

DIED: February 21, 1988, Larchmont, NY

RESIDENCES: 1914–1916, Irwindale, CA § 1916–1928, Hiroshima, Japan § 1928–1942, Irwindale, CA § 1942, Baldwin Park, Covina, Fresno, and Sanger, CA; Colorado River Relocation Center, Poston, AZ § 1943–1988, New York and Larchmont, NY

MEDIA: watercolor painting, illustration, animation, and murals

ART EDUCATION: ca. 1932–1933, Pomona College, Claremont, CA § 1935–1938, Chouinard Art Institute, Los Angeles

SELECTED GROUP EXHIBITIONS: California Watercolor Society, Los Angeles, 1937 § Los Angeles County Fair, 1939 § *San Francisco Art Association*, San Francisco Museum of Art, 1941 § *Cambridge Art Exhibit of 10 Relocation Centers*, Cambridge, MA, 1943

SELECTED COLLECTION: Cornell University Library, Ithaca, NY

SELECTED BIBLIOGRAPHY: Gesensway, Deborah, and Mindy Roseman. *Beyond Words: Images from America's Concentration Camps*. Ithaca, NY: Cornell University Press, 1987. § Ralph, Cecile. E-mail to CAAABS researcher. September 2000. Asian American Art Project, Stanford University.

You have to create something! You have to be different. If you're going to paint something just to see what it looks like—like a photograph—there's no sense painting it.

GENE I. SOGIOKA
Gesensway and Roseman, *Beyond Words*, 152

AT THE AGE OF one and a half, California-born Gene Sogioka was taken to Japan to be raised by his maternal grandmother, who lived outside Hiroshima. At fourteen, he returned to California, where he was initially placed in a second-grade class because he did not know English; he eventually graduated from Covina High School in 1931. He attended Pomona College for two years, but seeing that college-educated Japanese Americans were often relegated to low-paying jobs in fields such as gardening or produce work, he decided that a career in art

might place him in more open-minded environments, where he could be accepted and advance professionally.

Sogioka attended the Chouinard Art Institute and studied fine and commercial art on a full scholarship for three years. Fellow students included **Chris Ishii**, Howard Yamagata, Sue Matsueda, and Kay Watanabe. During this time he was also an adjunct art instructor at Scripps College, in Claremont, California, and assisted Millard Sheets on two murals, including one for the 1939 Golden Gate International Exposition, held on Treasure Island in San Francisco.

Sogioka married Mine Mayebo in 1940. He was employed as a background artist for Walt Disney Studios from 1940 to 1942, where he worked on *Fantasia, Dumbo, Bambi*, and several short animated films. He exhibited *Sea Junction* in the San Francisco Art Association watercolor show in 1941, alongside work by artists including **Chee Chin S. Cheung Lee**, **Miyoko Ito**, and **Dong Kingman**. A daughter was born in January 1942, a month after the bombing of Pearl Harbor, and in an attempt to avoid internment the family moved in April to Fresno, which at that time was still considered a "free zone." When the Japanese Americans in Fresno were evacuated, Sogioka and his wife and daughter moved to Sanger, California, and ultimately spent the month of June hiding in canyons before they were sent to the Poston Relocation Center in Arizona.

At Poston, Sogioka taught art, painted the camp's Buddhist shrine (including the walls and curtains), and was commissioned by the Bureau of Sociological Research under Dr. Alexander Leighton to make paintings documenting the camp. Sogioka produced one hundred fifty paintings of camp life that are now part of the permanent archive at the Cornell University Library. In the late 1980s, two graduate students at Cornell, Mindy Roseman and Deborah Gesensway, discovered Sogioka's paintings, and they contacted and interviewed Sogioka and other interned artists, ultimately publishing *Beyond Words: Images from America's Concentration Camps* in 1987. Prior to meeting Roseman and Gesensway, Sogioka had not known the whereabouts of his internment-era paintings.

In 1943 Sogioka was released from camp and settled in New York City. His wife and daughter joined him in January 1944, and other children were born in 1947 and 1951. His daughter Cecile Ralph later recalled, "Dad moved our family to New York City with hopes for better job opportunities, a less racist atmosphere, and also because of his interest in painting the culture of the urban scene and the lives of the people in northeast America." Sogioka first worked for a number of animation studios, but eventually he found employment in commercial art.

Throughout his life Sogioka maintained an interest in photography and painting but said that the years of commercial art and illustration work had affected his technique and spontaneity. He became more prolific late in life after several trips to Jamaica, where he began to document the lives of fishermen on the west coast of the island.

Susie and Henry Sugimoto at the opening of
his one-person exhibition at Hendrix College
in Conway, Arkansas, February 1944

Sugimoto, Henry

BORN: March 12, 1900, Wakayama, Japan

DIED: May 8, 1990, New York, NY

RESIDENCES: 1900–1919, Wakayama, Japan § 1919–
1924, Hanford, CA § 1924–1928, Oakland, CA §
1929–1932, Paris and Voulangis, France § 1932–1934,
Hanford, CA § 1934–1936, San Francisco and Oakland,
CA § 1936–1942, Hanford, CA § 1942–1944, Pinedale
Assembly Center, Fresno, CA; Jerome Relocation Center,
Denson, AR § 1944–1945, Rohwer Relocation Center,
Rohwer, AR § 1945–1990, New York, NY

MEDIA: oil, watercolor, and ink painting; printmaking; and
murals

ART EDUCATION: 1924, 1929, University of California,
Berkeley § 1924–1928, California School of Arts and
Crafts, Oakland, CA § 1928–1929, California School
of Fine Arts, San Francisco § 1929–1931, Académie
Colarossi, Paris

SELECTED SOLO EXHIBITIONS: *Exhibition of Paintings by
Henry Sugimoto*, California Palace of the Legion of Honor,
San Francisco, 1933 § Hendrix College, Conway, AR,
1944 § *Henry Sugimoto: Painting an American Experience*,
Japanese American National Museum, Los Angeles, 2001

SELECTED GROUP EXHIBITIONS: *Salon d'Automne*, Paris,
1931 § *Four Japanese Artists of the Pacific Coast*, Califor-
nia Palace of the Legion of Honor, San Francisco, 1934
(with Matsuta Narahara, Kenjiro Nomura, and Kanekichi
Tokita) § *San Francisco Art Association*, San Francisco
Museum of Art, 1935 (inaugural), 1936–1940, 1944,
1947, 1950 § *California Art Today*, Golden Gate Interna-
tional Exposition, San Francisco, 1940 § *The Japanese
American Artists Group*, The Riverside Museum, New York,

1947 § *The View from Within*, Wight Art Gallery, Univer-
sity of California, Los Angeles, 1992 § *Made in California:
Art, Image, and Identity, 1900–2000*, Los Angeles County
Museum of Art, 2000

SELECTED COLLECTIONS: Fine Arts Museums of San
Francisco § Japanese American National Museum,
Los Angeles § Smithsonian National Museum of
American History § Tokyo National Museum of Modern
Art § Wakayama Modern Art Museum, Japan

SELECTED BIBLIOGRAPHY: Gesensway, Deborah, and Mindy
Roseman. *Beyond Words: Images from America's Concen-
tration Camps*. Ithaca, NY: Cornell University Press,
1987. § Higa, Karin M. *The View from Within: Japanese
American Art from the Internment Camps, 1942–1945*.
Los Angeles: Japanese American National Museum,
1992. § "Japanese American Gloom on Canvas." *New
York Times*, March 28, 2001, B1. § Kim, Kristine. *Henry
Sugimoto: Painting an American Experience*. Los Angeles:
Japanese American National Museum, and Berkeley:
Heyday Books, 2001.

*When World War II broke out we Japanese [120,000] were
confined to the concentration camps. I thought that my artist
life was finished; on the contrary, the works—my paintings
that I had done in the camp—are more valuable and important
works as a historical documentation in [the] USA and Japan.*

HENRY SUGIMOTO
Boris Musich. "Interview with Henry Sugimoto."
Unpublished paper. December 1986, 6. Collection
Asian American Art Project, Stanford University.

BEST KNOWN FOR the important body of work he created while
interned during World War II, Henry Sugimoto had a career
that both transcended the three-and-a-half-year experience
and was forever affected by it. Born in Japan, Sugimoto was
raised primarily by his grandparents. His father had gone to
California when Sugimoto was a baby, and his mother joined
his father in Hanford, California, when Sugimoto was nine.
At nineteen, he joined his parents. He studied at Hanford
High School and then enrolled at the University of California,
Berkeley. Sugimoto soon realized he did not wish to pursue
the medical career that his father had envisioned for him, and
when a friend took him to the campus of the California School
of Arts and Crafts, he enrolled at the school. He focused his
studies on oil painting, since he admired Cézanne and van
Gogh as well as the contemporary French artist Maurice de
Vlaminck. He graduated with honors and subsequently took
classes at the California School of Fine Arts. Yet despite fre-
quent visits to exhibitions at local museums, Sugimoto was not
satisfied with the artwork he was seeing and decided to travel
to Europe to expand his knowledge.

Knowing no one in Paris and little prepared for his ar-
rival, Sugimoto hoped to meet someone who was Japanese,

and fatefully the first Japanese person he approached on the street was the artist **Noboru Foujioka**. Sugimoto became part of the community of Japanese artists in Paris, which included Tsugouharu Foujita; Sugimoto studied painting at the Académie Colarossi and French at the Alliance Française. In 1930, after a painting he submitted was not included in the prestigious *Salon d'Automne*, a depressed Sugimoto traveled to the French countryside to sketch. Enjoying his surroundings so much, he stayed in the area for most of his remaining time in France. This focused period of art-making resulted in a strong body of work, and when he submitted again to the *Salon d'Automne* in 1931, his painting was selected for exhibition. While in France, Sugimoto developed a palette including rich browns, moody grays, and earth tones highlighted with areas of blue and green, and these colors would continue to appear in his work into the 1940s.

Once Sugimoto was back in California, his former anatomy instructor was so impressed with his French paintings that he recommended that Dr. Walter Heil, director of the California Palace of the Legion of Honor, look at Sugimoto's work, and Heil presented a solo exhibition of Sugimoto's paintings in 1933. Receiving critical acclaim, Sugimoto began participating in exhibitions throughout the state. He married Susie Tagawa in 1934, and the couple lived in Hanford, where Sugimoto worked at a laundry, taught part-time, and continued to paint. In the mid- and late 1930s, he took several extended painting trips to Yosemite, which resulted in larger-scale works. Other destinations included Carmel, which reminded him of Japan, and Mexico, where he stayed for a month in 1939, painting primarily in Mexico City and Taxco. His time in Mexico inspired him to incorporate urban architecture, people, and narratives such as those he saw in Mexican murals into his work. The influence of artists such as Diego Rivera and José Clemente Orozco can be seen in the monumental quality of figures in his paintings from this time.

World War II abruptly put a halt to Sugimoto's promising career. While interned, first in Fresno, California, and then in Jerome, Arkansas, Sugimoto initially painted in secret, depicting narrative scenes of internment as well as the events that preceded his family's incarceration. He taught art in the camp high school and in adult night classes. His wife, young daughter, and mother figure prominently in many of his paintings. Visitors from Hendrix College in Conway, Arkansas, came to the camp and, impressed by Sugimoto's work, arranged for an exhibition of his work at the school in 1944. After Jerome was closed in June 1944, the family was moved to the Rohwer Relocation Center, where they lived for an additional year. In all, Sugimoto completed more than one hundred paintings, along with numerous sketches, while interned.

Following release, the Sugimotos moved to New York, where a second child was born and Sugimoto found permanent employment creating fabric patterns at a textile company. At the age of sixty-two, he retired and focused again on painting. Returning to France for a year, Sugimoto visited old friends, including Tsugouharu Foujita. He then traveled to Japan, where he was reunited with family members and met with artists **Takeo Edward Terada** and Tōgō Seiji, who invited him to submit work to the Nika Kai annual exhibition. His submission was accepted, allowing him to participate in the exhibition annually. He also completed a mural for the city of Wakayama. In New York he began to exhibit more frequently, and in the 1960s, he started to explore printmaking, reworking many of his internment paintings. In the 1960s and 1970s, he created a series of works depicting the Japanese immigrant experience. In the 1970s, Sugimoto became a vocal participant in the movement to tell the history of Japanese internment and passionately testified before the U.S. Commission on Wartime Relocation and Internment of Civilians.

Suski, Julia

BORN: March 6, 1904, San Francisco, CA

DIED: September 20, 1996, Steilacoom, WA

RESIDENCES: 1904–1906, San Francisco, CA § 1906–1942, Los Angeles, CA § 1942–1945, Santa Anita Assembly Center, Santa Anita, CA; Heart Mountain Relocation Center, Heart Mountain, WY § 1945–1950, New Rochelle, NY § 1950–1965, Larchmont, NY § 1965–1996, Larchmont, NY, and Steilacoom, WA

MEDIA: illustration

SELECTED BIBLIOGRAPHY: Japanese-American Internee Data File, 1942–1946. File number 700006. Records of the War Relocation Authority. National Archives, Washington, D.C. § 1920 Federal Population Census. Los Angeles, Los Angeles, California. Roll T625_109, Page 37A, Enumeration District 234, Image 189.0. National Archives, Washington, D.C. § 1930 Federal Population Census. Los Angeles, Los Angeles, California. Roll 164, Page 11A, Enumeration District 735, Image 296.0. National Archives, Washington, D.C. § *Rafu Shimpo* (Los Angeles). August 1, 1926, 3. § *Rafu Shimpo* (Los Angeles), September 24, 1928, 3. § *Rafu Shimpo* (Los Angeles), April 25, 1933, 10. § Suski, P. M. *My 50 Years in America*. Hollywood: W. M. Hawley, 1960.

JULIA SUSKI'S FATHER, P. M. Suski, arrived in the United States in 1899, changing his name from Susuki to Suski. A photographer in Japan, he worked for I. W. Taber's studio in San Francisco retouching negatives and engravings on woodblocks prior to the earthquake. Following the quake, he and his wife and young daughter, Julia, moved to Los Angeles, where he ran his own photography studio. He eventually studied medicine at the University of Southern California, began a medical

practice in Little Tokyo, and was a published author. In this progressive household, where both art and science were valued, Julia Suski grew up.

As the eldest of seven children, Julia Suski herself studied medicine at the University of Southern California after graduating from Los Angeles High School, but she soon switched to music and art classes. After college Suski became a presence on the staff of the *Rafu Shimpo* newspaper. There she created highly stylized illustrations, primarily of women, with accompanying captions that humorously detailed the concerns of the "modern woman." These illustrations appeared in issues between 1926 and 1929. It is likely that Suski also authored the columns "What Shall I Wear" (written by "Julie") and "Judie," both of which discussed clothing and fashion, and which included illustrations that appear to be by Suski. Starting in 1928, stories referencing Suski's work as a piano teacher begin to appear in the newspaper, and her work as an illustrator decreased.

In 1933 Suski married successful artist **Robert Kuwahara**, who at that time was working as an illustrator for Walt Disney Studios. Artist **Gyo Fujikawa**, who also worked at Disney at the time, served as Suski's maid of honor at the ceremony. The family, which by 1941 included two sons, was interned first at the Santa Anita Assembly Center and then at the Heart Mountain Relocation Center. Robert Kuwahara was released in 1943 to work in Chicago. The family was reunited in 1945, when Suski and their children were released. After internment, they settled in New York State.

Suzuki, James (Jimi) H.

BORN: 1933, Yokohama, Japan

RESIDENCES: 1933–1952, Japan § 1952, Los Angeles, CA, and Portland, ME § 1953–1954, Washington, D.C. § 1955–1962, New York, NY § 1962–2001, Berkeley, Oakland, and Davis, CA § 2001–present, Kawasaki, Japan

MEDIA: painting, printmaking, and sculpture

ART EDUCATION: 1952, School of Fine Arts, Portland, ME § 1953–1954, Corcoran School of Art, Washington, D.C.

SELECTED SOLO EXHIBITIONS: Graham Gallery, New York, 1957–1961 § University of California, Berkeley, 1963 § Nihonbashi Gallery, Tokyo, 1963 § Berkeley Art Center, Berkeley, CA, 1971 § Candy Store Gallery, Folsom, CA, 1974 § Henry Miller Memorial Library, Big Sur, CA, 1991

SELECTED GROUP EXHIBITIONS: *Corcoran Biennial*, Corcoran Gallery of Art, Washington, D.C., 1956, 1958, 1960 § *Contemporary Painters of Japanese Origin in America*, Institute of Contemporary Art, Boston,

1958 § *Painting and Sculpture Annual*, Whitney Museum of American Art, New York, 1959 § *Seven from Oakland*, Oakland Museum of California, 1976

SELECTED COLLECTIONS: Crocker Art Museum, Sacramento, CA § National Museum of Modern Art, Tokyo § Oakland Museum of California

SELECTED BIBLIOGRAPHY: Albright, Thomas. *Art in the San Francisco Bay Area, 1945–1980: An Illustrated History*. Berkeley, CA: University of California Press, 1985. § Suzuki, James. Biographical Folder. Oakland Museum of California. § Suzuki, Jimi. *Best Time*. Japan: Jimi Suzuki, 1997. § Wechsler, Jeffrey, ed. *Asian Traditions/Modern Expressions: Asian American Artists and Abstraction, 1945–1970*. New York: Abrams in association with the Jane Voorhees Zimmerli Art Museum, Rutgers, the State University of New Jersey, 1997.

I'm interested in an idea of art beneficial to [the] human race...for humanity.

JAMES H. SUZUKI
Survey Form, ca. 1975,
Biographical Folder, Oakland Museum of California

JAMES SUZUKI'S DESIRE to study in the United States was influenced by both his father, a successful businessman who had studied at Stanford University, and Japanese artist **Yoshio Markino**, who had achieved great success in London prior to World War II. Markino was forced to return to Japan during the war and lived for a time at the Suzuki home, with the elder Suzuki as his patron. James Suzuki studied with Markino, who was known for using the "silk veil" painting style to depict atmospheric scenes of foggy London, and Markino encouraged Suzuki to study in the West.

At nineteen, Suzuki traveled to Los Angeles, but he found the city too commercial. Looking for a completely different place to live and study, Suzuki chose Maine and attended the School of Fine Arts in Portland for a year. After receiving a scholarship, he moved to Washington, D.C., to study at the Corcoran School of Art. Suzuki began to exhibit, most notably at the Graham Gallery in New York, where he held numerous solo shows in the late 1950s. While living in New York he met many artists, including Kenzo Okada, **Saburo Hasegawa**, Jackson Pollock, Jim Dine, Jasper Johns, and Marcel Duchamp. His work from this time is characterized by abstraction influenced by the colors of impressionism, and by impasto painting of pointillist-like small squares and circles of color. Critics praised the serene nature of his paintings, which were frequently interpreted as manifestations of his Japanese heritage.

In 1958 and 1959 Suzuki received the prestigious John Hay Whitney Opportunity Fellowship. By the early 1960s, in reaction to what he felt was the stereotypical reading of his previ-

James Suzuki, ca. 1970

ous work in an era rife with fascination for all things Asian, he began to explore bolder colors and a painting style influenced by the early works of de Kooning and Pollack. A move to the San Francisco Bay Area in 1962 provided greater freedom, and he started creating bronze sculptural pieces in the studio of his friend Peter Voulkos. His hard-edged painting from this period reflects the influence of sculpture. Suzuki exhibited frequently at the Braunstein/Quay Gallery in San Francisco and taught widely, including at the University of California, Berkeley; the California College of Arts and Crafts, Oakland; the University of California, Davis; and the University of Kentucky. His works from the 1970s, including assemblage pieces and oil paintings that looked like collage, were more figurative and political with a surrealist influence. In the early 1970s, Suzuki began his tenure at California State University, Sacramento, where he taught until his retirement in 2000. He currently lives in Japan.

Suzuki, Lewis

BORN: November 29, 1920, Los Angeles, CA

RESIDENCES: 1920–1926, Los Angeles, CA § 1926–1929, Dos Palos, CA § 1929–1939, Tokyo, Japan § 1939–1941, Los Angeles, CA § 1941, Washington, D.C. § 1942–1943, New York, NY § 1943–1945, Camp Savage, MN (U.S. military service) § 1945–1952, New York, NY § 1953–present, Berkeley, CA

MEDIA: watercolor painting and printmaking

ART EDUCATION: 1939, Kawabata Art Academy, Tokyo § 1940–1941, Otis Art Institute, Los Angeles § 1941,

Corcoran School of Art, Washington, D.C. § 1945, Art Students League, New York § 1964–1965, California College of Arts and Crafts, Oakland, CA

SELECTED SOLO EXHIBITION: *Nikkei Journey: Retrospective by Watercolorists Lewis Suzuki and Lawrence Yamamoto*, National Japanese American Historical Society, San Francisco, 2003

SELECTED GROUP EXHIBITIONS: *Society of Western Artists*, de Young Museum, San Francisco, 1966–1969 § California State Fair, Sacramento, 1968–1975 § American Watercolor Society, 1968–1969 § *National Exhibition of Watercolor, USA*, Springfield Art Museum, Springfield, MO, 1971, 1995 § *Great Western Artists Show*, Washington Square, Portland, OR, 1986

SELECTED BIBLIOGRAPHY: Bryant, Dorothy. "The Suzuki Odyssey." *Berkeley Daily Planet*, February 1, 2005. § Harrington, Deedee. "Strength of Human Spirit Illuminates Paintings of Third World Squalor." *The Oregonian*, March 12, 1986. § "'Smokey Mountain' in U.S. Exhibition." *Philippine News*, May 24–30, 1995. § Suzuki, Lewis. CAAABS project interview. March 17, 2001. Berkeley, CA.

I feel that art has a place in enriching the life of humanity.... Through my art, I try to strengthen that part of culture. And I feel that the arts should project the future of human society. To me it cannot be non-objective or abstract in that sense.

LEWIS SUZUKI
Harrington, "Strength of Human Spirit"

LEWIS SUZUKI'S FATHER initially entered San Francisco in 1912 by jumping ship, after which he made his way to Los Angeles and supported himself as a musician. Eventually returning to Japan and marrying, he and his wife moved to Los Angeles, where he opened a dry-cleaning business, and where Lewis Suzuki was born in 1920. In 1929, Suzuki's father died, and his mother returned to Japan with her six children. There, Suzuki excelled in the art programs in his primary school, attended the Kawabata Art Academy in Tokyo, and began exploring the possibility of studying art in the United States. In 1939, a fellow passenger on a commuter train saw him looking at a catalog of American art schools, and upon learning that Suzuki had been born in the United States, he strongly suggested that Suzuki leave Japan immediately. Suzuki later recalled how the man showed him photos of the atrocities committed by the Japanese in Nanking, and he warned that if Suzuki stayed in the country he would be forced to join the military and participate in such acts. He gave Suzuki the name of a man to contact in Los Angeles, which Suzuki did when he returned to California later that year. The man, Edo Mita, helped him get settled in Los Angeles, where Suzuki completed high school, took classes at the Otis Art Institute, and worked as a house-

Lewis Suzuki, 1952

boy. Edo invited Suzuki to Marxist study groups at his house frequented by Japanese members of the film industry who discussed their concerns of Japan's growing militarism.

Suzuki moved to Washington, D.C., in 1941, where he worked at the Japanese embassy primarily as a "tea boy" and took classes at the Corcoran School of Art. After the bombing of Pearl Harbor, all embassy officials were to return to Japan; however, Suzuki wished to remain in the United States. He joined the U.S. Army and taught Japanese at the Military Intelligence Language School in Minneapolis. After the war he moved to New York, where he studied at the Art Students League and earned a living as a cabinetmaker. He became politically active in issues of peace and justice, and he believed in the role of art in furthering these causes. He traveled to postwar Hiroshima and later would create the graphic work *No More Hiroshimas* and other peace posters for the American Friends Service Committee.

In 1952, Suzuki traveled to China with the American Peace Crusade and met his wife, Mary, an American citizen who had grown up in the Philippines and who was in China with a Quaker group. The couple married and settled in Berkeley, California, where Mary was attending school. Suzuki continued to work as a cabinetmaker while also painting, teaching, and exhibiting. Eventually he was able to make art full time.

Suzuki was a member of the politically active Graphic Arts Workshop from 1953 to 1963. He has also been a participant in the many art fairs held throughout the state, preferring to sell his art directly to people rather than through a gallery. Shows at shopping malls and parks, he thinks, are a way to connect with people who may not visit a gallery or have a strong knowledge of art. Working primarily in watercolors, his works are loosely painted, brightly colored still lifes, landscapes, seascapes, or city scenes. A trip to Manila in 1986 prompted him to make *Smoky Mountain*, which depicts the dire conditions of the community that existed on the city's landfill and has become a popular, controversial image. Today Suzuki continues to work in his studio on Grant Street in Berkeley.

Suzuki, Sakari

BORN: October 16, 1899, Iwate, Japan

DIED: January 1995, Chicago, IL

RESIDENCES: 1899–1918, Iwate, Japan § 1918–1927, San Francisco, CA § 1928–ca. 1929, Berkeley, CA § ca. 1929–ca. 1951, New York, NY § ca. 1951–1995, Chicago, IL

MEDIA: oil painting and murals

ART EDUCATION: 1924, California School of Fine Arts, San Francisco

SELECTED SOLO EXHIBITION: Artists' Gallery, New York, 1951

SELECTED GROUP EXHIBITIONS: *Sangenshoku Ga Kai and Shaku-do-sha Association Joint Exhibition*, Kinmon Gakuen, San Francisco, and Central Art Gallery, Los Angeles, 1927 § *San Francisco Art Association*, California School of Fine Arts, 1927–1929 § *Exhibition by Japanese Artists in New York*, ACA Gallery, New York, 1936 § *American Artists Congress*, New York, 1937 § New Jersey College for Women, Newark, 1945 § *The Japanese American Artists Group*, The Riverside Museum, New York, 1947

SELECTED COLLECTION: Smithsonian American Art Museum, Washington, D.C.

SELECTED BIBLIOGRAPHY: "Art Shows Afford Diverse Interests." *New York Times*, January 13, 1951, 13. § Falk, Peter Hastings, ed. *Who Was Who in American Art*. Madison, CT.: Sound View, 1985. § *Japan in America: Eitaro Ishigaki and Other Japanese Artists in the Pre–World War II United States*. Wakayama, Japan: Museum of Modern Art, Wakayama, 1997. § *Passenger Lists of Vessels Arriving at San Francisco, 1893–1953*. Roll 107, Page 28. National Archives, Washington, D.C.

SHIP PASSENGER RECORDS indicate that Sakari Suzuki came to the United States at the age of eighteen to join his father. By 1924 he was a student at the California School of Fine Arts. Suzuki exhibited frequently, beginning with the exhibition of the San Francisco group Sangenshoku Ga Kai (Three Primary Colors Art Group) in their joint show with the Shaku-do-sha group from Los Angeles. Others participating in this show included **Teikichi Hikoyama**, **Yotoku Miyagi**, **Koichi Nomiyama**, and **Kiyoo Harry Nobuyuki**. Suzuki exhibited landscapes, still lifes, and a self-portrait in San Francisco Art Association shows; four of his paintings were included in the 1929 exhibition.

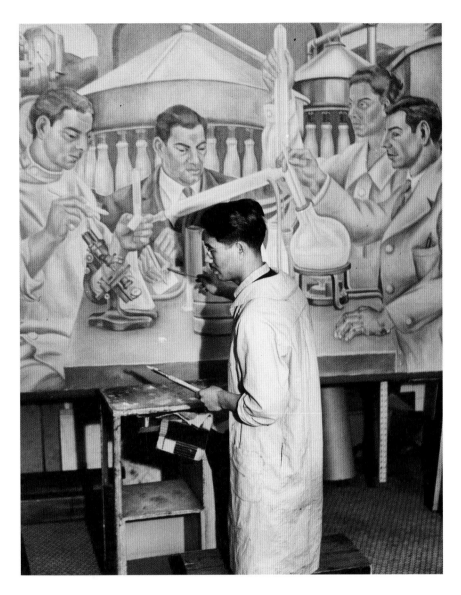

Sakari Suzuki working on
a mural for Willard Parker
Hospital, New York, 1936

By 1931, Suzuki was living on the East Coast, and that summer he shared a house in Woodstock, New York, with **Hideo Benjamin Noda** and **Jack Chikamichi Yamasaki**, both of whom he likely knew from San Francisco. Suzuki worked for the WPA and in 1936 created a mural for the Willard Parker Hospital in New York City entitled *Preventative Medicine*. In 1938, Suzuki was an instructor at the American Artists School in New York, where Anton Refregier was also teaching at the time.

Suzuki participated in the Japanese American Artists Group exhibition at the Riverside Museum in 1947 along with **Isamu Noguchi**, **Mine Okubo**, **Henry Sugimoto**, **Eitaro Ishigaki**, and **Taro Yashima**. A 1951 review in the *New York Times* of his show at the Artists' Gallery described Suzuki as a representational artist working in bright colors who "chops his subject matter—landscapes, figures and still-life—into tightly organized prismatic facets, zigzag patterns of much animation."

Suzuki moved to Chicago in the 1950s, where he lived until his death in 1995 at the age of ninety-five.

Suzuki, Shunryu
(Shogaku Shunryu Suzuki)

BORN: May 18, 1904, Hiratsuka, Kanagawa, Japan

DIED: December 4, 1971, San Francisco, CA

RESIDENCES: 1904–1959, Japan, various locations §
1959–1971, San Francisco and Carmel Valley, CA

MEDIA: ink painting

SELECTED GROUP EXHIBITIONS: *With New Eyes: Toward An Asian American Art History in the West*, San Francisco State University, 1995 § *Beat Culture and the New America: 1950–1965*, de Young Museum, 1996 § *Zen and Modern Art: Echoes of Buddhism in Western Paintings and Prints*, University Art Gallery, California State University, Hayward, 2003/4

SELECTED COLLECTION: San Francisco Zen Center

SELECTED BIBLIOGRAPHY: Chadwick, David. *Crooked

Shunryu Suzuki

Cucumber: The Life and Zen Teaching of Shunryu Suzuki. New York: Broadway Books, 1999. § Suzuki, Shunryu. *Not Always So: Practicing the True Spirit of Zen.* New York: HarperCollins, 2002. § Suzuki, Shunryu. *Zen Mind/ Beginner's Mind.* New York: Weatherhill, 1970.

We should practice with a beginner's real innocence, devoid of ideas of good or bad, gain or loss.

SHUNRYU SUZUKI
Chadwick, *Crooked Cucumber,* 194

ALTHOUGH SHUNRYU SUZUKI was not known as a professional artist, the Soto Zen priest had an enormous influence on the California cultural landscape. The son of a temple abbot in Japan, Suzuki was educated in Buddhist schools, studied at the Komazawa Daigakurin University (Soto College) from 1926 to 1930, and trained as a monk at Eiheiji Temple. After the tragic death of his first wife and following a personal curiosity, Shunryu Suzuki in 1959 accepted the position of abbot at San Francisco's Soto Mission, Sokoji, succeeding the Reverend **Hodo Tobase**, who had returned to Japan in 1957. Shortly thereafter, Suzuki began teaching in English and built a large English-language Zen circle in addition to the Japanese community congregation.

With his English-speaking students, Suzuki established a monastery at Tassajara in the Carmel Highlands during the mid-1960s, and fundraising "Zenefits" featured performances by rock bands, including the Grateful Dead in 1966. In January 1967 at the Human Be-In, Suzuki sat onstage with Allen Ginsberg, Gary Snyder, and Timothy Leary, a position that suggested Suzuki's developing prominence as the best-known Zen priest in California. In 1969, a separate English-speaking temple was established in a classic red brick residence building designed by Julia Morgan on Page Street in San Francisco.

Suzuki's traditional calligraphy was often presented as gifts, and he sometimes experimented with unusual materials. A compilation of transcribed teachings entitled *Zen Mind/ Beginner's Mind,* in which several of his calligraphy works were reproduced, was published in 1970 and sold more than a million copies. Artists such as filmmaker Al Wong and painter Mike Dixon studied with him at the San Francisco Zen Center and Tassajara, and noted intellectuals and religious leaders including Tibetan teacher Chögyam Trungpa Rinpoche, Joseph Campbell, and Alan Watts had important relationships with Suzuki and the Zen Center. Even before Suzuki's death from cancer in 1971, the Zen Center had a notable influence on California gardening, food, architecture, and religious practice.

Taira, Frank

BORN: August 21, 1913, San Francisco, CA

RESIDENCES: 1913–1942, San Francisco, CA § 1942–1944, Santa Anita Assembly Center, Santa Anita, CA; Topaz Relocation Center, Topaz, UT § 1944–present, New York, NY

MEDIA: oil and watercolor painting, and sculpture

ART EDUCATION: 1935–1938, California School of Fine Arts, San Francisco § 1945, Columbia University, New York § 1956, Art Students League, New York § 1957, New School for Social Research, New York

SELECTED SOLO EXHIBITIONS: Hudson Guild Gallery, New York, 1967 § *Frank Taira: Oils,* Caravan House Gallery, New York, 1980 § *Frank Taira: The Evolution of an American Artist,* Garzoli Gallery, San Rafael, CA, 1992 § *Frank Taira: Small Works,* ArtsForum Gallery, New York, 1999 § *Frank Taira,* Hudson Guild Gallery, New York, 2005

SELECTED GROUP EXHIBITIONS: Oakland Municipal Gallery, Oakland, CA, 1939 § *San Francisco Art Association,* San Francisco Museum of Art, 1941 § Friends Center, Cambridge, MA, 1943 § *Knickerbocker Artists,* New York, 1968 § National Academy of Design, New York, 1976 § Salmagundi Club, New York, 1983 § *First International Biennial of Contemporary Art,* Trevi Flash Museum, Trevi, Italy, 1998

SELECTED BIBLIOGRAPHY: *Encyclopedia of Living Artists,* 10th ed. Penn Valley, CA: ArtNetwork, 1997. § "40 Years of Taira Paintings on Display in San Rafael." *Nichi Bei Times* (San Francisco), July 21, 1992. § "Gallery Exhibits Paintings of JA Artist Frank Taira." *Hokubei Mainichi* (San Francisco), July 14, 1992. § Taira, Frank. Letter to CAAABS project researcher. July 2001. Asian American Art Project, Stanford University.

*I try to control both strength and sensitivity while working....
all art must resort to personal feelings, the harmony and vision
within you.*

<div align="right">

FRANK TAIRA
"Gallery Exhibits Paintings
of JA Artist Frank Taira"

</div>

WHEN FRANK TAIRA was fifteen years old, his family moved to Japan. Taira, however, who was born in San Francisco, couldn't imagine leaving his hometown, his friends, and the art teachers from whom he had received encouragement, and so he chose to stay behind. Taira finished high school while working as a houseboy and wanted to attend art school, but he did not have enough money for tuition. Seeing a competition in a Japanese American newspaper to create a cartoon promoting Japanese American friendship, he submitted a drawing and won. With his winnings, he was able to enroll for one month at the California School of Fine Arts. Seeing Taira's artistic talents, administrators at the school awarded him a scholarship that covered his tuition for the remainder of his education there. He studied painting and drawing with Lee Randolph, Otis Oldfield, and Victor Arnautoff and found this formal academic training pivotal to his career. At this time he also studied voice and classical guitar at the San Francisco Conservatory of Music.

Self-portrait by Frank Taira, 1954

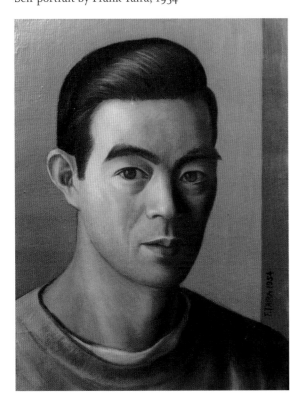

Just as Taira began to exhibit his paintings and gain recognition for his work, the United States entered World War II. Taira was interned first at the Santa Anita Assembly Center and then at the Topaz Relocation Center, where he taught art classes with **Chiura Obata**, **Mine Okubo**, and **George Matsusaburo Hibi**. His work was included in the 1943 exhibition organized by the Friends Center in Cambridge, Massachusetts, which presented work of interned artists. He won the show's award for best portrait.

After his release from Topaz, Taira moved to New York, where he attended Columbia University in 1945 and later took classes at the Art Students League and the New School for Social Research. Taira noted the changes taking place in New York's art world resulting from the growing influence of abstract expressionism, and he began working in a semi-abstract, cubist style, which he continued for almost ten years. Religious themes often figure in these works that use an almost mosaic-like approach to shape and color. To support himself, Taira worked as a china decorator at the Charles China Decorating Company and also made and sold fine jewelry. In the early 1950s, Taira was commissioned to paint a five-by-six-foot canvas for the china company workers' union retirement home.

Since about 1960, Taira has returned to more realistic landscapes and portraits, sometimes tinged with surrealist elements. He has also created a body of small figurative works in bronze. Finding his New York environment especially inspirational, Taira often paints scenes from Central Park. Taira has continued to paint, exhibit, and win awards into his nineties, and says he finds his artwork a source of peace and tranquility.

Takahashi, Katsuzo

BORN: March 2, 1860, Watari, Miyagi, Japan

DIED: July 15, 1917, Tokyo, Japan

RESIDENCES: 1860–1871, Watari, Miyagi, Japan §
 1871–1875, Hokkaido, Japan § 1875–1877, Tokyo,
 Japan § 1877–1879, Japanese military service and
 Hokkaido, Japan § 1879–1885, Tokyo and Yokohama,
 Japan § 1885–1893, San Francisco, CA § 1893,
 Chicago, IL § 1893–1917, Tokyo and Miyagi, Japan

MEDIA: oil and watercolor painting, and textiles

ART EDUCATION: ca. 1889–1891, California School of Design,
 San Francisco

SELECTED GROUP EXHIBITIONS: *Mechanics' Institute
 Exhibition*, San Francisco, 1889, 1890, 1893, 1895 §
 California State Fair, Sacramento, 1890–1892 §
 California Exhibit, World's Columbian Exposition,
 Chicago, 1893 § California Midwinter International
 Exposition, San Francisco, 1894

Katsuzo
Takahashi

SELECTED COLLECTIONS: Masayoshi Hirano Art Museum, Akita, Japan § University Art Museum, Tokyo National University of Arts and Music

SELECTED BIBLIOGRAPHY: Halteman, Ellen Louise. *Publications in [Southern] California Art 7: Exhibition Records of the San Francisco Art Association, 1872–1915; Mechanics' Institute, 1857–1899; California State Agricultural Society, 1856–1902.* Los Angeles: Dustin Publications, 2000. § *Japanese Artists Who Studied in U.S.A. 1875–1960 (Taiheiyō o koeta Nihon no gakatachi ten).* Wakayama, Japan: Museum of Modern Art, Wakayama, 1987. § Matsuura, Akira, ed. *Takahashi Katsuzo no kaiga.* Privately published, 1982.

KATSUZO TAKAHASHI WAS BORN in Watari in the Miyagi Prefecture to a family of twelve children. When he was eleven, his family moved to a town in Hokkaido, and at fifteen he moved to Tokyo to train as an electrical engineer. Takahashi was drafted to fight in the Seinan War, then returned to Hokkaido, where he worked briefly in a sugar refinery. Interested in painting since childhood, in 1879 Takahashi decided to pursue art and returned to Tokyo to study. He worked in the household of Senjin Oka, a Chinese literature scholar, and studied painting on his own. His next job as a police officer in Chiba enabled him to afford to study painting under a teacher.

By 1885 Takahashi was designing handkerchiefs and shawls in Yokohama. American businessman Charles Fletcher saw Takahashi's work and recruited him, along with thirteen other Japanese artisans, to come and work in his store in San Francisco. Takahashi was hired as a portrait painter. After arriving in San Francisco, however, Takahashi soon became unemployed when Fletcher's business failed. Takahashi worked washing dishes and took classes at the California School of Design. He studied Western painting with Arthur Mathews, Amédée Joullin, and Raymond Yelland and excelled as an artist, receiving an honorable mention award for drawing in 1889, an honorable mention award for oil painting in 1890, and the Avery Gold Medal for oil painting in 1891. In 1893 he exhibited twenty-seven works in the twenty-seventh annual exhibition of the Mechanics' Institute in San Francisco.

In 1893, with the support of architect Samuel Newson, Takahashi moved to Chicago and studied set design and the-

ater backdrop painting. His *Still Life with Swan* won a gold medal at the World's Columbian Exposition in Chicago.

Takahashi returned to Japan in late 1893 and established Shibayama Kenkyūjo (Shibayama Lab) in Shiba, Tokyo, and taught. Influenced by his experiences in Chicago, Takahashi participated in a movement to raise the status of Japanese theater to art and was one of the earliest artists to contribute to Japanese theater set painting.

In 1894 Takahashi exhibited more than twenty of his oil and watercolor paintings in the sixth annual exhibition of the Meiji Bijutsu Kai (Meiji Art Group), including *San Francisco Beach*. This watercolor painting reportedly convinced some young Japanese artists, who had believed in the superiority of oil painting, that watercolors could stand on their own and be used in a way that employed perspective. Another painting by Takahashi in the same exhibition that addressed the Sino-Japanese War was controversial and harshly criticized, and as a result Takahashi did not exhibit with the group again. In 1902, a nude painting by Takahashi shown in the Tomoe exhibition was censored by the police, and these cumulative experiences made him stay away from established art circles and the exhibitions they sponsored. After 1906, Takahashi exhibited his work in independent exhibitions. He showed work described as "traditional" in a 1912 exhibition in Hakodate, Hokkaido, and spent many of his remaining years in his birthplace of Miyagi.

Takayama, Michio

BORN: October 11, 1903, Tateyama, Chiba, Japan

DIED: January 9, 1994, Denver, CO

RESIDENCES: 1903–ca. 1921, Tateyama, Chiba, Japan § ca. 1921–1945, Tokyo, Japan § 1945–1949, Mito, Japan § 1949–1956, Tokyo, Japan § 1956–1967, Los Angeles, CA § 1967–1989, Taos, NM § 1990, Takasaki, Japan § 1991–1994, Denver, CO

MEDIA: oil and ink painting

ART EDUCATION: 1921–1924, Meiji University, Tokyo

SELECTED SOLO EXHIBITIONS: Felix Landau Gallery, Los Angeles, 1958, 1960, 1962, 1968 § *Michio Takayama,* Palm Springs Desert Museum, Palm Springs, CA, 1969, 1978 § Nippon Club, New York, 1988 § *Taos: Michio Takayama Drawings from 1966–1969,* Harwood Museum, Taos, NM, 1999 § *Michio Takayama: A Retrospective,* Harwood Museum, Taos, NM, 2005

SELECTED GROUP EXHIBITIONS: *Artists of Los Angeles and Vicinity,* Los Angeles County Museum, 1957, 1958 § *Japanese Artists Abroad: Europe and America,* The National Museum of Modern Art, Tokyo, Japan, 1965

SELECTED COLLECTIONS: Harwood Museum, Taos, NM § Santa Fe Fine Arts Museum, Santa Fe, NM

SELECTED BIBLIOGRAPHY: Dredge, William. "Japanese Artist's Class Draws Varied Students." *Los Angeles Times*, March 10, 1958, sec. 3, 1. § *Exhibition of Japanese Artists Abroad: Europe and America*. Tokyo: The National Museum of Modern Art, 1965. § "Japanese Abstractionist Pleases Senses, Sensibilities." *Los Angeles Times*, March 13, 1960, sec. 5, 6. § Langsner, Jules. "Art News from Los Angeles." *Art News* 56, no. 10 (February 1958). § Takayama, Wako. CAAABS project interview. February 4, 2000. San Francisco, CA. Transcript, Asian American Art Project, Stanford University.

I conceive of art in dualistic terms—intellect and emotion, straight-line and curve, white and black.

MICHIO TAKAYAMA

Taos: Michio Takayama Drawings from 1966–1969.
Taos, NM: Harwood Museum, 1999, 16.

THE ELDEST SON of wealthy parents, Michio Takayama was exposed to art early in life when his father invited Tokyo artists to paint at the family's country home. Following his graduation from university, Takayama began to work in his family's bank in Tokyo while he studied art with prominent painter Kurihara Shin. Kurihara, who received his training in Europe, took Takayama out into nature for sketching trips, teaching him not only artistic skills but also a more relaxed approach to life. A painting by Takayama that was accepted into a prestigious exhibition brought notoriety to this banker-painter, whose dual careers were seen as highly unusual. At age thirty-six, with a wife and two young children to support, Takayama left the bank permanently to become a professional painter and was immediately disowned by his father.

During the war years of the 1940s, Takayama, like many Japanese artists, was encouraged to paint patriotic scenes and received awards and national recognition for his work. Following the war, the family built a new home in Tokyo in which the art studio predominated. Takayama was extremely active in the Tokyo art community of the early 1950s and exhibited widely; he later dubbed the years his "realism period."

In 1956, Takayama and his wife, Yaye, traveled to California to attend the wedding of their daughter, who was attending Pepperdine University. During their stay Yaye was diagnosed with breast cancer, and the couple remained in Los Angeles for her successful treatment. During this time Takayama's work became increasingly abstract. It attracted the attention of gallery dealer Felix Landau, a leading proponent of California

From left to right: Kurihara Shin, Felix Landau, and Michio Takayama at Felix Landau Gallery, ca. 1958

Henry Takemoto, ca. 1956

modernism, who presented several solo exhibitions of Takayama's paintings that were favorably received. During his eleven years in Los Angeles, Takayama taught painting, first at the Palette Club and later at other studios. A former student who had moved to Taos, New Mexico, invited the Takayamas for a visit, prompting Michio to apply for a Taos-based Wurlitzer Residency Grant, which he received in 1967. Providing accommodations and a stipend, the residency allowed Takayama to focus exclusively on painting and was extended for an unprecedented second year. Following the residency, the couple made Taos their permanent home, and Michio was one of several local artists to gain prestige, benefiting from a period of public interest in abstract expressionist art.

Takayama's early experiences with Kurihara had a significant impact on his work stylistically, as he emulated his mentor's use of the palette knife and thick application of paint; although Takayama's work grew increasingly abstract over time, this method remained. He greatly admired the work of artist Paul Klee and credited him as a strong influence. Michio and Yaye would meet visiting monks from Japan at the Bhodi Mandala Center in New Mexico, where Michio occasionally

gave lessons in *sumi-e* painting. The *Zen Meditation* series of paintings, distinguished by their bold monochromatic brushstrokes, reflects Michio Takayama's Buddhist beliefs. Takayama stopped painting in the late 1980s following the death of his wife and the decline of his own health.

Takemoto, Henry

BORN: 1930, Honolulu, HI

RESIDENCES: 1930–1957, Honolulu, HI § 1957–present, Los Angeles and Claremont, CA

MEDIA: ceramics

ART EDUCATION: 1953–1957, University of Hawaii, Honolulu § 1957–1959, Los Angeles County Art Institute

SELECTED SOLO EXHIBITION: Oregon Ceramic Studio, Portland, OR, 1960

SELECTED GROUP EXHIBITIONS: *New Talent USA, 1959,* traveling exhibition organized by the American Federation of Arts, New York § *Artists of Los Angeles and Vicinity,*

Los Angeles County Museum, 1959 § *Collector: Object/ Environment*, Museum of Contemporary Craft, New York, 1965 § *Abstract Expressionist Ceramics*, Art Gallery, University of California, Irvine, 1966 § *Made in California: Art, Image, and Identity, 1900–2000*, Los Angeles County Museum of Art, 2000 § *Rebels in Clay: Peter Voulkos and the Otis Group*, Grand Central Art Center, Fullerton, CA, 2003

SELECTED COLLECTION: Ruth Chandler Williamson Gallery, Scripps College, Claremont, CA

SELECTED BIBLIOGRAPHY: "Henry Takemoto." *Craft Horizon* 20 (July/August 1960): 44. § Jones, Catherine. "Takemoto Art Headlines Exhibition." *The Oregonian*, June 12, 1960. § La Verdiere, Bruno. "From Monastery to Studio." *Ceramics Monthly* 37, no. 8 (October 1989): 22–28. § MacNaughton, Mary Davis. *Revolution in Clay, The Marer Collection of Contemporary Ceramics.* Claremont, CA: Ruth Chandler Williamson Gallery, Scripps College, and Seattle, WA: University of Washington Press, 1994. § Nagle, Ron. *Ron Nagle: A Survey Exhibition, 1958–1993.* Oakland, CA: Mills College Art Gallery, 1993. § Slivka, Rose. "The New Ceramic Presence." *Craft Horizon* 20 (July/August 1961): 31–37.

BORN IN HONOLULU, Henry Takemoto attended the University of Hawaii, where he studied with Claude Horan. After four years there, Takemoto moved to California and became an early student of Peter Voulkos at the Otis College of Art and Design (then known as the Los Angeles County Art Institute), along with others including Paul Soldner and John Mason. Takemoto was a key participant in the ceramics revolution that took place in California during these years. Like other members of the Voulkos group, he worked in large scale. Takemoto also employed abstract surface treatments, approaching his markings with the sensibility of an abstract expressionist painter instead of that of a traditional potter.

Takemoto was a guest instructor at the California School of Fine Arts in the summer of 1960. Ron Nagle, who at the time was a student at San Francisco State University, attended Takemoto's course and later described it as pivotal—it opened his eyes to what was happening in Southern California and to the possibilities of clay. Takemoto continued to influence students throughout his long teaching career. He taught at Scripps College and the Claremont Graduate School from 1965 to 1969 and at Otis from 1971 to 1974, and again from 1980 to 1983. He also did commercial design work for Interpace Corporation and Wedgwood Pottery in the 1960s.

Takemoto's work is characterized by intricate surface designs of gestural markings, influenced by calligraphy. Large pots and other abstract forms measure as much as three feet across, and some have leg-like bases. Colors frequently appear as blue on a white ground, or earth red on a brown ground.

Tam, Reuben

BORN: January 17, 1916, Kapaa, Kauai, HI

DIED: January 3, 1991, Kauai, HI

RESIDENCES: 1916–1941, Kauai, HI § 1941–1979, New York, NY (Monhegan Island, ME, summers 1946–1979) § 1979–1991, Kauai, HI

MEDIA: oil, watercolor, and acrylic painting

ART EDUCATION: 1933–1938, University of Hawaii, Honolulu § 1940 (summer), California School of Fine Arts, San Francisco § 1943–1945, Columbia University and New School for Social Research, New York

SELECTED SOLO EXHIBITIONS: California Palace of the Legion of Honor, San Francisco, 1940 § The Honolulu Academy of Arts, 1941, 1967, 1991 § The Downtown Gallery, New York, 1945, 1946, 1949, 1952 § Sheldon Memorial Art Gallery, University of Nebraska, Lincoln, 1976 § Farnsworth Art Museum, Rockland, ME, 1996

SELECTED GROUP EXHIBITIONS: The Honolulu Artists Association, 1934, 1937 § The Downtown Gallery, New York, 1940–1952 § *Annual Exhibition of Paintings by Artists Under Forty*, Whitney Museum of American Art, New York, 1941 § *Twenty-First Biennial Exhibition of Contemporary American Oil Paintings*, Corcoran Gallery of Art, Washington, D.C., 1949 § The Brooklyn Museum, Brooklyn, NY, 1958

SELECTED COLLECTIONS: The Brooklyn Museum, Brooklyn, NY § Honolulu Academy of Arts § Metropolitan Museum of Art, New York § San Diego Museum of Art § Whitney Museum of American Art, New York

SELECTED BIBLIOGRAPHY: Burrey, Suzanne. "Reuben Tam: Painter of the Intimate Landscape." *Arts* 32, no. 4 (February 1958): 36–41. § Sawin, Martica. "Reuben Tam, Island Paintings." *Arts Magazine* 50, no. 4 (1975): 92–94. § Tam, Reuben. *Archipelago.* Honolulu: Honolulu Academy of Arts, 1999. § Tam, Reuben. *The Wind-Honed Islands Rise.* Honolulu: University of Hawaii Press, 1996.

The fact that I do most of my work, finally, indoors, away from the scene, indicates that I need a great deal of the quality of essence. I think I prefer to work it out in a state of solitude, in almost a divorcement from the original. Then I try to get at that part of the landscape that really haunts me.

REUBEN TAM
Burrey, "Reuben Tam: Painter
of the Intimate Landscape," 40

ALTHOUGH REUBEN TAM spent the majority of his career in New York and Hawaii, his first solo exhibition, held when he was twenty-four years old, took place at the California Palace of the Legion of Honor in San Francisco. Months later, in 1940,

his work *Koko Crater* won first prize in the Golden Gate International Exposition American painting competition held at San Francisco's Treasure Island. With this spectacular introduction to the mainland art world, Tam began a successful career that would span more than fifty years and enable him to immerse himself in the island terrains he loved—be it in Kauai, Hawaii, or Monhegan, Maine.

Tam was born in Kauai and attended the University of Hawaii, where he received early acclaim for his work. While there, he studied with Californian Henry Rempel, who had studied at the Bauhaus, and Huc Luquiens, a Swiss painter. Both instructors emphasized accuracy in art and the need for artists to immerse themselves completely in their subject matter. These teachings would influence Tam's working process, which involved focused study of a single facet of a landscape. Another important influence was a poem by Sara Teasdale entitled "The Coastlines of the World Are Ours," which prompted what would be dual interests in Tam's life—poetry and the exploration of coastline terrains through his art.

A stay in San Francisco in 1940 resulted in his successful Bay Area exhibitions, and soon after, Tam moved to New York. There he began a long association with the Downtown Gallery, frequently exhibiting with other Downtown Gallery notables, including **Yasuo Kuniyoshi**, John Marin, Georgia O'Keeffe, Ben Shahn, and Jacob Lawrence. Tam was frequently singled out for recognition by curators and critics during the 1940s and 1950s, and his work was exhibited widely throughout the United States. In 1947, he began his tenure at the Brooklyn Museum Art School, where he taught until 1975, and in 1948 he received a Guggenheim Fellowship. While in New York, Tam spent summers on Monhegan Island in Maine, affording him the opportunity to continue painting coastal landscapes. Tam also visited Hawaii to paint, and he and his wife, artist Geraldine King, returned permanently to Kauai in 1979.

Tam's abstract works reference the rugged, weathered terrains found in both Kauai and Monhegan, and the ways in which the earth is shaped by environmental forces. Tam's working process involved repeated sketching and contemplation of his subject, with the actual painting being done in his studio. Tam chose adventurous, yet subtle colors not from a realistic memory of the landscape, but instead from his impressions and emotional responses to it.

Tam's creative interest did not slow with age. In 1989, when he was seventy-three, Tam received the prestigious Elliot Cades Literary Award as promising newcomer in the field of poetry. His last series of paintings, entitled *Archipelago*, was created in Kauai. In it, the artist details the lifecycle of the formation of islands below the sea, their emergence above water, and then their final oceanic submergence—a final tribute to a beloved subject.

Joseph, Emily, Mamie, Frank, and Mary Tape, ca. 1884–1885

Tape, Mary

BORN: June 1857, Shanghai, China

DIED: 1934, Berkeley, CA

RESIDENCES: 1857–1868, Shanghai, China § 1868–1895, San Francisco, CA § 1895–1934, Berkeley, CA

MEDIA: photography, oil painting, and china painting

SELECTED GROUP EXHIBITIONS: *Mechanics' Institute Exhibition*, San Francisco, 1885 § *With New Eyes: Toward an Asian American Art History in the West*, Art Department Gallery, San Francisco State University, 1995 § *Separate Is Not Equal: Brown vs. Board of Education*, Smithsonian National Museum of American History, Washington, D.C., 2004/5

SELECTED BIBLIOGRAPHY: Gamble, Leland. "What a Chinese Girl Did: An Expert Photographer and Telegrapher." *San Francisco Morning Call*, November 23, 1892, 12. § "Our Chinese Edison." *San Francisco Daily Examiner*, August 4, 1889, 10. § Palmquist, Peter E. *Mrs. Tape as Wonderwoman!* http://www.womeninphotography.org/archive09-Jan02/gallery4. Downloaded February 18, 2005. § Thompson, Daniella. *The Tapes of Russell Street.* http://www.berkeleyheritage.com/essays/tape_family.html. Downloaded June 1, 2005. § Yung, Judy. *Unbound Voices: A Documentary History of Chinese Women in San Francisco.* Berkeley: University of California Press, 1999, 171–175.

AN ORPHAN, MARY TAPE spent her early years with Presbyterian missionaries in Shanghai. She traveled to California when she was eleven years old and later recalled that after five months in Chinatown she was taken in by the Ladies Relief Society on Franklin Street, which was also run by Presbyterian missionaries. The matron in charge was Mary McGladery, and Tape was given Mary's name. She remained there for five years, during which time she received a solid education, and she soon met and married Joseph Tape, who had also come from China to San Francisco as a child.

Joseph Tape was a successful businessman with a monopoly on transporting Chinese to California in bond. He also bonded Chinese ships' crew members, transported goods for merchants in Chinatown, and was the interpreter for the Chinese consulate in San Francisco. The Tapes were a prosperous middle-class family and lived outside the confines of Chinatown, which was very unusual for the time. The family, which grew to include four children, lived at Gough and Vallejo streets, and later nearby on Green Street. The Tapes challenged the San Francisco School Board after their daughter Mamie was prevented from attending a school in their neighborhood. Although the case was ruled in their favor in the San Francisco courts, it was appealed and overturned in the California Supreme Court, and the Tape children were forced to attend a Chinese-only school. As a pioneer in the fight to stop school segregation, Mary Tape wrote an impassioned letter to the San Francisco School Board that is a lasting document of her fight to end school segregation.

While known today for her role in the history of civil rights, Tape is less known for her pioneering work as a painter,

Takeo Edward Terada at Coit Tower, 1934

photographer, and telegrapher. She was a member of the California Camera Club and was active in the amateur photography community, winning salon awards for her work. In 1885, the same year as her Supreme Court battle, she exhibited eight paintings in the annual Mechanics' Institute show in San Francisco: *Cliff House, Hunting, Sentinel Rock (Yosemite), Fruit Piece, St. Joseph's Lily, Mirror, Blue Mountain*, and *Calla Lily*. An 1889 article in the *San Francisco Examiner* profiling inventor Wong Hong Tai mentioned how Wong and Tape would hold discussions about science and photography over their telegraph lines. It also noted that Tape made her own slow- and fast-dry plates and was developing extrasensitive plates to be used with a new camera Wong was building, which would have a faster shutter speed. The writer said that "both show some splendid, instantaneous work on the large and small plates, mostly of street scenes; but they are not yet satisfied, and will not be until they can take trotters in motion and birds in their flight."

The February 1892 issue of the *Pacific Coast Photographer* also praised Tape's technical abilities, stating, "Mrs. Tape, the bright and intelligent Americanized Chinese lady, is becoming a slide expert. She probably does what but few amateurs have undertaken—the manufacture of her own slide plates." Word of Tape's abilities spread in the press, and later that year Leland Gamble from the *San Francisco Morning Call* visited the Tapes' home. Illustrating the racial bias of the time, Gamble expressed his surprise at the refined nature of the family, the beauty of their home, and the abilities of Mary Tape. He described seeing landscape, still life, and portrait photographs as well as diplomas that she received from the Mechanics' Institute for her work. Tape said that many of her best photos were given to friends, and continued by explaining that "every summer my husband and I go somewhere in the country, and I always make a success of the majority of my pictures." Gamble also praised paintings by Tape, including a still life of fruit and a landscape.

In 1895, the Tapes moved to Berkeley, where Joseph continued to be successful in business, buying property in Berkeley and other locations. Family photo albums document the later years of the Tapes' lives as they traveled, spent time on their ranch in Hayward, and hunted on their 640-acre property in Ukiah.

Terada, Takeo Edward

BORN: April 27, 1908, Fukuoka, Japan

DIED: September 10, 1993, Tokyo, Japan

RESIDENCES: 1908–1922, Fukuoka, Japan § 1922–1928, Chico, CA § 1928, Berkeley, CA § 1929–1935, San Francisco, CA § 1935–1993, Tokyo, Japan

MEDIA: oil and watercolor painting, printmaking, sculpture, and murals

ART EDUCATION: 1928, University of California, Berkeley § 1928–1932, California School of Fine Arts, San Francisco

SELECTED GROUP EXHIBITIONS: *Amateur and Professional Art Exhibition*, San Francisco, 1929 § Japanese Art Association Exhibition (First and Second Annual), Kinmon Gakuen, San Francisco, 1929, 1930 § *San Francisco Art Association*, California Palace of the Legion of Honor, 1929–1932 § *First Annual Western Watercolor Painting*, California Palace of the Legion of Honor, San Francisco, 1932 § *The Contemporary Oriental Artists*, Foundation of Western Art, 1934 § *California Artists*, California Palace of the Legion of Honor, San Francisco, 1934, 1935 § *San Francisco Art Association*, San Francisco Museum of Art, 1935 (inaugural)

SELECTED COLLECTIONS: Fine Arts Museums of San Francisco § Japanese American National Museum, Los Angeles

SELECTED BIBLIOGRAPHY: Hughes, Edan Milton. *Artists in California, 1786–1940*. San Francisco: Hughes Publishing Company, 1989. § International Association of Art, Japanese National Committee. *Who's Who Among Japanese Artists*. Tokyo: Printing Bureau, Japanese Government, 1961. § *Japanese and Japanese American Painters in the United States: A Half Century of Hope and Suffering, 1896–1945*. Tokyo: Tokyo Metropolitan Teien Art Museum and Nippon Television Network Corporation, 1995. § Zakheim Jewett, Masha. *Coit Tower, San Francisco, Its History and Art*. San Francisco: Volcano Press, 1983.

AT THE AGE OF FOURTEEN, Takeo Edward Terada left high school and immigrated to the United States. He graduated from Chico High in 1928 and was enrolled briefly at the University of California, Berkeley, where he studied literature. After winning first prize in the California State Fair for his artwork, Terada enrolled at the California School of Fine Arts. While there, he studied under Otis Oldfield and **George Matsusaburo Hibi** and became friends with fellow students **Henry Sugimoto**, **Miki Hayakawa**, Yoshio Inokuma, and **Hideo Benjamin Noda**.

Terada met Diego Rivera in 1931 when Rivera was creating the mural *The Making of a Fresco Showing the Building of a City* at the California School of Fine Arts. Rivera's fresco style and social realism had a strong impact on Terada, and soon he was creating his own mural for San Francisco's Coit Tower. Of twenty-six people selected to design murals for this WPA project, Terada was the only Asian artist. His mural *Sports*, completed in 1934, features hurdlers, polo players, and golfers grouped in postures often associated with Persian miniatures.

Terada exhibited widely in the Bay Area until his return to Japan in 1935. Eleven of Terada's paintings were included in the 1929 joint *Amateur and Professional Art Exhibition* orga-

nized by George Matsusaburo Hibi, and he exhibited almost monthly from September 1934 to August 1935 at the *California Artists* series at the California Palace of the Legion of Honor. He participated regularly in the San Francisco Art Association exhibitions and had two paintings in the 1935 inaugural show at the San Francisco Museum of Art. Works exhibited during these years were frequently landscape paintings, and titles such as *Abalone Work on Point Lobos, Monterey Fishermen*, and *The Autumn Coast of Marin County* are evidence of frequent outings in the Bay Area. In addition to the many oil and watercolor paintings produced during these years, Terada also created woodblock prints that appeared weekly in the *Hokubei Asahi Daily News*.

In 1935, Terada returned to Japan, where he continued to work as a muralist. He produced *Florida Kitchen* for a bar in Akasake, Tokyo, and *Cotton Club*, which he completed for a bar in Tokyo with friend Hideo Noda. In 1936, Terada received a prize in the twenty-third Nika Kai exhibition, and he continued to exhibit regularly with the group. Terada became a member of the Nika Kai and eventually served as its director.

Sadly, most of Terada's early California works were destroyed in the fire bombings of Tokyo during World War II. However, Terada continued to be an important figure in the arts during the postwar years and was respected as a writer, artist, and thinker. Beginning in 1956, he traveled for two years in Europe, the United States, the Middle East, and Southeast Asia and held exhibitions of his work in many of these locations. He won the Emperor's Award in 1984 for a painting entitled *Morning in Mexico* and, in 1985, received the lifetime achievement award from the Nihon Geijutsu-in (Japan Art Academy).

Teraoka, Masami

BORN: January 1, 1936, Onomichi, Japan

RESIDENCES: 1936–1961, Onomichi and Kobe, Japan § 1961–1980, Los Angeles, CA § 1980–present, Oahu, HI

MEDIA: oil and watercolor painting, sculpture, and printmaking

ART EDUCATION: 1954–1955, Kwansei Gakuin University, Kobe, Japan § 1964–1968, Otis Art Institute of Los Angeles County

SELECTED SOLO EXHIBITIONS: International Museum of Erotic Art, San Francisco, 1973 § Whitney Museum of American Art, New York, 1979 § Oakland Museum of California, 1983 § *Teraoka Erotica*, Santa Barbara Contemporary Arts Forum, Santa Barbara, CA, 1985 § *Waves and Plagues: The Art of Masami Teraoka*, The Contemporary Museum, Honolulu, 1988 (traveling exhibition) § *Paintings by Masami Teraoka*, Arthur M.

Masami Teraoka, ca. 1966

Sackler Gallery, Smithsonian Institution, Washington, D.C., 1996

SELECTED GROUP EXHIBITIONS: *Current Concerns Part II*, Los Angeles Institute of Contemporary Art, 1975 § *L.A. 8*, Los Angeles County Museum of Art, 1976 § *The Biennale of Sydney*, Art Gallery of New South Wales, Sydney, Australia, 1986 § Fukuoka Prefecture Museum of Art, Fukuoka, Japan, 1990 § *Asia/America: Identities in Contemporary Asian American Art*, Asia Society, New York, 1994 § *Made in California: Art, Image, and Identity, 1900–2000*, Los Angeles County Museum of Art, 2000

SELECTED COLLECTIONS: Fine Arts Museums of San Francisco § Hirshhorn Museum and Sculpture Garden, Smithsonian Institution, Washington, D.C. § Honolulu Academy of Art § Los Angeles County Museum of Art § Smithsonian American Art Museum, Washington, D.C.

SELECTED BIBLIOGRAPHY: Clarke, Joan, and Diane Dods, eds. *Artists/Hawaii*. Honolulu: University of Hawaii Press, 1996. § Link, Howard A., and Masami Teraoka. *Waves and Plagues: The Art of Masami Teraoka*. San Francisco: Chronicle Books, 1988. § Stevenson, John. *Masami Teraoka: From Tradition to Technology, the Floating World Comes of Age*. Seattle: University of Washington Press, 1997. § Teraoka, Masami. E-mail correspondence to CAAABS project researcher. September 12, 2000. § Teraoka, Masami, James T. Ulak, Alexandra Munroe, and Lynda Hess. *Paintings by Masami Teraoka*. Washington, D.C.: Arthur M. Sackler Gallery, Smithsonian Institution in association with Weatherhill, 1996.

If I were living in Japan, I would not have been an artist, but a mentally tormented businessman. I would never have had the chance to appreciate my own culture and Ukiyo-e art. I would never have had the chance to dream of painting like the way I painted for years in the Ukiyo-e style. It was a matter of the unexpected chance I was given to appreciate where I'm coming from and was able to detach myself from Japan physically and mentally. Freedom I felt in Los Angeles and California was the key to my work.

MASAMI TERAOKA
Email correspondence, September 12, 2000

MASAMI TERAOKA WAS nine years old and living in a small coastal town when Japan surrendered to the United States in 1945. His parents, who owned a kimono shop, recognized the artistic talents of their son and encouraged his creativity. Despite financial hardships resulting from the war, they arranged for Teraoka to receive private art lessons with a local painter and supplied him with materials and art books. Teraoka studied aesthetics, drama, and literature in college and received his first award for painting in 1957—a first-place prize in the annual Gengetsukai exhibition at the Kwansei Gakuin University. Teraoka became increasingly interested in Western abstract painting and eventually moved to Los Angeles to further his art studies.

In Los Angeles, Teraoka embraced the openness and experimentation of 1960s California. This freedom is evident in his early sculptural work, such as *Male and Female Form*, an abstract fiberglass sculpture emphasizing the natural, sensuous qualities of the human body. Influenced by California technology and artists such as Claes Oldenburg, Teraoka experimented with plastic, plexiglass, fiberglass, resin, and candy-colored spray paints to create three-dimensional forms.

In the early 1970s, exploring his relationship with his California home and his Japanese homeland, Teraoka developed his unique style of blending traditional *ukiyo-e* prints with the modern motifs of American culture. Influenced by artists Kunisada and Hokusai, as well as pop art, Teraoka used this hybrid form to comment on contemporary issues, such as the growing influence of American consumerism, environmental degradation, and the AIDS epidemic. Teraoka often used friends as "actors" in these predominantly watercolor works and, despite the frequently serious subject matter, employed a humorous, sometimes bawdy visual approach. A major touring exhibition in 1988, *Waves and Plagues: The Art of Masami Teraoka*, solidified Teraoka's role as a preeminent American painter.

Teraoka moved from California to Hawaii in 1980 and has continued to address social issues metaphorically in his paintings. Work since the early 1990s has been influenced by religious and iconic themes from the Renaissance. Using oil paints, Teraoka has taken on issues of sexual abuse in the Catholic church, the growing influence of technology and ethics of cloning, the Clinton impeachment trials, and other topi-

cal subjects. Sprawling tableaus, sometimes in triptych form, these paintings continue to incorporate humor, but often with a darker, more biting edge.

Thiel, Midori Kono

BORN: June 7, 1933, Berkeley, CA

RESIDENCES: 1933–1934, Berkeley, CA § 1934–1936, Los Angeles, CA § 1936–1947, Honolulu and Lahaina, Maui, HI § 1947–1948, Richmond, CA § 1948–1951, Riverside, CA § 1951–1960, Berkeley, CA § 1960–1961, Kamakura, Japan § 1961–present, Seattle, WA

MEDIA: oil and ink painting, printmaking, and textiles

ART EDUCATION: 1951–1960, University of California, Berkeley § 1966, 1968, 1976, University of Washington, Seattle

SELECTED GROUP EXHIBITIONS: *San Francisco Art Association*, San Francisco Museum of Art, 1956, 1958 § *Prints by Bay Area Artists*, San Francisco Museum of Art, 1959 § Yōseidō Gallery, Tokyo, 1961 § Wing Luke Asian Museum, Seattle, 1979

SELECTED COLLECTIONS: Fine Arts Museums of San Francisco § Oakland Public Library, Oakland, CA

Midori Kono Thiel

SELECTED BIBLIOGRAPHY: Thiel, Midori Kono. CAAABS project interview. August 26,1999. § Tsutakawa, Mayumi, ed. *They Painted from Their Hearts: Pioneer Asian American Artists.* Seattle: Wing Luke Asian Museum/University of Washington Press, 1994.

My work is involved with the feeling of landscape; trying to capture its essence.
<div align="right">MIDORI KONO THIEL
CAAABS project interview</div>

AFTER SPENDING HER first years in California, Midori Kono moved with her family to Hawaii when she was three and, as a result, avoided internment during World War II. Although she remembers modeling plaster sculpture as a child and creating abstract expressionist paintings during high school in Riverside, California, her principal education in art was at the University of California, Berkeley, where she received her B.F.A. and M.F.A. There, she was exposed to the work of Franz Kline, an important influence on her work, and to such teachers as Karl Kasten and John Haley. During graduate school at Berkeley, Kono focused on printmaking techniques, including woodblock printing employing abstract imagery, and participated in many group shows in San Francisco.

In 1955, after her marriage, Midori Kono started using her married name, Thiel. In 1960, the artist received a University of California fellowship to study traditional woodcut methods in Japan. There, she became interested in the work of Munakata Shikō while working with Hiratsuka Unichi and Hagiwara Hideo, and she immersed herself in Japanese culture. She began to study Japanese calligraphy, the Japanese musical instruments *koto* and *shamisen*, and the theater forms of *Kyōgen* and Noh.

After returning to the United States, the artist moved with her family to Seattle, where she expanded her interest in Japanese arts. Inspired by her interest in the kimono, tea ceremony, and *sumi-e* painting, she explored weaving and dyeing fabric. She was a founding member of the Puget Sound Sumi Artists Association and has taught many workshops in the Seattle area. Throughout her professional career, working in varied media, the artist has drawn much of her inspiration from landscape and nature.

Tominaga, Chio

BORN: February 2, 1883, Kumamoto, Japan

DIED: November 5, 1986, Berkeley, CA

RESIDENCES: 1883–1912, Kumamoto, Japan § 1912–1937, San Jose, Oroville, and other farming communities in Sutter, Butte, and Sacramento counties, CA § 1937–1942, Berkeley, CA § 1942–1945, Pinedale Assembly Center,

Chio Tominaga

Fresno, CA; Topaz Relocation Center, Topaz, UT § 1945–1986, Berkeley, CA

MEDIA: textiles

SELECTED GROUP EXHIBITIONS: *Putting the Pieces Together*, Falkirk Cultural Center, San Rafael, CA, 1993 § *The Fabric of Life*, Fine Arts Gallery, San Francisco State University, 1997

SELECTED BIBLIOGRAPHY: Leon, Eli. *Putting the Pieces Together: American Quilts by 19th and 20th Century Migrants to California*. San Rafael, CA: Falkirk Cultural Center, 1993. § Sakamoto, Sadie. CAAABS project interview. September 1998.

CHIO TOMINAGA LEFT JAPAN in 1912 as a picture bride. The day she arrived in California, she married a man from her hometown whom she had never met. For the next twenty-five years, they worked as truck farmers in California's Central Valley. Tominaga's life revolved around the care of her eight children, and as an accomplished seamstress she made all of her children's clothes. She started making quilts in the late 1910s or early 1920s from family clothing too worn to be remade into other garments.

While her use of eclectic and recycled materials was initially born of necessity, it eventually became an artistic choice. A prolific craftswoman who created to the final years of her long life, Tominaga made quilts and other textiles that frequently display her interest in unconventional materials and her belief that nearly anything could be used to good effect. Thus, she often employed strands of unraveled onion sacks and carpeting and tiny pieces of intact cloth from worn-out clothing. Another major component of Tominaga's style is her ready use of improvisation. She frequently introduced unexpected colors or materials, juxtaposed dissimilar patterned and textured cloths, varied the scale of a repeat or the elements within it in an unpredictable manner, and used irregular piecing, all to create unexpected results.

Tse, Wing Kwong

BORN: November 7, 1902, Guangzhou, China

DIED: January 21, 1993, Richmond, CA

RESIDENCES: 1902–1914, Guangzhou, China § 1914–1922, Honolulu, HI § 1922–ca. 1934, Los Angeles, CA § ca. 1934–1986, San Francisco, CA § 1986–1993, Richmond, CA

MEDIA: watercolor painting and drawing

ART EDUCATION: 1922–1925, University of Southern California, Los Angeles

SELECTED SOLO EXHIBITION: Gumps Gallery, San Francisco, 1934

SELECTED GROUP EXHIBITIONS: *California Artists*, California Palace of the Legion of Honor, San Francisco, 1934 § *The Contemporary Oriental Artists*, Foundation of Western Art, Los Angeles, 1934 § Golden Gate International Exposition, San Francisco, 1939 § *Society of Western Artists*, de Young Museum, San Francisco, 1951 § *Brushstrokes of Old Chinatown*, Museum of Chinese American History, Los Angeles, 1994 § *Made in California: Art, Image, and Identity, 1900–2000*, Los Angeles County Museum of Art, 2000

SELECTED COLLECTIONS: Courthouse Museum, Shasta State Historic Park, Redding, CA § Los Angeles County Museum of Art

SELECTED BIBLIOGRAPHY: Caen, Herb. *San Francisco Chronicle*, January 25, 1993. § Kimberlin, Cynthia Tse, and Jerome Kimberlin. CAAABS project interview. April 21, 2001. § 1930 Federal Population Census. Los Angeles, Los Angeles, California. Roll 143, Page 10A, Enumeration District 269, Image 361.0. National Archives, Washington, D.C. § *San Francisco Chronicle*, December 9, 1934, D3. § Yang Fang-chih. "Wing Kwong Tse: No Teacher for This Painter of Portraits (Based on an interview with Michael Brown)." *Hsiung-shih Arts Monthly* (Taipei), no. 288 (February 1995): 90–95.

Wing Kwong Tse

I live to draw, it is my life. When I die, I hope they will say,
"Wing was a damn good artist."

WING KWONG TSE

Michael D. Brown. *Views from Asian California,*
1920–1965. San Francisco: Michael D. Brown, 1992.

DESPITE A LACK of formal training and not beginning his career as an artist until in his thirties, Wing Kwong Tse became a successful San Francisco painter known for his stunningly photorealistic portraits. Tse was born to a wealthy family in Guangzhou, China; his father was an important politician and Christian minister. After the Chinese Revolution in 1911, the family fled the country and relocated to Hawaii, where Tse studied at the Mills School. He left Hawaii for California in 1922 to attend the University of Southern California and received a generous allowance from his family, which afforded him a life of high style in Los Angeles—complete with a Duesenberg automobile. While at USC, Tse created cover art for the campus magazine as well as for a West Coast theater publication.

During his third year at USC, Tse dropped out to pursue a career in acting, but he found himself cast in stereotypical Chinese roles. He continued to make art during this period and, with the support of Julius Goldwater, who admired Tse's work and served as his patron, Tse became more confident in his abilities. The 1930 federal census shows Tse living in Los Angeles with a wife and young daughter, and "self employed artist" listed as his profession.

In the early 1930s, Tse moved to San Francisco to further his career as a professional artist. His photorealistic portrait and still-life watercolor paintings received praise, and he began participating in exhibitions and held a solo show at Gumps Gallery. Soon Tse was being commissioned to paint portraits for wealthy San Franciscans. This steady work sustained him as an artist, but it cut short his exhibition career, as he was nearly unable to keep up with demands for his work.

Although Tse was a skilled draftsman who worked in pen and ink, his specialty was using a fine-haired brush with watercolors to produce very detailed, realistic paintings. He claimed to prefer using a ten-cent brush and his own ground inks in the extremely time-consuming process of painting thousands of tiny strokes. Some paintings took several months to complete. Tse primarily created portraits, but he also painted still lifes and stylized floral works, many with Chinese themes or mythical subjects.

Tse's studio was located in North Beach, above City Lights Books. He became a well-known, respected fixture of the artistic community and knew writers such as William Saroyan and Allen Ginsberg. He lived and worked there for nearly fifty years. When he died, famed San Francisco columnist Herb Caen described him as "one of the last of the real old North Beach crowd…when Wing had a skylighted studio, right out of 'La Boheme,' atop poet Ferlinghetti's bookstore on Columbus—yes, that was San Francisco."

Tseng Yuho (Zeng Youhe, Betty Ecke)

BORN: November 27, 1925, Beijing, China

RESIDENCES: 1925–1949, Beijing, China § 1949–2005, Honolulu, HI § 2005–present, Beijing, China

MEDIA: ink painting, mixed media, and printmaking

ART EDUCATION: ca. 1940–1942, Furen University, Beijing § ca. 1964–1965, University of Hawaii, Honolulu § ca. 1967–1972, New York University

SELECTED SOLO EXHIBITIONS: *Chinese Painting by Tseng Yuho*, de Young Museum, San Francisco, 1947 § *Chinese Paintings: Tseng Yu Ho*, traveling exhibition organized by the Smithsonian Institution, 1957–1961 § *Recent Paintings by Tseng Yu-ho*, Stanford University, 1959 § *Paintings by Tseng Yu-ho*, San Francisco Museum of Art, 1962 § *Dsui Paintings by Tseng Yuho: A Retrospective Exhibition*, traveling exhibition shown at Shanghai Municipal Museum of Modern Art; China Art Museum, Beijing; Taipei Fine Arts Museum; Art Centre, National Museum of Singapore, 1992–1993 § *Tseng Yuho: Crossing the Line*, Chinese Historical Society of America, San Francisco, 2004

SELECTED GROUP EXHIBITIONS: *Fresh Paint: A Selective Survey of Recent Western Painting*, Stanford University Art Gallery, 1958 § *Pacific Heritage*, Municipal Art Gallery, Los Angeles, 1965 § *The Living Brush: Four Masters*

of *Contemporary Chinese Calligraphy*, Pacific Heritage
Museum, San Francisco, 1997 § *Asian Traditions/Modern
Expressions*, Jane Voorhees Zimmerli Art Museum, Rutgers
State University, New Brunswick, NJ, 1997

SELECTED COLLECTIONS: Asian Art Museum, San
Francisco § Hawaii State Foundation on Culture
and the Arts, Honolulu § Honolulu Academy of Arts §
Iris & B. Gerald Cantor Center for Visual Arts, Stanford
University § National Museum of Modern Art,
Stockholm, Sweden § Walker Art Center, Minneapolis

SELECTED BIBLIOGRAPHY: Link, Howard, and Tseng Yuho.
The Art of Tseng Yuho. Honolulu: Honolulu Academy
of Arts, 1987. § Thompson, Melissa. "Gathering Jade,
Assembling Splendor: The Life and Art of Tseng Yuho."
Ph.D. diss., University of Washington, 2001. § Tseng,
Yuho. *A History of Chinese Calligraphy*. Hong Kong: Chinese
University Press, 1993. § *Tseng Yuho: Crossing the Line*.
San Francisco: Chinese Historical Society of America,
2004. § Zeng, Youhe. *Dsui hua, Tseng Yuho*. Hong Kong:
Hanart T. Z. Gallery, 1992.

Tseng Yuho, 1957. Photo by Man Ray

*My basic artistic training in China technically and meta-
physically was intensive and profound. I lived in the United
States and have been an American citizen nearly fifty years.
My personal style of painting developed entirely in Hawaii.
By definition, I am an American artist.* TSENG YUHO
CAAABS project questionnaire.
Undated, ca. 1997. Asian American Art Project,
Stanford University.

TSENG YUHO, born in Beijing, is a descendant of Zengzi, a dis-
ciple of Confucius. She was raised in a household that valued
both Confucian ideology and progressive Western social and
educational ideas—forces that would shape her life. She stud-
ied with private tutors, including Pu Jin and Pu Quan (both
cousins of China's last emperor), mastering a range of Chi-
nese painting techniques and acquiring an appreciation of the
painting style kept alive by her mentors.

Tseng met her husband, art historian Gustav Ecke, while
attending Furen University, and in 1949 the couple moved to
Honolulu. There, Tseng received a B.A. from the University
of Hawaii. She would later receive her doctorate from the In-
stitute of Fine Arts at New York University. In Hawaii Tseng
was exposed to Western modernism, and in the 1950s trips
to Europe led to friendships with Man Ray, Max Ernst, and
Jean Charlot. This creative environment opened the way for
her own experimentation, which resulted in what she refers
to as the *dsui hua* painting technique, a collage process based
on the methods used to mount scrolls that utilizes handmade
papers, inks, paints, pigments, and metallic leaf. Tseng would
employ experimental materials such as Hawaiian tapa paper
in the collage layers and sometimes did her calligraphy work
directly on tapa. Tseng was lauded for her ability to draw from
her early classical training and use her *dsui hua* process and
contemporary influences to create works that were uniquely
modern and of ethereal beauty.

Tseng was a studio art instructor at the Honolulu Academy
of Arts from 1950 to 1963, and professor of Chinese art history
at the University of Hawaii from 1963 to 1986, where she holds
the title of professor emeritus. She served as a consultant to
the Honolulu Academy of Arts for many years and in 1990
was recognized as a "Living Treasure of Hawaii." Tseng has au-
thored several books on Chinese painting and is a well-known
scholar of calligraphy. Tseng acted as an advisor and wrote the
catalog essay for the first major exhibition in the United States
of Chinese calligraphy, organized by the Philadelphia Museum
of Art and presented in 1971 at that institution and at the
Nelson-Atkins Museum of Art and the Metropolitan Museum
of Art. Her own works have been in numerous exhibitions,
including shows in Beijing, Hong Kong, Singapore, Shanghai,
Munich, Zurich, and Paris.

Tseng's long relationship with San Francisco began in
1947 when she had her first exhibition in the city, a solo show
at the de Young Museum that featured paintings modeled on

works of past masters. A second de Young show followed in 1952. Tseng taught at the University of California, Berkeley, during the summer of 1953, and a touring exhibition of her work organized by the Smithsonian was presented at the Rosicrucian Museum in San Jose in 1954. Tseng participated in a group exhibition and a solo show at Stanford University in 1958 and 1959, respectively, and frequent trips to San Francisco continued through the 1960s. Tseng held another solo show in 1962 at the San Francisco Museum of Art, and in 1964 she completed a major multi-panel mural for the Golden West Savings and Loan Association in the city. The nine sections were composed of abstract designs inspired by California redwoods; the commission was the most ambitious work of her career. In 2005 Tseng moved back to China and is working to support the appreciation of folk art forms that are rapidly disappearing, again underscoring her commitment to scholarship and culture.

Tsuzuki, Byron Takashi

BORN: September 20, 1900, Hamamatsu, Japan

DIED: September 1967, New York, NY

RESIDENCES: 1900–1917, Japan § 1917–1932, New York, NY § 1932–1942, San Mateo County, CA § 1942–1945, Tanforan Assembly Center, San Bruno, CA; Topaz Relocation Center, Topaz, UT § 1945–1967, New York, NY

MEDIA: oil painting

ART EDUCATION: ca. 1920s, Art Students League, New York § ca. 1920s, Columbia University, New York

SELECTED GROUP EXHIBITIONS: Society of Independent Artists, New York, 1926–1927 § Salons of America, New York, 1926–1929 § *The First Annual Exhibition of Paintings and Sculpture by Japanese Artists in New York*, The Art Center, New York, 1927 § *Half Century of Japanese Artists in New York, 1910–1950*, Azuma Gallery, New York, 1977 § *From Bleakness*, Gallery at Hastings-on-Hudson, Hastings-on-Hudson, NY, 1989 § *The View from Within*, Wight Art Gallery, University of California, Los Angeles, 1992 § *With New Eyes: Toward an Asian American Art History in the West*, Art Department Gallery, San Francisco State University, 1995

SELECTED COLLECTION: Japanese American National Museum, Los Angeles

SELECTED BIBLIOGRAPHY: Falk, Peter Hastings, ed. *Who Was Who in American Art, 1564–1975: 400 Years of Artists in America*. Madison, CT: Sound View Press, 1999. § Hershenson, Roberta. "Remembering the Relocation Camps." *New York Times*, October 15, 1989, WC19. § Higa, Karin M. *The View from Within: Japanese American Art from the Internment Camps, 1942–1945*. Los Angeles: Japanese American National Museum, 1992. § Japanese-American Internee Data File, 1942–1946. File number 606266. Records of the War Relocation Authority. National Archives, Washington, D.C. § Japanese Artists Association. *Half Century of Japanese Artists in New York, 1910–1950*. New York: Azuma Gallery, 1977.

BYRON TAKASHI TSUZUKI's desire to become an artist resulted in his immigration at the age of sixteen from Japan directly to New York, which was somewhat unusual during a time when most immigrants arrived first on the West Coast. Tsuzuki soon joined the Art Students League and while there studied with **Yasuo Kuniyoshi**. In the early 1920s, at the same time as he was going to classes at the Art Students League, Tsuzuki also attended Columbia University. He participated in the 1927 exhibition of Japanese artists in New York along with Kuniyoshi, **Noboru Foujioka**, **Eitaro Ishigaki**, **Torajiro Watanabe**, and **Yoshida Sekido**. Tsuzuki participated in annual exhibitions at the Salons of America, the Society of Independent Artists, and the Anderson Galleries in the late 1920s. Eventually, Tsuzuki became co-director of the Salons of America with Kuniyoshi. In 1932, when his father became ill, Tsuzuki and his wife and daughter moved to the San Mateo area south of San Francisco, where Tsuzuki became the caretaker on an estate.

At the onset of World War II, the family first was interned at the Tanforan Assembly Center and then moved to the Topaz Relocation Center, where they remained for almost three years. There Tsuzuki taught in the camp art school along with **Chiura Obata** and **George Matsusaburo Hibi**. Tsuzuki's admiration for the Ashcan school painters frequently landed him in heated debates with Hibi, whose approach to art was very different. Today Tsuzuki is best known for his studies of life in internment. His pictures of Topaz depict people in everyday activities—doing laundry, playing *shōgi*—often against a backdrop of harsh environmental conditions.

After release from camp, Tsuzuki and his family returned to New York, where he worked as a dental technician. However, the hardships he endured during his internment did not cripple Tsuzuki's creativity; he continued painting until his death in 1967.

Uetsuji, Kitaro

BORN: 1899, Southern Honshu, Japan

DIED: unknown

RESIDENCES: 1899–1913, Southern Honshu, Japan § 1913–1942, Los Angeles, CA § 1942–ca. 1945, Manzanar Relocation Center, Manzanar, CA § ca. 1945–date unknown, location unknown

MEDIA: watercolor and oil painting, and illustration

ART EDUCATION: ca. 1924–ca. 1927, Otis Art Institute of the Los Angeles Museum of History, Science and Art

SELECTED GROUP EXHIBITIONS: *Modern Art Workers*, Los Angeles Museum, 1926 § *Japanese Artists of Los Angeles* (Second Annual), Little Tokyo, 1930

SELECTED BIBLIOGRAPHY: "Art Exhibit in Block 2 Office." *Manzanar Free Press*, August 5, 1942, 2. § "Art Talent Among the Local Japanese." *Los Angeles Times*, December 21, 1930, part 3, 15. § Hughes, Edan Milton. *Artists in California, 1786–1940*. San Francisco: Hughes Publishing Company, 1989. § Japanese-American Internee Data File, 1942–1946. File number 108932. Records of the War Relocation Authority. National Archives, Washington, D.C. § "Japanese Wins Many Prizes at Art School." *Rafu Shimpo* (Los Angeles), February 21, 1927, 3. § Jarrett, Mary. *The Otis Story: Of Otis Art Institute since 1918*. Los Angeles: The Alumni Association, 1975. § "Local Artists Show Humor in Sketches." *Manzanar Free Press*, March 24, 1943, 4. § Millier, Arthur. "City's Japanese Show Art." *Los Angeles Times*, December 29, 1929, part 3, 9.

KITARO UETSUJI, whose family name also appears as Uetsuzi and Uetsugi, was a painter active in Los Angeles in the 1920s and 1930s. A 1927 *Rafu Shimpo* article describes him as a student of design and commercial art at the Otis Art Institute who had studied art in Japan. The article states that "he enrolled at the Otis Art Institute three years ago with the hopes of learning the American methods in order to combine the two vastly different techniques (Occidental and Oriental). That he has met with much success is indicated by the fact that he has won several prizes at the Institute and is rapidly winning recognition."

Uetsuji exhibited *The Letter* in the 1926 Modern Art Workers show, and a 1930 *Los Angeles Times* article describes him as one of the few young artists carrying on in the "Japanese manner," in contrast to others mentioned, including **Yotoku Miyagi**, **Tokio Ueyama**, and **Hideo Date**.

In 1942, Uetsuji was interned at the Manzanar Relocation Center, and he is listed as a widower on internment records, with his profession described as a decorator and window dresser. While at Manzanar he taught art classes, and his students exhibited commercial art posters. Uetsuji himself exhibited a series of more than one hundred humorous pictures, described as cartoons, depicting the everyday life of Manzanar residents.

Ueyama, Tokio

BORN: September 22, 1889, Wakayama, Japan

DIED: July 12, 1954, Los Angeles, CA

RESIDENCES: 1889–1908, Japan § 1908–1910, San Francisco, CA § 1910–1917, Los Angeles, CA § 1917–1919, Philadelphia, PA § 1920, France, Germany, Italy, and Spain § 1921, Philadelphia, PA § 1922–1942, Los Angeles, CA § 1942–1945, Santa Anita Assembly Center, Santa Anita, CA; Granada Relocation Center, Amache, CO § 1945–1954, Los Angeles, CA

MEDIA: oil painting

ART EDUCATION: 1909–1910, San Francisco Institute of Art § 1910–1914, University of Southern California, Los Angeles § 1917–1921, Pennsylvania Academy of the Fine Arts, Philadelphia

SELECTED SOLO EXHIBITION: Miyako Hotel, Los Angeles, 1936

SELECTED GROUP EXHIBITIONS: *Southern California Japanese Art Club*, Nippon Club, Los Angeles, 1916 § *East West Art Society*, San Francisco Museum of Art, 1922 § *Painters and Sculptors of Southern California*, Los Angeles Museum, 1922, 1923, 1925, 1926, 1928, 1930, 1935 § *Shaku-do-sha Association Exhibition*, Union Church, Little Tokyo, Los Angeles, 1923 § *Japanese Artists of Los Angeles* (First and Second Annual), Little Tokyo, 1929, 1930 § *San Francisco Art Association*, California Palace of the Legion of Honor, 1931 § *The Contemporary Oriental Artists*, Foundation of Western Art, Los Angeles, 1934 § *California Art Today*,

Self-portrait by Tokio Ueyama, July 1943

Golden Gate International Exposition, San Francisco, 1940 § *The View from Within*, Wight Art Gallery, University of California, Los Angeles, 1992 § *From Gold Rush to Pop*, Orange County Museum of Art, Newport Beach, CA, 1998/99 § *Made in California: Art, Image, and Identity, 1900–2000*, Los Angeles County Museum of Art, 2000

SELECTED COLLECTION: Japanese American National Museum, Los Angeles

SELECTED BIBLIOGRAPHY: "Art Talent Among the Local Japanese." *Los Angeles Times*, December 21, 1930, part 3, 15. § Higa, Karin M. *The View from Within: Japanese American Art from the Internment Camps, 1942–1945.* Los Angeles: Japanese American National Museum, 1992. § *Japanese and Japanese American Painters in the United States: A Half Century of Hope and Suffering, 1896–1945.* Tokyo: Tokyo Metropolitan Teien Art Museum and Nippon Television Network Corporation, 1995. § Millier, Arthur. "City's Japanese Show Art: Exhibit Here Revealed Several Fine Talents and Wide Interest in Local Colony." *Los Angeles Times*, December 29, 1929, part 3, 9. § "Rec Art Class." *Granada Pioneer*, November 7, 1942, 2. § "7E Recreation Hall Becomes Art Studio." *Granada Pioneer*, November 14, 1942, 4.

TOKIO UEYAMA CAME TO San Francisco from Japan at nineteen to study at the San Francisco Institute of Art. He moved to Los Angeles in 1910 and attended the University of Southern California, where he completed a degree in fine arts. Ueyama continued his studies at the Pennsylvania Academy of the Fine Arts. Upon receiving the Cresson travel scholarship to study in Europe, he traveled and painted in France, Germany, Italy, and Spain in 1920.

By 1922, Ueyama was back in Los Angeles, where he co-founded the association Shaku-do-sha with the painters Hojin Miyoshi and **Sekishun Masuzo Uyeno** and the poet T. B. Okamura. Ueyama traveled to Mexico in 1924 and exhibited in Mexico City. He may have met photographer Edward Weston during his time in Mexico, as Weston exhibited in Los Angeles in a show sponsored by Shaku-do-sha the following year.

Ueyama exhibited frequently during the 1920s and 1930s, both within and outside of Little Tokyo, and gained recognition for his talents. In 1929, Arthur Millier, writing for the *Los Angeles Times*, said that Ueyama "impressed us by the consistent quality of the two oils he showed and by the fine craftsmanship that brings each of his pictures to a reposeful completeness. His large landscape 'Monterey' is flooded with clear light which creates a fine pattern of light and shadow on headlands, houses and blue water. He paints calmly and thoughtfully. His portrait of a young Japanese woman in black hat and coat holds one's interest by its poise, feeling for textures and character, and the way in which he uses the design made by cuffs and collar, face and hands. He is an accomplished and painstaking artist."

Ueyema's talent was noted again in 1930 in the *Los Angeles Times*, where he is described as among the most skilled portraitists in the country. The 1930 federal census shows Ueyama living with his wife, Suye, and lists his profession as a salesman in a bookstore, indicating that despite his success as an artist, he was painting during off-hours from regular employment.

In 1931 Ueyama exhibited the painting *Church at Taxco, Mexico* in the San Francisco Art Association exhibition. In the 1940 *California Art Today* exhibition in San Francisco, held in association with the Golden Gate International Exposition, he exhibited two oil paintings, *Misumi, Japan* and *The Rain*. Passenger list records show that Ueyama returned from a visit to Japan through San Francisco in 1937, so it is likely that *Misumi, Japan* depicts the town near Hiroshima.

By the time the United States entered World War II, Ueyama was back in Los Angeles. Along with his wife, he was held first at the Santa Anita Assembly Center and then at the Granada Relocation Center in Amache, Colorado. At Granada he supervised the art department with **Koichi Nomiyama**. A week after the art school opened—offering instruction in watercolors, charcoal, and oils—fifty-five adult students were enrolled in classes held multiple times daily, three days a week.

Ueyama was a technically skilled artist who created realistic landscape, still-life, and portrait paintings throughout his career. Unlike the work of other interned artists, the paintings Ueyama produced while at Granada were less documentary in nature and more formal. Even his internment masterpiece, *The Evacuee*, which shows his wife sitting, crocheting in the open doorway of their barracks home, is carefully composed.

Following his release from internment, Ueyama returned to Los Angeles's Little Tokyo, where he opened the gift shop Bunka Do.

Uno, Sadayuki Thomas

BORN: January 1, 1901, Hiroshima, Japan

DIED: April 3, 1989, Oakland, CA

RESIDENCES: 1901–1917, Hiroshima, Japan § 1917–ca. 1924, Oakland, CA § ca. 1924–ca. 1930, Chicago, IL, and New York, NY § ca. 1930–1942, Alameda, CA § 1942–1944, Pinedale Assembly Center, Fresno, CA; Jerome Relocation Center, Denson, AR § 1944–1945, Rohwer Relocation Center, Rohwer, AR § 1945–1989, Oakland, CA

MEDIA: painting and sculpture

ART EDUCATION: ca. 1923, 1957–1964, California School of Arts and Crafts, Oakland, CA § ca. 1927, New York Photography Institute, New York

SELECTED GROUP EXHIBITIONS: *The View from Within*, Wight Art Gallery, University of California, Los Angeles, 1992 § *With New Eyes: Toward an Asian American Art*

Self-portrait by Sadayuki Uno, ca. 1944

History in the West, Art Department Gallery, San Francisco State University, 1995

SELECTED COLLECTION: Japanese American National Museum, Los Angeles

SELECTED BIBLIOGRAPHY: Higa, Karin M. *The View from Within: Japanese American Art from the Internment Camps, 1942–1945*. Los Angeles: Japanese American National Museum, 1992. § Mirikitani, Janice, ed. *Ayumi: A Japanese American Anthology*. San Francisco: Japanese American Anthology Committee, 1980. § Takanashi, Patricia. Personal conversation. February 11, 2006. § Uno, Sadayuki. Artist File. Japanese American National Museum, Los Angeles.

BORN IN HIROSHIMA, Sadayuki Uno joined his father in California in 1917. After attending Oakland High School, he received a scholarship for the California School of Arts and Crafts, which he attended briefly. During this time, Uno began a lifelong friendship with **Henry Sugimoto**. Uno moved to Chicago and then to New York to study photography and cinematography with the goal of working as a cinematographer in Hollywood. While in New York, he studied at the New York Photography Institute and worked at a photography studio in Long Island. When his father became ill in the late 1920s, Uno returned to the Bay Area, settling in Alameda. Encouraged by the success of actor-director **Sessue Hayakawa**, Uno tried to find work in Hollywood, but opportunities were limited. In Alameda he worked as an interior decorator and later as a gardener, but he always continued to paint. He married in 1931.

During World War II, Uno and his wife and children were interned first at the Pinedale Assembly Center and then at the Jerome and Rohwer Relocation Centers. At Pinedale, Uno began wood carving with a butter knife, as other tools were prohibited. During internment he created his greatest body of work, making portrait and landscape paintings, carved sculpture, and wooden masks. His skilled paintings from this period are energetic compositions in sensuous impasto that often capture sinewy tree forms characteristic of the southern landscape. While at Rohwer, he taught at the camp's art school with his old friend Henry Sugimoto. During this time Uno also took up *shigin*, a Japanese form of spoken poetry. Following his release from camp, Uno and his family returned to the Bay Area, where he started a *shigin* group. He continued to take classes at the California College of Arts and Crafts and showed work in such venues as the Oakland Museum, which exhibited his masks and paintings.

Uyeno, Sekishun Masuzo

BORN: ca. 1892, Tokyo, Japan

DIED: unknown

RESIDENCES: ca. 1892–1908, Tokyo, Japan § 1908–1925, Los Angeles, CA § 1925–date unknown, location unknown

MEDIA: oil painting and drawing

SELECTED SOLO EXHIBITION: La Golondrina, Los Angeles, 1925

SELECTED GROUP EXHIBITIONS: *East West Art Society*, San Francisco Museum of Art, 1922 § *Shaku-do-sha Association Exhibition*, Union Church, Little Tokyo, Los Angeles, 1923 § *Painters and Sculptors of Southern California*, Los Angeles Museum, 1925

SELECTED BIBLIOGRAPHY: Anderson, Anthony. "Of Art and Artists: This Week in the Local Galleries." *Los Angeles Times*, March 15, 1925, 26. § 1920 Federal Population Census. Los Angeles, Los Angeles, California. Roll T625_109, Page 41B, Enumeration District 234, Image 0198. National Archives, Washington, D.C. § Passenger Lists of Vessels Arriving at San Francisco, 1893–1953. Roll 153, Page 33. National Archives, Washington, D.C. § Ueyama, Tokio. Review of 1923 Shaku-do-sha exhibition. *Rafu Nichi Bei*, June 20, 1923. Shiyei Kotoku biographical file, Asian American Art Project, Stanford University.

SEKISHUN UYENO, WHOSE NAME sometimes appears as Ueno or Uyena, was active as a painter in Los Angeles in the 1920s and is noted as a cofounder, along with painters Hojin Miyoshi and **Tokio Ueyama** and poet T. B. Okamura, of the artists' association Shaku-do-sha. The 1920 federal census shows a Masuzo Uyeno living on North San Pedro Street, and working as an artist. Sekishun M. Uyeno maintained a studio in the same location in the early 1920s, so Masuzo Uyeno likely used "Sekishun" as a professional name. Census records indicate that he first came to the United States in 1908, and his name on a 1921 passenger list from a ship arriving in San Francisco indicates he visited Japan during his residency in Los Angeles.

Uyeno most likely is the "A. Ueno" who participated in the 1922 East West Art Society exhibition in San Francisco. Because other artists' names are misspelled in the exhibition catalog, "Ueno" is probably a typographical error, as his friend and colleague **Tokio Ueyama** also participated in the show.

Uyeno exhibited *Cloudy Day* in the first Shaku-do-sha show in 1923. In a review of the exhibition, Tokio Ueyama described Uyeno's constructive use of pointillism in the landscape painting.

Vallangca, Roberto

BORN: June 16, 1907, Lapog, Ilocos Sur, Philippines

DIED: June 9, 1979, San Francisco, CA

RESIDENCES: 1907–1912, Lapog, Ilocos Sur, Philippines § 1912–1927, Buguey, Cagayan, Philippines § 1927, San Francisco, Santa Clara, and San Jose, CA § 1928–1979, San Francisco, CA

MEDIA: oil and watercolor painting, and illustration

SELECTED SOLO EXHIBITIONS: Shell Building, San Francisco, ca. 1935 § Philippine Consulate, San Francisco, 1990

SELECTED GROUP EXHIBITIONS: Duncan Vail Galleries, Oakland, Monterey, and Santa Cruz, ca. 1930s § *San Francisco Art Association*, San Francisco Museum of Art, 1935 § *With New Eyes: Toward an Asian American Art History in the West*, Art Department Gallery, San Francisco State University, 1995

SELECTED BIBLIOGRAPHY: Brown, Michael D. *Views from Asian California, 1920–1965*. San Francisco: Michael D. Brown, 1992. § Vallangca, Caridad Concepcion. CAAABS project interview. 1998. § Vallangca, Roberto V. *Pinoy: The First Wave, 1898–1941*. San Francisco: Strawberry Hill, 1977.

I landed in the port of San Francisco in July 28, 1927. I had only five dollars in my pocket. I was discouraged, but determined to succeed.

ROBERTO VALLANGCA
Pinoy: The First Wave, 62

A LEADING FIGURE in the Filipino immigrant community, Roberto Vallangca achieved distinction as a painter, author, chiropractor, and lawyer. His illustrated autobiography, *Pinoy: The First Wave, 1898–1941*, is an important firsthand account of the *Manong* generation in San Francisco.

Roberto Vallangca grew up in a family of poor farmers. Even before he could write, Vallangca drew—with bamboo sticks on banana leaves. Because there were no photographers in his community, he was sometimes asked to create pictures of his teachers or commissioned to draw portraits of the recently deceased. When he was twenty, Vallangca persuaded one of his brothers to sell family property so he could study in the United States. Arriving in San Francisco with few resources, he worked as a fieldhand, houseboy, janitor, and stockboy and created window displays at the Emporium department store. He attended night school for nine years to obtain his high school diploma and continued his studies at Heald Business College, where he studied architectural engineering. He also took sporadic classes at the California College of Arts and Crafts in Oakland.

Vallangca was most artistically active in the 1930s. He participated in the first San Francisco Art Association graphic

Roberto Vallangca (center figure) in his illustration from *Pinoy: The First Wave, 1898–1941*

arts exhibition held at the San Francisco Museum of Art. Vallangca also was employed by the WPA, assisting in the painting of the murals at Coit Tower, and was commissioned to create a "Fountain of Youth" mural at the 1939 Golden Gate International Exposition. In addition, he illustrated a book on California Indians for the California Forestry Service. During this time, Vallangca held a solo exhibition and participated in several group shows in the Bay Area, presenting tightly focused romantic landscapes, figurative paintings, watercolors, and drawings. He worked with or met many well-known artists, including George Post, Maynard Dixon, Diego Rivera, and Beniamino Bufano, and he interacted with others at the Black Cat bar on Montgomery Street.

During World War II, Vallangca worked as a marine engineer for the U.S. Navy. A back injury led him to study chiropractic medicine, and after becoming licensed in 1946, he practiced in San Francisco. For the next twenty years, Vallangca rarely painted. However, after an injury following a car accident in 1968, he resumed painting. He also pursued a law degree through correspondence from LaSalle University. In his late paintings, he focused on landscapes, seascapes, and floral motifs, some from observation and photographs and others from remembered scenes in the Philippines.

Vallangca's late works, influenced by his 1974 trip to Europe, display a brighter palette. His attempts to exhibit these paintings were unsuccessful beyond outdoor festival expositions, but he was honored posthumously in 1990 with a solo exhibition held at the Philippine consulate in San Francisco.

Valledor, Leo

BORN: January 18, 1936, San Francisco, CA

DIED: December 20, 1989, San Francisco, CA

RESIDENCES: 1936–1961, San Francisco, CA § 1961–1968, New York, NY § 1968–1989, San Francisco, CA

MEDIA: oil painting and drawing

ART EDUCATION: 1953–1955, California School of Fine Arts, San Francisco

SELECTED SOLO EXHIBITIONS: Six Gallery, San Francisco, 1955, 1956, 1957 § Dilexi Gallery, San Francisco, 1959 § Park Place Gallery, New York, 1965 § San Francisco Museum of Art, 1971 § de Young Museum, San Francisco, 1974 § *Four Solo Exhibitions*, Los Angeles Institute of Contemporary Art, 1976 § *Leo Valledor: A Memorial Tribute*, San Francisco Art Institute, 1990

SELECTED GROUP EXHIBITIONS: Six Gallery, San Francisco, 1954–1957 § Walker Art Center, Minneapolis, 1955 § *San Francisco Art Association*, San Francisco Museum of

Art, 1961 § Park Place Gallery, New York, 1963, 1964, 1965–1967 § Smithsonian Institution, Washington, D.C., 1965 § San Francisco Museum of Art, 1965, 1974, 1977 § San Francisco Art Institute, 1968, 1970, 1973, 1974, 1976, 1985 § *MIX: Third World Painting/Sculpture Exhibition*, San Francisco Museum of Art, 1974 § *Six Painters—Six Attitudes*, Oakland Museum of California, 1975 § *Other Sources*, San Francisco Art Institute, 1976 § San Jose Institute of Contemporary Art, San Jose, CA, 1985

SELECTED COLLECTIONS: Fine Arts Museums of San Francisco § Oakland Museum of California

SELECTED BIBLIOGRAPHY: Ballatore, Sandy. *Four Solo Exhibitions: Nancy Genn, John Okulick, Jack Scott, Leo Valledor.* Los Angeles: Los Angeles Institute of Contemporary Art, 1976. § Bourdon, David. "E=MC² à Go-Go." *Art News* (January 1966): 22–25, 57–59. § Howard, Seymour, and John Natsoulas. *The Beat Generation Galleries and Beyond.* Davis, CA: John Natsoulas Press, 1996. § *Leo Valledor: Selected Works.* Essay by Lawrence Rinder. San Francisco: Valledor Estate, 2005. § Natsoulas, John. *Lyrical Vision: The Six Gallery, 1954–1957.* Davis, CA: Natsoulas Novelozo Gallery, 1989. § Valledor, Mary, and Carlos Villa. CAAABS project interview. July 24, 2003. Transcript, Asian American Art Project, Stanford University.

LEO VALLEDOR WAS BORN in San Francisco's ethnically diverse Fillmore District. While at Galileo High School, he received a scholarship to study at the California School of Fine Arts, and he began attending the school at the age of seventeen. There, he excelled in painting and was befriended by a community of Beat Generation artists that included Wally Hedrick, Jay DeFeo, and Joan Brown; Valledor and Brown were the youngest of the fabled Studio 15 group at the school. Valledor was an honorary seventh member of the renowned Six Gallery and exhibited there and at the Dilexi Gallery in the late 1950s. His work from this period is characterized by gestural abstraction with calligraphic elements in a palette that was often limited to black and white. Works such as his *Jazzus* series and *Black and Blue* series, exhibited at the Six and Dilexi galleries, respectively, were influenced by jazz music and the African American community in which he grew up and with whom he identified. During this time Valledor also created large ink and pencil drawings incorporating handwritten phrases on torn shapes.

Like other artists in 1950s San Francisco, Valledor be-

Leo Valledor at Park Place Gallery, New York, 1966

444

came exposed to the ideas of Zen Buddhism, and the simplicity characteristic of Zen would shape his work. The minimal and meditative influence of Zen was not limited only to his art. As the artist's wife Mary Valledor later explained, "A part of Leo's whole character is this kind of connection to Zen and simplification and taking away and doing with less. And he really believed in all of that...that's the way our studio or our apartment or whatever we had was. It was like, why do you need more?"

Valledor moved to New York in 1961, and his work shifted from the abstract expressionist paintings he created in San Francisco to more minimal, geometric abstraction. Work from the early 1960s contained hard-edged, symmetrical shapes in a horizontal format, with color becoming the artist's main interest. Valledor also began using acrylic paints, which allowed him more flexibility in his quest to explore the spatial aspects of color. With friends Mark di Suvero, Dean Fleming, and Peter Forakis from the California School of Fine Arts and Robert Grosvenor, Anthony Magar, Tamara Melcher, Forrest Myers, and Ed Ruda, Valledor formed the Park Place Group out of a shared interest in geometric abstraction and minimalism. By the mid-1960s Valledor's paintings were concerned with ideas of perception, and he worked with color and line in a zigzag motif that would blur optically. He exhibited with Robert Smithson and Sol LeWitt at the Park Place Gallery, and his two-person show with Robert Grosvenor inaugurated the Park Place Gallery's move to a new location.

Returning to San Francisco in 1968, Valledor again focused on simplifying the geometric forms in his work. He completed his *East/West* series, which was exhibited at the San Francisco Museum of Art and the San Francisco Art Institute. During this period he made several paintings using clear acrylic polymer medium over the raw canvas as color. By 1972 he was creating larger, more complex, multiple-panel color-field studies that emphasized contrasts between dark and light and between fluid and stable shapes. This work was exhibited at the de Young Museum in 1974.

In the Bay Area, Valledor taught at the San Francisco Art Institute, Lone Mountain College, the University of California, Berkeley, and the Academy of Art College. He received a National Endowment for the Arts Artists Fellowship Grant in 1979/1980 and a second in 1985/1986. He died of cancer in 1989 at the age of fifty-three.

Villa, Carlos

BORN: December 11, 1936, San Francisco, CA

RESIDENCES: 1936–1955, San Francisco, CA § 1955–1957, Korea (U.S. military service) § 1957–1961, San Francisco, CA § 1961–1963, Oakland, CA § 1963–1964, San Francisco, CA § 1964–1969, New York, NY § 1969–present, San Francisco, CA

MEDIA: painting, performance, installation, and sculpture

ART EDUCATION: 1958–1961, California School of Fine Arts, San Francisco § 1961–1963, Mills College, Oakland, CA

SELECTED SOLO EXHIBITIONS: Poindexter Gallery, New York, 1967 § Nancy Hoffman Gallery, New York, 1973, 1975 § San Francisco Art Institute, 1974 § San Francisco Museum of Modern Art, 1982 § University of San Francisco, 2000

SELECTED GROUP EXHIBITIONS: *Ratbastards*, Spatsa Gallery, San Francisco, 1958 § San Francisco Museum of Art, 1961, 1974, 1976, 1982 § *Invitational*, California Palace of the Legion of Honor, San Francisco, 1962 § Oakland Museum of California, 1971, 1990, 1996 § *Whitney Annual*, Whitney Museum of American Art, New York, 1972

SELECTED COLLECTIONS: Crocker Art Museum, Sacramento, CA § Oakland Museum of California § Whitney Museum of American Art, New York

SELECTED BIBLIOGRAPHY: Kim, Elaine H., Margo Machida, and Sharon Mizota. *Fresh Talk, Daring Gazes: Conversations on Asian American Art*. Berkeley: University of California Press, 2003. § Lippard, Lucy. *Mixed Blessings*. New York: Pantheon Books, 1990. § Tani, Diane, Moira Roth, and Mark Johnson, eds. *Carlos Villa*. Berkeley: Visibility Press, 1994. § Villa, Carlos. *Carlos Villa: Selected Works, 1961–1984*. Davis, CA: Memorial Union Art Gallery, University of California, Davis, 1985. § Villa, Carlos. *Other Sources: An American Essay*. San Francisco: San Francisco Art Institute, 1976. § Villa, Carlos. *Worlds in Collision: Dialogues on Multicultural Art Issues*. San Francisco: International Scholars Publications, San Francisco Art Institute, 1994.

Contribute as artists. Stimulate, reform and expand creative mindsets and artist paradigms that envision and develop art purpose for community and social change from inside.

CARLOS VILLA
"Worlds in Collision" class syllabus,
1996. Collection of the Asian American Art Project,
Stanford University.

WIDELY REGARDED AS Northern California's principal proponent of a multicultural understanding of American art history, criticism, and practice, Carlos Villa has had a professional career in California that spans five decades. Villa, the son of immigrant parents from the Philippines, was born in San Francisco's Tenderloin District. An important early influence was his cousin **Leo Valledor**, who amazed Villa with the magic of his drawing and his ambition to become an artist. After graduating from Lowell High School in 1954, Villa joined the U.S. Army. After being stationed in California, Virginia, and Louisiana, Villa spent two years in Korea as a clerk typist. After his discharge in 1957, Villa began to focus on art-making. The follow-

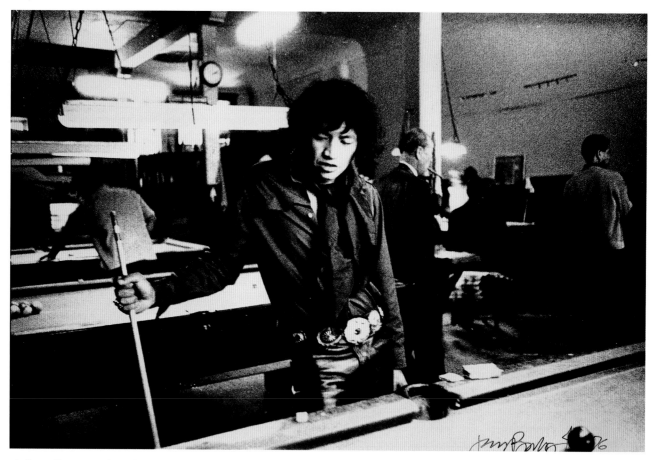

Carlos Villa, 1974. Photo by Jerry Burchard

ing year, on the GI Bill, he enrolled at the California School of Fine Arts, where he studied with such faculty as Elmer Bischoff and Manuel Neri. He was also involved with a circle of artists and fellow students, including Joan Brown, William Wiley, and Bruce Conner. Villa later pursued his M.F.A. degree at Mills College in Oakland. During this period, Villa created large impasto abstract canvases. After graduation, Villa moved in 1964 to New York, where his cousin had also relocated. There, his work became more minimal and sculptural.

In 1969, Villa returned to San Francisco. He began teaching in neighborhood community centers, as well as at Sacramento State College (1973–1979) and the San Francisco Art Institute (1969–1973, 1979–present). Villa's art during this period reflected a shift in priorities, interests, and materials. In addition to canvas and paint, he worked with blood, bone, hair, teeth, and shells, influenced by tribal art from Melanesia and New Guinea. During the 1970s, he created several feathered cloaks, which he sometimes used in performance, suggesting shamanic rituals. Later series included sculpture incorporating cast paper pulp, as well as gallery installations. On the occasion of the U.S. bicentennial in 1976, he hosted a highly influential exhibition and symposium, and in 1989 he began an extended series of symposia entitled "Sources of a Distinct Majority." These programs involved national and regional cultural theorists including Moira Roth and Amalia Mesa-Bains, and several

related exhibitions and collectives developed from this organizing. One important outcome was the development of Bay Area research into California Asian American art history.

In the late 1990s, Villa refocused his energies on his painting, blending the minimal aesthetic of his New York period with the multicultural concerns of his mature San Francisco period. At the same time, he created a number of works using historical photographs of his family and the Filipino community. In some works he used a series of engraved brass plaques in repeated but reordered formats, an allusion to Malaysian poetry forms as well as to jazz improvisation. Villa has received many honors, including a National Endowment for the Arts Artists Fellowship Grant in 1973 and a Pollock Krasner Grant in 1997. His studio work continues to explore social themes associated with the *Manong* generation of immigrants of his youth, and he remains active as an organizer of cultural programs and new approaches to teaching.

Wang, C. C. (Wang Chi-Ch'ien, Wang Jiqian)

BORN: February 14, 1907, Suzhou, China

DIED: July 3, 2003, New York, NY

RESIDENCES: 1907–1949, Suzhou, China § 1949–1961, New York, NY § 1962–1964, Hong Kong § 1964–

446

1968, New York, NY § 1968–1969, Berkeley, CA § 1969–2003, New York, NY

MEDIA: ink painting

ART EDUCATION: Suzhou University, Suzhou, China § Suzhou University, Shanghai, China § ca. 1950s, Art Students League, New York

SELECTED SOLO EXHIBITIONS: de Young Museum, San Francisco, 1968 § Los Angeles County Museum of Art, 1971 § Honolulu Academy of Arts, 1972 § Fogg Art Museum, Harvard University, Cambridge, MA, 1973 § The Brooklyn Museum, New York, 1977 § *Mind Landscape: The Paintings of C. C. Wang*, Henry Art Gallery, University of Washington, Seattle, 1987 § Taipei Fine Arts Museum, 1994 § *Living Masters: Recent Paintings by C. C. Wang*, Asian Art Museum, San Francisco, 1996

SELECTED GROUP EXHIBITIONS: *The New Chinese Landscape: Six Contemporary Chinese Artists*, American Federation of Arts, New York, 1966 § *Six Twentieth-Century Chinese Artists*, Los Angeles County Museum of Art, 1989 § *Asian Traditions/Modern Expressions*, Jane Voorhees Zimmerli Art Museum, Rutgers State University, New Brunswick, NJ, 1997 § *The Living Brush: Four Masters of Contemporary Chinese Calligraphy*, Pacific Heritage Museum, San Francisco, 1997

SELECTED COLLECTIONS: Asian Art Museum, San Francisco § Berkeley Art Museum, Berkeley, CA § Fogg Art Museum, Harvard University § Los Angeles County Museum of Art § Metropolitan Museum of Art, New York

SELECTED BIBLIOGRAPHY: *C. C. Wang: Landscape Paintings*. Introduction by James Cahill. Seattle: University of Washington Press, 1987. § Hsu Hsiao-hu. *Mountains of the Mind: The Landscape Paintings of Wang Chi-ch'ien*. New York and Tokyo: John Weatherhill, 1970. § Katz, Lois, and C. C. Wang. *The Landscapes of C. C. Wang: Mountains of the Mind*. New York: Arthur M. Sackler Foundation, 1977.

My attitude toward Chinese painting is different from the old masters'. For instance, all the old masters after seventy were already settled into their styles, and they didn't change any more. They played around all the time with their "maturity," but within limits.... I want to develop new ideas. That's where I'm different. My attitude is different. I'm still young in mind. It's odd, but I've never rested, not in my mind.

 C. C. WANG
 Jerome Silbergeld. *Mind Landscapes:*
 The Paintings of C. C. Wang. Seattle:
 University of Washington Press, 1987, 37.

AT THE TIME OF his death in 2003 at the age of ninety-six, C. C. Wang was recognized as among the twentieth century's preeminent Chinese scholar-artists. Wang began studying callig-

raphy with his father as a young child and received a classical Chinese education at home from both his father and a private tutor, developing an early interest in art. He studied painting in high school, attended the university in his hometown, and received a law degree from Suzhou University in Shanghai. While at the university, he continued his painting studies with Wu Hu-fan and eventually decided to pursue a career in art.

In 1936, Wang was asked to be an advisor to the committee organizing the important London exhibition of works from the Palace Museum in Beijing. As the first private citizen to have access to the imperial collection, Wang was able to study the most important Chinese paintings in existence and build his expert knowledge of Chinese art.

Wang, along with his wife and children, immigrated to New York in 1949, escaping the political chaos of postwar China. Wang served as a consultant to Sotheby's, acquired and sold art, and was widely regarded as a foremost authority of Chinese painting. The Metropolitan Museum of Art acquired more than sixty works from Wang and appointed him a Lifetime Fellow in 1969.

His own painting career continued in New York. He was influenced by abstract expressionism and his studies at the Art Students League, where he began taking classes in 1950. His landscape paintings incorporate references to calligraphy and ancient models and employ a wide range of colors, including vivid reds, purples, and blues. Although his early work in China was based on the conventions of Chinese landscape painting, in the 1960s Wang developed an experimental style,

C. C. Wang

often beginning by blotting his paper with ink and discovering images in the random marks. He also created highly innovative calligraphic forms. Wang served as a visiting lecturer both at Columbia University in the early 1950s and at the University of California, Berkeley, in 1968–1969 and was chairman of the art department at the Chinese University in Hong Kong from 1962 to 1964. He continued painting into his nineties.

Watanabe, Torajiro

BORN: ca. 1880, Fukushima, Japan

DIED: unknown

RESIDENCES: ca. 1880–ca. 1909, Japan § ca. 1909–ca. 1913, San Francisco, CA § ca. 1913–ca. 1919, Denver, CO § ca. 1919–ca. 1927, New York and Woodstock, NY § ca. 1927–ca. 1930, Los Angeles, CA § ca. 1930–date unknown, location unknown

MEDIA: oil, watercolor and ink painting, drawing, and sculpture

ART EDUCATION: Manchu School of Art, Tokyo § 1910–1911, San Francisco Institute of Art § ca. 1913–ca. 1919, Academic School, Denver § Art Students League, New York

SELECTED SOLO EXHIBITIONS: Chuo Bijutsu Kwai Kwan (Japanese Art Club), Los Angeles, 1927 § Pasadena Art Institute, Pasadena, CA, 1928 § Olympic Hotel, Los Angeles, 1928 § Miyako Hotel, Los Angeles, 1932 § Denver Art Museum, Denver, CO, 1933

SELECTED GROUP EXHIBITIONS: *Exhibition of Paintings and Sculptures by the Japanese Artists Society of New York City*, The Civic Club, New York, 1922 § Society of Independent Artists, New York, 1922–1927 § *The First Annual Exhibition of Paintings and Sculpture by Japanese Artists in New York*, The Art Center, New York, 1927 § *Japanese Artists of Los Angeles* (First and Second Annual), Little Tokyo, 1929, 1930 § Los Angeles Artists and Vicinity, Los Angeles Museum, 1941 § *Half Century of Japanese Artists in New York, 1910–1950*, Azuma Gallery, New York, 1977

SELECTED BIBLIOGRAPHY: "A Japanese Artist." *Los Angeles Times*, November 27, 1927, part 3, 20. § "Art Exhibit Held at Olympic Hotel." *Rafu Shimpo* (Los Angeles), October 22, 1928. § "Art Talent Among the Local Japanese." *Los Angeles Times*, December 21, 1930, 15. § Bear, Donald J. "Japanese Have Mastered Art of Western Painters." Unknown Denver newspaper, September 3, 1933. Donald Bear Papers, Archives of American Art, reel 1286, fr. 149. § Bryan, William Alanson. *Catalogue of the Sketch Designs Submitted in the International Mural Competition The Dynamic of Man's Creative Power*. Los Angeles: Los Angeles

Museum, n.d. § Halteman, Ellen Louise. *Publications in [Southern] California Art 7: Exhibition Records of the San Francisco Art Association, 1872–1915; Mechanics' Institute, 1857–1899; California State Agricultural Society, 1856–1902*. Los Angeles: Dustin Publications, 2000. § "Local Art Exhibitions Given Review." *Los Angeles Times*, August 14, 1932, part 3, 8. § Marlor, Clark S. *The Society of Independent Artists: the exhibitions record 1917–1944*. Park Ridge: Noyes Press, 1984. § Millier, Arthur. "City's Japanese Show Art." *Los Angeles Times*, December 29, 1929, part 3, 9. § Moure, Nancy Dustin Wall. *Publications in Southern California Art 1, 2, & 3*. Los Angeles: Dustin Publications, 1984. § 1920 Federal Population Census. Manhattan, New York, New York. Roll T625_1198, Page 4A, Enumeration District 585, Image 837. National Archives, Washington, D.C.

TORAJIRO WATANABE WAS BORN in Fukushima, Japan, and studied at the Manchu School of Art in Tokyo. His birth date, often cited as 1886, is listed as 1880 in the 1920 U.S. Federal Census, which also states that Watanabe immigrated to the United States in 1909. After initially spending time in San Francisco, he continued his studies in 1913 at the Academic School in Denver, Colorado, studying with William Henry Read, and trained there until approximately 1919. He then moved to New York City and attended the Art Students League, where he studied painting with John Sloan and sculpture with Hunt Deidrich. Watanabe also studied and painted at the Woodstock art colony in upstate New York, where he became a member of the Woodstock Art Association and served on its board. He exhibited with the Japanese Artists Society of New York in 1922 alongside fellow artists Toshi Shimizu, Bumpei Usui, and **Eitaro Ishigaki**, and in *The First Annual Exhibition of Paintings and Sculpture by Japanese Artists in New York* in 1927, he exhibited with Ishigaki, **Noboru Foujioka**, **Yasuo Kuniyoshi**, **Yoshida Sekido**, and others. He also participated in the Society of Independent Artists' annual exhibitions every year between 1922 and 1927, presenting six works in the 1926 show. Titles for paintings exhibited in these shows include *Monstrosity in the World of Thought*, *Symbol of Righteousness* (described as a screen), *Earthquake*, and *Mob and Persecution*. He also exhibited "coal carvings."

In approximately 1927, Watanabe moved to Los Angeles, where he held many one-person shows and participated in numerous group exhibitions. His solo show of 1927 was reported in the *Los Angeles Times* to have taken place at the Chuo Bijutsu Kwai Kwan (Japanese Art Club), and the artwork was described as being in the "murky palette popular at Woodstock." With the tone common at the time, the writer praised the "oriental" qualities of Watanabe's work for their "sensitivity," but is critical of any modern forays by the artist: "While in many of his canvases he seems to accept too readily a momentary occidental fashion—as for instance in the building up of house

forms devoid of all but geometrical interest, there are certain subjects he can approach with a sympathy and skill very rare among occidentals. Whenever he composes with rocks and water falls, for instance, one feels these things have deep meaning for him. The rendering of hands and features in some of his figure pieces was very noteworthy, and best of all, when he sketched a passing rainstorm or low-hanging rain clouds, then one felt the legitimate descendant of Hokusai."

Watanabe showed approximately one hundred works comprising oils, watercolors, pastels, pencil drawings, and black-and-white washes at the Olympic Hotel in 1928. A related *Rafu Shimpo* article said that he had spent much time in the Carmel area and recently began giving art classes in Los Angeles. Work by Watanabe was included in both the 1929 and 1930 *Japanese Artists of Los Angeles* shows, alongside that of **Yotoku Miyagi**, **Tokio Ueyama**, **Kazuo Matsubara**, and **Hideo Date**.

At the Denver Art Museum in 1933, Watanabe exhibited wood carvings and twenty-two oil paintings, including landscapes and still lifes with patterned backgrounds. One of his works was included in a 1941 exhibition at the Los Angeles Museum.

Weakland, Anna Wu

BORN: May 1, 1924, Shanghai, China

RESIDENCES: 1924–1947, Shanghai, China § 1947–1953, New York, NY § 1953–present, Palo Alto, CA

MEDIA: ink, watercolor and oil painting, and printmaking

ART EDUCATION: 1953–1955, Stanford University

SELECTED SOLO EXHIBITIONS: de Young Museum, San Francisco, 1959 § La Jolla Museum of Art, La Jolla, CA, 1960 § Pasadena Art Museum, Pasadena, CA, 1962 § Seattle Art Museum, 1963 § Downtown Gallery, New York, 1967 § *Anna Wu Weakland*, Stanford University Museum of Art, 1988

SELECTED GROUP EXHIBITIONS: Hunter College, New York, 1953 § Mills College, Oakland, CA, 1958 § *Five Thoughts on Seeing*, San Francisco Museum of Art, 1961 § *Leading the Way: Asian American Artists of the Older Generation*, Gordon College, Wenham, MA, 2001

SELECTED COLLECTIONS: Ashmolean Museum, Oxford, England § Greater Victoria Art Museum, Victoria, Canada § Iris & Gerald B. Cantor Center for Visual Arts, Stanford University § Palacio De Bellas Artes, Mexico City § Seattle Art Museum

SELECTED BIBLIOGRAPHY: *Anna Wu Weakland*. Stanford, CA: Stanford Art Gallery, 1965. § Maveety, Patrick J. *Anna Wu Weakland*. Stanford, CA: Stanford University Museum of Art, 1988. § Poon, Irene. *Leading the Way: Asian American*

Artists of the Older Generation. Wenham, MA: Gordon College, 2001. § Weakland, Anna Wu. CAAABS project interview. October 17, 1997.

When I put down spontaneous lines, dots or dribbles, the brush strokes are alive and immediate. Sometimes, the surface of the paper becomes instant magic. For centuries, the Chinese painters called this "the spirit of the brush." I keep on working, meditating, and practicing until that certain space and time have been obtained.

ANNA WU WEAKLAND
Maveety, *Anna Wu Weakland*

ANNA WU WEAKLAND was greatly influenced by her father, who had studied in the West and held progressive ideas about education and the role of women in society. He had been one of the first two pupils at Shanghai University, opened by Baptist missionaries, and then studied at and graduated from Columbia University, the University of Chicago, and the Rockefeller Theological Seminary in the United States. When he returned to Shanghai, he became a Protestant minister, lawyer, educator, and publisher.

Anna Wu Weakland, ca. 1988

Following in her father's footsteps, Weakland graduated from Shanghai University in 1943. After graduation, she worked in an advertising agency. In 1947, she left China for the United States and studied sociology at Columbia University, where she received an M.A. in 1948. As she began to pursue her Ph.D., her life changed direction when the Dean of the graduate school at Columbia asked her to serve as a translator for noted artist Wang Ya-chen, who was curating an exhibition for the Metropolitan Museum of Art. Weakland, who often gave presentations at the China Institute in New York to introduce Americans to Chinese culture, was proficient in English and several Chinese dialects and was an ideal translator for Wang. Wang, one of the top artists in Shanghai, brought the best contemporary Chinese art to be exhibited in New York, and the experience changed Weakland's life. Weakland studied privately with Wang after her classes at Columbia, and he became her artistic mentor. She later became his assistant.

Weakland studied the work and brushstroke techniques of masters like Qi Bashi and **Chang Dai-chien**, with whom she became friends during his visits to New York, when she would take him out shopping for his family. She also visited him in Hong Kong and later in Carmel, California.

Weakland, who had met and married John Weakland while both were at Columbia, moved with her husband to California in 1953 when he received a professorship at Stanford University. Weakland studied Western painting at Stanford in the mid-1950s, working in oil paint, and began a long exhibition history that included solo shows at the de Young Museum, the Seattle Art Museum, and the La Jolla Museum of Art, and several exhibitions at Stanford University. Her work primarily employed inks or pigments on rice paper and incorporated calligraphic markings and abstraction. Her 1988 exhibition at Stanford featured a series of monoprints, indicative of Weakland's interest in experimentation and exploration of new media, which has also resulted in designs for tapestries and ceramics.

Weakland taught in schools and in art programs at senior centers. She has been awarded many honors for her community work, including a Lifetime Achievement Award from the city of Palo Alto, where she lives.

Wong, Charles

BORN: September 24, 1922, San Francisco, CA

RESIDENCES: 1922–1942, San Francisco, CA § 1942–1946, Phoenix, AZ (U.S. military service) § 1946–present, San Francisco, CA

MEDIA: photography

ART EDUCATION: 1940–1942, 1949–1951, California School of Fine Arts, San Francisco

SELECTED SOLO EXHIBITION: *Charles Wong*, George Eastman House Study Room, Rochester, NY, 1956

SELECTED GROUP EXHIBITIONS: *San Francisco Art Association*, San Francisco Museum of Art, 1941, 1942 § *Seven Photographers*, San Francisco Museum of Art, 1951 § *Perceptions*, San Francisco Museum of Art, 1954 § *Creative Photography 1956*, University of Kentucky Art Gallery, Lexington, KY, 1956 § *Subjektive Fotografie: Images of the '50s*, Museum Folkwang, Essen, Germany, 1984/85 § *Leading the Way: Asian American Artists of the Older Generation*, Gordon College, Wenham, MA, 2001

SELECTED COLLECTIONS: Ann Bremer Library, San Francisco Art Institute § George Eastman House, Rochester, NY § Museum Folkwang, Essen, Germany

SELECTED BIBLIOGRAPHY: *Aperture* 4, no. 1 (1956): 18. § Klochko, Deborah. *Ten Photographers, 1946–54: The Legacy of Minor White, California School of Fine Arts, The Exhibition Perceptions*. San Francisco: Paul M. Hertzmann, 2004. § Poon, Irene. *Leading the Way: Asian American Artists of the Older Generation*. Wenham, MA: Gordon College, 2001. § *U.S. Camera*, August 1954, 76. § Wong, Charles. CAAABS project interview. July 23, 1999. Transcript, Asian American Art Project, Stanford University. § Wong, Charles. "1952/The Year of the Dragon." *Aperture* 2, no. 1 (1953): 4–12. § "The Year of the Dragon." *San Francisco Chronicle*, Panorama, October 1, 1952, 19. § "The Year of the Dragon." *San Francisco Chronicle*, Panorama, October 2, 1952, 15.

Charles Wong, 2000. Photo by Irene Poon

If I could satisfy their hunger with a tiny experience or renew the flame of a forgotten pleasure, then I believe it is worth the effort to make an exposure.

CHARLES WONG
Aperture 4, no. 1 (1956): 18

CHARLES WONG WAS BORN and grew up in San Francisco's Chinatown but attended high school outside of Chinatown at Mission High, where he was one of approximately twenty Chinese students in a school of two thousand. While at Mission High, he began taking art classes, and by the time he graduated, he received a scholarship to attend the California School of Fine Arts.

At the California School of Fine Arts, Wong took a variety of courses and exhibited watercolor paintings with the San Francisco Art Association. World War II, however, derailed Wong's education, and he enlisted in the U.S. Air Force. Wong spent the war years in Arizona, where he served as a member of the ground support crew for Chinese pilots training in the United States. Wong returned to San Francisco and civilian life in 1946, working for Bethlehem Steel as a marine draftsman. But after three years there, he decided to resume his art studies. Although he thought about going to school in Los Angeles, Wong by this time was married and had children, so he returned to the California School of Fine Arts. He focused on photography, seeing a career as a commercial photographer as a way to be creative while also supporting himself and his family.

Established by Ansel Adams only a few years before as one of the first photography programs in the country, the California School of Fine Art's photography department afforded Wong access to some of the field's most important artists. In addition to taking classes with Adams, Wong studied with Minor White, Edward Weston, and Imogen Cunningham. Although no one particular artist served as a mentor to Wong, he distilled what he learned from all of them into his unique style. Wong initially shot primarily in his own neighborhood, and his photographs offered a more personalized view of Chinatown than the commonly seen images taken by nonresidents. Yet his work was not simply community documentation; it was often compositionally formal. Wong's preferred working method was not to create individual photographs, but instead to create a group of images that could tell a story from beginning to end. His series *The Year of the Dragon—1952* is an example of this storytelling, and it brought a great deal of attention to Wong and his work. The photos, which are accompanied by Wong's prose, show the diversity within the Chinese community. They were reproduced in a two-part series in the *San Francisco Chronicle* and served as the foundation for an issue of the photography journal *Aperture*.

In 1951, Wong was the first photographer to receive the Bender Grant-in-Aid, an award given to promising artists, which he used to create the *Year of the Dragon* series. That same year he received honorable mention in *Life* magazine's contest for young photographers. Wong's photographs were in exhibitions, including the San Francisco venue of *Perceptions* (1954), and a solo show of his work was held at the prestigious George Eastman House in 1956. Despite his growing success, Wong in the mid-1950s stopped making photographs and, to support his family, returned to regular employment at Bethlehem Steel. He continued to work there, and later at the Bechtel Corporation, until his retirement in 1985.

Wong, Jade Snow (Connie Ong)

BORN: January 21, 1922, San Francisco, CA

DIED: March 16, 2006, San Francisco, CA

RESIDENCE: 1922–2006, San Francisco, CA

MEDIA: ceramics and metalwork

ART EDUCATION: 1940–1942, Mills College, Oakland, CA

SELECTED SOLO EXHIBITIONS: Portland Art Museum, Portland, OR, 1951 § Chicago Art Institute, 1952 § Detroit Institute of Arts, 1952 § Joslyn Memorial Museum, Omaha, NE, 1952 § *Jade Snow Wong: A Retrospective*, Chinese Historical Society of America, San Francisco, 2002

SELECTED GROUP EXHIBITIONS: National Ceramics Exhibitions, 1947–1951 § San Francisco Museum of Art, 1947, 1950, 1951 § de Young Museum, San Francisco, 1948, 1949

SELECTED COLLECTIONS: Detroit Institute of Arts § International Ceramic Museum, Faenza, Italy § Mills College, Oakland, CA § Oakland Museum of California § Seattle Art Museum

SELECTED BIBLIOGRAPHY: Agueros, Jack, et al. *The Immigrant Experience: The Anguish of Becoming American*. New York: Dial Press, 1971. § Wong, Jade Snow. *Fifth Chinese Daughter*. New York: Harper and Row, 1950. § Wong, Jade Snow. *No Chinese Stranger*. New York: Harper and Row, 1975. § Wong, Jade Snow, Irene Poon, and Maxine Hong Kingston. *Jade Snow Wong: A Retrospective*. San Francisco: Chinese Historical Society of America, 2002. § Yung, Judy. *Unbound Feet: A Social History of Chinese Women in San Francisco*. Berkeley: University of California Press, 1995.

My abiding motivation in both pottery and enamels is that... let's say it's a Sunday or any day... I spent that time at that piece and that is a mirror of me at that time.

JADE SNOW WONG
CAAABS project interview.
July 22, 1997. San Francisco, CA.

JADE SNOW WONG's name commemorates a rare San Francisco snowfall on the day of her birth. She was the fifth daughter of nine children and grew up in a Chinatown basement apartment, where her father operated a small garment factory and taught his children about Chinese calligraphy and culture. A determined student, Wong graduated Phi Beta Kappa from Mills College with a double major in economics and sociology.

During her senior year at Mills, Wong initially studied ceramics as part of her social work training. Her abilities were recognized and encouraged, and she enrolled in further art classes. After graduation, a benefactor funded her summer session study at Mills, where she worked with Bernard Leach, Charles Merritt, and F. Carlton Ball, who also provided instruction in copper enameling. Although the forms of her work were generally simple and functional, Wong became known for the thick textures and the jewel-like surfaces of her ceramic and enamel ware. After World War II, Wong joined the Ceramics Guild at Mills.

In the mid-1940s, Wong rented a storefront on Grant Avenue in Chinatown and produced pottery on the wheel in the shop's window—even during her pregnancy. This public display attracted significant newspaper attention and at the same time brought criticism from more traditional members of the Chinese community. Her work was collected, exhibited both regionally and nationally, and awarded important prizes, including a Craftsmanship Medal from *Mademoiselle* magazine in 1948.

Wong also wrote short stories, which were published in journals such as *Holiday* and *Common Ground*. Her autobiographical book, *Fifth Chinese Daughter*, was published by Harper and Row in 1950. In 1951, she was invited by the U.S. State Department to speak internationally on behalf of the Leaders and Specialists Exchange Program. During her extensive traveling, Wong studied both Japanese and Chinese ceramic glazing and later incorporated aspects of these traditions into her work.

In 1958, Wong and her husband opened a combined studio, travel agency, and gift store, which sold her work. She continued to pursue writing and published books, including *Puritans From the Orient* (1971) and *No Chinese Stranger* (1975).

Jade Snow Wong, 1945

Fifth Chinese Daughter was produced as a half-hour PBS television special in 1976 and broadcast nationally. Wong stopped creating ceramics in 1985 after the death of her husband, but she continued an active career as both author and enamel artist. She received many honors and awards for her work as a writer, artist, and pioneer.

Wong, Lui-sang

BORN: September 29, 1928, Taishan, Guangdong, China

RESIDENCES: 1928–1960, China and Hong Kong § 1960– ca. 1977, San Francisco, CA § ca. 1977–present, Taipei, Taiwan

MEDIA: ink painting

ART EDUCATION: ca. 1946–ca. 1949, University of Canton, Guangdong, China § ca. 1950, Lingnan Art School, Hong Kong

SELECTED SOLO EXHIBITIONS: Occidental College, Los Angeles, 1960 § Paulson's Gallery, Pasadena, CA, 1962 § Rutgers University, Newark, NJ, 1969 § de Saisset Art Museum, Santa Clara University, Santa Clara, CA, 1975 § Taipei Fine Arts Museum, Taiwan, 1995 § *The Art of Lui-Sang Wong*, Dr. Sun Yat-Sen Memorial Hall, Taipei, Taiwan, 1998

SELECTED GROUP EXHIBITIONS: *Society of Western Artists*, de Young Museum, San Francisco, 1968 § National Museum of History, Taipei, Taiwan, 1970, 1982 § American Watercolor Society (traveling exhibitions), 1971–1973

SELECTED COLLECTIONS: Central Art Museum, Tokyo § Chinese Information and Culture Center Library, New York § Museum Royaux of Art and History, Brussels, Belgium § Taiwan Museum of Art, Taichung

SELECTED BIBLIOGRAPHY: Huang, Leisheng, and Wallace S. Baldinger. *Paintings by Lui-Sang Wong*. Eugene, OR: Museum of Art, University of Oregon, 1965. § Wong, Lui-sang. *Chinese Painting*. Hong Kong: East Wind Studio, 1960. § Wong, Lui-sang. Correspondence. May 12, 2001. § Wong, Lui-sang. *Lui-Sang Wong's Paintings*. Taipei: Art Book Co., Ltd., 1982.

LUI-SANG WONG'S INTEREST in painting and calligraphy began at an early age, and he started studying Western and Chinese art when he was fourteen. In approximately 1950, he attended the Lingnan Art School and studied with Chao Shao-an, who was an important influence. Wong started exhibiting widely in the 1950s in China, Taiwan, and Japan, and in 1954 he established the East Wind Art Studio in Hong Kong, where he taught Chinese painting theory and practice. He continued his teaching at South China College, and in 1956 he held his first one-person show in Hong Kong.

Wong moved to San Francisco in 1960 and re-established his East Wind Art Studio in the city's Chinatown. In addition to teaching at the studio, he also used the East Wind as an exhibition space for fellow artists, including **Cheng Yet-por**. During his years in the United States, Wong frequently lectured on art and held many exhibitions of his work at universities. His dramatic landscapes, painted with ink and mineral pigments and often presented as scrolls, still convey a contemporary sensibility. Many people, such as San Francisco artist Leland Wong, studied with Wong and were influenced by his teaching style, described as a modern approach to Chinese painting that encouraged self-expression. Wong also lectured and exhibited extensively in Canada. In 1961, at the Sino-American Cultural Society in Washington, D.C., Wong presented President John F. Kennedy with the painting *Attempting to Land on the Moon*.

Wong has had more than fifty solo exhibitions and is currently a professor at the University of Chinese Culture in Taipei. He founded the Three Stone Art Association in Taiwan in 1984 and is an advisor and board member of many arts associations and organizations in the United States and Taiwan.

Wong, Martin

BORN: July 11, 1946, Portland, OR

DIED: August 12, 1999, San Francisco, CA

RESIDENCES: 1946–1964, San Francisco, CA § 1964–1978, San Francisco and Eureka, CA § 1978–1994, New York, NY § 1994–1999, San Francisco, CA

MEDIA: acrylic and oil painting, printmaking, ceramics, set design, and public art

ART EDUCATION: 1964–1968, Humboldt State University, Arcata, CA § 1968, Mills College, Oakland, CA

SELECTED SOLO EXHIBITIONS: *Chinatown USA*, San Francisco Art Institute Gallery, 1993 § *Sweet Oblivion: The Urban Landscape of Martin Wong*, The New Museum of Contemporary Art, New York, 1998 § *Martin Wong: The Eureka Years*, Humboldt State University, First Street Gallery, Eureka, CA, 1999 § *Martin Wong's Utopia*, Chinese Historical Society of America, San Francisco, 2004

SELECTED GROUP EXHIBITIONS: *San Francisco Public School Children's Art Show*, de Young Museum, San Francisco, 1959 § *Ceramics 70*, de Young Museum, San Francisco, 1970 § *New Narrative Painting*, Museo Rufino Tamayo, Mexico City, 1984 § *The Decade Show*, Museum of Contemporary Hispanic Art, New York, 1990

SELECTED COLLECTIONS: Fine Arts Museums of San Francisco § Humboldt State University, Arcata, CA § The Metropolitan Museum of Art, New York § Whitney Museum of American Art, New York

SELECTED BIBLIOGRAPHY: Cotter, Holland. "Martin Wong." *Arts Magazine* 58, no. 13 (September 1984): 2. § Ramirez-Harwood, Yasmin. "Writing in the Sky: An Interview with Martin Wong." *East Village Eye*, October 1984, 25. § Rosenblatt, Roger. "A Christmas Story." Illustrations by Martin Wong. *Time* 126, no. 26 (December 30, 1985): 18–30. § Schwabsky, Barry. "A City of Bricks and Ciphers." *Art in America* 86, no. 9 (September 1998): 100–105. § Wong, Martin, Dan Cameron, and Amy Scholder. *Sweet Oblivion: The Urban Landscape of Martin Wong*. New York: Rizzoli, 1998.

Taking it down to street level this time, I wanted to focus in close on some of the endless layers of conflict and confinement that has us all bound together in this life, without possibility of parole, by whatever chains of desire, be they financial, chemical or karmic.

MARTIN WONG
Artist's statement for exhibition
at Semaphore East Gallery, New York, October 1985

WHILE HIS PAINTINGS of 1980s and 1990s New York cityscapes are in the permanent collections of some of that city's most prestigious museums, Martin Wong first exhibited work in his

Martin Wong, 1974

hometown of San Francisco in 1959. Already displaying a brilliant drawing ability during his early teens, Wong created early works that reflect influences of the psychedelic era and his interest in the diverse cultures of Asia. He studied privately in Mendocino with Dorr Bothwell during the summer of 1964.

Beginning in 1964, Wong lived for fifteen years in Eureka, where he developed an extensive body of work in ceramics, including a series of "Loveletter Incinerators" and poetry written in a personalized calligraphy in English that suggested Chinese writing. He became a central figure of the Humboldt County arts community and a friend of Morris Graves. Wong became widely known for his "Human Instamatic" drawn portraits, and for his activism on behalf of preserving the adorned home of outsider artist Romano Gabriel. His paintings included eclectic imagery drawn from various Eastern mythologies, local scenes, and toys. During this period, he maintained an artistic presence in San Francisco through the outdoor exhibitions of the San Francisco Arts Festival. Wong created important stage backdrops for the San Francisco alternative theater troupe The Angels of Light; one particularly spectacular set design of a mountainous landscape from 1971 was seemingly inspired by ancient Chinese paintings of the Song dynasty.

In 1978, Wong moved to New York City, where he became associated with the artistic developments of the Lower East Side. He was included in the 1985 group photograph "The New Irascibles," alongside Kiki Smith and David Wojnarowicz. Wong's realist painted imagery reflected the gritty urban environment surrounding his apartment, including handball courts, security-gated storefronts, and the youth culture and Hispanic community of his neighborhood. He also created a large body of work about the history and stereotypes of Chinatown, which often included his self-portrait as a child. Several of his works with homoerotic content were included in important exhibitions concerning gay aesthetics. Wong created several public works in Manhattan, including a 1994 mural painted in a Washington Heights public school, PS-90, that depicts the Statue of Liberty peering down into the school's lobby, and a 1990 street sign project for the hearing-impaired that incorporated drawn imagery of signing hands. Wong likened his use of text in signing hands to the esoteric inscriptions that appear in ancient Chinese painting. He received several awards, including the 1993 New York City Council's All Star Salute to Chinese American Cultural Pioneers. In New York, Wong was also known as a wide-ranging collector of graffiti art and kitsch objects such as lunch boxes.

Wong returned to San Francisco for the final five years of his life. He painted up to the day of his death from complications relating to AIDS.

Wong, Nanying Stella

BORN: March 30, 1914, Oakland, CA

DIED: January 12, 2002, Berkeley, CA

RESIDENCES: 1914–1938, Oakland, CA § 1939, Ithaca and New York, NY § 1940–1950, San Francisco, CA § 1951, Mexico City, Mexico § 1952–2002, Berkeley, CA

MEDIA: watercolor painting and mixed media

ART EDUCATION: 1932–1933, University of California, Berkeley § 1933–1935, California School of Arts and Crafts, Oakland § 1938, Mills College, Oakland, CA § 1939, Cornell University, Ithaca, NY

SELECTED SOLO EXHIBITIONS: Gumps Gallery, San Francisco, c. 1940s § Paul Elders Gallery, San Francisco, 1940 § *Watercolors of San Francisco Chinatown by Nanying Stella Wong*, Association for Asian American Studies, Asian Resource Center, Oakland, CA, 1995 § Piezo Electric Gallery, New York (with son Colin Lee), 1987 § *Nanying Stella Wong: A Tribute*, Chinese Historical Society of America, San Francisco, 2002

SELECTED GROUP EXHIBITIONS: *Chinese Art Association of America*, de Young Museum, San Francisco, 1935/36 § *California Art Today*, Golden Gate International Exposition, San Francisco, 1940 § *San Francisco Society of Women Artists Annual*, San Francisco Museum of Art, 1940, 1941 § *San Francisco Art Association*, San Francisco Museum of Art, 1941 § *Chinatown Artists Club*, de Young Museum, San Francisco, 1942 § *With New Eyes: Toward an Asian American Art History in the West*, Art Department Gallery, San Francisco State University, 1995

SELECTED BIBLIOGRAPHY: Custodio, Maurice. *Peace and Pieces: An Anthology of Contemporary American Poetry*. San Francisco: Peace and Pieces Press, 1973. § Harvey, Nick, ed. *Ting: The Caldron, Chinese Art and Identity in San Francisco*. San Francisco: Glide Urban Center, 1970. § Poon, Irene. *Leading the Way: Asian American Artists of the Older Generation*. Wenham, MA: Gordon College, 2001. § Revilla, Linda. *Bearing Dreams, Shaping Visions: Asian Pacific American Perspectives*. Pullman, WA: Washington State University Press, 1993. § Townsend, Betty. "Oakland Chinese Girl Scores as Gifted Artist." *Oakland Post-Enquirer*, September 26, 1941, 16. § Wong, Nanying Stella. CAAABS project interview. September 25, 1997. Berkeley, CA.

Moving from painting to prose to poetry to song to dance in my endeavor to express my longing for truth, beauty, compassion and peace, and to understand from my life's experiences the meaning of our human existence, our kinship to other beings, globally and galactically.

NANYING STELLA WONG
CAAABS project interview

NANYING STELLA WONG was born into a family of progressive and creative women. Her grandmother opened the first Chinese restaurant in Oakland after relocating there following the 1906 San Francisco earthquake, and her mother starred in the film *The Curse of Quon Gwon*, directed by Stella's aunt Marion Wong and filmed in the East Bay in 1916—one of the first films to be directed by a woman. Wong herself was identified as a talented artist as a child, and she received support and guidance for both her art and her poetry during her years at Oakland Technical High School. Her work figured prominently in the school magazine, *Tecolote*, and a teacher submitted her artwork to the National Scholastic Art Exhibition. As one of seven thousand finalists, Wong won three third-place awards. On the strength of these prizes and her work, Wong received a scholarship to the California School of Arts and Crafts, where she had already begun taking classes while in high school.

At the California School of Arts and Crafts, Wong studied watercolor painting with Ethel Abeel. Subjects of her watercolor work were primarily people and scenes from daily life. One of her watercolors from her San Francisco Chinatown series echoed her often-published poem "Angel Island" and addressed the difficult history of what she called "the Chinese Plymouth Rock." Wong also took classes at the University of California, Berkeley, studying writing with Margaret Shedd.

Wong studied with **Chiura Obata** in his home studio, and in the mid-1930s, she met a group of Chinese painters, including **Chee Chin S. Cheung Lee**, Suey B. Wong, and **David P. Chun**, who lived in the artists' community that grew up around the San Francisco Montgomery Block. Wong was invited to join their newly formed group, the Chinese Art Association, and participated in their first exhibition at the de Young Museum in San Francisco. Wong also became a mem-

Nanying Stella Wong at San Francisco's Capwell, Sullivan, & Furth store, ca. 1935

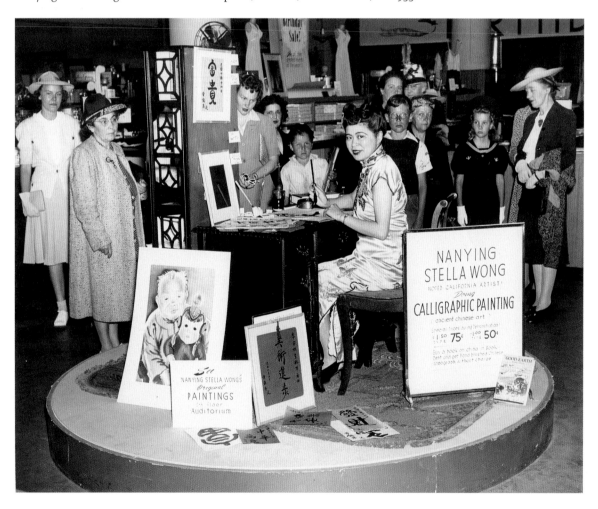

ber of the San Francisco Society of Women Artists and was their only Chinese member.

In 1935, Wong was commissioned by Fong Fong, the first bakery and soda fountain in San Francisco's Chinatown, to help design their store. Although only reimbursed for her materials, she defined the look of this popular establishment by creating characters who were twins—small, round, futuristic figures. Wong made several 48-by-96-inch, lacquer-on-Masonite murals and designed the neon cornucopia ice cream cone for the store façade, as well as tea sets and menu covers.

In 1939, Wong moved to Ithaca, New York, where she studied at Cornell University. Seeing Wong's portfolio, a Cornell classmate referred her to Helena Rubenstein, where Wong designed jewelry, but she returned to the Bay Area soon after, in 1940.

Wong met and married photographer **Kem Lee**, whose studio was a gathering place for artists such as **Dong Kingman** and **George Chann**. Although surrounded by other artists and writers, Wong had her own ideas about her creative pursuits, and as early as 1941 she described her work as "cosmic art." An article from that year described her as a serious student of Buddhism whose works were entitled *Evolution, Space, Time*, and *Creative Earth*. Wong worked as a freelance artist and designer and, in 1951, studied in Mexico City as a recipient of a Margaret Shedd Writers Award.

Throughout her life, Wong's dual careers as artist and poet merged in many exhibitions, competitions, and publications. She made many friends in the literary world, including William Carlos Williams, who in a letter to Wong said, "You know, one feels closer to some people than to others and I feel closer to you than some of my best friends or even relatives." Wong served on the Berkeley Arts Commission in the 1970s, taught at Vista College, and received several California Arts Council Grants to present free art workshops to senior citizens and children. She died shortly before a retrospective of her career at the Chinese Historical Society of America in 2002.

Wong, Tyrus

BORN: October 21, 1910, Guangzhou, China

RESIDENCES: 1910–1919, Guangzhou, China § 1919–1926, Sacramento, CA § 1926–1930, Pasadena, CA § 1930–1937, Los Angeles, CA § 1937–1948, Hollywood, CA § 1948–present, Sunland, CA

MEDIA: watercolor, ink, and oil painting; lithography, illustration, animation, greeting cards, film set design, and kite building

ART EDUCATION: 1928–1935, Otis Art Institute of the Los Angeles Museum of History, Science and Art

SELECTED SOLO EXHIBITIONS: Zeitlin Gallery, Los Angeles,

1939 § Pasadena Art Institute, Pasadena, CA, 1947 § *Two Behind the Scenes*, Chinese Historical Society of America, San Francisco, 2003 (two-person exhibition with Wah Ming Chang) § *Tyrus Wong: A Retrospective*, Chinese American Museum, Los Angeles, 2003/4

SELECTED GROUP EXHIBITIONS: Palos Verdes Library and Art Gallery, Palos Verdes, CA, 1933 § *The Contemporary Oriental Artists*, Foundation of Western Art, Los Angeles, 1934 § *Exhibition of California Oriental Artists*, Los Angeles Museum, 1936 § *San Francisco Art Association*, San Francisco Museum of Art, 1937, 1948, 1957 § California Watercolor Society, 1947, 1951, 1954–1956, 1959/60, 1964/65, 1967 § *Annual Exhibition of Artists of Los Angeles and Vicinity*, Los Angeles County Museum, 1954, 1955

SELECTED COLLECTIONS: The Butler Institute of American Art, Youngstown, OH § Chinese American Museum, Los Angeles § Santa Barbara Museum of Art

SELECTED BIBLIOGRAPHY: Canemaker, John. *Before the Animation Begins: The Art and Lives of Disney Inspirational Sketch Artists*. New York: Hyperion, 1996. § Govig, Valerie. "The Eye of Tyrus Wong." *Kitelines* 4, no. 4 (Summer–Fall 1983): 30–33. § Poon, Irene, Roger Garcia, Webster Colcord, Leslee See Leong, and Lisa See. *Wah Ming Chang & Tyrus Wong: Two Behind the Scenes*. San Francisco, CA: Chinese Historical Society of America, 2003. § See, Lisa. *On Gold Mountain: The One-Hundred Year Odyssey of My Chinese-American Family*. New York: Vintage Books, 1995. § Solomon, Charles. "Drawing on the Wind." *Los Angeles Times Magazine*, May 23, 1999, 22–23.

My painting has always been very poetic—that's the Chinese influence. In Chinese art, the poet is a painter and the painter is a poet. The object isn't to reproduce photographic reality as it is in Western painting, but to capture a feeling.

TYRUS WONG
Solomon, "Drawing on the Wind," 23

TYRUS WONG MOVED at the age of nine from Guangzhou to California. After spending two weeks without family on Angel Island, he was reunited with his father in Sacramento. Wong followed his father to Los Angeles and became friends with **Benji Okubo**. Wong's talent in art was recognized during middle school, and he received a scholarship to attend the Otis Art Institute. He received the Huntington Assistance Prize during his final year in 1935. Wong also learned Chinese calligraphy from his father and was self-educated in Asian art practice, history, and philosophy. In 1936, the artist worked for the WPA, and his paintings from exhibitions of that period show Chinese subjects and a sparse, calligraphic style. An ink painting of a monkey by Wong appeared on the cover of the Oc-

Tyrus Wong, 1997. Photo by Irene Poon

tober 1939 issue of *California Arts and Architecture* magazine. The issue, dedicated to artists of Chinese ancestry active in California, signaled a mainstream recognition of Asian artists in California.

In 1938, Wong began an important association with Walt Disney Studios, where he spent four years as a pre-production illustrator for the 1942 film release *Bambi*; his work created the mood for each scene. Although Wong continued to regularly exhibit moody landscape watercolor paintings in the years that followed, he was very active in Hollywood studios, including Warner Brothers and RKO, and worked on pre-production illustrations for films including *Rebel Without a Cause*, *The Wild Bunch*, and *Around the World in Eighty Days*. During this period, Tyrus Wong, **James Wong Howe**, and **Keye Luke** were among the most prominent Asian American artists in the American film industry.

In the early 1950s, Wong began using his distinctive brush style to create fine-art greeting cards, which were marketed through such companies as Hallmark. A 1954 Christmas card sold more than one million copies. He participated in many group exhibitions of the California Watercolor Society during the 1950s and 1960s and was awarded many prizes for his work, including awards for watercolors in 1954 and 1955 and for his work in oil in 1960. In his later life, Wong began a new career as a designer of kites and gradually stopped painting. Since the late 1970s, the artist has been acclaimed for his complex kite structures that consist of twenty or more segments.

Wong's kites include centipedes, flocks of birds, and abstract forms; they have been reproduced and discussed in several magazines and books.

Woo, Gary

BORN: February 14, 1925, Guangzhou, China

DIED: January 16, 2006, San Francisco, CA

RESIDENCES: 1925–1939, Guangzhou, China § 1939–1944, San Francisco, CA § 1944–1945, Japan (U.S. military service) § 1945–2006, San Francisco, CA

MEDIA: oil and watercolor painting

ART EDUCATION: 1948–1949, Art League of California, San Francisco § 1951–1952, California School of Fine Arts, San Francisco

SELECTED SOLO EXHIBITIONS: Gumps Gallery, San Francisco, 1955 § Mi Chou Gallery, New York, 1958 § de Young Museum, San Francisco, 1960 § John Bolles Gallery, San Francisco, 1966, 1967 § *The Art of Gary Woo: Looking Back 50 Years*, Chinese Historical Society of America, San Francisco, 2004

SELECTED GROUP EXHIBITIONS: *San Francisco Art Association*, San Francisco Museum of Art, 1955, 1957 § *Art in the 20th Century*, San Francisco Museum of Art, 1955 § Mi Chou

Gallery, New York, 1958 § Mills College, Oakland, CA, 1967 § Oakland Museum of California, 2003

SELECTED COLLECTION: Chinese Historical Society of America, San Francisco

SELECTED BIBLIOGRAPHY: Frankenstein, Alfred. "Now Is the Time to Say Mr. Woo Has Arrived." *San Francisco Chronicle*, This World, December 4, 1960. § Woo, Gary. "Artist Answers Critic." *East West*, November 21, 1967. § Woo, Gary. CAAABS project interview. December 16, 2003. San Francisco, CA.

Chinese writing is the abstract painting of the Chinese, that expresses form, rhythm, momentum, tension and strength. Martial art does the same.

<div align="right">

GARY WOO
CAAABS project interview

</div>

IN THE 1950s and 1960s, the storefront studio of Gary Woo at the corner of Green and Grant avenues in San Francisco's bohemian North Beach positioned the artist at the veritable epicenter of California's burgeoning counterculture. During this time, Woo's quietly meditative abstractions were championed by regional journalists, including Herb Caen and Alfred Frankenstein.

After arriving from China in 1939 at the age of fourteen, Woo spent a difficult eight months at the Angel Island Immigration Center. He served in World War II and was stationed in Japan during the occupation. After returning to San Francisco following his service, supported by the GI Bill, Woo enrolled in art classes. Despite having been blinded in one eye in his youth, he chose to pursue art, and he studied with such noted painters as Lundy Siegriest at the Art League and David Park at the California School of Fine Arts. Although his paintings sometimes depicted still-life or animal forms, Woo principally developed a distinctive abstract vocabulary. These paintings reference both the Chinese calligraphy he had learned from his father and the subtleties of monochrome ceramic glazes such as celadon and oxblood, which were featured in the Chinese antiques that Woo saw and handled through his friendship with San Francisco dealer Charles Fong.

After being selected for a John Hay Whitney Opportunity Fellowship in 1956, an award received the previous year by **James Leong**, Woo was invited to exhibit at the Mi Chou Gallery in New York. An important San Francisco exhibition at the de Young Museum in 1960 (the same year as **Ruth Asawa**'s exhibition there) and several shows at John Bolles Gallery marked Woo as one of the region's preeminent Asian American abstract painters of the time. The reproduction of his work on the cover of the activist Asian American literary journal *Aion* in 1970 suggests that Woo's elegant and innovative art was also seen as an important achievement within the politically engaged community.

In 1972, Woo's North Beach lease expired, and he moved with his wife, acclaimed artist and educator Yolanda Garfias, to a small house at the southern edge of San Francisco, near Daly City. Woo continued to paint, generally in smaller scale, and to travel internationally, but he increasingly eschewed gallery exhibitions. While walking in 1994, he was hit by a bus, but he returned to painting after his recovery, creating works that continued to evidence the delicacy of beauty for which he was first recognized.

Gary Woo, 1957

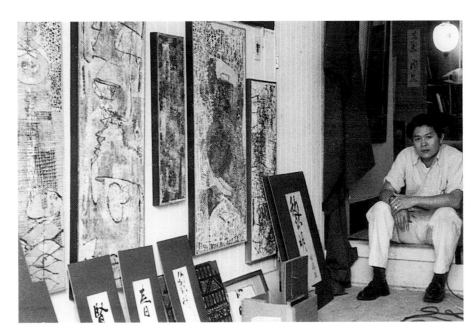

Woo, Jade Fon (Jade Fon)

BORN: September 7, 1911, San Jose, CA

DIED: November 14, 1983, Bakersfield, CA

RESIDENCES: 1911–ca. 1915, San Jose, CA § ca. 1915–ca. 1935, Winslow and Flagstaff, AZ § ca. 1935–ca. 1943, Los Angeles, CA § ca. 1943–ca. 1949, San Francisco, CA § ca. 1949–ca. 1960, Oakland, CA § ca. 1960–1983, Pacheco, CA

MEDIA: watercolor painting and pastels

ART EDUCATION: 1931–1934, Northern Arizona University, Flagstaff § ca. late 1930s, Otis Art Institute, Los Angeles § ca. late 1930s, Art Students League, Los Angeles

SELECTED SOLO EXHIBITION: Garzoli Gallery, San Rafael, CA, 1994

SELECTED GROUP EXHIBITIONS: *San Francisco Art Association*, San Francisco Museum of Art, 1935 (inaugural), 1937, 1940 § California Watercolor Society, Los Angeles Museum, 1936, 1938–1944, 1946, 1947 § *Painters and Sculptors of Southern California*, Los Angeles Museum, 1938 § *Chinatown Artists Club*, de Young Museum, San Francisco, 1943 § California State Fair, Sacramento, 1954, 1962–1964, 1967, 1968 § *Society of Western Artists Annual*, de Young Museum, San Francisco, 1962 § *West Coast Watercolor Society*, Crocker Art Museum, Sacramento, 1971

SELECTED BIBLIOGRAPHY: Fon, Jade. Biographical Folder. Oakland Museum of California. § McClelland, Gordon T., and Jay T. Last. *The California Style: California Watercolor Artists, 1925–1955*. Beverly Hills: Hillcrest Press, 1985. § Millier, Arthur. "Here's Public's Chance to Pick Winners in Art." *Los Angeles Times*, December 5, 1943, part 3, 4. § Nelson, Mary Carroll. "Jade Fon: Master Artist, Master Teacher." *American Artist* 49, no. 517 (August 1985): 60–63, 80–86. § Obituary. *San Francisco Chronicle*, November 24, 1983, 55.

I never considered myself as a bridge between cultures. As a bridge to help students cross to where they want to go? Yes. Students should be prepared or trained toward the fundamentals of picturemaking.

JADE FON WOO

Nelson, "Jade Fon: Master Artist,
Master Teacher," 65

A VIRTUOSO WATERCOLOR PAINTER and renowned teacher, Jade Fon Woo maintained an active career for more than six decades in California. Born in San Jose, Woo moved to the Southwest with his family when he was a child. There, Woo worked at an uncle's restaurant as a waiter. He often recounted the story of receiving his first art lesson from a cowboy who pointed to an outhouse in the sunlight and said, "See, now that is light and shade, which you need to get form." After at-tending Northern Arizona University at Flagstaff, Woo moved to Los Angeles to attend the Otis Art Institute and took classes at the Art Students League. He also studied Chinese painting privately in Los Angeles.

By the mid-1930s, works by Jade Fon (his professional name) appeared in exhibitions in both San Francisco and Los Angeles. The artist was very active with the California Watercolor Society, and his plein-air style incorporating strong contrast and sparkling detail received important recognition, eventually garnering more than two hundred prizes. During the late 1930s, Woo worked on WPA projects and for Hollywood film studios, including as a scenic artist for the 1939 release *Gone With the Wind*. In the early 1940s, he moved to San Francisco because of an extended strike in Hollywood and participated in the 1943 exhibition of the Chinatown Artists Club. Woo worked for a few years as a singer and the emcee at the famous Forbidden City nightclub on Sutter Street, sometimes creating watercolor portraits of patrons and performers. However, the smoky atmosphere of the nightclub aggravated the artist's asthma and prompted his move to Oakland, where he operated a Chinese restaurant for the next five years. In Oakland, Woo continued to paint and became friends with artist **Chang Shu-chi**.

During the early 1950s, Woo began teaching adult art classes in the East Bay. His teaching was grounded in painting demonstrations that included Chinese ink techniques. In 1954, he began thirty years of teaching at Diablo Valley College in Livermore, and he subsequently moved to Pacheco, near Martinez. Although he sometimes worked commercially, including creating murals and designs for the San Francisco Chinatown Wax Museum in 1970, Woo was most widely known for his teaching. In 1962, he founded the Jade Fon Watercolor Workshop at Asilomar, the California state convention facility located on the Monterey Peninsula. Woo's popular workshops usually took place over one week in the spring and several weeks in July. These workshops continued for the next twenty-one years, until 1983, when Woo died suddenly from a heart attack as he returned from a watercolor workshop in Las Vegas. Just before his death, Woo was sponsored for associate membership in the National Academy of Design by artists including Tom Nicholas, **Dong Kingman**, and Millard Sheets. Sheets later wrote that Woo "offered some of the finest workshops in watercolor painting ever given in the United States."

Yamamoto, Noriko

BORN: September 22, 1929, Qingdao, China

RESIDENCES: 1929, Qingdao, China § 1929–1935, Tokyo, Japan § 1935–1941, Honolulu, HI § 1941–1952, Tokyo, Japan § 1952–1962, San Rafael, Oakland, and San Francisco, CA § 1962–present, Pound Ridge, NY

MEDIA: oil and acrylic painting, and printmaking

ART EDUCATION: 1950–1951, Sophia University, Tokyo § 1951–1952, Dominican College of San Rafael, CA § 1952–1957, California College of Arts and Crafts, Oakland, CA § 1957–1958, Mills College, Oakland, CA

SELECTED SOLO EXHIBITIONS: Gumps Gallery, San Francisco, 1956, 1961 § Oakland Museum of Art, 1957 § de Young Museum, San Francisco, 1960 § Minami Gallery, Tokyo, 1960–1962

SELECTED GROUP EXHIBITIONS: *1st Pacific Coast Biennial*, California Palace of the Legion of Honor, San Francisco, 1955 § California State Fair, Sacramento, 1955, 1956, 1958 § *San Francisco Art Association*, San Francisco Museum of Art, 1956, 1957, 1959, 1960 § *Young America*, Whitney Museum, New York, 1960 § *Asian Traditions/ Modern Expressions*, Jane Voorhees Zimmerli Art Museum, Rutgers State University, New Brunswick, NJ, 1997

SELECTED COLLECTIONS: Chase Manhattan Bank, New York § Grey Art Gallery and Study Center, New York University § Sophia University, Tokyo

SELECTED BIBLIOGRAPHY: Goodrich, Lloyd, and John I. H. Baur. *Young America 1960*. New York: Whitney Museum of American Art, 1960. § Jenks, Anne L., and Thomas M. Messer. *Contemporary Painters of Japanese Origin in America*. Boston: Institute of Contemporary Art, 1958. § Yamamoto, Noriko. CAAABS project interview. November 11, 1998.

Because of my Japanese and western background, I am trying to integrate both cultures . . . to synthesize the greatness of both. . . . I would like to create something beautiful through my feeling and experience with respect to harmony and serenity.

NORIKO YAMAMOTO
Goodrich and Baur,
Young America 1960, 118

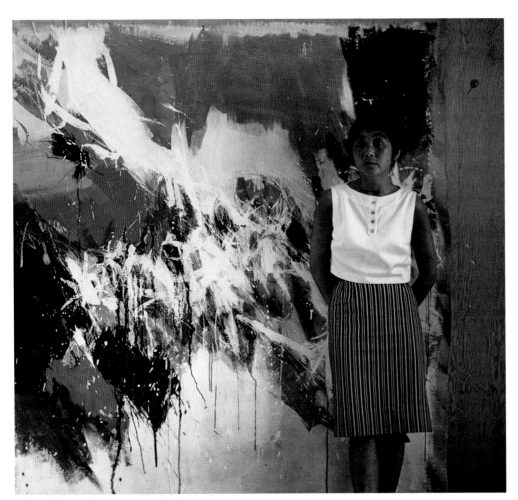

Noriko Yamamoto, 1958

DURING NORIKO YAMAMOTO's ten-year residence in California, she participated in numerous prestigious exhibitions and assumed important teaching appointments. Born in China, Yamamoto lived in Japan and Hawaii during her youth as a result of her father's work as a banker, and most of her education, including training in calligraphy, took place in Tokyo. Yamamoto resolved early on to leave Japan, where she was bullied as a child and perceived as a foreigner during the war years.

Arriving in California at the age of twenty-three, she embarked on a period of intensive artistic training, including study with Richard Diebenkorn, Nathan Oliveira, and Leon Goldin at the California College of Arts and Crafts (CCAC), where she received her B.F.A. and M.F.A. She then took classes with Italian abstract painter Afro at Mills College and began exhibiting frequently in the Bay Area, sometimes under the name Nora Yamamoto. While at CCAC, she also studied and made an important friendship with **Saburo Hasegawa**, whose influential philosophy incorporated Zen Buddhism and Japanese traditions such as tea ceremony. She later said, "It was the perfect time to meet Saburo Hasegawa for the recognition of my roots and the Japanese traditions that were in my genes." After Hasegawa's death in 1957, Yamamoto was chosen to take over his teaching position at the school. During the 1950s, Yamamoto also served as interpreter for ceramicists Kitaōji Rosanjin and Hamada Shōji, who came to the Bay Area to lecture about Japanese art and culture. In 1960, her work was featured at the Whitney Museum's *Young America* exhibition along with fellow California artists Joan Brown, **Sung-woo Chun**, Sonia Gechtoff, **Dale Joe**, and William T. Wiley. During this period, she created both formal and gestural abstractions in varied media, including silkscreen, ink, watercolor, collage, acrylic, and oil paint.

Yamamoto moved to the East Coast in 1962 and worked on public community projects in the 1970s, including a mural at an elementary school in New York's East Village and a relief design in a public park in Stanford, Connecticut. She has received numerous prizes for her work, especially during her years in California, including awards at the San Francisco Art Association Annuals, Gumps' Invitational, and the Santa Barbara Annual. Yamamoto feels that her work draws upon her training in the art of both Japan and the United States, synthesizing elements of Western abstract painting with Asian calligraphy practice.

Yamasaki, Jack Chikamichi

BORN: November 19, 1904, Kagoshima, Japan

DIED: November 14, 1985, Los Angeles, CA

RESIDENCES: 1904–1922, Kagoshima, Japan § 1922–ca. 1928, Imperial Valley, CA § ca. 1928–1931, San Francisco, CA (summer 1931, Woodstock, NY) § 1931–ca. 1937, New York, NY § ca. 1937–1942, Los Angeles, CA § 1942–1945, Santa Anita Assembly Center, Santa Anita, CA; Heart Mountain Relocation Center, Heart Mountain, WY § 1945–1985, Los Angeles, CA

MEDIA: oil painting, sculpture, and drawing

ART EDUCATION: 1930–1931, California School of Fine Arts, San Francisco § 1931, Art Students League, New York

SELECTED GROUP EXHIBITIONS: *Amateur and Professional Art Exhibition*, San Francisco, 1929 § *San Francisco Art Association*, California Palace of the Legion of Honor, 1930, 1931 § *Exhibition by Japanese Artists in New York*, ACA Gallery, New York, 1936 § ACA Gallery, New York, 1937 § *31st Annual Exhibition of Resident Artists*, Municipal Art Galleries, New York, 1938 § *Half Century of Japanese Artists in New York, 1910–1950*, Azuma Gallery, New York, 1977

SELECTED COLLECTIONS: Japanese American National Museum, Los Angeles

SELECTED BIBLIOGRAPHY: Higa, Karin M. *The View from Within: Japanese American Art from the Internment Camps, 1942–1945*. Los Angeles: Japanese American National Museum, 1992. § *Japanese and Japanese American Painters in the United States: A Half Century of Hope and Suffering, 1896–1945*. Tokyo: Tokyo Metropolitan Teien Art Museum and Nippon Television Network Corporation, 1995. § *Japan in America: Eitaro Ishigaki and Other Japanese Artists in the Pre–World War II United States*. Wakayama, Japan: Museum of Modern Art, Wakayama, 1997. § Mirikitani, Janice, ed. *Ayumi: A Japanese American Anthology*. San Francisco: Japanese American Anthology Committee, 1980. § "Youth Replaces Old Favorites in First Woodstock Exhibition." Unidentified newspaper, May 5, 1932. Asian America Art Project, Stanford University.

AT THE AGE of eighteen, Jack Chikamichi Yamasaki left Kagoshima, Japan, and traveled to California's Imperial Valley to work on a farm with his father. He eventually moved to San Francisco, where he attended the California School of Fine Arts and began to exhibit regularly, including in San Francisco Art Association exhibitions. At school he became friends with fellow students **Hideo Benjamin Noda** and **Takeo Edward Terada**, and in the summer of 1931 he shared a house in Woodstock, New York, with Noda and **Sakari Suzuki**. In New York, Yamasaki studied at the Art Students League. A May 1932 newspaper article that reviewed a Woodstock Art Association exhibition singled out Yamasaki and Noda for praise, also adding that both were students of Arnold Blanch. Yamasaki was one of the fifty-four signers of the Call for an American Artists Congress in 1936. Members of the American Artists Congress, a leftist group organized in opposition to war and fascism, included Stuart Davis, **Yasuo Kuniyoshi**, Rockwell

Kent, José Clemente Orozco, and Aaron Douglas. The group continued as an important organization in the years preceding World War II, and Yamasaki's early participation demonstrates his involvement with progressive art and political circles in New York.

Yamasaki returned to the West Coast in the late 1930s and was living in Los Angeles at the outbreak of World War II. He was first held at the Santa Anita Assembly Center and then interned at the Heart Mountain Relocation Center in Wyoming, where he remained for the rest of the war. Yamasaki continued to make artwork during his internment, and he created illustrations for the camp newspaper, the *Heart Mountain Sentinel*. Today he is best known for the paintings he created in this period.

After World War II, Yamasaki worked as a civilian employee of the United States Army, and during this time he made sketches and drawings in India, China, and Japan. Later he returned to Los Angeles, where he worked as a gardener and continued to paint.

Yang, Chao-chen

BORN: May 15, 1909, Hangzhou, China

DIED: August 31, 1969, Bellevue, WA

RESIDENCES: 1909–1933, China § 1933–1939, Chicago, IL § 1939–1946, Seattle, WA § 1946–1947, Los Angeles, CA § 1947–1960, Seattle, WA § 1960–1969, Bellevue, WA

MEDIA: photography, cinematography, and painting

ART EDUCATION: 1927–1929, Hsing-Hwa Academy of Arts, Shanghai, China § 1927–1929, Shanghai University, Shanghai, China § 1935–1939, Art Institute of Chicago

SELECTED SOLO EXHIBITIONS: Seattle Public Library, 1941 § Seattle Art Museum, 1942

SELECTED GROUP EXHIBITIONS: Chicago Art Institute Annual Exhibitions, 1935–1938 § *7th International Salon of Photography*, American Museum of Natural History, New York, 1940 § *19th Annual All American Photography Salon*,

Chao-chen Yang

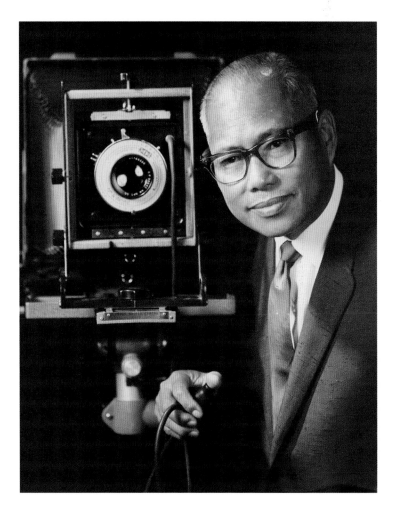

San Francisco Museum of Art, 1941 § *Pictorialist Photographers*, San Francisco Museum of Art, 1943 § *Through Our Eyes: 20th Century Asian American Photography in the Pacific Northwest*, Wing Luke Asian Museum, Seattle, 2000

SELECTED COLLECTION: Seattle Art Museum

SELECTED BIBLIOGRAPHY: Tsutakawa, Mayumi, ed. *They Painted from Their Hearts: Pioneer Asian American Artists.* Seattle: Wing Luke Asian Museum/University of Washington Press, 1994. § Yang, Chao-chen. Chao-Chen Yang Papers, 1945–1967. Archives of American Art, Smithsonian Institution.

The concept of photography as a representational art is not merely to reproduce nature but to use it as a means to interpret our inner emotion, sensitivity and sympathy. Thus we create an illusion in graphic form rather than an imitation of existing nature.

CHAO-CHEN YANG
Chao-Chen Yang Papers,
1945–1967, roll 4883, frame 955

AS A UNIVERSITY STUDENT in Shanghai, Chao-chen Yang studied both art and foreign relations, and following graduation he taught high school and worked in graphic design. His reputation as a skilled teacher resulted in his appointment as director of the Chinese Government Institute's Department of Art in Nanjing from 1929 to 1933. Yang met and married his wife, Jean, also a teacher, but just as their first child was to be born in 1933, Yang was sent to work for the Chinese consulate-general in Chicago (Jean joined him later in the United States).

Because of his artistic and diplomatic background, Yang was chosen to go to Chicago, which was hosting the 1933 World's Fair. Yang remained in Chicago until 1939 and during this period took advantage of the opportunities available to him in the city. He took night classes at the Art Institute of Chicago, studying painting and sculpture, and his work was included in annual exhibitions at the Art Institute every year between 1935 and 1938. Yang began to take classes in photography and started to focus on this medium, especially color photography. His own work with color photography, which began in 1937, paralleled the establishment of Chicago as a center for experimental photography when László Moholy-Nagy moved to the city and founded the "New Bauhaus" (later to be known as the School of Design and the Institute of Design) the same year.

In 1939, Yang was transferred to Seattle as Chinese deputy consul, continuing his diplomatic service during World War II, and he taught Chinese language and literature in the Far East Department at the University of Washington for a year and a half. Disappointed to find that Seattle did not have a photography program, or the strong photographic community of Chicago, Yang became an advocate for the art form. He convinced reluctant Seattle Art Museum curators to present group photography exhibitions, and his own show at the museum in 1942 was the first solo photography exhibition held at the institution.

In 1945, Yang went to San Francisco for the United Nations inaugural conference and helped prepare the Chinese version of the U.N. Charter. Following this historic event, he traveled to Los Angeles, where he studied motion picture photography and cinematography at RKO Studios with the idea of returning to China to create educational audiovisual aids. But the political situation in China preceding the Communist revolution derailed this plan, and Yang decided to return to Seattle and pursue photography full-time. In 1948, Yang became director of the Northwest Institute of Photography, and three years later he opened Yang Color Photography, one of the first studios and laboratories in Seattle to specialize in color photography.

In addition to being recognized for his expertise with the dye-transfer process (a precursor to color film), Yang from 1942 to 1947 also experimented with what he called the "atom-chrome color process," whereby color prints were made from black-and-white negatives by converting metallic silver to various dye components. His work with this method ended during the war, as he was unable to get the uranium he needed for processing. Later, Yang implemented a method for color control during film processing that was adopted by many labs. Yang exhibited hundreds of photographs in salons nationally and internationally and was a juror for many exhibitions. He also trained photographers and lab workers through the many courses and seminars he conducted. Johsel Namkung apprenticed with him in the mid-1950s, learning the dye-transfer process and the Type C process utilizing color negatives that then had been recently released by Eastman Kodak. As a fine-art photographer, Yang used color to create dramatic and atmospheric landscapes and portraits, and as a commercial photographer he was known for distinctive industrial, advertising, and food photography.

In 1965, following the diagnosis of terminal kidney disease, Yang merged his studio with two others, and the business became Dudley, Hardin, & Yang, Inc. He was an early recipient of kidney dialysis, which prolonged his life for four years.

Yang Ling-fu

BORN: December 16, 1888, Wuxi, Jiangsu, China

DIED: September 4, 1978, Carmel, CA

RESIDENCES: 1888–1934, China § 1934–1938, Asia, Europe, and Canada § 1938–1978, Berkeley, Monterey, and Carmel, CA

MEDIA: ink painting

SELECTED GROUP EXHIBITIONS: Sesquicentennial Exposition, Philadelphia, 1926 § East West Gallery, San

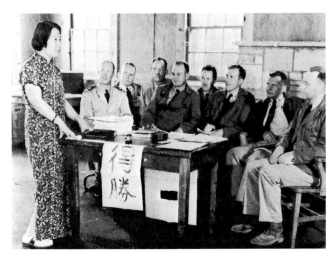

Yang Ling-fu teaching at the Army Language School, Monterey

Francisco, 1928 § Vancouver Art Gallery, Vancouver, B.C., 1936 § Chinese Pavilion, Golden Gate International Exposition, San Francisco, 1939 § Smithsonian Institution, Washington, D.C., 1948

SELECTED COLLECTION: National Palace Museum, Beijing

SELECTED BIBLIOGRAPHY: "An Accomplished Artist-Poet-Teacher-Writer/The Honorable Lady Ling-fu Yang." *Game & Gossip* (Monterey, CA), November 15, 1972, 14–19. § Brown, Michael D. *Views from Asian California, 1920–1965.* San Francisco: Michael D. Brown, 1992. § Yang, Ling-fu. *Thrice Across the Pacific Ocean.* Taipei: National Palace Museum, 1976. § Yang, Ling-fu. *Translations of My Art, Volume One: The Dragon Fights.* N.p.: Yang Ling-fu, 1939.

My Exile in America. *We crossed the bay in the shining noon. / Our boat broke the dark blue shadow of the bridge. / The chimneys were like candles standing, / The sea gulls flew above our heads. / They, too, were within the peaceful shelter / Of the haven enclosed by the Golden Gate.*

YANG LING-FU
Translations of My Art, 22

AS A GIRL in China at the turn of the twentieth century, Yang Ling-fu received unusual recognition and opportunities as an artist. She pursued an education in both Western techniques and classical Chinese poetry and painting in Beijing, and she was commissioned in 1927 to create formal portraits of ancient emperors and empresses. These works blended Western modeling with Chinese linear styles. She painted several other portraits of public officials, and she was appointed president of the Art College in Harbin, Manchuria, in 1928. She also participated in several international exhibitions during the 1920s and 1930s. Yang fled Manchuria in 1934 after the Japanese invasion and traveled across Mongolia and Siberia to Europe. While living in Berlin, she was introduced at a tea reception to Adolf Hitler, who commissioned a work from her. She pre-

sented him with a painting of quarreling birds with accompanying calligraphy. In response to his query about the meaning of the poem, Yang provided the following English translation and left immediately for the United States.

TO THE WARLORDS

Life is transient as a sun beam.
Why should you hate each other?
You are brothers of the same blood.
Why harm each other? Why bruise your wings?
You will need them for loftier flights.
Let there be Peace.

Yang exhibited works in Chinatown in 1936 and then at the Chinese Pavilion of the 1939 Golden Gate International Exposition, but she found little interest in her art, which was rooted in the conventions of ink painting. She worked initially in Berkeley as a photo developer and aide for the elderly. In the years that followed, she offered many Chinese painting workshops and demonstrations, while she taught Chinese language and cooking at such institutions as the International House at the University of California, Berkeley, Stanford University, and the Army Language School, Monterey. During this period, she created traditional Chinese scrolls with imagery that included trees, flowers, and birds and that generally contained lengthy calligraphic inscriptions. She also at times incorporated Western motifs, such as roses, and signed works bilingually. Yang created two hundred designs for greeting cards for Cathay Arts and sold various reproductions of her work, including a suite of the "Four Seasons." The artist eventually retired to Carmel. A book of reproductions of her paintings was published in Taiwan in 1976, when the artist was nearing ninety. After her death, Yang's works were widely dispersed and many lost.

Yashima, Mitsu (Tomoe Iwamatsu)

BORN: October 11, 1908, Innoshima, Japan

DIED: December 7, 1988, Los Angeles, CA

RESIDENCES: 1908–ca. 1926, Innoshima, Japan § ca. 1926–1939, Tokyo, Japan § 1939–1953, New York, NY (and San Francisco during World War II) § 1953–ca. 1968, Los Angeles, CA § ca. 1968–1983, San Francisco, CA § 1983–1988, Los Angeles, CA

MEDIA: watercolor and oil painting, and drawing

ART EDUCATION: ca. 1926–1929, Bunka Gakuin, Tokyo § 1939–1941, Art Students League, New York

SELECTED SOLO EXHIBITION: *Mitsu Yashima: An Exhibit of Artworks from the Past 40 Years,* JACL National Headquarters, San Francisco, 1980

SELECTED GROUP EXHIBITION: *Transcendent Blossoms*, Syntex Gallery, Palo Alto, CA, 1975

SELECTED BIBLIOGRAPHY: Fong, Suzin, Joyce Kawasaki, and Jeanne Quan. "The People's Artist: Mitsu Yashima." In *Asian Women*, 3rd printing. Los Angeles: Asian American Studies Center, UCLA, October 1975. Originally published by Asian Women's Journal, University of California, Berkeley, 1971. § Mirikitani, Janice, ed. *Ayumi: A Japanese American Anthology*. San Francisco: Japanese American Anthology Committee, 1980. § Yashima, Mitsu. "Letter to Mako to Meet Again." *Common Ground*, Spring 1948, 41–46. § Yashima Taro. Taro Yashima Papers. McCain Library and Archives, University of Southern Mississippi, Hattiesburg, MS.

I like art with some rules and a purpose. Art not just for yourself, for other people. If not for other people, [there's] no use painting.

MITSU YASHIMA
Fong, Kawasaki, and Quan,
"The People's Artist: Mitsu Yashima," 42

MITSU YASHIMA WAS BORN Tomoe Sasako in 1908 and spent her early years on Innoshima, a small island in the Sea of Japan. Her father was the chief designer and general manager of a shipyard. In the family of eight children the daughters were allowed the freedom to pursue their own interests, and Mitsu chose to attend the Bunka Gakuin, a small private college in Tokyo. There she studied art and met **Taro Yashima** (born Jun Atsushi Iwamatsu), who was studying at the Ueno Imperial Art Academy. Both were members of the left-wing Proletarian Artists' Union, which was organizing against the growing militarism of the government. Taro and Mitsu were arrested numerous times and were held for up to twenty-eight days in jail. Mitsu's last arrest occurred while she was in the final stage of pregnancy, and she survived on little food before being released.

To avoid future imprisonment and to further their art studies, the couple traveled to New York in 1939 on tourist visas, leaving their son behind with Mitsu's parents. In New York, they began attending the Art Students League and were able to secure student visas and extend their stay. After the outbreak of World War II, they worked briefly on a project for the Office of War Information. Later Taro joined the Office

Mitsu Yashima. Photo by Russ Halford

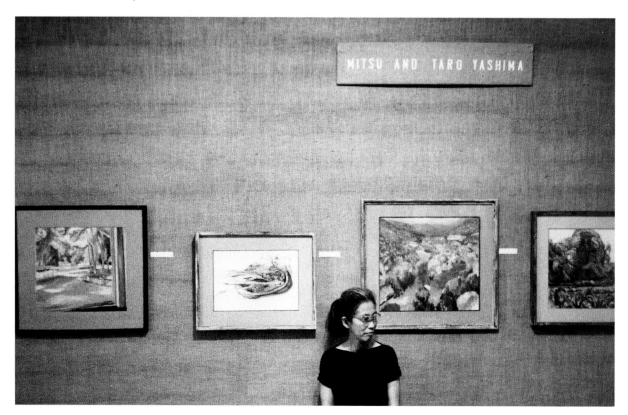

466

of Strategic Services, where he worked until the end of the war. While her husband was on assignment in India, Mitsu worked on a radio program, *Voice of the People*, which required her to move to San Francisco. While there, she encountered much racial hostility, and she returned to New York at the war's end. Concerned that their work for the U.S. government might have repercussions for their family in Japan, the couple changed their names, taking the surname Yashima (meaning "eight islands," a reference to Japan), and kept the pseudonym for the remainder of their lives.

In 1947, back in New York, the Yashimas were able to send for their son, Mako, then fifteen, and the family was granted permanent U.S. residency status. A daughter, Momo, was born in 1948. The Yashimas lived on the Lower East Side in humble conditions. The prime support for the family was Mitsu's income, which she earned by doing piecework, such as painting designs on hand lotion dispensers sold in department stores. Friends in New York included **Mine Okubo**, **Isamu Noguchi**, and **Lewis Suzuki**.

The Yashima family moved to Southern California in the early 1950s and opened the Yashima Art Institute and the East West Studio. Mitsu taught occasional classes in the Yashima Art Institute that Taro directed, and she was active in the Women's Strike for Peace group. She worked with her husband on the children's book *Plenty to Watch* (1954); however, personal conflicts with Taro caused her to withdraw from working on *Crow Boy* (1954). Mitsu eventually left Taro and moved to San Francisco once their daughter graduated from college.

In San Francisco, Mitsu taught art classes at Kimochi, a Japanese American community center, and became a revered instructor at the Japantown Art and Media Workshop. She also lectured on "People's Art in Japan" in the Asian studies program at the University of California, Berkeley. Occasionally she would show and sell her art at Japanese American community events or in small exhibitions. She continued to be politically active and was an inspiration to younger activists, who saw her as a mentor and role model.

Throughout her life Mitsu created portraits of friends and family, still lifes, landscapes, and politically informed work sometimes compared to that of Käthe Kollwitz. She employed soft colors, and because of her often limited time to make art, she generally used pastels, pencil, or charcoal. Mitsu also did writing and illustration work for Japanese and American magazines. In the spring 1948 issue of *Common Ground*, she contributed an open letter to her son upon their reunion following the war; her illustrations accompanied this piece. Mitsu returned to Los Angeles in 1983, where she lived with her daughter for the last five years of her life.

Yashima, Taro (Jun Atsushi Iwamatsu)

BORN: September 21, 1908, Kagoshima, Kyushu, Japan

DIED: June 30, 1994, Los Angeles, CA

RESIDENCES: 1908–ca. 1926, Kagoshima, Kyushu, Japan § ca. 1926–1939, Tokyo, Japan § 1939–1952, New York, NY, and various locations, India (U.S. military service) § 1952–1994, Los Angeles, CA

MEDIA: watercolor and oil painting, and drawing

ART EDUCATION: ca. 1926–1929, Ueno Imperial Art Academy, Tokyo § 1939–1941, Art Students League, New York

SELECTED SOLO EXHIBITION: *Taro Yashima: A Tribute*, Japanese Cultural and Community Center, Los Angeles, 1996

SELECTED GROUP EXHIBITIONS: *The Japanese American Artists Group*, The Riverside Museum, New York, 1947 § Laguna Beach Festival of Art, Laguna Beach, CA, 1955 § California Watercolor Society, 1955, 1958, 1967 § Laguna Beach Annual Association, Laguna Beach, CA, 1972

SELECTED COLLECTIONS: Iwasaki Chihiro Art Museum, Tokyo § Kagoshima City Museum, Kagoshima, Japan § Kerlan Collection, University of Minnesota Library, Minneapolis § Pasadena Library, Pasadena, CA

SELECTED BIBLIOGRAPHY: *Fortune* 29, no. 4 (April 1944): cover, 121, 154–159, 216. § Holley, David. "Japanese Artist Who Aided U.S. in War Finds Acceptance." *Los Angeles Times*, August 2, 1982, C1. § Shibusawa, Naoko. "The Artist Belongs to the People." *Journal of Asian American Studies* 8, no. 3 (October 2005): 257–275. § *Taro Yashima: A Tribute*. Los Angeles: Japanese Cultural and Community Center, 1996. § Yashima, Taro. Taro Yashima Papers.

Taro Yashima

McCain Library and Archives, University of Southern Mississippi, Hattiesburg, MS. § *Yashima Taro: Amerika gadan no ishoku*. Tokyo: Odakyū hyakkaten bijutsu garō, 1970.

Let children enjoy living on this earth, let children be strong enough not to be beaten or twisted by evil on this earth.

<div align="right">

TARO YASHIMA

http://www.lib.usm.edu/~degrum/findaids/
yashima.htm. Downloaded July 24, 2001.

</div>

TARO YASHIMA, born Jun Atsushi Iwamatsu, was raised in the southern region of Kyushu Island, where his father was a doctor. Also a collector of Asian art, Taro's father strongly encouraged his son's artistic aspirations.

Taro studied art at the Ueno Imperial Art Academy in Tokyo and was soon recognized as a talented illustrator and cartoonist in Japan. In Tokyo he met Tomoe Sasako (**Mitsu Yashima**), who shared his passion for art and progressive politics. The couple married and became members of the Proletarian Artists' Union. Both were repeatedly imprisoned for their views and opposition to Japan's militaristic government. In 1939, leaving their son, Mako, with relatives, they traveled to New York to escape political persecution, study, and prevent Taro from being drafted into a war against the United States that they saw as inevitable.

While living in New York, the couple attended the Art Students League from 1939 to 1941 and visited museums in Boston, New York, and Philadelphia. After war was declared on Japan, the Yashimas were concerned about the racist caricatures of Japanese that began to appear in the American press. Taro Yashima believed that Japanese militarism, not the Japanese people, was to blame for the war, and that the Japanese people themselves were devastated by their country's warmongering. As a result, the couple worked on projects that promoted international understanding. In 1941 they were asked to work on a project for the Office of War Information, but they left soon after, unhappy with aspects of the project. Taro then published his first book, *The New Sun*, which was a pictorial and anti-militarist autobiography. In 1943, he joined the Office of Strategic Services, where he worked until the end of the war. He served primarily in India, creating propaganda material, and following the war was in Japan for several months, investigating the psychological impact of the bombings of Hiroshima and Nagasaki through interviews with survivors. To protect their son and other relatives in Japan, the couple adopted the pseudonyms Taro and Mitsu Yashima and kept these names after the war. Returning to New York, they were granted permanent U.S. residence, and soon Mako, who was also granted residency, joined them. Shortly after their reunion with their son, their daughter, Momo, was born.

The Yashimas remained in New York in the years following the war. Taro's studio became a gathering place for a group of artists that included **Hideo Kobashigawa** and others who moved to New York following internment. Taro exhibited his vibrantly colored, Cézanne-influenced paintings in such exhibitions as the 1947 show of the Japanese American Artists Group, which included **Eitaro Ishigaki**, Chuzo Tamotsu, **Mine Okubo**, **Sakari Suzuki**, and **Miyoko Ito**. Taro suffered from severe stomach ulcers, and during his illness he sought comfort by telling his daughter, Momo, stories based on his own memories of Japan, eventually leading to his career as a successful children's book author and illustrator. In 1952, Taro accepted a fellowship from the Hartford Foundation to attend their residency program in Pacific Palisades, California. His family joined him in 1953, the same year his first book for children, *The Village Tree*, was published.

By 1954 the family was living in the Boyle Heights neighborhood of Los Angeles, where they founded the East West Studio (a framing shop) and the Yashima Art Institute. There, Taro taught classes in drawing and painting. In 1956, he received the Caldecott Honor for *Crow Boy*; other Caldecott Honors followed for *Umbrella* (1958) and *Seashore Story* (1967). Wishing to avoid relationships with art galleries, Taro sold his paintings in semi-private showings at his studio. He was a founder of the Los Angeles Japanese American Artists Society, was twice awarded the Southern California Council on Literature of Children and Young People Award, and in 1974 received the University of Southern Mississippi's Silver Medallion; his papers are held at this institution. He continued to paint and teach until his death in 1994.

Yip, Richard D.

BORN: July 15, 1919, Guangdong, China

DIED: October 27, 1981, Stockton, CA

Richard Yip,
ca. 1961

RESIDENCES: 1919–1931, Guangdong, China § 1931–1947, Stockton and Oakland, CA (and U.S. military service, location unknown) § 1947–1948, Guangdong, China § 1948–1981, Stockton, CA

MEDIA: watercolor painting

ART EDUCATION: ca. 1930s, California College of Arts and Crafts, Oakland, CA § ca. 1930s, College of the Pacific, Stockton, CA § ca. 1940s, University of California, Berkeley

SELECTED SOLO EXHIBITION: *Journey for a Creative Spirit*, Pacific Grove Art Center, Elmarie Dyke Gallery, Pacific Grove, CA, 2001

SELECTED GROUP EXHIBITIONS: California Watercolor Society, 1948, 1951, 1953, 1956 § California State Fair, Sacramento, 1954–1956, 1958–1960

SELECTED COLLECTION: Carnegie Art Museum, Oxnard, CA

SELECTED BIBLIOGRAPHY: Brown, Michael D. *Views from Asian California, 1920–1965*. San Francisco: Michael D. Brown, 1992. § McClelland, Gordon T., and Jay T. Last. *California Watercolors, 1850–1970: An Illustrated History & Biographical Dictionary*. Santa Ana, CA: Hillcrest Press, 2002. § "The World of Mr. Yip." *Game & Gossip* (Monterey, CA), June 15, 1961, 24–25.

RICHARD YIP CAME to the United States in 1931 and while in high school received a scholarship to the California College of Arts and Crafts. He served in the U.S. Air Force during World War II, finished his studies after the war at the University of California, Berkeley, and returned briefly to China, where he also studied painting. Settling in Stockton with his wife and son, Yip began a successful career as a watercolor painter and teacher and was particularly known for landscape work. He exhibited frequently with the California Watercolor Society and traveled and painted in Italy, China, and Mexico.

Yip taught extensively. He was an instructor at the College of the Pacific and taught numerous classes and workshops in various California locales, including Villa Montalvo in Saratoga. A Carmel area workshop he held in 1961 included field courses in watercolor painting. A local newspaper described Yip as one of the "outstanding watercolorists in California as well as a fine teacher."

Yong, Lai

BORN: 1840, China

DIED: unknown

RESIDENCE: ca. 1867–ca. 1882, San Francisco, CA

MEDIA: oil painting, photography

SELECTED GROUP EXHIBITION: Mechanics' Institute Exhibition, San Francisco, 1869

SELECTED COLLECTIONS: Beinecke Library, Yale University, New Haven, CT § California Historical Society, San Francisco

SELECTED BIBLIOGRAPHY: "The Easel." *San Francisco Chronicle*, February 4, 1877, 1. § 1870 Federal Population Census. San Francisco Ward 6, San Francisco, California. Roll M593_81, Page 37, Image 76. National Archives, Washington, D.C. § Yong, Lai, et al. *The Chinese Question, from a Chinese Standpoint*. Translated by Rev. O. Gibson. San Francisco: Cubery & Co., 1874.

…in the name of justice and humanity, in the name of Christianity (as we understand it), we protest against such severe and discriminating enactments against our people while living in this country under existing treaties.

LAI YONG
Lai Yong et al., *The Chinese Question, from a Chinese Standpoint*

Self-portrait by Lai Yong, ca. 1871

LAI YONG, WHOSE NAME sometimes appears as Yung or Young, is the first documented Chinese painter active in California. It appears that Yong began as a portrait painter, as he is listed as such in city directories beginning in 1867, and maintained a studio at 659 Clay Street from 1867 until he moved to 743 Washington Street in 1871. In the years between 1871 and 1881, Yong appears in directories as a "portrait painter" and "portrait painter and photographer," and in the 1876 and 1880 directories, the business is listed as "Lai Yong and Brother." The 1870 census shows Yong living with a doctor, a cook, a photographer named Ah Hing, and another portrait painter named Lai Chong, who was likely Yong's younger brother (indicating that the family name was Lai, despite the artist's being indexed in city directories under the letter "Y"). From 1883 to 1885 Lai Yong is no longer listed at 743 Washington Street. Instead, Sing Sung Co.—also alternately described as portrait painters and photographers—appears at this address. Yong may have sold his business to new proprietors.

Yong's photographic cartes de visite and cabinet cards that have survived document Chinese men, young performers in costume, and the artist himself. In a self-portrait, Yong is posed at an easel, working on a painting of a Caucasian woman. He wears his hair in a traditional queue (or braid) but advertises his trade in English. Yong exhibited *Portrait of a Gentleman* and *Portrait of a Lady* in the 1869 Mechanics' Institute exhibition. His Western-style paintings were distinguished by their verisimilitude and exquisitely glazed oil paint surfaces, as is evidenced by his portrait of Adolph Sutro. That his subject, Sutro, was an affluent and distinguished member of San Francisco society (and later would become the city's mayor) indicates that Yong's talents were recognized beyond the boundaries of Chinatown.

The growing hostility and violence toward Chinese along the West Coast in the 1870s, and the founding of the Workingmen's Party in 1877, are likely reasons for Yong's disappearance from historic records after 1882. Yong personally fought this growing tide of racism by drafting the article *The Chinese Question, from a Chinese Standpoint* with four other Chinese men, including Ah Yup, who in 1878 would lose a legal fight for naturalized citizenship (see *Ah Yup*, 1 F. Cas. 223 [C.C.D. Cal 1878]). This statement, translated and read before the San Francisco Board of Supervisors in May 1873 by an advocate for Chinese rights, the Reverend O. Gibson, offered what was likely a rarely heard perspective on U.S.-Chinese relations. The authors documented the West's desire for trade agreements with China, which included stipulations for the free movement of Americans and Europeans into China for trade, travel, and Christian evangelization. They noted how the introduction of steamships had displaced tens of thousands of traditional sailors, how many foreigners living in China had amassed large fortunes, and how the trade situation had greatly benefited the United States. In conclusion, they proposed that if the Chinese were so detrimental to the United States, then the treaty between the United States and China should be repealed, with all Chinese people and trade withdrawn from the United States, and all Americans and trade withdrawn from China. Although no such dissolution of relations between the countries was considered, a step backwards was taken in 1880, when the Burlingame Treaty was renegotiated to allow even more constraints on Chinese immigration and rights. In this growing anti-Chinese climate, Lai Yong may have followed his own proposition and withdrawn himself, his talents, and his business from the United States.

Yoshida Sekido

BORN: January 21, 1894, Tokyo, Japan

DIED: November 1965, New York, NY

RESIDENCES: 1894–1921, Tokyo, Japan § 1921–1922, Toronto, Canada, and Chicago, IL § 1922–1929, New York, NY § 1929–1931, Tokyo, Japan § 1931, Watsonville and Pasadena, CA § 1932–1941, San Francisco, CA § 1941–ca. 1962, Japan § ca. 1962–1965, New York, NY

MEDIA: ink and oil painting, and printmaking

ART EDUCATION: 1921, Ontario College of Art, Toronto § 1922–1929, Art Students League, New York

SELECTED SOLO EXHIBITIONS: National Academy of Design, New York, 1928 § Stendahl Art Galleries, Ambassador Hotel, Los Angeles, 1931 § California Palace of the Legion of Honor, San Francisco, 1932 § Portland Art Museum, Portland, OR, 1934 § Japanese Pavilion, Golden Gate International Exposition, San Francisco, 1939

SELECTED GROUP EXHIBITIONS: Society of Independent Artists, New York, 1925 § *The First Annual Exhibition of Paintings and Sculpture by Japanese Artists in New York*, The Art Center, New York, 1927 § *1st Annual Exhibition of Western Watercolor Painting*, California Palace of the Legion of Honor, 1932/33 § *San Francisco Art Association*, San Francisco Museum of Art, 1935 (inaugural), 1936 § Federal Arts Project, Stendahl Gallery, Pasadena, 1937 § *Half a Century of Japanese Artists in New York*, Azuma Gallery, New York, 1977

SELECTED COLLECTION: Art Gallery of Ontario, Toronto, Canada

SELECTED BIBLIOGRAPHY: Marlor, Clark S. *The Society of Independent Artists: the exhibitions record 1917–1944.* Park Ridge, NJ: Noyes Press, 1984. § "Yoshida Sekido." *California Art Research.* San Francisco: WPA, 1937. § "Yoshida Sekido, Painter and Good-Will Ambassador." *The Argus,* September 1928, 18.

In Japanese art . . . composition is the greatest thing in our pictures, and directness the chief charm of our drawings. Now in America, the art student gets a nice "underwear" of perspective, a nice "coat" of color theory, nice "shoes" of anatomy to stand on . . . he hops right in and goes anywhere.

YOSHIDA SEKIDO
"Yoshida Sekido,"
California Art Research, 95

VARIATION IN HOW Yoshida Sekido's name appears in exhibition records and other historical documents has resulted in confusion about his life and career history. His surname is Yoshida, his original given name was Tokichi, and he is referred to interchangeably as Yoshida Sekido and Sekido Yoshida.

In spite of family objections, Yoshida began his formal art education at the age of fifteen in Tokyo with rigid traditional apprenticeships. Looking for greater freedom, he began a seven-year study with Takeuchi Seihō, who had studied in Europe and who bestowed on the young artist the professional name "Sekido," meaning "rock-like." After winning several important annual national awards and building a reputation as an outstanding painter of sparrows, Yoshida decided to study in the West. Leaving his wife and infant child, Yoshida traveled first to Canada in 1921, where he studied at the Ontario College of Art, and later to Chicago, where he crafted wax flowers at the Field Museum. In 1922, he moved to New York, where he studied with George Bridgman at the Art Students League. He focused on mastering skills of perspective,

Yoshida Sekido, 1937

which he incorporated into his Japanese ink and distemper paintings on silk, and on etching, which he hoped to introduce to Japan. His successful exhibitions in 1927 and 1928 generated significant press coverage, including a page of reproductions in the *New York Times*, and enabled him to return to Japan in 1929.

In Tokyo, Yoshida presented three successful exhibitions of his New York paintings and started an art school that combined the international approaches to teaching he had personally experienced. Nevertheless, he returned to the United States in 1931, initially settling in the Pajaro Valley near Watsonville, where he painted regional scenes while living on a ranch owned by a friend. He exhibited at the Stendahl Gallery and Grace Nicholson Gallery, both in Pasadena, later that year.

In 1932, Yoshida moved to San Francisco and exhibited spare silk paintings at the California Palace of the Legion of Honor, a year after the museum's **Chiura Obata** exhibition. Work included images of California missions and Bay Area scenes, as well as flowers and birds. Throughout the 1930s, Yoshida exhibited consistently and taught privately in a hotel attic studio on Sutter Street in Japantown. He also worked on a witty, unpublished autobiography, entitled "Eating Around," that largely focused on issues of art education. Yoshida worked for the Federal Art Project in the late 1930s and sometimes painted in oils. His important exhibition of forty-seven paintings, including many Bay Area scenes, presented in the Japanese Pavilion of the 1939 Golden Gate International Exposition, was largely forgotten after World War II, like much of the pre-war work produced by artists of Japanese ancestry. Just prior to the war, Yoshida moved back to Japan, where he continued to teach. **Takeo Edward Terada**, who had returned permanently to Japan in 1935, and who likely had met Yoshida when both men were in San Francisco, studied with the elder artist in Tokyo. Yoshida later returned to the United States in about 1962, settling in New York, and died there in 1965.

Yuan, S. C. (Si-chen Yuan, Wellington S. C. Yuan)

BORN: April 4, 1911, Hangzhou, China

DIED: September 6, 1974, Carmel, CA

RESIDENCES: 1911–1949, China § 1949–1950, Jamaica § 1950–1952, San Francisco, CA § 1952–1974, Carmel and Pacific Grove, CA

MEDIA: oil and ink painting, drawing, and mixed media

ART EDUCATION: ca. 1935, Fine Arts Academy of Central University at Nanjing

SELECTED SOLO EXHIBITIONS: Defense Language Institute, Monterey, CA, 1953 § Carmel Art Association, Carmel, CA, 1958, 1962, 1967, 1974, 1994 § Monterey Peninsula Museum of Art, Monterey, CA, 1968 § Laky Gallery, Carmel, CA, 1968

SELECTED GROUP EXHIBITIONS: *Society of Western Artists*, de Young Museum, San Francisco, 1957, 1958, 1960 § San Francisco Museum of Art, 1962 § Monterey County Fair, Monterey, CA, 1966, 1972 § Monterey Peninsula Museum of Art, Monterey, CA, 1967

SELECTED COLLECTION: Monterey Museum of Art, Monterey, CA

SELECTED BIBLIOGRAPHY: Alexander, Irene. "Sensitive Paintings by S. C. Yuan on Display." *Monterey Peninsula Herald*, February 14, 1962. § Morrison, Brenda. *S. C. Yuan*. Carmel, CA: Carmel Art Association, 1994. § *S. C. Yuan: Drawings 1968.* Foreword by Lois Strobridge. Carmel, CA: Yuan Gallery, 1969. § Sullivan, Michael. *Chinese Art in the Twentieth Century*. Berkeley and Los Angeles: University of California Press, 1959.

Art should have something to say to the viewer, and only then is it honest art, which has permanent value.

S. C. YUAN
Morrison, *S. C. Yuan*, 16

AS A YOUNG CHILD, Si-chen Yuan was sent to his grandparents to be raised. Overcoming family objections, he chose to study art at the Fine Arts Academy of Central University at Nanjing, where his teacher was the renowned twentieth-century Chinese painter Xu Beihong. At that time, Xu's teaching largely reflected Western influences based on his ten-year stay in Paris, and Yuan absorbed and admired both Western and Chinese painting aesthetics.

During the years of the Sino-Japanese War and World War II, Yuan worked for the Nationalist government and as an interpreter for the U.S. Air Force. He also presented three major exhibitions in China. He sometimes used the first name "Wellington" because of his admiration for Wellington Koo, the Chinese ambassador to the United States at that time.

Immigrating to the West following the Communist revolution, Yuan served briefly as the principal of a Chinese school in Jamaica before relocating to San Francisco. Within a few years, he had moved to Carmel and married a prior acquaintance from Shanghai who had been studying in the United States and Canada. Together, they opened two gallery/restaurants, first on Monterey's Cannery Row (Yuan's, 1958) and later in Carmel (The Merry Peach, 1969). Yuan also opened private galleries in 1955, 1965, and 1968, but these businesses were all short-lived. The artist also traveled extensively, making three trips to Europe as well as to Mexico and California's Sierra Nevada Mountains. He became a U.S. citizen in 1965.

Yuan exhibited frequently in Monterey Peninsula galleries and won prizes in several group shows (Monterey County Fair, 1959; *Society of Western Artists*, de Young Museum, 1960; Monterey Peninsula Museum of Art, 1967). He exhibited with the Laky Gallery during the same years that **Chang Dai-chien**'s work was represented there. Although Yuan sometimes worked with ink and collage, he is best known for his heavily impastoed oil paintings of regional scenes. He would often begin with small, initial renderings in oils using a Chinese ink brush to create broad, gestural drawing and generally maintained this energy in the completed work.

S. C. Yuan's suicide at sixty-three fulfilled his frequent pronouncement that he would not outlive his father, who had died at that age. By the time of his death, Yuan had produced a large and consistent body of work that reflected both the Monterey Peninsula impressionist style of Armin Hansen as well as his art training in China.

Chronology

Chronology of

Asian American Art and History, 1850–1965

Shelley Sang-Hee Lee and Sharon Spain

Sources for art information found in this chronology can be located in the related artists' biographies (names are indicated by boldface type). For information not pertaining to a particular artist, citations are provided in footnotes.

PROGRESS OF THE ARTS AMONG US.—Daguerreotypists, look out! John Chinaman, so famous for his imitative powers, is in the field. In our ramble round town to-day, we noticed in the upper part of that street noted for coffins and crackers, 'yclept Sacramento, that "Ka Chau" has opened a "Daguerrean Establishment." His place is immediately above "Maige, Patissier." There, the passers by will observe on the street wall some very beautiful specimens of Ka Chau's handiwork, many of which are of course portraits of Chinese men and women. There is no reason why Chinamen should not enter and succeed in any profession among us which requires nice manipulation. If some of the better class from China would only learn the English language, discard a few of their now exclusive national customs, and enter into ordinary business, as handicraftsmen—from cabinet-making up to jewelry,—we think the public opinion against the race would soon be materially modified in San Francisco.

Daily California Chronicle, June 8, 1854.

1854 First mention of Chinese photography studio in San Francisco, Ka Chau's "Daguerrean Establishment," located on Sacramento Street.[1]

1850 Chinese population in California estimated at 4,000 by the end of 1850 and at 25,000 by the end of 1851.

California becomes thirty-first state.

California passes Foreign Miner's Tax requiring all foreign miners to pay a monthly $20. Tax primarily targets Chinese miners, who are often forced to pay more than once.

1852 First group of Chinese contract laborers arrives in Hawaii.

1853 Commodore Matthew Perry enters Japan's Edo Bay with ten armed ships, resulting in the opening of Japan to the West and the beginning of U.S.-Japan trade.

1854 In *People v. Hall*, California Supreme Court reverses conviction of George Hall in a murder case because his conviction is based on the testimony of a Chinese. Ruling establishes that Chinese cannot give court testimony for or against whites and is overturned in 1872.

Bumpei Usui, *Party on the Roof,* 1926 (detail, p. 492).

1857 San Francisco opens a school for Chinese children.

1858 California legislature passes "An Act to Prevent the Further Immigration of Chinese or Mongolians to This State."

1859 Oregon becomes thirty-third state.

1860 Fong Noy, Fong Ah-Sing, and Ah Chew, among others, work as photographic printers for premier San Francisco portrait studio Bradley and Rulofson beginning in the 1860s.[2]

1860 Chinese in California recorded in 1860 U.S. census for first time: 34,933.

Abraham Lincoln elected sixteenth president of the U.S., precipitating the secession of southern states from the Union and the outbreak of the Civil War.

California statute forbids "Mongolians, Indians, and Negroes" from attending public schools.

1865 Civil War ends.

Central Pacific Railroad Company recruits Chinese laborers for transcontinental railroad, first from California and later from Guangdong. Two years later 2,000 railroad workers strike for a week.

1867 Earliest documentation of **Lai Yong** operating a portrait painting studio at 659 Clay Street, San Francisco. He moves to 743 Washington Street in 1871 and is listed as both a portrait painter and a photographer.

1868 Eleven-year-old **Mary Tape** arrives in San Francisco.

Kai Suck operates a photography studio on Dupont Street in San Francisco.[3]

1868 The U.S. and China sign Burlingame Treaty, which affirms friendship between the nations and recognizes the right of immigration to citizens of both countries for "curiosity, trade, or permanent residence."

Congress ratifies Fourteenth Amendment of the U.S. Constitution, guaranteeing citizenship to those born or naturalized in the U.S. and forbidding states from denying any person equal protection and due process of the law.

Meiji Restoration in Japan concentrates power in the emperor and begins industrialization and modernization.

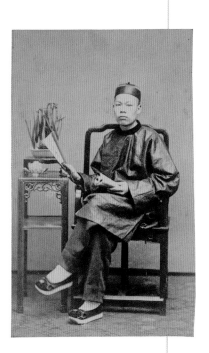

Lai Yong, *Untitled (Portrait of a Gentleman)*, ca. 1870. Carte de visite, 4 × 2 ¼ in.

1869 **Lai Yong** exhibits paintings *Portrait of a Gentleman* and *Portrait of a Lady* in the Mechanics' Institute annual exhibition in San Francisco.

1869

First transcontinental railroad completed at Promontory Point, Utah. Ninety percent of the 12,000 workers on the railroad's western portion are Chinese.

November 27 edition of *Sacramento Daily Record-Union* uses the records maintained by the Chinese Six Companies to report 16 self-described artists and photographers working in San Francisco's Chinatown.[4]

1870 Census shows **Lai Yong** living with a doctor, a cook, a photographer named Ah Hing, and another portrait painter named Lai Chong, who was possibly Yong's younger brother. Other photographers active in San Francisco in the 1870s include Ah Soo, Fong Noy, Ah Chew, and War Tong Ho.[5]

Lai Yong, *Untitled (Two Young Performers in Costume)*, ca. 1872. Carte de visite, 4 × 2 ¼ in.

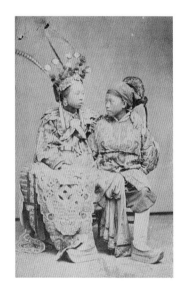

1873 Carlton Watkins's staff includes Chinese men who assist in producing stereographs. Ah Fue works as permanent staff with Watkins.[6]

Lai Yong drafts *The Chinese Question, from a Chinese Standpoint* with four other Chinese men, including Ah Yup (see 1878). Statement is translated and read before the San Francisco Board of Supervisors in May by Reverend O. Gibson.

1875 **Tameya Kagi** arrives in San Francisco.

1870 Populations in U.S. per 1870 census:
CHINESE: 63,199
JAPANESE: 55 (recorded for first time)

Fifteenth Amendment of the U.S. Constitution ratified, establishing the right to vote for all male citizens "regardless of race, color, or previous condition of servitude."

1871 Series of anti-Chinese riots and burnings of Chinese communities occur in 1870s throughout California in cities including Los Angeles, Yreka, Weatherville, Chico, and San Francisco. Homes and businesses are looted, Chinese are murdered, and whites drive out Chinese from towns.

1875 Congress passes Page Law, which prohibits entry of Chinese and Japanese contract laborers, women intended for prostitution, and felons. Entry to the U.S. becomes increasingly difficult for Chinese women.

1877 Under leadership of Irish immigrant and labor leader Denis Kearney, Workingmen's Party is formed in San Francisco. For the next three years, the party is one of the strongest anti-Chinese voices in California.

479

1877 Gospel Society, or Fukuin Kai, established in San Francisco is first Japanese Christian association and likely first Japanese community association formed in the U.S.

1878 **Tameya Kagi** becomes the apprentice to Juan (James) Buckingham Wandesforde (former first president of the San Francisco Art Association).

1878 The U.S. Supreme Court rules in "Re: Ah Yup" that Chinese cannot become naturalized citizens.

Tameya Kagi, *Untitled (Landscape with Quail)*, 1880. Oil on canvas, 16 × 24 in.

1880 Approximate date **Toshio Aoki** arrives in San Francisco. He is recruited from Japan by San Francisco store Deakin Brothers to create works of art for sale.

Ming Hin Chio and Sim Chung are active as photographers in San Francisco ca. 1880s.[7]

Wong Hong Tai is the subject of *San Francisco Examiner* article, "Our Chinese Edison," which describes his photographic collaborations with **Mary Tape**. Wong Hong Tai makes cameras and lenses, Mary Tape makes her own dry plates, and together they discuss photography over telegraph lines.

Tameya Kagi is listed as "portrait painter" in 1880 census. His work from this time also includes still lifes and landscapes.

1883 **Tameya Kagi** exhibits in the Mechanics' Institute exhibition in San Francisco.

1880 Populations in U.S. per 1880 census:
 CHINESE: 105,465
 JAPANESE: 148

California legislature prohibits the issuing of marriage licenses between whites and "Mongolians, Negroes, mulattoes and persons of mixed blood."

In response to anti-Chinese pressures, the U.S. renegotiates treaty with China allowing the U.S. to regulate, limit, or suspend immigration of laborers from China.

1882 Chinese Exclusion Act prohibits entry of Chinese laborers for ten years. Law is renewed in 1892 by the Geary Act, and again in 1902.

1884 Theodore Wores teaches Western-style art to a group of twelve Chinese students in San Francisco. One young student, Ah Gai, nicknamed "Alphonse," works as Wores's studio assistant and often accompanies Wores as a translator during sketching trips in Chinatown (possibly as early as 1881).[8]

Tameya Kagi exhibits for a second year in the annual Mechanics' Institute exhibition and also participates in the San Francisco Art Association exhibition.

1885 **Mary Tape** exhibits eight paintings in the annual Mechanics' Institute exhibition in San Francisco.

Charles Fletcher recruits fourteen Japanese artisans to bring to his stores in San Francisco and Chicago, including **Katsuzo Takahashi**, who is hired as a portrait painter.

Wai Cheu Hin, *Untitled (Portrait of a Young Girl)*, ca. 1888. Cabinet card, 6 × 4 in.

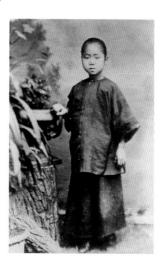

1888 Wai Cheu Hin is among many to operate photography studios in San Francisco's Chinatown. Records indicate his business continues until the early 1890s.[9]

1889 **Katsuzo Takahashi** receives honorable mention for drawing at the California School of Design in San Francisco.

1890 Wy Yee is active as a commercial photographer in Los Angeles. His brother, who changed his name to George A. Bicknell, is a photojournalist in Santa Barbara and the West, ca. 1890–1910.[10]

1891 **Katsuzo Takahashi** receives the Avery Gold Medal for oil painting from the California School of Design in San Francisco.

1892 **Mary Tape** is the subject of *San Francisco Morning Call* article, "What a Chinese Girl Did: An Expert Photographer and Telegrapher."

1884 Joseph and **Mary Tape** challenge San Francisco School Board to enroll their daughter in neighborhood school. Case is ruled in their favor in San Francisco court, but appealed and overturned in California Supreme Court the following year.

1885 Twenty-eight Chinese are killed and fifteen are injured in a riot in Rock Springs, Wyoming, when a mob of whites attacks and sets fire to a Chinese mining camp. Similar acts of anti-Chinese violence and forced expulsions occur in Washington and Oregon.

1888 Scott Act bans the return migration of Chinese laborers to the U.S. and ends the reentry certification process. Approximately 20,000 Chinese who had temporarily left the U.S. for China with reentry certificates are refused reentry.

1890 Populations in U.S. per 1890 census:
 CHINESE: 107,488
 JAPANESE: 2,039

San Francisco Morning Call,
November 23, 1892.

Toshio Aoki, Illustration for
Los Angeles Herald, February 17, 1895.

1893 **Yoshio Markino** arrives in San Francisco and attends the Mark Hopkins Institute of Art intermittently for four years before relocating to London. He recounts the racism he experienced in San Francisco in his autobiography, *A Japanese Artist in London* (1910).

Katsuzo Takahashi exhibits twenty-seven works in the *Industrial Exhibition of the Mechanics' Institute and Preliminary World's Fair Exhibit of California* (San Francisco) and four works in the *California Exhibit* of the World's Columbian Exposition (Chicago), one of which wins first prize. Takahashi returns to Japan the same year.

Senko Kobayashi begins his studies at the Mark Hopkins Institute of Art, becoming friends with **Yoshio Markino**. Kobayashi will receive awards from the school for life drawing in 1896 and for oil painting in 1897.

Senko Kobayashi,
Seated Male Nude, 1897.
Oil on canvas, 26¾ × 19 in.

1895 **Toshio Aoki** moves to Pasadena and works for the G. T. Marsh and Company store, where he does painting demonstrations. *Los Angeles Herald* publishes "To See Yourselves as Aoki Sees You," a full-page article featuring sketches of prominent Los Angeles residents in Japanese costume, accompanied by Aoki's comments.

Ann Ting Gock & Company operates portrait studio on Clay Street in San Francisco's Chinatown.[11]

1896 **Senko Kobayashi** founds an art association for Japanese people living in San Francisco and opens his own atelier.

1893 American-led coup in Hawaii results in the deposing of Queen Lili'uokalani. The U.S. subsequently establishes a protectorate over the islands.

Katsuzo Takahashi, *San Francisco Beach*, 1892.
Watercolor on paper, 13 × 21½ in.

1894 Japanese Tea Garden opens as the Japanese Pavilion in the Midwinter Exposition, San Francisco.

1895 Japan defeats China in first Sino-Japanese War fought over control of Korea.

1896 Nippon Yusen Kaisha line of Japan begins monthly steamship service between Yokohama and Seattle, marking the first regular trans-Pacific line between the U.S. and Asia.

In *Plessy v. Ferguson* the U.S. Supreme Court establishes doctrine of "separate but equal" by ruling that separate facilities and accommodations do not violate the Fourteenth Amendment.

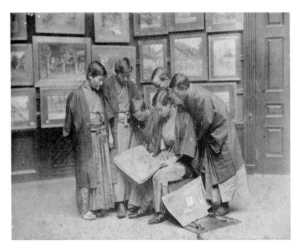

Japanese artists in Boston, 1900.

1900 Yoshida Hiroshi and Nakagawa Hachirō organize exhibition of paintings by Japanese artists at the Boston Art Club. In addition to their own work, paintings by Mitsutani Kunishirō, Kawai Shinzō, Kanokogi Takerō, and Maruyama Banka are presented. All artists are present for the exhibition.[12]

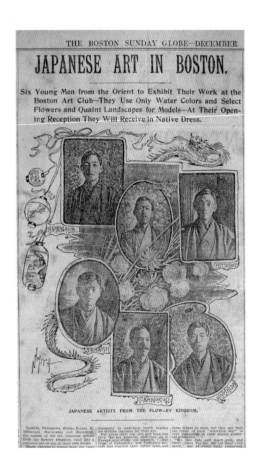

1898 *Wong Kim Ark v. U.S.* rules that Chinese born in the U.S. cannot be stripped of their citizenship.

Conflict over Cuba leads Spain and the U.S. to war. With Spain's defeat, the U.S. controls Cuba, the Philippines, Puerto Rico, and Guam.

The U.S. annexes Hawaii.

Britain leases Hong Kong's New Territories for ninety-nine years.

1899 Philippine-American War begins when Filipino nationalist Emilio Aguinaldo renounces the Treaty of Paris and leads an insurrection against American forces. Filipinos are defeated in 1902.

1900 Populations in U.S. per 1900 census:
CHINESE: 89,863
JAPANESE: 24,326

Bubonic plague scare in San Francisco leads to quarantine of Chinatown and mass inoculation. Honolulu's Great Chinatown Fire, accidentally begun by health officials, leaves thousands homeless.

Organic Act makes U.S. laws applicable in Hawaii, ending contract labor and triggering major immigration of Japanese plantation workers to the mainland.

Japanese begin to buy land and property in California. Japanese communities are established in Sacramento, Fresno, and Merced Counties, where Japanese own farms, vineyards, and orchards.

Boston Globe,
December 2,
1900.

1901 **Teikichi Hikoyama** arrives in San Francisco.

1902 C. J. Ishiguro, photographer and gallery owner, locates his business on Fillmore Street in San Francisco, 1902–1908.[13]

1903 **Chiura Obata** arrives in San Francisco.

Sadakichi Hartmann publishes *Japanese Art*.

Toshio Aoki hosts elaborate "cherry blossom dinner" at his studio in Pasadena. Reported guests include J. P. Morgan and John D. Rockefeller.

Frank Matsura arrives with photographic equipment in Conconully, a town in eastern Washington, and will open a photographic studio there, in Okanogan County, in 1907.[14]

PINES ON THE SHORE

Teikichi Hikoyama, *Pines on the Shore*, n.d. Woodcut, 11¾ × 6¾ in.

1903
The U.S. passes the Pensionado Act, allowing Filipino students, or *pensionados*, to come to the U.S. on scholarships for higher education. About 400 *pensionados* enter between 1903 and 1924.

Hawaiian Sugar Planters Association brings the first group of Korean contract workers to Hawaii. By 1905, there are about 7,000 Koreans in the islands.

Japanese and Mexican sugar beet workers in Oxnard, California, go on strike. Following the strike, the American Federation of Labor grants the Mexican workers membership into its organization, but they refuse because of the union's exclusion of Japanese workers.

Frank Matsura, *Self-Portrait Series*, ca. 1910. Photograph, two panels, 6 × 8 in.

1903 Moriye Ogihara attends New York Art School. He will also study at the Art Students League in New York.[15]

1904 **Isamu Noguchi** is born in Los Angeles.

Henry Yoshitaka Kiyama arrives in San Francisco; he begins classes at the San Francisco Institute of Art in 1910.

Okakura Tenshin begins work at the Museum of Fine Arts, Boston, to catalog their collection of Japanese art and organize exhibitions.[16]

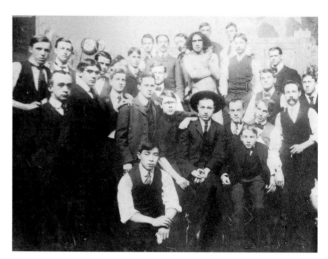

Moriye Ogihara (foreground) at the New York Art School, 1903.

1905 Fifteen-year-old **Shiyei Kotoku** arrives in San Francisco by way of Seattle; he relocates to Los Angeles in 1907.

Henry Motoyoshi, portrait photographer, locates his business on Stockton Street and later O'Farrell Street, ca. 1905–1915. Other San Francisco photographers from this era include George C. Kurimoto, a studio proprietor on Fillmore Street, 1907–1908.[17]

1906 **Yun Gee**'s father takes advantage of the destruction of immigration records and claims U.S. birth and citizenship, thus allowing for the immigration of his son in 1921.

Chiura Obata records the aftermath of the San Francisco earthquake in sketches. **Henry Yoshitaka Kiyama** later documents his earthquake experience in his 1931 autobiographical comic book.

1905 Asiatic Exclusion League, originally called the Japanese and Korean Exclusion League, is formed in San Francisco by trade unionists.

Japan halts Korean immigration to Hawaii and the U.S., abruptly curtailing the growth of Korean immigrant communities.

1906 San Francisco earthquake and subsequent fire result in massive losses and damage, including the destruction of thousands of Chinese immigration records, opening the door for the immigration of "paper sons" from China.

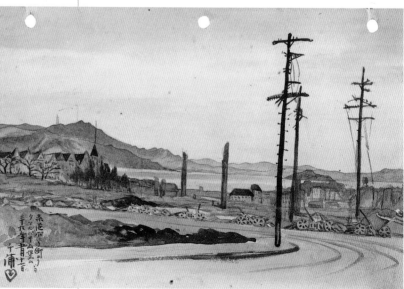

Chiura Obata, *View of Mt. Tamalpais from Polk Street*, 1906. Watercolor and graphite on paper, 5 × 7 ½ in.

Seventeen-year-old **Kamesuke Hiraga** arrives in San Francisco and is reportedly present for the earthquake. **Kyohei Inukai**, a student at Mark Hopkins Institute of Art, leaves San Francisco following the earthquake.

1907 After emigrating from Japan in 1906, **Yasuo Kuniyoshi** begins attending the California School of Art and Design in Los Angeles, where he will study until 1910.

1908 **Hideo Benjamin Noda** is born in Santa Clara, California. He is sent to Japan to attend school from age three to eighteen, then returns to California, attending California School of Fine Arts in San Francisco.

Nine-year-old **Miki Hayakawa** arrives in California with her mother, joining her father in Oakland.

Gozo Kawamura attends the National Academy of Design in New York.[18]

Yukihiko Shimotori.

1909 Painter Yukihiko Shimotori is hired by the American Museum of Natural History to create sketches and models of marine life.[19]

San Francisco School Board orders the segregation of Japanese and Korean schoolchildren into the city's Oriental School, resulting in diplomatic crisis between the U.S. and Japan.

Fifteen Tagalogs, the first group of Filipino contract laborers in Hawaii, arrive on the islands to work on sugar plantations. Filipino sugar plantation workers, known as *sakadas*, become the largest ethnic group in the plantation labor force by the 1920s.

1907 "Gentlemen's Agreement" reached between the U.S. and Japan, partially resulting from Roosevelt's appeasement of anti-Japanese voices in California. Japan agrees to stop issuing passports to Japanese laborers who intend to immigrate to the U.S.

President Theodore Roosevelt signs Executive Order 589, which prohibits Japanese migration from Hawaii, Mexico, or Canada.

1908 In San Francisco, Japanese form the Japanese Association of America, which becomes the central body for local Japanese immigrant groups in the U.S.

Gozo Kawamura (left) in New York, 1908.

1909 Koreans form the Korean Nationalist Association in San Francisco, an organization devoted to working for Korea's liberation from Japan. It also becomes the primary organization representing Koreans in the U.S.

1910 Takuma Kajiwara's photograph of Emma Goldman appears as the frontispiece in Goldman's book *Anarchism and Other Essays*.

1911 **Senko Kobayashi** dies in Japan at the age of forty-one.

1913 **Kazuo Matsubara** attends the San Francisco Institute of Art from 1913 to 1916 and while there befriends **Kamesuke Hiraga** and **Henry Yoshitaka Kiyama**.

1914 Midori and Mistume Kawi art student clubs in Los Angeles hold joint exhibition at the Cannon School of Art.[20]

 Kamesuke Hiraga receives the Julian Prize to study in Paris in 1914 and 1915.

1915 Seattle artist Yasushi Tanaka exhibits *Shadow of the Madrone* in the American artists' section of the Panama-Pacific International Exposition in San Francisco.[21]

 Following study at the San Francisco Institute of Art, **Eitaro Ishigaki** moves to New York and studies at the Art Students League.

1916 Sixth annual exhibition of the Southern California Japanese Art Club is held under the auspices of the Nippon Club in Los Angeles. Exhibiting artists include **Shiyei Kotoku**, **Tokio Ueyama**, H. T. Miyoshi, and H. W. Cannon.[22]

1910 Populations in U.S. per 1910 census:
 CHINESE: 71,531
 JAPANESE: 72,157
 KOREAN: 462
 FILIPINO: 160

 Angel Island Immigration Station, located in San Francisco Bay, opens and serves as the main port of entry to the U.S. for immigrants crossing the Pacific. Immigrants, primarily Asian, are often detained for months before granted or denied entry.

 Japan formally annexes Korea.

1911 Founding of the Republic of China following the revolution of Sun Yat-sen.

1913 California passes Webb-Hartley Law (Alien Land Law), banning "aliens ineligible to citizenship" from buying and leasing land for more than three years. Law amended in 1919 and 1920 to further restrict leasing and close other loopholes.

 Hindustan Gadar, a Hindi-language illustrated journal, begins publication in San Francisco.

1914 World War I begins in Europe.

Imogen Cunningham, *Yasushi Tanaka*, ca. 1915. Vintage platinum print, 6 ½ × 4 ¾ in.

1917 **Wy Log Fong** begins three years of study at the Museum Art School in Portland, Oregon.

Kyohei Inukai moves to New York after studying at the Art Institute of Chicago.

Yajiro Okamoto joins the U.S. Army and serves in World War I.

1918 **Sadikichi Hartmann** resides temporarily in the Verdier mansion on Russian Hill in San Francisco, holding court to many guests.

Chee Chin S. Cheung Lee enrolls at the California School of Fine Arts in San Francisco and wins multiple awards for work in the 1921–1922 and 1922–1923 school years.

Sessue Hayakawa and Tsuru Aoki in *The Dragon Painter*, 1919.

1919 **Sessue Hayakawa** produces and stars in the film *The Dragon Painter*. His wife, Tsuru Aoki, adopted daughter of artist **Toshio Aoki**, is also featured in the film.

1917 Congress delineates a declared "barred zone," including West, South, and Southeast Asia, from which immigration to the U.S. is denied.

U.S. enters World War I.

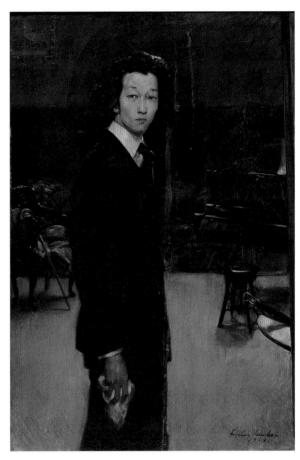

Kyohei Inukai, *Self-Portrait*, 1918. Oil on canvas, 50 × 34 in.

1919 Treaty of Versailles sets terms of peace after First World War.

1920 Populations in U.S. per 1920 census:
CHINESE: 61,639
JAPANESE: 111,010
KOREAN: 1,224
FILIPINO: 5,603

Ten thousand Japanese and Filipino sugar plantation workers in Hawaii strike, marking first coordinated strike effort by the two ethnic groups, whom white plantation owners had previously set in opposition.

489

1921 **Yun Gee** arrives in San Francisco at the age of fifteen.

Tamiji Kitagawa, who studied at the Art Students League in New York, moves to Mexico. He will join the Field Art School and remain in Mexico until 1936, when he returns to Japan.[23]

Tamiji Kitagawa, *Memorial Services of the Cemetery of Tlalpam*, 1930. Oil on canvas, 39 ¼ × 35 ¼ in.

1922 *First Exhibition of Paintings and Sculpture by the Japanese Artists Society of New York City* takes place at the Civic Club. Exhibiting artists include **Eitaro Ishigaki**, T. K. Gado, **Yasuo Kuniyoshi**, Toshi Shimizu, Bumpei Usui, and **Torajiro Watanabe**.

Second exhibition of the East West Art Society (founded 1921) takes place at the San Francisco Museum of Art. Exhibiting artists include **George Matsusaburo Hibi**, **Teikichi Hikoyama**, **Chee Chin S. Cheung Lee**, Spencer Macky, **Kazuo Matsubara**, Perham Nahl, **Kinichi Nakanishi**, **Chiura Obata**, and **Tokio Ueyama**.

1922 *Takao Ozawa v. U.S.* rules that Japanese are ineligible for U.S. citizenship because Ozawa is neither a "free white person" nor of African ancestry, at that time the only categories eligible for naturalization.

Cable Act declares American women will lose citizenship when they marry aliens ineligible for citizenship.

East West Art Society
1922 exhibition catalog.

1923 Shaku-do-sha, an arts association formed in Los Angeles's Little Tokyo by painters **Tokio Ueyama**, Hojin Miyoshi, and **Sekishun Masuzo Uyeno** and poet T. B. Okamura, organizes a major art exhibition. Works by **Shiyei Kotoku**, Hojin Miyoshi, Sojiro Masuda, Kainan Shimada, Terasu Tanaka, **Sekishun Masuzo Uyeno**, and **Tokio Ueyama** are exhibited.

May's Photo Studio opens in San Francisco's Chinatown and will be active until 1976.

Toyo Miyatake opens Toyo Studio in Los Angeles's Little Tokyo.

Shiyei Kotoku exhibition opens at the Los Angeles Museum.

Miki Hayakawa attends the California School of Fine Arts in San Francisco, taking classes until 1929.

1924 The *Rafu Shimpo* sponsors an exhibition by the Japanese Camera Pictorialists of California, a Los Angeles group. The group holds annual salons from 1926 to 1940.[24]

Michi Hashimoto has solo exhibition at the Los Angeles Museum.

Pictorialist photographer **Taizo Kato** dies in Los Angeles at the age of thirty-six.

Charles Park begins four years of study at the Otis Art Institute in Los Angeles.

1925 Shaku-do-sha stages a solo show of work by Edward Weston. Weston will also have photography exhibitions sponsored by the group in 1927 and 1931.[25]

1926 The Chinese Revolutionary Artists Club is established in San Francisco by **Yun Gee**. Gee also founds the Modern Gallery in San Francisco with Otis Oldfield.

The Sangenshoku Ga Kai (Three Primary Colors Art Group) holds its first of two annual exhibitions in San Francisco. Exhibiting artists include **Kiyoo Harry Nobuyuki**, and **Teikichi Hikoyama**.

Yotoku Miyagi moves to Los Angeles and works as an artist and proprietor of the Owl Restaurant, until he returns to Japan in 1933.

Hisako Hibi enrolls in the California School of Fine Arts in San Francisco.

Miki Hayakawa, *Japanese Tea House*, ca. 1925. Oil on canvas, 19 ½ × 23 ½ in.

1924 Immigration Act (also known as Johnson Reed Act) passed by Congress severely limits immigration from southern and eastern Europe and denies entry to virtually all Asians.

Chinese Revolutionary Artists Club, ca. 1926.

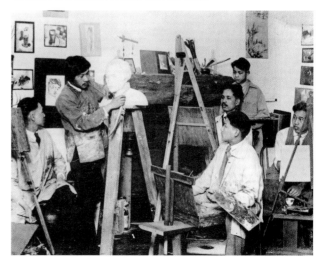

1926 **Kamesuke Hiraga** returns to Los Angeles from Paris and exhibits more than two hundred works in a solo show in Little Tokyo reviewed in the *Los Angeles Times*.

Charles Isamu Morimoto begins attending the Otis Art Institute in Los Angeles, graduating in 1930.

1927 **Yun Gee** leaves San Francisco for Paris.

Exhibition by Japanese Artists in New York is held at the Art Center in New York. Exhibiting artists include **Noboru Foujioka**, **Kyohei Inukai**, **Eitaro Ishigaki**, **Yasuo Kuniyoshi**, Toshi Shimizu, Chuzo Tamotsu, **Byron Takashi Tsuzuki**, Bumpei Usui, **Torajiro Watanabe**, and **Yoshida Sekido**.

Bumpei Usui, *Party on the Roof*, 1926. Oil on canvas, 46 ¼ × 58 in.

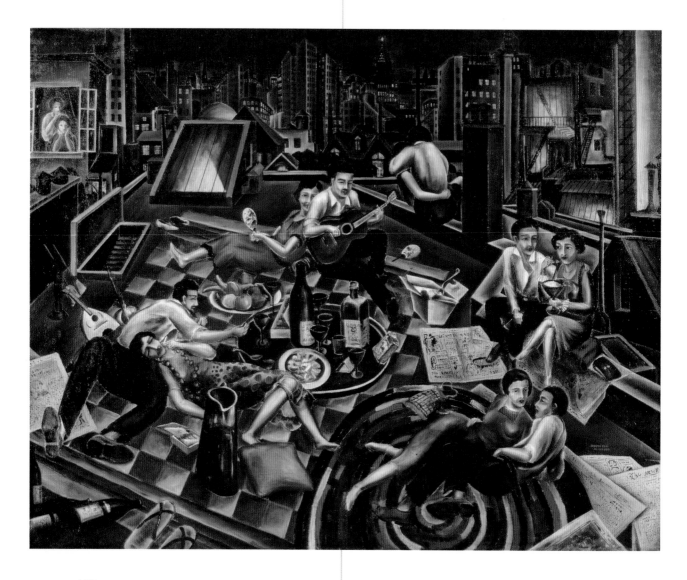

Henry Yoshitaka Kiyama's paintings are exhibited at the Kinmon Gakuen in San Francisco, sponsored by the Sangenshoku Ga Kai. Also exhibited are his biographical Japanese/English cartoons, which he publishes as a book, *Manga Yonin Shosei* (*The Four Students Comic*), in 1931.

Chiura Obata backpacks through Yosemite and the next year makes a master series of woodblock prints in Japan from paintings made during the trip.

The San Francisco Sangenshoku Ga Kai organizes joint exhibition with the Los Angeles Shaku-do-sha association. Show opens in San Francisco and travels to Los Angeles. Exhibiting artists include **Kiyoo Harry Nobuyuki**, **Sakari Suzuki**, **Yotoku Miyagi**, and **Teikichi Hikoyama**.

Noboru Foujioka has solo exhibition at the California Palace of the Legion of Honor, San Francisco, which travels to San Diego, Portland, and the University of Washington in Seattle.

Torajiro Watanabe moves to Los Angeles from New York, where he had been a student at the Art Students League and board member of the Woodstock Art Association.

Ten-year-old **Wah Ming Chang**'s work is exhibited alongside James McNeill Whistler's at the annual exhibition of the Brooklyn Society of Etchers.

Isamu Noguchi receives John Simon Guggenheim Fellowship, which enables him to travel and study in Paris and Asia.

1928 **Chiura Obata** has solo show and **Yang Ling-fu** exhibits work at the East West Gallery, San Francisco.

While studying at the University of California, Berkeley, **Sylvester P. Mateo** receives scholarship to study at the Federal School of Illustration in Minneapolis, Minnesota.

Otis Art Institute students produce *El Dorado, Land of Gold*, featuring cover design by **Benji Okubo** and illustrations by **Charles Isamu Morimoto**, **Hideo Date**, Kiyoshi Ito, and Ryuichi Dohi.

Noboru Foujioka, *Untitled*, ca. 1925.
Ink on paper, 12 × 9 in.

1929 First annual exhibition of *Japanese Artists of Los Angeles* in Little Tokyo. Exhibiting artists include **Yotoku Miyagi**, **Tokio Ueyama**, **Kazuo Matsubara**, and **Torajiro Watanabe**. Reviewed by Arthur Millier with three reproductions in the *Los Angeles Times*.

First annual exhibition of the San Francisco Japanese Art Association. Participating artists include **Hideo Benjamin Noda** and **Takeo Edward Terada**.

Los Angeles resident **Hiromu Kira** is made full fellow in the Royal Photographic Society, London.

Henry Sugimoto travels to Europe to further his studies following his graduation from the California School of Arts and Crafts in 1928.

1929 Stock market plunges on "Black Tuesday," precipitating a worldwide depression that lasts through the 1930s.

Eva Fong Chan, *Landscape*, ca. 1931. Oil on canvas, 9½ × 11 in.

1930 Working from the offices of Fox West Coast Theaters, **Keye Luke** makes enhancements to the artwork for Grauman's Chinese Theater in Los Angeles, which opened in 1927.

Eva Fong Chan joins the Chinese Revolutionary Artists Club, which has continued despite **Yun Gee**'s relocation to Paris in 1927.

Hu Wai Kee, at the age of forty, attends the California School of Fine Arts.

Second annual exhibition of *Japanese Artists of Los Angeles* in Little Tokyo. Exhibiting artists include **Yotoku Miyagi**, **Tokio Ueyama**, **Torajiro Watanabe**, **Hideo Date**, **Kitaro Uetsuji**, and E. Miamo. Reviewed in the *Los Angeles Times*.

Second annual exhibition of the San Francisco Japanese Art Association. Participating artists include **Miki Hayakawa**, **George Matsusaburo Hibi**, and **Chiura Obata**.[26]

Hideo Date joins the Art Students League of Los Angeles and studies with Stanton Macdonald-Wright.

1931 **Chiura Obata** has solo exhibition at the California Palace of the Legion of Honor.

Hideo Benjamin Noda assists Diego Rivera with California School of Fine Arts mural in San

1930 Populations in U.S. per 1930 census:
CHINESE: 74,954
JAPANESE: 138,834
KOREAN: 1,860
FILIPINO: 45,208

Outrage over Filipino men dancing with white women at a dance hall near Watsonville, California, results in violence. Approximately two hundred white men descend on the town's Filipino neighborhood, attacking residents and killing one man.

Japanese American Citizens League is formed in Seattle. It is later headquartered in San Francisco and becomes the largest organization for second-generation Japanese, or Nisei.

Francisco and then attends the Art Students League summer session in Woodstock, New York, sharing a house with fellow artists **Jack Chikamichi Yamasaki** and **Sakari Suzuki**.

Gilbert Leong attends the Chouinard Art Institute in Los Angeles.

1932 **Chiura Obata** begins teaching at the University of California, Berkeley.

Yoshida Sekido and **Isamu Noguchi** each have a solo exhibition at the California Palace of the Legion of Honor in San Francisco.

Nanying Stella Wong receives a scholarship to attend the California School of Arts and Crafts, Oakland. She attends the University of California, Berkeley, concurrently.

Radio City Music Hall opens with women's room murals by **Yasuo Kuniyoshi** and men's room murals by Stuart Davis.

1933 **Hideo Benjamin Noda** assists Diego Rivera on the Rockefeller Center mural in New York.

Henry Sugimoto has solo exhibition at the California Palace of the Legion of Honor in San Francisco, presenting work made during his sojourn in France.

Yotoku Miyagi returns to Japan and dies in prison in 1943, accused of participating in the Sorge Communist spy ring.

Hideo Date and **Benji Okubo** have joint exhibition in Los Angeles sponsored by newspapers *Rafu Shimpo* and *Kashu Mainichi*.

Frank A. Mancao settles in Reedley, California, and begins photographing Filipino community there.

Sakari Suzuki, *Merrick Road*, 1934. Oil on canvas, 20¼ × 26 in.

1933 Appellate court rules in *Salvador Roldan vs. L.A. County* that Roldan could marry a white woman because Filipinos are "Malays, not Mongolians." Legislature is soon added to existing laws to include Filipino-white unions in anti-miscegenation prohibitions.

Los Angeles art group on the occasion of Yotoku Miyagi's departure for Japan, 1933 (Miyagi, back row fifth from left, Toyo Miyatake front row center, Hojin Miyoshi front row right).

Frank A. Mancao, *Mrs. Frank Mancao and daughters with unidentified farm laborers*, ca. 1930.

1934 Exhibition *Four Japanese Artists of the Pacific Coast* at the California Palace of the Legion of Honor. Artists are **Henry Sugimoto**, Masuta Narahara, Kenjiro Nomura, and Kamekichi Tokita.

Hideo Noda participates in Whitney Second Biennial; his painting *Street Scene* is purchased by the museum.

Takeo Edward Terada completes mural *Sports* for Coit Tower project in San Francisco.

The *Contemporary Oriental Artists* exhibition held at the Foundation of Western Art, Los Angeles. Exhibiting artists include **Benji Okubo**, **Hideo Date**, **Gilbert Leong**, **Tokio Ueyama**, **Henry Sugimoto**, **Takeo Edward Terada**, **Miki Hayakawa**, **Tyrus Wong**, and **Wing Kwong Tse.**

After attending Catholic boarding schools in England, Philippines-born Alfonso Ossorio enters Harvard University. His encounters with non-Western art at Harvard's Fogg Art Museum will inform his mature work.

1934 Tydings-McDuffie Act passed, providing for eventual Philippine independence. Act also reduces quota for Filipino immigration to 50 per year and changes Filipinos' status from "nationals" to "aliens."

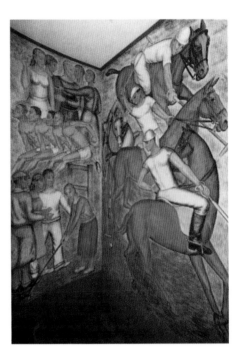

Takeo Edward Terada, *Sports* mural at Coit Tower, 1934. Fresco, two panels, 9 × 10 ft. each.

1935 Chinese Art Association and Japanese Artists of San Francisco groups participate in pageant for the Parilia, Artists' Ball of the San Francisco Art Association.[27]

The San Francisco Museum of Art opens. Artists in inaugural exhibition include **David P. Chun**, **Jade Fon Woo**, **Miki Hayakawa**, **Dong Kingman**, **Kiyoo Harry Nobuyuki**, **Koichi Nomiyama**, Kenjiro Nomura, **Yajiro Okamoto**, **Henry Sugimoto**, **Takeo Edward Terada**, Kamekichi Tokita, and **Yoshida Sekido.**

Takeo Edward Terada returns to Japan, where he continues to work as a successful artist until his death in 1993.

Isamu Noguchi creates his first set design for Martha Graham's *Frontier*, beginning a three-decade-long collaborative relationship.

Chinese Art Association of America opens first exhibition at the de Young Museum. Exhibiting artists include **Eva Fong Chan**, **David P. Chun**,

1935 Repatriation Act of 1935 offers Filipinos who wish to leave the U.S. free transportation, and subjects them to the quota established by the Tydings-McDuffie Act if they intend to return.

Hon Chew Hee, **Hu Wai Kee**, **Nanying Stella Wong**, and Suey B. Wong.

Chingwah Lee and Thomas W. Chinn found the *Chinese Digest* (arts and culture magazine).

Hon Chew Hee has solo exhibition at the Honolulu Academy of Arts.

April 1937 *Chinese Digest* cover with photograph by Wallace H. Fong.

Fong Fong soda fountain, 1935.

Fong Fong soda fountain opens in San Francisco's Chinatown. **Nanying Stella Wong** paints a mural for the interior and designs a neon ice cream sign, plus tea sets and menus.

1936 *Exhibition of California Oriental Artists*, a three-person show with work by **Hideo Date**, **Benji Okubo**, and **Tyrus Wong** at Los Angeles Museum.

Exhibition by Japanese Artists in New York is held at the ACA Gallery, New York. Exhibiting artists include Isamu Doi, **Eitaro Ishigaki**, **Yasuo Kuniyoshi**, Thomas Nagai, Mitsu Nakayama, Kiyoshi Shimizu, **Sakari Suzuki**, Chuzo Tamotsu, Bumpei Usui, and **Jack Chikamichi Yamasaki**.

WPA-sponsored project *California Art Research* begins detailed biographies of prominent California artists, including **Chee Chin S. Cheung Lee**, **Yoshida Sekido**, **Dong Kingman**, and **Chiura Obata**.

1937 **Hideo Benjamin Noda** creates mural at Piedmont High School, near Oakland, California, and returns to Japan by way of Europe. He dies in Japan two years later of a brain tumor at the age of thirty.

Exhibition of California Oriental Painters held at the Foundation of Western Art, Los Angeles. Exhibiting artists include **Hideo Date**, **Miki Hayakawa**, **Keye Luke**, **Charles Isamu Morimoto**, **Tyrus Wong**, **Jade Fon Woo**, **Mine Okubo**, **Benji Okubo**, and **Henry Sugimoto**.

Release of the film *The Good Earth*, based on the novel by Pearl S. Buck and featuring Chinese actors, including **Chingwah Lee**. **Gilbert Leong**'s sculpture *The Good Earth* is exhibited at the Los Angeles County Fair.

1938 **Eitaro Ishigaki**'s murals in Harlem depicting "American Independence" and the "Freeing of the Slaves" are completed. They will be destroyed three years later.

1937 Full-scale war between Japan and China begins.

Eitaro Ishigaki with Harlem mural, ca. 1937.

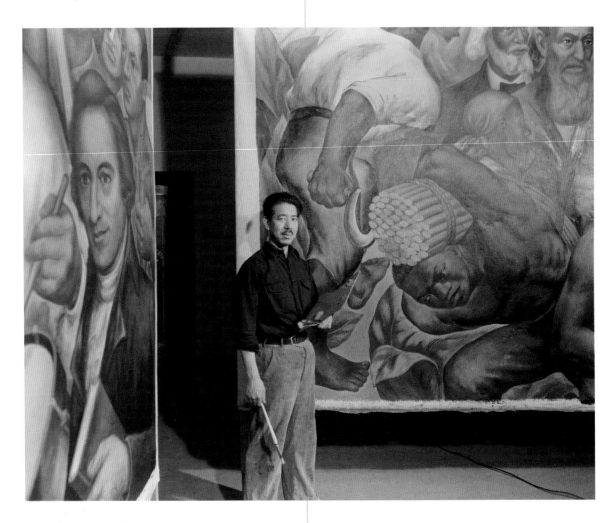

1939 *California Arts and Architecture* magazine dedicates entire issue to Chinese influence in California and includes work by **James Wong Howe**, **George Chann**, **Jade Fon Woo**, **Milton Quon**, **Chee Chin S. Cheung Lee**, **Dong Kingman**, **Tyrus Wong**, **Keye Luke**, and **Gilbert Leong**.

Yoshida Sekido exhibits in the Japanese Pavilion at the Golden Gate International Exposition (GGIE) on San Francisco's Treasure Island. **Yang Ling-fu** exhibits in the Chinese Pavilion.

Contemporary Art Exhibition of the GGIE includes work by **Yasuo Kuniyoshi**, Isami Doi, Kenjiro Nomura, **Henry Sugimoto**, and Chuzo Tamotsu.

1940 **Peter Lowe** assists Diego Rivera on the mural *Pan American Unity* at Treasure Island as part of the GGIE. **Mine Okubo** demonstrates fresco technique.

GGIE *California Art Today* exhibition at the Palace of Fine Arts in San Francisco shows work by **David P. Chun**, Yan-ting Fong, **Hisako Hibi**, **Dong Kingman**, **Chee Chin S. Cheung Lee**, **Ken Nishi**, **Mine Okubo**, **Henry Sugimoto**, **Tokio Ueyama**, **Nanying Stella Wong**, and Thomas S. Yamamoto. **David P. Chun** demonstrates printmaking techniques in the *Art in Action* section, and paintings by **Yasuo Kuniyoshi** are included in the *American Painting* exhibition.

Mine Okubo has solo exhibition at the San Francisco Museum of Art, and a second the following year.

Milton Quon serves as first assistant animator for Walt Disney's *Dumbo*. **Chris Ishii** works on animation for *Fantasia* and *Dumbo*; **Gyo Fujikawa** creates promotional materials for *Fantasia*. Other Disney employees at this time include James Tanaka, **Gene I. Sogioka**, and **Tyrus Wong**.

Chang Shu-chi's painting *Messengers of Peace* is presented to Franklin Roosevelt on the occasion of his third presidential inauguration on behalf of the Chinese government.

1941 **Reuben Tam**'s work is included in the Whitney Museum of American Art's annual exhibition of paintings by artists under forty.

Nineteen-year-old Salinas Junior College student **George Lee** begins series of photographic portraits of elder bachelors in the Chinese community of Santa Cruz, California.

Mine Okubo, *Self-Portrait*, 1941. Tempera on board, 14 × 9 in.

1940 Populations in U.S. per 1940 census:
 CHINESE: 77,504
 JAPANESE: 126,947
 KOREAN: 1,711
 FILIPINO: 45,563

George Lee, *Ah Fook/ Santa Cruz Chinatown*, 1941.

1941 Japan attacks Pearl Harbor on December 7, resulting in U.S. declaration of war.

1941 **Sueo Serisawa**'s one-person exhibition opens at
the Los Angeles Museum on December 7, the day
Pearl Harbor is bombed.

Tyrus Wong paints *Chinese Celestial Dragon* mural
at 951 Broadway in Los Angeles Chinatown.

1942 **Wah Ming Chang** (in model department) and **Tyrus Wong** (1938–1941 pre-production illustration) work on Disney's *Bambi*, released this year.

Chinatown Artists Club (formerly Chinese Art Association of America) holds exhibition at the de Young Museum. Exhibiting artists include **Dong Kingman, Chee Chin S. Cheung Lee, David P. Chun, Peter Lowe**, and **Nanying Stella Wong**. The group exhibits annually at the museum through 1945.

While interned, **Chiura Obata** and others form an art school at the Tanforan Assembly Center. It is reestablished at the Topaz Relocation Center. Teachers include **George Matsusaburo Hibi, Frank Taira, Byron Takashi Tsuzuki**, and **Mine Okubo. Taneyuki Dan Harada** and **Kay Sekimachi** receive their first art training. Art schools are also established at other relocation centers.

Toyo Miyatake smuggles a camera lens into Manzanar Relocation Center and photographs internment experience. Supporters Ansel Adams and Edward Weston later advocate on his behalf to allow him to open a darkroom at Manzanar.

Tokio Ueyama and **Koichi Nomiyama** supervise the art department at the Granada Relocation Center.

Isamu Noguchi voluntarily enters Colorado River Relocation Center in Poston, Arizona, for six months. During this time a solo exhibition of his work is presented at the San Francisco Museum of Art.

Dong Kingman receives a two-year John Simon Guggenheim Fellowship.

1943 After a serious assault, **Chiura Obata** is released from Topaz as part of an early-release program; **George Matsusaburo Hibi** takes over leadership of the art school.

1942 President Franklin D. Roosevelt signs Executive Order 9066, which leads to the incarceration in internment camps of approximately 120,000 Japanese Americans from the West Coast.

Tyrus Wong, *Deer in Woods*, ca. 1940. Ink on paper, 3 1/16 × 4 3/8 in.

Tens of thousands of Japanese, Filipino, Korean, and Chinese Americans serve in the U.S. military.

Nationality Act of 1940 is amended, granting citizenship to noncitizens who join the military and resulting in the enlistment of nearly 10,000 Filipino nationals.

1943 Congress repeals Chinese Exclusion Act and all exclusion laws against Chinese, establishes a small quota of 105 per year, and grants Chinese the right to become naturalized U.S. citizens.

1943 **Chee Chin S. Cheung Lee** has solo exhibition at the California Palace of the Legion of Honor, San Francisco.

Dong Kingman is profiled in and on the cover of *American Artist* magazine.

Chang Shu-chi has first of three solo exhibitions at the de Young Museum, San Francisco.

Miyoko Ito receives release from Topaz Relocation Center to attend graduate school, first at Smith College and later at the School of the Art Institute of Chicago.

George Chann, *Winter Sky*, ca. 1940. Oil on canvas, 12 × 16 in.

1944 **George Chann** has solo exhibition at the de Young Museum, San Francisco.

Kiyoo Harry Nobuyuki creates landscape paintings while at the Gila River Relocation Center.

Chee Chin S. Cheung Lee, *Woman Sewing*, 1932. Oil on canvas, 48 × 38 in.

1944 Draft reinstated for American-born Japanese living in internment camps.

Kiyoo Harry Nobuyuki, *Landscape, Gila River Relocation Center, Rivers, Arizona*, ca. 1944. Oil on canvas, 20 × 24 in.

After leaving the Colorado River Relocation Center, **Isamu Noguchi** designs sets for Martha Graham's ballet *Appalachian Spring*.

Japanese Americans serving in the U.S. Armed Forces include **Chris Ishii**, **Ken Nishi**, **Taro Yashima**, **Nobuo Kitagaki**, **Lewis Suzuki**, and **Sadamitsu Neil Fujita**.

1945 **Dong Kingman** has solo exhibition at the de Young Museum, San Francisco.

New Jersey College for Women presents exhibition of work by interned artists, which travels throughout the U.S.[28]

Jade Snow Wong opens shop in Chinatown, working at her potter's wheel in the store window.

Seriously injured **Ernie Kim** is held in a German POW camp after being the only member of his unit to survive the Battle of the Bulge. He will later learn ceramics as part of occupational therapy in the U.S. Veterans Administration.

1946 Ansel Adams establishes photography program at the California School of Fine Arts in San Francisco and selects students for first classes, including **Benjamen Chinn**.

Chao-chen Yang studies motion picture photography and cinematography at RKO Studios.

Kem Lee opens a photography studio in San Francisco and is active until 1980.

Ruth Asawa begins three years of study at Black Mountain College.

1947 *The Japanese American Artists Group* exhibition is held at the Riverside Museum in New York. Exhibiting artists include **Eitaro Ishigaki**, **Miyoko Ito**, **Isamu Noguchi**, **Koichi Nomiyama**, **Mine Okubo**, **Henry Sugimoto**, **Sakari Suzuki**, Bumpei Usui, and **Taro Yashima**.

Ken Nishi, Mural at Fort Leonard Wood military base (section).

1945 The U.S. drops atomic bombs on Hiroshima and Nagasaki, Japan; World War II ends with Japan's surrender.

1946 Filipinos and Asian Indians gain small immigration quota and right to become naturalized citizens with the passage of the Luce-Celler Bill.

The Philippines gains independence from the U.S.

1947 India achieves independence from Great Britain.

1947 George Tsutakawa begins teaching at the University of Washington in Seattle, where he will teach until 1976.[29]

Contemporary Chinese Painting exhibition at the de Young Museum features work by artists including **Chang Dai-chien**.

Tseng Yuho has solo exhibition at the de Young Museum.

Emiko Nakano attends the California School of Fine Arts from 1947 to 1951.

1948 The Whitney Museum of American Art selects **Yasuo Kuniyoshi** for historic first-ever solo exhibition of a living artist.

1948 The U.S. Supreme Court rules that some provisions of the alien land laws in California are unconstitutional in *Oyama v. California*. California completely ends the laws in 1956.

Korea is divided into North and South.

1949 **Tseng Yuho** relocates from China to Hawaii. **C. C. Wang** moves from China to New York. **Chang Shu-chi** moves permanently to the San Francisco Bay Area. **Chang Dai-chien** leaves China.

1949 Communist leader Mao Zedong announces the formation of the People's Republic of China. The Republic of China continues on the island of Taiwan.

U.S. citizen Iva Toguri D'Aguino, trapped in Japan at the outbreak of World War II and forced with U.S. POWs to participate in propagandistic radio broadcasts as Tokyo Rose, is sentenced to ten years in prison for treason in U.S. court.

Fifth Chinese Daughter by Jade Snow Wong.

1950 Kenzo Okada moves to New York.[30]

Harper and Row publishes **Jade Snow Wong**'s *Fifth Chinese Daughter*, which recounts her struggles against Chinese tradition and American intolerance while growing up in San Francisco's Chinatown.

S. C. Yuan moves to San Francisco, settling in Carmel two years later.

George Lee, who served as a U.S. military photographer in World War II, serves again as a combat photographer in the Korean War.

1950 Populations in U.S. per 1950 census:
 CHINESE: 117,629
 JAPANESE: 141,768
 KOREAN: included in "other race" category
 FILIPINO: 61,636

Korean War begins.

1951 **Katherine Choy** receives M.A. in ceramics from Mills College and the next year is hired to head the ceramics department at Newcomb College, Tulane University.

Hodo Tobase begins living in California. He will serve as the priest at the San Francisco Zen temple Sokoji. During the 1950s he teaches calligraphy at the American Academy of Asian Studies (later called the California Institute of Intregral Studies); his students include Gordon Onslow Ford, **Ruth Asawa**, Joseph Brotherton, and **Saburo Hasegawa** (who also lectured at the academy).

Living in New York, **Eitaro Ishigaki** is threatened with deportation by the FBI and moves permanently back to Japan.

Benjamen Chinn, *Aperture* cover, 1952.

1952 A photograph by **Benjamen Chinn** appears on the cover of the second issue of *Aperture* magazine.

Emiko Nakano exhibits in *American Drawings, Watercolors, and Prints* at the Metropolitan Museum of Art, New York.

Nong (Robert Han) relocates to the U.S. for art study and stays permanently.

Influential Japanese potter Hamada Shōji, with Bernard Leach and Yanagi Sōetsu, gives series of seminars across U.S. Hamada returns frequently to California in the 1960s to teach workshops.[31]

1952
McCarran-Walter Act provides naturalization rights to U.S. residents from Japan or Korea and sets small immigration quotas for other Asian countries.

Yanagi Sōetsu, Bernard Leach, Rudy Autio, Peter Voulkos, and Hamada Shōji at Archie Bray Foundation, Helena, Montana, 1952.

1953 **James Wong Howe** makes *The World of Dong Kingman*, a documentary film.

Yasuo Kuniyoshi dies.

1953 End of Korean War results in renewed immigration of Koreans to the U.S. While immigrants include students and professionals, the majority are servicemen's wives and adoptees.

1953 **Miki Hayakawa** dies in Santa Fe, New Mexico, at forty-nine.

 Leo Valledor attends the California School of Fine Arts and is befriended by artists Wally Hedrick, Jay DeFeo, and Joan Brown. He exhibits frequently at Dilexi and Six Galleries in San Francisco in the 1950s.

1954 *Perceptions* exhibition at the San Francisco Museum of Art includes photography by **Benjamen Chinn** and **Charles Wong**.

 Gyo Fujikawa is featured in *American Artist* magazine.

 Kay Sekimachi studies with Trude Guermonprez at the California College of Arts and Crafts.

 Chang Dai-chien visits **Chang Shu-chi** in Piedmont, beginning annual visits to Northern California prior to establishing residence in Carmel in 1967.

1955 **Saburo Hasegawa** begins teaching at the California College of Arts and Crafts.

 Ruth Asawa, **Emiko Nakano**, and Kenzo Okada exhibit in the São Paulo Biennial Exhibition in Brazil.[32]

1956 **Ernie Kim** is appointed head of the ceramics department at the California School of Fine Arts in San Francisco.

 Gary Woo receives a John Hay Whitney Opportunity Fellowship.

 James Leong travels to Norway on a Fulbright scholarship, having received a John Hay Whitney Opportunity Fellowship the previous year.

 Charles Wong's *Year of the Dragon* photo series appears in *Aperture* magazine.

1954 The U.S. Supreme Court's decision in *Brown v. Board of Education* reverses *Plessy v. Ferguson*, rejecting the rationale of "separate but equal" schools.

 Vietnam is divided into North and South.

1955 The Montgomery bus boycott begins after bus passenger Rosa Parks refuses to yield her seat to a white passenger. The boycott helps spark the civil rights movement.

1956 Dalip Singh Saund of California becomes the first member of the U.S. House of Representatives of Asian descent.

James Leong, *One Hundred Years: History of the Chinese in America*, 1952. Egg tempera and casein on Masonite panels, 60 × 210 in.

1957 Traveling exhibition of work by **Tseng Yuho** is organized by the Smithsonian Institution.

Yayoi Kusama arrives in New York, beginning sixteen-year residence.

Bernice Bing studies under **Saburo Hasegawa** as undergraduate at the California College of Arts and Crafts.

Exhibition of work by **Saburo Hasegawa** is held at the Oakland Museum of California. Months later Hasegawa dies of cancer at fifty.

Chang Shu-chi dies in Piedmont, California, at fifty-seven.

Henry Takemoto studies under Peter Voulkos at the Otis Art Institute (then Los Angeles County Art Institute).

Sessue Hayakawa is nominated for Academy Award for his performance in *The Bridge on the River Kwai.*

James Suzuki, *Introvert*, 1957.
Oil on canvas, 52 × 69 in.

1958 **James Suzuki** receives a John Hay Whitney Opportunity Fellowship.

Hodo Tobase has solo show of calligraphy at the San Francisco Museum of Art.

1958 **James Leong** receives a Guggenheim Fellowship to study in Rome, where he remains for the next thirty years.

Contemporary Painters of Japanese Origin in America at the Boston Institute of Contemporary Art features work by eight artists, including Kenzo Okada.[33]

1959 **Anna Wu Weakland** has solo exhibition at the de Young Museum.

Sadamitsu Neil Fujita creates cover for Dave Brubeck's *Time Out* album.

Contemporary Chinese American Artists exhibition is held at the Los Angeles County Art Institute. Artists include **John Kwok**, **Tyrus Wong**, **Dale Joe**, **Jake Lee**, and **George Chann**.

Victor Duena's work is exhibited frequently in the late 1950s and early 1960s at the Vesuvio Café in San Francisco's North Beach.

Win Ng graduates from the California School of Fine Arts and enters the graduate program at Mills College.

1959 Hawaii becomes fiftieth state. Hawaiian Hiram Fong is first Chinese American elected to the U.S. Senate, and Hawaiian Daniel Inouye becomes first Japanese American in the U.S. House of Representatives.

Victor Duena, *Vesuvio Café, North Beach*, ca. 1955–1960. Gouache or watercolor on paper, 21½ × 27½ in.

1960 **Noriko Yamamoto**, **Ruth Asawa**, Fao Chao-ling, and **Gary Woo** each have a solo exhibition at the de Young Museum.[34]

Whitney Museum's annual *Young America* exhibition includes work by **Sung-woo Chun**, **Dale Joe**, and **Noriko Yamamoto**.

Lui-sang Wong opens East Wind Art Studio in San Francisco.

1960 Populations in U.S. per 1960 census (first inclusion of Alaska and Hawaii populations in census):
CHINESE: 237,292
JAPANESE: 464,332
KOREAN: included in "other race" category
FILIPINO: 176,310

1961 Ceramicist **Win Ng** founds craft and cooking store, Taylor and Ng, with Spaulding Taylor.

1962 **Arthur Shinji Okamura** has solo exhibition at the California Palace of the Legion of Honor.

Win Ng, *Wave*, 1959. Glazed earthenware, 18 × 39 × 6 in.

James Yeh-jau Liu moves to San Francisco and in 1967 establishes Han Syi Studio in Tiburon, California, a small, personal gallery where he makes and sells work until his death in 2003 at ninety-two.

Dong Kingman begins twenty-year tenure as judge for Miss Universe contest.

Matsumi Mike Kanemitsu is included in *14 Americans*, a show at the Museum of Modern Art, New York.

Tseng Yuho has solo exhibition at the San Francisco Museum of Art.

Jade Fon Woo begins annual Jade Fon Watercolor Workshop at Asilomar on the Monterey Peninsula. The popular workshops continue for the next twenty-one years.

1963 **Nong** (Robert Han) opens the Nong Gallery in Oakland, California, which serves as a studio and exhibition space for his work.

Lim Tsing-ai has solo exhibition at the de Young Museum in San Francisco.

Chang Dai-chien sells *Giant Lotus* to *Reader's Digest* for highest price to date for work by a living Chinese artist.[35]

Arthur Shinji Okamura, *Descending Patterns of a Tree*, 1959. Oil on canvas, 60 × 34 in.

1964 **Tseng Yuho** completes multi-panel mural composed of abstract studies of redwood trees for the Golden West Savings and Loan Association in San Francisco.

Cheng Yet-por immigrates to San Francisco.

Nam June Paik makes first visit to New York.[36]

George Miyasaki receives a John Simon Guggenheim Fellowship to study in Paris; when he returns to California, he begins teaching at the University of California, Berkeley.

Masami Teraoka begins four years of study at the Otis Art Institute.

Yoko Ono's influential, conceptual art book, *Grapefruit*, is published.

Martin Wong studies privately under Dorr Bothwell in Mendocino before attending Humboldt State University.

1965 **Lim Tsing-ai** opens the Chinese Art Gallery in San Francisco's Chinatown, showing the work of such artists as **Chang Dai-chien** and Long Ching-san.

Pacific Heritage exhibition tours venues in California and features work by Morris Graves, Paul Horiuchi, **Shiro Ikegawa**, **Arthur Shinji Okamura**, **Sueo Serisawa**, Mark Tobey, George Tsutakawa, and **Tseng Yuho**.

Matsumi Mike Kanemitsu begins teaching at the California Institute of the Arts.

The New Japanese Painting and Sculpture exhibition opens at the San Francisco Museum of Art and travels to venues including the Museum of Modern Art, New York. Artists living in the U.S. included in the exhibition are Genichiro Inokuma, Shusaku Arakawa, Tadasky (Tadasuke Kuwayama), Masaaki Kusumoto, Takeshi Kawashima, Masanobu Yoshimura, Minoru Niizuma, Reiji Kimura, and Minoru Kawabata.[37]

1964 Congress passes the Civil Rights Act, prohibiting racial discrimination in public accommodations, federally funded programs, and public and private employment.

Tonkin Gulf Resolution allows for American combat in Vietnam.

I. M. Pei selected to design the John F. Kennedy Memorial Library in Boston, Massachusetts.

George Miyasaki, *Ode to Evening*, 1964. Color lithograph, 16 ½ × 16 in.

1965 Patsy Takemoto Mink of Hawaii is first Asian American woman elected to the U.S. House of Representatives.

Immigration and Nationality Act abandons the national origins quota system established by the 1924 Immigration Act. It allows for immigration based on family reunification and occupation and leads to unprecedented surge in Asian immigration, particularly from China, Korea, and the Philippines.

Genichiro Inokuma,
Wall Street, 1964.
Oil on canvas,
80 ¼ × 70 ⅛ in.

Notes

The following references were consulted for creating the historical-events portion of the chronology:

Census data from U.S. Census Bureau: www.census.gov/population/documentation/twps0056/tab19.xls; www.census.gov/population/documentation/twps0056/tab C-11.xls. Downloaded January 11, 2006.

Chan, Sucheng. *Asian Americans: An Interpretive History*. Boston: Twayne, 1991.

Daniels, Roger. *Asian America: Chinese and Japanese in the United States since 1850*. Seattle: University of Washington Press, 1988.

Gall, Susan, and Irene Natividad, eds. *Reference Library of Asian America*. Detroit: Gale Research, 1995.

Niiya, Brian, ed. *Encyclopedia of Japanese American History*. New York: Facts on File, 2001.

Okihiro, Gary Y. *The Columbia Guide to Asian American History*. New York: Columbia University Press, 2001.

Tung, William L. *The Chinese in America, 1820–1973*. Dobbs Ferry, N.Y.: Oceana Publications, 1974.

1 "Progress of the Arts among us," *Daily California Chronicle*, June 8, 1854, 2.

2 See Peter E. Palmquist, "Asian American Photographers on the Pacific Frontier, 1850–1930," in *With New Eyes: Toward an Asian American Art History in the West*, by Irene Poon Andersen, Mark Johnson, Dawn Nakanishi, and Diane Tani, 16 (San Francisco: Art Department Gallery, San Francisco State University), 1995.

3 See Peter E. Palmquist, "Preliminary Checklist of Asian and Asian American Photographers and Related Trades, Active in California/Oregon/Washington, 1850–1930," in Andersen et al., *With New Eyes*, 21.

4 See Mark Johnson's essay in this volume.

5 Palmquist, "Preliminary Checklist," 19, 20, 21.

6 Peter E. Palmquist, *Facing the Camera: Photographs from the Daniel K. E. Ching Collection* (San Francisco: Chinese Historical Society of America, 2001), 10, 13.

7 Palmquist, "Preliminary Checklist," 19.

8 Lewis Ferbrache, *Theodore Wores: Artist in Search of the Picturesque* (San Francisco: California Historical Society, 1968), 12, 15.

9 Palmquist, *Facing the Camera*, 14.

10 Palmquist, "Preliminary Checklist," 19.

11 Ibid.

12 Okabe Masayuki, "New World for Artists—History of Artistic Interchange between Japan and U.S. 1896–1945," in *Japanese and Japanese American Painters in the United States: A Half Century of Hope and Suffering, 1896–1945*, 13–15 (Tokyo: Tokyo Metropolitan Teien Art Museum and Nippon Television Network Corporation), 1995.

13 Palmquist, "Preliminary Checklist," 20.

14 See Kazuko Nakane's essay in this volume for more information on Matsura.

15 *Geijutsu Shinchō* (Tokyo) no. 10 (October 1995): 39.

16 See Kazuko Nakane's essay in this volume. Also see *Okakura Tenshin to Bosuton Bijutsukan = Okakura Tenshin and the Museum of Fine Arts, Boston* (Nagoya: Nagoya Bosuton Bijutsukan), 1999.

17 Palmquist, "Premilinary Checklist," 20.

18 Okabe, *New World for Artists*, 14.

19 Ibid., 13.

20 See Nancy Dustin Wall Moure, "Index to Artists Clubs and Exhibitions in Los Angeles before 1930," in *Publications in Southern California Art 1, 2 & 3* (Los Angeles: Dustin Publications, 1984), B-14.

21 *Official catalogue of the Department of fine arts, Panama-Pacific International exposition (with awards) San Francisco, California*. San Francisco: The Wahlgreen Company, 1915, 80.

22 "Japanese Exhibit Art," *Los Angeles Times*, April 23, 1916, 18.

23 *Japanese Artists Who Studied in U.S.A. 1875–1960 (Taiheiyō o koeta Nihon no gakatachi ten)* (Wakayama: Museum of Modern Art, Wakayama, 1987), 99–101.

24 See the essays of Karin Higa and Dennis Reed in this volume.

25 Ibid.

26 "Northern Artists to Hold Big Salon," *Rafu Shimpo* (Los Angeles), November 17, 1930, n.p.

27 See Mark Johnson's essay in this volume.

28 See Gordon Chang's essay in this volume.

29 Mayumi Tsutakawa, ed., *They Painted from Their Hearts: Pioneer Asian American Artists* (Seattle: Wing Luke Asian Museum/University of Washington Press, 1994), 79.

30 For information on Kenzo Okada, see Jeffrey Wechsler, ed., *Asian Traditions/Modern Expressions: Asian American Artists and Abstraction, 1945–1970* (New York: Abrams in association with the Jane Voorhees Zimmerli Art Museum, Rutgers, the State University of New Jersey, 1997), 170.

31 Timothy Wilcox, ed., *Shoji Hamada: Master Potter* (London: Lund Humphries Publishing, 1998), 79.

32 Wechsler, *Asian Traditions/Modern Expressions*, 170.

33 See Tom Wolf's essay in this volume.

34 Ink painter Fao Chao-ling was a friend and student of Chang Dai-chien's. Though a resident of Taiwan, she has had a presence in the San Francisco Bay Area for many years and has exhibited frequently, including a solo exhibition of her work at the Asian Art Museum in San Francisco in 2005.

35 Fu Shen, *Challenging the Past: The Paintings of Chang Dai-chien* (Seattle: University of Washington Press, 1991), 82.

36 See Tom Wolf's essay in this volume.

37 William S. Leiderman, *The New Japanese Painting and Sculpture* (Garden City, NY: Doubleday, 1966).

Acknowledgments

As this publication has been in development for more than a decade, a host of individuals and institutions have played important roles. While it is impossible to credit everyone involved, we want to acknowledge the support we have received from some of these contributors. At the outset, we want to thank the following interns who participated as students conducting primary research and interviews, as their work serves as the foundation for our project. They include Maki Aizawa, Ann H. Bittl, Stine Cacavas, Connie M. Chan, Christine Cheung, Jennifer Cho, Barbara Cooke, Rodney Benedito Ferrao, Christine Abadilla Fogarty, Alison Foley, Michelle Gagnon, Angela Goding, Jasmine Granados, Krystal Reiko Hauseur, Laureen D. Hom, Daniel Huerwitz, Grace Jan, Jamisen Jenkins, Sonia Jerez, Pei-Chi Juan, Lewis Kawahara, Carol Kim, Hee-Jeong Kim, Kelly Kim, Unjung Kim, Kelly Kinoshita, Rebecca Klassen, Jennifer Kong, Brooke Krystosek, Maria Landsberg, Cynthia Lee, Hyung Suk Lee, Di Yin Lu, Nicholas Machida, Sonia Mak, Monica Lee Merritt, Meghan Monahan-Lesseps, Stephani Naruse, Melissa Potter, Eduardo A. Puelma, Rachelle Regan, Mari Shimada, Jung-eun Shin, Melissa R. Singson, Unjung Surh, Reliang Tsang, Vanessa Van Orton, Rochelle Vedres, Allison Watanabe, Jessie Wilson, Cheryl Wong, and Reid Yokoyama. This curriculum initiative was developed in association with the Archives of American Art, Smithsonian Institution and served as a continuation of the Archives' Pacific Northwest Asian American Artists Directory.

Several people have played key roles over many years and warrant special recognition: Irene Poon for her research, photography, and unceasing dedication to the project from its inception to the present; Yoriko Yamamoto for her ongoing commitment, especially in the translation of Japanese-language materials and as a liaison with curators and institutions in Japan; Wei Chang for his role as principal photographer; Marian Yoshiki Kovinick for leading Southern California research in the initial years of the project; and Darlene Tong for her long-term advisory assistance. Several individuals also participated in the organization of the 1995 exhibition *With New Eyes: Toward an Asian American Art History in the West* and were integral in the initial conceptualization of this project, including Dawn Nakanishi, Susan Sterling, and Diane Tani.

We extend our gratitude to colleagues at other museums and institutions who have shared informa-

tion and resources, including Karin Higa and Kristine Kim of the Japanese American National Museum; Daniell Cornell and Timothy Anglim Burgard of the Fine Arts Museums of San Francisco; Ilene Susan Fort of the Los Angeles County Museum of Art; Ba Dong of the Taiwan National Museum of History; the staff of the Chinese Historical Society of America; the staff of the Japanese American History Archives; Franklin Odo of the Smithsonian Institution; and, at museums in Japan, Okawa Eiji of the Okawa Museum of Art; Joe Takeba of the Nagoya City Art Museum; Sugimura Hiroya of the Tochigi Prefec-tural Museum of Fine Arts; Izui Hidekazu and Ōkubo Shizuo of the Museum of Modern Art, Saitama; Kondo Megumi of the Hiroshima Prefectural Museum; Morita Hajime of the Urawa Art Museum; Miwa Kenjin and Kuraya Mika of the National Museum of Modern Art, Tokyo; Sakamoto Makiko of the Masakichi Hirano Museum of Fine Art; Watanabe Miho and Kinouchi Mayumi of the Nagano Prefectural Shinano Art Museum; Sakakibara Kanji, Nakatani Tomoki, and Sakai Tsuyoshi of the Wakayama City Library; Okumura Yasuhiko of the Museum of Modern Art, Wakayama; and Ikeda Yūko of the National Museum of Modern Art, Kyoto. We also would like to extend our appreciation to our educational colleagues, including Carlos Villa at the San Francisco Art Institute; Cecile Whiting and Valerie Matsumoto, who facilitated project internships for students at UCLA; Moira Roth at Mills College, who organized a seminar course on Asian American art; Lorraine Dong at San Francisco State University; Elaine Kim of the University of California, Berkeley; and Bert Winther-Tamaki at the University of California at Irvine.

This project would not have been possible without the generous support of Stanford University, and our deepest gratitude goes to Karen Nagy and the Office of the Dean, School of Humanities and Sciences; Wanda Corn; Bryan Wolf; Martha Coleman; Jeffrey Schnapp and the staff of the Stanford Humanities Lab; Dorothy Steele of the Research Institute for the Comparative Study of Race and Ethnicity; and Muriel Bell, Alan Harvey, Rob Ehle, and Patricia Myers of Stanford University Press.

Great thanks also go to Christine Taylor, Jennifer Uhlich, Melody Lacina, and Tag Savage of Wilsted and Taylor Publishing Services.

Others whose support was integral to the project throughout the years include Rae Agahari, Victoria Alba, George Berticevich, Barbara Bishop, Sharon Bliss, Michael Brown, Carey Caldwell, Arnold Chang, Gerry Chow, Florence Fie, Jeff Gunderson, Manabu Hikoyama, Yoshiko Kakudo, Kimi Kodani Hill, Maxine Hong Kingston, Deborah Kirshman, Ben Kobashigawa, N. Trisha Lagaso Goldberg, Barry Lam, Ibuki Lee, Shelley Sang-Hee Lee, Gretchen B. Leffler, Li Huayi, Li-lan, Larry Lytle, Minoru and Michiko Matsumoto, Peter Palmquist, Harry S. Parker III, former director of the Fine Arts Museums of San Francisco, Vasundhara Prabhu, David Quinteros, Bruce Robertson, Kuiyi Shen, Michael Sullivan, Mayumi Tsutakawa, Denni Usui, Shi-Pu Wang, and Crix Wu.

This book is published with the assistance of the Getty Foundation. We are also grateful for the financial support of the National Endowment for the Humanities and the E. Rhoades and Leona B. Carpenter Foundation. Thanks also to the art collectors and staff at institutions who have allowed the reproduction of their artwork in this volume. Finally, we would like to extend our greatest thanks to the artists and their families and friends who have so generously shared their time, memories, photographs, and artwork with us.

About the Authors

GORDON H. CHANG is a professor of history at Stanford University and specializes in the study of Asian Americans and East Asia–United States relations. He is the author of many books and essays on these subject areas, including *Friends and Enemies: The United States, China, and the Soviet Union, 1948–1972* and *Morning Glory, Evening Shadow: Yamato Ichihashi and His Internment Writings, 1942–1945.* He is co-director of the Stanford Asian American Art Project, and he has received fellowships from the Guggenheim Foundation and the American Council of Learned Societies.

KARIN HIGA is the senior curator of art at the Japanese American National Museum, Los Angeles, where she has curated exhibitions, including *The View from Within: Japanese American Art from the Internment Camps, 1942–1945* and *Living in Color: The Art of Hideo Date,* with accompanying publications that she has authored. She has taught at Mills College, the University of California, Irvine, and Otis Institute of Art and Design and has lectured on Asian American art at institutions across the country.

MARK DEAN JOHNSON is a professor of art at San Francisco State University, where he has directed the "California Asian American Artists Biographical Survey" project. He is also co-director of the Stanford Asian American Art Project. He has collaboratively organized exhibitions, including *Chang Dai-chien in California* and *With New Eyes: Toward an Asian American Art History in the West,* and conferences that include *Expanding American Art History to Reflect Multiethnic Diversity.* He is also the editor of *At Work: The Art of California Labor* and other catalogs.

MAYCHING KAO is the former dean at the Open University of Hong Kong. Prior to serving as dean, she worked for the Chinese University of Hong Kong as a professor of fine arts, the head of the graduate division of fine arts, and the director of the art museum from 1972 to 1998. As a scholar, she specializes in Chinese painting with an emphasis on the Ming, Qing, modern, and contemporary periods, as well as cross-cultural influences and art education. She is the editor of publications including *Twentieth-Century Chinese Painting.*

515

PAUL J. KARLSTROM, former West Coast regional director of the Smithsonian's Archives of American Art, writes about modern and contemporary art in the United States. He is the editor of *On the Edge of America: California Modernist Art, 1900–1950* and has contributed to major studies of Diego Rivera, Jacob Lawrence, and Yun Gee. His Archives of American Art video interview in Seattle and Japan with George Tsutakawa is part of the Smithsonian research collections.

SHELLEY SANG-HEE LEE is an assistant professor of history and comparative American studies at Oberlin College. She has published work on the Seattle Camera Club, a predominantly Japanese pictorial organization that was active from 1924 to 1929. She is completing a book manuscript on pre–World War II Japanese Americans and cosmopolitanism in Seattle.

MARGO MACHIDA is a scholar, independent curator, and writer specializing in contemporary Asian American art and serves as an associate professor of art history and Asian American studies at the University of Connecticut at Storrs. She organized the national touring exhibition *Asia/America: Identities in Contemporary Asian American Art* and is co-editor of *Fresh Talk/Daring Gazes: Conversations on Asian American Art*.

VALERIE J. MATSUMOTO is an associate professor of history and Asian American studies at the University of California, Los Angeles. Her first book, *Farming the Home Place*, examined three generations in a Japanese American community; she also co-edited *Over the Edge*, a collection of essays on the U.S. West. Presently she is writing about Nisei women and the creation of ethnic youth culture in Los Angeles during the Jazz Age and the Great Depression.

KAZUKO NAKANE is an art historian who specializes in Asian American and Asian art. She has contributed essays to catalogs, including *Roger Shimomura: Reaction*; *Asian Traditions/Modern Expressions: Asian American Artists and Abstraction, 1945–1970*; and *Paul Horiuchi* for the Yamanashi Prefectural Museum of Art. Her research article "How Japanese art was introduced in the United States from the late nineteenth century to the early twentieth century" appeared in *Bujutsu Forum* 5 (Winter 2001), published by Daigo Shobo, Kyoto.

DENNIS REED is a collector, curator, and writer focusing on the history of photography. His publications include *Pictorialism in California: Photographs, 1900–1940*, published by the J. Paul Getty Museum and the Huntington Library, and *Japanese Photography in America, 1920–1940*, the catalog for an exhibition shown at the Whitney Museum of American Art, the Corcoran Gallery, the Oakland Museum, and the Japanese American Cultural and Community Center in Los Angeles. He is the dean of arts at Los Angeles Valley College.

SHARON SPAIN has been the associate director of the Stanford Asian American Art Project since 2004 and has managed the "California Asian American Artists Biographical Survey" project for more than ten years. She holds an M.A. in museum studies and has overseen major exhibition and publication projects, including *At Work: The Art of California Labor* and *Chang Dai-chien in California*.

TOM WOLF is a professor of art history at Bard College. He has written extensively about twentieth-century American art, including publications about Yasuo Kuniyoshi (*Yasuo Kuniyoshi*; *Yasuo Kuniyoshi's Women*; and "Kuniyoshi in the Early 1920s," in *The Shores of a Dream: Yasuo Kuniyoshi's Early Work in America*) and studies of the art colony at Woodstock, New York, and the Byrdcliffe Arts and Crafts colony that preceded it.

Credits

P. XIV LEFT: Courtesy Mei Yun Tang Collection.

P. XIV RIGHT: Courtesy University of Washington Libraries, Special Collections, UW 23723z. © Mark Tobey Estate/Seattle Art Museum.

P. XVIII: Courtesy Los Angeles County Museum of Art, purchased with funds provided by Mrs. James D. Macneil, M.2004.27.2. Photo © 2006 Museum Associates/LACMA.

P. XIX: Courtesy Los Angeles County Museum of Art, purchased with funds provided by Mr. and Mrs. Robert B. Honeyman Jr. and Mrs. James D. Macneil, M.2004.27.1. Photo © 2006 Museum Associates/LACMA.

FIG. 1: Courtesy Daniel K. E. Ching Collection, Chinese Historical Society of America.

FIG. 2: Courtesy California Historical Society, TN-6170.

FIG. 3: Courtesy Alisa J. Kim.

FIG. 4: Courtesy San Francisco History Center, San Francisco Public Library. Photo by T. E. Hecht.

FIG. 5: Courtesy Masakichi Hirano Museum of Fine Art, Akita, Japan.

FIG. 6: Courtesy Orange County Museum of Art, Gift of Nancy Dustin Wall Moure.

FIG. 7: Courtesy San Francisco History Center, San Francisco Public Library.

FIG. 8: Courtesy Marilyn Blaisdell.

FIG. 9: Courtesy Vedanta Society of Northern California.

FIG. 10: Courtesy Gyo Obata.

FIG. 11: Whereabouts unknown. Illustration from catalog of 1925 48th annual San Francisco Art Association exhibition. Courtesy San Francisco Art Institute.

FIG. 12: Courtesy Obata Family Collection. Photo by Kinso Ninomiya.

FIG. 13: Courtesy Obata Family Collection. Photo by Kinso Ninomiya.

FIG. 14: Courtesy private collection.

FIG. 15: From Henry (Yoshitaka) Kiyama, *Manga Yonin Shosei (The Four Students Comic)* (San Francisco: Yoshitaka Kiyama Studio, 1931). (Reprinted as *The Four Immigrants Manga,* translated by Frederik L. Schodt [Berkeley, CA: Stone Bridge Press, 1999], 47.) Courtesy Kiyama estate.

FIG. 16: Courtesy Fine Arts Museums of San Francisco, Gift of Herbert Fleishhacker, 1927.225.

FIG. 17: Courtesy private collection.

FIG. 18: Courtesy Ishida Family.

FIG. 19: Courtesy Chinese Historical Society of America.

FIG. 20: From *Chinese Digest,* May 1938, 6. Courtesy San Francisco History Center, San Francisco Public Library.

FIG. 21: Courtesy Freeman Chee.

FIG. 22: Courtesy Aaron Shurin.

FIG. 23: Courtesy San Francisco Museum of Modern Art.

FIG. 24: Whereabouts unknown. Photo courtesy Wing Kwong Tse family collection.

FIG. 25: From *Chinese Digest,* November 13, 1936, 12. Courtesy San Francisco History Center, San Francisco Public Library.

FIG. 26: Courtesy Okawa Museum of Art, Gunma, Japan.

FIG. 27: From *The Records of an Unbroken Friendship but the Mortal Severance, 1907–1924,* Courtesy The Bancroft Library, University of California, Berkeley, BANC PIC 1993.028—fALB.

FIG. 28: Courtesy Archie Miyatake, Toyo Miyatake Studio.

FIG. 29: Courtesy private collection.

FIG. 30: Courtesy Japanese American National Museum, Gift of the Peter Norton Family Foundation, 2005.135.1.

FIG. 31: Courtesy Japanese American National Museum, Gift of the Obata Family, 2000.19.12.

FIG. 32: Courtesy Japanese American National Museum, Gift of the Obata Family, 2000.19.12.

FIG. 33: Courtesy Robert Yamasaki.

FIG. 34: Courtesy Irene Tsukada Germain.

FIG. 35: Courtesy Richard and Amber Sakai Collection. Photo by Wei Chang.

FIG. 36: Courtesy George Eastman House.

FIG. 37: Courtesy Isamu Noguchi Foundation and Garden Museum. © 2007 The Isamu Noguchi Foundation and Garden Museum, New York/Artists Rights Society (ARS), New York.

FIG. 38: Courtesy Archie Miyatake, Toyo Miyatake Studio.

FIG. 39: Courtesy Millard Sheets Library, Otis College of Art and Design.

FIG. 40: Courtesy Tyrus Wong.

FIG. 41: Courtesy Japanese American National Museum, Gift of Hideo Date, 99.111.60.

FIG. 42: Courtesy Japanese American National Museum, Gift of Chisato Okubo, 2003.159.53.

FIG. 43: Courtesy Chinese American Museum at El Pueblo de Los Angeles Historical Monument.

FIG. 44: Courtesy Leslee See Leong.

FIG. 45: Courtesy Okanogan County Historical Society.

FIG. 46: Courtesy Okanogan County Historical Society.

FIG. 47: Louisgarde, "Yasushi Tanaka at Devambez," *Paris Review: An American Magazine in France,* undated clipping in Yasushi Tanaka Letters to Frederic C. Torrey Collection, 1913–1924, in the Archives of American Art, Smithsonian Institution.

FIG. 48: Courtesy George and Betty Nomura.

FIG. 49: Courtesy Urawa Art Museum, Saitama, Japan.

FIG. 50: Courtesy The Museum of Modern Art, Saitama, Japan.

FIG. 51: Courtesy University of Washington Libraries, Special Collections, UW 26363z.

FIG. 52: Courtesy Patrick Suyama Collection.

FIG. 53: Courtesy University of Washington Libraries, Special Collections, UW 13200.

FIG. 54: Courtesy Jean and Edgar Yang.

FIG. 55: Courtesy Jean and Edgar Yang.

FIG. 56: Courtesy Seattle Art Museum, Gift of West Seattle Art Club, Katherine B. Baker Memorial Purchase Award, 33.225.

FIG. 57: Image courtesy Kamekichi Tokita Papers, ca. 1900–1948, in the Archives of American Art, Smithsonian Institution.

FIG. 58: Courtesy Goro Tokita.

FIG. 59: Courtesy Neta Ding. Photo by Richard Nicol.

FIG. 60: Courtesy Priscilla Chong Jue. Photo by Richard Nicol.

FIG. 61: Courtesy John Matsudaira. Photo by John Matsudaira.

FIG. 62: Courtesy John Matsudaira. Photo by Richard Nicol.

FIG. 63: Courtesy Fay Hauberg Page. Photo by Eduardo Calderón, and courtesy Seattle Art Museum.

FIG. 64: Courtesy University of Washington Libraries, Special Collections, UW 23194. Photo by Elmer Ogawa.

FIG. 65: Courtesy A. A. Lemieux Library, Seattle University.

FIG. 66: Courtesy University of Washington Libraries, Special Collections, UW 26361z. Photo by Mary Randlett.

FIG. 67: Courtesy Estate of George Tsutakawa.

FIG. 68: Courtesy Bernadette Horiuchi.

FIG. 69: Courtesy Portland Art Museum, Portland, Oregon, Museum purchase, Caroline Ladd Pratt Fund, 71.4.

FIG. 70: Courtesy Patti Warashina.

FIG. 71: Courtesy Johsel Namkung.

FIG. 72: Courtesy Print Collection, Miriam and Ira D. Wallach Division of Art, Prints and Photographs, The New York Public Library, Astor, Lenox and Tilden Foundations.

FIG. 73: Courtesy private collection.

FIG. 74: Courtesy Tochigi Prefectural Museum of Fine Arts, Utsunomiya, Japan.

FIG. 75: From *Japanese and Japanese American Painters in the United States: A Half Century of Hope and Suffering, 1896–1945* (Tokyo: Tokyo Metropolitan Teien Art Museum and Nippon Television Network Corporation, 1995).

FIG. 76: From *Japanese and Japanese American Painters in the United States: A Half Century of Hope and Suffering, 1896–1945* (Tokyo: Tokyo Metropolitan Teien Art Museum and Nippon Television Network Corporation, 1995).

FIG. 77: Courtesy The Museum of Modern Art, New York, and VAGA, New York. Given anonymously, 15.1936. Digital image © The Museum of Modern Art/Licensed by SCALA/Art Resource, New York.

FIG. 78: Courtesy Whitney Museum of American Art, New York.

FIG. 79: Courtesy Tochigi Prefectural Museum of Fine Arts, Utsunomiya, Japan.

FIG. 80: Courtesy Tochigi Prefectural Museum of Fine Arts, Utsunomiya, Japan.

FIG. 81: Courtesy National Museum of Modern Art, Kyoto, Japan.

FIG. 82: From Ayako Ishigaki (Haru Matsui), *Restless Wave: An Autobiography* (New York: Modern Age Books, 1940). (Reprinted as *Restless Wave: My Life in Two Worlds* [New York: The Feminist Press, 2004].)

FIG. 83: From *New York World Telegram,* December 1937. Photo courtesy Library of Congress, Prints and Photographs Division, NYWT&S Collection.

FIG. 84: From *New York Herald Tribune,* September 26, 1931, 19.

FIG. 85: Courtesy private collection.

FIG. 86: Courtesy Isamu Noguchi Foundation and Garden Museum. © 2007 The Isamu Noguchi Foundation and Garden Museum, New York/Artists Rights Society (ARS), New York.

FIG. 87: Courtesy Isamu Noguchi Foundation and Garden Museum. © 2007 The Isamu Noguchi Foundation and Garden Museum, New York/Artists Rights Society (ARS), New York.

FIG. 88: Courtesy Albright-Knox Art Gallery, Buffalo, NY, Room of Contemporary Art Fund, 1950.

FIG. 89: Courtesy National Gallery of Art, Washington, D.C., Gift of Paul and Hannah Tillich, and courtesy Michael Rosenfeld Gallery, LLC, New York, NY. Image courtesy of the Board of Trustees, National Gallery of Art, Washington, D.C.

FIG. 90: Courtesy Freeman Chee.

FIG. 91: Courtesy Japanese American National Museum, Gift of Hideo Date, 99.111.98.

FIG. 92: Courtesy Whitney Museum of American Art, New York.

FIG. 93: From Photographs of San Francisco's Chinatown, Taken by James Wong Howe 1944, Courtesy The Bancroft Library, University of California, Berkeley, BANC PIC 1996.014—PIC.

FIG. 94: From Earle Liederman, *The Unfinished Song of Achmed Mohammed* (Hollywood, CA: House-Warven Publishers, 1951).

FIG. 95: Courtesy *Fortune* magazine. © 1944 Time Inc. All rights reserved. FORTUNE is a registered trademark of Time Inc. Used with permission.

FIG. 96: Courtesy Ohara Museum of Art, Kurashiki, Japan.

FIG. 97: Courtesy Franklin D. Roosevelt Presidential Library and Museum, Hyde Park, NY.

FIG. 98: Courtesy Isamu Noguchi Foundation and Garden Museum. © 2007 The Isamu Noguchi Foundation and Garden Museum, New York/Artists Rights Society (ARS), New York.

FIG. 99: Courtesy McClelland Collection.

FIG. 100: Courtesy Wakayama City Library, Wakayama, Japan.

FIG. 101: Courtesy Obata Family Collection.

FIG. 102: Courtesy Japanese American National Museum, Gift of the artist, 96.81.1.

FIG. 103: Courtesy Japanese American National Museum, Gift of Kayoko Tsukada, 92.20.3.

FIG. 104: Courtesy Ibuki H. Lee.

FIG. 105: Courtesy Ibuki H. Lee. Photo by Wei Chang.

FIG. 106: Whereabouts unknown. Illustration from catalog of 1943 seventh annual drawing and print exhibition, San Francisco Art Association. Courtesy San Francisco Art Institute.

FIG. 107: Courtesy Fine Arts Museums of San Francisco, Gift of Ibuki Hibi Lee, 1997.2.2.

FIG. 108: Courtesy Karl G. Yoneda Papers (Collection 1592), Department of Special Collections, Charles E. Young Research Library, UCLA.

FIG. 109: Courtesy Eitaro Ishigaki Memorial Museum, Wakayama, Japan.

FIG. 110: Courtesy San Francisco Museum of Modern Art, Gift of the Women's Board.

FIG. 111: Courtesy Chien-fei Chiang.

FIG. 112: Courtesy Asian American Art Project, Stanford University.

FIG. 113: Courtesy Wylie Wong Collection.

FIG. 114: Courtesy George C. Berticevich.

FIG. 115: Courtesy private collection.

FIG. 116: Courtesy Irene Poon.

FIG. 117: From *The Year of the Dragon—1952*. Courtesy San Francisco Art Institute.

FIG. 118: Courtesy Irene Poon.

FIG. 119: Courtesy Jean and Shuji Kashiwabara.

FIG. 120: Courtesy Los Angeles County Museum of Art, Gift of Karl Struss, 28.24.2. Photo © 2006 Museum Associates/LACMA.

FIG. 121: Courtesy Jean and Shuji Kashiwabara.

FIG. 122: Courtesy private collection.

FIG. 123: Courtesy private collection.

FIG. 124: Courtesy private collection.

FIG. 125: Courtesy private collection.

FIG. 126: Courtesy The Nelson-Atkins Museum of Art, Kansas City, Missouri, Gift of Hallmark Cards, Inc., 2005.27.307.

FIG. 127: Courtesy Ruby Graupner.

FIG. 128: Courtesy Japanese American National Museum, Gift of Frank and Marian Sata and Family, 2005.187.1.

FIG. 129: Courtesy private collection.

FIG. 130: Courtesy The Marjorie and Leonard Vernon Collection.

FIG. 131: Courtesy Wilson Centre for Photography.

FIG. 132: Courtesy Archie Miyatake, Toyo Miyatake Studio.

FIG. 133: Courtesy Japanese American National Museum, Gift of Jack and Peggy Iwata, 93.102.102.

FIG. 134: Courtesy Archie Miyatake, Toyo Miyatake Studio.

FIG. 135: Courtesy Colin Lee.

FIG. 136: Courtesy Margaret Herrick Library, Academy of Motion Picture Arts and Sciences.

FIG. 137: Courtesy The Art Institute of Chicago, Gift of David C. and Sarajean Ruttenberg, 1992.1101.

FIG. 138: Courtesy The J. Paul Getty Museum, Los Angeles.

FIG. 139: Courtesy The Nelson-Atkins Museum of Art, Kansas City, Missouri, Gift of Hallmark Cards, Inc., 2005.27.2948.

FIG. 140: Courtesy Colin Lee.

FIG. 141: Courtesy Linda Doler.

FIG. 142: Courtesy Richard and Amber Sakai Collection. Photo by Wei Chang.

FIG. 143: Courtesy private collection. Photo by Wei Chang.

FIG. 144: Courtesy The Ong Family Trust.

FIG. 145: Courtesy Anna Wu Weakland.

FIG. 146: Courtesy Fine Arts Museums of San Francisco, Gift of the Estate of Bernice Bing, 1999.148.

FIG. 147: Courtesy Fine Arts Museums of San Francisco, Gift of Mrs. Edgar Sinton, 1957, A016596.

FIG. 148: Courtesy private collection. Photo courtesy Carlson Gallery, Carmel, CA.

FIG. 149: Courtesy Jim and Sara Coffou Collection, Chicago. Photo courtesy McCormick Gallery, Chicago.

FIG. 150: Courtesy Rosalind Wong.

FIG. 151: Courtesy Ruth Asawa. Photo by Laurence Cuneo.

FIG. 152: From *Honolulu Star Bulletin*, November 13, 1964, 14. Courtesy Melissa Walt.

FIG. 153: Courtesy Eric S. Lee and Teresa Pargeter.

FIG. 154: Courtesy Momo Yashima Brannen.

FIG. 155: Courtesy the Hume family.

FIG. 156: Vessel on left: Courtesy Clay Art Center, Port Chester, NY. Vessel on right: Courtesy Robert A. Ellison Jr.

FIG. 157: Courtesy Eli Leon.

FIG. 158: Courtesy Patrick and Darle Maveety. Photo by Wei Chang.

FIG. 159: Courtesy Valerie Matsumoto.

FIG. 160: Courtesy The Oakland Museum of California, Gift of the Collectors Gallery.

FIG. 161: Courtesy Los Angeles County Museum of Art, Purchased with funds provided by Mr. and Mrs. Thomas H. Crawford Jr., M.2005.115.4. Photo © 2006 Museum Associates/LACMA.

FIG. 162: Courtesy Automobile Club of Southern California Archives.

FIG. 163: From Yang Ling-fu, *Thrice Across the Pacific Ocean* (Taipei: National Palace Museum, 1976).

FIG. 164: Courtesy Guangzhou Art Academy.

FIG. 165: Courtesy Michael D. Brown Collection.

FIG. 166: Courtesy Jane Voorhees Zimmerli Art Museum, Rutgers, The State University of New Jersey. Gift of the International Council of the Museum of Modern Art, Photograph by Jack Abraham, 84.054.013.

FIG. 167: Courtesy private collection.

FIG. 168: Courtesy Wen Lipeng.

FIG. 169: Courtesy private collection. Photo by Wei Chang.

FIG. 170: Courtesy Zhang Shuqi (Chang Shu-chi) Collection, Hoover Institution Archives, Stanford University.

FIG. 171: From *Wang Chi-yuan's Paintings* (Taipei: National Museum of History, 1974).

FIG. 172: Courtesy Shao F. and Cheryl L. Wang.

FIG. 173: Courtesy private collection, Taipei.

FIG. 174: Courtesy Los Angeles County

Museum of Art, Gift of George Kuwayama, AC1993.230.1. Photo © 2006 Museum Associates/LACMA.

FIG. 175: Courtesy Honolulu Academy of Arts, Gift of Tseng Yuho Ecke in honor of Stephen Little, 2005, 13,451.1.

FIG. 176: Courtesy Tseng Yuho.

FIG. 177: Property of Mary Griggs Burke. Photo by Otto E. Nelson.

FIG. 178: Courtesy Lutz Franz.

FIG. 179: From Chen Chi, *Heaven and Water* (New York: Chen Chi Studio, 1983).

FIG. 180: Courtesy private collection.

FIG. 181: Courtesy Fine Arts Museums of San Francisco, 1964.142.83.46.

FIG. 182: Courtesy private collection.

FIG. 183: Private collection, Taipei. Photo courtesy David Diao.

FIG. 184: Photographer unknown. Photo courtesy private collection.

FIG. 185: Courtesy Japanese American National Museum, Gift of Hideo Date, 99.111.104.

FIG. 186: Courtesy Wadsworth Atheneum Museum of Art, Hartford, CT, Gift of an anonymous donor. Photo by Rudy Burckhardt. © 2007 The Isamu Noguchi Foundation and Garden Museum, New York/Artists Rights Society (ARS), New York. Photo © Estate of Rudy Burckhardt/Artists Rights Society (ARS), New York.

FIG. 187: Courtesy The National Museum of Modern Art, Tokyo, Japan.

FIG. 188: Courtesy Gordon Onslow-Ford Collection on extended loan to the San Francisco Zen Center. Photo by Wei Chang.

FIG. 189: Courtesy Noriko Yamamoto.

FIG. 190: Courtesy Paul Karlstrom.

FIG. 191: Courtesy Michael D. Brown Collection.

FIG. 192: Courtesy Nancy Uyemura.

FIG. 193: Courtesy private collection.

FIG. 194: Courtesy Masami Teraoka.

FIG. 195: Courtesy Osaka Contemporary Art Center. Photo courtesy Nancy Uyemura.

FIG. 196: Courtesy Fine Arts Museums of San Francisco, Museum Collection, Z1981.223.

FIG. 197: Courtesy Yolanda Garfias-Woo. Photo by Wei Chang.

FIG. 198: Courtesy Ruth Asawa. Photo by Laurence Cuneo.

FIG. 199: Courtesy Leo Holub Collection.

FIG. 200: Courtesy Museum of Arts &

Design, New York, Gift of the Johnson Wax Company through the American Craft Council, 1977. Photo by Christopher Dube.

FIG. 201: Courtesy Carlos Villa.

FIG. 202: Courtesy Estate of Leo Valledor.

FIG. 203: Courtesy Florence Wong Fie.

FIG. 204: Courtesy Florence Wong Fie.

FIG. 205: Courtesy private collection.

FIG. 206: Courtesy Berkeley Art Museum, Gift of the Theresa Hak Kyung Cha Memorial Foundation. Photo by Trip Callaghan.

FIG. 207: Courtesy Johanna Poethig.

FIG. 208: Courtesy Sekio Fuapopo. Photo courtesy Timothy Drescher.

FIG. 209: Courtesy Jim Dong.

FIG. 210: Courtesy Jack Loo.

FIG. 211: Courtesy Michael D. Brown Collection.

FIG. 212: Courtesy Leland Wong.

FIG. 213: Whereabouts unknown (last displayed at Mission Cultural Center, San Francisco). Photo courtesy Jim Dong.

FIG. 214: Courtesy Leland Wong.

FIG. 215: Courtesy Nancy Hom.

FIG. 216: Courtesy Sekio Fuapopo.

FIG. 217: Courtesy Lars Speyer.

P. 290: Courtesy The Alvarado Project.

P. 291: From *The Pasadena Daily News,* February 9, 1907, 15.

P. 292: Imogen Cunningham, *Ruth Asawa kneeling on the floor of her dining room with tied-wire sculptures*, 1963, gelatin silver print, 9 × 7¾ in. Courtesy Fine Arts Museums of San Francisco, Gift of Ruth Asawa and Albert Lanier, 2006.114.5.

P. 293: Courtesy Soo Masson.

P. 295: Courtesy Jerry Burchard.

P. 296: Eva Fong Chan, *Self-Portrait*, oil on canvas, 11½ × 7½ in. Courtesy Rosalind Wong.

P. 297: Courtesy Leo Holub.

P. 299: Courtesy private collection.

P. 301: Courtesy Irene Poon.

P. 302: Courtesy George Chann Archives.

P. 303: Courtesy Cheng Yet-por family.

P. 304: Courtesy Irene Poon.

P. 305: Courtesy Clay Art Center, Port Chester, NY.

P. 307: From *The San Francisco News,* July 17, 1935, 2.

P. 308: Courtesy Sung-woo Chun.

P. 309: Courtesy Japanese American

National Museum, Gift of Hideo Date, 2001.77.19A.

P. 311: From *Chinese Digest*, August 21, 1936. Courtesy San Francisco History Center, San Francisco Public Library.

P. 313: Courtesy Asian American Art Project, Stanford University.

P. 314: From Robert Perine, *Chouinard: An Art Vision Betrayed: The Story of the Chouinard Art Institute, 1921–1972* (Encinitas, CA: Artra Publishing, 1985).

P. 318: Courtesy Irene Poon.

P. 319: Used by permission of Special Collections, University of California, Riverside Libraries, University of California, Riverside.

P. 321: Courtesy Shobu Hasegawa and Saburo Hasegawa Memorial Gallery.

P. 322: Courtesy private collection.

P. 323: Courtesy Ibuki H. Lee.

P. 324: Courtesy Asian American Art Project, Stanford University.

P. 327: Courtesy Ibuki H. Lee.

P. 328: Courtesy The Bancroft Library, University of California, Berkeley, BANC PIC 1967.014 v.59 GC-172.

P. 329: Courtesy Teikichi Hikoyama family.

P. 332: From *Picturegoer Weekly,* June 12, 1937. Courtesy James Wong Howe Scrapbook, Margaret Herrick Library, Academy of Motion Picture Arts and Sciences.

P. 334: From *The Phoenix* (San Francisco State University newspaper), October 2, 1975.

P. 335: Courtesy Paul Karlstrom.

P. 337: From "The Calligraphic Class of the Sensai," *San Francisco Chronicle*, October 14, 1962, 10.

P. 338: Courtesy Eitaro Ishigaki Memorial Museum, Wakayama, Japan.

P. 340: Courtesy McCormick Gallery, Chicago. Photographer unknown.

P. 341: Courtesy Japanese American National Museum, Gift of Jack and Peggy Iwata, 93.102.96.

P. 343: Courtesy Norman Jayo.

P. 344: Courtesy Irene Poon.

P. 346: From *Japanese Artists Who Studied in U.S.A. 1875–1960 (Taiheiyo o koeta Nihon no gakatachi ten)* (Wakayama, Japan: Museum of Modern Art, Wakayama, 1987).

P. 347: Courtesy Jun Kaneko.

P. 348: Courtesy Nancy Uyemura.

P. 349: From *The Records of an Unbroken*

Friendship but the Mortal Severance, 1907–1924, The Bancroft Library, University of California, Berkeley, BANC PIC 1993.028—fALB.

P. 350: Courtesy Sandria Hu.

P. 351: Courtesy Asian American Art Project, Stanford University.

P. 353: Reproduced with permission from the cover of the February 1943 issue of *American Artist* magazine. © 1943 by VNU Inc., 770 Broadway, New York, NY. All rights reserved.

P. 354: Courtesy Sadamura Rui.

P. 356: Courtesy Masatoyo Kishi.

P. 357: Courtesy Leo Holub.

P. 358: From *The Four Immigrants Manga,* trans. Frederik L. Schodt (Berkeley, CA: Stone Bridge Press, 1999). Courtesy Frederik Schodt. Courtesy Kiyama Estate.

P. 359: Hideo Kobashigawa, *Self-Portrait,* oil on canvas, approx. 24 × 20 in. Courtesy Hideo Kobashigawa Family Collection.

P. 360: From *Japanese Artists Who Studied in U.S.A. 1875–1960 (Taiheiyo o koeta Nihon no gakatachi ten)* (Wakayama, Japan: Museum of Modern Art, Wakayama, 1987).

P. 361: Courtesy Robert Yamasaki.

P. 362: Yasuo Kuniyoshi, *Self-Portrait as a Golf Player,* oil on canvas, 50¼ × 40¼ in. Courtesy The Museum of Modern Art, New York, and VAGA, New York. Abby Aldrich Rockefeller Fund, 293.1938. Digital image © The Museum of Modern Art/Licensed by SCALA/Art Resource, New York.

P. 364: Courtesy David Kuraoka.

P. 367: Courtesy Estate of John Kwok.

P. 368: Pauline Vinson, *Chee Chin,* lithograph, image: 12½ × 15 in. Courtesy Fine Arts Museums of San Francisco, California State Library long loan, A054620.

P. 369: Courtesy Asian American Art Project, Stanford University.

P. 370: From Geoffrey Dunn, *Chinatown Dreams: The Life and Photographs of George Lee* (Capitola, CA: Capitola Book Co., 2002).

P. 372: Courtesy Colin Lee.

P. 373: Courtesy Dan Begonia.

P. 375: Courtesy Leslee See Leong.

P. 376: Courtesy Irene Poon.

P. 378: Courtesy Irene Poon.

P. 379: Courtesy Mary Fuller and Robert McChesney.

P. 380: From 1939 Chouinard School of Art course catalog. Courtesy California Institute for the Arts.

P. 381: From Fred Cordova, *Filipinos: Forgotten Asian Americans* (Dubuque, IA: Kendall/Hunt Publishing, 1983).

P. 382: From *Japanese Artists Who Studied in U.S.A. 1875–1960 (Taiheiyo o koeta Nihon no gakatachi ten)* (Wakayama, Japan: Museum of Modern Art, Wakayama, 1987).

P. 383: Courtesy Orville Jundis.

P. 385: Courtesy George C. Berticevich.

P. 386: From Ippei Nomoto, *Miyagi Yotoku: imin seinen gaka no hikari to kage* [Yotoku Miyagi: Light and Shade of an Immigrant Artist] (Naha, Japan: Okinawa Taimususha, 1997).

P. 388: Courtesy George Miyasaki.

P. 389: Toyo Miyatake, *Self-Portrait,* bromide print, approx. 13 × 10 in. Courtesy Archie Miyatake, Toyo Miyatake Studio.

P. 390: Shiro Miyazaki, *Self-Portrait with Totem Poles,* linocut, 7 × 5 in. Courtesy Michael D. Brown Collection.

P. 392: Courtesy Millard Sheets Library, Otis College of Art and Design.

P. 393: Kinichi Nakanishi, *Self-Portrait,* oil on canvas, 20 × 17 in. Courtesy Kirk and Linda Edgar.

P. 394: Courtesy Kenjilo Nanao.

P. 395: Courtesy San Francisco History Center, San Francisco Public Library.

P. 397: From *Japanese Artists Who Studied in U.S.A. 1875–1960 (Taiheiyo o koeta Nihon no gakatachi ten)* (Wakayama, Japan: Museum of Modern Art, Wakayama, 1987).

P. 399: Courtesy Isamu Noguchi Foundation and Garden Museum. © 2007 The Isamu Noguchi Foundation and Garden Museum, New York/Artists Rights Society (ARS), New York.

P. 401: From *Southwest Art* 10, no. 1 (June 1980): 75.

P. 403: Courtesy Obata Family Collection.

P. 404: Courtesy Irene Poon.

P. 406: Courtesy National Archives and Records Administration, War Relocation Authority records, 210-G-E601.

P. 407: From War Relocation Authority Photographs of Japanese-American Evacuation and Resettlement, Courtesy The Bancroft Library, University of California, Berkeley, BANC PIC 1967.014—PIC.

P. 408: Courtesy Otis College of Art and Design.

P. 409: Courtesy Mei-Lan Shaw.

P. 410: Courtesy Irene Poon.

P. 413: Courtesy Kay Sekimachi.

P. 414: Lou Jacobs Jr., *Sueo Serisawa,* gelatin silver print, 10⅞ × 7¾ in. © Lou Jacobs Jr. Courtesy Tobey C. Moss Gallery, Los Angeles.

P. 416: Courtesy Yayoi Ailene Shibata.

P. 418: Courtesy Japanese American National Museum, Gift of Henry Sugimoto, 93.131.39.

P. 421: From Jimi Suzuki, *Best Time* (Japan: Jimi Suzuki, 1997). Courtesy James Suzuki.

P. 422: Courtesy Lewis Suzuki.

P. 423: Sakari Suzuki working on a mural for Willard Parker Hospital, New York, December 2, 1936. Photo by Andrew Herman. Courtesy Federal Art Project, Photographic Division Collection, 1935–1942, in the Archives of American Art, Smithsonian Institution.

P. 424: Courtesy San Francisco Zen Center.

P. 425: Frank Taira, *Self-Portrait,* oil on canvas, 12 × 9 in. Courtesy Michael D. Brown Collection.

P. 426: From *Japanese Artists Who Studied in U.S.A. 1875–1960 (Taiheiyo o koeta Nihon no gakatachi ten)* (Wakayama, Japan: Museum of Modern Art, Wakayama, 1987).

P. 427: Courtesy Takayama Estate.

P. 428: Courtesy the Voulkos & Co. Catalogue Project, www.voulkos.com.

P. 430: Courtesy Jack G. Kim.

P. 431: Courtesy Masha Zakheim.

P. 433: Courtesy Masami Teraoka.

P. 434: Courtesy Midori Kono Thiel.

P. 435: Courtesy Eli Leon.

P. 436: Courtesy Cynthia Tse Kimberlin Collection.

P. 437: Man Ray, *Tseng Yuho,* 1957, gelatin silver print. Courtesy Tseng Yuho. © 2006 Man Ray Trust/Artists Rights Society (ARS), New York/ADAGP, Paris.

P. 439: Tokio Ueyama, *Self-Portrait,* oil on canvas, 17¼ × 14¾ in. Courtesy Irene Tsukada Germain.

P. 441: Sadayuki Uno, *Self-Portrait,* oil on canvas, approx. 26 × 22½ in. Courtesy Sadayuki Uno family.

P. 443: Courtesy Caridad Concepcion Vallangca.

P. 444: Courtesy Estate of Leo Valledor.

P. 446: Photo taken 1974, printed 1976. Courtesy Carlos Villa and Jerry Burchard.

P. 447: Courtesy Y. K. King.

P. 449: From Patrick J. Maveety, *Anna Wu Weakland* (Stanford, CA: Stanford University Museum of Art, 1988).

P. 450: Courtesy Irene Poon.

P. 452: Courtesy The Ong Family Trust.

P. 454: Courtesy Florence Wong Fie.

P. 456: Courtesy Colin Lee.

P. 458: Courtesy Irene Poon.

P. 459: Courtesy Yolanda Garfias-Woo.

P. 461: Courtesy Noriko Yamamoto.

P. 463: Courtesy Edgar Yang.

P. 465: From *Game & Gossip* (Monterey, CA), November 15, 1972, 17.

P. 466: Courtesy Momo Yashima Brannen.

P. 467: Courtesy Momo Yashima Brannen.

P. 468: From *Game & Gossip* (Monterey, CA), June 15, 1961, 24.

P. 469: Lai Yong, *Self-Portrait,* albumen print/carte de visite, approx. 4 × 2½ in. Courtesy Steve Turner, Los Angeles.

P. 471: From "Yoshida Sekido," in *California Art Research* (San Francisco: WPA, 1937). Courtesy San Francisco Art Institute.

P. 477: "Progress of the Arts among us," *Daily California Chronicle,* June 8, 1854, 2. Courtesy The Bancroft Library, University of California, Berkeley.

P. 478: Courtesy James P. Crain.

P. 479: Courtesy California Historical Society, TN-7013.

P. 480: Courtesy Michael D. Brown Collection.

P. 481: Courtesy Carl Mautz Collection.

P. 482 LEFT: From Leland Gamble, "What a Chinese Girl Did: An Expert Photographer and Telegrapher," *San Francisco Morning Call,* November 23, 1892, 12.

P. 482 RIGHT: From *Los Angeles Herald,* February 17, 1895, 17.

P. 483 LEFT: Courtesy Hiroshima Prefectural Art Museum, Hiroshima, Japan.

P. 483 RIGHT: Courtesy Date City Institute of Funnkawann Culture, Hokkaido, Japan.

P. 484 TOP AND BOTTOM: From *Geijutsu Shinchō* (Tokyo), no. 10 (October 1995).

P. 485 TOP: Courtesy private collection.

P. 485 BOTTOM: Courtesy Okanogan County Historical Society.

P. 486 TOP: From *Geijutsu Shinchō* (Tokyo), no. 10 (October 1995).

P. 486 BOTTOM: Courtesy Fine Arts Museums of San Francisco, Museum purchase, Gift of the Graphic Arts Council, 2001.28.2.

P. 487 LEFT: From *Geijutsu Shinchō* (Tokyo), no. 10 (October 1995).

P. 487 RIGHT: From *Japanese and Japanese American Painters in the United States: A Half Century of Hope and Suffering, 1896–1945* (Tokyo: Tokyo Metropolitan Teien Art Museum and Nippon Television Network Corporation, 1995).

P. 488: Courtesy Japanese American National Museum, Gift of the Peter Norton Family Foundation, 2005.103.1.

P. 489 LEFT: Courtesy Pacific Film Archive.

P. 489 RIGHT: Collection of The National Museum of Modern Art, Tokyo, Japan.

P. 490 TOP: Courtesy Nagoya City Art Museum, Nagoya, Japan.

P. 490 BOTTOM: Courtesy Ibuki H. Lee.

P. 491 TOP: Courtesy Japanese American National Museum, Gift of Yukiyo Hayashi, 99.165.1.

P. 491 BOTTOM: From Joyce Brodsky, *The Paintings of Yun Gee* (Storrs, CT: William Benton Museum of Art, University of Connecticut, 1979).

P. 492: Courtesy Nagano Prefectural Shinano Art Museum, Nagano, Japan.

P. 493: Courtesy Fine Arts Museums of San Francisco, Gift of Archer M. Huntington, 1927.298.

P. 494: Courtesy Rosalind Wong.

P. 495 TOP: Courtesy Smithsonian American Art Museum. Transfer from the U.S. Department of Labor.

P. 495 BOTTOM LEFT: From Fred Cordova, *Filipinos: Forgotten Asian Americans* (Dubuque, IA: Kendall/Hunt Publishing, 1983).

P. 495 BOTTOM RIGHT: From Ippei Nomoto, *Miyagi Yotoku: imin seinen gaka no hikari to kage* [Yotoku Miyagi: Light and Shade of an Immigrant Artist] (Naha, Japan: Okinawa Taimususha, 1997).

P. 496: From *Geijutsu Shinchō* (Tokyo), no. 10 (October 1995).

P. 497 LEFT: Fong Fong advertisement from *Chinese Digest,* November 13, 1936. Courtesy San Francisco History Center, San Francisco Public Library.

P. 497 RIGHT: Courtesy San Francisco History Center, San Francisco Public Library.

P. 498: Image courtesy Federal Art Project, Photographic Division Collection, 1935–1942, in the Archives of American Art, Smithsonian Institution.

P. 499 TOP: Courtesy The Oakland Museum of California, Gift of Roy Leeper and Gaylord Hall.

P. 499 BOTTOM: From Geoffrey Dunn, *Chinatown Dreams: The Life and Photographs of George Lee* (Capitola, CA: Capitola Book Co., 2002).

P. 500: Courtesy Security Pacific Collection, Los Angeles Public Library. Photo by Harry Quillen.

P. 501: Courtesy Irene Poon.

P. 502 TOP LEFT: Courtesy Janet Chann.

P. 502 TOP RIGHT: Courtesy Susie Tompkins Buell.

P. 502 BOTTOM: Courtesy Richard and Amber Sakai Collection. Photo by Wei Chang.

P. 503: From *Fort Wood News* 3, no. 5 (April 9, 1943): 4.

P. 504: Cover illustration by Kathryn Uhl. Courtesy the Estate of Kathryn Uhl and reprinted by permission of HarperCollins Publishers.

P. 505 TOP: *Aperture* 1, no. 2. Courtesy Benjamen Chinn. Reprinted courtesy Minor White Archive, Princeton University Art Museum. Copyright © 1952 by Minor White, renewed by the Trustees of Princeton University.

P. 505 BOTTOM: Courtesy Archie Bray Foundation Archives.

P. 506: Courtesy Chinese Historical Society of America. Photo by Wei Chang.

P. 507: Courtesy Beau R. Ott.

P. 508: Courtesy Los Angeles County Museum of Art, purchased with funds provided by Mr. and Mrs. Thomas H. Crawford Jr., M.2005.115.2. Photo © 2006 Museum Associates/LACMA.

P. 509 TOP: Courtesy Allen R. Hicks.

P. 509 BOTTOM: Courtesy Randall S. and Sheila S. Ott.

P. 510: Courtesy Fine Arts Museums of San Francisco, Gift of Mrs. Edgar Sinton, May 1972, in memory of Dr. E. Gunter Troche, 1972.57.33.

P. 511: Courtesy San Francisco Museum of Modern Art, Gift of Madeleine Haas Russell. © The MIMOCA Foundation.

Index

Asian American Art: A History, 1850–1970
was produced under the auspices of Stanford University Press.

Acquiring Editors Muriel Bell and Alan Harvey
Director of Editorial, Design & Production Patricia Myers
Art Director Rob Ehle

Produced by Wilsted & Taylor Publishing Services
Project Manager Christine Taylor
Art Manager Jennifer Uhlich
Production Assistants Andrew Patty and Mary Lamprech
Copy Editor Melody Lacina
Proofreader Jennifer Brown
Designer and Compositor Tag Savage
Indexer Frances Bowles
Color Supervisor Susan Schaefer
Printer's Devil Lillian Marie Wilsted

Printed and bound by Regal Printing Ltd., Hong Kong,
through Stacy and Michael Quinn of QuinnEssentials
Books and Printing, Inc., on 140 gsm matte art paper